The Illustrated
Encyclopedia of the
Butterfly World

TIGER BOOKS INTERNATIONAL
LONDON

Anthene amarah
Lycaenidae (X30)

The Illustrated
Encyclopedia
of the
Butterfly World

Paul Smart FRES

This edition published in 1991 by
Tiger Books International PLC, London.

©Salamander Books Ltd, 1975
Reprinted 1989

ISBN 1 85501 168 9

Published in the United Kingdom by
Salamander Books Limited,
52 Bedford Row, London WC1R 4LR.

©Salamander Books Limited 1975

This 1989 edition published by Crescent
Books, distributed by Crown Publishers Inc.,
225 Park Avenue South, New York, New York
10003

Printed and bound in Belgium

ISBN 0-517-679728

hgfedcba

Author's Acknowledgements

From conception to completion this book has taken a little over a year and while every care has been taken to ensure that the information conveyed is accurate and up-to-date, I take full responsibility for all errors or omissions which may appear and apologise for these in advance.

The amount that has been achieved in this relatively short time is due in no small measure to the help and encouragement I have received from my wife who has uncomplainingly transcribed the whole of my execrable manuscript and suggested valuable modifications at every stage.

The plates of mounted specimens owe much to the tireless efforts of Trevor Scott who set and prepared for photography thousands of butterflies to make the fullest possible use of the space available. Where this is the main requirement, the aesthetic consideration is naturally secondary but I believe that they succeed admirably in this respect also.

Chris Samson, in addition to producing the artwork on which the diagrams and drawings are based, made significant material contributions to the text, particularly the section on the Heliconiidae – the arrangement of which is based on the most recent work undertaken on this complex group. This, and other work, has entailed long hours at the British Museum (Natural History) and I would like to extend our thanks to the members of the Entomological Department, especially T. G. Howarth and P. R. Ackery, for their unstinted help and cooperation. The majority of the works consulted are in the Saruman library but a few were kindly provided by the Royal Entomological Society of London.

To Hamilton A. Tyler of California I am grateful for information on the status of Nearctic and other Papilionidae. My special thanks also to Dr Arthur Rydon who provided much helpful advice on the taxonomy of the Nymphalidae, although responsibility for the tentative arrangement adopted for this section is mine alone.

Most of the specimens photographed are from the reference collections at Saruman but a number were generously loaned by individuals. In particular J. A. Burgess, John H. Drake, Dr J. W. J. Fearne, Professor Eric Laithwaite, and Lt Col J. C. S. Marsh allowed unlimited access to their fine collections. Specimens were also kindly provided by Dr P. Burdon, R. J. Ford, B. O. C. Gardiner, Nigel Hodges, and Dr A. D. Morton. These and the photographs showing book plates, techniques, etc, were all taken at Saruman by Bruce Scott and the consistently high quality of the results bears witness to his painstaking efforts to ensure accuracy of reproduction.

Thanks are also due to Chris Steer, who designed the book, and to Joan Farmer Artists through whom the drawings, by Marion Mills and Patricia Capon, were commissioned.

To Gita, Rima and the butterflies

'I suppose you are an entomologist?'
'Not quite so ambitious as that, sir.
I should like to put my eyes on the
individual entitled to that name. No
man can be truly called an entomologist,
sir; the subject is too vast for any single
human intelligence to grasp.'

Oliver Wendell Holmes
The Poet at the Breakfast Table

Paul Smart

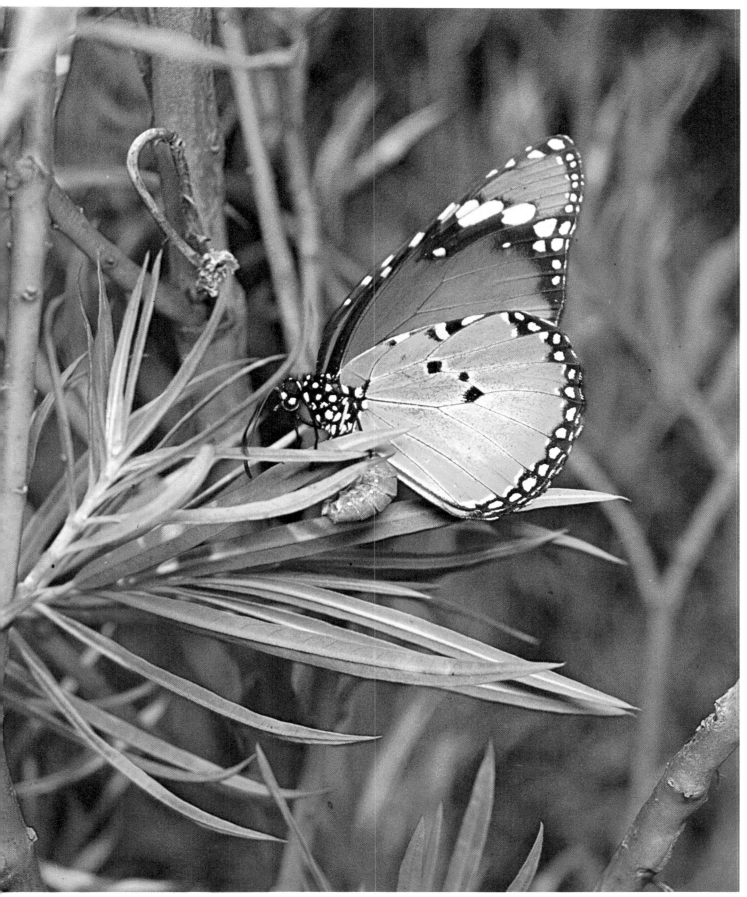

Danaus chrysippus Danaidae (X4)

Contents

Pieridae– 160

whites, jezebels, orange tips, brimstones and sulphurs

Lycaenidae– 170

hairstreaks, blues, coppers etc

Hesperiidae– 110

skippers

Libytheidae and Nemeobiidae– 176

snouts judies, metalmarks

Heliconiidae– 180

helicons

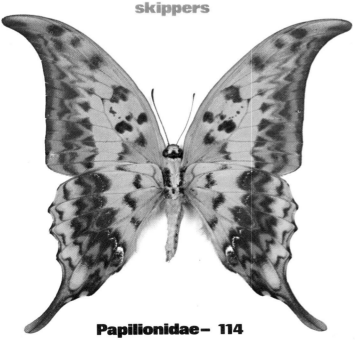

Papilionidae– 114

apollos, swallowtails and birdwings

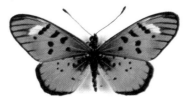

Acraeidae– 188

acraeas

Nymphalidae– 192
fritillaries, vanessas, admirals,
maps, emperors, rajahs etc

Brassolidae– 238
owls

Amathusiidae– 222
fauns, saturns, palm-kings,
duffers, jungle-glories,
jungle-queens etc

Satyridae– 244
browns and satyrs

Morphidae– 228
morphos

Danaidae– 254
tigers, crows etc

Ithomiidae– 250
ithomiids

Introduction

Butterflies are among the most easily recognizable of all animals. Their wings, unlike those of most other insects, are colourful and opaque and they are of characteristic shape. Butterflies are instantly familiar and also universally popular. They seem to escape the general revulsion reserved for most other insects, perhaps because they do not bite, sting, carry disease or (in the adult form) do any serious damage.

Certainly their popularity is due largely to their appearance. Many butterflies are among the most gorgeous of creatures, noted for their glorious colours. In this book a whole chapter has been devoted to the subject of colour and the topic recurs frequently elsewhere. It is worth remembering that while we take colour for granted, in the animal world it is the exception rather than the rule. The development of colour—its range, diversity, brilliance—and the kaleidoscopic assortment of patterns exhibited by butterflies, is unrivalled anywhere in the Animal

Kingdom, except possibly by the birds. Colour is not just a form of eye-catching advertisement, but may be used also for camouflage and defense. As the chapters on Mimicry and Variation show, the adaptability of butterfly coloration, for example in copying other species, is quite remarkable—no other animals show such versatility in their appearance. Butterflies are truly the 'jewels of creation' and amply justify the attention paid to their colours here and elsewhere.

Butterflies are typically active during the day. This is another important factor drawing them to our attention because it not only ensures that their colours will be fully appreciated, but it contrasts sharply with the behaviour of a great majority of animals which are elusively nocturnal.

It is therefore hardly surprising that butterflies have been so popular among collectors. Moreover in many opinions a collection of butterflies is more than just a selection of creatures for scientific study, it is a thing of beauty in itself. The serried ranks of related forms, pinned out in

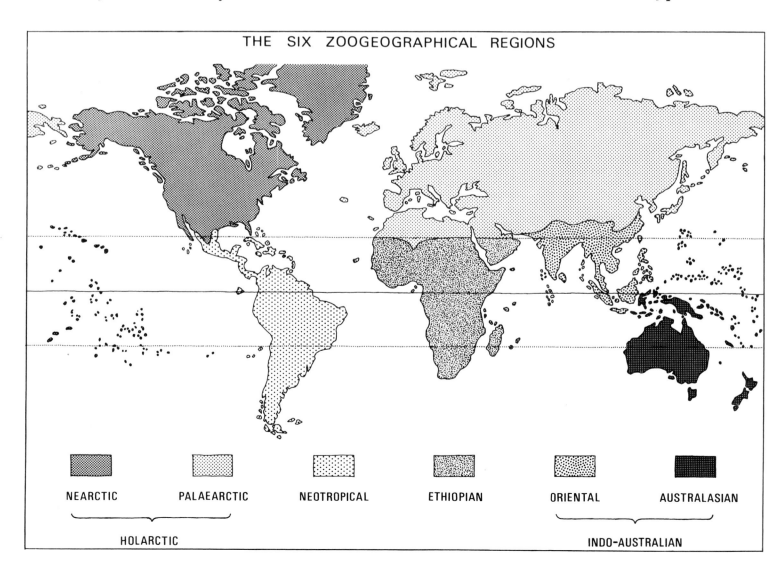

THE SIX ZOOGEOGRAPHICAL REGIONS

NEARCTIC PALAEARCTIC NEOTROPICAL ETHIOPIAN ORIENTAL AUSTRALASIAN

HOLARCTIC

INDO-AUSTRALIAN

drawers and cabinets, provide a scene of regimented symmetry which satisfies some inner demand for orderliness; a feeling perhaps shared by collectors of postage stamps and coins. Enormous collections have been amassed in the past and the study of butterflies, particularly the determination of species and geographical distribution, owes a great deal to the energetic efforts of collectors both amateur and professional. A similar situation is found with the molluscs (where shell collectors have spearheaded the study of the group), and even today malacology, like entomology, rests on a firm foundation built by collectors.

However, to see butterflies merely as pretty objects is to miss half the story, for they are of exceptional interest in many other ways. The wings of these insects are emblazoned with the evidence of their ancestry, like the quarterings on the shields of ancient nobles. This feature makes them fine subjects for an investigation of the ways in which all living things evolve. Moreover, the selective breeding of races and forms has revealed some of the complexities involved in the mechanism of inheritance. The results of these studies may in some cases be of direct benefit to ourselves.

Perhaps the most dramatic example of such a benefit is the recent advance made in combating Rhesus disease; one of the major causes of infant mortality. The way in which this disease is transmitted to the unborn child was initially suggested by quite unrelated research into the genetics of the African swallowtail *Papilio dardanus*. Other butterflies, or their early stages, are used in the study of cancers, anaemia and many virus infections.

Because butterflies are so skilled in flight they have achieved an almost world-wide distribution, though as with most animal groups (particularly cold-blooded ones) there is a greater diversity to be found in the tropics. However, a butterfly can fly only so far and there is a very clear separation between the butterflies which live in widely-

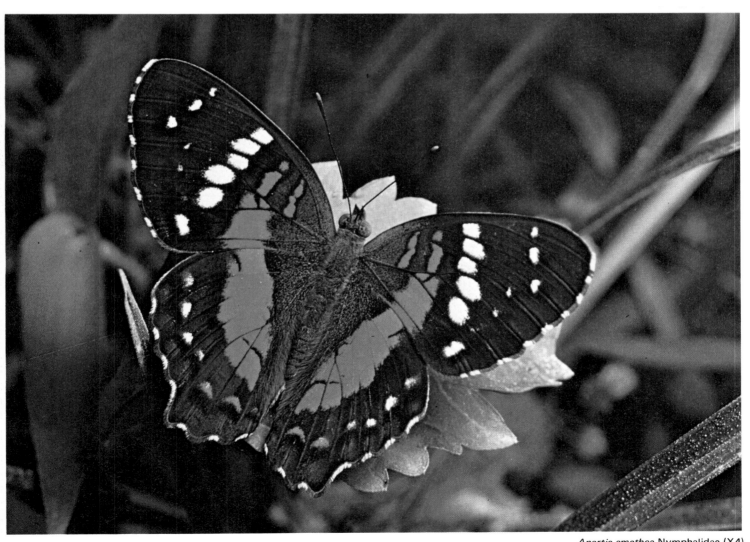

Anartia amathea Nymphalidae (X4)

separated continental land masses. The zoogeographical distribution of butterflies is a fundamental element of their biology and frequent reference is made throughout this book to the major faunal regions of the world (see map).

The butterfly life cycle is no less remarkable than the beauty of the adult. The transformation of the frequently ugly and often bizarre caterpillar into an elegant butterfly is one of the regularly performed miracles of Nature. This natural conjuring trick of turning beast into beauty also includes an ecological subtlety: the larva and the adult are able to lead totally different life styles—thus enabling these two stages of the life cycle to avoid competing with each other for the same food.

The first part of this book attempts to show not only what the butterfly is, but also how it comes to be that way and what it does. The second part aims to illustrate the traditionally recognized family groups of butterflies, showing similarity and diversity within the family and also how each differs from the next. This should help not only to provide an illustrated catalogue of butterflies but also, by reference to the colour plates of study specimens, provide a useful recognition guide.

A single volume cannot hope to cover more than a fraction of the world's butterflies and therefore considerable care has been taken with the systematic list involving much heartache. The arrangement adopted is naturally a compromise, but in eight families (Papilionidae, Libytheidae, Heliconiidae, Acraeidae, Amathusiidae, Morphidae, Brassolidae, and Danaidae) all known species are included. In three more families, (Pieridae, Nymphalidae, Ithomiidae) all genera are covered, and for the remaining families (Hesperiidae, Lycaenidae, Nemeobiidae, and Satyridae) selected genera in all tribes are represented. The colour plates are arranged to illustrate this section on a proportional basis, some families being much more extensively covered than others.

The arrangement of these families, and indeed their basic validity as natural groups, has been questioned, and perhaps here again the butterflies deserve to be singled out. In no other group of animals has the scientific nomenclature been so thoroughly bedevilled by a profusion of names, revisions and repeated attempts to sort out the muddle. The uninitiated should not despair but seek broad guidance from Chapters 1 and 13.

Sadly, butterflies are threatened by habitat destruction almost everywhere. Some of the richest areas for wildlife are being cleared and planted with agricultural crops. Even if the butterflies could survive in the new habitat, their

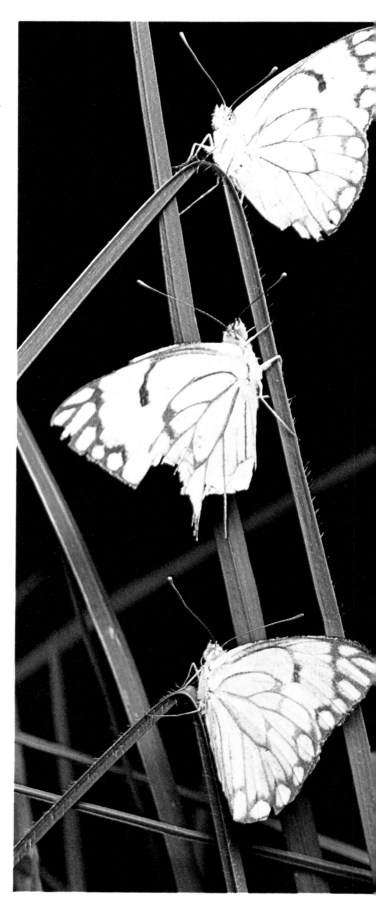

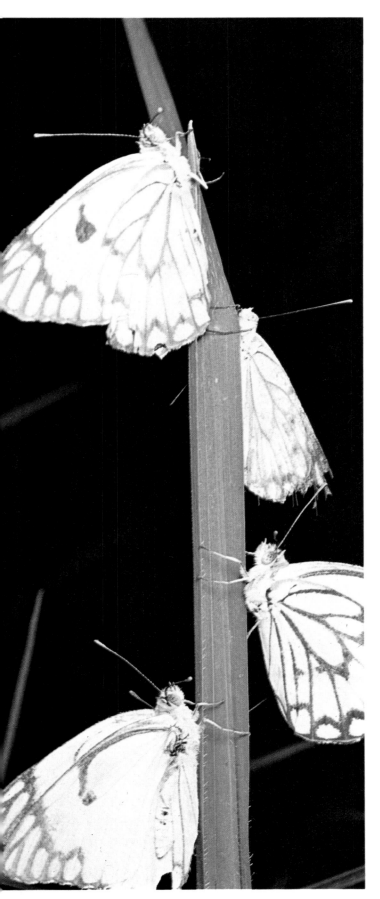

larvae probably would not, because of the loss of their specific food plants. If they took to feeding on the crops instead, they would then be deliberately destroyed as pests. In some countries people have begun to conserve desirable wildlife, but even here many important food plants are regarded as 'weeds' and removed—patches of rough, wild vegetation are anathema to town planners and highways authorities. It is no use protecting butterflies because they are attractive unless we take even greater care to conserve their unattractive larvae and the places where they live.

The lepidopterist may be accused of adding to these destructive forces, but the informed collector is the first to realize the dangers and may often be foremost in acting to conserve dwindling populations. A certain type of collector, however, can be the most dangerous menace. With single-minded determination he deliberately sets out to collect as many different forms as possible, and certain species have had uncommon local populations all but exterminated by selfish and irresponsible collectors.

The modern collector has a duty to make sure that he does not contribute to the problems facing wildlife in general. Certainly, no more specimens than are absolutely necessary for study should be killed, and species already threatened with extinction should not be taken at all.

There are movements in many countries to restrict and control the collecting of certain species, and the collector should accept that legislation may be necessary to ensure the survival of wildlife for future generations to enjoy. A positive contribution may be made by aiding conservation projects and by helping to breed and release healthy butterflies in suitable habitats, though this should always be done as part of a documented and properly organized project.

Paul Smart

Belenois aurota Pieridae (×4)

Chapter 1

The Lepidoptera–

their origin and classification

About three-quarters of all animal species are insects. Their present day abundance and diversity of form suggest a long and complex evolutionary history. In some orders of insects, at least part of this history may be traced by the study of fossils, but butterflies are delicate creatures whose bodies are likely to disintegrate after death and be lost rather than preserved as fossils. Consequently our knowledge of the past history of butterflies is very incomplete and details of their ancestry remain conjectural.

Butterfly and moth fossils which show details of wing venation (the structure and pattern of wing veins is an important clue to evolutionary relationships) are usually in the form of impressions in shale deposits. These were laid down about 30 million years ago during the Oligocene period. In evolutionary terms this is comparatively recent, and it is thus hardly surprising that these fossil butterflies are very similar to those alive today. We are left to guess about the more primitive forms which must have preceded it, for the insects as a whole have existed for at least 400 million years.

The great 'boom' in insect evolution seems to have occurred in the lush gloomy fern forests of the Carboniferous period (perhaps 300 million years ago) whose curious vegetation later formed our coal deposits. One of the more spectacular Carboniferous insects was the giant dragonfly *Meganeura monyi*, with a wingspan of over 65 cm. Today large dragonflies hunt butterflies among other insects, but it is unlikely that early butterflies were contemporary with *Meganeura monyi*. It is more probable that the Lepidoptera (butterflies and moths) evolved much later, perhaps from ancestors of the Mecoptera (scorpion flies) which did not appear until the Lower Permian period 250 million years ago.

The characteristic association of many Lepidoptera with flowering plants might suggest that the two evolved in parallel over a similar period of time. The earliest flowering plants are known from Upper Cretaceous fossils (about 90 million years old), but the wide range of families and genera already present by then strongly suggests that their origins were much earlier. If flowering plants and the Lepidoptera did in fact evolve at the same time, the latter group might then be 150–200 million years old. They would thus have originated in the Triassic period as contemporaries of the first mammals.

The nature of these ancestral butterflies is purely speculative. The early butterflies were probably dull in colour, mainly brown and white, with little of the variety and splendour seen in modern forms. Perhaps the modern Lepidoptera have some giants among their extinct relatives, just as the reptiles once included huge dinosaurs? Alternatively and more likely, the Lepidoptera may have always been small and the nearest they have come to evolving giant forms are the birdwing butterflies and atlas moths living in Asia at the present; none of which have a wingspan in excess of 30 cm.

There are several groups of butterflies alive today which might be considered as primitive, their basic structure having apparently changed little from the presumed ancestral form. Yet these same species may be highly advanced in other respects, for example, having evolved complex breeding patterns. Other modern butterflies would be considered as advanced, having anatomical features which differ in many respects from the primitive plan as well as specializations in other aspects of their biology. However, the fact that both primitive and advanced species are alive today does not mean that the latter are directly descended from the former (any more than humans have developed directly from modern apes). In fact both primitive and advanced species share a common ancestor;

THE PROBABLE EVOLUTION OF THE BUTTERF

ERA	PERIOD	DURATION OF PERIOD (in millions of years)	FLOWERIN PLANTS
CENOZOIC (age of mammals and of man)	Quaternary	2	
	Tertiary	68	
MESOZOIC (age of reptiles)	Cretaceous	65	
	Jurassic	45	
	Triassic	45	
PALAEOZOIC (age of invertebrates and primitive vertebrates)	Permian	55	
	Carboniferous	80	
	Devonian and lower periods	250	

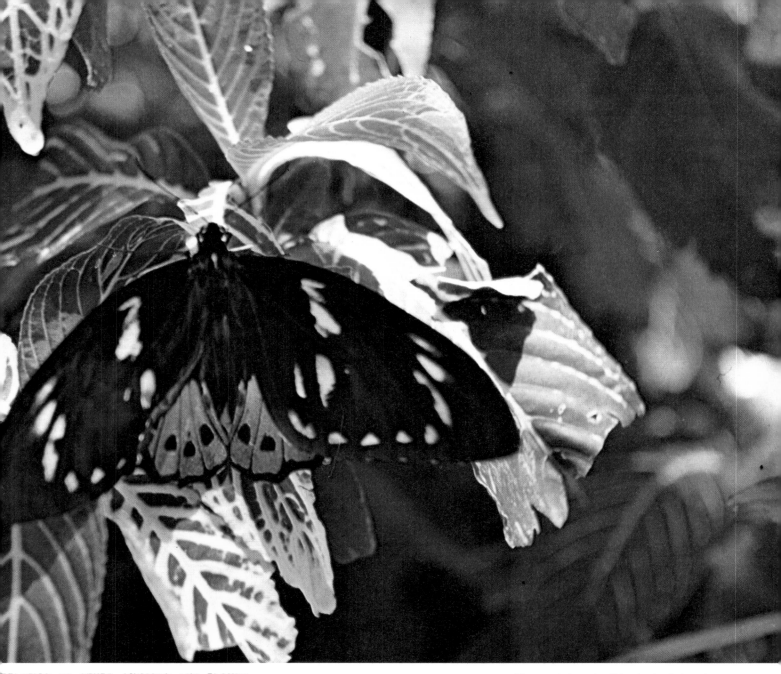

Above: A female (life size) of the giant birdwing butterfly *Ornithoptera priamus* in the jungle of New Guinea. This race is *poseidon* but females of all races are similarly marked, contrasting with the brilliant green of the males. The birdwings are among the largest of all Lepidoptera and females of some species may be almost twice this size.

RELATION TO OTHER ANIMALS AND PLANTS

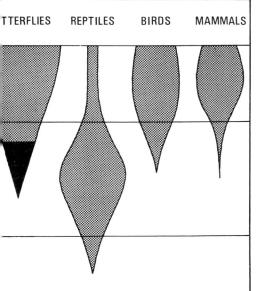

| TTERFLIES | REPTILES | BIRDS | MAMMALS |

Note: the solid black area in the diagram is based on information about insects other than butterflies.

the latter having progressed furthest from the original stock.

The place of butterflies in the Animal Kingdom

Animals are classified into groups called phyla. Each phylum contains creatures which are broadly similar and possess certain diagnostic features in common. For example, the phylum Arthropoda includes all those animals which have jointed limbs and a hard exoskeleton. A phylum is further subdivided into classes: in this case Crustacea (crabs, lobsters, woodlice, etc) Arachnida (spiders, scorpions, ticks, etc) Myriapoda (centipedes and millipedes) and some lesser groups. The largest class of the Arthropoda, and indeed the largest class in the Animal Kingdom, is the Insecta—to which the butterflies belong. Insects all have certain things in common; possessing a head, thorax and abdomen, six legs, and one pair of antennae; further details of their structure and life history form the

The Lepidoptera

basis for dividing the class into 29 orders. These orders are divided into two groups, the Apterygota (wingless) and the Pterygota (winged), the latter being the larger group of orders. The Pterygota are further divided into the Exopterygota and the Endopterygota; the life history of insects in the former groups consists of egg → larva (which is similar to adult) → adult, and that of the latter is egg → larva (which is unlike adult) → pupa → adult.

The Lepidoptera is a very distinctive order of insects in the Endopterygota, second only to another endopterygote order, the Coleoptera (beetles) in numbers of species. It is difficult to say exactly how many species of Lepidoptera there are since many new ones are described every year. Many more are certain to be discovered in the future, adding to the 140,000 or so already known.

Butterflies, including recently extinct forms, account for about 20,000 of these species.

Particular attention has been paid to the butterflies, perhaps because most are active during the daytime (therefore easily seen and collected) and many are strikingly coloured. It is therefore likely that fewer species remain to be discovered than for other insect groups and we might reasonably assume that less than 30,000 species exist.

With so many species in such variety, there is obviously need to devise an orderly system of classifying them into groups. Traditionally we think of butterflies and moths as though they were two equivalent subdivisions of the Lepidoptera (called by early entomologists respectively Rhopalocera – 'club-horned' and Heterocera – 'varied-horned'). In fact the numbers of species given above show that this is not the case. The 140,000 Lepidoptera comprise 20,000 butterflies plus six times as many moths in several equally distinct but quite separate groups. Even the division into 'butterflies' and 'moths' has little scientific validity, though it is still used for convenience. Conventionally, butterflies have clubbed antennae, fly by day and are often brightly coloured; whereas moths are nocturnal, usually dull coloured and have tapered or feathery antennae. The looseness of such a classification is shown by the abundance of exceptions to it, eg the many colourful day-flying moths, some of which even have clubbed antennae.

An alternative distinction is based upon the way in which the wings are linked during flight. In moths there is usually a lobe in the fore wing or spines on the hind wing which act as a coupling mechanism. In butterflies the coupling is achieved by the large area of overlap of the fore and hind wings; but this is again subject to exceptions.

Another method of dividing up the Lepidoptera, convenient though not universally accepted, involves grouping them into two suborders and then various superfamilies. Under this obsolete scheme, a few primitive moths which have similar fore and hind wings were placed in the suborder Homoneura. All butterflies and most moths make up the other suborder, Heteroneura, having structural differences between fore and hind wings. Within this huge group there are 20 superfamilies, only two of which (Hesperioidea and Papilionoidea) are described as butterflies. More recently the subdivisions of Monotrysia and Ditrysia have been used, these are based on characters describing the female genitalia.

The details of classification are controversial and perhaps better left to the specialist. In this book the traditional family divisions have been retained for simplicity, though there are strong arguments in favour of alternative groupings. For instance of the 15 families of

Right: Lepidoptera in relation to some other large orders of insects.
Numbers 3 and 4 belong to the division Exopterygota, the others to the division Endoterygota. Of the Lepidoptera number 7 belongs to the suborder Homoneura, 8 and 9 to the suborder Heteroneura.
1. Hymenoptera (ants, bees and wasps): bumble bee *Bombus hortorum*, Europe.
2. Neuroptera (alder flies, lacewings, etc): ant lion *Hybris* species, Borneo.
3. Odonata (dragonflies): demoiselle *Agrion virgo* ♀, Europe.
4. Hemiptera (true bugs): plant hopper *Penthicodes* species, Borneo.
5. Coleoptera (beetles): stag beetle *Lucanus cervus*, Europe.
6. Diptera (true flies): horse fly *Tabanus sudeticus*, Europe.
7. Lepidoptera (butterflies and moths): ghost swift *Hepialus humuli* ♀, Europe.
8. Lepidoptera: hawk moth *Xylophanes tersa*, Brazil.
9. Lepidoptera: small brown shoemaker butterfly *Hypanartia lethe*, Peru.

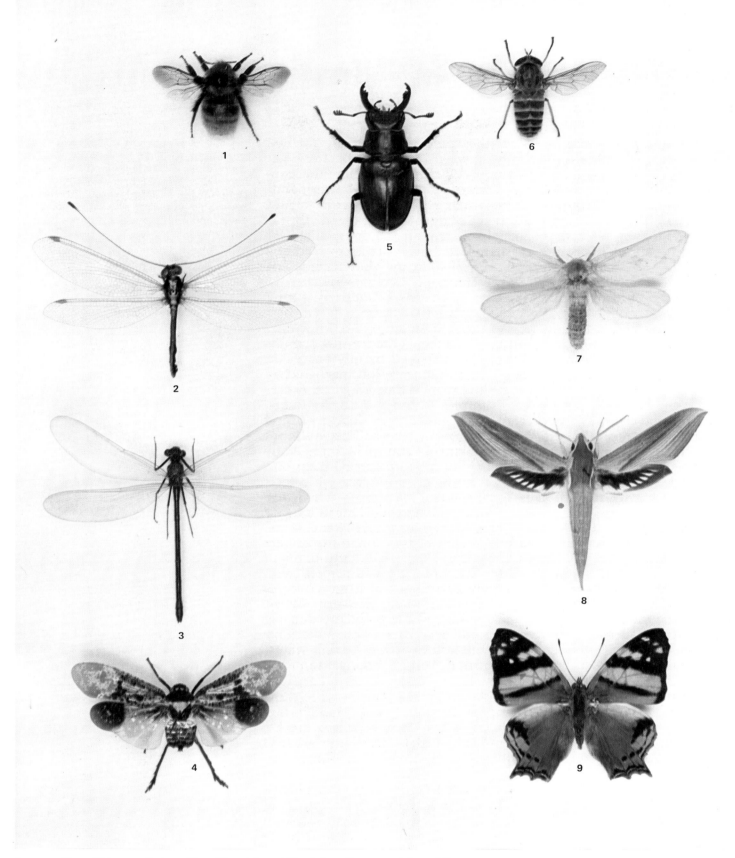

butterflies (Hesperiidae, Papilionidae, Pieridae, Lycaenidae, Nemeo-
biidae, Libytheidae, Heliconiidae, Acraeidae, Nymphalidae, Ama-
thusiidae, Morphidae, Brassolidae, Satyridae, Ithomiidae and Danai-
dae) some authorities would regard nine as constituting a single
complex family, the Nymphalidae, but such an arrangement would
be unwieldly and unhelpful.

 As a small guide amidst apparent confusion, readers should note
that all family names in the Animal Kingdom end in – idae to dis-
tinguish them from super family names (ending in – oidea) and sub
families which end in – inae.

Chapter 2

The Butterfly Body–

its structure and function

Adult butterflies are built on the same general plan as their other insect relatives such as the wasps, bees and beetles. The body is protected by an armour of chitin (forming the exo-skeleton) and this is arranged in a series of rings or segments separated by flexible membranous zones which allow movement to take place. The body consists of three main regions, the head, the thorax and the abdomen, all with a specialized structure to equip them for different functions in the life of the insect. Each part is covered in a layer of minute scales which are responsible for the soft, downy appearance of the body as well as the frequently vivid coloration so characteristic of butterflies.

The head

The head is a small spherical capsule which bears the feeding appara-tus and sensory structures. Adult butterflies feed mainly on nectar from flowers, although honey dew (the sweet secretion produced by aphids), decaying fruit, the sap exuding from damaged trees, excre-ment or the juices of carrion are examples of other butterfly foods. Butterflies have no jaws and must always take their food in liquid form using a specially modified 'tongue' or proboscis. This is a long, hollow tube which is coiled like a watch-spring and tucked under the head when not in use. It can be quickly unrolled to probe deep into flowers; this extension being brought about by an increase in blood pressure. This feeding tube is composed of two parts which are grooved on their inner surface and joined along their length by tiny interlocking spines. The liquid food is sucked up the central channel between the two parts and there is a special type of pump in the head to assist in this. The continuous passage of sticky fluid tends to clog the channel and so the proboscis has to be cleaned periodically.

Since butterflies never bite or chew their food, jaws or mandibles are absent. A pair of sensory palps or feelers (labial palps) are present instead, one on each side of the proboscis. These palps are densely covered with scales and sensory hairs and serve to test the suitability of the food source. Some species of butterflies actively drink water, by using their proboscis, and the enormous congregations on muddy

Right: A close-up view of the head of a small pearl-bordered fritillary *Clossiana euphrosyne,* a common woodland butterfly in Europe. Note the large compound eyes, labial palps, antennae, and coiled proboscis. The small, poorly developed fore-legs are a feature of the family Nymphalidae. (X 100).

Below: An anotated version of the photograph on the right.

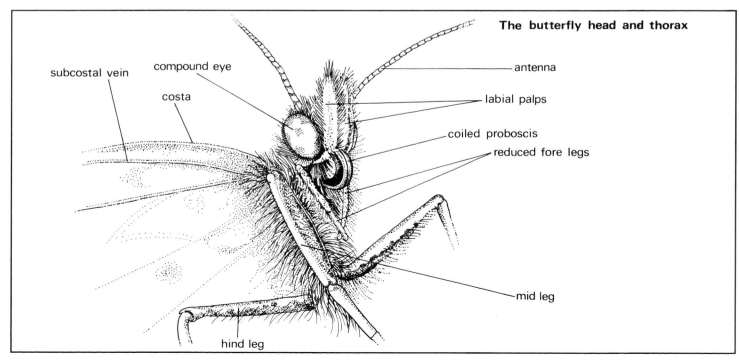

The butterfly head and thorax

subcostal vein

compound eye

costa

antenna

labial palps

coiled proboscis

reduced fore legs

mid leg

hind leg

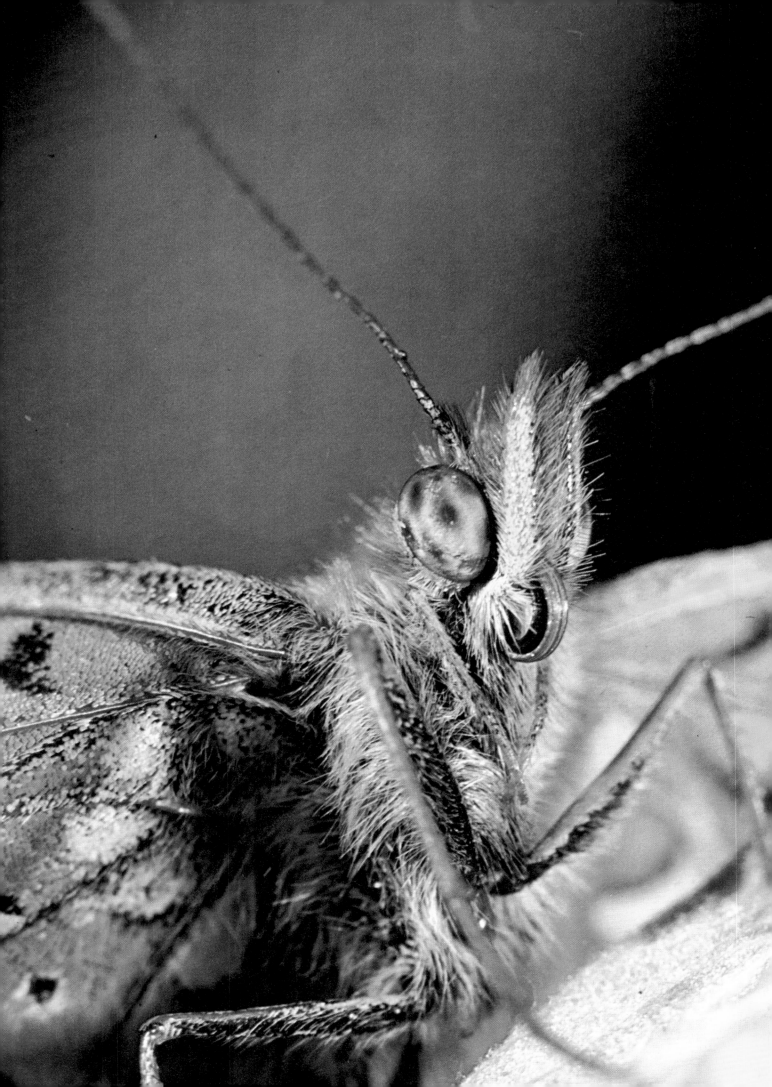

The Butterfly Body

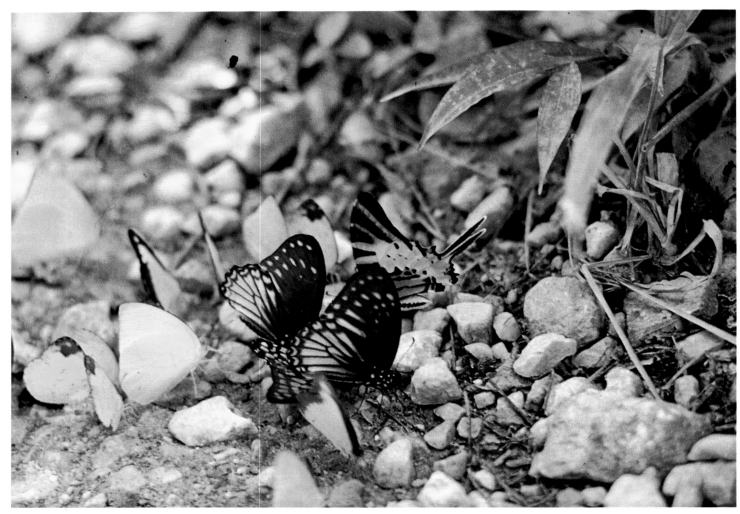

river banks are a notable feature of the tropics.

The antennae are typically club-ended in butterflies. Each antenna consists of a series of rings or segments and both the number of segments and size of the club varies in different families, the skippers (Hesperiidae) for example, often have very pronounced 'hooks'. The antennae are sense organs which are responsible for balance and smell. The base of the antenna houses a specialized organ, Johnston's organ, and it is this which is of value in sensing the insect's orientation, particularly during flight. The smell receptors are scattered over the entire surface of the antenna.

The eyes of butterflies are conspicuous hemispherical swellings on the top of the head. They are called 'compound' eyes because each

Above: Assemblies of butterflies in damp places are a common sight in the tropics. This Malayan group includes two specimens of *Graphium ramaceus* (trampling on *G. bathycles*), the long-tailed *G. antiphates, Appias lyncida, Catopsilia pomona* and *Terias hecabe*.

Right: This California pipevine swallowtail *Battus philenor* is hanging from its pupa case (X 15).

Below: An anotated version of the photograph on the right.

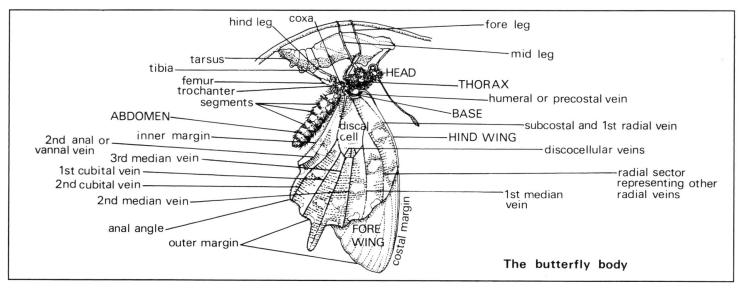

The butterfly body



20

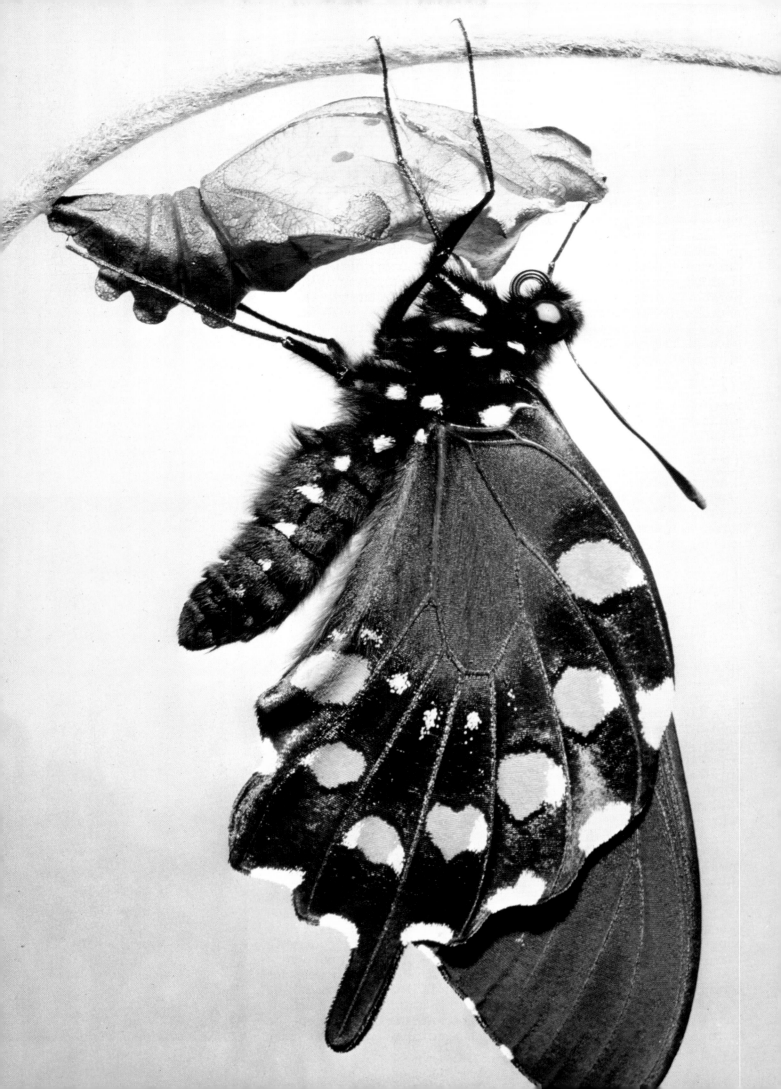

eye is composed of a large number of optical units or ommatidia. The individual ommatidium resembles a simple eye with a lens and a light receptive region, and each one is capable of forming its own visual image. Each ommatidium is sheathed by a layer of pigment which serves to separate it from its neighbours. A butterfly therefore sees its surroundings as a complex mosaic of tiny pictures, each picture being created by a single ommatidium. Although butterflies can readily detect the movement of objects, the acuity of their vision is much inferior to that of man. They are able to detect a limited number of different colours by discriminating between light sources of different wavelengths. This simple colour vision may be illustrated by the fact that certain types of butterfly will frequent flowers of a particular colour; for example, swallowtails (Papilionidae) regularly visit red flowers. Butterflies are also capable of detecting ultra-violet light, which is invisible to humans, and this suggests they may well see the colour of flowers in quite a different way to us. Other light sensitive structures known as the dorsal ocelli occur on the top of the head between the large compound eyes. These ocelli are very small and play little part in the vision of adult butterflies.

The thorax

The middle zone or thorax of the body is the locomotory region, where both the legs and wings are located. The head is joined to the thorax by a flexible neck or cervix. The thorax is composed of three segments and each carries a pair of legs adapted both for walking and clinging. Each leg consists of several regions, the basal joint (coxa), the thigh (femur), the shank (tibia) and the foot (tarsus). The coxa and femur are joined by a small triangular segment, the trochanter. The foot commonly has five joints and ends in a pair of claws. In the Nymphalidae the front legs are very short and held close to the body, giving the odd appearance of an insect having only four legs.

The shank or tibia of the fore leg in some species has a mobile spur or epiphysis which is armed with a brush of hairs and is used to clean the antennae. Surprisingly butterflies also use their feet to taste their food, so there are numerous sense organs on the tarsi.

The two pairs of wings belong to the second and third thoracic segments (meso- and meta-thorax). The delicate wings consist of an upper and lower membrane with a framework of hollow tubes between the layers. These supporting tubes are called veins and they are arranged in a very precise way. The overall pattern or venation is often a diagnostic feature of a group of butterflies and consequently wing venation is an important tool in classification. The principal veins are given names according to their position on the wing.

At the base of the wings are some small structures known as sclerites which form a flexible articulation between the wings and the thorax. These permit the beating of the wings in flight and also allow them to be folded away when at rest, in the upright position characteristic of butterflies. During flight the wings are regularly moved up and down and the movements of the two wings on each side are coupled or linked together in a special way. Usually the hind wing has a lobe which presses against the fore wing, thus ensuring that wing movements are synchronized to give maximum efficiency. The wing movements are created in two ways: firstly by muscles acting at the base of the wing and secondly by distortion of the thorax brought about by the thoracic musculature which is particularly well developed in the wing-bearing segments. During flight the orientation and balance of the insect is controlled by special sense

Right: A microphotograph of part of the wing of a European pearl-bordered fritillary *Clossiana euphrosyne,* showing how the scales overlap in the manner of roof tiles. To the naked eye the scales appear as particles of coloured 'dust'. (X 180).

Below: An enlarged portion of the hindwings of the Holarctic swallowtail *Papilio machaon,* demonstrating how the colour pattern is made up of scales containing different pigments. The long 'hairs' at top left are in fact modified scales (X 6).

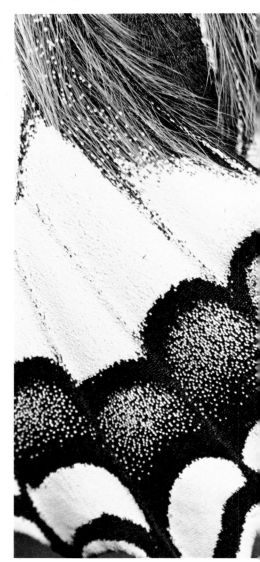

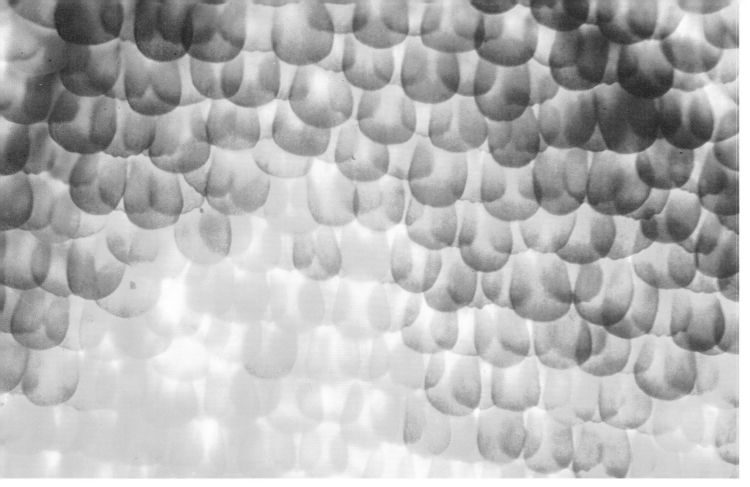

organs. Butterflies are typically active during the day (diurnal) and most species only fly in bright sunshine. The height at which they fly varies, some merely skim across the surface of low vegetation whilst others fly very much higher.

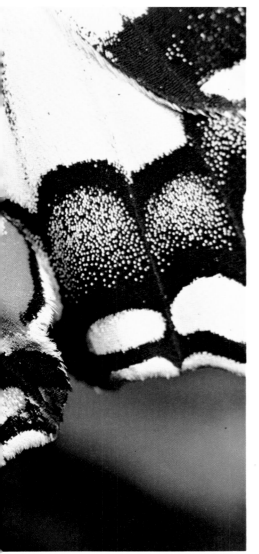

The colour patterns on the wings are due to the covering of scales (see Chapter 7). The scales overlap each other in a regular fashion resembling tiles on a roof. Each scale is more or less racquet shaped and has a small projection or stalk at its base which fits into a minute socket on the wing membrane. The handling of specimens damages this delicate articulation and the scales easily rub off. To the naked eye the scales look like coloured dust. Pigments contained within the scales give rise to the colour of some butterflies, whilst in others, microscopic ridges or striae on the surface break up the light falling on them and so produce the metallic colours of the blues and coppers.

Scattered among the scales are specialized scent scales known as androconia which are peculiar to the males. At the base of these scales is a small gland which produces an aphrodisiac to excite the female during courtship. The volatile secretion passes up the hollow stalk of the scale and is disseminated by the fine hair-like processes or plumes at its tip. These scent scales may be scattered over the upper surface of the wing or collected into special patches called scent brands, as in the fritillaries, where they are visible as thickenings on the veins. During courtship the male often flutters around the female waving his wings and attempting to stimulate her by his scent. In some butterflies, although the scent producing area is in the wings, the dissemination takes place by means of the hair pencils which are associated with the terminal abdominal segments. These hair brushes consist of a small sac which is pushed out by blood pressure during courtship. At the end of each sac is a tuft of hairs. During scent dissemination the wings are outspread and the hair brushes brought into contact with the scent producing areas on them. The hair brushes are then expanded fully to disperse the scent.

The abdomen

The abdomen is much softer than the head and thorax and consists of

ten rings or segments of which only seven or eight can be easily seen. The end segments are specialized for reproductive purposes and are generally known as the genitalia. In the male there is a pair of claspers which grip the female during mating and surround the central ejaculatory organ. The presence of a pair of claspers at the hind end of the body is a simple and reliable way to distinguish the sexes. In the female some fusion of the terminal segments occurs to give rise to an egg laying tube or ovipositor. The ovipositor is normally telescoped inside the body of the female. There is usually a special opening which receives the sperm from the male.

The female also produces a scent and this is attractive to the males of the species. The glands responsible for this are at the tip of the abdomen. The scent producing area is exposed by the extension of her abdomen. These substances are extremely effective in attracting the males and one female is able to lure vast numbers of males to her vicinity from great distances. These substances are known as pheromones and play an important communication role in the social behaviour of many groups of animals. Once both sexes have been stimulated by the respective scents, courtship is complete and the couple is ready for pairing. The female settles and the male grasps the end of her abdomen with his claspers. Pairing takes some time and the two insects may remain together for an hour or so. The male passes his sperm to the female in a package called a spermatophore which she retains inside her body until egg laying begins. If the couple are disturbed during pairing they will take to flight with one partner (usually the male) being dominant and dragging the other after it. A male is capable of mating with several females.

Internal structures

Within the toughened exoskeleton of an insect the internal organs are bathed in blood. Unlike humans the blood system does not consist of veins and arteries but instead the whole of the body cavity is one large blood filled space (the haemocoel). Circulation of the blood is maintained by a long, tubular heart which lies along the back of the insect (dorsal surface). The heart has muscular walls which contract rhythmically and push the blood or haemolymph forwards into the blood space. On its return from the body tissues the blood re-enters the heart via small pores or ostia.

The digestive system is specially designed to cope with a liquid diet. The base of the 'tongue' or proboscis opens into a spherical muscular region (pharynx). This region is often referred to as a sucking pump, since it is responsible for drawing liquids up the long proboscis. The sucking action is brought about quite simply by a change in volume of the pharynx. The enlargement of the pharynx creates within it a partial vacuum and the liquid in the proboscis is drawn upwards and into the pharynx. The muscular walls then contract and this serves to push the meal into the oesophagus, which is the next region of the alimentary canal. During this contraction of the pharynx there would also be a tendency for the fluid to flow back down the proboscis, but this is prevented by a shutter-like valve which closes the entrance to the proboscis. Once inside the digestive tract the food may be stored in a small reservoir (the crop) until it is needed. The actual digestion of the food takes place in the stomach and any unsuitable material is passed into the hind intestine and is voided as faeces, via the anus. The digested food is absorbed into the blood and is stored as fat in a structure known as the fat body until it is needed. The fat body takes the form of sheets of fatty tissue which either underlie the outer integument of the insect or surround the

Right: European brimstone *Gonepteryx rhamni* indulging in an early summer flirtation. The paler specimen flying above is the female; below is the more richly coloured male. This is one of a small number of species which hibernate as adults: although the butterflies emerge in July, courtship and pairing do not take place until the following Spring.

digestive tract. The fat body is usually better developed in the female since it is also needed to provide nourishment for her developing eggs.

Excretion is performed by structures known as malpighian tubules. In their mode of functioning they closely resemble kidneys although in appearance they are very different. The tubules are long filaments attached to the alimentary canal at the beginning of the hind gut. They float freely in the haemocoel and extract waste products from the circulating blood. These substances (collectively referred to as urine) are passed through the tubules and into the hind gut, from here they leave the body with the faeces.

The nervous system is composed of nerve cells or neurones and these are grouped together in nerve centres or ganglia. One of these is situated in the head and is generally referred to as the brain. The brain is connected to a nerve cord which lies under the digestive tract and passes to the hind end of the body. The nerve cord has a number of subsidiary nerve centres or ganglia along its length. Most butterflies have two ganglia in the thorax and four in the abdomen. From these centres smaller nerves pass to all parts of the body. Special nerve cells (visceral nerves) are associated with the digestive system and reproductive system whilst others (peripheral nerves) innervate the surface of the body.

The internal reproductive organs of insects consist of a pair of gonads and a system of tubes or ducts to carry their products (either sperm or eggs) to the outside of the body. In the female each ovary consists of four egg tubes or ovarioles. Each contains a large number of eggs at various stages of development. There is a special sac-like storage chamber (bursa) which retains the sperms until the eggs are ripe and about to be laid, only then are they fertilized. The female also has accessory glands associated with the reproductive system which secrete a sticky substance used for cementing her eggs to the substrate on which they are laid. The male has a pair of testes which are fused together in some butterflies. Sperm reservoirs are also present which store the sperm prior to pairing.

In many animals, including humans, oxygen is carried around the body by the blood but in butterflies (and other insects) the organs of the body are separately supplied with oxygen by a system of 'air tubes' or tracheae. These open to the atmosphere through special apertures in the exoskeleton called spiracles, of which there are nine pairs in butterflies. The actual exchange of gases takes place by simple diffusion at the ends of the tracheae, where the tubes become very narrow. In active insects the diffusion of oxygen into the body and the passage of carbon dioxide out is speeded up by ventilatory actions of the body comparable with our own breathing movements. Even so the system is relatively inefficient and the amount of oxygen available to the insect is quite small. This crucial point represents one of the main limitations on the size of butterflies, and without a major redesign of their whole system they cannot ever be more than relatively small creatures.

Right: A mating pair of the skipper *Abantis paradisea* in the Congo. Pairing generally takes place on leaf surfaces as shown, but some species will take flight if disturbed (X 15).

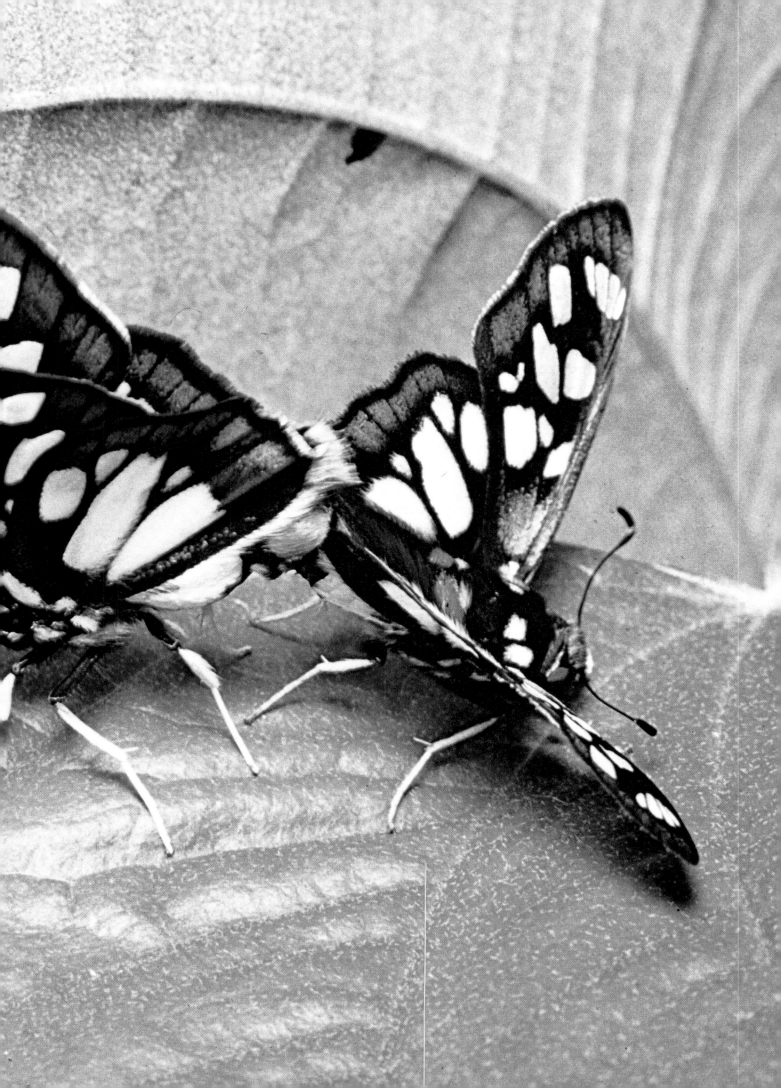

The Butterfly Life Cycle–
from egg to adult

Butterflies are examples of endopterygotes: insects which characteristically undergo a complete change or metamorphosis during the course of their development. Their life cycle includes both a larval and a pupal stage before the adult insect or imago emerges. The larva is completely different from the adult both in appearance and habits. The pupa is an inactive, non-feeding stage which gives rise to the adult. In grasshoppers, cockroaches and earwigs, which are examples of exopterygote insects, development is much more gradual with a series of young stages or nymphs which all resemble the adult and become progressively more like it at each successive stage. In these insects there is no pupal stage.

The egg

Female butterflies usually lay their eggs on or very near to the food plant on which the larva feeds. The oviposition site is carefully chosen, and touch, smell, taste and sight are probably all involved in its selection. Most species lay their eggs singly and cement them to the plant by a sticky secretion. The eggs are usually laid on a particular part of the plant, for example, on the leaves, flower heads or in crevices in the bark. Most frequently they are laid on the under surface of the leaf; the female alights on the upper surface and curves her abdomen under the leaf until a suitable position is found. Here the eggs are protected from rain and sunshine and to some extent from predators. However, a large number of eggs are laid by a

Right: *Danaus chrysippus* is one of the most familiar and widely distributed of the Danaidae. In India it is known as the plain tiger, while in Africa (as in the example shown) it is called the African monarch. This female is curving her abdomen in order to lay her eggs on the under side of a milkweed leaf. The poisonous property of this plant will be absorbed by the caterpillars; as a consequence, they and the adults are usually avoided by birds and other predators (X 4).

Below: In the life cycle of the swallowtail *Papilio machaon* the egg stage takes eight to ten days, the larval stage takes 30 days, and the pupal stage may take as little as 14 days or may last through the winter. The adult butterfly lives for 25 to 30 days.

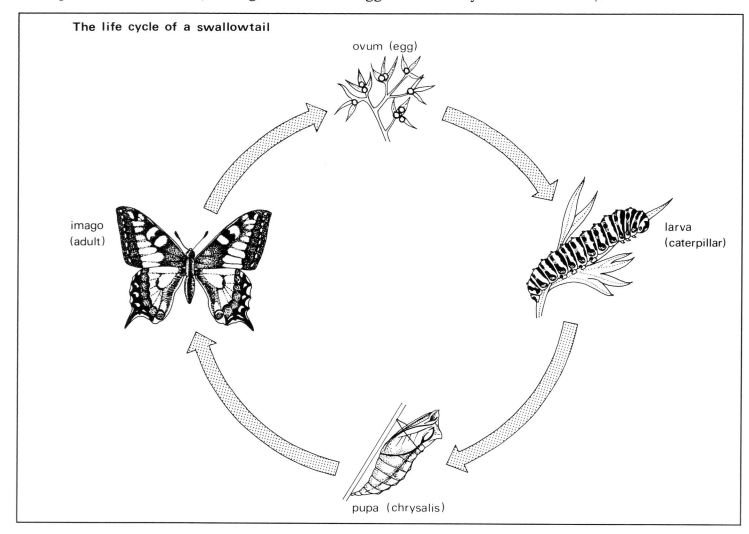

The life cycle of a swallowtail

ovum (egg)

larva (caterpillar)

pupa (chrysalis)

imago (adult)

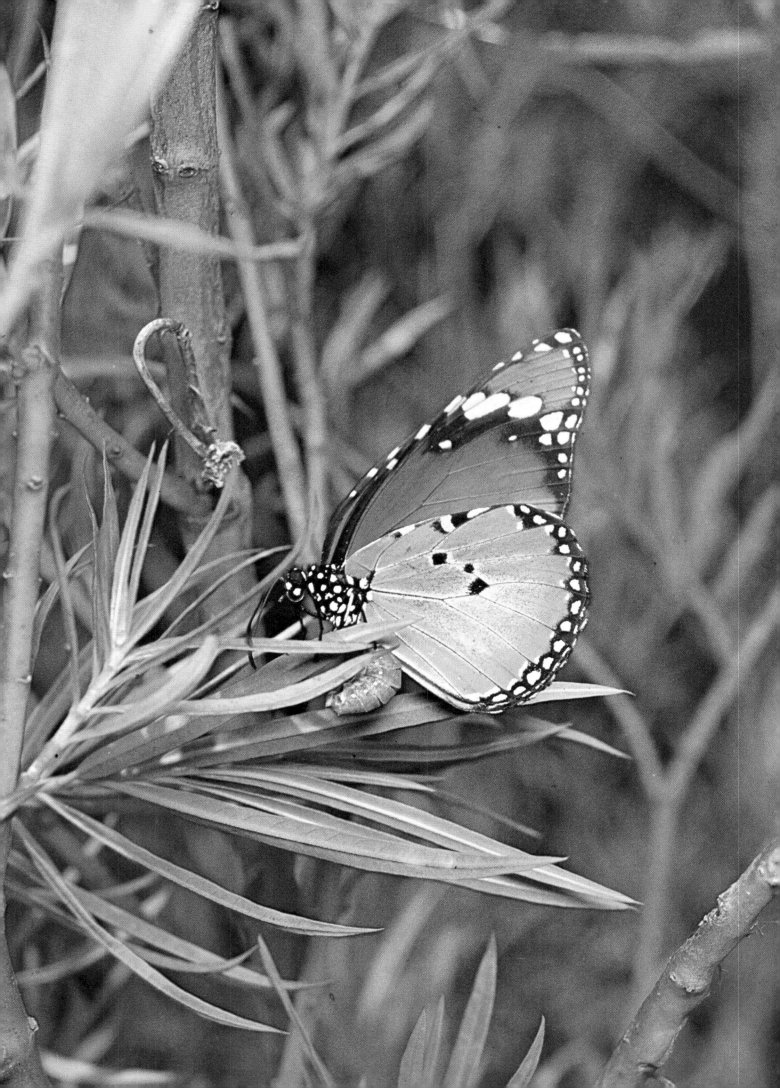

single female to ensure that at least some will hatch successfully. The large white *(Pieris brassicae)* often lays clusters of one hundred or more eggs, whilst a few others lay smaller batches of 5–15 eggs. The arrangement of the eggs varies, they may form regular bands around twigs or pendant strings of eggs. A small number of species merely scatter their eggs at random as they fly over vegetation (usually grassland).

Butterfly eggs are commonly yellow or green in colour although they may darken just before hatching. The shape of the egg varies in different species and may be spherical or oval and flattened. The shell is often elaborately sculptured with regular ribs or pits (reticulations). At the top of the egg is a slight depression within which is a minute opening or micropyle. The micropyle marks the entry point of the male sperm into the egg, and once the egg is laid, air and moisture pass to the developing embryo through this pore. Food is contained inside the egg in the form of yolk and this is gradually consumed as the young larva develops.

Just before hatching the fully formed embryo can be seen curled up within the transparent egg shell or chorion. The young larva gnaws its way through the shell and after hatching continues to eat the shell until only the base is left. In the large white butterfly, where the eggs are laid in clusters, a newly hatched larva may also eat off the tops of other unhatched eggs. The shell contains valuable nutrients and is immediately available to the larva. After this the food plant on which the egg was laid will be devoured.

The larva

Butterfly larvae, or caterpillars as they are commonly called, are quite variable in colour and in shape, although their basic structure is relatively constant. The larva has a head followed by 13 trunk segments of which the first three are regarded as the thorax and the remainder the abdomen. The larval skin or cuticle is soft and flexible, though spines or bristles (setae) which arise from surface tubercles may be present. These are particularly characteristic of the family Nymphalidae.

The head is a hardened round capsule with a completely different array of structures to the adult butterfly. The larvae feed on plant material which is relatively tough to a small insect. Consequently, the mouth parts are modified for biting and chewing. There is a prominent pair of toothed jaws or mandibles which bite off fragments of food and shred them into fine pieces. The maxillae (which form the proboscis in the adult) are very small and used to guide the food into the mouth. The other main mouth part (the labium) is modified to form the spinneret which is used in silk production.

Compound eyes (see Chapter 2) are lacking in the larva, the main visual organs being the lateral ocelli. These are arranged in two groups of six, one group on either side of the head. The ocelli in many ways resemble the single optical unit or ommatidium of the adult's compound eye. Each ocellus has a lens and receptive part or retina. It seems that they are unable to create an image of their visual field and probably only detect the difference between dark and light. The lateral ocelli can therefore be of little use in the location of food, the senses of touch and smell being more important in this context. The head also bears a pair of short, stubby antennae.

The three segments of the thorax each have a pair of short jointed legs which end in a single claw. The abdomen has ten fleshy rings or segments, five of these bearing a pair of false legs or prolegs. These are soft structures, without joints, present on the third to

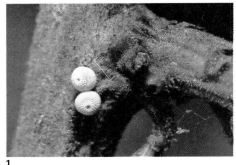

1

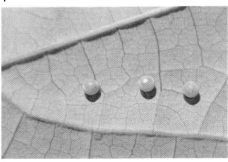

2

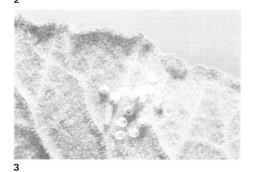

3

The shapes of butterfly eggs vary considerably from family to family. All have a thin but tough outer shell and a shallow depression (micropyle) at the apex. After hatching, the young caterpillar will often make a meal of the eggshell; in some species the shells contain nutrients that are vital for healthy development. 1. Lycaenidae: eggs of the European brown hairstreak *Thecla betulae* laid in the angle of a blackthorn twig (X 20).
2. Papilionidae: the large pearl-like eggs of Rajah Brooke's birdwing *Trogonoptera brookianus*, dissected from a female captured in Malaya (X 5).
3. Nemeobiidae: young caterpillars of the European duke of burgundy *Hamearis lucina* hatching from their shells and exploring a cowslip leaf (X 10). The heads of those as yet unhatched can be seen through the translucent shells. 4. Pieridae: the elongated egg of *Catopsilia florella* is characteristic of this family (X 20). The larvae of this African migrant can devastate large areas of leguminous cassia plants, including cultivated species. 5. Satyridae: like many of this

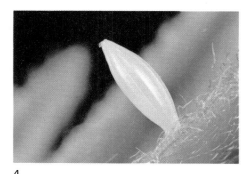

4

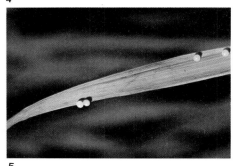

5

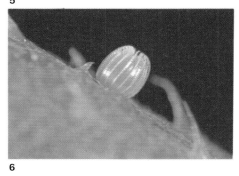

6

family, the European speckled wood *Pararge aegeria* lays its eggs on grasses (X 5). 6. Nymphalidae: an egg of the cosmopolitan painted lady *Vanessa cardui,* shown here on a South African *Gazania* plant. The delicate ribbing of the shell occurs in the eggs of many related species (X 20).

sixth segments. A final pair on the last segment are called claspers, and some larvae will be torn in half rather than release their hold with them. The end of each proleg is flattened and has a series of hooks or crochets which help the larva in locomotion. When not being used the prolegs can be withdrawn into the body. The arrangement of the hooks on the prolegs is a useful guide in the classification of larval types.

Since the skin of the larva is soft it is not able to provide a suitable skeleton for the attachment of muscles (as the exoskeleton does in the adult). Consequently the body has to be kept turgid by the pressure of the body fluid (haemolymph) rather like an earthworm. The characteristic crawling movement consists of a co-ordinated interaction between the muscles of the body wall and the internal pressure of the haemolymph.

As the larvae grow they entirely fill their skin, which becomes very tight. In order that a further size increase may occur this skin is shed from time to time, exposing a new and larger one which has formed beneath it. Rapid expansion of the 'new' larva occurs before the skin becomes toughened. This shedding of the skin is known as moulting or ecdysis and usually takes place four or five times before the larva is full grown. Each growth stage between moults is known as an instar. Moulting in insects is very carefully and precisely controlled by hormones, although environmental conditions and the availability of food may cause variations in the duration of the instars.

The larvae feed mainly on the leaves of flowering plants and trees. Ferns or mosses appear never to be eaten. They are extraordinarily specific in their feeding habits and will usually only feed on a small number of closely related plant species. If a suitable food plant is not available then larvae will starve to death rather than eat something else. A larva recognizes its food plants by certain aromatic vegetable oils which they contain. It is generally thought that selection may depend upon the detection of chemical attractants in the food species and of repellents in other plants.

The larva is the main feeding stage in the life cycle, and when they are present in sufficient numbers caterpillars can defoliate large areas of vegetation. This means that those butterfly species whose larvae feed on agricultural crops can be a serious pest. Single larvae may consume an entire leaf before moving on to the next, but more often only a part of the leaf is eaten. The way in which a larva tackles a leaf is often characteristic of the species; some eat holes in the leaf, whilst others attack the leaf margin. In some species feeding occurs at night and in others by day. Generally periods of active feeding alternate with periods of rest. Feeding ceases a day or so before a moult, but is resumed as soon as the new skin is fully developed.

A diet of plant leaves, in addition to requiring mouth parts for chewing the food, necessitates some modifications of the digestive tract. A large quantity of food is passed through the alimentary canal which is consequently a wide straight tube. The stomach is the largest region and has muscular walls which maintain continual churning movements, causing thorough mixing of the food material. The droppings of the larvae are discrete oval structures and are referred to as frass. Since much of the plant material consists of indigestible celulose a large amount of frass is produced and may even form a distinct layer under small trees or shrubs on which many larvae have been feeding.

The internal organization of the other systems closely resembles that found in the adult insect. However, the salivary glands, which in the adult produce substances to accelerate digestion, take on a

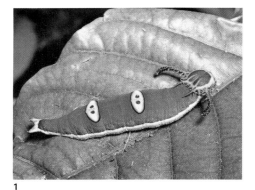

1

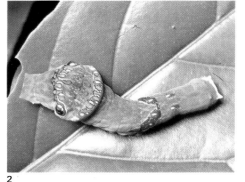

3

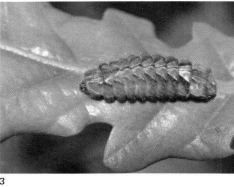

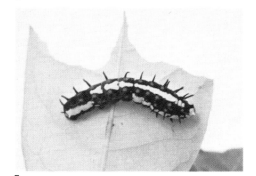

4

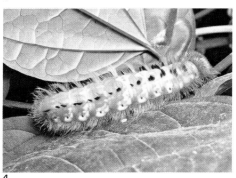

2

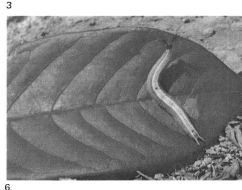

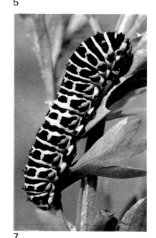

5

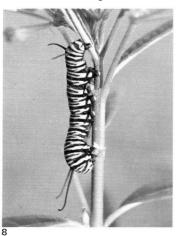

6

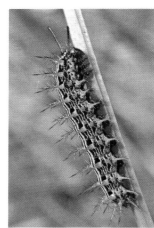

7

8

9

Butterfly larvae or caterpillars show great variety in colour-pattern and shape, some being quite grotesque.
1. Nymphalidae: the curious helmeted and slug-like appearance of this *Charaxes* species from Tanzania contrasts with the spiky form of most Nymphalid larvae. 2. Papilionidae: the larva of the blue mormon *Papilio polymnestor* from Thailand, in common with those of several other swallowtails, presents a fearsome 'eyed' appearance.
3. Lycaenidae: as its latin name implies, oak is the preferred food-plant of the European purple hairstreak *Quercusia quercus* (X 5).
4. Morphidae: this Peruvian *Morpho* species shows curious hairy tufts— unusual in butterfly larvae (X 0.75).
5. Papilionidae: the common mime *Papilio clytia* from Hongkong mimics the pattern of distasteful species in both its caterpillar and adult stages.
6. Nymphalidae: the Oriental *Apatura parisatis* is strikingly horned; its forked tail (bottom of picture) curiously resembles a second head.
7. Papilionidae: the handsomely banded larva of the swallowtail *Papilio machaon* feeds here on its usual English food-plant, milk parsley.
8. Danaidae: the widespread monarch *Danaus plexippus* is very agressive looking. Here it is walking down its food-plant, milkweed (X 0.75).
9. Nymphalidae: conspicuous branching spines, common in this family, are well developed in the European silver-washed fritillary *Argynnis paphia*.

new role in the larva, that of silk production. Several species are known to produce silk to make webs or cocoons. The silk is manufactured in the salivary glands which are a pair of long tubes, particularly conspicuous in the Saturniid moths. The spinning apparatus lies in the spinneret (part of the labium) and consists of a silk regulator and a directing tube. The characteristic side to side movement of the head of the larva draws the silk out into a fine thread which adheres to the substrate wherever it is touched by the directing tube. During spinning silk is continually passed from the regulator to the directing tube and hardens on exposure to the air. The silk net forms a protection for the larva, especially when it pupates.

Butterfly larvae are rather inactive sluggish creatures and this together with their soft outer covering makes them an ideal target for a wide range of predators. To protect themselves the larvae have evolved various structures and habits to either serve as camouflage or to make them appear unattractive or unpalatable to a would-be predator. Some of these devices will be discussed in more detail in later chapters.

The pupa

The end of larval life is marked by another moult which gives rise to a pupa or chrysalis. Fully grown larvae often select special sites to undergo this transformation and may for example leave their food plant and enter the soil. The digestive tract is emptied and the

larval skin shrivels and eventually splits to expose the pupa. During the pupal period much of the larval tissue is remoulded to give rise to adult structures, particularly the wings, mouth parts and reproductive organs.

The pupa is immobile and neither eats nor drinks since the mouth and anus are sealed over. The only functional openings in the pupal case are the spiracles which permit the exchange of respiratory gases. The legs and antennae are firmly stuck down and cannot be moved. Externally the pupa usually appears brown or green, and the abdominal region, with prominent segmental rings and tapering posteriorly, is very distinct from the thoracic part. All the major features of the adult can be seen within the pupal skin, but one specialized structure is to be found at the end of the abdomen, where a number of hooks form the cremaster. This is used for the attachment of the pupa to the substrate.

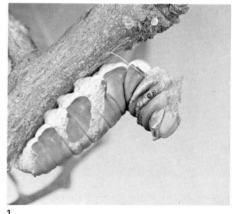

It is often desirable to distinguish the sex of a pupa before the adult emerges, and this is not usually difficult. In the male there is a single genital opening on the ninth abdominal segment whilst in the female there are two such openings, one on the eighth and another on the ninth segment of the abdomen.

Since the pupa is immobile it is particularly vulnerable to attack by predators and frequently pupation proceeds within a silken cocoon. This may take the form of a hollow of earth lined with silk, or a roll of leaves fastened together with silk threads (eg Hesperiidae and some Satyridae). Silk cocoons are generally much better developed among moths. In some butterflies the pupa is naked but it is then usually protectively coloured. The naked pupa may hang upside down attached only by the cremaster (many Satyridae and Nymphalidae) or it may be attached by the terminal cremaster but also supported head upwards by a silken girdle (Lycaenidae, Pieridae and Papilionidae). In each case the larva spins a little silken pad into which the hooks of the cremaster are firmly embedded.

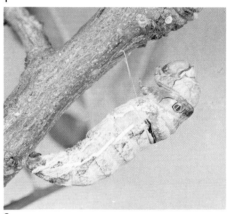

The adult

The emergence of the adult or imago is preceded by the colour pigment appearing in the wing scales, so that the wing patterns of the adult can be seen through the pupal case. The skin of the pupa splits behind the head, the insect first frees its legs and antennae and after a short while withdraws the rest of its body. Those species pupating within a cocoon have to free themselves from this as well as the pupal skin. In some Saturniid moths there may be a special arrangement of the silk to facilitate this, whilst in others a special softening fluid is produced.

Immediately after emergence the wings are soft and crumpled. The butterfly moves to a place from where its wings can hang downwards and blood is forced into them. The wings expand by the flattening of the numerous tiny folds and soon become the typical thin sheets supported by hollow veins. Once they have reached their full size the insect holds them apart until they are completely dry and hardened. The excretory material which has accumulated in the closed digestive tract during the pupal period is ejected from the anus. The time of adult emergence varies, it may occur early in the morning or in the evening; in the latter case they rest until the next day before becoming active.

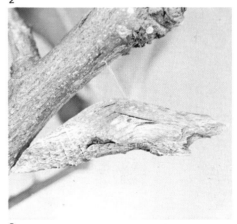

These three photographs (X 2) show the dramatic transformation of the African swallowtail *Papilio demodocus* from a larva into a pupa.
1. Using specialised appendages, the fully grown larva spins a silken tail pad and girdle prior to pupation.
2. The last larval skin is gradually sloughed off towards the tail. The fine white larval breathing tubes (tracheae) may be seen coming away.
3. The pupa is finally revealed, supported by the girdle; the outlines of the butterfly-to-be are clearly visible.

Interruption of the life cycle

The duration of the life cycle varies in different species. Some may have a single complete generation in a year whilst others have two

The Butterfly Life Cycle

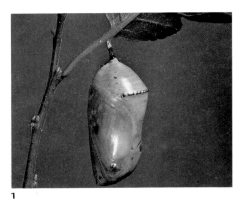

1

Left and below: Butterfly pupae or chrysalids usually show cryptic coloration or disruptive patterns, which afford some protection from predators at this vulnerable stage. 1. Danaidae: this monarch *Danaus plexippus* will emerge shortly; the pattern of the wings shows through the pupal shell (X 1.5).
2. Satyridae: the suspended chrysalis of the European hedge brown *Pyronia tithonus* resembles a withered leaf. Note the cast larval skin still attached at the base (X 3). 3. Nymphalidae: the beautiful jade-like pupa of the European

Charaxes jasius (X 2). 4. Pieridae: a cluster of pupae of the Hongkong jezebel *Delias aglaia*. 5. Nemeobiidae: the pupa of the European duke of burgundy *Hamearis lucina*, attached to a cowslip leaf (X 6).

Right: The delicate Brazilian *Morpho laertes* hangs from its pupal shell and dries its fully expanded wings. In the case of such a large butterfly, it may be several hours before it is ready to take its first exploratory flight (X 8).

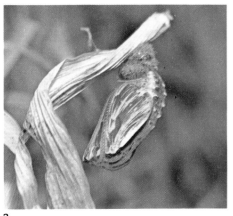

2

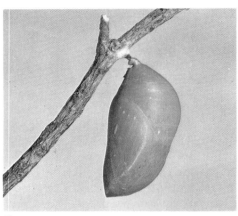

3

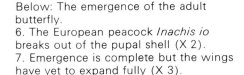

Below: The emergence of the adult butterfly.
6. The European peacock *Inachis io* breaks out of the pupal shell (X 2).
7. Emergence is complete but the wings have yet to expand fully (X 3).

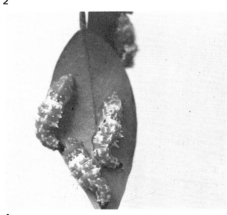

4

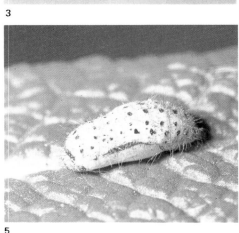

5

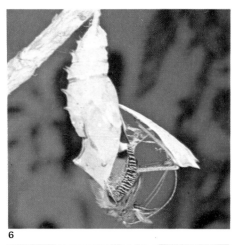

6

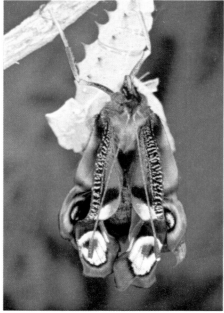

7

or even more. Unfavourable climatic conditions such as the winter in temperate regions or the dry season in the tropics often necessitate an interruption in the life cycle. Any of the developmental stages – egg, larva or pupa – may enter a period of arrested development (or diapause). This delay in development is induced by environmental conditions such as day length, but cannot then be terminated until a pre-determined period has passed. This ensures that the insects do not emerge too early during temporary favourable periods only to be caught out by a resumption of harsh conditions. The eggs and pupae are protected by their outer shell or skins respectively, whilst the overwintering larvae usually shelter at the base of their food plant or in a specially produced larval cocoon formed from plant leaves and silk. The stage in the life cycle which regularly undergoes hibernation (or aestivation in the tropics) varies in different species and also within the same species in different parts of its geographical range.

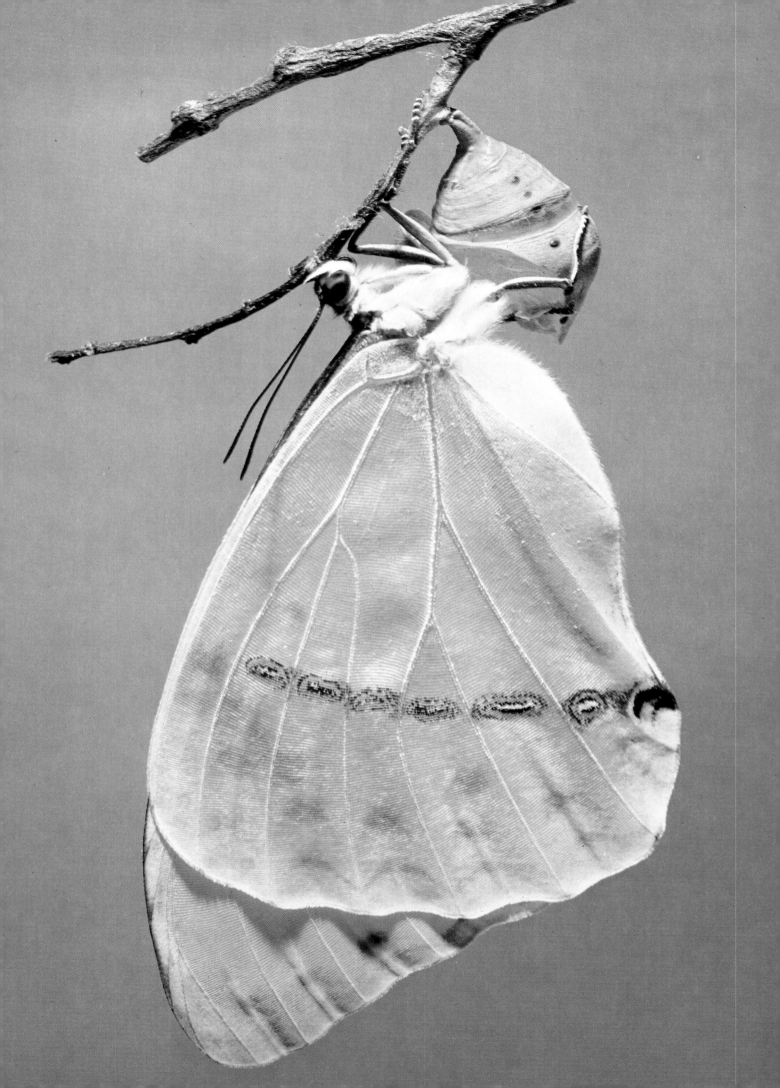

Chapter 4

Ecology–

butterflies and their environment

In a particular area or habitat there may be several species of butterflies; some present in very large numbers and others represented by only a few individuals. All the individuals of each species within that area may be thought of as a population, the members of which interbreed and are responsible for the survival of the species. Each adult female may lay several hundred eggs during her life but only a small proportion of these will produce viable adults. Deaths or mortality occur at all stages of the life cycle and it is this which keeps the size of the population stable. Of course variations in the number of animals in a population are apparent from time to time, mainly through changes in the birth or death rates and through the immigration of individuals into or emigration away from the habitat.

There are two main ways in which the size of a population or the population density may be regulated. Firstly by factors which have the same impact on the population regardless of the number of animals present. These are sometimes referred to as density independent factors and are mostly climatic influences which may have an advantageous or perhaps disastrous effect on a population of butterflies regardless of whether there is an enormous colony or only a few breeding pairs. The other way in which population regulation may occur is dependent on the number of individuals present: density dependent factors. It is these which are of vital importance when an essential resource such as food is in short supply. Overcrowding may occur when space is limited and this can have severe consequences on the success of a population. The more butterflies there are present, the more the effects of density dependent factors are felt.

Climatic factors

Changes in climate have a considerable effect on different stages in the life cycle. The unfavourable seasons of the year, such as the winter in temperate regions and the dry season in the tropics, are usually accompanied by an arrest in growth and development. This period of hibernation (or aestivation in the tropics) acts as a sort of timing device for the insect. It ensures that the occurrence of the actively feeding larvae coincides with the availability of a suitable food plant in the correct condition and also that the more vulnerable and delicate stages are not subjected to frosts or excessive dryness.

Daily fluctuations in temperature and moisture are also important to insects and when they are subjected to extremes heavy mortality may result. Butterflies, like reptiles, are cold-blooded animals and have to derive their body heat from external sources. They warm up by basking in the sun, usually with the wings outspread and the body orientated so that the maximum area of the wings is exposed to the sun. The colour patterns on the wings may assist in heat absorption; those species with large black patches are particularly efficient heat gatherers. Butterflies cool themselves by seeking the shade, or if shelter is not available they may close their wings together and face the sun so that the smallest possible surface is exposed to the sun's rays. It has been suggested that cooling of the body may also take place by the evaporation of water, but this idea is not fully accepted. Excessive dryness is avoided by the larvae or adults seeking out areas of high humidity for resting sites. Adult butterflies shelter from heavy rain by settling on the underside of leaves with their wings held slightly open so that the rain can run off them. If the wings were held tightly together in their usual resting posture and then became wet the surface layer of scales

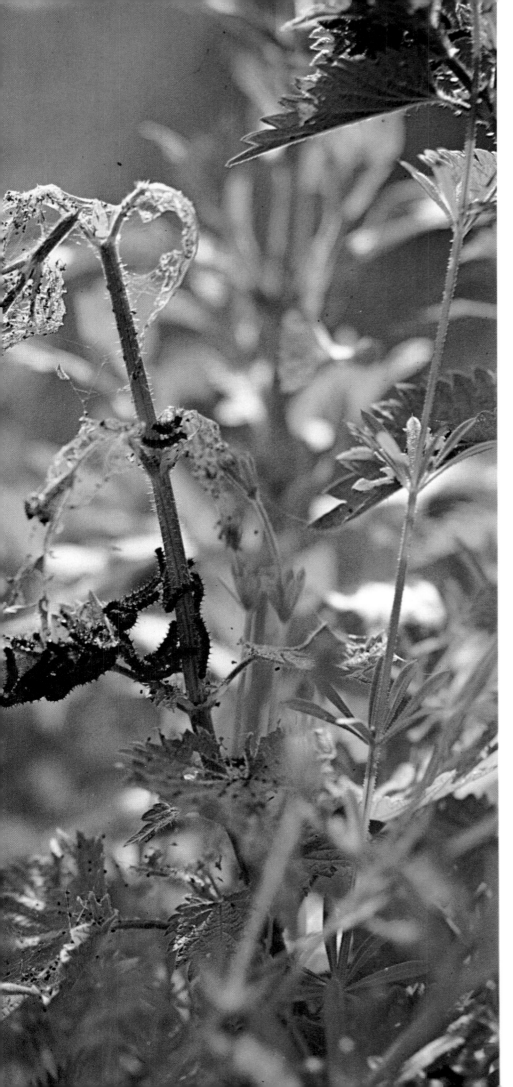

Some butterflies spend the greater part of their caterpillar stage feeding gregariously in silken webs or nests which may accommodate several hundred individuals. The masses of small tortoiseshell *Aglais urticae* are a familiar early summer sight in Europe. They feed on stinging nettles, often reducing them to bare stems before moving on. Their presence is betrayed not only by the webs but by the accumulation of droppings (frass) beneath the plant. Later in this stage the larvae will leave the nest to feed singly, and become much less easy to find.

might well become damaged. Generally butterflies are not found flying in high winds, although during the migration flights of some species they are able to look after themselves satisfactorily. Other phenomena, such as forest fires, may have a serious effect on a butterfly population; the adults are usually able to fly to another suitable area, but their eggs, larvae and pupae risk total destruction by fire.

Relationships with other species

The success of a population also depends on its relations with other species and also with other individuals of its own species. The effects of these interrelations are usually correlated with the density of the population in a particular area.

Almost all butterflies are herbivores in their larval stage and would therefore compete with other herbivores for the available plant material in a particular habitat. Butterflies have overcome the problem of competing with their own larvae by having the adults feed on different parts of the plant (eg flowers) and usually on different species to those used by the larvae. For example, the 'large white' larva feeds on species of cabbage *(Brassica)* whilst the adult will suck nectar from a wide variety of flowering plants. In this way competition for food within the species is kept to a minimum. Even so, when an increase in the size of a population occurs, food and space become in short supply and this may result either in heavy mortality or in the migration of some individuals to a less crowded habitat. In addition, many adult butterflies prevent overcrowding by maintaining territories rather like birds do, and may be seen from time to time driving off other butterflies which attempt to enter their territory. The threatening behaviour usually consists of facing the intruder and jerking the wings.

Methods of self-defense

All stages of the life cycle are vulnerable to attack by predators which may include other insects as well as spiders or vertebrates such as birds, reptiles and small mammals. Consequently, methods of protection have been evolved which reduce the chance of attack by these predators. There are two main types of device, those which enable the butterfly to escape attention because of its close resemblance to the surroundings and those which make the butterfly appear startling and unattractive, an indication that it is unpalatable to the predator.

Generally the eggs of butterflies are laid on the undersurface of leaves and are relatively small, so that they are unlikely to be noticed. However, the inactive, soft bodied larvae are very prone to attack, and it is this stage in the life cycle which displays a wide range of these protective devices. Some larvae spin silken webs and live in groups within them. The skippers (Hesperiidae) make tents out of silk and leaves, or may even live in a grass tube made by rolling up a grassblade and securing it with silk. Many larvae are coloured to blend with their surroundings, whilst in the young stages of the white admiral *(Limentis camilla)* camouflage is taken a stage further by the larvae adorning themselves with their own frass. The later stages do not adopt this habit and rely solely on protective coloration. Another difference in the devices employed by young and more mature larvae is seen in the swallowtail, where the very young instars are dark and resemble bird droppings whilst the later instars are brightly coloured.

Several types of warning device are found in the larvae of

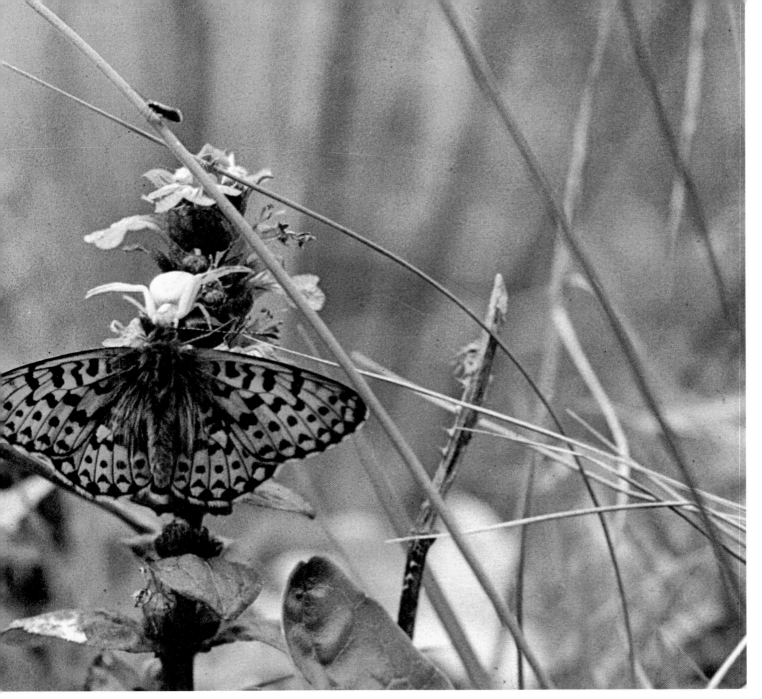

butterflies. The Nymphalidae are often brightly coloured and have an armour of sharp spines. Other larvae may produce an obnoxious smell or have an unpleasant taste. The Papilionidae have a gland just behind the head called the osmeterium which is everted and produces a strong odour when the larvae are disturbed. In other families similar defensive glands may be present on other parts of the body. Some gregarious larvae may jerk their bodies in unison to deter predators. Occasionally a palatable larva may copy or mimic a distasteful one and avoid predation this way. The phenomenon of mimicry will be discussed in more detail in Chapter 9.

The pupae are usually protected by their cryptic coloration patterns and sometimes their shape, for example, the pupa of the orange tip *(Anthocharis cardamines)* closely resembles a seed pod. The pupae of some Nymphalidae may be spiny rather like the larvae. Larvae normally seek out safe sites for pupation and consequently the pupae are found in inconspicuous positions and some occur within cocoons formed from dried leaves or hidden in the ground.

The adult butterfly is most vulnerable immediately after its emergence from the pupa and before the wings have expanded and dried. After this the insect can take to flight and avoid many predators. Most species visit flowers to suck nectar and are frequently attacked when they alight on the flower.

Even if a butterfly survives all the hazards of its early stages, there are many predators waiting for the unwary adult. Here a European pearl-bordered fritillary *Clossiana euphrosyne* falls prey to a small hunting spider *Misumena vatia*, which lurks in the heads of Bugle—a favourite flower of this butterfly (X 4).

Ecology

Protective coloration is also employed by adult butterflies whose wings may have a brilliantly coloured upper surface but are cryptically coloured below so that when they are folded together at rest the insect completely harmonizes with its surroundings. Some families have eye spots on the edges of their wings (Lycaenidae and Satyridae) and the Lycaenidae may also have long tails to their wings. Both the eye spots and the tails are thought to attract the attention of predators and by attacking these parts the actual body of the butterfly is left undamaged. Some species such as the monarch (*Danaus plexippus*) produce an obnoxious odour.

The role of parasites

Parasites are creatures which live either on or within the body of another animal, the host. Butterflies, particularly their larvae, are especially prone to attack by parasites, many of which are very highly adapted both in their structure and in their own life cycles to take advantage of them. Butterflies are particularly threatened by their insect cousins belonging to the orders Hymenoptera (wasps and bees) and Diptera (flies). Only certain specialized members of these orders live as parasites. The principal parasites of butterflies are the groups Ichneumonidae, Braconidae and Chalcidoidea among the Hymenopterans and the Tachinidae among the Diptera. Often among animals the parasite's way of life is carefully balanced so that both the host and parasite survive. However, in the case of an attack by these insect parasites the host usually dies. In this sense the parasites almost resemble predators and they are then usually described as parasitoids. Many parasitoids are associated with a particular species or group of butterflies while others parasitise a wide range of families. One of the most familiar and widely distributed is the genus *Apanteles* belonging to the Hymenopteran family Braconidae. *Apanteles glomeratus* attacks the 'large white' butterfly (*Pieris brassicae*). The female parasite lays her eggs in the larvae (or very occasionally the eggs or pupae) first piercing the host's skin with her sharp ovipostor. Then a large number of eggs are laid in each host. The eggs hatch and feed on the internal tissues of the host; initially consuming the fat body and later attacking the more vital organs such as the digestive tract and nervous system. This internal destruction results in the death of the host before it has completed pupation. The fully fed parasite larvae then eat their way out of the host and pupate on or near the carcass in bright yellow cocoons from which the adult parasites eventually emerge.

The dipterous parasites in the family Tachinidae are rather variable in their habits, but usually the eggs or in some cases young larvae are deposited by the female fly on the food plant of the butterfly larva. The parasite attaches itself to the larva as it is feeding on the plant and burrows into its tissues.

Other parasites live on the outside of their host where they suck the body fluids. Mites are examples of these ectoparasites and are found associated with butterflies from time to time. Mortality is also caused by bacterial and fungal diseases which are particularly prevalent in conditions of high humidity. Considerable care has to be exercised in rearing butterflies in captivity to prevent diseases caused by these organisms, since they normally result in the death of the entire colony.

An association between butterflies and other insects is not always harmful. An example of one which is mutually beneficial is the relationship between ants and many species of blues and coppers (Lycaenidae). The larvae of these butterflies are provided with a

Some enemies of butterflies

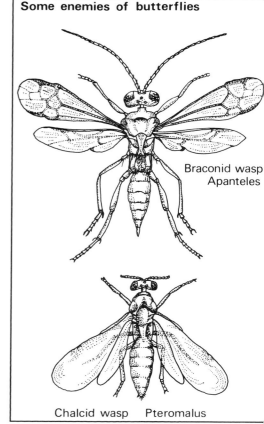

Braconid wasp
Apanteles

Chalcid wasp Pteromalus

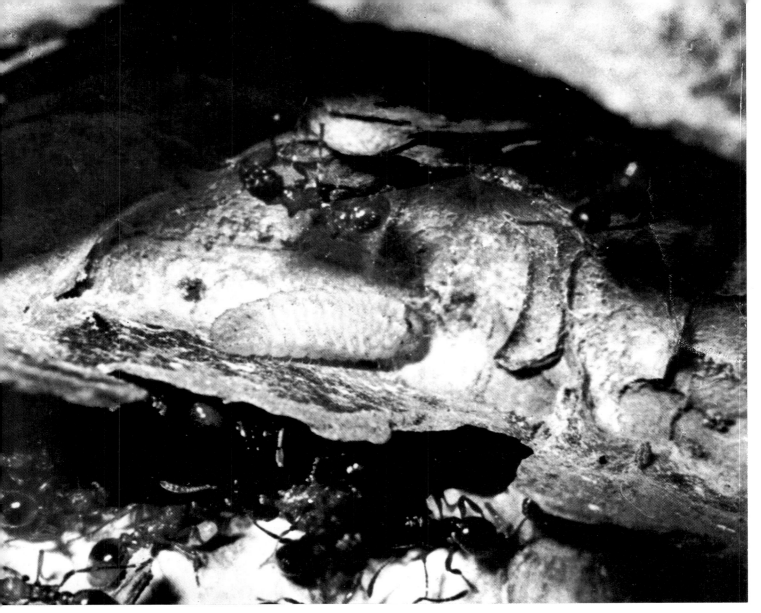

The European large blue *Maculinea arion* passes most of its remarkable larval stage in an ant's nest, feeding on the young grubs. It remains there as a pupa, and the emerging butterfly must find its way through the tunnels to the outside before it can expand its wings (X 8).

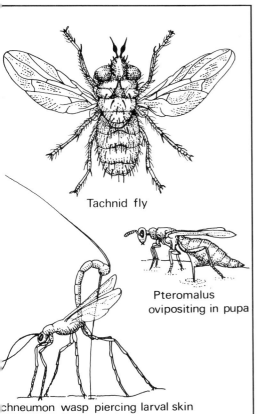

Tachnid fly

Pteromalus ovipositing in pupa

Ichneumon wasp piercing larval skin with ovipositor

honey gland which exudes small droplets of a sweet fluid. This is extremely attractive to ants, which 'attend' the larvae and stimulate the production of the fluid by stroking movements of the legs and antennae. The ants are pugnacious insects and serve as a deterrent to the usual predators and parasites of the butterfly larvae. The ants never damage the larvae, but merely lick the gland, enjoying the secretion it produces. Some larvae seem almost dependent on the ants and their development is impaired if the ants are absent.

The final relationship to be considered is that between butterflies and man. Many species of butterflies are nectar feeders and thus frequently visit flowers. In moving from one to another they undoubtedly perform a beneficial activity in assisting with plant pollination, although very little is known of their precise role in this context. On the other hand the damage caused by the larvae as they feed on crops is considerable. For example the larvae of many of the Satyridae feed on grass and cereal crops whilst some Lycaenidae feed on the flowers and seed pods of leguminous plants, many of which are of commercial value. One possibly beneficial outcome of the intense feeding activity of the larvae is that some have weed species as their favoured food plant, and so these larvae may play a useful part in weed control. Thus butterflies are both beneficial and detrimental to the human economy, and the control of the harmful species therefore needs to be done selectively.

Chapter 5

Butterfly Mobility—
distribution and migration

Butterflies are to be found all over the world, but the greatest number of species live in the tropical regions. Butterflies are particularly abundant where tropical rain forests abound; for example in Africa (south of the Sahara), in the Oriental region (Far East and India) and in the Neotropical region (South America). Some large genera of butterflies occur throughout the world, for instance *Papilio* (the swallowtails), *Danaus* (the monarchs) and *Eurema* (the 'yellows' from the family Pieridae, which also includes the 'whites'). A few genera are common to the Palaearctic (Europe, North Africa and Asia) and Ethiopian regions, these are mainly in the Pieridae, the Satyridae ('browns'), the Nymphalidae and the Lycaenidae (the 'blues' and 'coppers'). Among the Lycaenids the small copper *(Lycaena phlaeas)* occurs not only in the two regions but also in the Nearctic (North America) which is a remarkable distribution for one species. The Ethiopian region shares many species with tropical Asia (Oriental region) but has few affinities with the tropics of South America (Neotropical region).

Despite the fact that butterflies are one of the more mobile groups of animals, which considerably aid them in colonizing such large areas; many species are extraordinarily localized in their distribution. Some may be found only on a certain group of mountains, or one small part of a forest, and nowhere else in the world.

Ecological factors affecting distribution

The distribution of a species is dependent not only on the geography of the area and the ability of the species to move around within it, but also on the ecological demands of the species. Each species of butterfly has its own set of clearly defined preferences concerning the environment in which it lives. These requirements not only limit the overall distribution of that species but also the distribution within its range. Thus in Africa the largest number of species occur in the forests in and around the Congo basin. The number of species becomes smaller to the north and south of the equatorial forest and also towards the east coast, which is somewhat drier. But even within the rain forest there are marked differences in the species found in lowland and highland or montane forest. Still more different species are to be found in dry savanna conditions, derived savanna (cultivated land turned wild) and swamps.

In Britain the chalk-hill blue *(Lysandra coridon)* and the adonis blue *(L. bellargus)* are restricted geographically by being inhabitants only of chalk or limestone hills in southern England. But this does not mean to say that they are found throughout these hills, because they only occur where the food plant of their larvae, the horse-shoe vetch, is growing. However, one cannot be certain of finding either species in a chalkland locality where this vetch is growing because many other factors also affect the ecology and therefore the distribution of these species. The ecological requirements of a butterfly are unique to each species, and so these two have slightly differing distributions which are localized even though the butterflies involved are mobile animals which can move easily from one place to another at will. Other downland butterflies, whilst preferring chalk or limestone, are not entirely restricted to such areas. The grayling *(Hipparchia semele)*, for instance, occurs not only on downs but also on dry heaths; it therefore has a wide distribution in Britain even up to the north of Scotland, but it is mainly found in coastal areas except on the downlands of the south.

The ecological preferences of a species will largely govern its

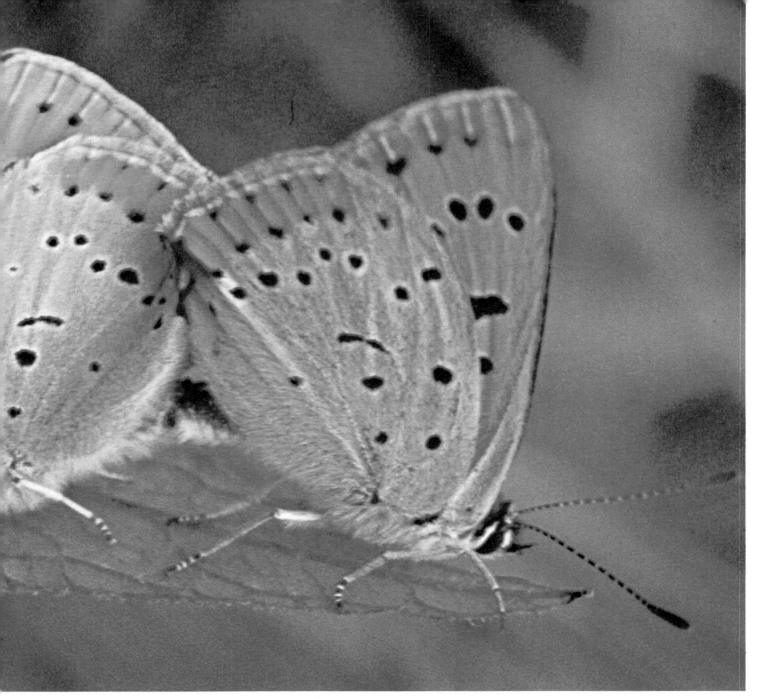

distribution within its range, and the permanence of the habitats which that species occupies will affect its migratory activity. On the whole insects living in permanent habitats (like established woodland) tend to migrate less than species in temporary habitats (like fields of agricultural crops). Even apparently permanent habitats may be temporary for a given species because either the weather is only suitable at certain times of the year (a species at the northern end of its range may not be able to survive the winters), or its food plant is only available in certain seasons. In order for any insect species to survive in habitats which are 'temporary' in nature it must develop either a resistant resting stage in the life cycle or be able to move out of the habitat before conditions become unfavourable (emigration) and migrate back again when conditions are favourable (immigration). During the course of evolution the species which are good at migrating have become the most successful colonizers of temporary habitats, and as a result have been able to extend their range as more of these habitats become available, often as a result of human activity.

The movement of whole populations of butterflies from place to place in the form of mass flights provides one of the most spectacular examples of insect migration. These migrations often take the form of persistent flights in one direction over a long distance by

An animal species is threatened if the ecology of its habitat is disrupted. Man, chief author of such disruptions, is today slowly learning the arts of conservation. The large copper *Lycaena dispar* became extinct in Britain in 1851 after its fenland home was reclaimed for agriculture. Early in the present century the similar Dutch race *batavus* (a mating pair is shown above, X 15) was introduced into a fenland nature reserve, where it survives to this day under man's protection.

large numbers of butterflies and are clearly different from local flights around the breeding area, which are associated with feeding, mating and egg laying. Anyone who has witnessed the mass migrations of the painted lady *(Vanessa cardui)* from the Mexico/California border northwards as far as San Francisco Bay will have been struck by the vast numbers of insects moving purposefully north west 'as if guided by a compass'. However this butterfly does not establish itself permanently after the migration and there is no return flight.

In other animals, such as mammals and birds, migration is understood to include a movement of the population from the breeding place to some other site and the subsequent return of the same individuals. In the case of insects (including butterflies) the concept of migration needs to be modified somewhat: the return flight is rarely made by the same individuals because insects are relatively short lived. Usually it is the next or even later generations which make the return trip, and in many cases the movement is one way only, and no return journey is made at all.

Why do butterflies migrate?

Many theories have been put forward to explain what causes butterflies to migrate and most of them centre round the idea that migration occurs in response to unfavourable conditions such as lack of food, insufficient food of the right quality, overcrowding or the onset of winter. In some insects, such as houseflies, flight seems to be a simple response to the environment—there is a shortage of food so they fly away. In butterflies the long migratory flights are almost certainly brought about by environmental factors which act in anticipation of unfavourable conditions before they actually happen. These triggers, acting through the hormone system of the developing larvae, change the physiology of the next generation so that specifically migrant adults are produced.

Systematic and quantitative information on butterfly migrations is scarce despite the many occasions when migrations have been observed. Individual marking (similar to ringing birds) is difficult. Small tags can be attached to the tip of the wings but the proportion of marked butterflies which are recovered during or after a migration is usually very small indeed. This is the result of mortality during migration, damage to wings resulting in the loss of the tag, and the fact that not all the population will necessarily migrate to the same place. Added to this is the fact that the marking cannot be done until just before migration commences (ie when the adults have emerged) since it is useless marking a larva or pupa as the mark will be left on the cast skin after the moult. In the light of these problems it is easy to see why most records of butterfly migration are of an observational or even anecdotal nature. Nevertheless butterflies do feature prominently in the literature on insect migration.

Lepidopteran migration has been divided by one authority into two main types, short to medium-range displacement and long-range displacement. He points out that although many butterflies appear to exert considerable influence over the direction in which they move, the longer they remain airborne the greater will be the effect of winds and other air movements. Much discussion has taken place about the influence of the insect versus the wind on the actual route taken during a migration. However there are clear examples of butterflies which direct their own movement over short to medium distances (less than 150km) and equally clear examples of long-range migrations of moths influenced almost entirely by meterological

The European apollo *Parnassius apollo* has numerous sub-species and local forms which can be very closely correlated with mountainous regions. The distribution of this and of several other alpine species suggests that they may have become widespread during periods of glaciation. The recession of the icecaps may have left local populations in the cooler high-altitude regions which were effectively cut off from each other by the temperate plains. The resulting discontinuous distribution, over a period of at least 50,000 years, probably encouraged the formation of a large number of sub-species (X 4).

conditions. The butterflies which migrate long (often inter-continental) distances have been alleged to have some control over their direction.

One very good example of a short to medium range migrating butterfly is the great southern white *Ascia monuste*. This butterfly breeds on the islands off the east coast of Florida where there is a plentiful supply of its food plant, vidrillos *(Batis maritima)*. The plant is a woody perennial and common on coastal salt marshes. The butterfly breeds all the year round in Florida but only for about four months in any one particular place and at different times of the year according to latitude. Populations of butterflies tend to spread from the breeding site in one of two ways. They either diffuse slowly through the country as a result of daily movement in the form of short random 'non-migratory' flights to find flowers on which to feed, or periodic mass migrations occur. The latter involve large populations at a time when food for the larvae is still abundant; the butterflies which join in one of these migrations are less than 2 days old and the females are sexually immature. The butterflies fly from the breeding site to their feeding site in the morning as usual, and after feeding set off in large clouds along the coast, following the line of the shore or nearby roads. In calm weather they appear to be capable of controlling their direction; in windy conditions they may be blown off course somewhat, but some will fly in sheltered situations such as the leeward side of sand dunes. Some of these migrating butterflies have been followed by car for over 20km and some

are known to have travelled 130km in one day (downwind). By no means all the individuals cover the whole distance travelled by a group, many fall by the wayside and others lose their direction. Those which succeed find new breeding sites and revert to their normal 'non-migratory' activities of feeding, flying short distances, and egg laying. The adults only live for about ten days, so any subsequent migration from the new breeding site will involve the following generations.

The above account is based on observations made on individual populations of butterflies which were followed as they migrated.

Migrating hordes of monarchs *Danaus plexippus* pass the winter on the Florida and California seaboard where they are protected by state laws and are a considerable tourist attraction. Thousands of butterflies may occupy a single tree, and the same trees tend to be visited year after year. With the coming of spring the butterflies set off on the long journey northward to their breeding grounds (X 0.35).

Most often the migrations of butterflies have to be pieced together like a jig saw puzzle from the isolated observations of many individual observers at different times of the year and in many different places within the range of a species. In just such a way C. B. Williams, who contributed so much to the study of insect migration, was able to build up a picture of the migrations of the large white butterfly *(Pieris brassicae)* in Europe. This species can be found migrating during the months of June, July and August in central Europe. By examining the records from many countries Williams was able to establish that migrations occur from breeding areas in Scandinavia and the Baltic through Germany to the Alps in the south and to Britain in the west. Like *Ascia monuste*, which is in the same family (Pieridae), the adults migrate when freshly emerged and immature and they do not return. They appear to migrate only when the temperature is high enough and in light winds; to some extent the butterflies can control their track while they fly, but more often than not the final route taken is a compromise between the course chosen by the butterflies and the direction of the wind.

The migration of the monarch

The supreme example of long distance displacement among butterflies is the annual migration of the monarch *(Danaus plexippus)* in North America. The northern race of this beautiful insect migrates the length of the sub-continent—a distance of some 3,200km—between its breeding areas in Canada and the northern United States and its over-wintering sites in the southern United States, California and Mexico.

Adult monarchs start to move south from the northern breeding sites in July and by September vast numbers can be seen on the move. They apparently move by daylight only, feeding on the way, and on the whole do not fly at a great height but maintain a southerly direction. Mark and recapture experiments have proved beyond doubt that this butterfly regularly covers distances in excess of 1,900km in only a few days, and at average speeds of up to 130km per day (though 25–35km is a more typical day's flight). The longest recorded flight by one insect is just under 3,000km in a period of 130 days. Opinions have differed as to how far most individuals fly and how much the migration is really made up of successive short migrations by different individuals. The mark and recapture experiments emphasize the fact that individuals can cover great distances, as do sightings of monarchs several hundred kilometres out to sea and the occasional landings in Britain of these American butterflies which have presumably strayed off course during their southerly flight.

At night and when the weather is poor, the butterflies roost in trees, often in large groups. Most of the movement occurs down the eastern United States and also on the west coast, but migrations through mountain passes, several over a thousand metres high, have been observed. There are many records which suggest that the insects are capable of directing their own flight, even in the face of a 15kph head-wind. On the other hand they are often seen being blown south by a strong north wind, which suggests that in the long run it is the wind direction and strength which determines where the migrating butterflies will end their journey. Unlike the butterflies previously mentioned, some of the individual monarchs which complete the long journey south to overwinter make the hazardous return journey the following spring. But the flight back follows a completely different pattern. Males with ripe sperm and females

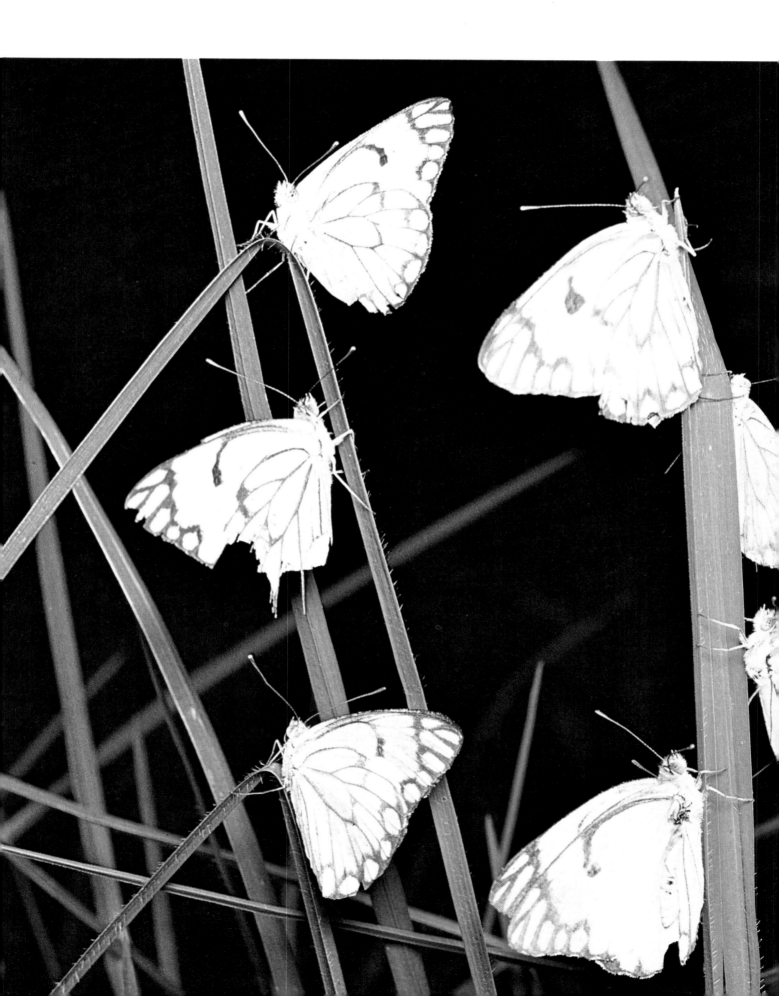

with ripening eggs set off northward separately and not in large groups. They fly high and fast, not bothering to feed on the way but using up their fat reserves, and they apparently rarely stop, flying by day and night. Some females may pause to lay eggs on the way and it is not at all certain whether they continue to migrate once their eggs are mature. It is also uncertain what proportion of the butterflies which arrive back at the northern breeding sites really have overwintered in the south and how many are from successive generations which may have been produced during the overwintering period. But there is little evidence of breeding at the overwintering site and certainly many of the butterflies which arrive back at the northern breeding sites have a very battered appearance, suggesting that they have overwintered.

The speed of flight

The remarkable distances covered by some migrating butterflies pose questions about the speed at which they fly, how long they can remain in the air, what sustains them in flight and what makes them stay airborne for such a long time. Butterflies are not among the fastest flying insects by any means: *Ascia monuste* was reported by Nielson to fly at about 8kph against a strong wing and 20kph with it; the painted lady, *Vanessa cardui,* has been observed flying at speeds in the region of 8–15kph, and probably the fastest known migrating butterfly is the monarch which can keep up with a car travelling at 30–40kph. To put this in perspective some horseflies and honey bee workers can fly at approximately 50–65kph and one large dragonfly, *Anax junius,* has even been reported keeping up with an aircraft travelling at 140kph. Even the slowest flying butterfly can cover considerable distances during migration if it is carried along with the wind. Flying at 8kph in a light breeze of similar speed it *could* cover perhaps 130–160 kilometres in a day.

Most migrations are usually characterized by the long periods which the insects spend in the air instead of resting or feeding on the ground. Flying for such long periods involves the use of enormous quantities of energy. This is provided from fat stored in the body, mainly in the abdomen in the form of a large mass of tissue called the fat body. Butterflies are well endowed with fat body when they emerge, perhaps 30 percent of the total body weight after drying. After a long migration this figure may be down to 1–2 percent in the case of the monarch, even though the insects will almost certainly have fed en route in order to partially replenish their energy reserves. In females the fat body is also used to nourish the developing eggs and this is partly why migrating butterflies often do not mature their eggs until after their long flight iscompleted.

The family Pieridae is especially noted for its migrant species. Some swarms contain millions of individuals of several different species. Shown here are members of a swarm of the South African brown-veined white *Belenois aurota.* Migrations of *Belenois* occur annually and the resulting larval progeny strip the leaves from large areas of Capparis and related plants, some of which are of economic importance (X 4)

Chapter 6

Genetics –

the mechanism of inheritance

Genetics is the study of the ways in which the characters of an organism are inherited by its offspring. A number of plants and animals have been studied intensively by geneticists because they have simplified mechanisms that lend themselves to scientific investigation and analysis. The genetic principles which have been discovered and understood in relatively simple systems can then be used to explain the situations found in a wide spectrum of species. Butterflies have received very little attention from geneticists but there has been a fair amount of work done on moths. In the absence of detailed information specifically relating to butterflies it is helpful that much of our understanding of the genetic processes which has been obtained by exhaustive study of the fruit fly *Drosophila* is probably equally applicable to butterflies.

Every cell in the body of a butterfly, or any other organism, contains in the nucleus microscopic structures called chromosomes. These chromosomes are a kind of chemical blueprint for all the structures and functions of the animal. The number of chromosomes in each cell is normally constant for any particular species, but may differ from one species to the next. The chromosomes occur in pairs and the two members of each pair are said to be homologous. The members of each homologous pair are derived from the parents in the following way. When reproductive cells are produced the individual chromosome pairs divide into single chromosomes which each pass into different cells so that each sperm or egg has only half the full number of chromosomes. At fertilization, sperm and egg fuse and their two half sets of chromosomes again pair up to produce a fertile egg cell that contains a full set of paired chromosomes.

The basic units of heredity are called genes and these are carried in the chromosomes. Like the chromosomes these genes are in pairs, one inherited from the father and one from the mother. In the simplest possible situation a single character is controlled by one such pair of genes. The actual situation is often more complicated because one gene pair may control several characters or alternatively several gene pairs may affect a single character. If the two genes of a pair are of similar type the animal is described as homozygous or a homozygote. Alternatively if the two genes of a pair are dissimilar then it is heterozygous and the animal is described as a heterozygote. It should be remembered that this description refers to a particular gene pair and one animal can be both homozygous for some characters and heterozygous for others.

Knowledge of the character and behaviour of the genes is of vital importance in understanding the genetic process. The two genes in a pair do not fuse or mix even when they are dissimilar in character. They retain their integrity and when reproductive cells are produced they can separate again. The separation of every pair of genes into different reproductive cells is termed segregation. These basic principles of inheritance may be referred to as 'Mendelian' after Father Gregor Mendel, an Augustinian abbot, who investigated the patterns of simple inheritance and first proposed the existence of inheritance factors. At that time, the mid-1860s, the existence of chromosomes and genes was not known, so it was not until much later, in the 20th century, that the importance of Mendel's work was properly appreciated.

The Mendelian principle can be illustrated by the case of the oriental swallowtail butterfly *Papilio memnon* (see pages 134/135). The female is polymorphic; that is, it exists in more than one form (see Chapter 8) and these different forms are determined genetically. The butterflies are tailed in the form *achates* and tail-less in the

The sex of a butterfly is determined genetically. Many species are sexually dimorphic—that is, the males and females differ widely in appearance. As in some other species, in the Australian eggfly *Hypolimnas bolina* the males (right, X 5) all look much alike, whereas the females (above, X 6) may occur in a number of different forms. In such a case the female is described as polymorphic. These variations are sex-controlled and therefore only operate in combination with the female characters and cannot appear in the male.

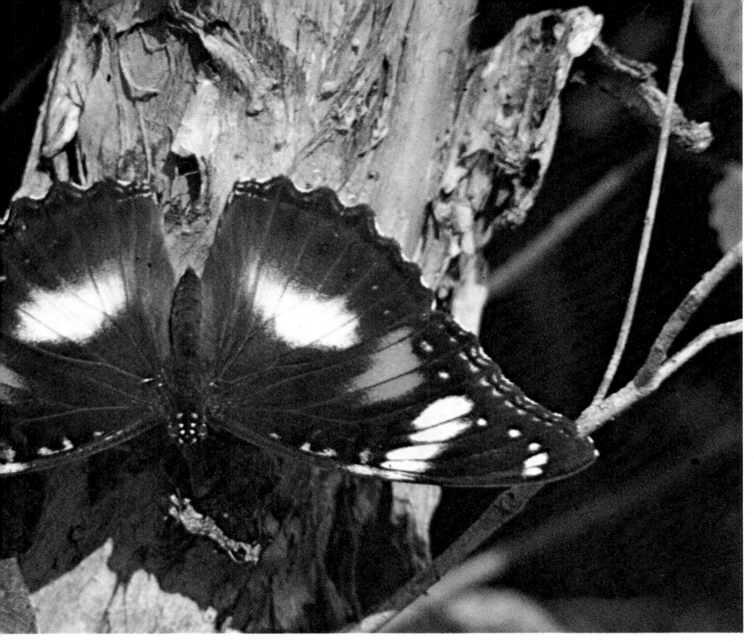

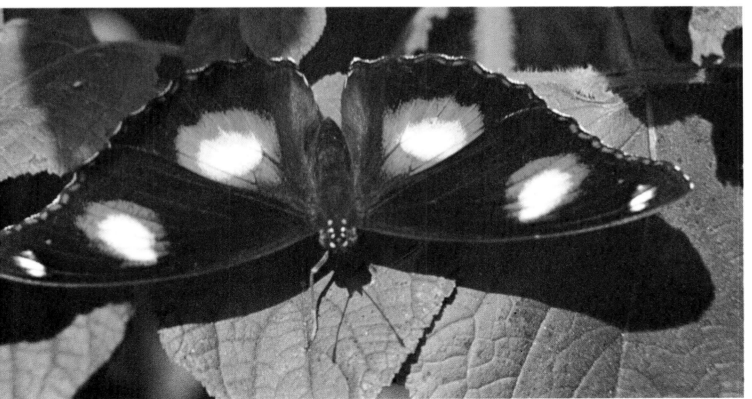

form *agenor*. The tail-less butterflies are homozygous (ie have two tail-less genes) while the tailed butterflies may be homozygous (two tailed genes) or heterozygous (one tailed gene, and one tail-less gene). It is the usual situation for one gene type in a pair to be dominant, suppressing the other member of the pair when they occur together in the heterozygous condition. In this species the tailed gene is dominant while the tail-less gene is recessive. It should be emphasized, however, that the recessive gene still retains its genetic potential for future generations, but it will not be expressed in the appearance of the butterfly unless it is paired with a second tail-less gene. This important point is underlined by the use of the terms 'genotype' for the genetic make-up of an individual and 'phenotype' for its actual appearance. This can be illustrated where the fate of the genes is traced through to the next generation in the following diagram. T represents the dominant tailed gene *(achates)* while t represents the recessive tail-less gene *(agenor)*. In the top diagram parents are both homozygous.

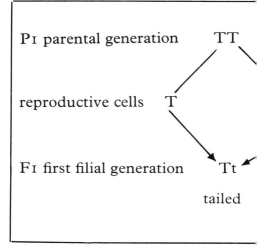

Because T is dominant over t, it will be seen that the first generation females are all tailed in appearance, while carrying both genes. It should be remembered that the male parent may carry the genetic constitution for *achates* or *agenor* but does not show either of these forms since they are exclusively female forms.

If a tailed F1 female of this brood is paired with one of her brothers the resulting F2 females will be tailed and tail-less in the ratio 3:1 respectively, as in the bottom diagram.
Three of the second generation have the dominant T gene, so have tails; one has no T factor (only the t gene) so has no tail.

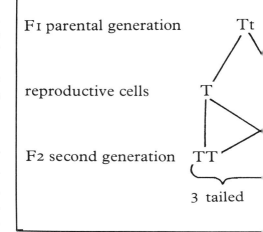

In practice this ratio may not be exactly achieved since some of these characters will be inherited by males and will not therefore be expressed in the F2 generation. This system of two alternatives, a character being either present or absent, is much more common than situations where 'mixing' occurs to give intermediate types between the parental forms.

Another example of this genetic process is proved by the small copper butterfly *Lycaena phlaeas*. The male and female of this species are similar in colour. They have coppery fore wings spotted with blackish-brown and brown hind wings with a copper band close to the hind margin. There is a rare variety called *obsoleta* in which this copper band is missing. It has been shown that the presence of this band is determined by a simple pair of genes. The typical form of the butterfly is dominant while the *obsoleta* gene is recessive. It is similar to the situation found in the oriental swallowtail except that the variety may be found in both sexes. When a normal parent with two normal genes is paired with an *obsoleta* parent which carries two *obsoleta* genes the first generation are all heterozygotes and they all appear normal because they all contain the normal gene which is dominant over their other *obsoleta* gene. When two of these heterozygotes are paired the offspring consist of normal and *obsoleta* forms in the ratio 3:1. This ratio is what is visibly apparent in the phenotypes, in fact the ratio is 1:2:1 because there is one homozygous normal, two heterozygous normal and one homozygous *obsoleta* form.

Further examples of departure from the normal form are described in Chapter 8. Butterflies such as the silverwashed fritillary *(Argynnis paphia)* and the clouded yellow *(Colias crocea)* have dimorphic females which are produced genetically. The variant genes can only find expression in the internal developmental environment of the female of the species and they are therefore called

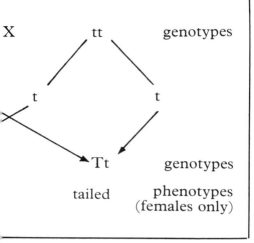

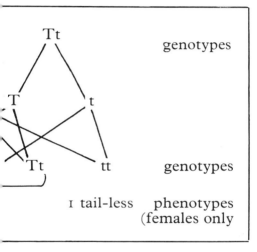

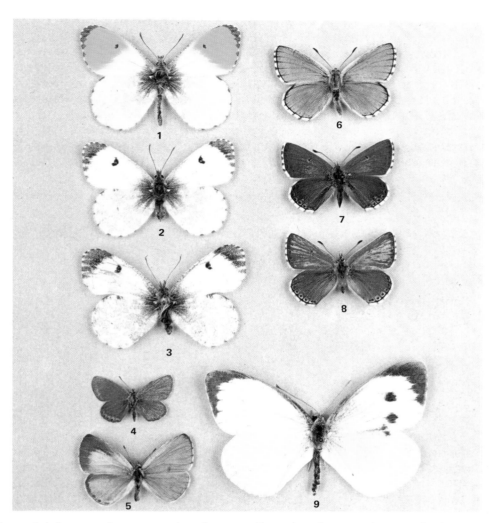

Examples of sexual abnormalities in a group of European butterflies.
1. Orange tip *Anthocharis cardamines* normal male; 2. Normal female; 3.
3. Gynandrous female, showing streaks of male colouring.

4. Silver-studded blue *Plebejus argus* partial gynandromorph: left side female, right side mostly male.

5. Holly blue *Celastrina argiolus* bilateral gynandromorph: left side female, right side male.

6. Adonis blue *Lysandra bellargus* normal male; 7. Normal female;
8. A sexual mosaic, predominantly female with irregular streaks of male scaling.

9. Large white *Pieris brassicae* bilateral gynandromorph, left side male, right side female.

sex-controlled genes. The examples which are given are dominant genes which produce the variety in the heterozygous animals, unlike *obsoleta* referred to above. Homozygous forms of these two species are unknown, presumably because they are non-viable and cannot survive in the wild.

Gynandromorphism

Gynandromorphs are butterflies which exhibit the external characters of both the male and female in the same individual. Such specimens are sometimes incorrectly referred to as hermaphrodites. These abnormal forms may be difficult to detect when there are no great differences in the appearance of the sexes, but in species with pronounced sexual dimorphism such insects look very odd indeed. In extreme examples (shown on page 55) the wings on one side belong to one sex while those on the opposite side belong to the other sex.

The sex of an organism is specified by its genetic make-up. In mammals the genetic composition determines whether the gonads are male (testes) or female (ovaries). All the other characters of each sex are then produced under the influence of the particular hormones which are produced by the gonads. Circulating in the blood, these hormones reach every part of the animal and so the whole body assumes a male or female character. In butterflies the situation is different since the sexual appearance of every individual part of the body is determined by the genetic composition of its component

cells. This is how it is possible for different parts of a butterfly to behave independently and have the appearance of different sexes.

Butterfly sex is determined by the sex chromosomes. There are two types of sex chromosomes, X and Y. A butterfly which possess two X chromosomes is male, while a butterfly which carries both X and Y is female. Sex is inherited in the same way as other characteristics. The homologous pair of sex chromosomes divides during reproduction and the male produces sperms which carry one X chromosome each. The female produces eggs with either X or Y chromosomes in equal numbers. The resulting progeny are males and females in approximately equal numbers.

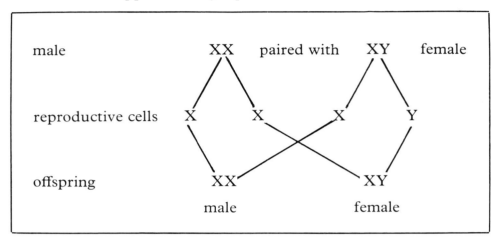

The actual sex determination depends on the presence of the extra X chromosome. Some abnormal forms with an extra Y chromosome are still male because two X chromosomes are present. Gynandromorphs are produced by abnormalities in the genetic composition of the butterfly. One way in which they can be produced is if the butterfly develops from an egg with two nuclei, one containing XX chromosomes and the other containing XY. Another way is if an error occurs during primary cell division of a male embryo so that an X chromosome is lost by one of the cells. Since it is the quantity of X chromosomes that determines the sex this results in a butterfly which is half normal male (XX) and half X, which is effectively female although there is no Y chromosome.

Halved gynandromorphs are generally rare and most gynandrous forms exhibit an unequal mixture of male and female characters. The appearance of the specimen of the adonis blue *Lysandra bellargus* (shown on page 53 fig. 6) may be due to another error during cell division. In this instance the insect is predominantly female. It is possible that during a late stage in wing development during division of the chromosomes the X chromosomes may have failed to separate. This would result in some cells having an XXY genetic make-up and others with Y alone. The latter would certainly die, while the cells with XXY would be male in character because of the two X chromosomes. These would develop male coloration giving rise to an insect with a mosaic appearance. Sometimes only a small part of the insect will be affected, as in the case of the female orange tip *Anthocharis cardamines* which shows a small patch of the orange scaling which is exclusively a male character (see page 53 fig. 3).

Intersexuality

Intersexes are mixed forms which originate in a different way from gynandromorphs. To understand how they arise it is necessary to

Above: The genetics of butterfly aberrations are far more complex than was formerly believed. This European ringlet *Aphantopus hyperantus* shows a marked reduction in the ring-like markings (ab. *arete*) compared with the typical form shown on page 244. Experimental evidence suggests that several different heriditary factors probably combine to produce such a form (X 6).

Right: Where the sexes differ widely in appearance, as in the Peruvian swallowtail *Papilio androgeos,* a bilateral gynandromorph presents a very striking appearance. In this example even the body and legs are 'halved', each side showing the colour of the respective sex. The left side is normal female. The right side is almost completely male (a single clasper may be seen at the end of the abdomen), with a few streaks of the blue female colouring on the hind wing. Such extreme sexual abnormalities are prized by collectors.

understand the way in which sex is determined by the X chromosomes. It is the quantity of X chromosome material, or its relative strength, which determines the sex. One X chromosome is sufficient only to produce a female, but when there are two X chromosomes there is sufficient X influence to produce a male. Sex is not determined by any particular agent carried in the chromosome. This is realized when it is appreciated that a male whose sex is determined by having two X chromosomes inherited one from his mother and that single X chromosome was what determined his mother's female sex. Similarly if he produces female offspring their sex will be determined by one of his X chromosomes. This works effectively provided that the 'dose' of sex factor carried by an X chromosome is always the same. Problems arise when individuals from widely separate races of the same species mate and produce offspring. Where races have been isolated and are unable to meet normally in the wild they may have developed X chromosomes of different 'strength'. A single X chromosome from race A may be equivalent in terms of the dose of sex factor to two X chromosomes from race B. In such an instance crossing individuals from separate races may result in offspring which develop as intersexes, or a peculiar mixture of the sexes, developing first as one sex and then later changing over to the other. This situation is known to occur in certain moths and may well be found in butterflies too.

It is remotely possible that the blue females found in *Morpho aega* are produced by genetic imbalance and are intersexual in origin. The difference between the colours of these and normal females is structural (see Chapter 7) and is not due to pigments. The form *pseudocypris* (shown on page 75) demonstrates scales of a type generally found in males of this species. Females with restricted areas of blue scaling are frequently met with, and these 'blue' forms are said to be much more frequent in some populations than others.

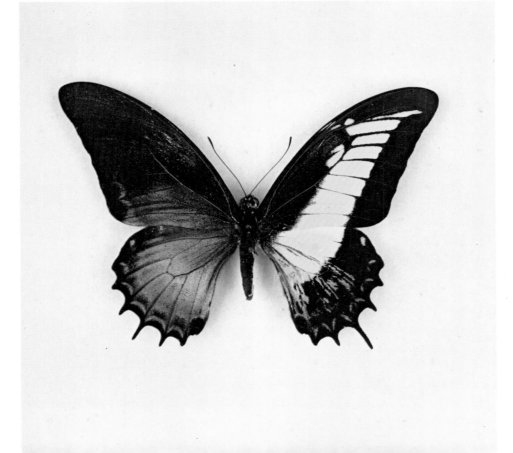

Chapter 7

Coloration–

for concealment and advertisement

I t is the presence of patterned and coloured wings that immediately distinguishes the Lepidoptera from most other groups of insects which tend to have rather uniform, transparent wings. Among the Lepidoptera appear some of the most exquisitely coloured of all living things. This undoubtedly contributes to their popularity, and the fact that they can also easily be preserved has made them a favourite quarry for collectors. Enthusiasm for butterflies especially is not confined to scientists; the same colours and and ease of preservation has made them a favourite material for the manufacture of ornamental goods. Regrettably butterfly wings, in glass or plastic, have been extensively used to decorate table mats and tea trays. Groups of the larger species, arranged in geometrical patterns to form wall decorations were especially popular in the late 19th century. Some of the most brilliant species, particularly those with a metallic lustre, have been incorporated into items of jewellery for personal adornment.

How colour is produced

Colours may be produced by pigments, by structure or by a combination of these two. The colour is usually present in the layer of microscopic scales which clothes the butterfly's wings, but it may also be present in the underlying epidermal tissue which remains if the scales are removed, as in the case of the *codrus* group of swallowtails (Papilionidae) (pages 122/123). Pigmentary colours are due to the presence of chemical substances derived from metabolic processes, often as by products of excretion. Butterfly pigments are inadequately known but some have been scientifically investigated and details of their chemical structure are fairly well understood.

Pigments

Melanin is a particularly common pigment and is responsible for blackish-brown colours. Pterins are pigments derived from uric acid and are found only in the family Pieridae among butterflies.

Below: The rather distorted appearance of this specimen of the Peruvian Satyrid *Pierella hyceta* is due to positioning it so as to demonstrate the peculiar glowing patch on its fore wings. The patch glows when light rays touch the wings at a certain angle.

Right: The European comma *Polygonia c-album* stands out when it settles on a leaf, as here, but when it hibernates among dead leaves its jagged shape and cryptic brown-grey under-side pattern of its wings afford perfect camouflage (X 15).

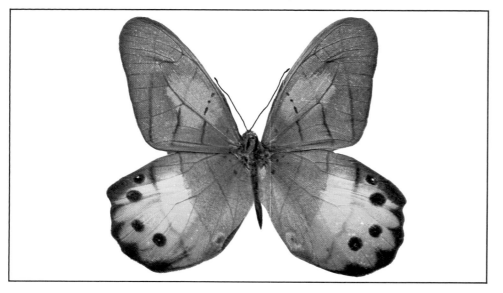

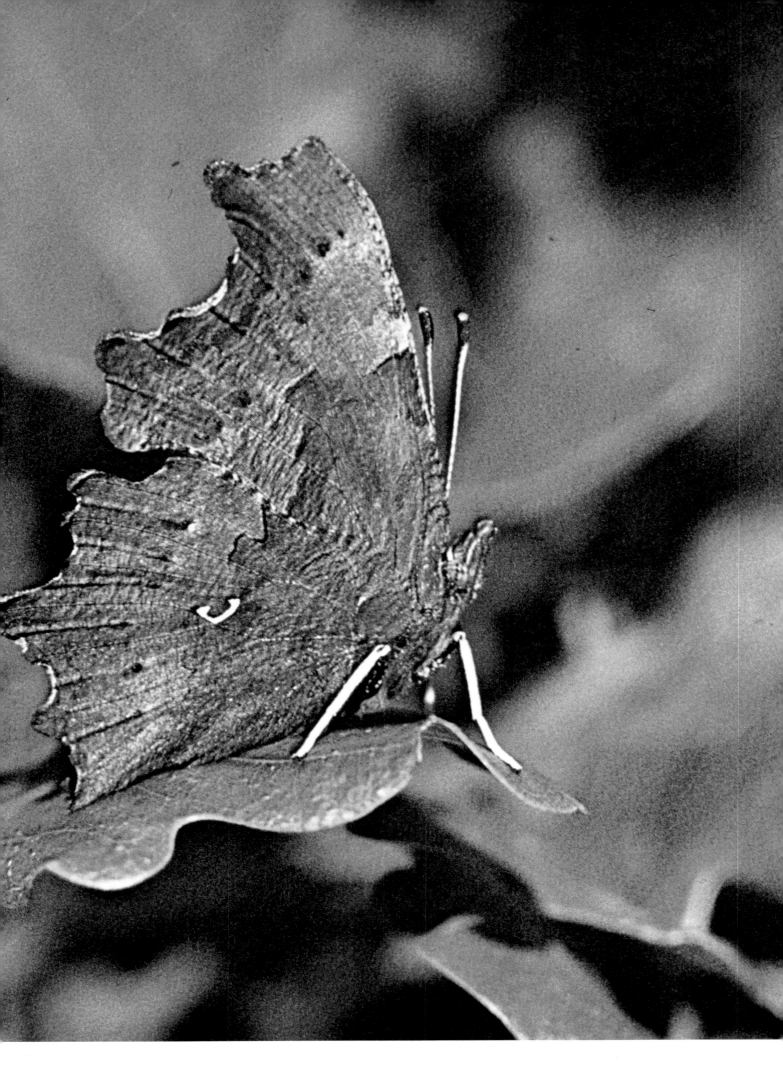

Leucopterin (white), xanthopterin (yellow), chrysopterin (orange) and erythropterin (red) in a variety of combinations produce most of the attractive colours found in this family. Flavones produce cream or yellow colours in several butterfly families. These pigments are interesting because they are apparently derived directly from plant leaves during the butterfly's larval stage. At one time it was thought that the green colours of many larvae and pupae could be plant chlorophyll directly obtained in the same way. It now appears that chlorophyll is not found in Lepidoptera but that green pigments are biochemically derived from it. Reds and reddish-browns are also produced by pigments. The unstable nature of many butterfly pigments causes them to fade if exposed to sunlight and many can also be altered artificially by chemical action. For example the brick-red of the small tortoiseshell *(Aglais urticae)* (Nymphalidae) can be converted to a dull purple by hydrochloric acid fumes (forms of similar colouration are occasionally found in wild populations).

Structural colours

Structural colours are produced by the physical properties of butterfly wing scales. When examined under a microscope the individual scales usually reveal longitudinal ridges or ribs. In some species these ribs consist of thin translucent layers of material set at a constant angle to the plane of the scale itself and separated by air spaces. This structure refracts light to produce an overall colour, which may vary somewhat depending on the angle at which the light strikes the scale but is otherwise fairly constant for the species. An analogy may be drawn with a thin layer of oil floating on water. Both are transparent and colourless, yet light passing through the oil and reflected back from the water surface suffers an interference which causes the appearance of rainbow colours.

Most animals which have a metallic sheen or iridescent colouring, including humming birds as well as butterflies, owe their unusual splendour to structural factors rather than pigments. The brilliant iridescent blue colour of many of the S. American *Morpho* butterflies is probable the most familiar example of a structural colour and as a rule green and blue colours in butterflies are produced by structure rather than pigment. There is a simple test to distinguish between these two kinds of colouring. If water is put on the butterfly wing, pigment colours are unaffected, but structural colours are dulled owing to the water spoiling the effect of the scale surface.

Another type of physical factor that produces colour has been reported by the physicist E. R. Laithwaite, who has examined a structure akin to a diffraction grating in some members of the Neotropical genus *Pierella* (Satyridae). In essence this is a series of fine structures which break up white light into its visible coloured components. The males of *Pierella* appear relatively dull until viewed from an acute angle, when a small dark patch on the fore wing 'lights up' in an extraordinary manner. The specimen of *P. hyceta* (shown on page 56) used to demonstrate this feature is naturally much distorted by the perspective. At its brightest the patch appears green but variation in the angle at which light impinges on the wing produces every colour in the visible spectrum.

White colours in butterflies may also be produced structurally. The scattering of light by microscope transparent particles produces a white effect in the same way that snow appears white, but no actual pigment is present. White hair in humans is similarly an effect created by tiny air bubbles within the hair rather than by a white

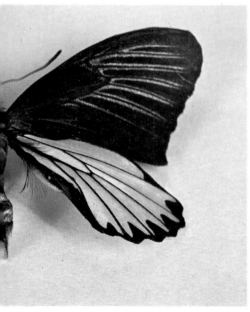

When viewed at an acute angle from the rear, the Formosan birdwing *Troides magellanus* exhibits beautiful structural colouring. The upper specimen shows the normal translucent gold appearance of the hind wings. The lower example (somewhat distorted by the angle) reveals the iridescent coloration caused by diffraction of light rays.

colouring matter of some sort.

Combination colours

Combinations of structural colour and underlying pigment are much commoner than structural colour alone. In the European purple emperor *Apatura iris* (Nymphalidae) (shown on page 211) the scales contain the dark brown pigment melanin, but this is overlaid by a structural violet blue colour which is visible only when viewed from certain angles. Butterflies of the genera *Colotis* and *Hebomoia* (Pieridae) (shown on page 166) possess a red pigment in the scale walls which is combined with a structural violet to produce orange-pink or shades of magenta. The true appearance of these species is not easily reproduced as photography often fails to reveal the underlying pigment and records only the colours due to structural elements.

Two species of birdwing butterflies *Troides* (Papilionidae) exhibit the most beautiful colours caused by the combined effect of structure and the translucent gold pigment present in this genus. In a specimen of *T. magellanus* (shown on pages 58/59) when viewed from above only the gold pigment is evident, but when illuminated from the rear and viewed acutely from this direction beautiful iridescent pinks and greens are visible on the hindwings.

Transparency

While the wings of most butterflies are coloured and opaque there are a few in which they are wholly or partially transparent. The best examples occur in the Apollo butterflies, genus *Parnassius* (Papilionidae). Though cases are generally uncommon in temperate latitudes, an extremely diaphanous example of the clouded Apollo *P. mnemosyne* from Switzerland is shown on page 60–1. Further semi-transparent *Parnassius* species are shown on pages 116–7. In these mountain butterflies the transparent areas are due to scale deficiency. Partial transparency, where patches of wing may be devoid of scales, is not uncommon in butterflies. It may be seen on the wing tips of the *protesilaus* group of swallowtails (Papilionidae) (pages 120/121) or in the small 'windows' found in the Nymphalid genera *Kallima* (page 63) and *Anaea* (pages 220/221).

The predominantly Ethiopian family Acraeidae includes many examples which are thinly scaled and have a largely transparent appearance. The most extreme forms bear more resemblance to insects of other orders such as dragonflies (Odonata). In the Neotropical region transparent species occur in a number of families, such as Danaidae, Ithomiidae, Satyridae and Pieridae. The Satyrid genus *Cithaerias* (page 246) and the glasswings Ithomiidae (pages 250–1) are good examples of butterflies which have largely transparent wings.

The same overall transparent appearance in butterflies can be produced in a number of different ways. The Pierid *Dismorphia orise* has scales which are reduced in size. In the Ithomiids the scales are further reduced to fine hairs. The Danaid *Ituna* has full-sized pigmented scales but they are very sparsely scattered. Some Neotropical moths have achieved the same effect as in the butterflies by having transparent scales, while one genus has its normal sized scales set on edge so that the light passes between them.

The adaptive significance of colour patterns

All the colour patterns found in butterflies, ranging from the most dark and drab to the most brilliantly colourful, have some survival

value or adaptive significance. This applies not only to the adult insect but also to every stage in the life cycle. The intricate patterns that we see on butterfly wings have been moulded, modified and perfected by a long process of natural selection. The purpose of coloration may vary throughout the life of a butterfly, with the young stages being cryptically coloured or camouflaged while the adults may be brightly coloured for courtship display. Different types of coloration may be found on one insect. It is quite common for the underside of butterflies to be cryptically coloured so that they are camouflaged at rest while the upper wing surfaces have bold markings which are only visible when the wings are opened. Coloration may be very closely related to the behaviour of the butterfly and the adaptive significance of a colour pattern may not become apparent until the insect has been studied in its natural surroundings.

Cryptic colours

Many examples of cryptic coloration are found among the larval and pupal stages of butterflies. During this phase of its life the developing insect is most vulnerable to predation. Coloration is usually combined with protective behaviour – for example many butterfly larvae feed at night, crawling up the foodplant at dusk and returning to the comparative safety of the bases of the leaves during daylight hours.

The European purple emperor *Apatura iris* affords a good example of camouflage colours in its young stages. The larvae feed on the leaves of sallow (*Salix capraea*). The eggs are laid on the leaves in July and the young larvae hatch and feed on the leaves till they reach their third instar. At this stage the tiny green slug-like larva crawls down and rests in the fork of a twig, where it will spend the winter. The over-wintering larva changes to a brownish colour when it matches the bark perfectly. In the spring the young larva resumes feeding as the leaf buds burst open. It quickly changes back to a green colour which exactly matches the shade of the leaves. When resting the larva characteristically sits head upwards on a leaf with its tail attached to the very point of the leaf. It adopts a pose with the anterior part of the body raised up in a curve so that it matches the curving outline of the sallow leaf. In addition to the colour and textural resemblance to the leaf the larva is also counter-shaded – with the anterior end darker green than the posterior end. This counteracts the natural shadowing effect so that the larva seems to be flat like the leaf. The pupa is another masterpiece of camouflage. The shape and colour exactly matches a dead or wilted sallow leaf. It is again counter-shaded except that now the tail end is darker.

Many other kinds of protective resemblance may be found in the early stages of butterflies. In addition to mimicking leaves they may resemble other parts of a plant such as buds or twigs, or they may resemble other objects that would be unattractive to a potential predator. There are a number of examples of young stages which resemble bird droppings, for example the larvae of some swallowtails *(Papilio)* and the pupae of certain Lycaenidae.

Among adult butterflies cryptic patterns are the most obvious forms of protective coloration. Many species are at least partially cryptically coloured, usually on those parts which are visible when the butterfly is at rest. In fact the majority of butterflies are less brightly coloured on the under surface than the upper. Even if a specimen seems strikingly patterned when it is seen isolated in a collection it may still blend totally with its surroundings in the wild.

Leaf-like patterns and shapes are particularly common examples of camouflage colouring (shown on pages 62/63). Butterflies of the

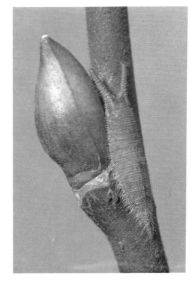

Above: The well-camouflaged young larva of the European purple emperor *Apatura iris* soon after emergence from hibernation (X 5).

Right: Members of several butterfly families have transparent wings, a characteristic due to reduced or modified scaling. These examples are:
1. *Parnassius mnemosyne* (Papilionidae), Europe; 2. *Hypoleria morgane* (Ithomiidae), Brazil; 3. *Haetera piera* (Satyridae), Peru.
Hybrids between species are rare in the wild. No. 5 shows a Peruvian example resulting from a cross between 4. *Callicore cynosura*, and 6 *C. pastazza* (Nymphalidae).

Below: Some butterfly pupae are protected by their resemblance to other objects. What appears to be a bird dropping on this leaf is the pupa of the European black hairstreak *Strymonida pruni* (X 5).

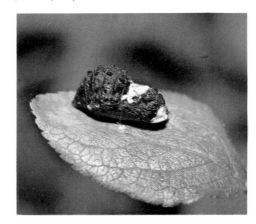

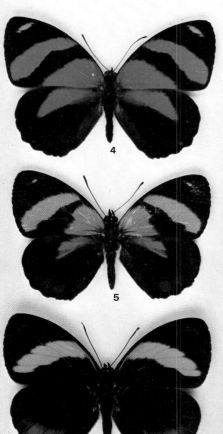

Nymphalid genus *Polygonia* have a ragged appearance and a dappled cryptic colour pattern. These insects are well concealed when resting among the withered leaves in which they hibernate.

The amazing leaf-butterflies, of the genus *Kallima* (Nymphalidae), which occur in the Indo-Malayan region are probably the most frequently quoted examples of natural camouflage in the Animal Kingdom. When at rest the fore and hind wings reproduce a large elliptical leaf shape complete with a stalk. The colour is basically that of a dry dead leaf but the resemblance is complete down to the last detail. The underside pattern has a 'midrib' and even 'blemishes' such as 'worm holes' and patches of 'mould'. With these embellishments the butterfly so exactly duplicates the natural appearance of a dry decaying leaf that naturalists have never ceased to marvel at it.

The species shown on page 63 is *Kallima paralekta*, the subject of an amusing account by the great naturalist and explorer Alfred Russel Wallace, who wrote in *The Malay Archipelago*:

'This species was not uncommon in dry woods and thickets, and I often endeavoured to capture it without success; for after flying a short distance, it would enter a bush among dry or dead leaves, and however carefully I crept up to the spot, I could never see it till it would suddenly start out again, and then disappear in a similar place. At length I was fortunate enough to see the exact spot where the butterfly settled; and though I lost sight of it for some time, I at length discovered that it was right before my eyes, but that in its position of repose it so closely resembled a dead leaf attached to a twig as almost certainly to deceive the eye even when gazing full upon it'.

Such cryptic patterns are usually found on the underside of the wing but in some cases they may appear on the upper surface. Members of the Neotropical genus *Hamadryas* (Nymphalidae) frequently rest head-downwards on tree trunks with the wings spread, an unusual butterfly posture. The dappled blue and grey colours of the upper surface of the wings blend perfectly with the bark. The wings of the butterfly are held flat against the tree so that they appear to be part of the surface and there is no shadow to accentuate the outline of the butterfly. The effectiveness of cryptic colours may be considerably reinforced by behaviour such as this. A perfect colour resemblance to the surroundings can easily be spoilt if the resting butterfly casts a shadow which gives away its presence. This danger is greatest in the case of species that habitually rest on the ground or some other flat surface. When resting many Satyrids orientate themselves towards the sun to eliminate their shadow, or at least to minimize it. Some butterflies, such as the grayling *Hipparchia semele*, tilt their bodies and wings towards the sun to reduce their shadow size. They behave in a similar manner towards an approaching observer so that little of the wings is visible. Butterflies of the genus *Oeneis*, which inhabit the flat Arctic tundra, adopt the most extreme poses by lying on their sides to eliminate their shadow, which would be very noticeable in their natural habitat.

Some of the transparent butterflies referred to earlier represent another type of probable cryptic coloration. The Satyrids and some Ithomiids inhabit forest situations where there is dappled light and shade. They fly close to the ground and settle frequently. Since they are almost entirely transparent the natural background is visible through the wings and the butterfly itself is difficult to distinguish. When in flight the combination of transparency and dappled light

makes these insects very difficult to follow with the eye.

Disruptive patterns

Cryptic coloration may be combined with patterns, wing shapes and resting attitudes that enhance the camouflage effect. The most recognisable and obtrusive feature of a resting butterfly is often its triangular outline. It is common to find patterns superimposed on the overall cryptic colours that tend to disguise the shape of the butterfly either by obliterating the outline or by disrupting the overall shape. The underside of the European small tortoiseshell *Aglais urticae* affords a good example of both these devices. The brown colour of the underside resembles a dead leaf. The wing margin is chequered in dark and light brown to break up visually the otherwise clear-cut edge. In addition the wing bases are dark brown, changing abruptly to light yellowish-brown in the areas furthest from the body. When the insect is resting the contrasting patterns cutting across the wings break up their characteristic outline. The pattern itself is also particularly obvious and the attention of an observer (or a predator) is drawn to an abstract pattern of colours rather than an instantly recognisable butterfly of a clearly defined shape.

This disruptive type of pattern may be part of the uniform in cryptically coloured species, or it may take over completely as the main form of protection. The Neotropical zebra butterfly *Colobura dirce* has the underside strongly marked in cream and brown to form a bizarre pattern of stripes, bands and zig-zags that visually fragment the wing shape. Similarly the Neotropical genus *Diaethria* includes species with spectacular patterns in black and white on the under-wing surfaces. These patterns are striking and conspicuous in isolation, and in no way match the surroundings as in cryptically coloured forms. Instead they present a bizarre jumble which is visually meaningless rather than easily recognisable as a butterfly. With cryptic coloration, protection is gained by making the butterfly match its surroundings so that it is difficult to see; with disruptive coloration, the animal can be seen but not recognised for what it is. Both stratagems are effective in keeping predators from eating the butterflies concerned.

Eye-spots or ocelli

Another protective device is the use of patterns which draw the attention of a predator away from the vital parts of its potential prey. Eye-spots or ocelli, which occur in the wing patterns of most families of butterflies, are probably the best example of this type of coloration. Ocelli are most frequent among members of the Satyridae, Brassolidae, Morphidae and Amathusiidae. The resemblance of these spots to real eyes may be very superficial, for example many Satyrid 'eyes' consist of a round black spot with only a tiny white 'highlight'. Sometimes the eye-spot may bear a startling resemblance to a vertebrate eye as in the case of the Neotropical genus *Caligo* — the so-called owl butterflies (pages 238–239). When a specimen of one of these butterflies is seen with its lower wing surfaces displayed and the butterfly is viewed upside down, it is strangely reminiscent of an owl's face with two large staring eyes, but it is difficult to imagine any natural situation when the butterfly could display both eyes in this way. Statements that the butterfly habitually rests upside down are quite erroneous.

The survival value of ocelli has been the subject of much discussion. The chains of eye-spots that may be seen on the underside

Right: Cryptic coloration is demonstrated most effectively by the amazing Oriental leaf butterflies. The example shown in numbers 1–6 is the Malayan *Kallima paralekta*. The variability of this species is well demonstrated in the illustration, and it would be very difficult to find two under sides exactly alike. Variation is not infinite, however, and an examination of hundreds of specimens reveals perhaps eight or ten basic forms in various combinations. This suggests that the underside pattern is not random but is determined by the interaction of a number of genes.

Below: The African dry-leaf butterfly *Precis tugela* at rest exactly duplicates a leaf appearance, even to a 'stalk' formed by the hind wing tails (X 2).

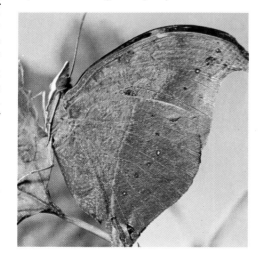

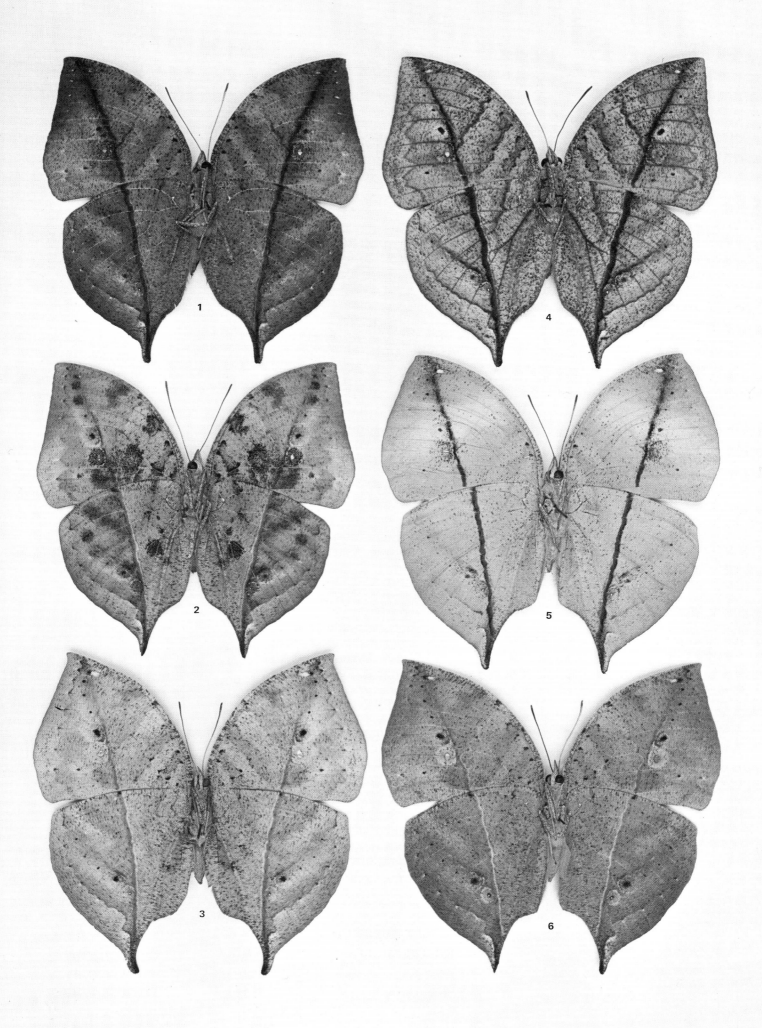

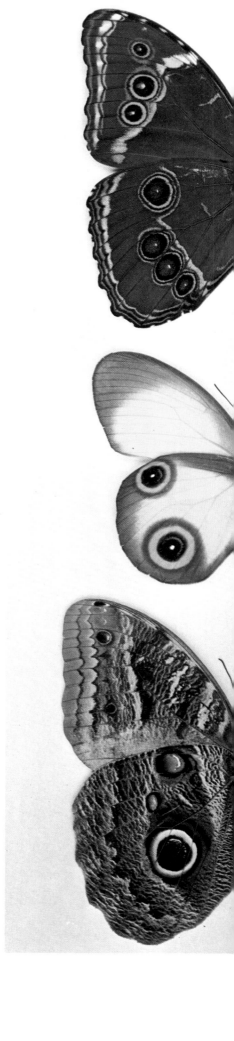

of most species of Morphidae (shown on pages 64/65 and 228–237) are probably disruptive patterns helping to break up the shape of the underside. However, in most cases ocelli are believed to act as deflecting patterns acting as 'target areas' for potential predators, such as birds. The idea being that a bird, confronted with a butterfly marked in this way, will take a swift peck at a prominent eye spot rather than some more vulnerable part of the butterfly's body. The resulting damage to the wing would be less harmful than if it had been done to the body; certainly the loss of quite major portions of this wing area in *Taenaris* butterflies (shown on page 223 and 226/227) would not adversely affect them to any great extent. In many Lycaenids the ocelli are combined with structural features that reproduce a 'false head' at the rear inner angle of the hind wings. This part of the wing is drawn out into fine tails (shown on page 171), which may be quite long and elaborate in some tropical species, for example in the Ethiopian genus *Hypolycaena*. The attention of a predator is further drawn to the rear end of the insect by special wing movements. These butterflies habitually rub their wings together, causing the tails to twist about and creating the illusion of a head with actively moving antennae. The supposed function of these patterns requires more careful field observation and verification but certainly it is quite common to find tropical Lycaenids with triangular sections of the rear wings missing where a bird has presumably taken a peck at what it thought was the head of a large insect.

Startling colours

Butterflies with eye-spot markings or other striking colour patterns may also gain protection by startling their enemies with sudden movements that reveal their colours. This is similar to the flash coloration displayed by some moths. The resting moth may be quite inconspicuous with drab coloured fore-wings but when it is disturbed it suddenly raises its forewings to reveal hind-wings with vivid markings such as the bright red under wings of *catocala* species or the huge eye-spots of the bull's eye moth *Automeris io*. This shock tactic may startle a predator long enough to enable the insect to escape unharmed. Although moths show this combination of colour and behaviour particularly well, it is also seen in some butterflies. For example when the grayling butterfly *Hiparchia semele* is at rest only the cryptic colours of the underside are visible. If the butterfly is approached and disturbed it responds by suddenly raising the fore wings to reveal a large black eye-spot on the underside of the fore wing which is just concealed by the hind wing when at rest. The peacock (*Nymphalis io*) similarly shows only cryptic colours when at rest, but it can dramatically reveal its four big eye-spots by suddenly flashing its wings open if disturbed. Ocelli are also employed by larvae to startle their enemies. The mature larva of the American spicebush swallowtail *(Papilio troilus)* has two spectacular eye-spots on its thorax. When disturbed it can cause that part of its body to swell up, thus stretching the skin and making the eye-spots even bigger.

Conspicuous colour patterns

There is a great variety of butterfly colour patterns whose survival value is not so obvious. There are some species, for instance, which are brilliantly coloured and seemingly very conspicuous indeed. Such colour patterns would appear to advertize the butterflies and place them at risk from predators rather than offering them protection, but such coloration may have its purpose in fulfilling some

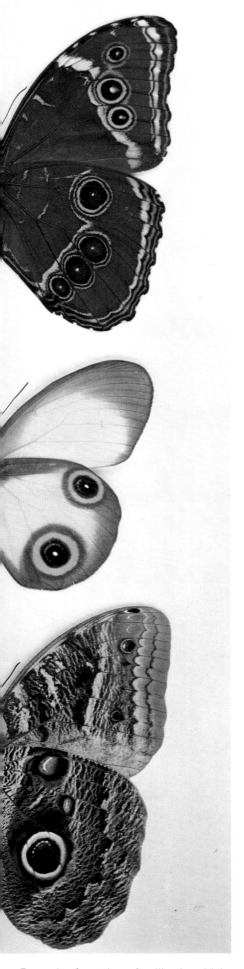

Examples from three families in which underside eye-spots (ocelli) are well developed: 1. *Morpho achilles* (Morphidae), Brazil; 2. *Taenaris catops* (Amathusiidae), New Guinea; 3. *Caligo illioneus* (Brassolidae), Peru.

role other than a protective one. In particular, brilliant colours and striking patterns may play their part in recognition between individual butterflies for the purpose of territorial behaviour and courtship, just as they do in many birds. Certainly it is possible to attract the blue male *Morpho* butterflies by waving a piece of bright blue card in the sunlight in the localities which they inhabit.

In these particular insects, the brilliant iridescent blue colour probably also serves another function. They inhabit tropical rain forest and are usually found near water, especially waterfalls. The butterflies follow stream courses with a fast erratic flight dashing through the dappled light and shade. As they pass through a sunny patch the wings flash electric blue, but in the shadows they appear only as dark silhouettes, making it difficult for predators to follow them in flight because one moment a brilliant blue object is being chased but the next instant it has disappeared, to be replaced by a dark shape. This in turn suddenly erupts into brilliant blue on reaching a sunny patch. The momentary confusion and indecision induced in a potential predator may be sufficient to help the butterfly escape unharmed.

Butterflies which are protected by poisonous or distasteful body fluids usually adopt a very striking colour pattern to advertize their presence and identity. It is a positive advantage for such butterflies if they are recognized by their enemies as inedible before they are attacked. For this reason they use bright warning colours such as red, orange or yellow in contrasting patterns, often with black or dark brown stripes. A bird or other predator which catches and tries to eat one of these butterflies learns to associate the pattern and colour with its unpleasant qualities, and avoids catching similar butterflies thereafter. Probably the most universally known butterfly which has warning colours of this type is the monarch, *Danaus plexippus* (Danaidae). Other particularly good examples of this type of coloration may be found amongst the families Heliconiidae and Acraeidae. There is a tendency for unrelated species which are protected by their distasteful nature to adopt a common colour pattern if they inhabit the same locality, and for other unprotected species to mimic the warning colour pattern. This fascinating phenomenon of mimicry is dealt with in Chapter 9.

Hybrids and transitional colour forms

Naturally occurring hybrids of butterflies are very rare, although such forms have been produced in breeding experiments, by hand-pairing, principally among Papilionidae. These hybrid forms may show colours (or perhaps other anatomical features) derived from both parents; and a wild-caught hybrid between *Callicore cynosura* and *C. pastazza* (Nymphalidae) from Peru is shown on page 61. The upper surface is principally *cynosura* although the inner fore wing band (not present in *pastazza*) is much reduced, and so is the hind wing band. The outer margins of the hind wings also show clearly the reflective purple-blue of *pastazza* and the under surface of this remarkable insect is entirely as in this species.

Transitional colour forms are not hybrids but simply examples which show features intermediate between two forms of the same species. Page 75 shows two specimens of the Neotropical Nymphalid *Anaea (Siderone) marthesia*. This species exists in a number of distinct forms which have sometimes been considered as constituting quite separate species. However, even the most dissimilar forms are linked by transitional types, each showing a different combination of the features which distinguish the particular forms. Similar transitional examples are found between colour forms of many other butterflies.

Chapter 8

Variation–

Variation is a fundamental characteristic of all animals. It is frequently overlooked that members of a species are not all stereotyped replicas of their parents. They are not like mass-produced objects stamped out on a machine; they are living creatures, each individual being the embodiment and expression of a unique combination of genetic material.

Seen in this light, variation between individuals becomes less unexpected and it is certainly true that butterflies exhibit this trait more clearly than most other animals. Indeed, the range of variation in the patterns on the wings of some butterflies is so great that it may be very difficult to find two identical examples in the same species. Some species, notably those which include butterflies with pronounced patterns or markings, have a much greater tendency towards variability than others. Variations are also more common in some families than others; and they are particularly prevalent in certain areas, especially where isolated populations occur. Indeed, French entomologists in the 19th century referred to Britain as *le pays de varieties* because of the comparative abundance of unusual forms which were to be found there. The abnormal forms may bear exaggerated or enhanced markings which make them even more attractive than the typical form of the butterfly. This has led to entomologists specializing in the study of variations and devoting a great deal of effort to accumulating examples in collections of specimens, after the fashion of philatelists who collect different watermarks on stamps.

There has been a tendency in the past for entomologists to justify these activities by creating a vast number of names, one for every distinguishable form of a species, when there are only tiny differences in detail. This is no more valid than inventing special scientific names for all the different minor variations among humans, as though blondes were fundamentally different from brunettes. Nevertheless many variations in both the colour pattern and the wing shape and size of butterflies are of interest and are produced by a number of well-known biological phenomena. The factors that may effect such variations can be internal or genetic, or they may be related to external influences in the butterfly's environment.

Geographical variation

The variability of a species is most easily appreciated by examining a series of specimens of the butterfly taken from all over its geographical range, and from a variety of different habitats which it occupies within that range. In the case of a variable species it may be found that the wing size varies depending on where it was collected and that it may be darker coloured in some localities than in others. Sometimes it is possible to correlate these visible differences in the butterfly's appearance with features in the environment such as the type of food plant available, the soil type or geology or the altitude or latitude. The differences between butterflies at the extremes of the range become more pronounced when the species is very widespread. Where there is a tendency for geographical isolation – that is, where physical barriers such as the sea, desert and mountain ranges prevent the meeting of butterflies of the same species living in different areas – local varieties often become very distinctive and common. When the isolation is total and when the physical separation has existed for a long period of time then each isolated group of a species tends to develop its own peculiar features, becoming a distinct and recognizable race or sub-species. When this process continues for a much longer period of time a separate species

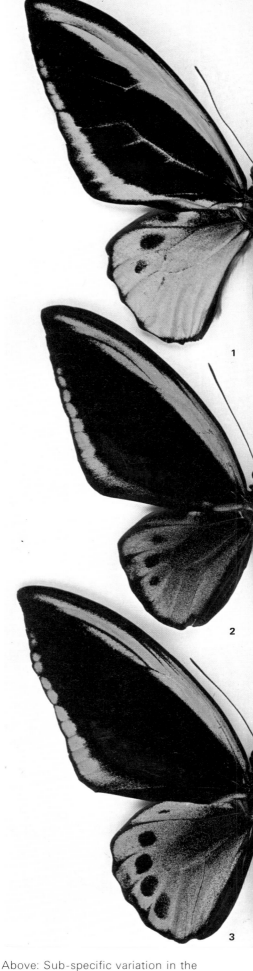

Above: Sub-specific variation in the birdwing *Ornithoptera priamus* (Papilionidae): 1. s.sp.*demophanes*, Trobriand Isles; 2. s.sp.*miokensis,* Duke of York group; 3. s.sp.*urvilleanus,* Solomon Islands.

may be formed.

The example shown on page 66 illustrates three sub-species of the birdwing butterfly *Ornithoptera priamus*, which occur in different regions of the Australasian archipelago. These widely different forms were selected to make the point dramatically obvious, but *O. priamus* is even more variable than this, for at least a dozen separate green forms alone have been distinguished.

The apollo butterfly *Parnassius apollo* (Papilionidae) is probably the best-known example of a variable species in Europe. This very attractive butterfly inhabits hillsides and mountain meadows throughout Europe and parts of Asia. It has tended to become isolated on different mountains or mountain ranges and a great many different local races have been described as a result of the great variability in the intensity of the black markings and the size and number of red spots.

In many instances the varieties of a species are not distinctly separate and the species shows a continuous gradation of forms over its geographical range. A progressive gradation from one extreme form to another from a distant area is described as a cline. An example of this clinal variation may be found in the large heath *Coenonympha tullia* in the British Isles. Southern forms of this butterfly have more spots and a deeper ground colour than the northern examples but there is no clear demarcation between the forms, and many subtle blends of intermediate coloration are found in localities lying between the geographical extremes.

In places where a number of closely related species of the same genus occur in different geographical areas the inter-relationship can be indicated by the use of a group name. Members of a species-group are not connected by intermediate forms but they are very closely related and are presumably derived from a common ancestral stock. These groups may be referred to by the name of the 'focal' species; for example, the various members of the Indo-Australian genus *Troides* (Papilionidae) are subdivided into the *amphrysus* species group, the *helena* species group and so on. Similarly there are sub-species groups, which are more recently evolved, where the individuals in the group are usually connected by intermediate forms.

Variability, particularly among closely related species, makes it

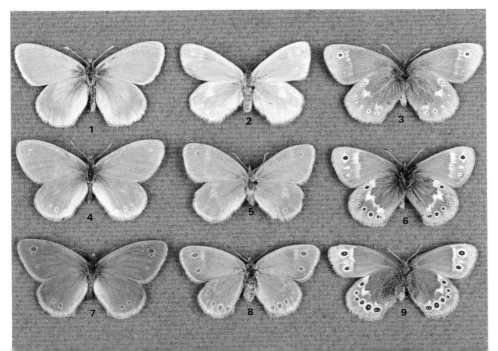

Left: Where a species shows a continuous gradient of variation within a limited geographical area it is said to form a cline. The large heath *Coenonympha tullia* shows such variation in the British Isles. In each case the male, female and underside are shown from left to right. Northern examples 1–3 are f. *scotica*. The darker, more heavily spotted examples from the southern part of the range, 7–9, are f. *davus*. Intermediate between these, 4–6, are f. *polydama*. Specimens are frequently found which cannot with certainty be assigned to a particular form. Such variants, in the absence of clear demarcation, should be regarded as clinal rather than as a series of sub-species.

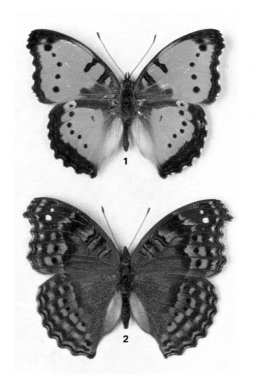

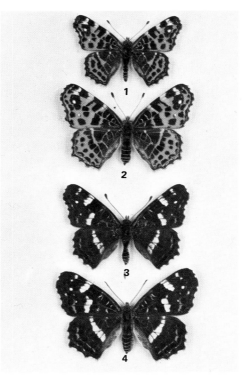

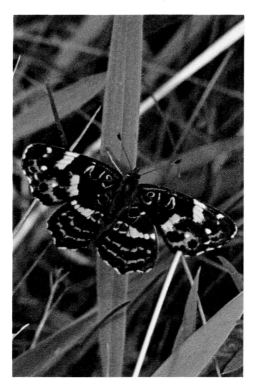

very difficult indeed to decide which animals belong to which species or sub-species, and indeed the whole demarcation of groups becomes very blurred. The Nymphalid butterflies of the genus *Agrias* are a case in point. A selection are shown on page 69, treated as one particular form (f. *narcissus*) of *A. aedon*. However, they also show some affinity with a form of a quite different species, *A. claudina*. In cases such as this, classification and naming of butterflies (see Chapter 13) gets very confusing and becomes more a matter of opinion than an exact science.

Seasonal variation

Butterflies which produce more than one brood during a year frequently exhibit seasonal variation, especially if the different broods occur in widely different climatic conditions. In temperate regions there may be differences between the spring (vernal) and summer (aestival) forms of the same species. In the tropics there is not such a pronounced difference in temperature throughout the year as in higher latitudes but there are still distinct seasons associated with periods of rainfall or drought. The pattern of wet and dry seasons may be very pronounced and also very regular.

There are many examples of butterflies that show a variation in their colour pattern during the different seasons. It would appear that the critical factor that determines the colour pattern is the average temperature during the developmental stages of each brood of the butterfly, though humidity may also play a part. The effect of temperature is not constant for all families, for while many double-brooded Nymphalids produce darker forms at lower temperatures the reverse is true for many Pierids.

Seasonal dimorphism may also include variation in the size and shape of the wings. In the most extreme examples the seasonal forms may appear so dissimilar that it is difficult to believe that they belong to the same species.

The European map butterfly *Araschnia levana* (Nymphalidae) (see above) has strikingly different seasonal forms. The spring brood (f. *levana*) resembles a fritillary on its upper side while the second generation (f. *prorsa*) resembles a small white admiral with blackish wings marked with white bars. The under sides are similar in the two broods. In this species environmental temperature appears to affect the pigmentation indirectly by influencing the rate

Above far left: The wet season (1) and dry season (2) forms of the African Nymphalid *Precis octavia* are so different in coloration that early entomologists believed them to be members of two different species.

Above centre: The spring form of the European map butterfly *Araschnia levana*, of which the male (1) and female (2) are shown, contrasts with a pair of the darker, different-patterned summer form, (3) and (4).

Above: Unusual climatic conditions sometimes produce forms intermediate in both colour and pattern between the characteristic seasonal forms, as in this example of *Araschnia levana* from southern France (X 2).

Right: Although there are probably only five species of *Agrias* (Nymphalidae), the enormous range of local variation, and extensive polymorphism and parallelism (resemblance to other *Agrias* species or to other Nymphalid genera), give rise to hundreds of forms. The *narcissus* forms shown here are classified as a sub-species of *Agrias aedon*, but many authorities regard *narcissus* as distinct. *Agrias aedon* Hew.s.sp.*narcissus* Stgr. (males at left, females at right): 1. typical male (Brazil); 2. form *stoffeli* Mast de Maeght and Descimon (Venezuela); 3. form *stoffeli* variant; 4. form *stoffeli* ab. *gerstneri* Mast de Maeght and Descimon (Venezuela); 5. form *obidona* Lathy (Brazil); 6. typical female (Brazil); 7. form *stoffeli* ab. *negrita* auct? (Venezuela); 8. form *stoffeli* ab. *lichyi* Mast de Maeght and Descimon (Venezuela).

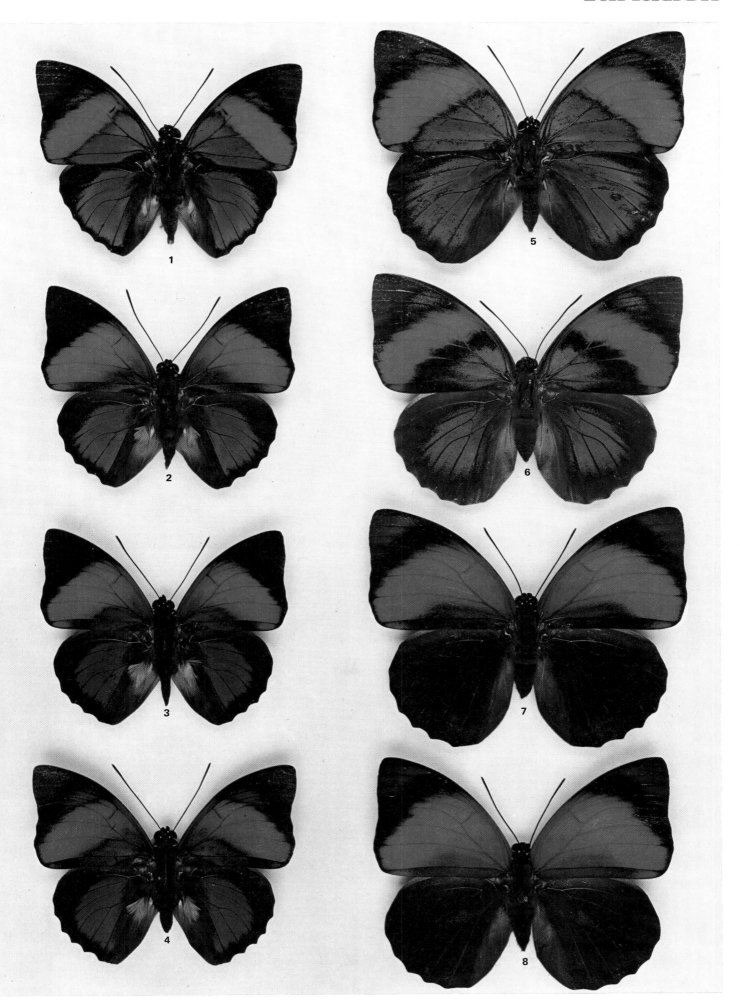

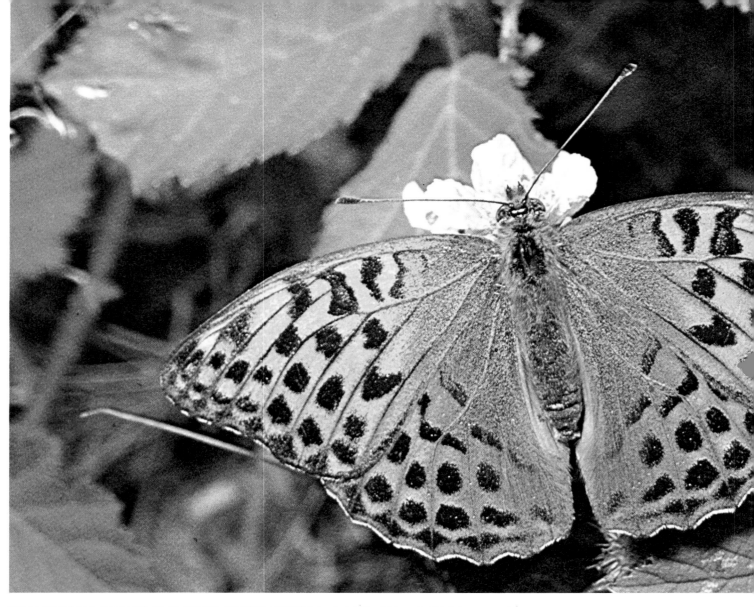
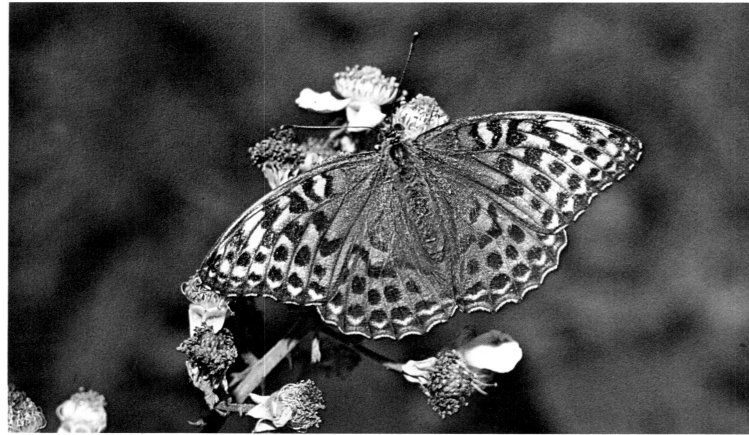

Females of the European silver-washed fritillary *Argynnis paphia* are normally dark orange-brown, as in the example above (X 4). However, a second, rarer form of the female known as *valezina* also occurs. In this form, shown left (X 2), the ground colour is bronze green. In such a case the female is said to be dimorphic. The factor which produces the *valezina* form is obviously sex-controlled since it does not occur in the male. For reasons as yet unknown the *valezina* form does not occur at all, or is extremely rare, in many areas, whereas in other areas—such as the New Forest in England—it is relatively common.

of development.

Another very striking example of seasonal dimorphism (see page 68) is found in an African Nymphalid, the gaudy commodore *Precis octavia*. This species has a wet season form which is predominantly orange with black markings and a dry season form which is predominantly black and blue with virtually no orange at all. In parts of Africa which have pronounced wet and dry seasons the wet season form is abundant during the wettest months but declines and is replaced by the dry season form as the climate becomes more arid. It seems possible that it is the rate of seasonal change which stimulates the production of seasonal forms rather than absolute temperature. The reasons for the different colour forms of this butterfly are not immediately apparent yet the colour patterns must serve some function that improves the survival of the butterfly, or at least does not hinder it. Perhaps the answer lies in the way in which the butterfly behaves during the spells of drought. Dry seasons in the tropics correspond to the temperate winter in so far as they present severe environmental conditions for many plants and animals. Species dependent on moisture may become inactive and aestivate during months of drought conditions. *Precis octavia* commonly shelters and aestivates amongst rocks, and in such places the blue dry season form would appear to be better camouflaged than the rather conspicuous wet season form. A similar case is found in the closely related species *Precis pelarga*, in which the dry season forms of the butterfly have more elaborate wavy margins to the wings, and cryptically coloured under sides which presumably offer them greater protection while they are aestivating among dead leaves.

It is quite possible to induce artificially the different seasonal forms when the above species are reared in captivity, by experimentally altering the temperature or humidity regimes during development. It is also possible to induce abnormal colour forms by subjecting the larval and pupal stages to extremes of temperature. The dark 'melanic' forms of Nymphalidae (see page 74) have been artificially produced in this way, by using extremely low temperatures. When the same experiment is tried using high temperatures, varieties with reduced dark areas are produced. In all such experiments the mortality rate is very high and such extreme examples are rare in the wild.

Another way in which the final colour pattern of a butterfly may vary as a result of external factors is if the insect is accidentally injured at a critical stage in its development. Such an injury is likely to result in a lack of some or all pigment from the affected area. These 'bleached' forms are particularly common in the meadow brown *Maniola jurtina*.

Genetic factors

Many variations in the colour patterns and appearance of butterflies are caused by genetic factors. Some genetic variants may be abnormalities or aberrant varieties while others are quite normal. The genetic process of inheritance has been dealt with in Chapter 6. This section deals with the types of variants produced by the genetic composition of butterflies.

Sexual dimorphism, or differences in the appearance of the male and female, is the most familiar example of genetically produced variation. In some species there may be very little difference between the sexes, but females are usually larger than their corresponding males. However, there are many instances of species in which the

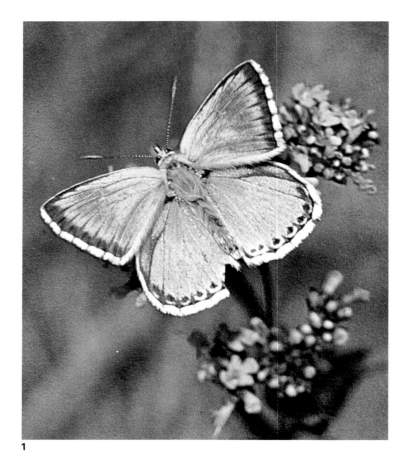

1

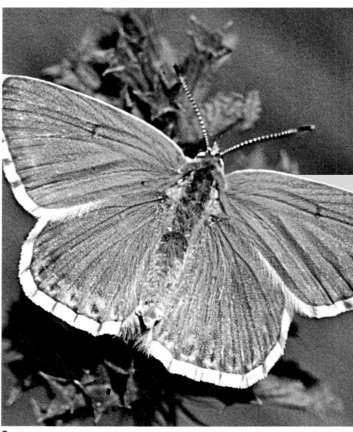

2

Although most butterflies show variation in some degree, some are particularly notable in this respect. One of the most variable members of the Lycaenidae is the European chalk-hill blue *Lysandra coridon*. Collectors in the past have enthusiastically studied and catalogued the various forms, and a major monograph has been devoted to them. A few of the most familiar are shown here: 1. typical male (X 3); 2. typical female (X 4); 3. female f. *semi-syngrapha*, with extended blue of a deeper colouring than the male (X 3); 4. female f. *syngrapha*, which closely resembles the male apart from the marginal lunules (X 4); 5. male ab. *fowleri* with white margins (X 2); 6. female ab. *fowleri,* an aberration much less common in the female (X 2).

sexes differ in size, colour and shape. These differences are sometimes so great that in the past entomologists have described the two sexes of one insect as separate species. The differences of wing size and shape are probably related to differences in the behaviour and flight pattern of the sexes. The colour differences may be attributed to other factors. Males are often conspicuous and brilliantly coloured presumably for recognition and courtship, while their corresponding females are dull or drab coloured for protection. The blues and coppers of the family Lycaenidae exhibit some fine examples of this type of dimorphism. Some of the more spectacular males can be sacrified without having too disastrous an effect on the population, while the more vulnerable females are given the protection of drab colours.

There are a great many other examples of genetic variation in butterflies. These are mostly abnormalities or at least atypical varieties. An interesting example is found in the silver-washed fritillary *Argynnis paphia*. In this species the female is dimorphic; that is, it exists in two forms. The typical female, while it differs in size from the male, is broadly similar in colour – a rich orange-brown. There is however a rather rare form (f. *valezina*) of the female of this species which is darker overall and has an olive green ground colour. The two forms occur together in the same localities but f. *valezina* is very much scarcer. The New Forest in southern England is a classic locality for this variety where it is fairly regularly encountered. This variety is a well known example of sex-controlled inheritance as it never occurs in the males. All the males appear normal, though a small percentage carry the *valezina* gene. When such a male mates with a typical female some of the female offspring will be of the *valezina* form.

Another example of this phenomenon is provided by the clouded yellow butterfly *Colias crocea*. The males of this species are a deep orange-yellow colour, while the females exist in two forms. The typical females resemble the male in colour while there is also a pale primrose yellow variety called *helice*. The variety is similarly produced by a sex-controlled gene. It is rather scarce and only

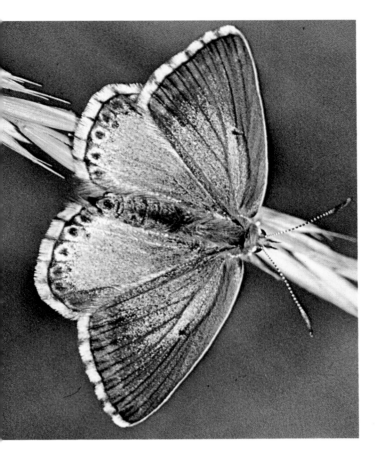
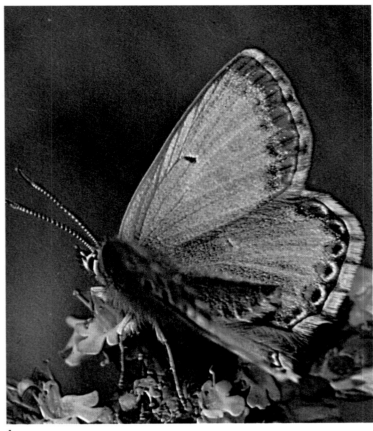

4

occurs as a small percentage of the female population; probably not more than about 5 percent. It is however easier to come across than the *valezina* variety of the silver-washed fritillary since the clouded yellow is a migratory butterfly that occurs over a wide area in the Palearctic.

A close study of variation within a single species may reveal both environmental and genetic factors at work. The chalkhill blue *Lysandra coridon* has been the subject of considerable attention in England since, in common with many other members of the Lycaenidae, it exhibits a very wide range of variation. The typical male and female are conspicuously dimorphic. The males are sky blue on the upper side while the females are brown-winged. In some populations the females have a small scattering of blue scales, but of a deeper colour than those of the male. There is, however, a form of the female (f. *semi-syngrapha*) in which the blue scaling almost covers the hind wing and extends to the base of the fore wings. There is a further variety in which the blue colour covers all four wings, giving the appearance of a male f. *syngrapha*. This can be easily distinguished from a proper male by the presence of orange lunules (semicircular patches) on the border of the hind wings which is a character exclusive to females. These are two quite separate varieties and not different degrees of the same variety. In addition to these upper wing surface varieties there are innumerable variations in the spotting of the under sides in this butterfly. Some of these forms are probably environmentally induced by different climatic conditions during development. These varieties have been extremely popular with collectors in the past and localities where varieties were frequently encountered became famous. A particularly well known colony of chalkhill blues at Royston Heath, near Cambridge in England, provided many examples of f. *semi-syngrapha* during a period of exceptional abundance of this butterfly.

It should be pointed out that the term 'variety' has no scientific standing. Speciments departing from the typical form of a species or sub-species are referred to as forms of aberrations. Strictly, forms are variations of regular occurrence which represent a fairly constant

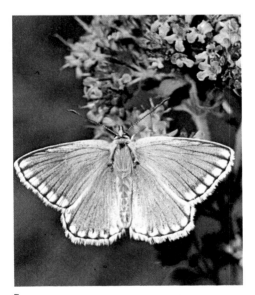

5

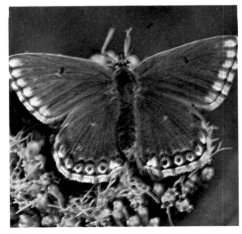

6

Variation

proportion, however small, of the total population. Aberrations are variations of irregular or random appearance, and where special names have been assigned to them these are preceded by the abbreviation 'ab'.

Melanism

Some variations are due to spasmodically occurring disturbances in the normal pigmentation mechanism of butterflies. Melanic variants are an example. Melanins are pigments which are responsible for the black or brown colours in butterflies. They are produced during development by the action of an oxidizing agent, tyrosinase, on the colourless amino acid tyrosin. The distribution of tyrosin may be influenced by genetic factors to produce butterflies in which the dark markings are much extended to give an overall dark appearance. One of these dark, or melanic, forms is shown opposite. Melanic forms of a number of the *machaon* group of swallowtails (Papilionidae) occur as rare varieties and are probably genetic recessives. In part of the range of *Papilio polyxenes* a melanic form is recurrent and it has been suggested that this may be a reversion to an ancestral type. This is supported by the theory that the drab brown females of many butterfly species have retained the 'primitive' colour form for protection, while the males have evolved bright conspicuous patterns.

Albinism

Aberrant varieties in which a red or yellow ground colour is replaced by white are not strictly albinos. Albinism is the absence of the pigment melanin alone. Such a condition is rare in butterflies but has been isolated in breeding experiments and is therefore an inheritable factor. An albino form of the meadow brown *Maniola jurtina* is shown opposite.

Homeosis

Homeosis is another type of variation in which the normal developmental processes have become muddled. Homeotic specimens have part of the fore wing appearance exhibited on the hind wing or *vice versa*. This assumption of the form and character proper to another part of the body structure may be due to injury at an early stage of development. Extreme examples are rare. A specimen of the clouded yellow *Colias crocea* (Pieridae), where the dark central spot, appropriate to the fore wing, is reproduced on the hind wings, is shown opposite. Strictly, this is also an example of heteromorphosis, since in the right fore wing this dark colour has also appeared in the 'wrong' area but on the same wing. Homeosis is, however, the general term used to describe both these phenomena.

Prolonged cold produces in some Nymphalidae an increase in the pigment melanin and results in darkening of the pairs shown, nos 2, 4 and 6 were produced by refrigeration of the pupae. 1, 2. peacock *Inachis io*, 3, 4. queen of spain fritillary *Issoria lathonia*; 5, 6. camberwell beauty *Nymphalis antiopa*.

Some examples of variation. *Anaea* (*Siderone*) *marthesia* (Nymphalidae) Peru: 7. Example of f. *nemesis*; 8. transition to f. *mars* (see page 221). *Morpho aega* (Morphidae), Brazil:

9. normal female; 10. female f. *pseudocypris*—the blue is normally found only in the male. Silver-washed fritillary *Argynnis paphia* (Nymphalidae), Europe: 11. typical male; 12. melanic form ab. *nigricans*. Clouded yellow *Colias crocea* (Pieridae), Europe: 13. typical male; 14. homeotic—extra dark areas produced on the wings. Meadow brown *Maniola jurtina* (Satyridae), Europe: 15. typical female; 16. albino form lacking dark pigment. *Papilio polyxenes* (Papilionidae) USA: 17. normal male; 18. melanic f. *melasina*.

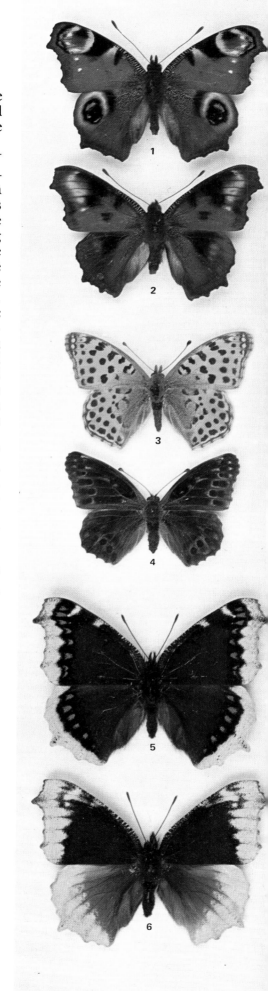

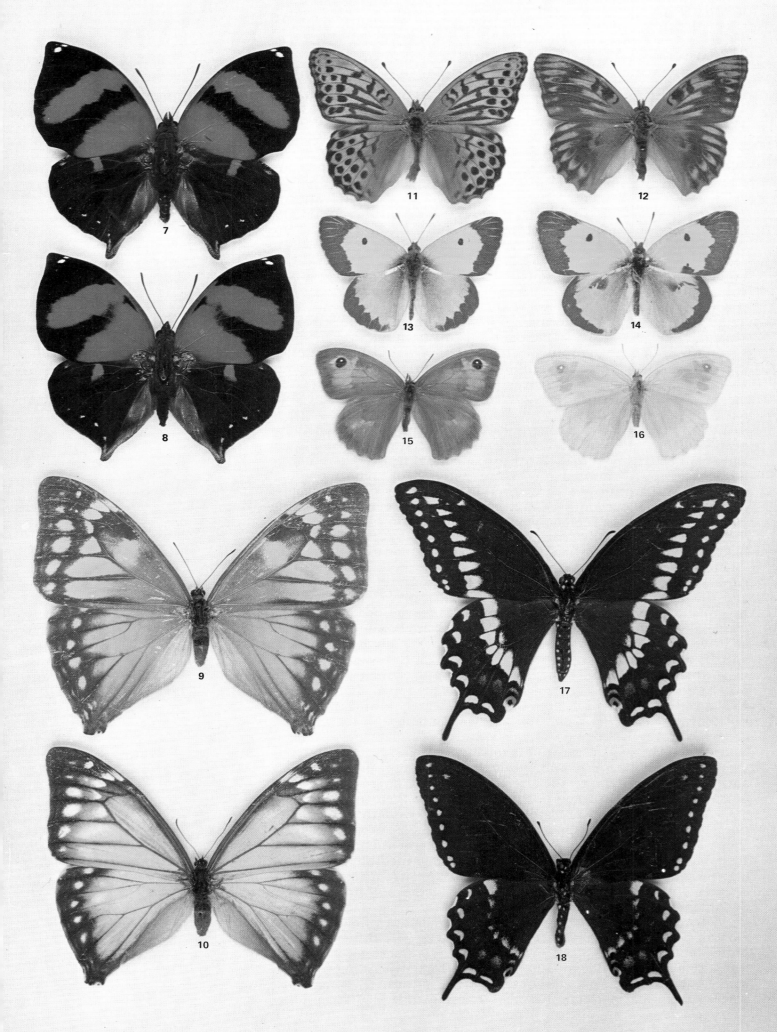

Chapter 9

Mimicry–
the art of impersonation

The incidence of mimicry among butterflies has been the subject of considerable study and controversy in the past. It is certainly one of the most striking and interesting features of tropical butterflies that so many apparently very similar forms in fact belong to quite different species or families. The concept of mimicry is based on the assumption that certain species are unpleasant, unpalatable or inedible to predators such as birds and other vertebrate enemies of butterflies, and that these species are coloured with conspicuous patterns of 'warning' colours which are recognized and avoided by the predators. It is further assumed that other harmless and quite palatable butterflies have evolved similar colour patterns and so derive protection because predators mistake them for the unpalatable species and leave them alone. The unpalatable butterflies are normally referred to as 'models' while the palatable species that resemble them are called 'mimics'.

Two basic kinds of mimicry have been distinguished: Batesian mimicry in which there is an unpalatable model species and a palatable mimic, and Müllerian mimicry in which two or more unpalatable, and often unrelated, species have evolved the same colour pattern.

Many of the basic assumptions of the theory of mimicry have been inadequately tested under scientifically controlled conditions. But there are many similar cases in the animal world where harmless species have adopted the colour patterns of some more unpleasant or harmful creature as a means of protection against predators. The markings of harmful species are usually simple patterns in striking colour contrasts that form a recognizable 'badge' which is easily learnt and recognized by predators. The black and yellow warning colours of a wasp is a good example of this. There are several unrelated and harmless creatures that have evolved similar wasp-type colour patterns such as some of the hoverflies and the wasp beetle *Clytus arietis*. Such examples of mimicry may be enhanced by behavioural mimicry such as the production of a wasp-like buzzing sound. The mimic species are bluffing; sheltering as it were behind the wasp's reputation. Among butterflies certain species may be unpalatable to predators because of an unpleasant taste or smell, or because they contain poisonous substances which may be derived in the larval stage from their foodplant. For example, Miriam Rothschild has shown that the widely distributed tiger butterfly *Danaus chrysippus* contains cardenolides (heart poisons) absorbed in the larval stage from the milkweed plants (Asclepiadacae) on which they feed. Such protected species are usually conspicuously coloured in combinations of black, red, orange, yellow and white. Furthermore they often fly slowly, do not attempt to escape when disturbed and positively advertize their presence.

It is assumed that predatory species quickly learn to recognize the pattern and general appearance of the inedible species and avoid them. A young inexperienced bird will attack and attempt to eat the tiger butterfly but will rapidly learn that it is inedible and highly unpleasant. It will subsequently associate its distasteful encounter with the conspicuous appearance of the butterfly and will not attempt to attack another one so long as it can remember its previous experience. There is some experimental evidence to confirm that this is actually the case when a bird is presented with unpalatable butterflies. The important point is that once a bird has learnt to avoid a particular colour pattern from attempting to eat an inedible butterfly it will subsequently avoid all butterflies with that pattern including perfectly harmless ones. In this way the mimics

Right: Batesian mimicry and polymorphism. *Hypolimnas misippus* (Nymphalidae), India: 1. typical male; 2. typical female, which 'copies' 3; 3. *Danaus chrysippus* (Danaidae).

The tailed male of the African *Papilio dardanus* is shown at 6. The females exhibit numerous forms modelled on distasteful species from other families: 4. f. *hippocoon* is patterned on 8. *Amauris niavius* (Danaidae); 5. f. *planemoides* mimics *Bematistes poggei* (Acraeidae) (see page 191); and 7. s.sp.*flavicornis* f. *cenea* resembles the smaller *Amauris echeria* s.sp.*septentrionis* (Danaidae) shown below (X 0.75). Particularly interesting is 9. f. *dionysos* because it combines features of *Amauris* species and 3. *Danaus chrysippus*, which also occurs in Africa.

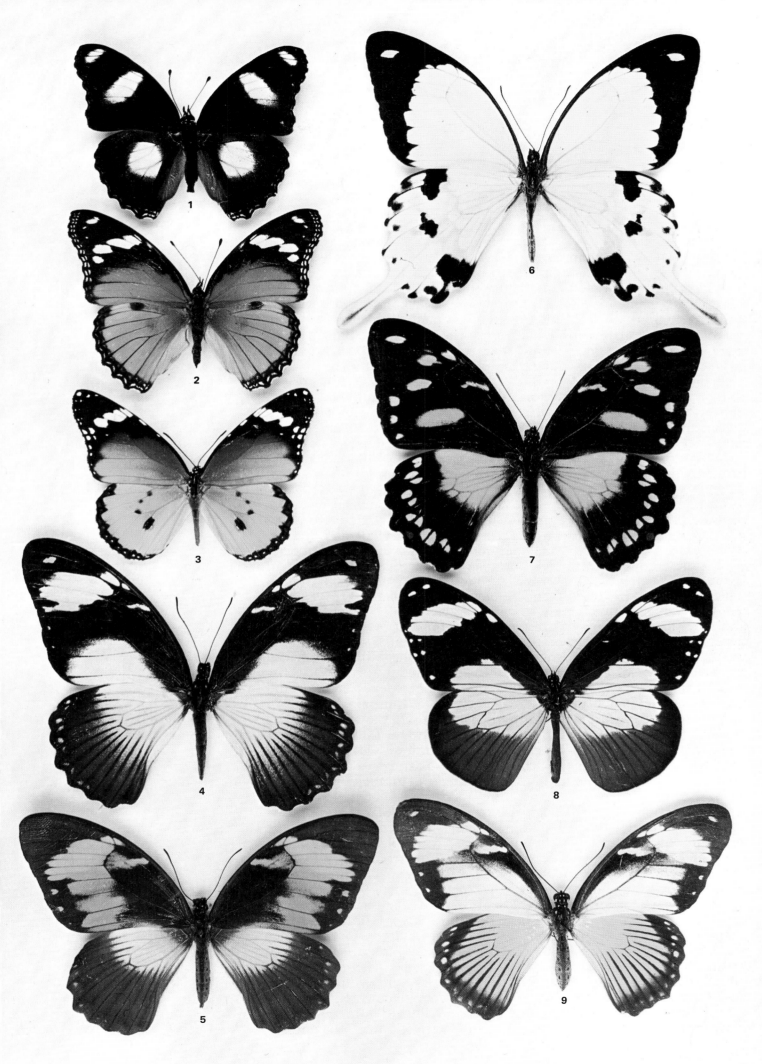

enjoy the same protection as the models in areas where they occur together.

It is quite easy to imagine the selective process which refines the mimics until in some cases they resemble their models so precisely that they can only be distinguished by a detailed examination of the wing venation. Mimics which resembled their models more closely would be mistaken more often by predators for the model and would therefore be avoided more often. Conversely butterflies which were poor mimics would tend not to be mistaken for the models and would be more likely to be predated. In this way poor mimics would gradually become eliminated, leaving only those forms that closely resembled the model. Mimicry often extends to behaviour as well as colour, so that the mimic may adopt the habits and flight behaviour of the model species. Any trait that tends to 'give away' the mimic will be eliminated over a long period of time by natural selection.

There are many examples of the two types of mimicry defined earlier. In practice it may be difficult to draw a distinction between the types because in some areas in the tropics many species may be involved in what are called 'mimicry rings'. These are groups of species including both Batesian and Mullerian mimics which all have a common colour pattern.

Batesian mimicry

Among butterflies certain families of butterflies include large numbers of unpalatable species which act as models for Batesian mimics. For instance the family Danaidae includes many distasteful species and thus supplies the models for many of the classic examples of mimicry by members of other families. The plain tiger *Danaus chrysippus* is a model for the female of the diadem *Hypolimnas misippus,* a member of the Nymphalidae, which is shown on page 77. These specimens are from India but the two species occur together throughout Africa, parts of Asia and much of Australasia. Another well known instance is provided by the North American monarch *Danaus plexippus*, which is the model for the viceroy mimic *Limenitis archippus*. In this species both sexes are mimics, unlike the previous example. The specimen of the monarch shown is unusually small as it is normally larger than the viceroy. The mimic in this case is very different from the normal *Limenitis* butterflies, as is demonstrated by comparing the mimic with the closely related *Limenitis arthemis* shown on page 205. In both these instances a member of the family Nymphalidae is mimicking a species from the family Danaidae.

The situation can become more complex when the mimic is found in areas where the usual model does not occur, or is at least uncommon. In such cases the mimic may resemble another species of model, as in the instance of the viceroy which mimics *Danaus gilippus* in parts of Florida and the south-western United States where the monarch is less common.

This raises some of the basic requirements for a successful Batesian mimicry situation. The model and the mimic must occur together in the same area, and in the same habitats. Furthermore the model should always be more abundant. This is because it is essential for the warning colour pattern to be learnt by predators by actual unpleasant experiences. In other words some distasteful butterflies must be eaten before the others are avoided. If the butterfly population includes a high proportion of edible mimics predators have a high chance of taking the harmless butterflies, and so will

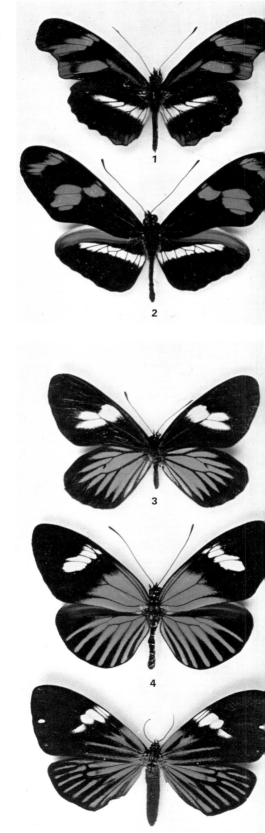

Above: Batesian Mimicry. Some butterflies which are palatable to predators mimic the colour patterns of unrelated distasteful species, and thereby gain protection. 6. African *Danaus formosa mercedonia* (Danaidae) is the model for 7. *Papilio rex mimeticus* (Papilionidae); 8. Indian *Euploea mulciber* (Danaidae) is 'copied' by 9. *Papilio paradoxa* (Papilionidae). Other forms of *paradoxa* are shown on pages 128/129.

Above, Left: Müllerian Mimicry. 1. *Podotricha telesiphe* and 2. *Heliconius telesiphe* (Heliconiidae) fly together in Peru and have evolved a mutually beneficial colour pattern. Forms of these species in Ecuador have a yellow hind-wing band (see pages 185 and 187).

Left: A Mimicry Ring. This association of South American distasteful species with a common pattern includes two butterflies, 3. *Archonias bellona* (Pieridae) and 4. *Heliconius xanthocles mellitus* (Heliconiidae), and a day-flying moth, 5. *Pericopis phyleis* (Arctiidae).

not learn to avoid the warning colour pattern so quickly, so much of its protective value is lost. In the wild this situation does not arise. Usually the mimics are decidedly scarce and difficult to encounter, while the models may be conspicuously abundant.

One of the most striking and ingenious of all Batesian mimics is the very local *Papilio laglaizei* from Papua. This species mimics not another butterfly but a day-flying moth, *Alcidis agarthyrsus*. The resemblance between their upper surfaces is remarkable enough, as the illustration on page 80 shows, but the outstanding feature is only visible from below. *A agarthyrsus* has a brilliant orange ventral surface to the abdomen – a body colour unlike that of any *Papilio*. This colour is matched exactly in a patch on the anal fold of each hind wing of *P. laglaizei* – just where it covers the abdomen when the butterfly is at rest.

The African mocker swallowtail *Papilio dardanus* has polymorphic females which provide an interesting example of multiple Batesian mimicry. The male is a rather distinctive insect with a creamy yellow ground colour and black markings, with a tail on the hind wing. In certain parts of its range (Ethiopia and Madagascar) the females are very similar to the males in colour, pattern and shape. The majority of female forms elsewhere are tail-less, quite different in appearance and mimic a great variety of distasteful species of other families. More than one hundred forms have been named and only four of the most familiar examples are illustrated here. The form *hippocoon* is modelled on the friar *Amauris niavius* (family Danaidae) while the orange form *planemoides* mimics *Bematistes poggei*, a member of another distasteful family (Acraeidae). Batesian mimicry on a large scale is evident within the family Papilionidae. In both the old and new world the swallowtails which feed on *Aristolochia* 'advertize' the presence of body poisons with their *aposematic* or warning colours, which are generally red spotting of the wings or body. Their mimics (pages 118/119 and 128), resemble them closely enough to deceive the inexperienced lepidopterist.

Müllerian mimicry

This is the term used to describe the close physical resemblance between different species which have similar unpleasant properties. It is an advantage to both species if two unpalatable butterflies which occur in the same area have a common badge or warning

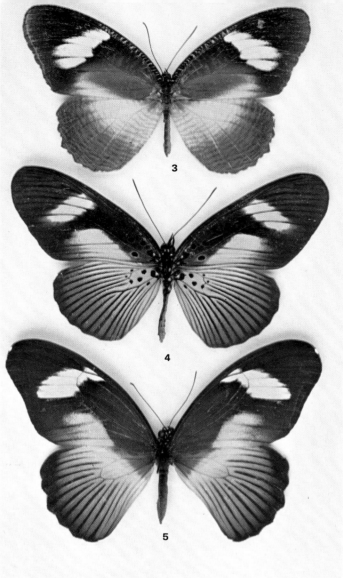

colour pattern. This will be apparent when it is remembered that predators will only learn to avoid a particular warning colour pattern after they have experienced the unpleasant taste by trying to eat the insects. In a given area a certain number of butterflies will have to be sacrificed before all the local predators have learnt to avoid their particular colour pattern. If two species are involved and they share the same pattern the losses to each species will be approximately halved. Evolutionary pressure caused by predator selection would tend to favour the convergent evolution of similar colour patterns until they become very similar. This process would of course have taken place over a very long period of time. In some cases mimetic forms may have arisen initially as random mutations which then survive because they quite fortuitously resembled another species which was unpalatable. Without fossils or other evidence of ancestral forms it is not possible to come to firm conclusions on these points. The appearance of closely related but non-mimetic species may provide pointers to possible lines of development but no more.

A better understanding of the selective processes that have produced these mimetic patterns could be obtained by carefully investigating how predators recognize warning colour patterns and what particular features in the pattern are significant. Research is needed to establish whether it is the generalized wing pattern, or only particular features such as spotting or banding; or whether it is the juxtaposition of certain colours that are learnt and recognized by the predators. This is particularly relevant to the evolutionary puzzles posed by some of those mimetic forms which reproduce every fine detail of their models, such as members of the Nymphalid genus *Pseudacraea*. There are many examples of Mullerian mimics

Above, left: Batesian Mimicry. The unusual feature of this pair is that 1. *Alcidis agarthyrsus* (Uraniidae) is a day-flying moth and its mimic is a swallowtail butterfly 2. *Papilio laglaizei* (Papilionidae); both are from New Guinea.

Above: A Mimicry Ring. These three Central African species are quite unrelated, although all very closely resemble the Acraeid *Bematistes epaea*: 3. *Elymniopsis bammakoo* (Satyridae); 4. *Pseudacraea eurytus* (Nymphalidae); 5. *Papilio cynorta* female (Papilionidae).

Above, right: Batesian Mimicry. Possibly the best-known example of how closely a mimic species can resemble its model is provided by 2. North American viceroy *Limenitis archippus* (Nymphalidae), which duplicates the colour and pattern of 1. monarch *Danaus plexippus* (Danaidae).

Right: False Mimicry. It is easy to draw false conclusions from closely similar species. For example, 1. *Heliconius atthis* (Heliconiidae) and 2. *Elzunia regalis* (Ithomiidae) are not found in the same area and therefore cannot reasonably be regarded as Müllerian mimics. *H. atthis* does in fact share a mimetic association with another *Elzunia* species, *E. pavonii* (see page 252).

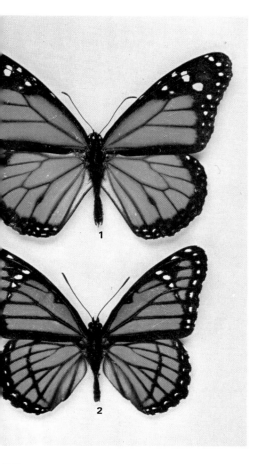

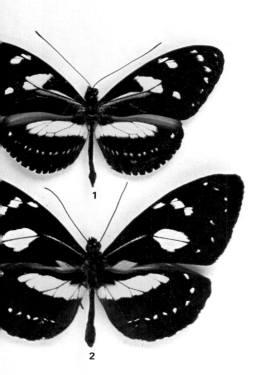

among the family Heliconiidae which share similar unpalatable characteristics and appearance. The mimetic pair *Heliconius telesiphe* and *Podotricha telesiphe* (shown on page 78) is particularly interesting. These are Peruvian butterflies, while the forms of the same species that fly together in Ecuador have a yellow hind wing band in place of white, demonstrating the long-standing interdependence of these species.

A pioneer in this field of study, the late R. C. Punnett, pointed out that even if one member of a Müllerian group were more abundant than the others it would still benefit from a common colour pattern, while the rarer species would gain considerable advantage, as in the Batesian situation.

This brief account is a very simplified survey of a fascinating and complex subject which needs considerably more intensive study and research. There are many controversies which have not been resolved and even some of the really basic assumptions, such as the idea that vertebrate predators are the selective agents in the evolutionary process, have been questioned. Some very complex mimetic associations exist where apparently both Batesian and Mullerian mimicry are at work. Furthermore there are many butterfly species that exhibit striking parallels in pattern and coloration, such as the Neotropical genera *Agrias, Callithea, Callicore,* and *Siderone.* There is no apparent explanation for these instances of parallel development which remain a puzzle.

Mimicry rings

The most complex associations of mimetic species occur in the socalled mimicry rings. These are groups of species, often quite unrelated, which all share a common mimetic pattern and appearance. The rich Neotropical fauna include some striking examples of such groups, the most interesting of which revolves around the orange and black patterned butterflies with long narrow wings. Possibly more than a dozen species, from several different families, are involved in this group, including *Heliconius numata* and *Melinaea mothone,* as well as at least two moths, *Castnia strandi* and *Pericopis hydra.* The two butterfly species are so similar, despite being unrelated, that only from a detailed examination of their structure is it possible to tell them apart. Three members of a similar group are shown on pages 78/79. These two butterflies and one moth fly together in Peru, where they form a Mullerian association as they all contain unpalatable substances. An interesting North American mimetic complex is developed around the pipe-vine swallowtail *Battus philenor.* This species is the model for at least one other swallowtail *(Papilio troilus),* the red-spotted purple *(Limenitis astyanax),* and possibly also the dark females of both *Papilio glaucus* and *Speyeria diana.*

Examples of mimetic groups from the old world are rather less frequent, but the most conspicuous occur in the Ethiopian region: on pages 80/81 for example are three Central African species of different families which share a very similar appearance based on the Acraeid species *Bematistes epaea.*

False mimicry

Further examples of similarity between butterflies may be noticed among the family sections of this book, but it may be easy to jump to the wrong conclusions solely on the basis of the appearance. Unless two butterflies occur in the same part of the world, they cannot be mimetically associated.

Chapter 10
Butterfly History–
famous books and collectors

From earliest times, the butterfly form has been celebrated in the art and poetry of many different cultures. Representations of butterflies are to be seen in Egyptian frescoes at Thebes, 3,500 years old, and on objects produced by the ancient peoples of China, Japan and America. Butterfly legends and beliefs have become incorporated into the folklore of many countries; for example the Brazilian dance to honour the dead, described by the anthropologist Sir James Frazer, in which the dancers assume the character of a giant *Morpho* butterfly.

It is strange that there is no reference to butterflies in the Bible; they are common enough in biblical lands. It is equally curious that the ancient writers on natural history, including Aristotle and later Pliny, mention few butterflies in their books and essays; yet butterflies were certainly not ignored by the Greeks. They believed the emergence of the adult butterfly from its pupa represented a personification of the human soul. In later Christian art the metamorphosis of the butterfly became a symbol of the Resurrection.

Butterflies figure in a lighter vein on illuminated manuscripts dating from the 9th century, where they often appear as a decorative border to the text. It is sometimes possible to recognise the actual species depicted, though usually these illustrations are very stylised and often rather crudely executed.

Right: The frontispiece of the most famous of all butterfly books, *The Aurelian* (1766) of Moses Harris.

Below: The purple *Sasakia charonda*, national emblem of Japan (X 0.25).

Bottom: Two pages from *The Theater of Insects* of 1658 (much reduced).

The Works of the Lord are Great, Sought out of all them.
that have Pleasure therein. Ps CXI. v. 2.

Left: This charming painting from *The Aurelian* depicts the life history of the swallowtail *Papilio machaon,* with the female laying eggs on the foodplant and the larvae and pupae in various attitudes. Even at this early date considerable attention had been devoted to the early stages of butterflies, and the life histories of many European species had been worked out. Much of the appeal of Harris's painting lies in the precision with which he records details of rearing and collecting techniques.

Insects, including butterflies, also appear frequently in the work of early oriental artists and the painting of 16th and 17th century Flemish artists, especially Jan van Kessel (1626–1679).

Early books

Few significant studies of insects were published prior to the Renaissance, and these often serve only to reveal the almost total lack of zoological understanding which then prevailed. For example, Albertus Magnus (*c*1205–1280) in his *De Natura Animalium* described butterflies as 'flying worms'.

The development of printing helped to disseminate information more widely and thus promoted the advance of all aspects of natural history, although the systematic study of insects had to wait until the major growth of scientific exploration in the 17th century.

Ulysses Aldromandus is often hailed as the father of entomology, having published his *De Animalibus Insectis* in 1602 as part of an encyclopedic work on zoology that was never completed. The *Theriotrophium Silesiae* was a contemporary attempt to describe a local fauna written by the Hieschberg physician Schwenckfield. But the first really important book devoted solely to insects was probably the *Insectorum Theatrum* published in 1634. This is generally attributed to Thomas Mouffet but much of the material it contained was derived from the manuscripts of earlier authors, among them the Swiss naturalist Gesner, the Elizabethan diplomat Sir Edward Wootton and his friend the physician Thomas Penny. Mouffet edited the material from his eminent predecessors and added some of his own, but the book was eventually published only after his death. Edward Topsell had earlier (1608) incorporated some of this work into his own *The Historie of Serpents* and in 1658 brought out an English translation of Mouffet's book, two pages of which (much reduced in size) are reproduced on page 82. The illustrations in this rare and curious volume are woodcuts, but despite their crudity it is possible in these two pages to recognise at least eight species of butterfly *(Papilio machaon, Iphiclides podalirius, Inachis io, Colias crocea, Vanessa atalanta, Vanessa cardui, Nymphalis polychloros, Mesoacidalia aglaja)*. The book includes over 20 identifiable species of European butterfly and also reproduces the famous drawing of the North American *Papilio glaucus* by John White, leader of the third expedition to Sir Walter Raleigh's colonies in Virginia. The significance of this particular picture has been the subject of intensive scholarly research by W. J. Holland in *The Butterfly Book,* 1930.

During the late 17th and early 18th centuries many books on travel and exploration appeared, often with extensive observations on insects. Similarly many primarily medical tomes included digressions into zoological fields. A number of specifically entomological books were also published during that time, including several treatises on bees which were of obvious economic importance; and there were even books wholly devoted to butterflies. Some European works of particular interest to the lepidopterist are as follows:

Below: This detail from *The Theater of Insects* shows the North American *Papilio glaucus,* taken from the original drawing by John White, leader of the third expedition to Sir Walter Raleigh's ill-fated Virginia colonies in the 1580s.

Author	Title	First Published
Goedart, Jean (ed.)	Metamorphosis et Historia Naturalis Insectorum	1662
Merrett, Christopher	Pinax Rerum Naturalium Britannicarum	1666
Swammerdam, John	The Book of Nature	c 1669
Lister, Martin	Johannes Godartius 'Of Insects'	1682
Redi, Franciscus	Opusculorum	1686

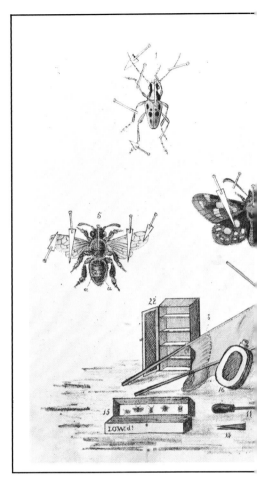

Above: Early collecting equipment from the *Instructions for Collecting* (1827) of Abel Ingpen. The two-handed bat-folder and the scissors net are now relics of the past, but his breeding cages and folding pocket-lens will be familiar to the present-day entomologist. Particularly interesting are the insects being set by the long-abandoned method of card braces, which would certainly have damaged the scales on delicate specimens.

The *Metamorphosis Insectorum Surinamensium* is the most sumptuously illustrated of these early entomological works. Its authoress was one of the most remarkable women of her day and her paintings of the insects she encountered in her South American travels show outstanding attention to detail. Of particular interest is the fact that her pictures often show the early stages of butterfly species, and although these illustrations are frequently inaccurate, their inclusion represents a significant advance over other contemporary works, showing that the relevance and importance of observations of larvae had been recognised as an integral part of the study of butterflies.

Perhaps the most celebrated of butterfly books is *The Aurelian* by Moses Harris. This was first published in 1766 with a number of later editions, the last issued by Westwood in 1840. The illustrations are truly works of art and each was dedicated to a notable personage of the day, as was the custom during this period. The charming frontispiece depicts two fashionable gentlemen collecting in a woodland ride. Only a few copies include this picture in colour as reproduced on page 83. Of further interest is the illustration here, and in other plates, of the types of collecting apparatus in contemporary use. An additional reproduction from Harris' book is shown on page 84.

Later books: 1767 to the present day

With the rapid explosion of scientific literature that began during the late 18th century and progressively increased till the present day, entomological works become too numerous to list here. There is space to mention only some of the most outstanding books, dealing with the world's butterflies, and their authors.

Right: The *Illustrations of Natural History* (1771–82), produced by Dru Drury with the help of the leading insect painters of the day, depicted tropical species accurately enough for identification today. Those shown are (left to right) *Azanus isis* (Lycaenidae) recto and verso, *Atrophaneura antenor* (Papilionidae) and *Anthene sylvanus* (Lycaenidae) recto and verso all from the Ethiopian region.

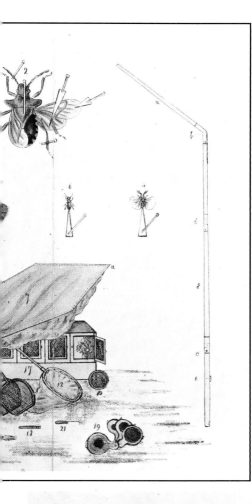

Many zoologists wrote books based upon their own collecting and observations in the field. But this was also the beginning of the great age of natural history collecting and professional collectors were engaged by the wealthy and the curious to journey to remote regions and bring back samples of exotic animals and plants. Such specimens often arrived in the great European centres of learning through purchase or exchange and were then the subject of scientific scrutiny. Many naturalists were thus able swiftly to expand their limited personal knowledge and enlarge the scope of their writings to encompass material from far-off lands.

The *Illustrations of Natural History*, published in three volumes from 1771 to 1782 were the work of Dru Drury, a London goldsmith. He was an enthusiastic collector and frequently paid large sums for specimens from abroad, a practice which eventually reduced him to bankruptcy. His book was re-issued in 1837 under the title *Illustrations of Exotic Entomology*. The work is mainly devoted to Lepidoptera and the illustrations are generally accurate. One of these, from the later edition, is reproduced on page .

Meanwhile, in Holland, Cramer's *Papillons Exotiques* was being produced. This comprises of four magnificent volumes, with a fifth added by Stoll; the whole work contain no less than 442 plates of Lepidoptera.

J. C. Fabricius of Schleswig was one of the foremost entomologists of his day. He had been a student of Linnaeus and the sound systematic basis of his books, including *Systema Entomologiae* (1775), *Genera Insectorum* (1777) and *Species Insectorum* (1781), clearly reflect the influence of his mentor. The name of Fabricius is familiar to entomologists, being appended to many scientific names in recognition of the fact that he was the first person to describe and name the animals concerned. Many of the actual specimens he

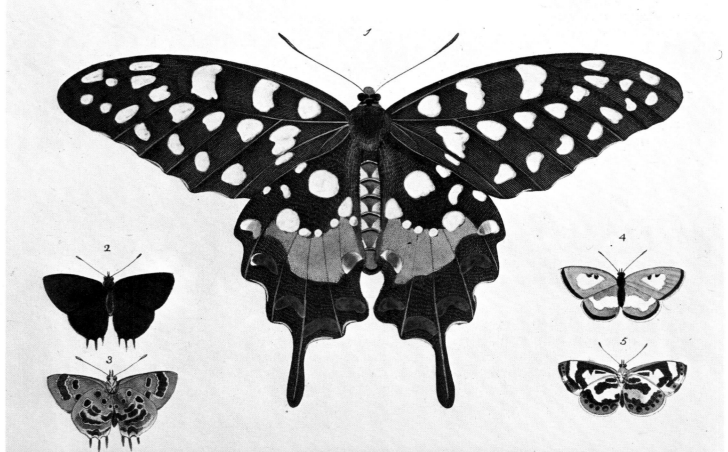

used to describe his new species can still be seen today, preserved in the collection of Sir Joseph Banks in the Natural History Museum, London.

Edward Donovan produced several works which included butterflies. Among these are the *Insects of China* (1798), *Insects of India* (1800) and *Insects of New Holland* (1805). This last year saw the commencement of two great·works on exotic Lepidoptera, the *Sammlung Exotischer Schmetterlinge* by Jacob Hubner of Augsburg, published from 1806 to 1824, and the *Zuträge zue Sammlung Exotischer Schmetterlinge* by the same author, completed by Geyer, from 1818 to 1835. Between 1819 and 1823 Latreille and Godart produced a monograph of the known butterflies (by then totalling 1,802 species) as part of the French *Encyclopédie Méthodique*.

In 1836 one volume of the *Nouvelle Suites à Buffon* was devoted to butterflies – the work of J. A. Boisduval. Other publications of Boisduval include material important to the study of classification, as is the *Genera of Diurnal Lepidoptera* of Edward Doubleday. The *Sammlung* of Herrich-Schaffer, produced from 1850 to 1858, consisted of a series of plates of exotic Lepidoptera, accompanied by a list of species and a system of revised classification. W. C. Hewitson, who provided the illustrations for Doubleday's *Genera*, produced his own *Exotic Butterflies* from 1851 to 1877. Five volumes, each with 60 plates, were completed. Many of the specimens which were used to make these were originally collected by Bates and Wallace.

Between 1864 and 1867 C. and R. Felder contributed the superbly illustrated section on butterflies to *Reise der Osterreichischen Fregatte Novara um die Erde*. This was followed by the *Lepidoptera Exotica* (1869–1874) of Dr. A. G. Butler, valuable chiefly for the monograph on the genus *Callidryas* (now *Catopsilia* and *Phoebis*) in the family Pieridae.

The total number of butterflies known to Fabricius in 1794 was 1,147; but by 1871, when W. F. Kirby's *Synonymic Catalogue of Diurnal Lepidoptera* was published, the number of known species had increased to 7,695. Kirby also wrote *A Handbook to the Order Lepidoptera* for Allen's Naturalist's Library (1894–97) and contributed similarly to Lloyd's Natural History (1896–97). Meanwhile in Germany an important contribution was made to the systematics of butterflies by the publication of *Exotische Schmetterlinge* (Schatz and Rober, 1885–92) and its companion volume *Exotische Tagfalter* by Dr. Staudinger, the doyen of German entomology.

Since 1900, books on butterflies have proliferated and there are now a great many available. A selection of these, relating to specific regions, are listed at the end of the book. Perhaps the most significant publication this century is *The Macrolepidoptera of the World* by a panel of authors under the general editorship of Dr. A. Seitz. This monumental production, in German, English and French editions, appeared in parts from 1906 to 1932. Although it is incomplete and now long out of date, it still remains an invaluable single reference work and is unlikely ever to be surpassed.

Early collecting

Through the centuries, intellectuals had amassed cabinets of curiosities in a more or less random fashion. Bones, fossils, seeds, shells, insects and indeed any curiosities of nature were eagerly hoarded and often earnestly discussed, but with no clearly defined objective. The wealth of material brought back from the far corners of the earth during the 17th and 18th centuries not only inspired men of

Right: In the early years of this century the naturalist and explorer A. S. Meek enlisted the help of Papuan natives to obtain new species of birdwing butterflies. This contemporary drawing from the *Illustrated London News* shows *Ornithoptera chimaera* being shot with four-pronged arrows.

Below: In the mid-19th century H. W. Bates first viewed the enormous assemblages of South American butterflies—an event recorded in this painting by Arthur Twidle.

science to record and classify these new wonders, but demanded a new and more systematic approach to the study of nature in order to make sense of it all. Books, and the information they contained, became more widely available so that new advances in science were more readily reported, thus showing more clearly in which direction the next moves needed to be made. The study of natural history became steadily more orderly and systematic, and with the adoption of the Linnaean system of classification a coordinated effort to catalogue the world's wildlife became a popular objective.

Despite these advances the study of natural history long remained a pleasant, often seemingly eccentric, diversion for a minority of wealthy people. An apocryphal story is told by Moses Harris concerning a Lady Glanville, for whom the Glanville fritillary was named. It seems that after the good lady's death, her relatives were displeased by the provisions of her will and attempted to have it set aside on the grounds of insanity, as 'none but those who were deprived of their senses would go in pursuit of butterflies'. The veracity of this legend has been disputed, but it clearly demonstrates how entomologists were regarded at that time.

Some of the equipment used by 18th and 19th century collectors was so cumbersome that it has long been abandoned by modern entomologists. Fortunately we know quite a lot about early collecting methods, not just from a few items of equipment that have survived, but also from the descriptions and illustrations which appear in old books.

In the frontispiece to Harris' work (shown on page 83) the bat-folder or clap-net is clearly visible; a clumsy contrivance, which required both hands to operate it was nevertheless beloved by the early collectors. Much later it appears again in J. O. Westwood's excellent illustration in Ingpen's *Instructions for Collecting* (1827), reproduced on pages 86/87. Despite the almost universal adoption of the simple circular ring-net and larger kite-nets by the 19th century collectors, this extraordinary 'bag of tricks' survived as late as 1908 in the tenth edition of *A History of British Butterflies* by the Rev. F. O. Morris.

Although some of the more elaborate collecting equipment has long been abandoned, most of the items in use today have changed little in the last 150 years, as may be seen by comparing the Ingpen plate with photographs of modern apparatus on pages 95 and 101.

The great years of collecting

With improvements in education, communications, and travel, the 19th century was the great age of the natural historian. There was plenty of scope for the enthusiast and many of the well-known authorities and collectors of this period were clergymen or doctors; members of a new, educated middle-class with money and leisure to pursue their interests. Their fine collections formed the basis for the great Natural History Museums of the world, and often the 19th century material still forms the bulk of the collections in these museums.

Explorers and collectors were making new discoveries in remote parts of the world, often risking their lives and enduring great hardships. To these intrepid and dedicated men we owe a great debt of gratitude.

One of the most famous and justly honoured of these collectors was Henry Walter Bates. Although the son of a manufacturing hosier, Bates showed an early interest in zoology and in 1848 went on an expedition to the Amazon with another great collector,

Alfred Russel Wallace who was to become one of the leading naturalists of his time.

Bates spent the next ten years assembling a vast collection of animals and plants of which about 8,000 species were new to science. The astronomical numbers of butterflies found in this region particularly fascinated him. Near Obidos in Brazil, he saw a large swarm of *Catopsilia* species settled on the banks of a stream; an event depicted in the painting by Arthur Twidle shown on pages 88/89. Some of the most marvellous Neotropical insects were first named by Bates and the resemblances found between butterflies of different families prompted his pioneering studies of mimicry (see Chapter 9). The story of his travels is told in *The Naturalist on the River Amazon* (1863).

Alfred Russel Wallace (1823–1913) was one of the greatest figures of the age, and the originator, together with Charles Darwin, of the theories of evolution which were to have such a profound effect on subsequent science and philosophy. In 1848 Wallace travelled to the Amazon region with H. W. Bates, where he spent four years collecting zoological specimens, including many previously undescribed species. These collections were lost in a fire on board ship during the homeward journey – a disaster that would have disheartened a lesser man. However, Wallace was not deterred and soon planned a new expedition. He set off in 1854 to spend eight years collecting in the hitherto little known Malay archipelago. Wallace was a real enthusiast as well as a fine naturalist. The account of his expedition *The Malay Archipelago* (1869) has a vividness which reveals the excitement aroused by the natural wonders of the region, even though his earlier years in the incredibly rich Amazonian region might have dulled his sense of novelty. His enthusiasm is clearly evident in his account of the discovery of the birdwing butterfly *Ornithoptera croesus* (page 155) on the island of Batchian in 1859. He wrote:

'I found it to be as I had expected, a perfectly new and most magnificent species, and one of the most gorgeously coloured butterflies in the world. Fine specimens of the male are more than seven inches across the wings, which are velvety black and fiery orange, the latter colour replacing the green of the allied species. The beauty and brilliancy of this insect are indescribable, and none but a naturalist can understand the intense excitement I experienced when I at length captured it. On taking it out of my net and opening the glorious wings, my heart began to beat violently, the blood rushed to my head, and I felt much more like fainting than I have done when in apprehension of immediate death. I had a headache the rest of the day, so great was the excitement produced by what will appear to most people a very inadequate cause.'

A fellow professional collector, A. S. Meek, was also excited by his encounters with birdwing butterflies. Though his reports are more matter-of-fact, the thrill experienced by a successful collector in securing a long-sought prize is still evident from his description of the time when at last he obtained the first male specimen of a new and gloriously coloured birdwing, *Ornithoptera chimaera* (page 154). He described the insect, then his own feelings:

'I felt more pleased than if I had been left a fortune when the male specimen came in, and I astonished the successful boy with the amount of the largesse he got. He had two

PERFECT S

the flat surface of the dresser hook, of the bent wing elevating spring; are glued together, to form the slot

The Indians of British Guinea proceed on somewhat different lines; they place the flowers of *Bignonia* under an open wicker-work basket (or "quake") by which many yellow species are secured, the butterflies which are attracted flying up into the "quake" on the approach of the operator. Similarly they are very successful in capturing the big blue *Morphos* by substituting the skins of bananas for the *Bignonia* flowers. A net contrived on the plan of the "robin trap" but larger, say two feet dia from a distance, would no doubt be

Decoying ought to make the ca deal easier than it is at present, and

Harnessing by means o thorax, between the primary and s tethered to a plant by the other, employed with success in the case of

The great majority o

Left: Alfred Russel Wallace (1823–1913) —photographed a few years before his death—was the greatest naturalist of his time and co-originator, with Darwin, of the theories of natural selection which were to have a profound effect on science and philosophy.

Below: One of the most hilarious products of an age noted for curious inventions was the 'mechanical butterfly', intended for use as a decoy, which appeared in *The Lepidopterist's Guide* (1901) of H. Guard Knaggs.

shillings – two tins of English bacon and five sticks of tobacco. A fine discovery of that sort stirs the heart of a collector.'

Meek discovered many new species, including the largest known butterfly *Ornithoptera alexandrae* (pages 156/7). As a professional collector, he was commissioned to obtain material for the private museum of Lord Walter Rothschild, whose butterfly collection became one of the most comprehensive in the world and is now housed in London in the British Museum (Natural History).

The Australian region, particularly New Guinea, attracted the attention of many pioneer naturalists and collectors. Among these were W. S. Macleay, William Doherty, the tireless Swiss entomologist Hans Fruhstorfer and later A. F. Eichhorn and the Pratt brothers.

Even where the collecting of specimens was not the main object, few explorers failed to be fascinated by the animal life they encountered in their travels. Even the fiery Sir Richard Burton found time to collect butterflies while seeking the source of the Nile; and in the present century many of the Everest expeditions have brought back specimens. One of these, *Parnassius acco*, is shown on page 117.

Collecting butterflies in the tropics requires a combination of endurance and skill that is a far cry from the popular image of a leisurely pursuit for schoolboys and doddery professors. It is often necessary to make long treks through difficult terrain to obtain a desired species, for even in warmer regions of the world butterflies are not abundant everywhere. These problems are a challenge even today, but in the last century the difficulties were enormous.

The collector not only had to be a survival expert, with conconsiderable determination, but he also had to know and understand the habits of his quarry. Many butterflies fly only at certain times of the day, or at certain heights; some fly in sunlight, others prefer the shade. The successful collector needs to appreciate these subtleties and to carefully record his observations to improve his own efficiency as well as to add to the knowledge of butterfly biology.

Various techniques have evolved to make collecting easier. For example the flashing blue *Morpho* butterflies generally fly far out of reach, high in the forest canopy, but will come lower in a sunlit clearing. Here a raised platform may be constructed so that the collector and his nets are positioned high enough above the ground to catch these treasured butterflies. Until recently, ex convicts from the notorious Devil's Island used to do just this in order to make a living from the sale of *Morphos*.

If all else failed the collector could bring down the elusive highfliers by shooting them. A contemporary illustration on page 89 shows a Papua tribesman in New Guinea shooting butterflies with pronged arrows for A. S. Meek. This was likely to result in many damaged specimens, but better these than none at all. No doubt this was the philosophy of John McGillivray, naturalist aboard HMS *Rattlesnake* exploring the Pacific in 1884–5. He was driven to use a shotgun for his collecting, but thereby obtained the first known specimen of the giant birdwing butterfly *Ornithoptera victoriae* shown on pages 154/155.

Despite disease, climate, hostile tribes and many other hardships, the 19th century collectors succeeded in bringing home astonishing quantities of material from the wildest regions. Even fragile creatures such as butterflies were successfully transported, often for months, on mules, aboard damp sailing ships and in the most primitive vehicles.

Chapter 11

Collecting –
a practical guide to modern methods

From the scientific point of view a specimen is almost useless unless it is accompanied by information on the date and place of capture. The value of the specimen is increased by ecological data – a description of the habitat for example – and collecting notes relating to time of day, altitude, weather, wind speed, height above ground and so on. No butterfly collector can honestly justify his activities on the grounds of 'scientific investigation' unless he seriously collects large quantities of information as well as butterflies.

We might truthfully say that the genuine collector's most important piece of equipment is not his net but his notebook. This would usefully record the facts and measurements suggested above, together with observations on feeding habits and species of flowers visited, courtship and social behaviour and indeed anything relevant to the life of the butterfly. Notes of how many are seen (and of which sex) in a given time and place may provide a useful guide to population size and structure, but the observer should not be tempted to draw rapid conclusions based upon such data. For example, in many species females appear much rarer than the males, but this may be due to behaviour, not numbers. The females may simply fly less or be more secretive and so harder to see and count. They may fly in different areas to the males or at different heights, or (as in many cases) they may only appear later in the season. Fairly accurate estimates of population size can be made by capturing specimens and marking them before they are released again. A fresh sample of the population taken later will then include a proportion of marked animals and simple calculations enable an estimate of population size to be made. However, the method is only as accurate as the sampling technique used and this is subject to all the same sources of bias described earlier.

Photography

The miniature camera is a piece of the modern collector's equipment which was not available to the great naturalists of the past. This is a pity because photographs are a useful adjunct to observation, especially for recording habitats and food plants. Photographs taken in one place during successive weeks or seasons may document habitat changes that can be correlated with the changing spectrum of butterfly species collected there.

The butterflies themselves are difficult subjects to photograph successfully without fairly elaborate equipment and a fair amount of expertise. Whereas any simple camera can be used to document a habitat, close-up pictures of insects or flowers really need a single lens reflex camera with extension tubes or a supplementary lens to permit close focussing (down to about 15cm or less). The photographer should aim to record the butterfly as it is *in life*, feeding or basking; nothing looks worse than a dead specimen pinned to a flower or a live one carelessly photographed so that it looks dead or distorted.

Photographing insects in the wild needs great patience and the ability to put up with some discomfort. Edward Ross, who took a number of the photographs of living butterflies in this book, shows what may be involved on page 97. In the absence of a camera, quick pencil sketches can capture the attitudes of a living butterfly more effectively than any description.

Collecting equipment

Making a good collection can be a very stimulating and satisfying activity. It can also be very useful if done properly. As a collector's

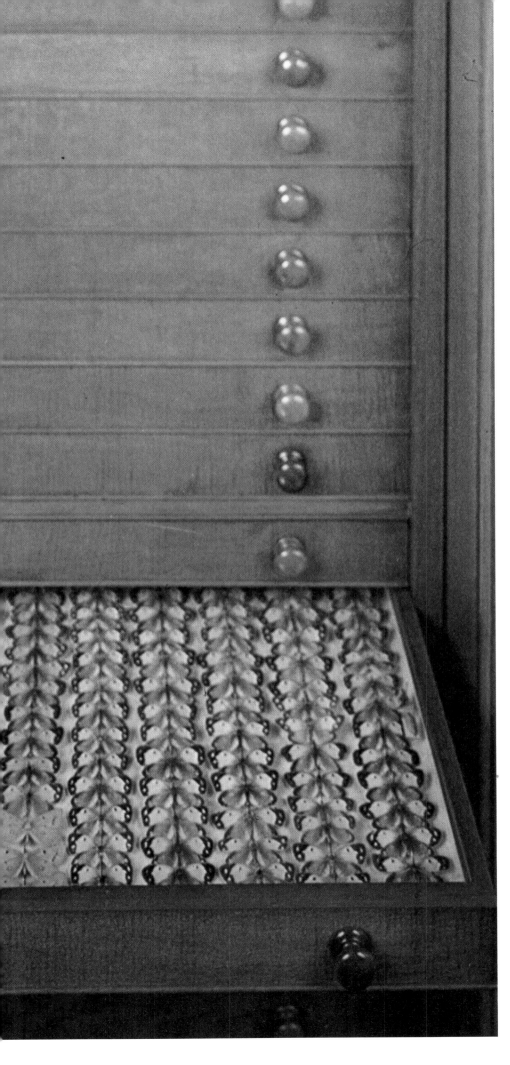

Left: Cabinets of close-fitting, glass-topped drawers are ideal for butterfly collections, and if well made they will exclude dust and light. The drawers should have a cell or container for chemicals to deter pests such as mites and museum beetles. The cabinets shown here, in the Saruman museum, date from the first half of this century. A few are still made in this traditional style, although such fine workmanship is now very costly. The open drawer shows variations in the clouded yellow *Colias crocea*.

skill and knowledge increase, more equipment may become necessary, but the basic items are few and simple. They can be home-made or purchased fairly cheaply from entomological suppliers.

Apart from the notebook (and pencil) the essential things are a net, collecting boxes, a killing jar and some setting boards with pins. Two styles of net are in general use; the 'ring' pattern and the larger 'kite' pattern, shown opposite. Both types can be made to fold or dismantled for convenience. A very serviceable net can be made with a loop of strong wire or cane firmly attached to a handle. The bag of the net should be of soft, fine-mesh, preferably green or black, and as deep as the collector's arm. A round-ended net is preferable to a square-ended one, for the latter will have corners into which insects will retreat. Here they easily become damaged either by the net or by attempts to extract them from it.

Some of the special problems encountered when collecting butterflies in the wild have already been mentioned but a few general hints may prove helpful. Netting butterflies is an art that can only be mastered with practice. Most species require to be carefully stalked and any sudden movements should be avoided until the 'stroke' is made. A quick sideways sweep of the net is often the most effective, followed immediately by a twist to fold the bag and ensure that the insect is trapped. Some species rest on the ground and here the best procedure is to cover the quarry with the net and hold the bag free above it, so that it flies up into the end. This technique is not always successful, especially with Lycaenids which tend to take refuge deep among the grass stems and are difficult to extract.

Not all butterflies are obliging enough to settle, or even fly, within reach of the collector. Under these circumstances it is necessary to resort to trickery. Some aggressive species like the *Morphos* will indulge in mock battles with their own kind and the collector can use a dead specimen as a decoy to lure the living butterflies within range of his net. Another useful technique is to put out 'bait'. Certain fruit or carrion feeders will be strongly attracted by a fermenting banana or a piece of rotting meat. An extension of this idea is the use of butterfly traps (shown opposite) especially for species like the African *Charaxes* which are strong fliers and difficult to catch with a hand net. The butterflies are lured through a narrow slit by the presence of an attractive bait in the trap chamber. Having fed freely they then either remain passive or flutter to the top of the netting, unable to find their way out.

When a butterfly is caught it should be put in a box, taking care not to brush scales from its wings. The boxes are often called 'pill boxes', harking back to the time when collectors really did use little round cardboard containers produced originally for the storage of pills. The modern entomologist's pill box is made for holding insects and has a detachable lid with a glass or plastic window in it to allow close examination of the specimen. Butterflies can be kept and transported in these boxes if live specimens are wanted for breeding purposes. If they are kept in the dark during a journey, butterflies are less likely to flutter about and chafe their wings.

The specimens which are destined for the cabinet collection must first be put in the killing jar. Any wide-mouthed jar is suitable, if provided with a well-fitting lid or cork bung; a pad of cotton wool moistened with ethyl acetate in the bottom soon kills most butterflies. Other chemicals may be effective, although some discolour insects or render them too stiff for setting. The traditional killing jar, in which Potassium cyanide crystals were embedded under a

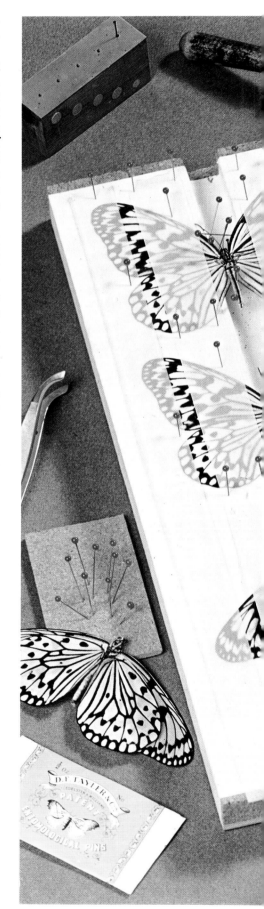

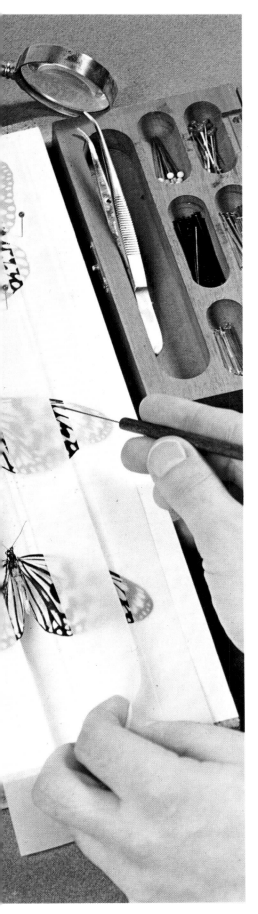

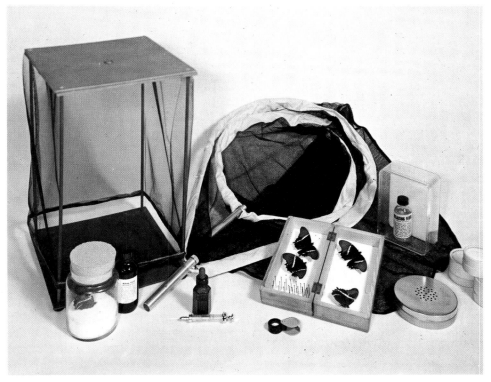

Left: Stages in setting *Idea leuconoe* (Danaidae). From bottom: 1. the insect pinned in the groove; 2. easing the wings into position; 3. the finished result.

Above: Modern collecting equipment: kite and ring nets, killing and relaxing fluids, and pill boxes. In the tropics a butterfly trap (rear left) is invaluable.

layer of plaster, is rarely used nowadays as cyanide is an unnecessarily hazardous substance to carry about. Many collectors dispense with a killing agent altogether, preferring to kill the insects quickly with a sharp pinch on the thorax. If this is carefully done no damage will result, although it is less suitable for the larger species and certain tougher butterflies like the Danaids, which soon recover from such treatment and fly away.

Setting the specimens

Setting is the process in which butterflies are pinned out so that they dry into a permanent standardized posture which displays their structure as fully as possible. Setting is necessary not only to obtain a uniform appearance but to facilitate the arrangement and comparison of specimens in the collection.

Normally captures should be set as soon as possible after death otherwise they become stiff and difficult to manipulate. However, it is not always convenient to set butterflies immediately they are killed, and specimens are often 'papered' for storage or transport. This consists of placing the dead insect, with the wings folded over its back, in a small triangular paper packet (shown on page 96) which is made from a pre-folded rectangle in such a way that it stays closed and prevents unnecessary movement of the specimen. Many thousands of dried insects can be packed cond posted in this way with the least possible damage and most modern collectors use this technique.

If the freshly killed insect has its wings closed, gentle pressure at the base will open them and allow a pin to be passed vertically through the centre of the thorax. Care should be taken to see that

the pinning is absolutely straight since this will make setting easier and ensure a neat, finished appearance.

Pins must be bought from special entomological suppliers since household or dressmakers pins are too thick and quite unsuitable. 'Continental' are the pins most widely used, either black enamelled or stainless steel. These are a standard length, generally 38mm, but they vary in thickness. Many cabinets and boxes in use will not take this length and in such cases the pin-heads will need to be clipped off with strong wire cutters. Because of this many collectors prefer the 'English' style of pin – these vary in length as well as thickness.

Setting boards are flat pieces of wood which are covered with cork sheeting surfaced with a layer of paper. A groove running centrally down the length of the board accommodates the body of the butterfly and allows the wings to be spread out on either side. Flat boards are universally preferred; the curved 'saddle' type used by earlier collectors is now out of favour because it gives an unnatural curve to the wings, bringing them too low down on the pin. It also makes them difficult to photograph. This method does have one advantage; it is particularly suitable for displaying those butterflies which show changing colours when viewed from different angles.

Using a setting board produces better results than the older method of pinning freshly-killed insects directly into a cork lined collecting box (shown on page 83). If a proper cork setting board is not available then sheets of polystyrene foam can be made into a good substitute.

On the setting board (shown on page 94) the specimen is pinned out with its body lying in the groove and the wings spread on either side. Before attempting to move the wings it is a good practice to insert pins each side of the abdomen, close to where it joins the thorax – this prevents unwanted movements later. It is important that the height is just right – the wings should not droop, or bend at the 'shoulders'. With a mounted needle, each wing may be gently eased into the correct position (the base of the fore wing forming a right angle with the body) and held in place with paper strips. Entomological pins are not needed to secure the setting paper;

Above: Insect photography requires great patience and the ability to put up with some discomfort, as demonstrated by Edward Ross in a California swamp.

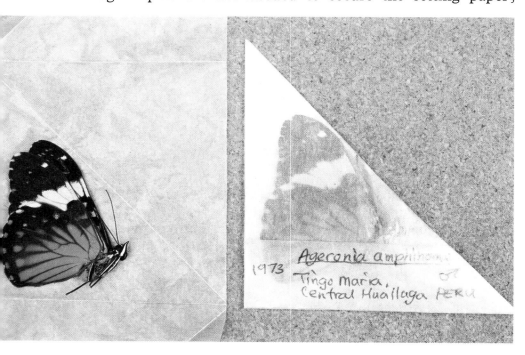

Left: Butterflies may be stored in prefolded paper triangles—an essential procedure if time is short and setting facilities are not available. With care they can be kept quite perfect for many years in this way, and can always be relaxed and set when required. The species shown here is *Hamadryas (Ageronia) amphinome* (Nymphalidae).

ordinary pins will suffice, though glass-headed pins are better, since they are much easier to handle.

If care is taken the setting needle should not pierce the wing. The best procedure is to set both wings on one side of the insect and then repeat the process for the other side. The antennae should form a neat 'V' in line with the fore wings. Finally, if the abdomen has a tendency to sag, this can be cured by placing two pins at angles beneath it to give support. Specimens should be left on the boards to become thoroughly dry, a process which may take a couple of weeks or more, depending on their size and the humidity of the air around them.

Papered specimens (shown opposite) which are dry and stiff cannot be set until they have been properly softened with a relaxing fluid. This is done in a relaxing box (any airtight plastic box will do) lined with cotton wool moistened with dilute phenol solution. The cotton wool is covered with a sheet of blotting paper on which the butterflies are laid out. They are left in the box for 48 hours, at the end of which time they will be almost as soft and pliable as freshly-killed specimens, and may be set in the normal way. Another means of relaxing specimens, where speed is essential, is to inject them with hot water, using a hypodermic syringe, at the base of the wings and water pumped in until it spurts out through the body orifices. This

Below: The most sought after species of butterflies are those which are both rare and exceptionally beautiful—the purple and orange *Hypolimnas pandarus* from Serang being a striking example.

may need to be repeated after a short interval, but renders the specimen pliable and ready to set in a few minutes. The antennae may be softened by dipping them in hot water for a few seconds. Care should be taken not to immerse the wings as this may spoil their colours.

At first relaxing and setting butterflies may seem very difficult, but with patience and perseverance the collector will soon grasp the techniques and may find many ways in which the methods may be refined. For example, setting on an inclined plane rather than a flat table; mounting all specimens as undersides, that is to say, upside down and then re-pinning, producing an outstandingly flat result; and various methods of accelerated drying using a desiccator, hot cupboard or vacuum freezer. The last are most suitable for injection-relaxed specimens but all such methods are best left until the basic skills are mastered.

Specimens have scientific value only if accurate data are preserved with them. For this purpose a small label is attached to the pin of each specimen, bearing information concerning the place and date of capture, plus other relevant details which may be important, such as altitude and wind direction. Papered specimens should also have these details recorded on their envelopes, to be transferred to labels when the specimens are set.

Preserved egg shells, pupa cases and larval skins also add to the interest and value of a collection. The skins are mounted by rolling them from head to tail with a pencil to squeeze out the internal organs. The flaccid skin is then gently inflated with a fine glass blow-pipe inside a heated drum or warming oven. If this is done carefully the result is reasonably naturalistic, although green larvae tend to lose their colour. If the collector wants to make a detailed study of these early stages they should be preserved in alcohol. A pair of entomological forceps, with curved tips, will be found invaluable for handling all preserved material.

The storage of collections

With proper care, butterfly specimens can be kept for centuries without serious deterioration. In large museums cabinets of shallow glass-topped drawers as shown on page 93 are used. These protect the specimens, yet allow them to be easily seen; more detailed examination is also possible if the glass covers are removed. The drawers are usually lined with cork and paper, but in some systems the bottoms are also glazed and the specimens pinned on narrow wooden strips so that their undersides can be inspected through the bottom of the drawer.

Large drawer cabinets are rapidly becoming too expensive for most private collectors and commercially made store boxes or glass cases are used instead. These have the advantage that re-arrangement of material is simple compared with the cabinet system. Many important private collections are stored in this way, which is quite satisfactory, provided that the containers have close-fitting lids and each has a cell for crystals of napthalene or the stronger paradichlorobenzene, the vapours of which serve to keep at bay the insects and perhaps mould which would otherwise destroy the specimens.

The arrangement of insects in the collection should follow a basic plan. For butterflies of some countries label lists are published, which may be cut up and pinned in rows, leaving spaces for the specimens not yet acquired. Tropical species are too numerous for such treatment and with these it is best to concentrate on one family, such as Papilionidae or butterflies from one region, perhaps

Above: Stevens' auction rooms in Covent Garden, London, were for more than a century the most prolific source of natural history specimens.

Left: The rarest members of the Nymphalid genus *Charaxes* may be sold for several hundred pounds. *C. fournieriae* has a metallic gold and malachite underside recalling certain *Euphaedra* species (X 0.75).

South America. For rarer species a single example will be enough, but generally speaking upper and under sides (known as *recto* and *verso* respectively) of both sexes, should be displayed. In species which show considerable geographical variation or polymorphism it may be desired to show a range of examples.

Lepidopterists are sometimes described as mere collectors and classifiers rather than scientists. Many, unfortunately, would have to plead guilty to such a charge, but the serious enthusiast can (and should) see his collection not as an end in itself but as a point of reference for a particular study. There are sound reasons why making a study collection is scientifically important. Butterflies are fragile creatures and short-lived and it is largely by examining preserved specimens that zoologists can determine the various features which reflect their relationships, though breeding experiments and photographic records of development and behaviour are equally important.

Sale and exchange of butterflies

Relatively few lepidopterists have both the time and money to study butterflies in faraway countries at first hand. For the majority, the entomological supplier must be the substitute for a trip to Borneo or wherever. In previous centuries, it was not only expensive to travel to distant parts of the world but took far too long. A student would be an old man before he had finished expeditions to even a few classic localities on different continents. Many important zoologists, particularly those interested in insects and mollusc shells, have therefore relied heavily on purchasing their specimens from suppliers, who in turn have maintained their own network of field collectors permanently stationed in strategic parts of the world.

A number of specialist firms exist today who buy, sell and exchange butterflies. The best of them breed many of their specimens and are staffed by experts who can offer much useful advice to the beginner.

In general the rarer Papilionidae, especially birdwings *(Ornithoptera)*, are most valued by collectors and, after these, the Nymphalid genera *Agrias, Charaxes* and *Prepona*. Spectacular aberrations, even of common butterflies, are sometimes sold for large sums.

Great rarities are eagerly sought by wealthy collectors and are consequently expensive. But even these are relatively low-priced, compared to the phenomenal sums that rare coins or postage stamps sometimes command. The highest price paid for a single butterfly was £750 for a male type specimen of *Ornithoptera allotei* at the sale of the Rousseau Decelle collection in 1966. This sale, and that of the Le Moult collection in 1968, were the most important of recent years, but the great period of butterfly auctions is now past. These had their heyday at the turn of the century when the famous firm of Stevens in Covent Garden, London, held natural history sales on virtually every day of the year. A page from one of Stevens' auction catalogues is reproduced opposite.

The decline and conservation of butterflies

Sadly it is an inescapable fact that the numbers of butterflies are declining in many parts of the world. Mankind is largely to blame, both direct and indirectly. It is inevitable that pressures of human expansion will gradually impinge upon even the most remote habitats. The spread of agriculture, the evils of pollution and the general disruption of delicately balanced ecological systems must inevitably take their toll.

Butterflies in Captivity–
breeding and rearing

Keeping adult butterflies in captivity is relatively easy, and it is not usually difficult to keep and rear their larvae. This gives the lepidopterist an opportunity to study various stages of the butterfly life cycle and add a fresh dimension to his knowledge of the animals. There is a further advantage which benefits the collector: adults which emerge from the pupa in captivity may be killed and added to the collection before they have a chance to fly and damage their wings. Rearing butterflies thus provides the opportunity to collect specimens in pristine conditions and large numbers may be preserved without undue extra expense and without depleting wild populations.

If the collector has access to a garden he can enhance its lepidopteran interest by planting flowers which produce a lot of nectar and are therefore attractive to butterflies. Buddleia bushes are especially favoured. He can also try to ensure that important larval food plants are available, though beds of nettles to encourage tortoiseshells are not popular with gardeners. Moreover, making such provisions in the garden not only enhances its interest, but also makes a useful contribution to butterfly conservation.

However, acres of ground are not essential for rearing butterflies in captivity. Even a garden is not absolutely necessary because most of the work can be done indoors. The basic equipment (shown above) required is very simple. The beginner will need a number of plastic boxes of various sizes, preferably clear or at least clear-topped, two or three small breeding cages (these can be

Although Rajah Brooke's birdwing *Trogonoptera brookianus* has long been familiar to collectors, the details of its life history have only recently been discovered. Here a pair of the Malayan race *albescens* (female left, male right) are fed on sugar solution before an attempt to breed from them.

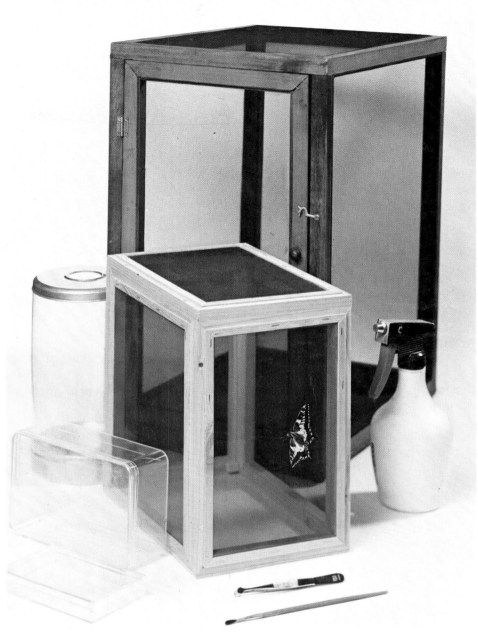

Breeding containers take various forms, from simple clear-plastic boxes or cylinders for larvae to larger mesh-sided cages for emergence and pairing. Other essential equipment includes a fine sprayer to prevent drying out, a small paintbrush for moving young larvae, and blunt forceps for general handling.

cylindrical plastic with a perforated lid, or wooden with muslin sides). Later on, larger cages will be needed for flight and pairing but these are not difficult to make. An inexpensive flight cage can be built using a large cardboard box with the side panels cut out and replaced by net curtain.

Some entomological dealers will supply butterfly eggs by post. It may also be possible to obtain a batch of eggs by persuading a freshly caught gravid female to deposit her eggs in captivity. Searching for eggs or larvae in the wild is a pleasant though time consuming activity, but with practice many commoner species may be located without too much difficulty, especially if the preferred food plant is known. Certain species have gregarious larvae and many of them may cluster on a single plant.

Young caterpillars may be kept in ventilated plastic boxes, but overcrowding should be avoided and in some species the larvae are cannibalistic and will have to be reared singly. It is essential that sprigs of the correct food plant be provided daily and that excreta or frass is not allowed to accumulate. Regular cleaning out is important to minimize the risk of disease. It is quite likely that a high proportion of wild-collected larvae will be parasitized. Those reared from captive stocks should be free from this, but may be less resistant to disease.

The young larvae grow very rapidly and need to be transferred to progressively larger boxes. They should not be handled if this can be avoided, and the smallest caterpillars should only be moved

using a fine paint brush. Muslin cages may be placed in a sunny window, but that is not suitable for plastic boxes as condensation may appear inside them. Excessive moisture is harmful to larvae, and to guard against it a piece of blotting-paper should be placed in the bottom of each box. This also makes cleaning easier.

When the larvae are half-grown they should be transferred to a cage with netting sides. By now they will be consuming large quantities of the food plant daily and very frequent fresh supplies will be needed.

When they have reached full size, the larvae begin to become lethargic and many species spin a fine web of silk around themselves prior to pupation. At this stage the food plant may be removed and the pupae will need no further regular attention until the emergence of the adult.

Those species which pass the whole winter in the pupal stage may conveniently be kept in cardboard boxes (lined with a little peat or moss). Winter pupae require little attention, although if kept indoors they should not be allowed to dry out, and their peat ought to be slightly dampened from time to time. Most tropical species, accustomed to more humid conditions, need to be sprayed daily with tepid water otherwise the imagines may be crippled.

Before the butterflies emerge, a few twigs should be placed at angles across the cage, or the pupae hung from netting (if they have cremastral hooks) to provide a foothold for the adults when drying their wings.

To complete the life cycle in captivity requires that the adult butterflies be persuaded to mate and lay eggs. Many species are reluctant to do this in artificial surroundings and may need some assistance. With some of these hand-pairing may be possible. Gentle pressure on the sides of the abdomen of the male will cause the valvae to open and clasp the offered female. Several attempts may be necessary before they will remain paired.

Some butterflies require a large flight area, for courtship rituals, before mating. However, a wild-caught female which has already mated may be induced to lay eggs as shown in the delightful painting on page 84. She should be placed in a small cage and provided with food in the form of fresh flowers or a sugar solution on cotton wool pads. If the species is one which lays its eggs directly on the food plant, fresh sprigs should be provided. Preferably the cage may enclose the growing plant, either potted, or outdoors in a sheltered position.

All this is only a brief and very general summary of the techniques of rearing. There are many variations of procedure, depending upon availability of food and materials and also depending upon the special needs of individual species. Instead of keeping larvae in cages, they may be put on branches of a growing food plant which are enclosed in muslin sleeves. Some species can be artificially encouraged to emerge early from pupation by a combination of heat with constant spraying. But by the time the novice breeder is ready to attempt these and other experiments, he will have progressed far beyond the scope of these simple hints.

Finally, it is important to keep a diary in which times of feeding, amounts of food eaten, skin changes, dates of emergence, and numbers of eggs laid are recorded in detail. This is all scientifically useful information and it also helps to avoid repeating early mistakes. Much work remains to be done in this field and even beginners could make new discoveries concerning the life histories of many familiar species.

The Butterfly Families

The Butterfly Families–

an introduction to the systematic section

The classification of Lepidoptera has already been briefly mentioned in Chapter 1 and it is now necessary to look in more detail at butterfly species and their names.

Scientific names

We owe the modern system of naming and classifying animals and plants to the Swedish biologist Carolus Linnaeus (1707–1778). He proposed a binomial system, with all living things given a two-part name derived from Latin or Greek. The scheme was similar to that in which people have a surname and a Christian (or 'given') name. A number of closely related people may have the same surname, setting them apart from other family groups, but are individually distinguished within the family by their Christian names. Similarly, in the Linnean system close relatives are put in the same genus (the first scientific name, always spelt with a capital letter) and individual species have their own different *specific* name (the second name, beginning with a small letter). Thus the red admiral *(Vanessa atalanta)* and the painted lady *(Vanessa cardui)* both belong to the same genus, and share the basic characteristics of that group, but are separate and easily distinguished species. These scientific names are, by convention, italicized; but the names of other taxa like families, orders and phyla are not.

A criticism frequently made by amateur naturalists is that the latinized scientific names of animals are long-winded and difficult to remember. These names may make a book, such as this one, more difficult to read, because the text is constantly broken by unfamiliar words which seem to be there only to flaunt the author's erudition before the unitiated. Why not stick to vernacular names which are in popular use and often helpfully descriptive of a species?

In fact the scientific names often *are* highly descriptive, though the disappearance of Latin from modern school curricula means that most of us fail to appreciate their meaning. For instance the small tortoiseshell *(Aglais urticae)* and the painted lady *(Vanessa cardui)* have specific names which refer to the nettles *(Urtica)* and thistles *(Carduus)* upon which their larvae feed. Arguably these particular scientific names are more helpfully descriptive than the vernaculars.

There are three main disadvantages to popular names. First, they tend to confuse true relationships. For example, the common European butterflies *Aglais urticae* and *Nymphalis polychloros* are respectively known as the small and the large tortoiseshell, implying a close relationship. In fact they are not very close relatives, a point made clear by their different generic names.

The second disadvantage to popular names is that they are inconsistent (the monarch is often known as the milkweed butterfly for instance) and often of a local or national character. Consider the small pearl-bordered fritillary, a cumbersome name for a butterfly which is found from western Europe, across Asia to Korea and is widely distributed in North America. In France it is the *petit collier argenté*, in Sweden the *brunfläckig Pärlemorfjäril*, in Spain it is the *perlada castana* and the Germans call it *braunfleckiger Perlmutter-falter*. After that, the scientific name is a simple *Clossiana selene*, universally recognized not just in Europe, but throughout the world (even in places like Russia and Japan where they do not even use the same alphabet as we do).

The third disadvantage of popular names is that the majority of animals just do not have one. In many languages one word serves for a whole group of animals, and with prolific creatures like butter-

Above: Although *Aglais urticae's* common name implies a close relationship to the large tortoiseshell *Nymphalis polychloros* (shown sunning itself after hibernation), their generic names indicate that this is not so.

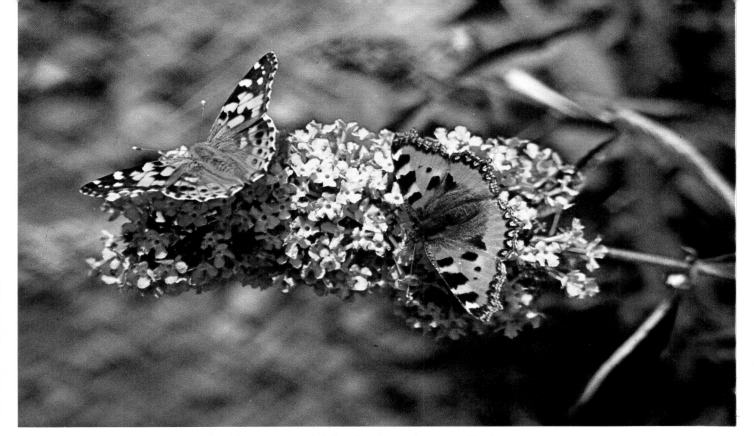

Above: In a country garden a small tortoiseshell *Aglais urticae* (right) shares a buddleia spray with the migrant painted lady *Vanessa cardui* (left).

flies it is unusual, except in Europe and North America, to find individual species each with a separate vernacular name.

Newly discovered species, almost by definition, will have no popular name and a scientific name is assigned following a strict set of internationally recognized rules. A description of the new species must be published in a recognized journal; a description which not only shows what the animal is like but also how it differs from its known relatives. The genus will usually be evident from a comparison with previously known forms and the person describing the new species is free to choose an appropriate specific name. He may choose a descriptive one like *alba* (white) or make reference to a place or to a food plant, as we have already seen in the case of *Vanessa cardui*, for example. Very often the collector of the original specimen, or a collector's wealthy patron or some other person, has been honoured by having a latinized version of his own name used to designate a new species. Many butterfly names recall deities or heroes of mythology such as *juno*, *jupiter* and *achilles*.

To save space and unnecessary repetition, generic names are often reduced to their initial letter, but only where it is clearly understood which genus is being referred to. Entomologists also frequently refer to an insect by the specific name alone. In the context of a particular group under discussion this would be understood. However, some species of different genera bear the same names. To distinguish these it is usually sufficient to indicate the genus by its capital letter such as *P. nobilis* or *C. nobilis*. A rare exception is provided by *L. dispar* which could be either a butterfly, *Lycaena dispar*, or a moth, *Lymantria dispar*.

The actual specimen from which a new species is described is called the 'type'. It is obviously of fundamental importance and most type specimens are kept safely in large museums. Occasional privately-owned types may be advertized for sale and, because of their historic and scientific value, command a high price. However, the collector should beware of these unless their authenticity is beyond all possible doubt. A type specimen should not be confused with a type species which is merely the species chosen to be representative of its genus.

Technically, a full scientific name should have appended to it the name of the original describer and the date that the new name was first published. This helps in tracing obscure or doubtfully valid

names and ensures that the correct person is given credit for the name used. To avoid unnecessarily cumbersome terminology the describer's name is usually abbreviated. For example, *Lycaena dispar* Haw. 1803, means that the name was originally proposed for this butterfly by Haworth and published in 1803, while the abbreviation L. after a scientific name (eg in *Papilio machaon* L.) is universally recognized to mean that the original Linnean name has been retained. The authorities for names used in the systematic section of this book have been cited and a list of their abbreviations appears at the end of this chapter. For the earlier part of the book, where taxonomic precision is less important than an easily read text, these rather cumbersome additions to scientific names have been omitted.

Despite the fact that scientific names are more constant than vernacular ones, they are not immutable and as new knowledge is acquired, some revision may become necessary. It sometimes happens that two species, originally thought to be different, turn out to be the same. In this case, the older name takes precedence and the newer one is abandoned. Sometimes a zoologist will reclassify a group, perhaps deciding that a particular genus includes too great a diversity of species, and that a new genus (or subgenus) needs to be created to accommodate a few of them. Revisions like these often result in changes in nomenclature, giving rise to 'old' or 'out of date' Latin names. Such reappraisals usually do not affect a large number of animals and certainly do not seriously reduce the value of the Linnean system of naming and classifying animals.

In the Linnean system the species, or interbreeding community, was regarded as the fundamental unit. Thus the binomial system of nomenclature was sufficient to identify the species referred to and the genus to which it was assigned. The use of a capital initial letter for the genus and a small initial letter for the species make the distinction quite clear. However, since the time of Linnaeus, many new animals have been discovered, with the result that his system has had to be continually expanded to accommodate them. For example, Linnaeus created a single genus *Papilio* for all butterflies, but this

Above: These females of the European green-veined white (Pieridae) provide an example of successive additions to its original Linnean name: 1. *Pieris napi napi* L. type form (Sweden); 2. *P. napi britannica* Vty. (Ireland); 3. *P. napi britannica* Vty. f. *flava* Kane; 4. *P. napi britannica* Vty. f. *flava* Kane; ab. *fasciata* Kautz.

Left: Carolus Linnaeus (1707–78), who originated the binomial (genus and species) system of classification.

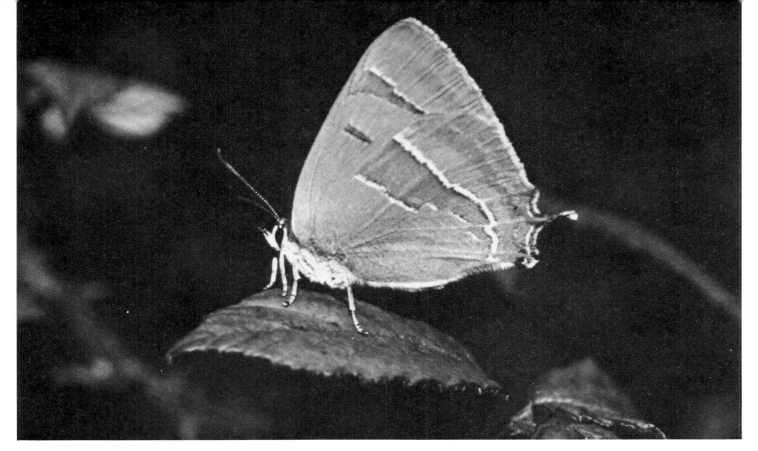

Above: The European brown hairstreak *Thecla betulae* (Lycaenidae) is the type species—that is, the species chosen as the representative—of the genus *Thecla* (X 8). This name is frequently mis-applied to a whole range of South American allies, some of which, designated *'Thecla'*, are on pages 172/173.

Below: A problem of classification. This Nymphalid butterfly has a wide distribution, ranging from Africa to the Far East. *Precis hierta* (1), from India, is regarded as the typical form. The sub-species *cebrene* (2) is from Africa, and some authorities believe it should be classified as a separate species.

has been subdivided until now the genera run into thousands. Further, while the species remains the basic unit, it is now recognized that within a species there may be several recognizably different forms, each of which differs consistently from the rest of the species and is often related to a particular geographical region. If these variants possess fixed characteristics which enable them to be consistently differentiated from the form of the type specimen of the species, then a third name is added to the binomial designation to denote a subspecies. Thus the green-veined white was first described in Sweden by Linnaeus, so the form found there is the nominate subspecies *Pieris napi napi* L.; whilst the one occurring in Ireland is recognizably distinct, though still the same species, and designated *P. napi britannica* Vty. In the latter case, 'Vty' refers to Verity who was responsible for describing this as a separate subspecies.

With animals like butterflies which are prone to variation and also studied in minute detail, we often find that many different forms may be reported within a single species. Some of these will consistently occur in a particular region only, and merit consideration as subspecies, and given a Latin trinomial name as described above. Sometimes these variations are not sufficiently distinct to warrant the status of subspecies, so are designated as 'forms'. Where these have been given a special name, it is preceded by the abbreviation f. and follows the standard Linnean binomial. Random varieties or aberrations (sometimes referred to as 'sports') may also have been given their own name and this is preceded by the abbreviation ab. (for aberration) or var. (for variety).

Forms and aberrations are considered briefly in Chapter 8 and are designated, where appropriate, in the captions to the plates in the systematic section of this book. These categories have no scientific validity, they are just a convenience. However the use of a multiplicity of names has meant that the classification of butterflies has been more confused by a tangle of nomenclature than probably any other animal group. Countless forms and varieties have been named, sometimes elevated to full species or subspecies status Some zoologists repudiate a batch of names, whilst others create still more. This whole situation is regrettable and probably stems in part from the over enthusiastic activities of amateur lepidopterists

in the past who did not have access to sufficient specimens to set their 'new' discoveries in their true perspective. To be fair, it is also true that butterflies, more than most animals, are very prone to variation and thus prompt the description of many minor forms.

The beginner (and the professional) must often despair at these complexities and the seemingly irrational name changes that are a particular plague in the entomological literature. However, this is to be expected in a field where new information is constantly arriving and necessitates almost continuous review of the whole field of study. Faced with the brown argus butterflies for instance, who is to say with finality whether all those in Europe are a single species or a group of allied species so similar as to be indistinguishable? With *Precis hierta* we have either a single species with three subspecies and races, or we may have geographically separate species which have recently evolved from *P. hierta* and differ little from it. The situation is obviously even more fluid with the less well known groups from the tropics. Lest the beginner should decide that the whole system is too impossibly complex and muddled to be of any use, it should be pointed out that there are over a million species of animals known. There are 140,000 species of Lepidoptera; 35 times as many as there are mammals. Some system is thus essential and any system, no matter how imperfect, is better than none.

Butterfly families

While we must accept that the butterfly families are largely artificial units (one frequently including species which 'link' with another) their use is essential to provide a reasonably stable arrangement and facilitate the study of relationships and evolutionary development. It has already been indicated in Chapter 1 that the classification of butterfly families is open to dispute and has been the subject of revisions in the past. In order to provide a simple system (at the price of being out of step with some modern thinking) we have chosen to retain the obsolete scheme of dividing the butterflies into 15 families. These traditional family names are in widespread popular use and form an easily comprehensible system.

A brief introduction to each family lists any special characteristics and is followed by a selection of life-size specimens. Each butterfly is numbered and captioned under its genus name, but its actual position on the page is not significant. Naturally it has not been possible to include all butterflies, and the selection has been made on grounds of importance and appearance. However, more than 2,000 specimens make this an extremely valuable assembly of the world's butterflies.

Abbreviations of descriptor's names

The abbreviation immediately following a scientific name indicates who it was that first applied that name to a particular species of animal. This system ensures that the correct person is given credit (or blame) for the name used, and also helps further details of the original description. The following list shows the original authors to whom these abbreviations refer.

Alph.	Alpheraky	B.-H.	Bang-Haas
Atk.	Atkinson	Berg.	Bergstrasser
Auriv.	Aurivillius	B.-Baker.	Bethune-Baker
Avin.	Avinoff	Blach.	Blachier
		Blanch.	Blanchard

Bsdv.	Boisduval
Brem.	Bremer
Btlr.	Butler
Coms.	Comstock
Cr.	Cramer
Dalm.	Dalman
Dew.	Dewitz
Dist.	Distant
Don.	Donovan
Dbldy.	Doubleday
Dry.	Drury
Edw.	Edwards
Eisn.	Eisner
Elt.	Eltringham
Er.	Erichson
Esch.	Eschscholtz
Esp.	Esper
Evers.	Eversmann
Fab.	Fabricius
Feisth.	Feisthamel
Feld.	Felder(s)
Friv.	Frivaldsky
Fruhst.	Fruhstorfer
Godt.	Godart
Godm.	Godman
G. & S.	Godman & Salvin
Grand.	Grandidier
G.-Smith.	Grose-Smith
Gr.-Grsh.	Grum-Grishimailo
Guen.	Guenée
Guér.	Guérin-Ménéville
Hem.	Hemming
Hbst.	Herbst
H.-Schaff.	Herrich-Schäffer
Hew.	Hewitson
Hoev.	van der Hoeven
Holl.	Holland
Hon.	Honrath
Hopff.	Hopffer
Horsf.	Horsfield
Hbn.	Hübner
Ill.	Illiger
Jack.	Jackson
Jans.	Janson
J.	Joicey
Jord.	Jordan
Koll.	Kollar
Latr.	Latreille

Le.D.	Le Doux
L.	Linnaeus
Mab.	Mabille
Mait.	Maitland
Mart.	Martin
Math.	Mathew
Mats.	Matsumura
Meerb.	Meerburgh
Ménétr.	Ménétries
Mont.	Montrouzier
Mosch.	Möschler
Neus.	Neustetter
de Nicév.	de Nicéville
Nick.	Nickerl
Oberth.	Oberthur
Ochs.	Ochsenheimer
Pag.	Pagenstecher
Poul.	Poulton
Reak.	Reakirt
Rob.	Rober
Rogen.	Rogenhofer
Roths.	Rothschild
R. & J.	Rothschild & Jordan
Rott.	Rottemburg
Salv.	Salvin
Sndrs.	Sanders
Sanf. & Bnt.	Sanford & Bennett
Schiff.	Schiffermüller
Sch.	Schultze
Scop.	Scopoli
Semp.	Semper
Snell.	Snellen
Stgr.	Staudinger
Stich.	Stichel
Swains.	Swainson
T.	Talbot
Trim.	Trimen
van Som.	van Someren
Vty.	Verity
Voll.	Vollenhoven
Wall.	Wallace
Wallen.	Wallengren
Westw.	Westwood
Weym.	Weymer
W.-Mas.	Wood-Mason
Zink.	Zincken -sommer
Zett.	Zetterstedt

Abbreviations of countries and regions

The abbreviation which appears in brackets after the descriptor's name refers to the country or region where a particular specimen was found.

Afghan.	Aghanistan
Alg.	Algeria
And.	Andaman
Argent.	Argentina
Aus.	Australia
Bol.	Bolivia
Born.	Borneo
Bougain.	Bougainville
Braz.	Brazil
Cam.	Cameroun
Can.	Canada
Celeb.	Celebes
C.A.R.	Central African Republic
Chin.	China
Col.	Colombia
Cong.	Congo (Zaire)
C. Rica.	Costa Rica
Ecua.	Ecuador
El Sal.	El Salvador
Eng.	England
Eth.	Ethiopia
Form.	Formosa (Taiwan)
Fran.	France
Gam.	Gambia
Germ.	Germany
Guad.	Guadalcanal
Guat.	Guatemala
Guy.	Guyana
Halm.	Halmaheira
Hond.	Honduras
Hun.	Hungary
Ind.	India
Irld.	Ireland
Jam.	Jamaica
Jap.	Japan
Ken.	Kenya
Key I.	Key Island (New Guinea)
Madgr.	Madagascar

Manus I.	Manus Island (Admiralties)
Maur.	Mauritius
Mex.	Mexico
Moroc.	Morocco
Moz.	Mozambique
N. Brit.	New Britain
N. Caled.	New Caledonia
N.G.	Papua (New Guinea)
N. Heb.	New Hebrides
N. Ireland	New Ireland
Nicar.	Nicaragua
Nig.	Nigeria
Nor.	Norway
Pak.	Pakistan
Pal.	Palawan
Pan.	Panama
Phil.	Philippines
Rhod.	Rhodesia
Sard.	Sardinia
Scot.	Scotland
S. Leone.	Sierra Leone
Solom.	Solomon Islands
Som.	Somalia
S. Af.	South Africa
S.W.Af.	South West Africa
Sri Lank.	Sri Lanka (Ceylon)
Sum.	Sumatra
Swed.	Sweden
Switz.	Switzerland
Tan.	Tanzania
Tas.	Tasmania
Thai.	Thailand (Siam)
Tib.	Tibet
Tky.	Turkey
Ugan.	Uganda
Urug.	Uruguay
USA	United States of America
USSR	Union of Soviet Socialist Republics
Venez.	Venezuela
Zam.	Zambia

Chapter 14

Hesperiidae –

skippers

T he members of the family Hesperiidae derive their popular name from the darting flight of most species, which is quite unlike that of other butterflies. In addition they possess many structural features which set them apart as a more 'primitive' group with close affinities among moth families, such as the ability to rest with the fore wings folded flat on each side of the body.

The family is well represented in all world regions and comprises several thousand species. In wing-span these vary from about 19mm to 90mm although the latter is exceptional and the majority of species are much smaller. In colouring they are rather subdued; principally shades of brown with lighter markings, although some tropical species, particularly in South America, possess brilliant iridescent colouring. The stoutly built bodies, sharply angled fore wings, and pointed antennal 'clubs' are features which are shared by nearly all species. A small number have tailed hind wings.

Among the most unusual are the large American *Megathyminae* which have very powerful wings and rounded tips to the antennae. In earlier literature these may be found treated as members of a moth genus *Castnia*.

A very strange problem of classification is posed by *Euschemon rafflesia* from Australia. The male of this species has a wing-coupling apparatus or frenulum which is generally regarded as a characteristic

Above: A brilliant member of this family is the Neotropical *Pyrrhopyge cometes* Cr. This is s.sp *staudingeri* Plotz from Peru (X 10).

Left: *Hesperia comma* L. photographed in England, where it is local in downland areas (X 10).

Right: The male of the Australian *Euschemon rafflesia* Macleay is unique, having a frenulum connecting the wings —usually a characteristic only of moths.

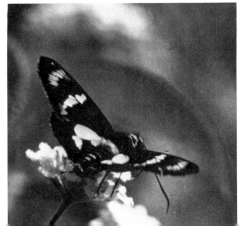

feature of moths. If this definition is interpreted logically then only the female (which lacks this structure) can be regarded as a butterfly – one of several examples which point to the artificiality of any division between butterflies and moths.

The eggs are spherical or oval with flattened bases and may be smooth, reticulated, or finely ribbed. The larvae are stout and somewhat spindle-shaped, usually with large heads but without extensive hair. Most are green or whitish in shade but some are banded or spotted in striking colours. A large number of species feed on grasses. The pupae are smooth without prominent angular projections except at the head end which may be extended into a point. The majority are formed in a partial silk cocoon among leaves.

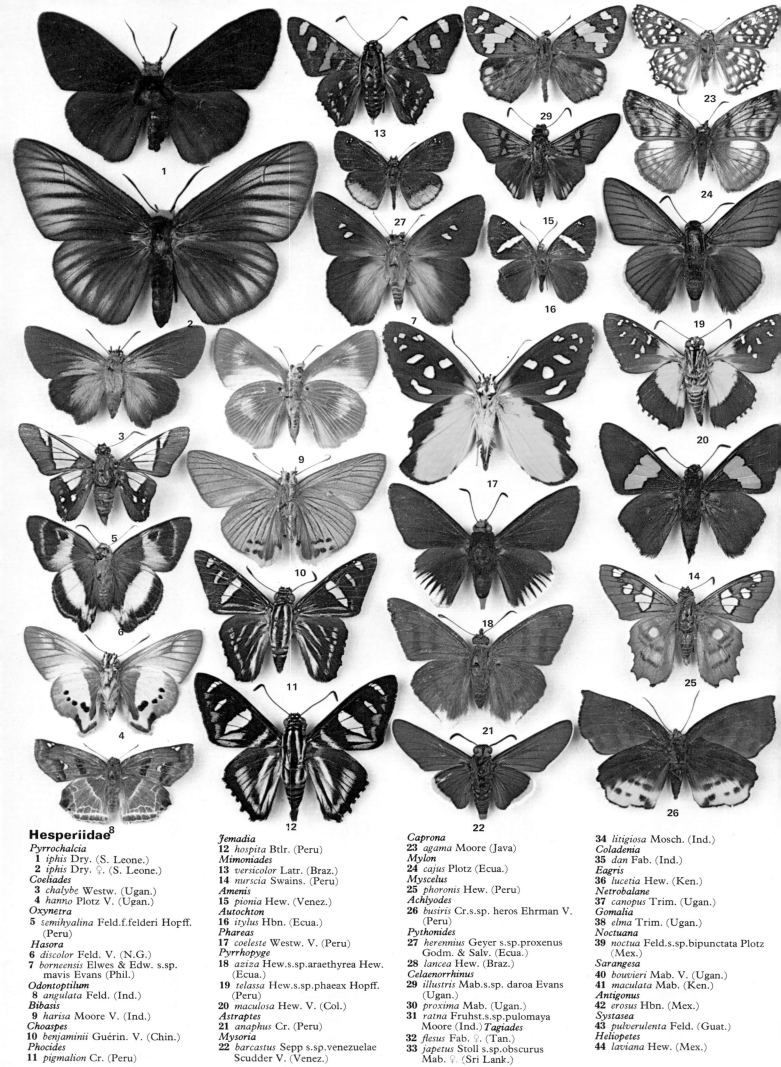

Hesperiidae[8]

Pyrrochalcia
1 *iphis* Dry. (S. Leone.)
2 *iphis* Dry. ♀. (S. Leone.)
Coeliades
3 *chalybe* Westw. (Ugan.)
4 *hanno* Plotz V. (Ugan.)
Oxynetra
5 *semihyalina* Feld.f.felderi Hopff. (Peru)
Hasora
6 *discolor* Feld. V. (N.G.)
7 *borneensis* Elwes & Edw. s.sp. mavis Evans (Phil.)
Odontoptilum
8 *angulata* Feld. (Ind.)
Bibasis
9 *harisa* Moore V. (Ind.)
Choaspes
10 *benjaminii* Guérin. V. (Chin.)
Phocides
11 *pigmalion* Cr. (Peru)

Jemadia
12 *hospita* Btlr. (Peru)
Mimoniades
13 *versicolor* Latr. (Braz.)
14 *nurscia* Swains. (Peru)
Amenis
15 *pionia* Hew. (Venez.)
Autochton
16 *itylus* Hbn. (Ecua.)
Phareas
17 *coeleste* Westw. V. (Peru)
Pyrrhopyge
18 *aziza* Hew.s.sp.araethyrea Hew. (Ecua.)
19 *telassa* Hew.s.sp.phaeax Hopff. (Peru)
20 *maculosa* Hew. V. (Col.)
Astraptes
21 *anaphus* Cr. (Peru)
Mysoria
22 *barcastus* Sepp s.sp.venezuelae Scudder V. (Venez.)

Caprona
23 *agama* Moore (Java)
Mylon
24 *cajus* Plotz (Ecua.)
Myscelus
25 *phoronis* Hew. (Peru)
Achlyodes
26 *busiris* Cr.s.sp. heros Ehrman V. (Peru)
Pythonides
27 *herennius* Geyer s.sp.proxenus Godm. & Salv. (Ecua.)
28 *lancea* Hew. (Braz.)
Celaenorrhinus
29 *illustris* Mab.s.sp. daroa Evans (Ugan.)
30 *proxima* Mab. (Ugan.)
31 *ratna* Fruhst.s.sp.pulomaya Moore (Ind.) *Tagiades*
32 *flesus* Fab. ♀. (Tan.)
33 *japetus* Stoll s.sp.obscurus Mab. ♀. (Sri Lank.)

34 *litigiosa* Mosch. (Ind.)
Coladenia
35 *dan* Fab. (Ind.)
Eagris
36 *lucetia* Hew. (Ken.)
Netrobalane
37 *canopus* Trim. (Ugan.)
Gomalia
38 *elma* Trim. (Ugan.)
Noctuana
39 *noctua* Feld.s.sp.bipunctata Plotz (Mex.)
Sarangesa
40 *bouvieri* Mab. V. (Ugan.)
41 *maculata* Mab. (Ken.)
Antigonus
42 *erosus* Hbn. (Mex.)
Systasea
43 *pulverulenta* Feld. (Guat.)
Heliopetes
44 *laviana* Hew. (Mex.)

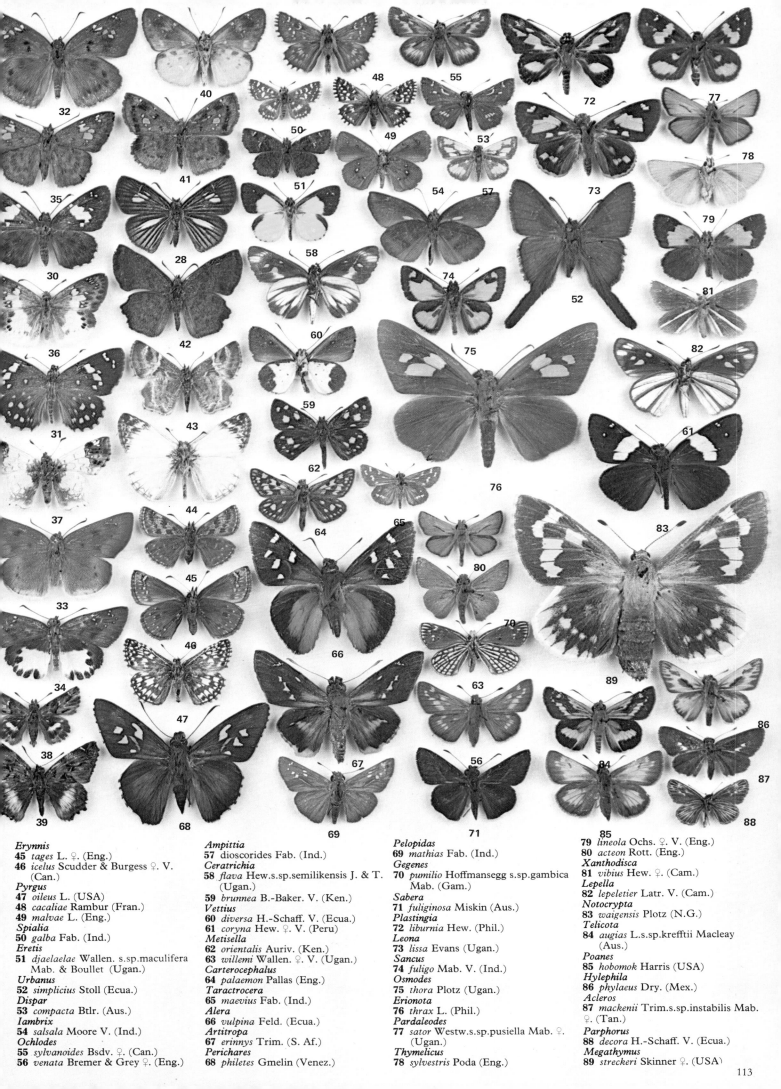

Papilionidae –

apollos, swallowtails and birdwings

The family Papilionidae contains about 700 species distributed throughout the world. They are generally powerful fliers and are among the most conspicuous butterflies in the countries where they are found. This family includes the largest and some of the most splendid of all butterflies.

Particularly outstanding are the enormous birdwing butterflies (*Ornithoptera*), found principally in the Australian region. Females of some of the *Ornithoptera* have a wing-span of 25cm or more. The males, although smaller, are often arrayed in dazzling gold or green. To give an idea of the size range within the family, at the other end of the scale are the tiny long-tailed dragontail butterflies (*Lamproptera*) from India and Malaysia; they have a wing-span of less than 50mm.

The swallowtails are so called as most have tailed hind wings. There are many species and they are subdivided into three groups; true swallowtails, kite swallowtails and poison-eaters. Representatives of these groups occur in the temperate or tropical zones of most countries. True swallowtails (*Papilio*) include some of the most familiar species. Kite swallowtails (*Eurytides* and *Graphium*) have narrow pointed wings giving the appearance of an old-fashioned kite. The poison-eaters (*Parides* and *Troides*) are so called because their larvae feed on the *Aristolochia* vines from which they derive poisonous substances. Poison-eaters are examples of 'protected' species, ie they are less subject to attack by predators, and some members of non-poisonous groups which closely resemble them seem to share this protection.

Another and most curious group, the apollos (*Parnassius*), are very unlike other members of the family. They have rounded, semi-transparent wings and their bodies are densely clothed with hair. They are confined to higher altitudes in northern regions and are among the most familiar mountain butterflies. Unlike most other members of the Papilionidae they are relatively slow and lazy fliers.

One strange little butterfly *Baronia brevicornis*, found only in part of Mexico, is so different from the other members of the family

Right: *Ornithoptera priamus* L. is one of the birdwings. This male, of the race *poseidon* Dbldy., was photographed in the jungles of New Guinea (for the female, see pages 14/15).

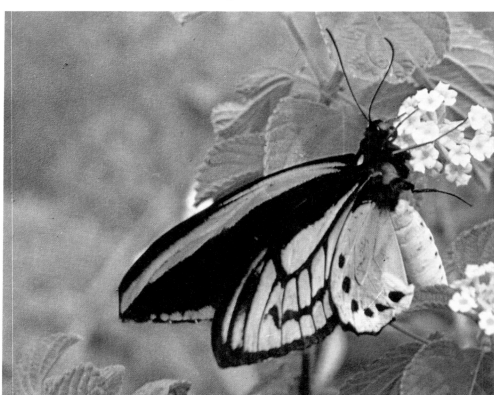

Above left: The kite swallowtail *Iphiclides podalirus* L. occurs in the southern Palaearctic region, but its range may once have extended farther north: it was included in early works on British butterflies as the 'scarce swallowtail' (X 1.25).

Above: *Papilio xuthus* L., shown here feeding in a Japanese garden, is a member of the true swallowtails.

that it is placed in a subfamily of its own. It is considered by experts to be one of the most primitive members of the Papilionidae.

The attractive colours and wing shapes of many species of this family, and their relatively large size, arouses the enthusiasm of lepidopterists everywhere. Consequently they have received more attention and study than the more numerous members of some other butterfly families.

The eggs of the Papilionidae are usually spherical and unremarkable. However, the smooth-skinned caterpillars possess a very curious structure called an osmeterium. This is a strong-smelling forked 'horn', often brightly coloured, which the caterpillar can erect just behind the head. This device is believed to deter would-be predators. The pupae are angular with two projecting points at the head end. They are usually formed upright within a silken girth.

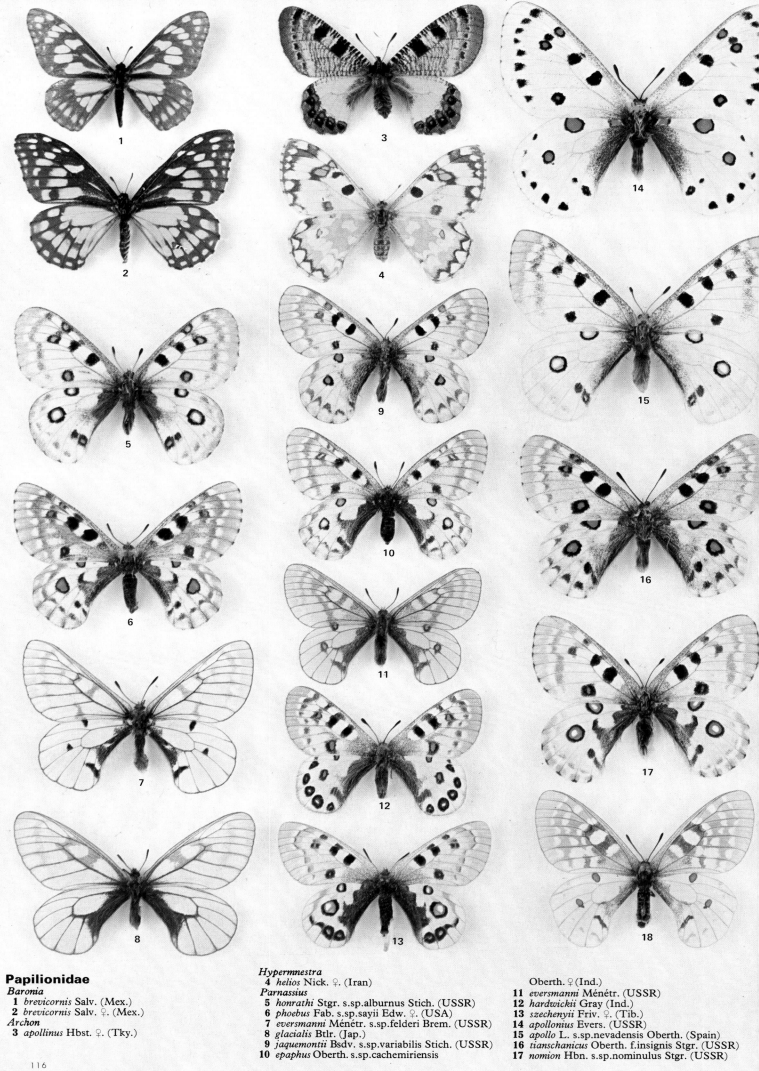

Papilionidae

Baronia
1 *brevicornis* Salv. (Mex.)
2 *brevicornis* Salv. ♀. (Mex.)
Archon
3 *apollinus* Hbst. ♀. (Tky.)

Hypermnestra
4 *helios* Nick. ♀. (Iran)
Parnassius
5 *honrathi* Stgr. s.sp.alburnus Stich. (USSR)
6 *phoebus* Fab. s.sp.sayii Edw. ♀. (USA)
7 *eversmanni* Ménétr. s.sp.felderi Brem. (USSR)
8 *glacialis* Btlr. (Jap.)
9 *jaquemontii* Bsdv. s.sp.variabilis Stich. (USSR)
10 *epaphus* Oberth. s.sp.cachemiriensis

Oberth. ♀ (Ind.)
11 *eversmanni* Ménétr. (USSR)
12 *hardwickii* Gray (Ind.)
13 *szechenyii* Friv. ♀. (Tib.)
14 *apollonius* Evers. (USSR)
15 *apollo* L. s.sp.nevadensis Oberth. (Spain)
16 *tianschanicus* Oberth. f.insignis Stgr. (USSR)
17 *nomion* Hbn. s.sp.nominulus Stgr. (USSR)

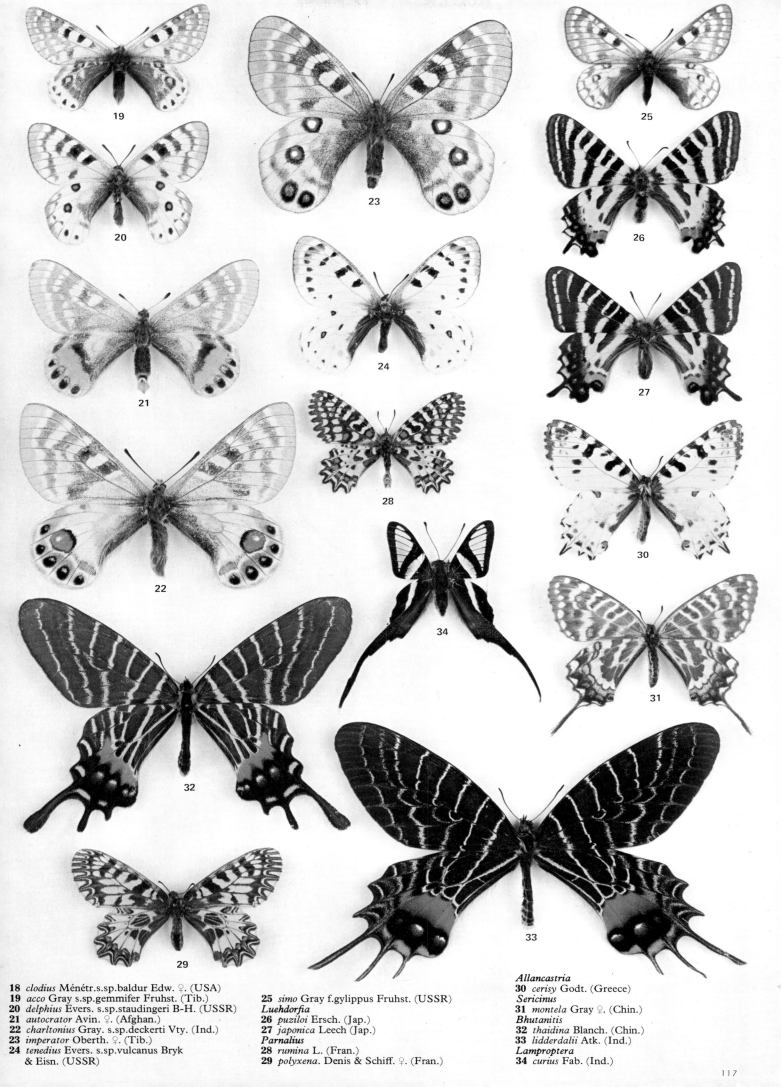

18 *clodius* Ménétr.s.sp.baldur Edw. ♀. (USA)
19 *acco* Gray s.sp.gemmifer Fruhst. (Tib.)
20 *delphius* Evers. s.sp.staudingeri B-H. (USSR)
21 *autocrator* Avin. ♀. (Afghan.)
22 *charltonius* Gray. s.sp.deckerti Vty. (Ind.)
23 *imperator* Oberth. ♀. (Tib.)
24 *tenedius* Evers. s.sp.vulcanus Bryk
 & Eisn. (USSR)

25 *simo* Gray f.gylippus Fruhst. (USSR)
Luehdorfia
26 *puziloi* Ersch. (Jap.)
27 *japonica* Leech (Jap.)
Parnalius
28 *rumina* L. (Fran.)
29 *polyxena*. Denis & Schiff. ♀. (Fran.)

Allancastria
30 *cerisy* Godt. (Greece)
Sericinus
31 *montela* Gray ♀. (Chin.)
Bhutanitis
32 *thaidina* Blanch. (Chin.)
33 *lidderdalii* Atk. (Ind.)
Lamproptera
34 *curius* Fab. (Ind.)

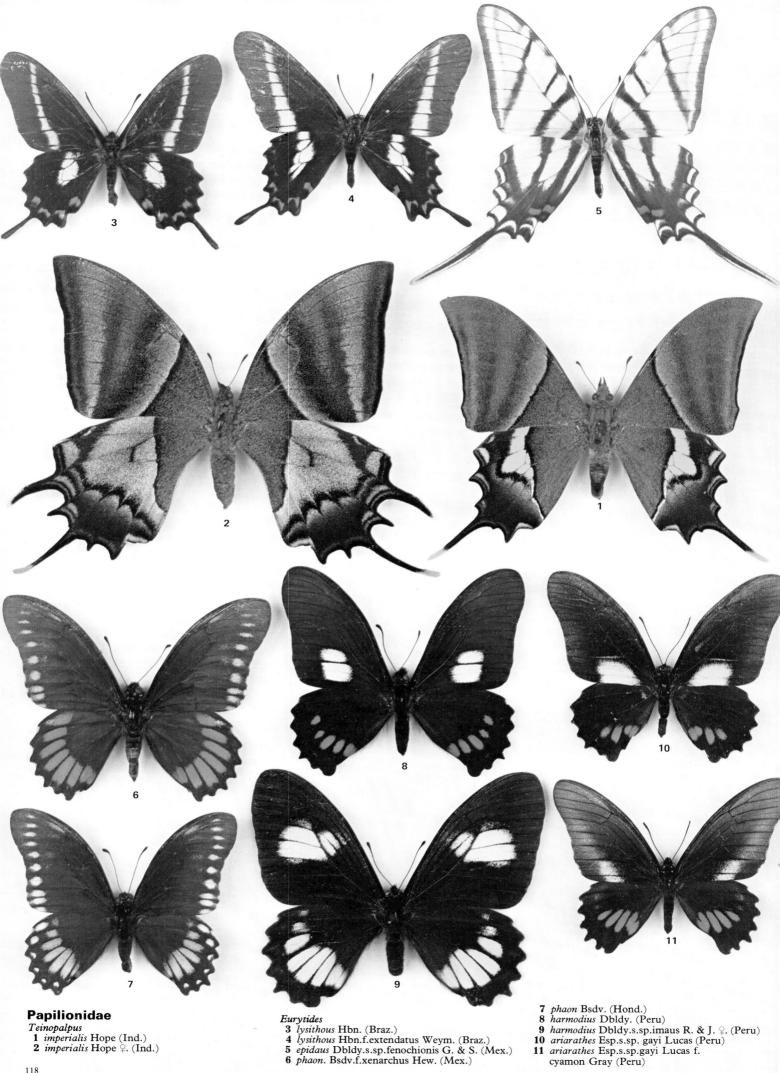

Papilionidae

Teinopalpus
1 *imperialis* Hope (Ind.)
2 *imperialis* Hope ♀. (Ind.)

Eurytides
3 *lysithous* Hbn. (Braz.)
4 *lysithous* Hbn.f.extendatus Weym. (Braz.)
5 *epidaus* Dbldy.s.sp.fenochionis G. & S. (Mex.)
6 *phaon*. Bsdv.f.xenarchus Hew. (Mex.)

7 *phaon* Bsdv. (Hond.)
8 *harmodius* Dbldy. (Peru)
9 *harmodius* Dbldy.s.sp.imaus R. & J. ♀. (Peru)
10 *ariarathes* Esp.s.sp. gayi Lucas (Peru)
11 *ariarathes* Esp.s.sp.gayi Lucas f.
cyamon Gray (Peru)

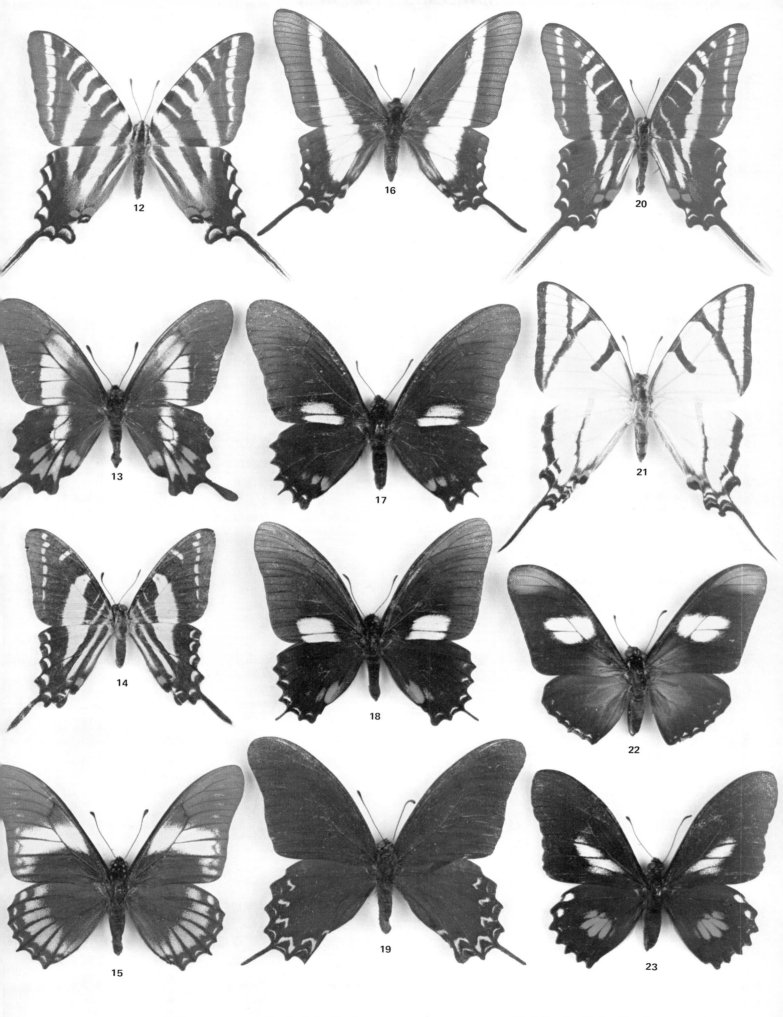

12 *marcellus* Cr.f.telamonides Feld. (USA)
13 *lysithous* Hbn.f.platydesma R. & J. (Braz.)
14 *marcellinus* Dbldy. (Jam.)
15 *protodamas* Godt.f.choridamas Bsdv. (Braz.)

16 *asius* Fab. (Braz.)
17 *trapeza* R. & J. (Ecua.)
18 *xynias* Hew. (Peru)
19 *thymbraeus* Bsdv.s.sp.aconophos Gray (Mex.)
20 *philolaus* Bsdv. (Mex.)

21 *bellerophon* Dalm. (Braz.)
22 *pausanias* Hew. (Peru)
23 *euryleon* Hew.s.sp.haenschi R. & J. (Ecua.)

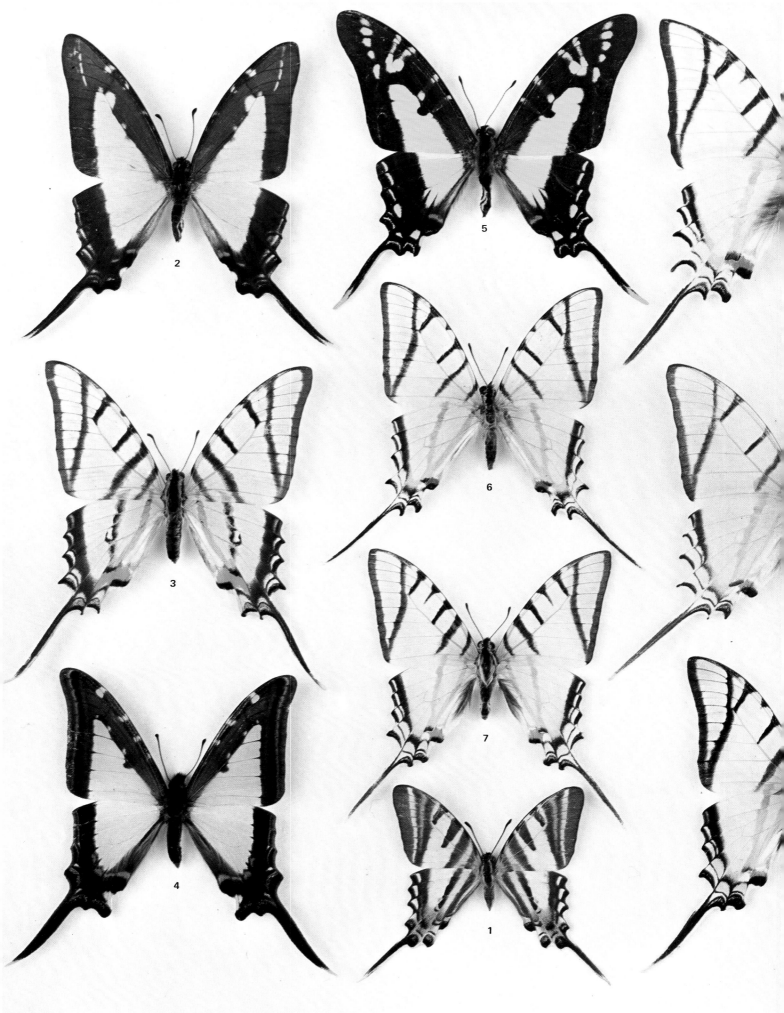

Papilionidae
Protographium
 1 *leosthenes* Dbldy. (Aus.)

Eurytides
 2 *lacandones* Bates (Guat.)
 3 *orthosilaus* Weym. (Braz.)
 4 *leucaspis* Godt. (Peru)

 5 *thyastes* Dry.s.sp.thyastinus Oberth. (Peru)
 6 *stenodesmus* R. & J. (Braz.)
 7 *molops* R. & J. s.sp.hetarius R. & J. (Col.)
 8 *protesilaus* L.s.sp.penthesilaus Feld. (Mex.)

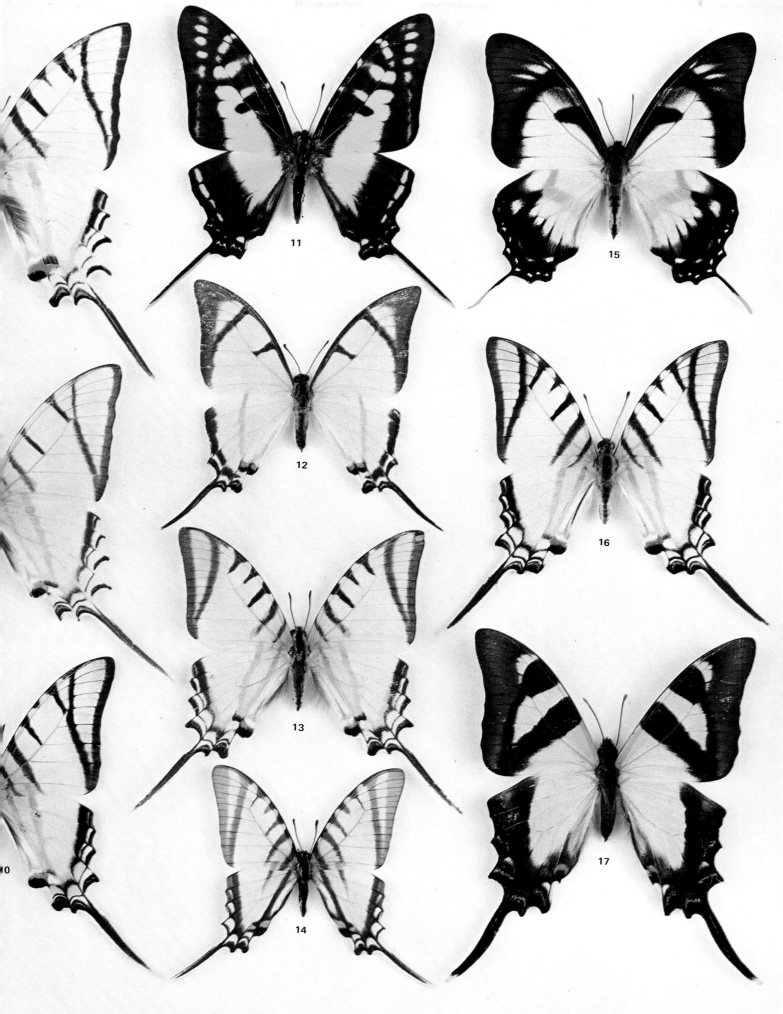

9 *protesilaus* L.s.sp.macrosilaus Gray. (Hond.)
10 *telesilaus* Feld. (Peru)
11 *marchandi* Bsdv. (Mex.)
12 *salvini* Bates (Guat.)

13 *glaucolaus* Bates (Pan.)
14 *agesilaus* Guér.s.sp.fortis R. & J. (Mex.)
15 *dolicaon* Cr.s.sp.deileon Feld. (Peru)
16 *protesilaus* L.s.sp.nigricornis Stgr. (Braz.)

17 *columbus* Koll. (Col.)

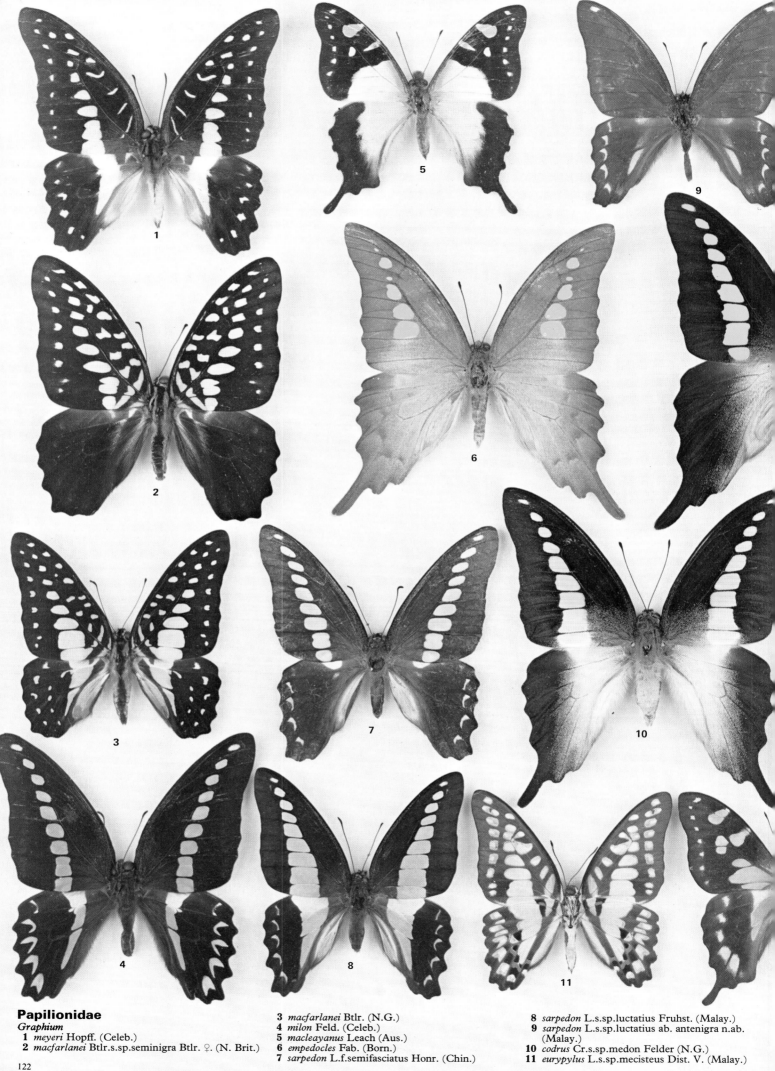

Papilionidae
Graphium
1 *meyeri* Hopff. (Celeb.)
2 *macfarlanei* Btlr.s.sp.seminigra Btlr. ♀. (N. Brit.)

3 *macfarlanei* Btlr. (N.G.)
4 *milon* Feld. (Celeb.)
5 *macleayanus* Leach (Aus.)
6 *empedocles* Fab. (Born.)
7 *sarpedon* L.f.semifasciatus Honr. (Chin.)

8 *sarpedon* L.s.sp.luctatius Fruhst. (Malay.)
9 *sarpedon* L.s.sp.luctatius ab. antenigra n.ab. (Malay.)
10 *codrus* Cr.s.sp.medon Felder (N.G.)
11 *eurypylus* L.s.sp.mecisteus Dist. V. (Malay.)

122

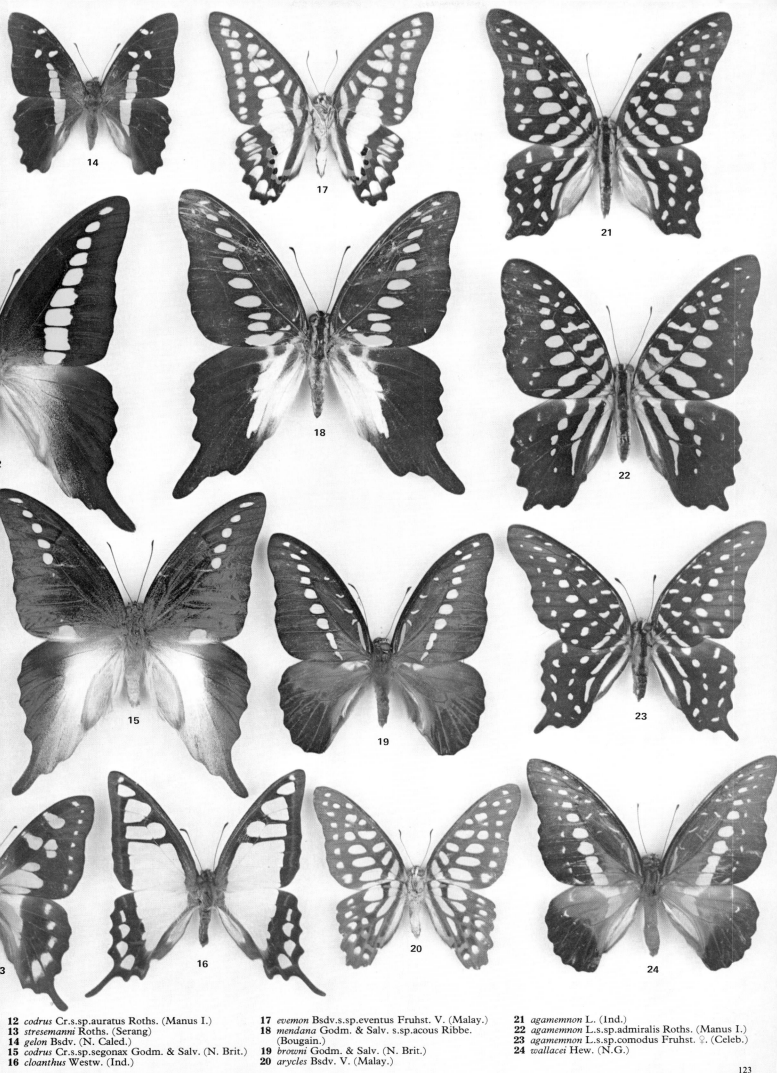

12 *codrus* Cr.s.sp.auratus Roths. (Manus I.)
13 *stresemanni* Roths. (Serang)
14 *gelon* Bsdv. (N. Caled.)
15 *codrus* Cr.s.sp.segonax Godm. & Salv. (N. Brit.)
16 *cloanthus* Westw. (Ind.)

17 *evemon* Bsdv.s.sp.eventus Fruhst. V. (Malay.)
18 *mendana* Godm. & Salv. s.sp.acous Ribbe.
 (Bougain.)
19 *browni* Godm. & Salv. (N. Brit.)
20 *arycles* Bsdv. V. (Malay.)

21 *agamemnon* L. (Ind.)
22 *agamemnon* L.s.sp.admiralis Roths. (Manus I.)
23 *agamemnon* L.s.sp.comodus Fruhst. ♀. (Celeb.)
24 *wallacei* Hew. (N.G.)

123

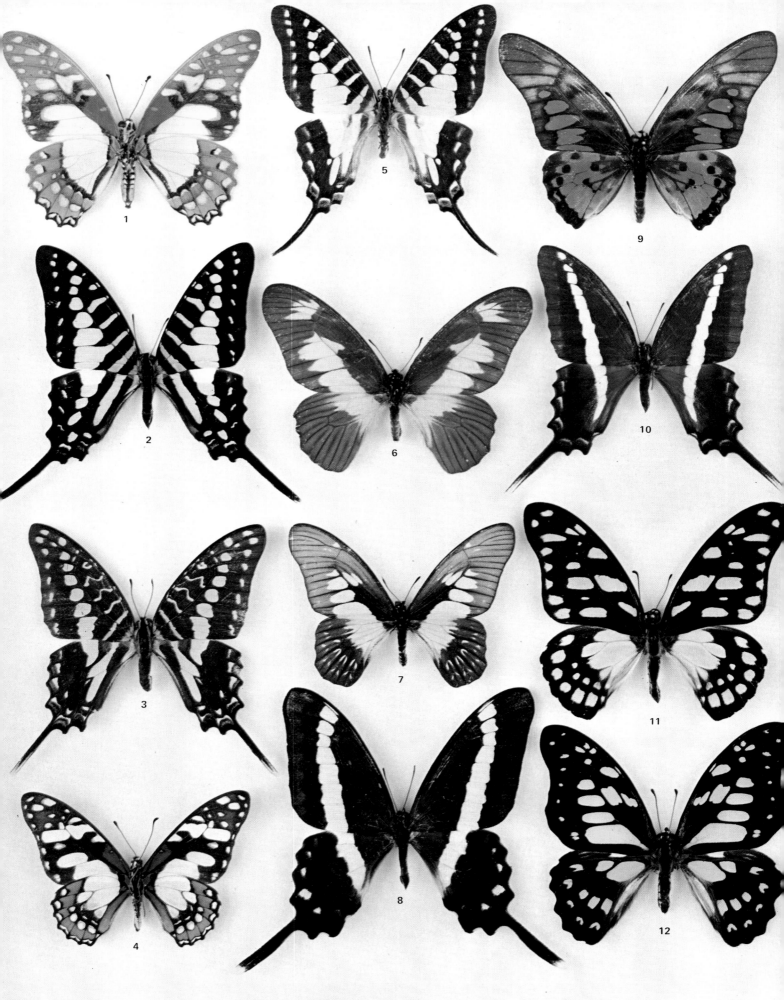

Papilionidae
Graphium
1 *pylades*. Fab.s.sp.angolanus Goeze ♀. V. (S. Af.)
2 *policenes* Cr. (C.A.R.)
3 *porthaon* Hew. (Ken.)
4 *taboranus* Oberth. V. (Tan.)
5 *evombar* Bsdv. (Madgr.)
6 *ucalegon* Hew.s.sp.schoutedeni Berger (Ugan.)
7 *agamedes* Westw. (C.A.R.)
8 *illyris* Hew. (Cong.)
9 *ridleyanus* White (C.A.R.)
10 *kirbyi* Hew. (Ken.)
11 *leonidas* Fab. (Cam.)
12 *cyrnus* Bsdv. (Madgr.)

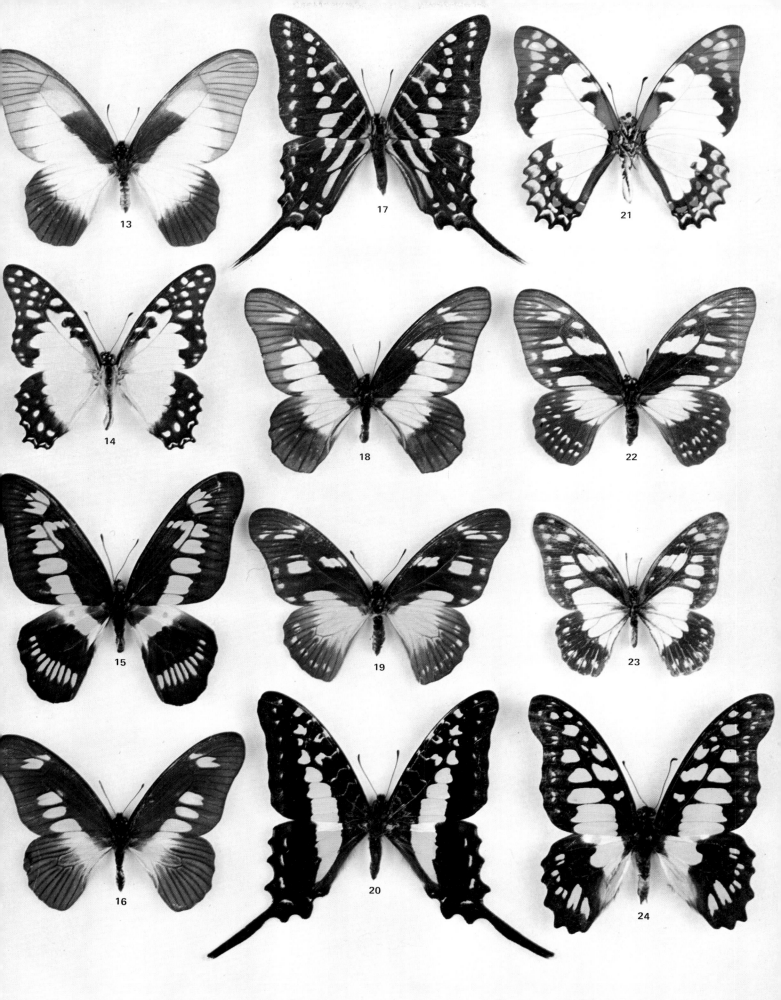

13 *hachei* Dew. (Cong.)
14 *pylades* Fab. (Cam.)
15 *latreillianus* Godt.s.sp.theorini Auriv. (Ugan.)
16 *ucalegonides* Stgr. (Cong.)
17 *polistratus* G.-Smith (S. Af.)

18 *odin Strand* (C.A.R.)
19 *almansor* Hon.s.sp.uganda Lathy ♀. (Ugan.)
20 *gudenusi* Rebel (Ugan.)
21 *endochus* Bsdv. V. (Madgr.)
22 *adamastor* Bsdv. ♀. (C.A.R.)

23 *philonoe* Ward. (Ken.)
24 *tynderaeus* Fab. (Cong.)

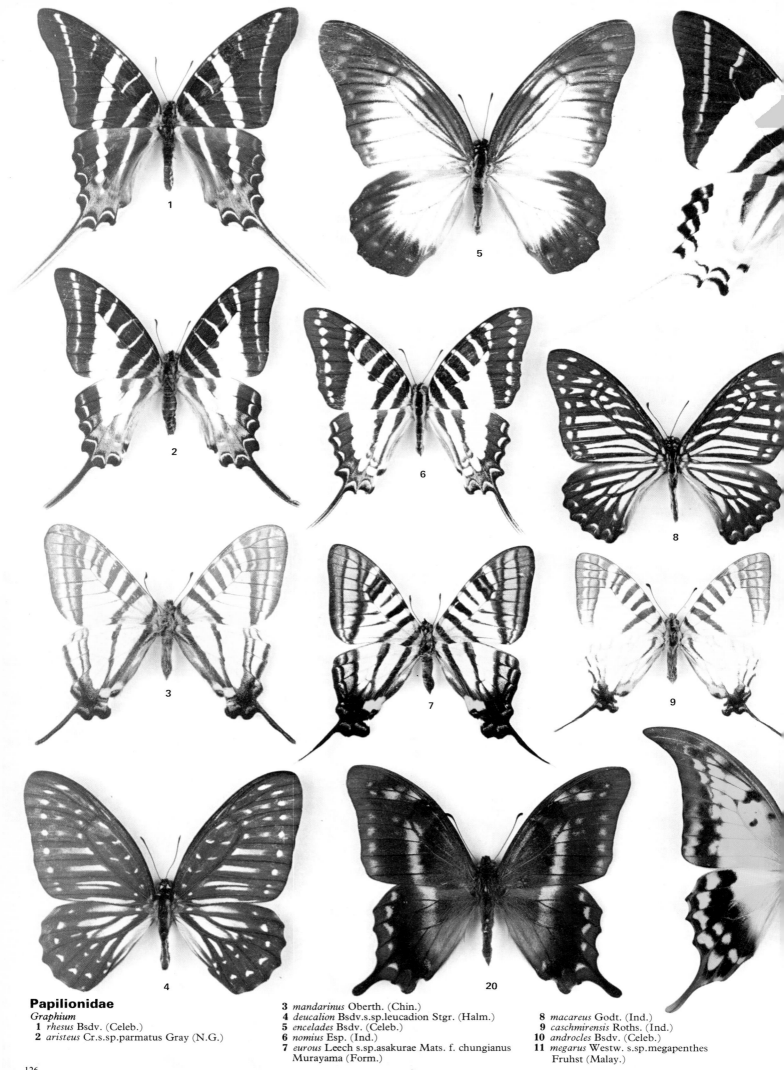

Papilionidae
Graphium
1 *rhesus* Bsdv. (Celeb.)
2 *aristeus* Cr.s.sp.parmatus Gray (N.G.)

3 *mandarinus* Oberth. (Chin.)
4 *deucalion* Bsdv.s.sp.leucadion Stgr. (Halm.)
5 *encelades* Bsdv. (Celeb.)
6 *nomius* Esp. (Ind.)
7 *eurous* Leech s.sp.asakurae Mats. f. chungianus Murayama (Form.)

8 *macareus* Godt. (Ind.)
9 *caschmirensis* Roths. (Ind.)
10 *androcles* Bsdv. (Celeb.)
11 *megarus* Westw. s.sp.megapenthes Fruhst (Malay.)

126

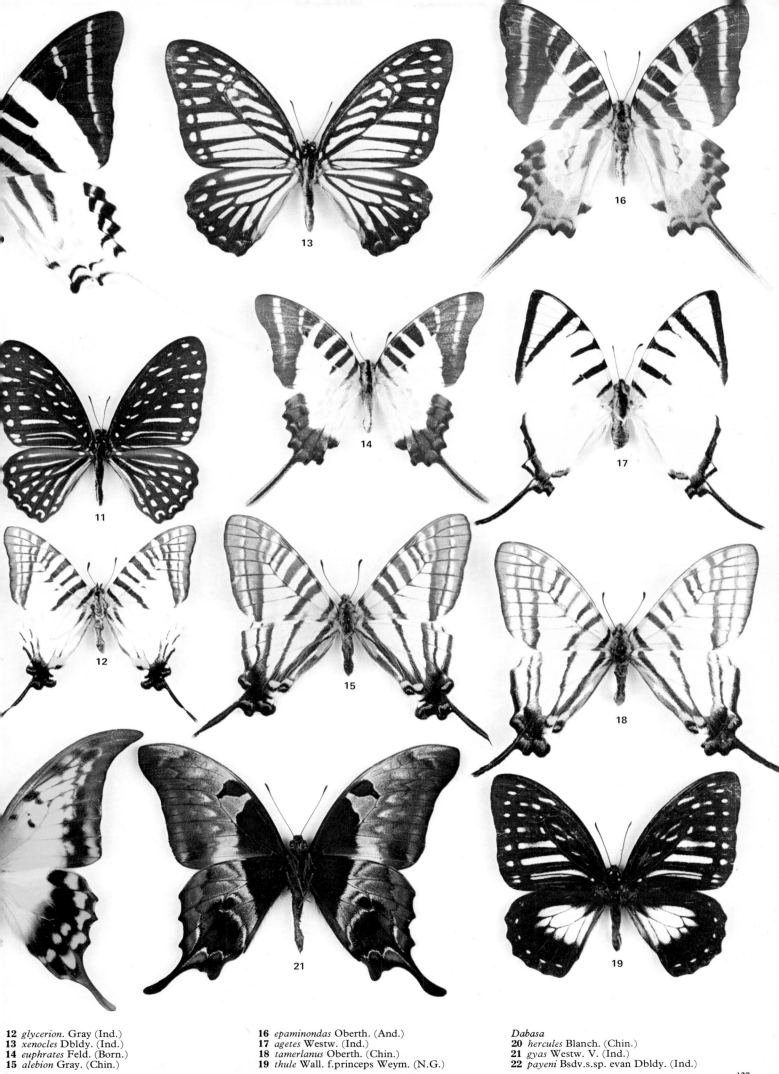

12 *glycerion*. Gray (Ind.)
13 *xenocles* Dbldy. (Ind.)
14 *euphrates* Feld. (Born.)
15 *alebion* Gray. (Chin.)

16 *epaminondas* Oberth. (And.)
17 *agetes* Westw. (Ind.)
18 *tamerlanus* Oberth. (Chin.)
19 *thule* Wall. f.princeps Weym. (N.G.)

Dabasa
20 *hercules* Blanch. (Chin.)
21 *gyas* Westw. V. (Ind.)
22 *payeni* Bsdv.s.sp. evan Dbldy. (Ind.)

127

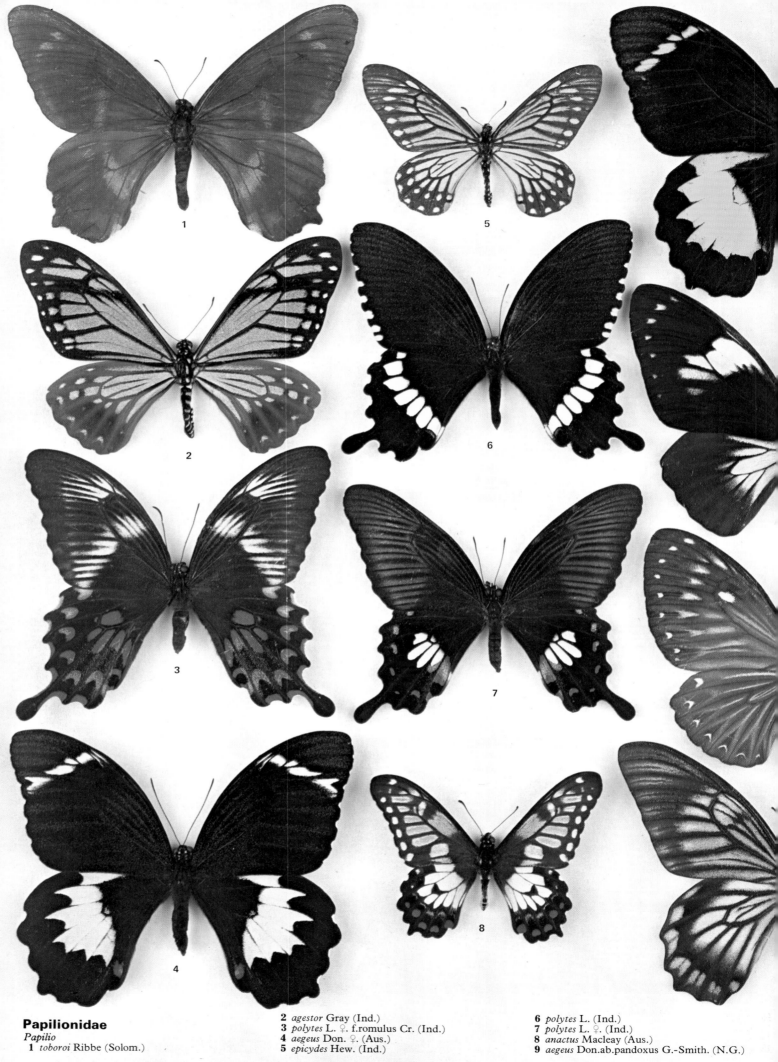

Papilionidae
Papilio
1 *toboroi* Ribbe (Solom.)

2 *agestor* Gray (Ind.)
3 *polytes* L. ♀. f.romulus Cr. (Ind.)
4 *aegeus* Don. ♀. (Aus.)
5 *epicydes* Hew. (Ind.)

6 *polytes* L. (Ind.)
7 *polytes* L. ♀. (Ind.)
8 *anactus* Macleay (Aus.)
9 *aegeus* Don.ab.pandoxus G.-Smith. (N.G.)

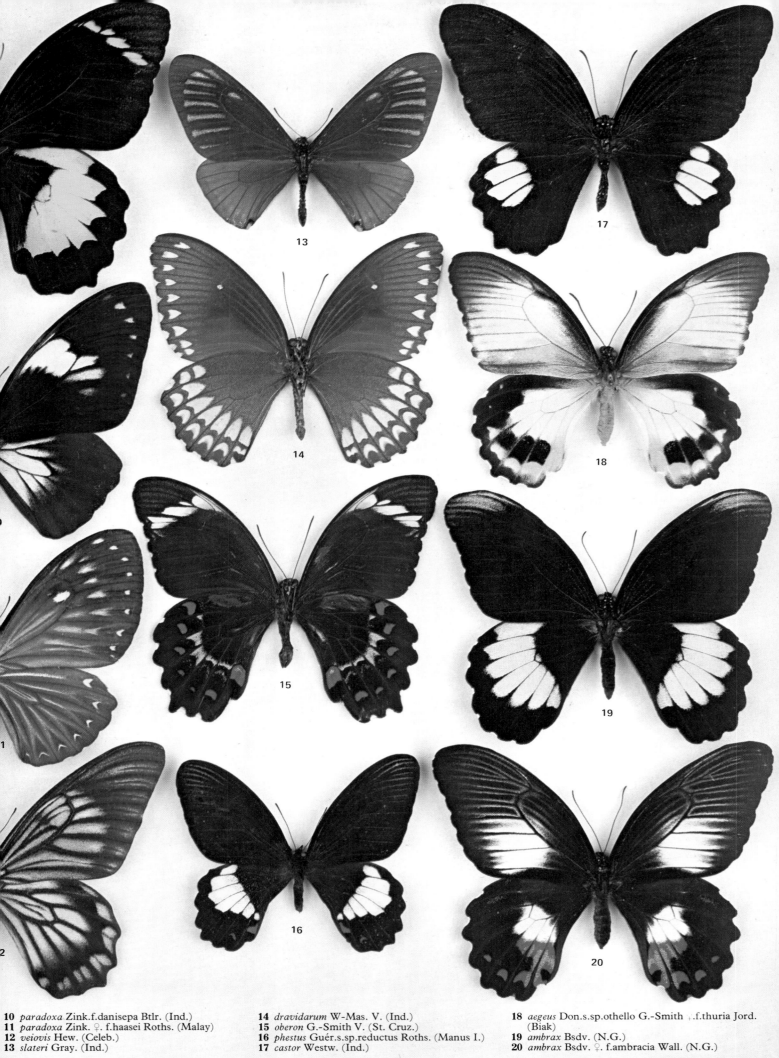

10 *paradoxa* Zink.f.danisepa Btlr. (Ind.)
11 *paradoxa* Zink. ♀. f.haasei Roths. (Malay)
12 *veiovis* Hew. (Celeb.)
13 *slateri* Gray. (Ind.)

14 *dravidarum* W-Mas. V. (Ind.)
15 *oberon* G.-Smith V. (St. Cruz.)
16 *phestus* Guér.s.sp.reductus Roths. (Manus I.)
17 *castor* Westw. (Ind.)

18 *aegeus* Don.s.sp.othello G.-Smith ♀.f.thuria Jord. (Biak)
19 *ambrax* Bsdv. (N.G.)
20 *ambrax* Bsdv. ♀. f.ambracia Wall. (N.G.)

129

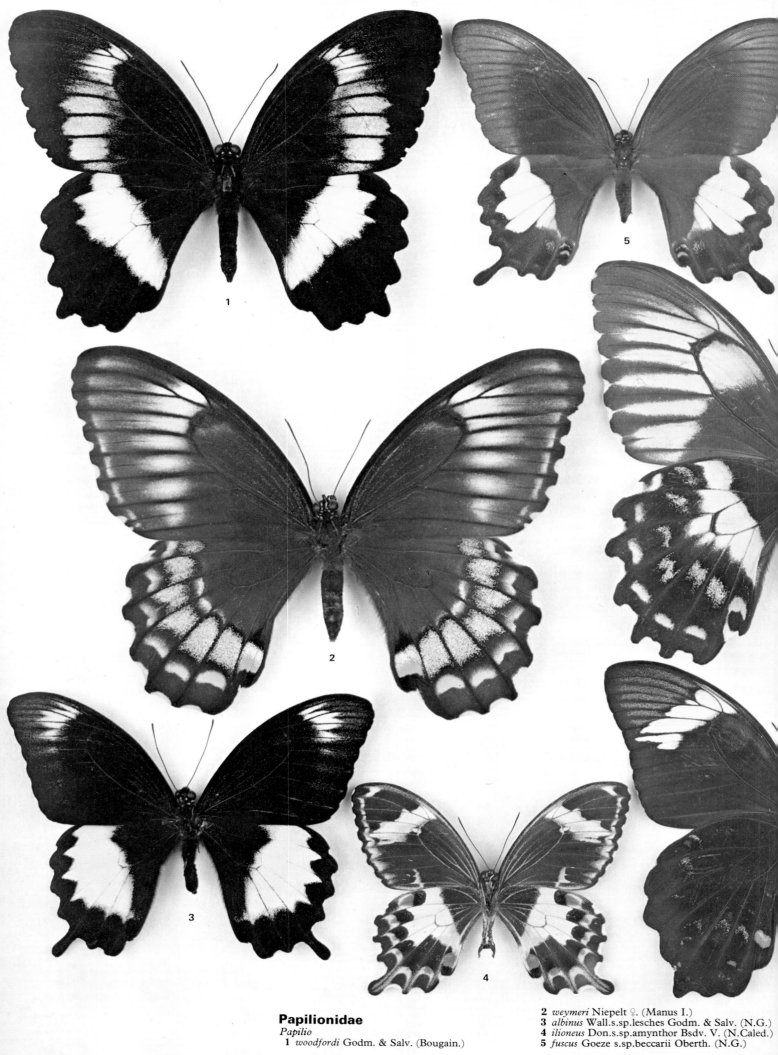

Papilionidae
Papilio
1 *woodfordi* Godm. & Salv. (Bougain.)

2 *weymeri* Niepelt ♀. (Manus I.)
3 *albinus* Wall.s.sp.lesches Godm. & Salv. (N.G.)
4 *ilioneus* Don.s.sp.amynthor Bsdv. V. (N.Caled.)
5 *fuscus* Goeze s.sp.beccarii Oberth. (N.G.)

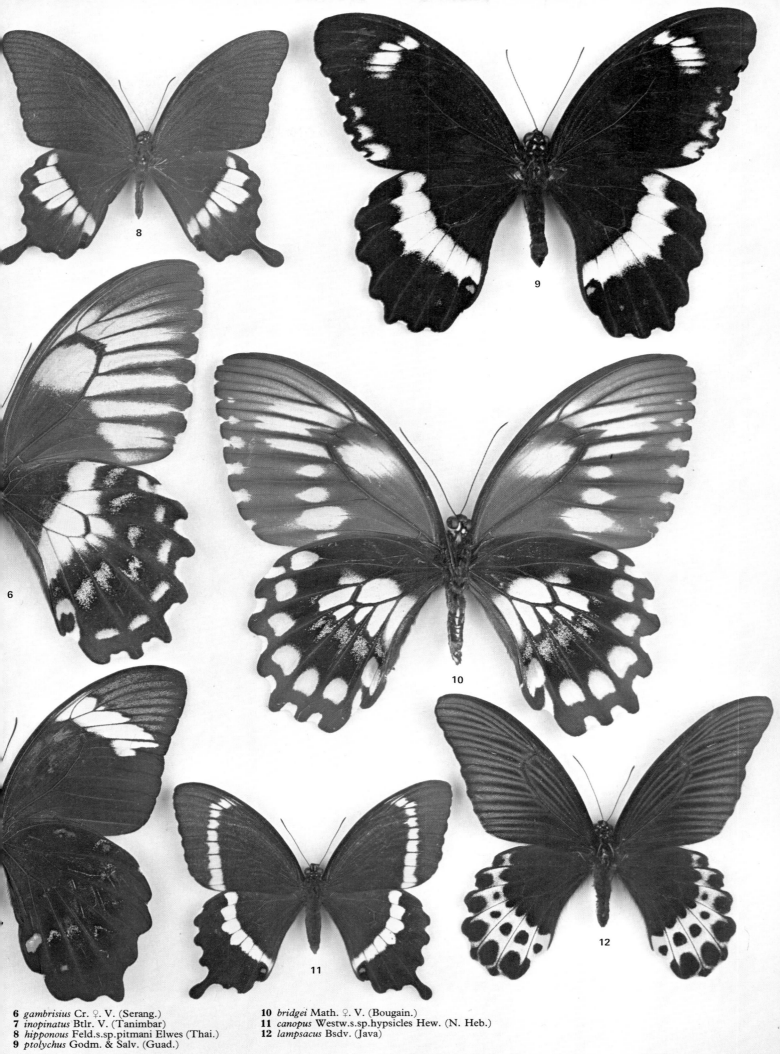

6 *gambrisius* Cr. ♀. V. (Serang.)
7 *inopinatus* Btlr. V. (Tanimbar)
8 *hipponous* Feld.s.sp.pitmani Elwes (Thai.)
9 *ptolychus* Godm. & Salv. (Guad.)

10 *bridgei* Math. ♀. V. (Bougain.)
11 *canopus* Westw.s.sp.hypsicles Hew. (N. Heb.)
12 *lampsacus* Bsdv. (Java)

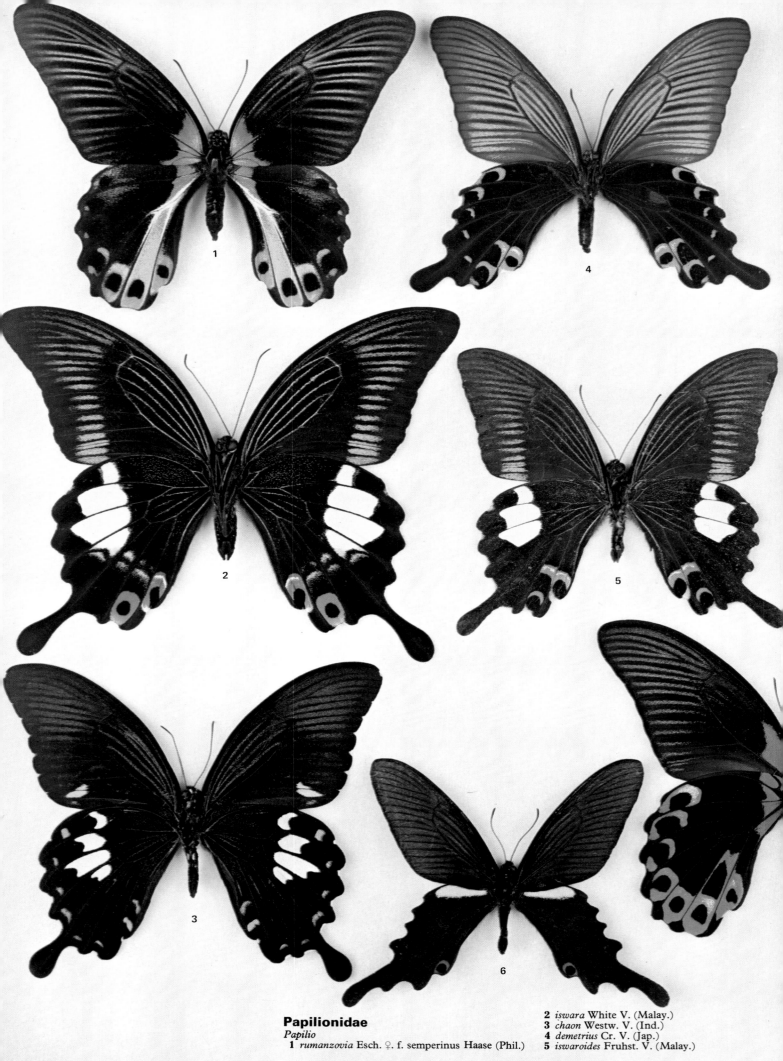

Papilionidae
Papilio
1 *rumanzovia* Esch. ♀. f. semperinus Haase (Phil.)

2 *iswara* White V. (Malay.)
3 *chaon* Westw. V. (Ind.)
4 *demetrius* Cr. V. (Jap.)
5 *iswaroides* Fruhst. V. (Malay.)

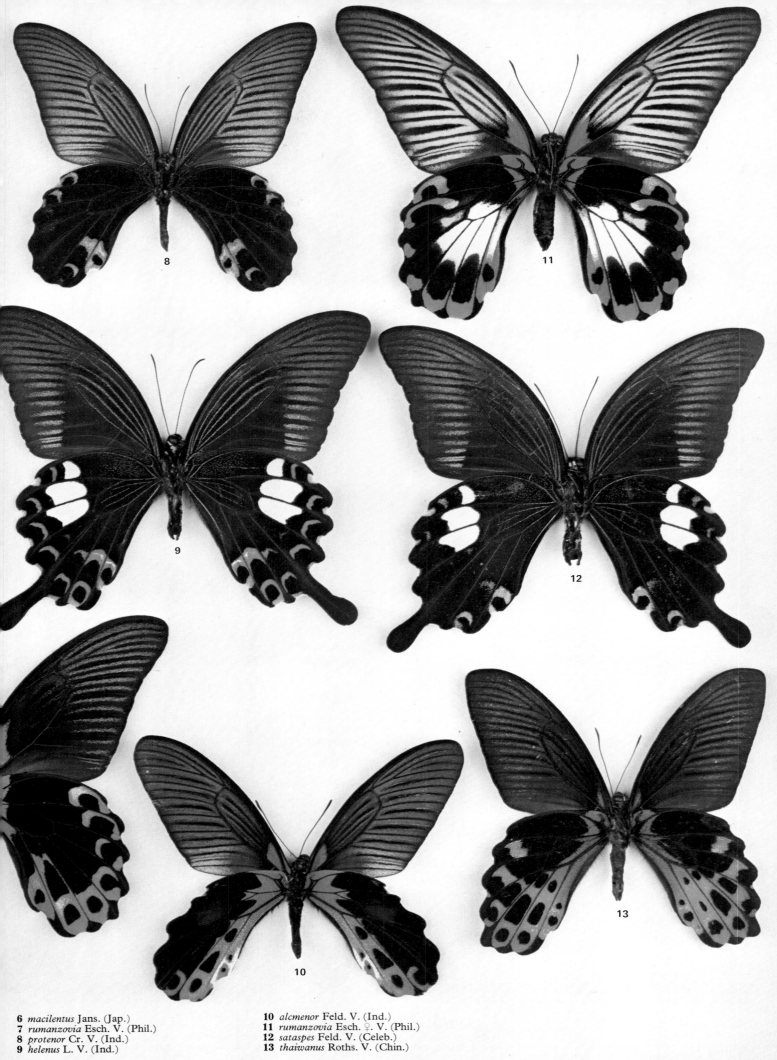

6 *macilentus* Jans. (Jap.)
7 *rumanzovia* Esch. V. (Phil.)
8 *protenor* Cr. V. (Ind.)
9 *helenus* L. V. (Ind.)

10 *alcmenor* Feld. V. (Ind.)
11 *rumanzovia* Esch. ♀. V. (Phil.)
12 *sataspes* Feld. V. (Celeb.)
13 *thaiwanus* Roths. V. (Chin.)

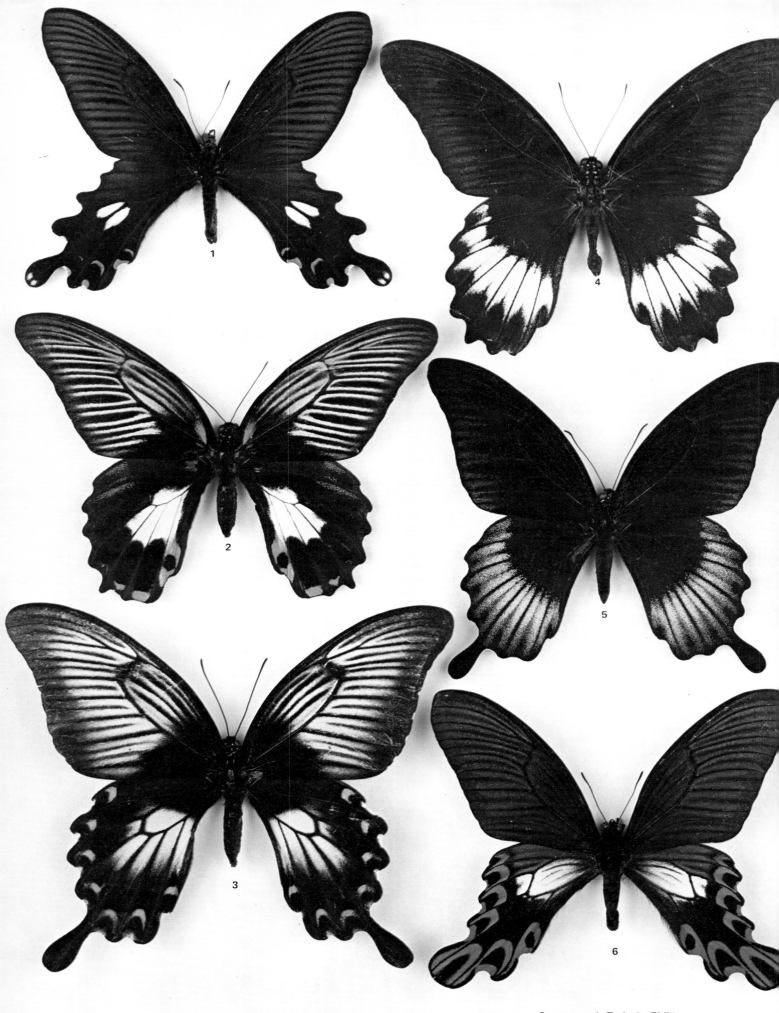

Papilionidae
Papilio
 1 *bootes* Westw. (Ind.)

2 *rumanzovia* Esch. ♀. (Phil.)
3 *ascalaphus* Bsdv. ♀. (Celeb.)
4 *mayo* Atk. (Andam.)
5 *lowi* Druce (Palawan)

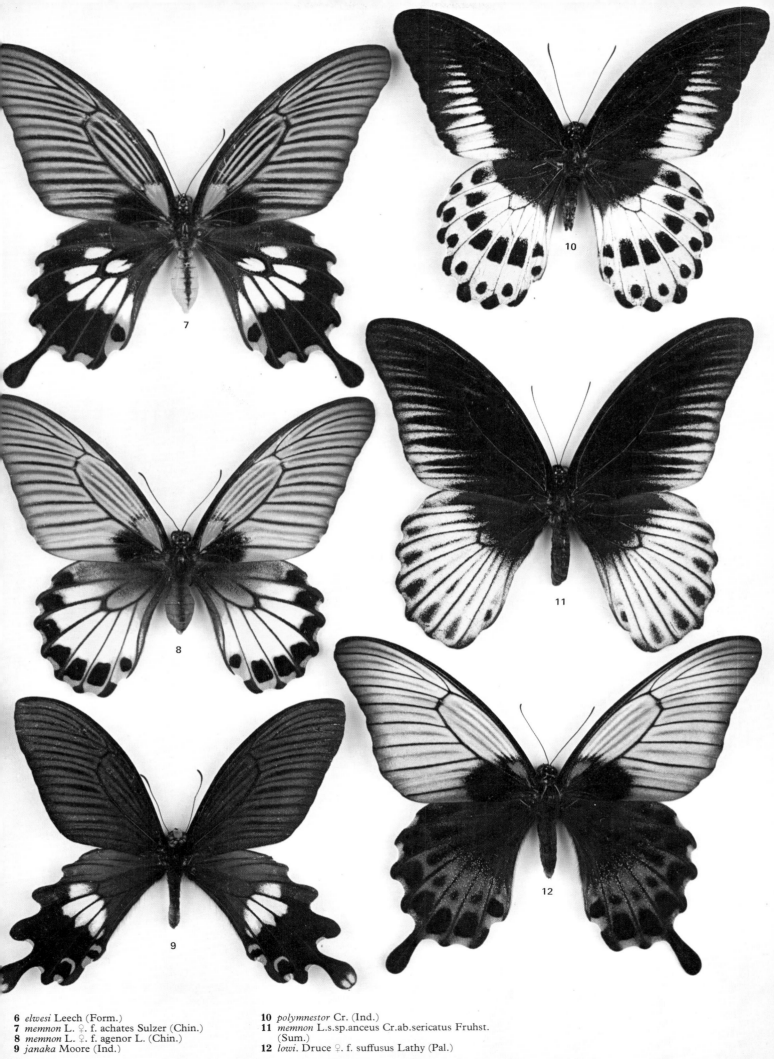

6 *elwesi* Leech (Form.)
7 *memnon* L. ♀. f. achates Sulzer (Chin.)
8 *memnon* L. ♀. f. agenor L. (Chin.)
9 *janaka* Moore (Ind.)

10 *polymnestor* Cr. (Ind.)
11 *memnon* L.s.sp.anceus Cr.ab.sericatus Fruhst. (Sum.)
12 *lowi*. Druce ♀. f. suffusus Lathy (Pal.)

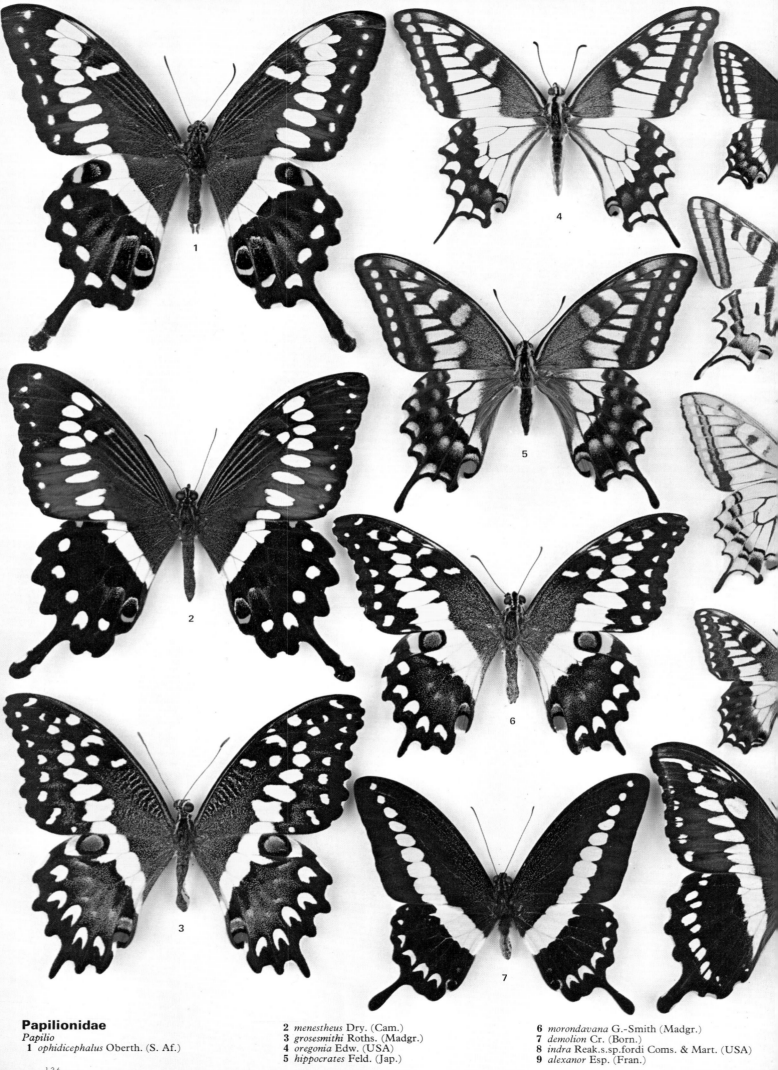

Papilionidae
Papilio
1 *ophidicephalus* Oberth. (S. Af.)

2 *menestheus* Dry. (Cam.)
3 *grosesmithi* Roths. (Madgr.)
4 *oregonia* Edw. (USA)
5 *hippocrates* Feld. (Jap.)

6 *morondavana* G.-Smith (Madgr.)
7 *demolion* Cr. (Born.)
8 *indra* Reak.s.sp.fordi Coms. & Mart. (USA)
9 *alexanor* Esp. (Fran.)

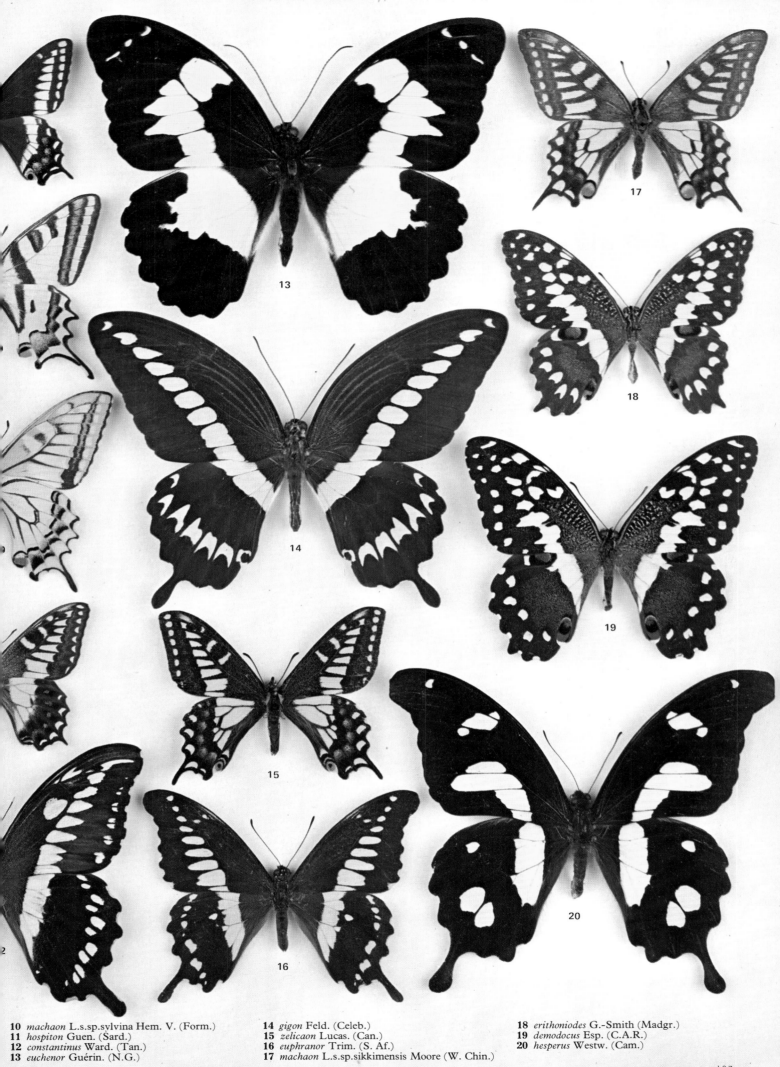

10 *machaon* L.s.sp.sylvina Hem. V. (Form.)
11 *hospiton* Guen. (Sard.)
12 *constantinus* Ward. (Tan.)
13 *euchenor* Guérin. (N.G.)

14 *gigon* Feld. (Celeb.)
15 *zelicaon* Lucas. (Can.)
16 *euphranor* Trim. (S. Af.)
17 *machaon* L.s.sp.sikkimensis Moore (W. Chin.)

18 *erithoniodes* G.-Smith (Madgr.)
19 *demodocus* Esp. (C.A.R.)
20 *hesperus* Westw. (Cam.)

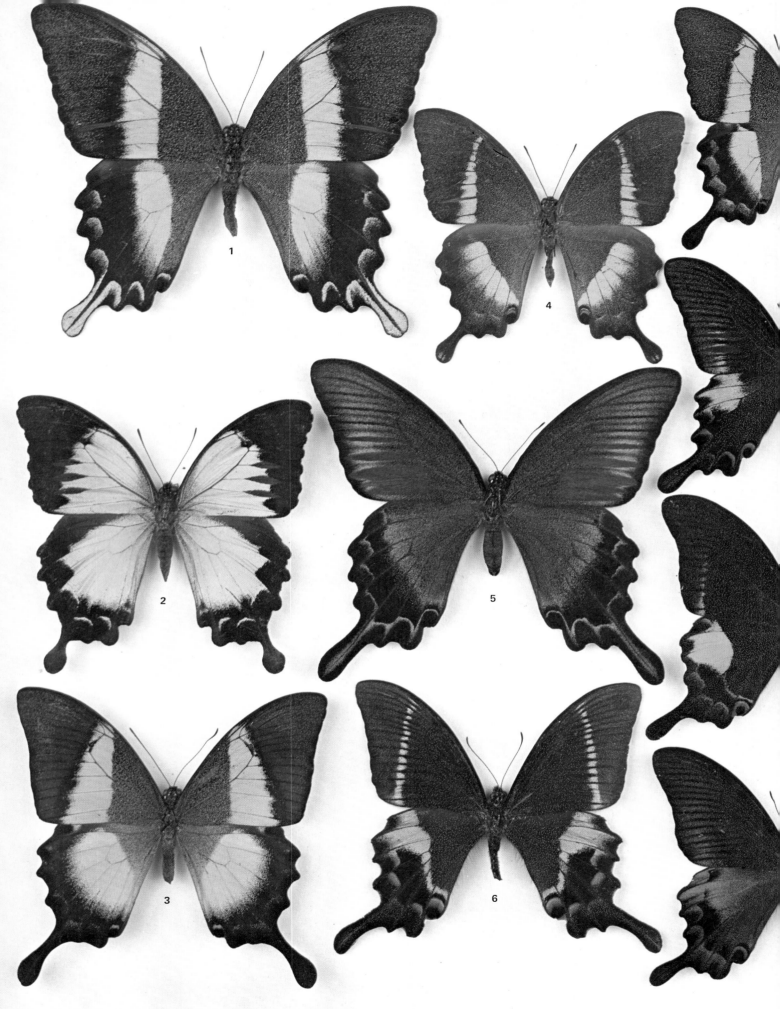

Papilionidae
Papilio
1 *blumei* Bsdv. (Celeb.)
2 *montrouzieri* Bsdv.f.ulyssellus Westw. (New. Cal.)
3 *buddha* Westw. (Ind.)
4 *crino* Fab. (Sri Lank.)
5 *bianor* Cr.s.sp.dehaani Feld. (Jap.)
6 *krishna* Moore (Ind.)

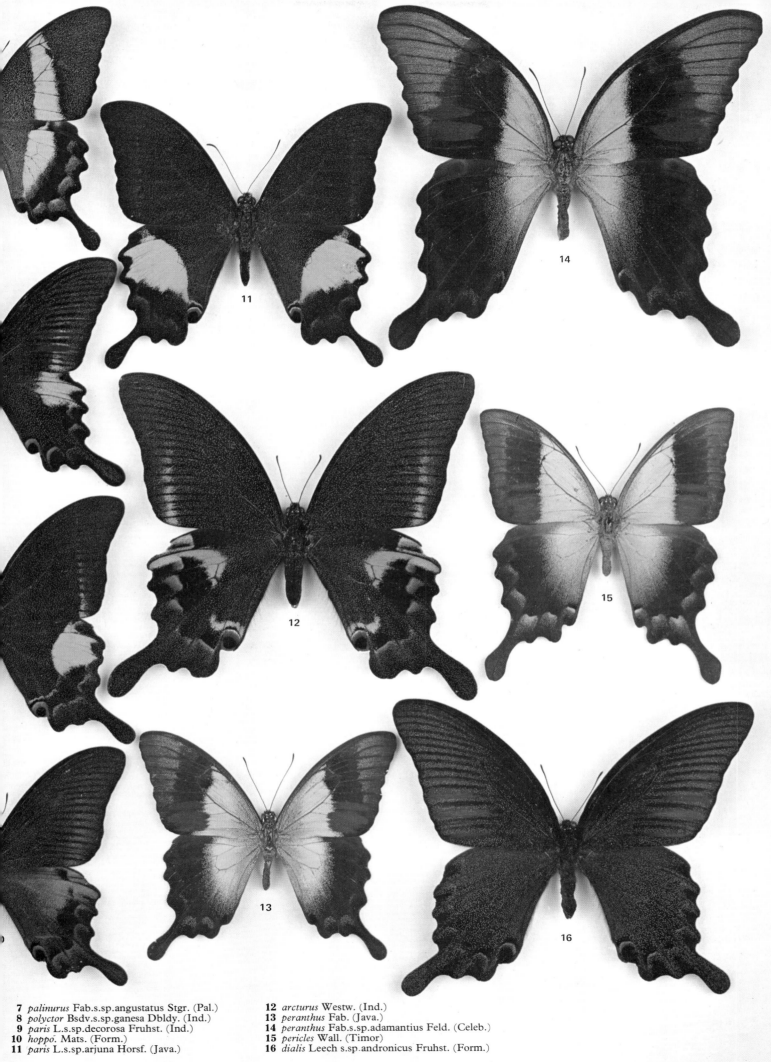

7 *palinurus* Fab.s.sp.angustatus Stgr. (Pal.)
8 *polyctor* Bsdv.s.sp.ganesa Dbldy. (Ind.)
9 *paris* L.s.sp.decorosa Fruhst. (Ind.)
10 *hoppo*. Mats. (Form.)
11 *paris* L.s.sp.arjuna Horsf. (Java.)

12 *arcturus* Westw. (Ind.)
13 *peranthus* Fab. (Java.)
14 *peranthus* Fab.s.sp.adamantius Feld. (Celeb.)
15 *pericles* Wall. (Timor)
16 *dialis* Leech s.sp.andronicus Fruhst. (Form.)

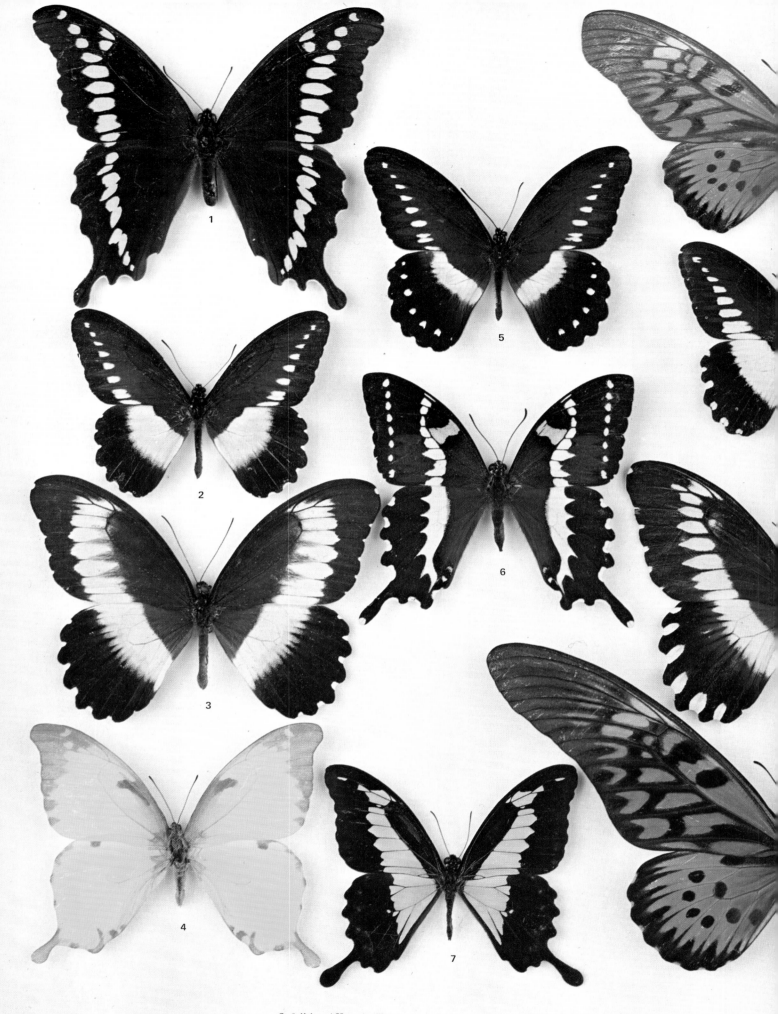

Papilionidae
Papilio
1 *mackinnoni* Sharpe (Ken.)

2 *fulleborni* Karsch (Tan.)
3 *mechowianus* Dewitz (C.A.R.)
4 *nobilis* Rogen. (Ken.)
5 *jacksoni* Sharpe (Ugan.)

6 *delalandii* Godt. (Madgr.)
7 *phorcas* Cr. (C.A.R.)
8 *echerioides* Trim. (Tan.)
9 *zenobius* Godt. ♀. (C.A.R.)

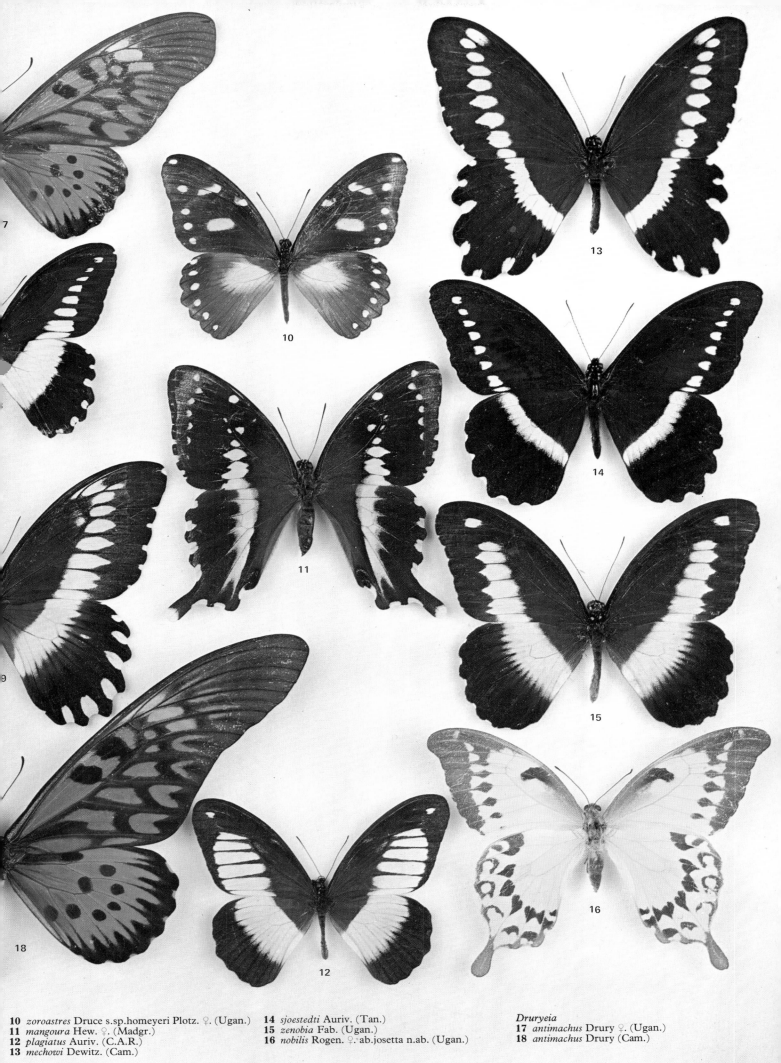

10 *zoroastres* Druce s.sp.homeyeri Plotz. ♀. (Ugan.)
11 *mangoura* Hew. ♀. (Madgr.)
12 *plagiatus* Auriv. (C.A.R.)
13 *mechowi* Dewitz. (Cam.)

14 *sjoestedti* Auriv. (Tan.)
15 *zenobia* Fab. (Ugan.)
16 *nobilis* Rogen. ♀. ab.josetta n.ab. (Ugan.)

Druryeia
17 *antimachus* Drury ♀. (Ugan.)
18 *antimachus* Drury (Cam.)

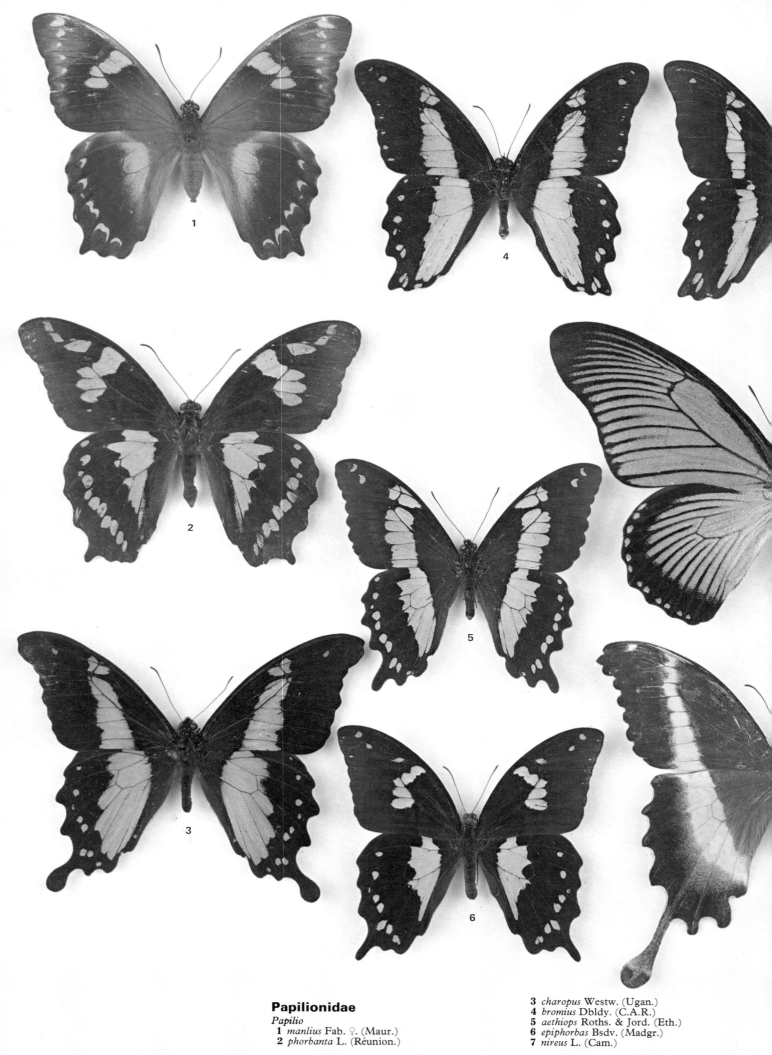

Papilionidae
Papilio
1 *manlius* Fab. ♀. (Maur.)
2 *phorbanta* L. (Réunion.)

3 *charopus* Westw. (Ugan.)
4 *bromius* Dbldy. (C.A.R.)
5 *aethiops* Roths. & Jord. (Eth.)
6 *epiphorbas* Bsdv. (Madgr.)
7 *nireus* L. (Cam.)

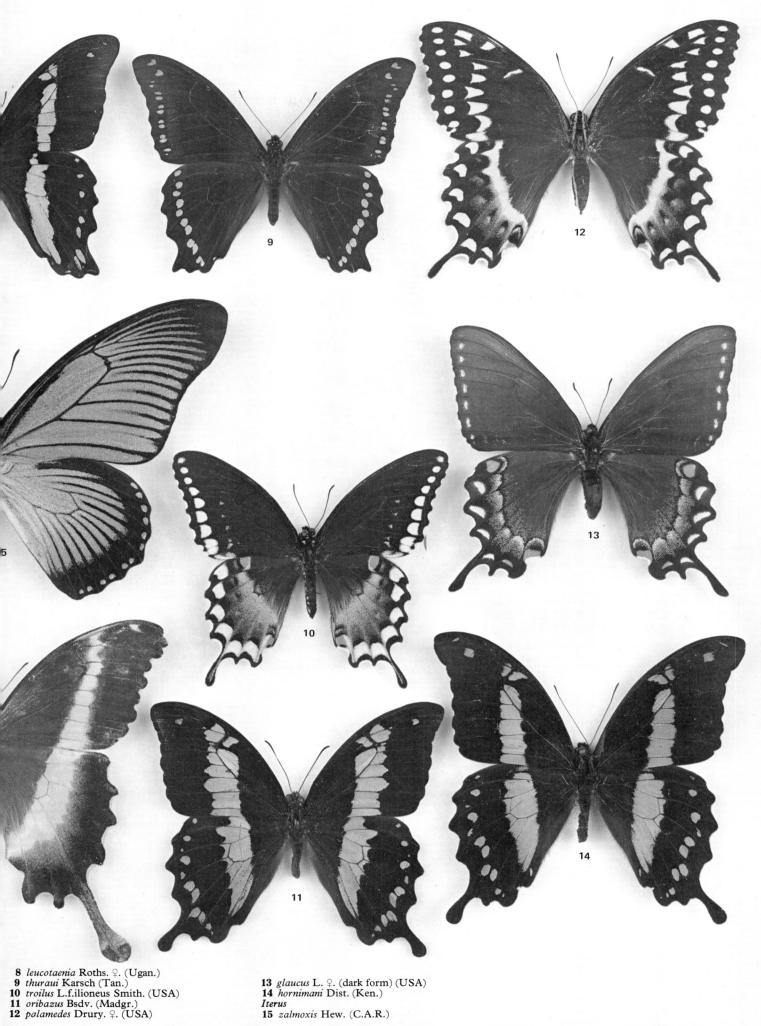

8 *leucotaenia* Roths. ♀. (Ugan.)
9 *thuraui* Karsch (Tan.)
10 *troilus* L.f.ilioneus Smith. (USA)
11 *oribazus* Bsdv. (Madgr.)
12 *palamedes* Drury. ♀. (USA)

13 *glaucus* L. ♀. (dark form) (USA)
14 *hornimani* Dist. (Ken.)
Iterus
15 *zalmoxis* Hew. (C.A.R.)

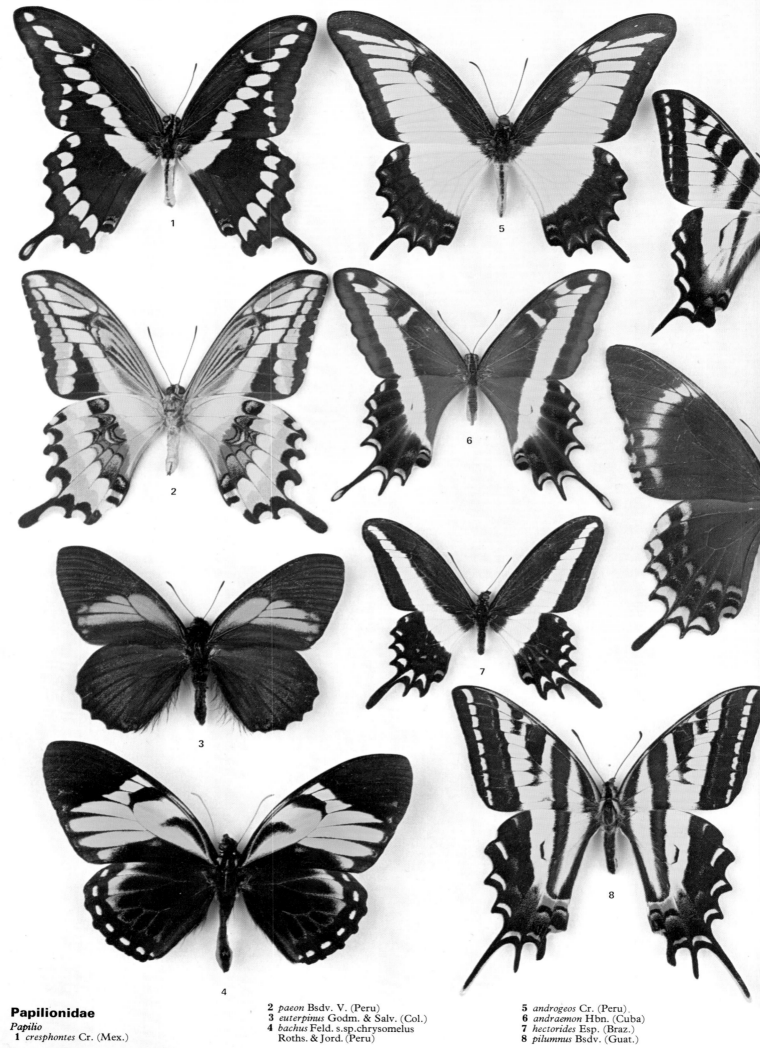

Papilionidae

Papilio
1 *cresphontes* Cr. (Mex.)

2 *paeon* Bsdv. V. (Peru)
3 *euterpinus* Godm. & Salv. (Col.)
4 *bachus* Feld. s.sp.chrysomelus
Roths. & Jord. (Peru)

5 *androgeos* Cr. (Peru)
6 *andraemon* Hbn. (Cuba)
7 *hectorides* Esp. (Braz.)
8 *pilumnus* Bsdv. (Guat.)

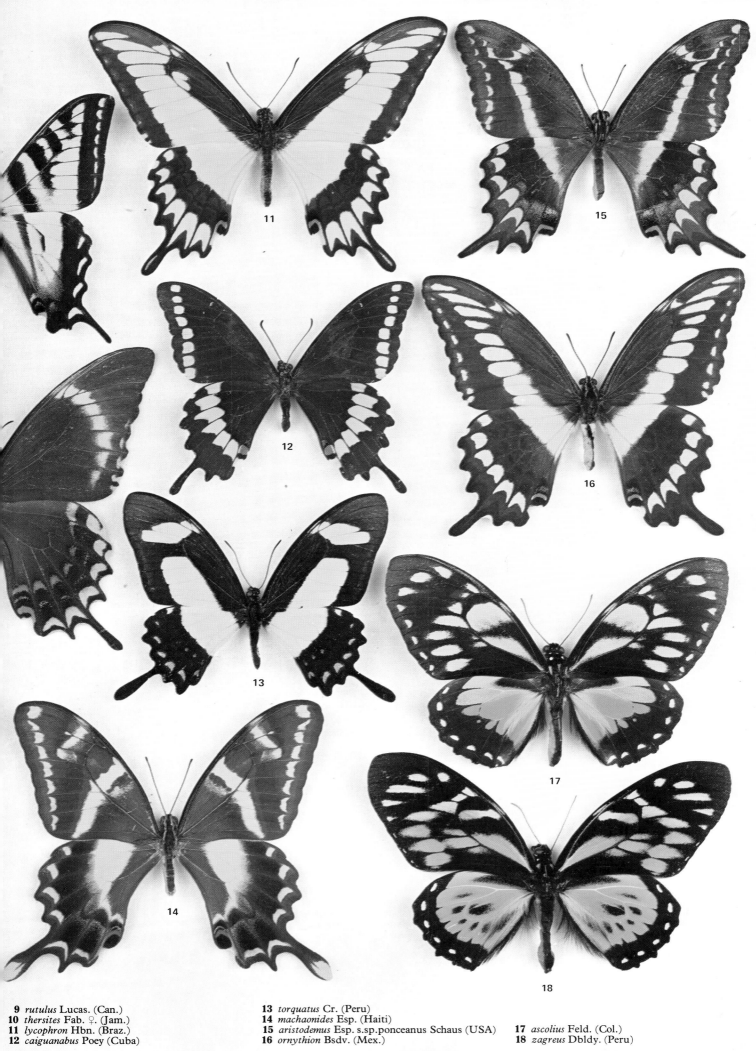

9 *rutulus* Lucas. (Can.)
10 *thersites* Fab. ♀. (Jam.)
11 *lycophron* Hbn. (Braz.)
12 *caiguanabus* Poey (Cuba)

13 *torquatus* Cr. (Peru)
14 *machaonides* Esp. (Haiti)
15 *aristodemus* Esp. s.sp.ponceanus Schaus (USA)
16 *ornythion* Bsdv. (Mex.)

17 *ascolius* Feld. (Col.)
18 *zagreus* Dbldy. (Peru)

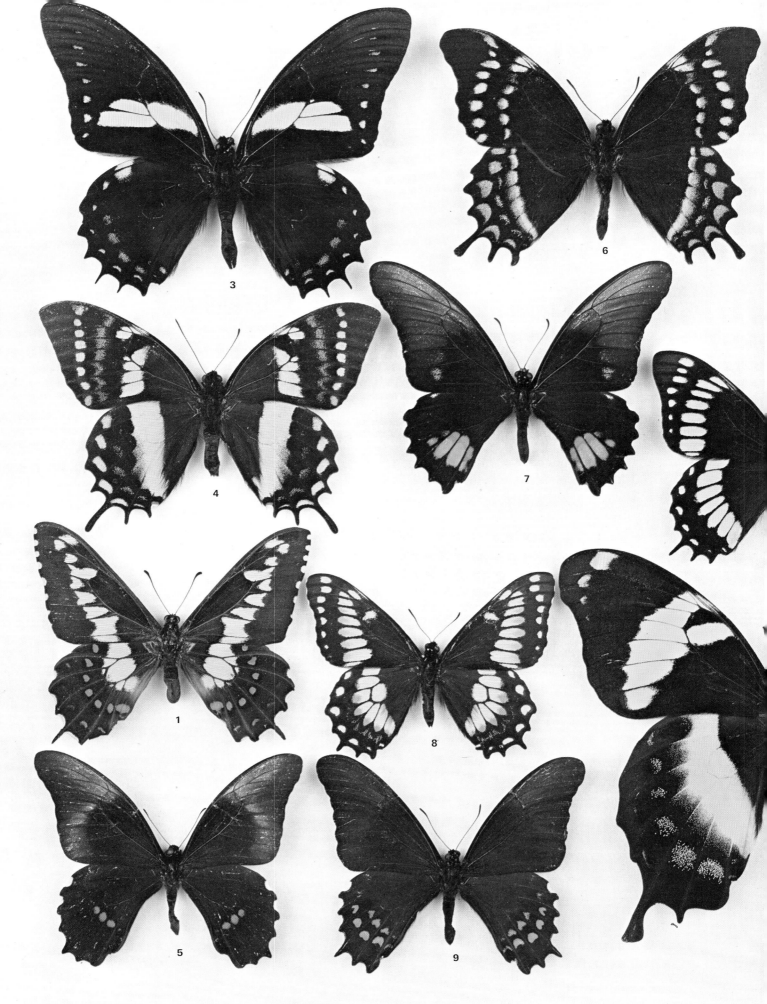

Papilionidae

Euryades
1 *duponchelii* Lucas (Argent.)

2 *corethrus* Bsdv. (Braz.)
Papilio
3 *aristeus* Cr.s.sp.bitias Godt. (Peru)
4 *cacicus* Lucas (Peru)

5 *rogeri* Bsdv. (Hond.)
6 *warscewiczi* Hopff. s.sp. mercedes Roths. & Jord. (Peru)
7 *anchisiades* Esp. (Peru)

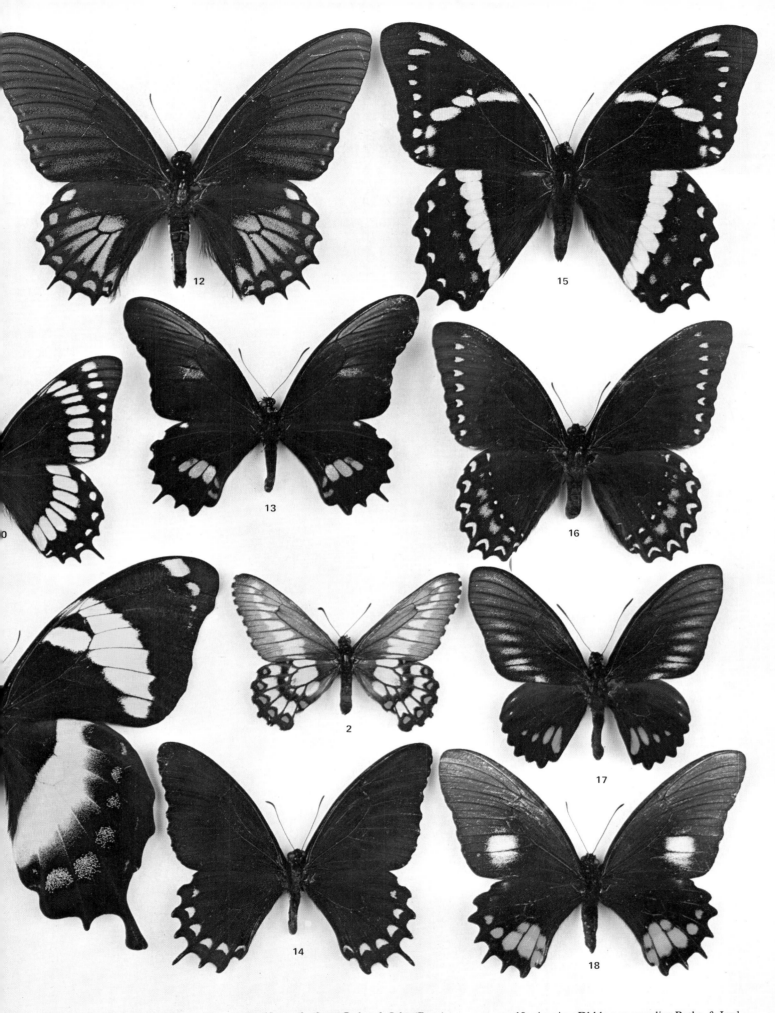

8 *hellanichus* Hew. (Urug.)
9 *pharnaces* Dbldy. (Mex.)
10 *scamander* Bsdv. (Braz.)
11 *homerus* Fab. (Jam.)

12 *xanthopleura* Godm. & Salv. (Braz.)
13 *isidorus* Dbldy. (Peru)
14 *erostratus* Westw. (Mex.)
15 *cleotas* Gray s.sp. phaeton Lucas (Col.)

16 *victorinus* Dbldy.s.sp.morelius Roths. & Jord. (Mex.)
17 *hyppason* Cr.(aberrant) (Peru)
18 *anchisiades* Esp. ♀. (Peru)

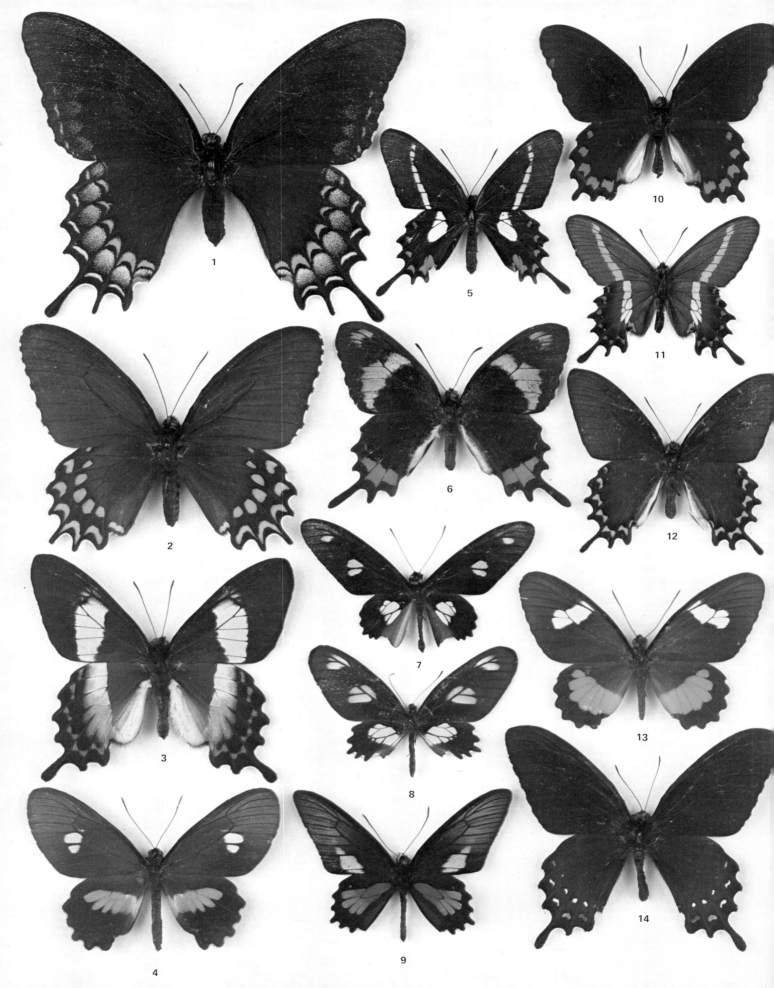

Papilionidae

Papilio
 1 *garamas* Hbn. ♀. (dark form) (Mex.)
Parides
 2 *photinus* Dbldy. ♀. (Mex.)

 3 *ascanius* Cr. (Braz.)
 4 *timias* Gray ♀. (Ecua.)
 5 *agavus* Drury (Braz.)
 6 *gundalachianus* Feld. (Cuba)
 7 *triopas* Godt. (Guy.)
 8 *triopas* Godt. ♀. (Guy.)

 9 *neophilus* Hbn.s.sp.olivencius Bates (Peru)
 10 *montezuma* Westw. (Mex.)
 11 *chamissonia* Esch. V. (Braz.)
 12 *perrhebus* Bsdv. (Braz.)
 13 *erithalion* Bsdv. ♀. (Col.)
 14 *alopius* Godm. & Salv. (Nicar.)

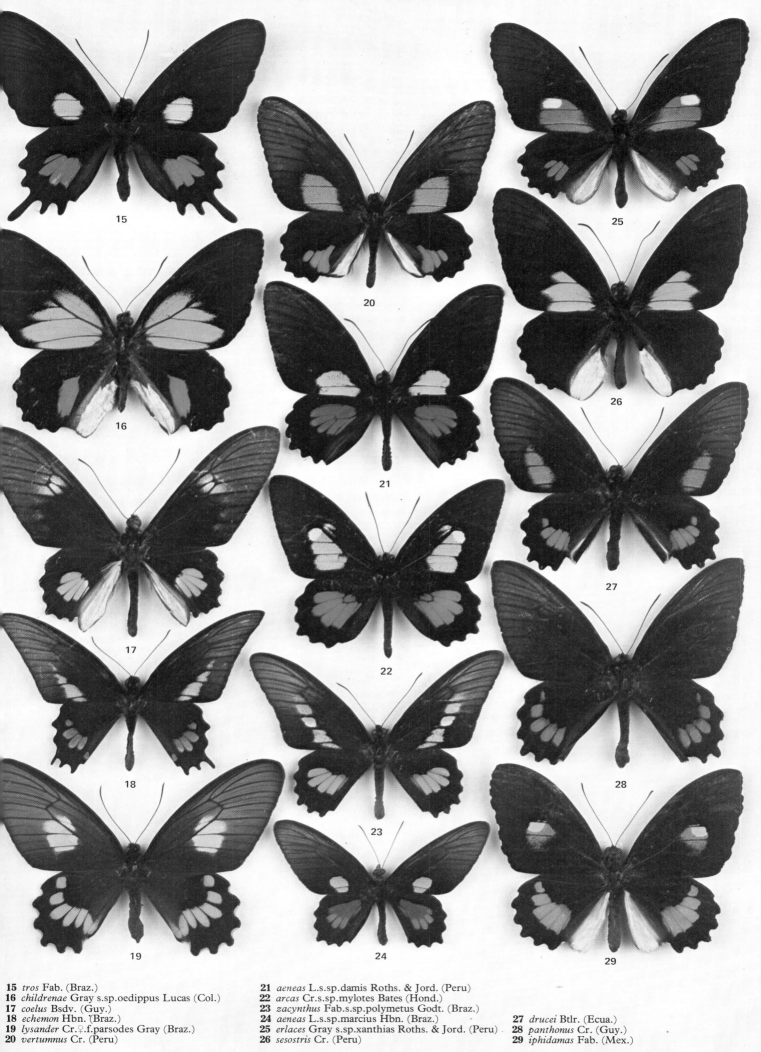

15 *tros* Fab. (Braz.)
16 *childrenae* Gray s.sp.oedippus Lucas (Col.)
17 *coelus* Bsdv. (Guy.)
18 *echemon* Hbn. (Braz.)
19 *lysander* Cr.♀.f.parsodes Gray (Braz.)
20 *vertumnus* Cr. (Peru)

21 *aeneas* L.s.sp.damis Roths. & Jord. (Peru)
22 *arcas* Cr.s.sp.mylotes Bates (Hond.)
23 *zacynthus* Fab.s.sp.polymetus Godt. (Braz.)
24 *aeneas* L.s.sp.marcius Hbn. (Braz.)
25 *erlaces* Gray s.sp.xanthias Roths. & Jord. (Peru)
26 *sesostris* Cr. (Peru)

27 *drucei* Btlr. (Ecua.)
28 *panthonus* Cr. (Guy.)
29 *iphidamas* Fab. (Mex.)

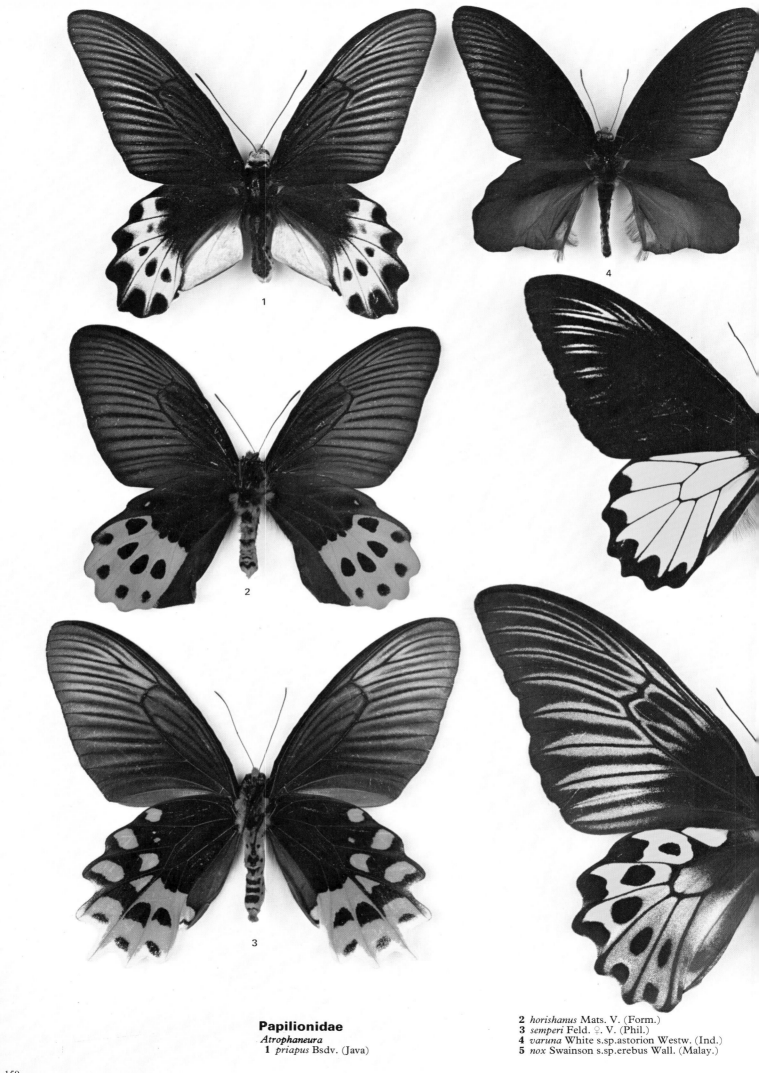

Papilionidae

Atrophaneura
1 *priapus* Bsdv. (Java)

2 *horishanus* Mats. V. (Form.)
3 *semperi* Feld. ♀. V. (Phil.)
4 *varuna* White s.sp.astorion Westw. (Ind.)
5 *nox* Swainson s.sp.erebus Wall. (Malay.)

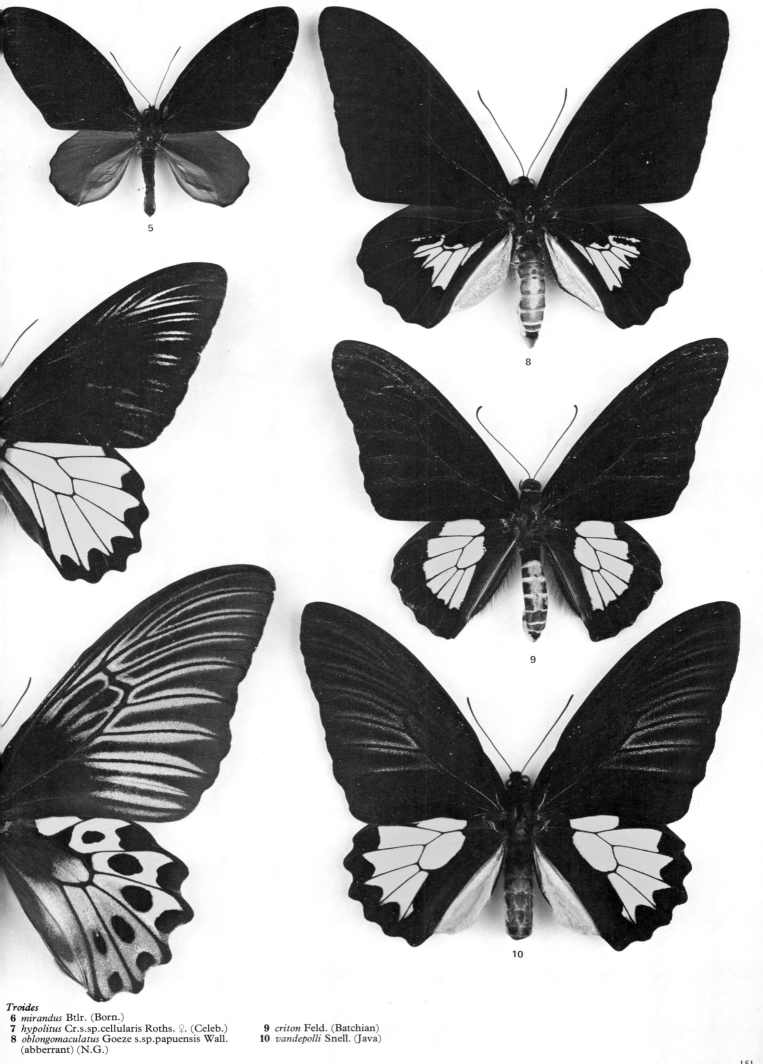

Troides
6 *mirandus* Btlr. (Born.)
7 *hypolitus* Cr.s.sp.cellularis Roths. ♀. (Celeb.)
8 *oblongomaculatus* Goeze s.sp.papuensis Wall.
 (abberrant) (N.G.)
9 *criton* Feld. (Batchian)
10 *vandepolli* Snell. (Java)

151

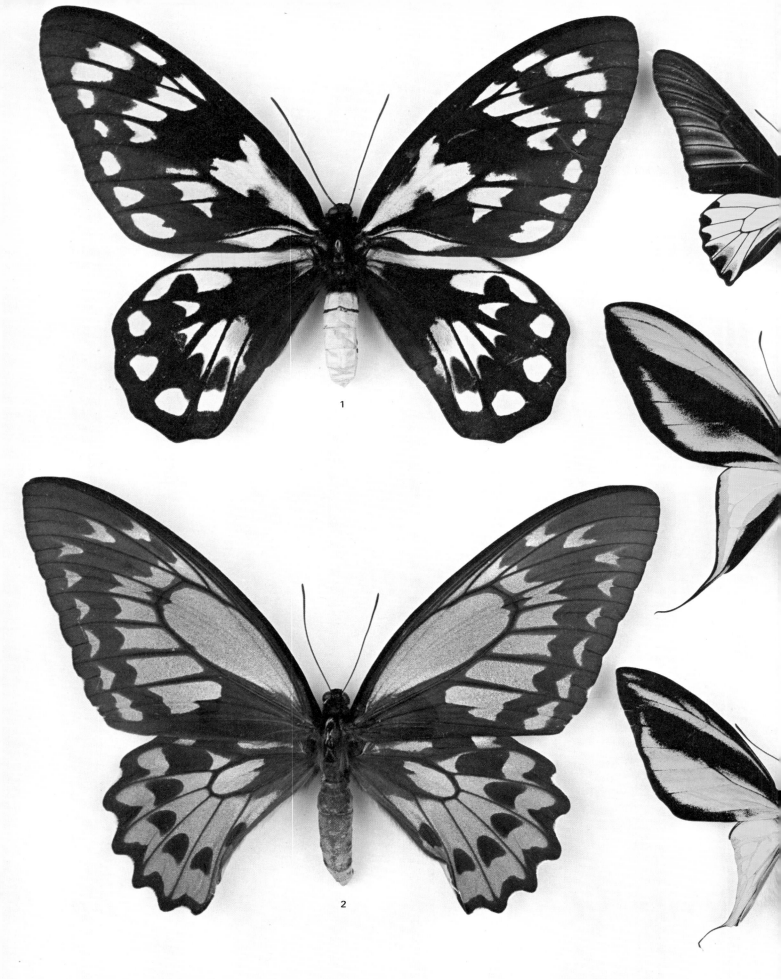

Papilionidae
Ornithoptera
1 *victoriae* Gray s.sp.epiphanes Schmid ♀. (San Cristoval)
2 *croesus* Wallace s.sp.lydius Feld. ♀. (Halmaheira)
3 *paradisea* Stgr. (N.G.)

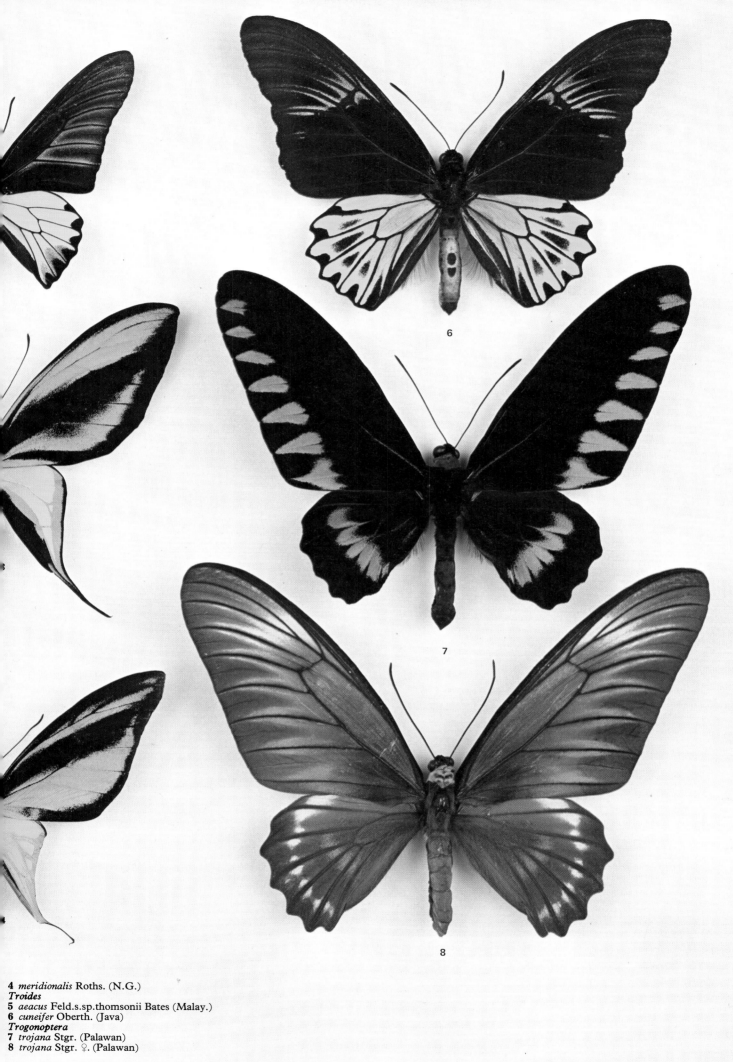

4 *meridionalis* Roths. (N.G.)
Troides
5 *aeacus* Feld.s.sp.thomsonii Bates (Malay.)
6 *cuneifer* Oberth. (Java)
Trogonoptera
7 *trojana* Stgr. (Palawan)
8 *trojana* Stgr. ♀. (Palawan)

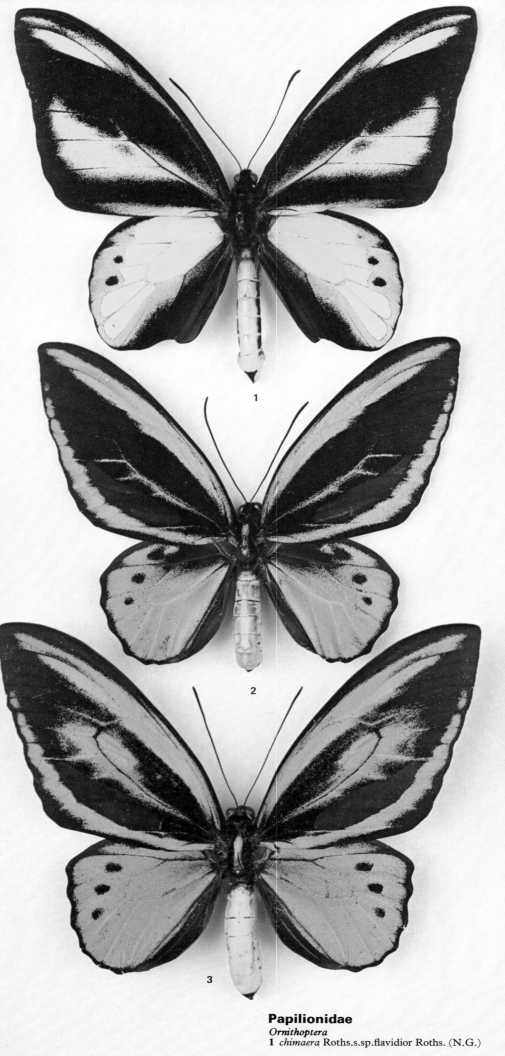
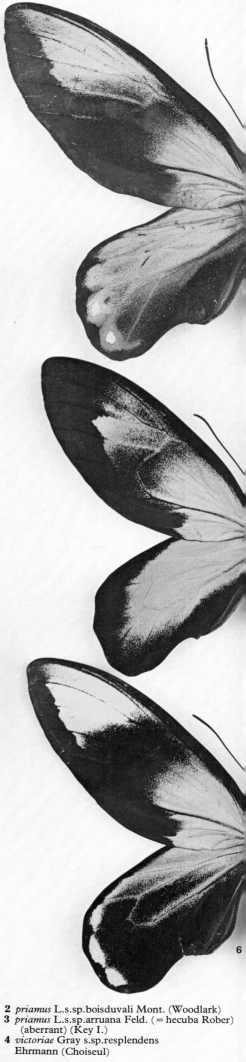

Papilionidae
Ornithoptera
1 *chimaera* Roths.s.sp.flavidior Roths. (N.G.)

2 *priamus* L.s.sp.boisduvali Mont. (Woodlark)
3 *priamus* L.s.sp.arruana Feld. (= hecuba Rober)
(aberrant) (Key I.)
4 *victoriae* Gray s.sp.resplendens
Ehrmann (Choiseul)

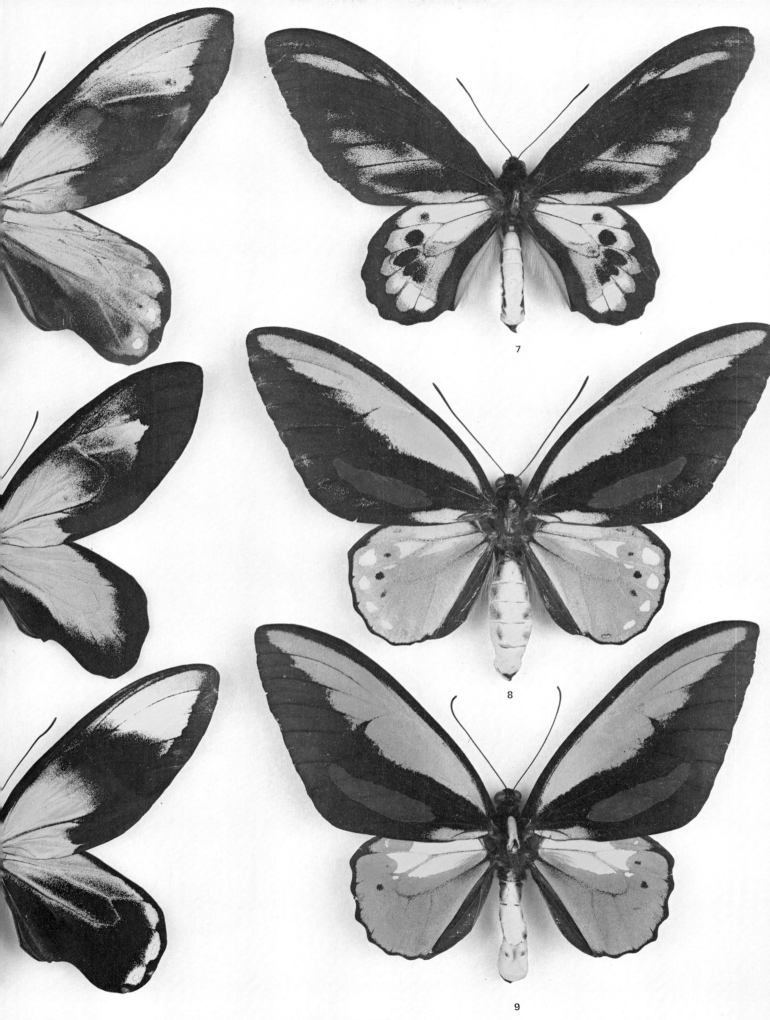

5 *victoriae* Gray s.sp.rubianus Roths. (aberrant)
 (Rubiana)
6 *victoriae* Gray s.sp.reginae Salvin (Malaita)

7 *rothschildi* Kenrick (N.G.)
8 *croesus* Wallace (Batchian)
9 *croesus* Wallace s.sp.lydius Feld. (Halmaheira)

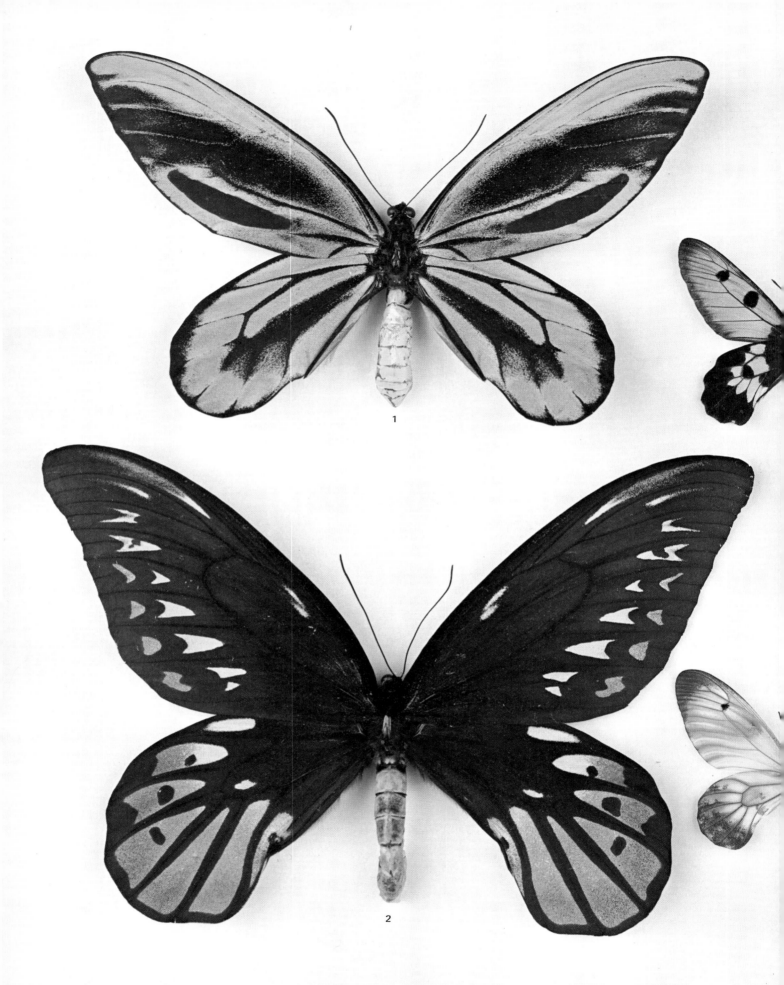

Papilionidae
Ornithoptera
1 *alexandrae* Roths. (N.G.)
2 *alexandrae* Roths. ♀. (N.G.)

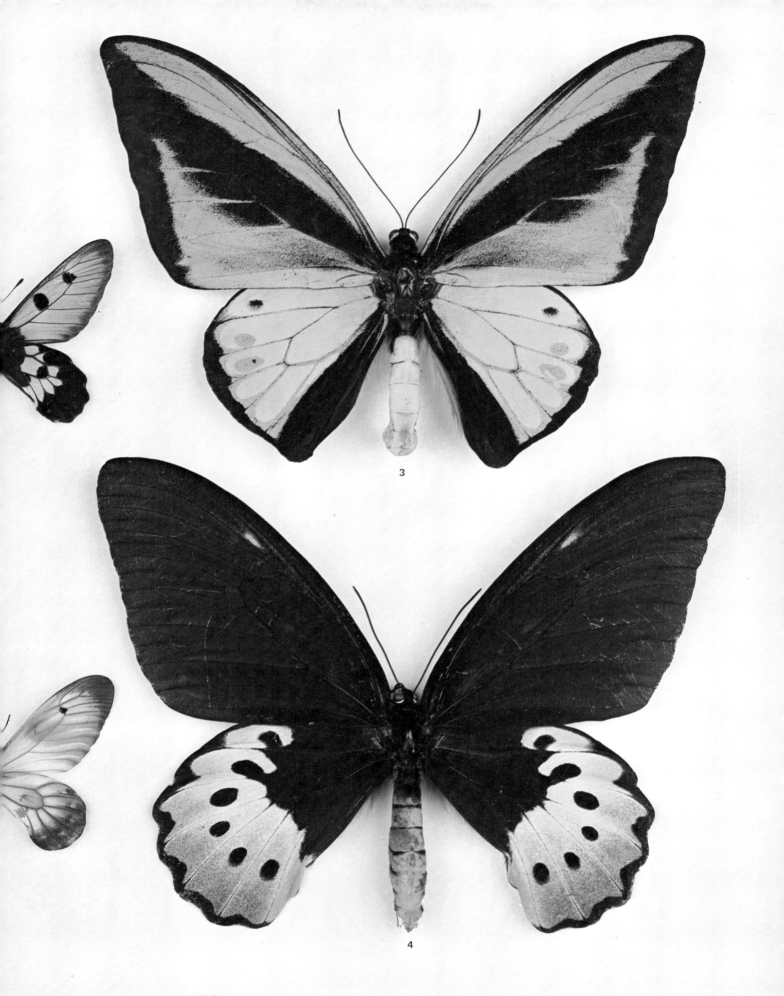

3 *goliath* Oberth.s.sp.supremus Rober (N.G.)
4 *goliath* Oberth.s.sp.titan G.-Smith ♀. (N.G.)
Cressida
5 *cressida* Fab. (Aus.)
6 *cressida* Fab. ♀. (Aus.)

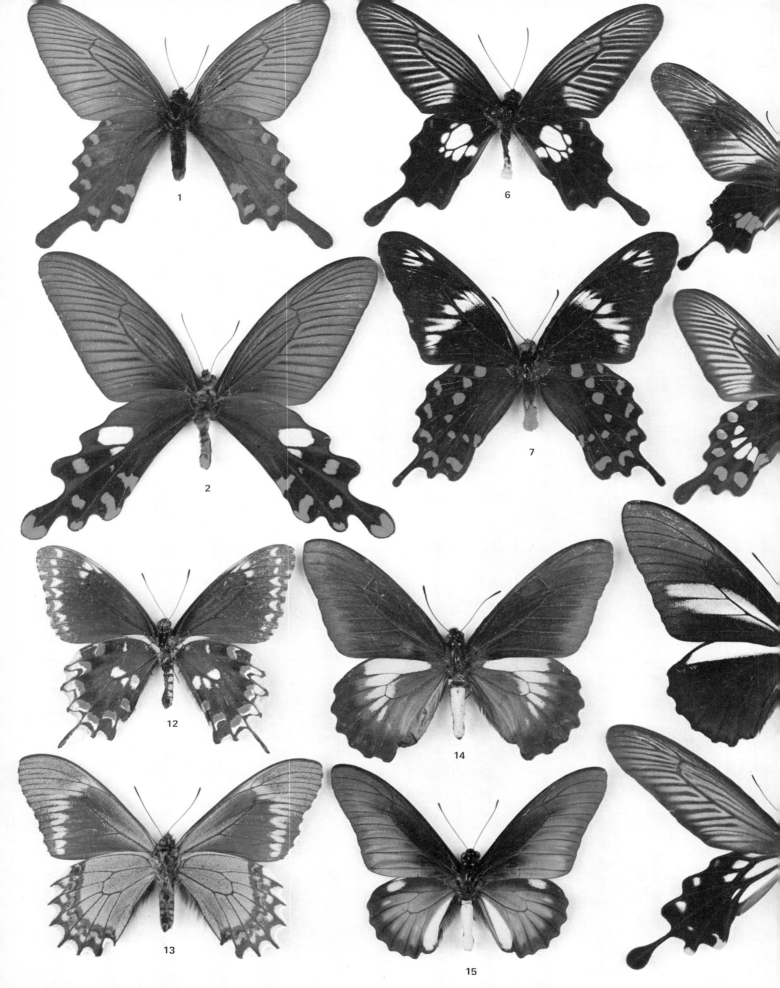

Papilionidae

Atrophaneura
1 *alcinous* Klug s.sp.mansonensis Fruhst. V.
(Form.)

2 *polyeuctes* Dbldy. V. (Ind.)
3 *neptunus* Guérin. (Malay.)
4 *coon* Fab. (Java)
5 *latreillei* Don. ♀. (Ind.)

Pachliopta
6 *annae* Feld.s.sp.phlegon Feld. (Mindanao)
7 *hector* L. (Ind.)
8 *aristolochiae* Fab. V. (Ind.)
9 *aristolochiae* Fab.s.sp.kotzebuea Esch. V. (Phil.)
10 *polydorus* L.s.sp.manus Talbot ♀. V. (Manus I.)

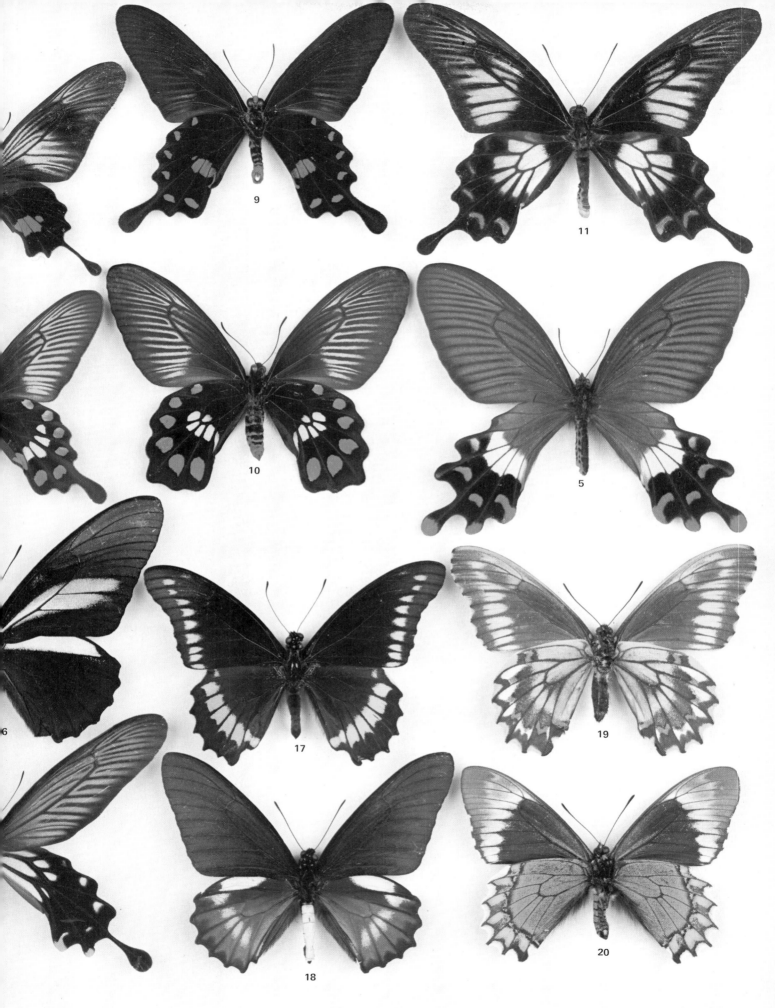

11 *jophon* Gray (Sri Lank.)
Battus
12 *devilliers* Godt. V. (Cuba)
13 *philetas* Hew. V. (Ecua.)

14 *laodamas* Feld. (Col.)
15 *lycidas* Cr. (Guat.)
16 *crassus* Cr. (Peru)
17 *polydamas* L. (Mex.)

18 *belus* Cr.s.sp.cochabamba Weeks (Peru)
19 *archidamas* Bsdv. V. (Chile)
20 *madyes* Dbldy. s.sp.chlorodamas Guen. V. (Peru)

Pieridae –

whites, jezebels, orange tips, brimstones and sulphurs

The family Pieridae comprises almost two thousand species and includes some of the most abundant butterflies in all regions. Many species are migratory and therefore widely distributed. They range in wing-span from less than 25mm *(Nathalis)* to about 100mm *(Hebomoia)*. Although the ground colour is usually white or yellow, many species are conspicuously patterned and some very colourful indeed.

Some of the 'whites' *Pierini*, are among the most familiar of all butterflies. Several of the species which migrate in large numbers are pests of economic importance (eg *Pieris brassicae* and *P. rapae*). Members of the Indo-Australian genus *Delias*, popularly known as jezebels, are unusual in that the under sides are generally more brightly coloured than the upper. This fascinating genus includes several species which are rarely seen.

Orange-tipped species are found in the *Pierini* and the *Colotini*. The latter sub-family is almost exclusively found in the Old World tropics and includes the largest members of the family.

The strange narrow-winged *Dismorphiinae* are characteristic of the Neotropical region and are only very poorly represented elsewhere. Even more curious is *Pseudopontia paradoxa*, a delicate little African species that has long baffled experts, some of whom maintain that it is not a butterfly but a moth.

The brimstones and sulphurs *(Coliadinae)* are, as their names imply, mostly yellow butterflies. They are represented in all regions of the world and some are notable migrants. The 'assembling' of vast numbers of such genera as *Catopsilia* and *Colias* in damp places affords an astonishing spectacle.

The eggs of Pieridae are characteristically spindle-shaped and the larvae smooth without prominent structures. The pupae usually have a single head projection and are formed upright.

Above, right: The brilliant yellow migrant *Phoebis agarithe* Bsdv. at rest in the Florida Everglades (X 4).

Right: The handsome *Delias mysis* Fab. popularly known as the union jack from its banded colours, shown feeding in a Queensland glade.

Left: The delicate European wood white *Leptidea sinapsis* L. is one of the few members of the Dismorphiinae found outside the Neotropical region (X 3).

Above: The black-veined white *Aporia crataegi* L. is found throughout most of the Palaearctic region. The wings are thinly-scaled, making the venation particularly clear (X 4).

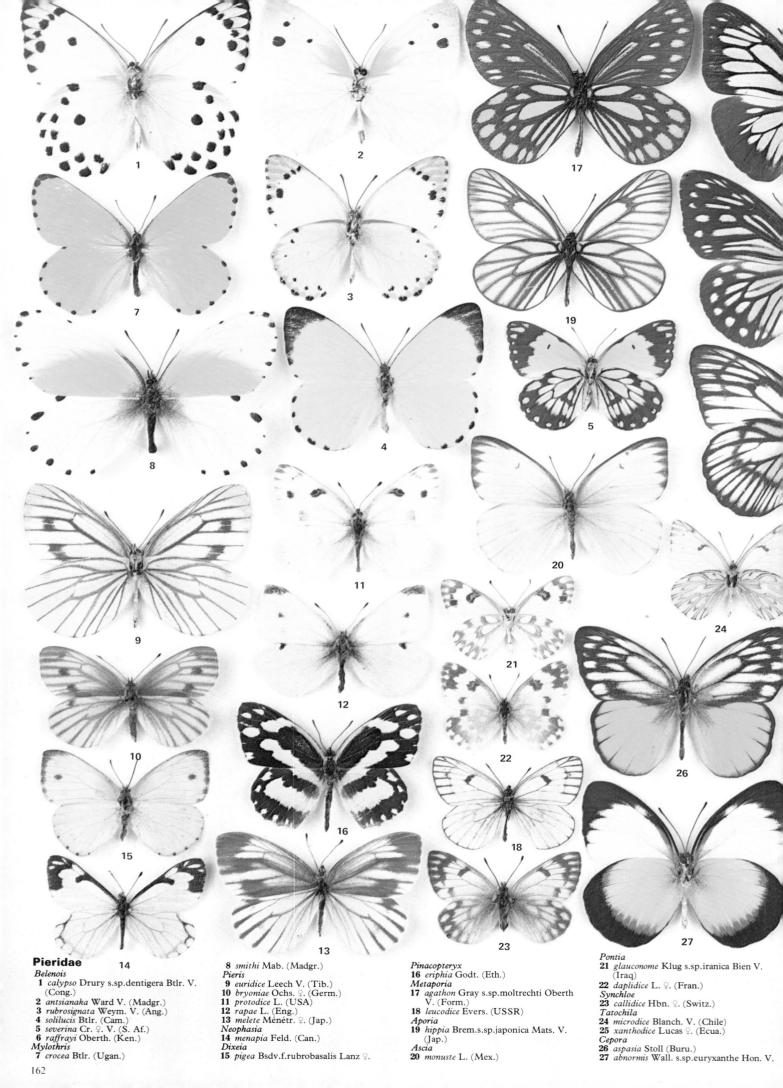

Pieridae

Belenois
1 *calypso* Drury s.sp.dentigera Btlr. V. (Cong.)
2 *antsianaka* Ward V. (Madgr.)
3 *rubrosignata* Weym. V. (Ang.)
4 *solilucis* Btlr. (Cam.)
5 *severina* Cr. ♀. V. (S. Af.)
6 *raffrayi* Oberth. (Ken.)
Mylothris
7 *crocea* Btlr. (Ugan.)

8 *smithi* Mab. (Madgr.)
Pieris
9 *euridice* Leech V. (Tib.)
10 *bryoniae* Ochs. ♀. (Germ.)
11 *protodice* L. (USA)
12 *rapae* L. (Eng.)
13 *melete* Ménétr. ♀. (Jap.)
Neophasia
14 *menapia* Feld. (Can.)
Dixeia
15 *pigea* Bsdv.f.rubrobasalis Lanz ♀.

Pinacopteryx
16 *eriphia* Godt. (Eth.)
Metaporia
17 *agathon* Gray s.sp.moltrechti Oberth V. (Form.)
18 *leucodice* Evers. (USSR)
Aporia
19 *hippia* Brem.s.sp.japonica Mats. V. (Jap.)
Ascia
20 *monuste* L. (Mex.)

Pontia
21 *glauconome* Klug s.sp.iranica Bien V. (Iraq)
22 *daplidice* L. ♀. (Fran.)
Synchloe
23 *callidice* Hbn. ♀. (Switz.)
Tatochila
24 *microdice* Blanch. V. (Chile)
25 *xanthodice* Lucas ♀. (Ecua.)
Cepora
26 *aspasia* Stoll (Buru.)
27 *abnormis* Wall. s.sp.euryxanthe Hon. V.

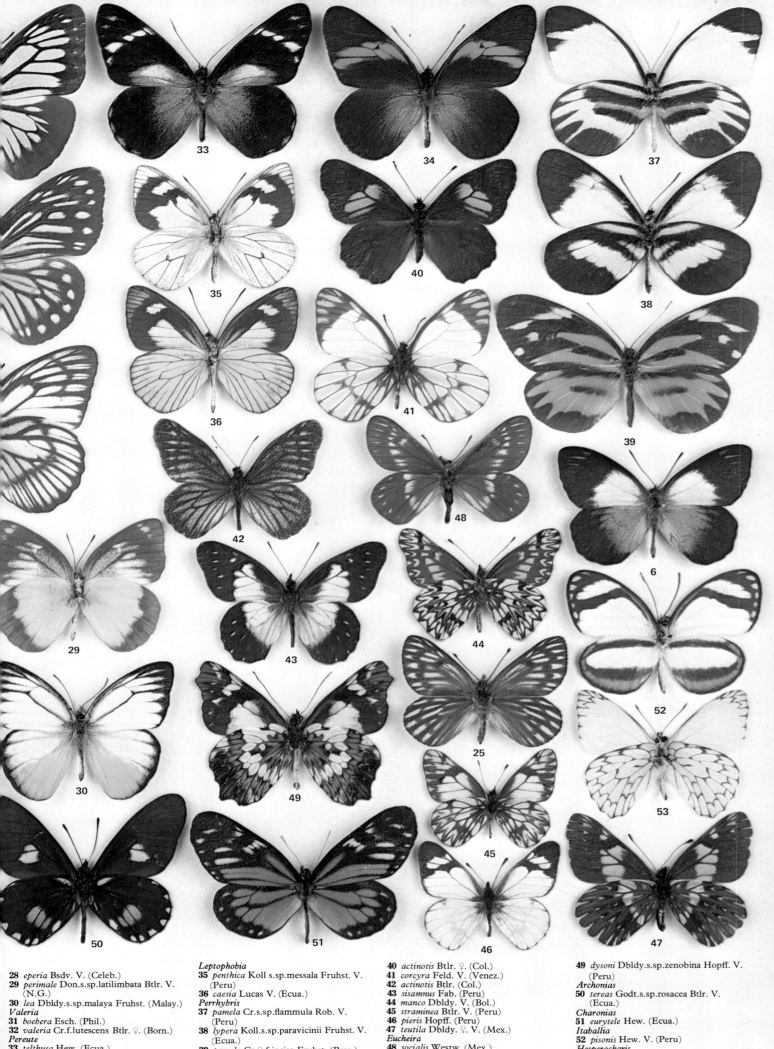

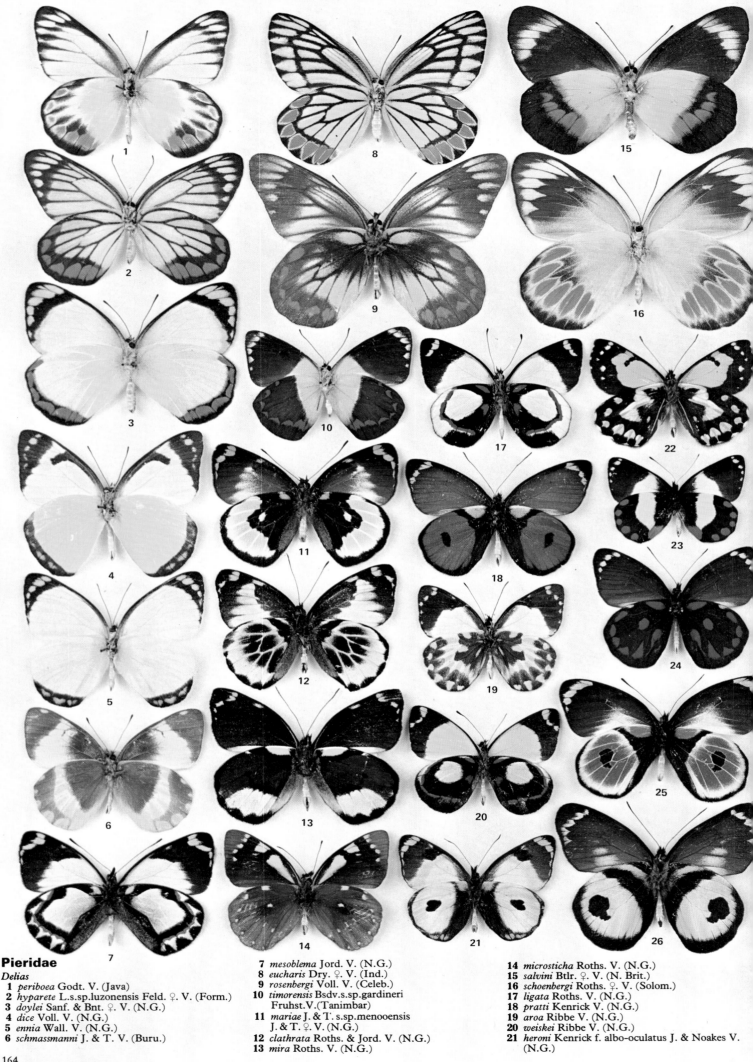

Pieridae

Delias

1 *periboea* Godt. V. (Java)
2 *hyparete* L.s.sp.luzonensis Feld. ♀. V. (Form.)
3 *doylei* Sanf. & Bnt. ♀. V. (N.G.)
4 *dice* Voll. V. (N.G.)
5 *ennia* Wall. V. (N.G.)
6 *schmassmanni* J. & T. V. (Buru.)

7 *mesoblema* Jord. V. (N.G.)
8 *eucharis* Dry. ♀. V. (Ind.)
9 *rosenbergi* Voll. V. (Celeb.)
10 *timorensis* Bsdv.s.sp.gardineri
 Fruhst.V.(Tanimbar)
11 *mariae* J. & T. s.sp.menooensis
 J. & T. ♀. V. (N.G.)
12 *clathrata* Roths. & Jord. V. (N.G.)
13 *mira* Roths. V. (N.G.)

14 *microsticha* Roths. V. (N.G.)
15 *salvini* Btlr. ♀. V. (N. Brit.)
16 *schoenbergi* Roths. ♀. V. (Solom.)
17 *ligata* Roths. V. (N.G.)
18 *pratti* Kenrick V. (N.G.)
19 *aroa* Ribbe V. (N.G.)
20 *weiskei* Ribbe V. (N.G.)
21 *heroni* Kenrick f. albo-oculatus J. & Noakes V. (N.G.)

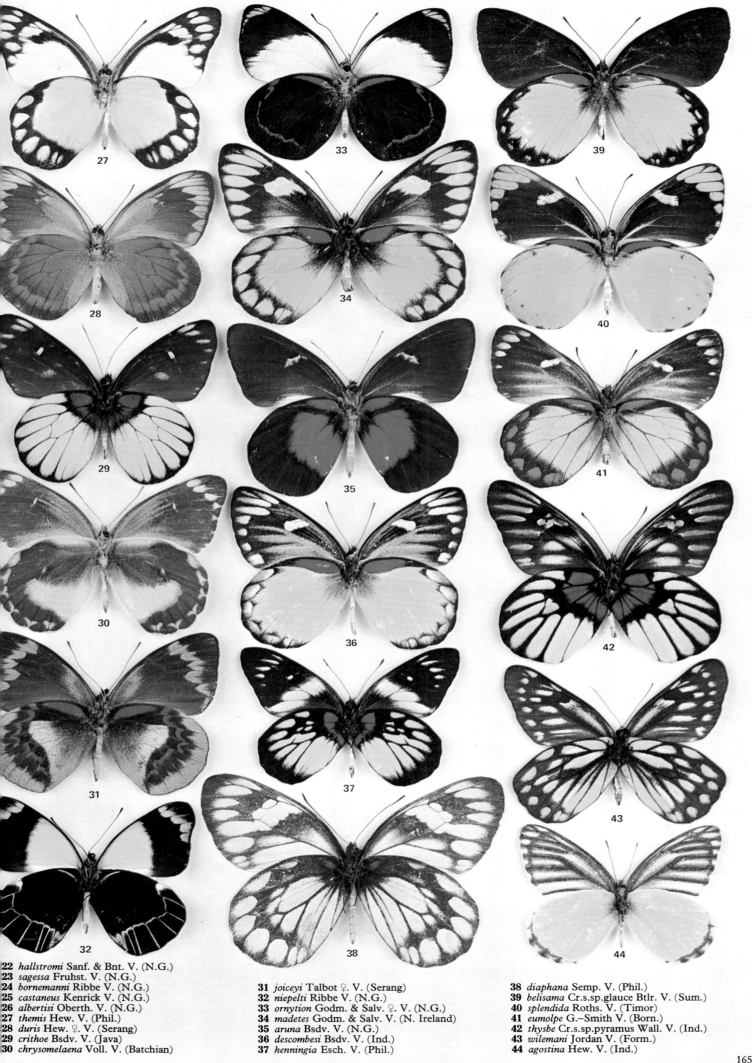

22 *hallstromi* Sanf. & Bnt. V. (N.G.)
23 *sagessa* Fruhst. V. (N.G.)
24 *bornemanni* Ribbe V. (N.G.)
25 *castaneus* Kenrick V. (N.G.)
26 *albertisi* Oberth. V. (N.G.)
27 *themis* Hew. V. (Phil.)
28 *duris* Hew. ♀. V. (Serang)
29 *crithoe* Bsdv. V. (Java)
30 *chrysomelaena* Voll. V. (Batchian)

31 *joiceyi* Talbot ♀. V. (Serang)
32 *niepelti* Ribbe V. (N.G.)
33 *ornytion* Godm. & Salv. ♀. V. (N.G.)
34 *madetes* Godm. & Salv. V. (N. Ireland)
35 *aruna* Bsdv. V. (N.G.)
36 *descombesi* Bsdv. V. (Ind.)
37 *henningia* Esch. V. (Phil.)

38 *diaphana* Semp. V. (Phil.)
39 *belisama* Cr.s.sp.glauce Btlr. V. (Sum.)
40 *splendida* Roths. V. (Timor)
41 *eumolpe* G.–Smith V. (Born.)
42 *thysbe* Cr.s.sp.pyramus Wall. V. (Ind.)
43 *wilemani* Jordan V. (Form.)
44 *agostina* Hew. V. (Ind.)

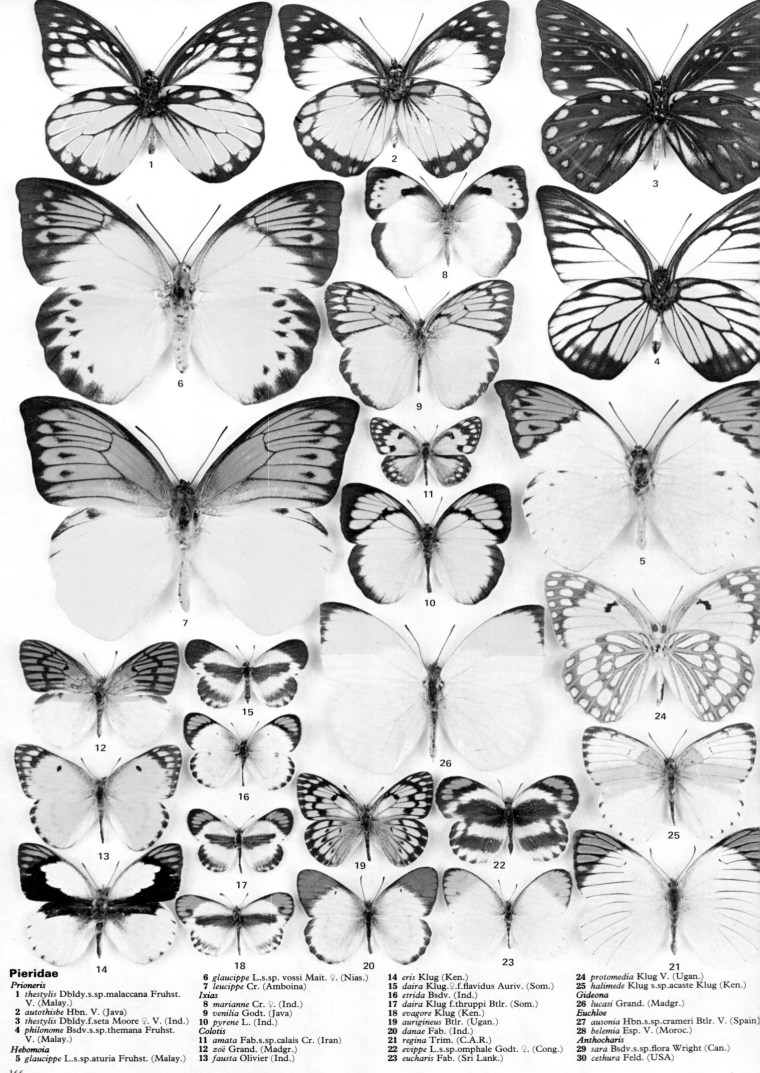

Pieridae

Prioneris
1 *thestylis* Dbldy.s.sp.malaccana Fruhst.
 V. (Malay.)
2 *autothisbe* Hbn. V. (Java)
3 *thestylis* Dbldy.f.seta Moore ♀. V. (Ind.)
4 *philonome* Bsdv.s.sp.themana Fruhst.
 V. (Malay.)

Hebomoia
5 *glaucippe* L.s.sp.aturia Fruhst. (Malay.)
6 *glaucippe* L.s.sp. vossi Mait. ♀. (Nias.)
7 *leucippe* Cr. (Amboina)

Ixias
8 *marianne* Cr. ♀. (Ind.)
9 *venilia* Godt. (Java)
10 *pyrene* L. (Ind.)

Colotis
11 *amata* Fab.s.sp.calais Cr. (Iran)
12 *zoë* Grand. (Madgr.)
13 *fausta* Olivier (Ind.)
14 *eris* Klug (Ken.)
15 *daira* Klug.♀.f.flavidus Auriv. (Som.)
16 *etrida* Bsdv. (Ind.)
17 *daira* Klug f.thruppi Btlr. (Som.)
18 *evagore* Klug (Ken.)
19 *aurigineus* Btlr. (Ugan.)
20 *danae* Fab. (Ind.)
21 *regina* Trim. (C.A.R.)
22 *evippe* L.s.sp.omphale Godt. ♀. (Cong.)
23 *eucharis* Fab. (Sri Lank.)
24 *protomedia* Klug V. (Ugan.)
25 *halimede* Klug s.sp.acaste Klug (Ken.)

Gideona
26 *lucasi* Grand. (Madgr.)

Euchloe
27 *ausonia* Hbn.s.sp.crameri Btlr. V. (Spain)
28 *belemia* Esp. V. (Moroc.)

Anthocharis
29 *sara* Bsdv.s.sp.flora Wright (Can.)
30 *cethura* Feld. (USA)

166

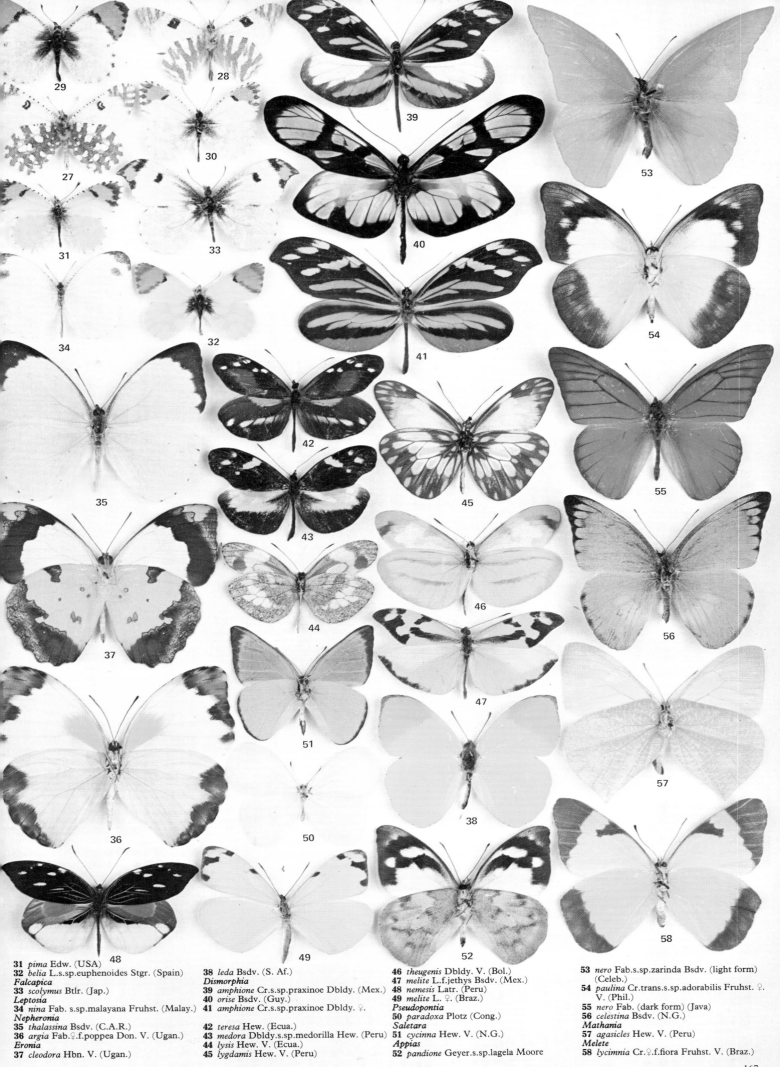

31 *pima* Edw. (USA)
32 *belia* L.s.sp.euphenoides Stgr. (Spain)
Falcapica
33 *scolymus* Btlr. (Jap.)
Leptosia
34 *nina* Fab. s.sp.malayana Fruhst. (Malay.)
Nepheronia
35 *thalassina* Bsdv. (C.A.R.)
36 *argia* Fab.♀.f.poppea Don. V. (Ugan.)
Eronia
37 *cleodora* Hbn. V. (Ugan.)

38 *leda* Bsdv. (S. Af.)
Dismorphia
39 *amphione* Cr.s.sp.praxinoe Dbldy. (Mex.)
40 *orise* Bsdv. (Guy.)
41 *amphione* Cr.s.sp.praxinoe Dbldy. ♀.
42 *teresa* Hew. (Ecua.)
43 *medora* Dbldy.s.sp.medorilla Hew. (Peru)
44 *lysis* Hew. V. (Ecua.)
45 *lygdamis* Hew. V. (Peru)

46 *theugenis* Dbldy. V. (Bol.)
47 *melite* L.f.jethys Bsdv. (Mex.)
48 *nemesis* Latr. (Peru)
49 *melite* L. ♀. (Braz.)
Pseudopontia
50 *paradoxa* Plotz (Cong.)
Saletara
51 *cycinna* Hew. V. (N.G.)
Appias
52 *pandione* Geyer.s.sp.lagela Moore

53 *nero* Fab.s.sp.zarinda Bsdv. (light form)
(Celeb.)
54 *paulina* Cr.trans.s.sp.adorabilis Fruhst. ♀.
V. (Phil.)
55 *nero* Fab. (dark form) (Java)
56 *celestina* Bsdv. (N.G.)
Mathania
57 *agasicles* Hew. V. (Peru)
Melete
58 *lycimnia* Cr.♀.f.fiora Fruhst. V. (Braz.)

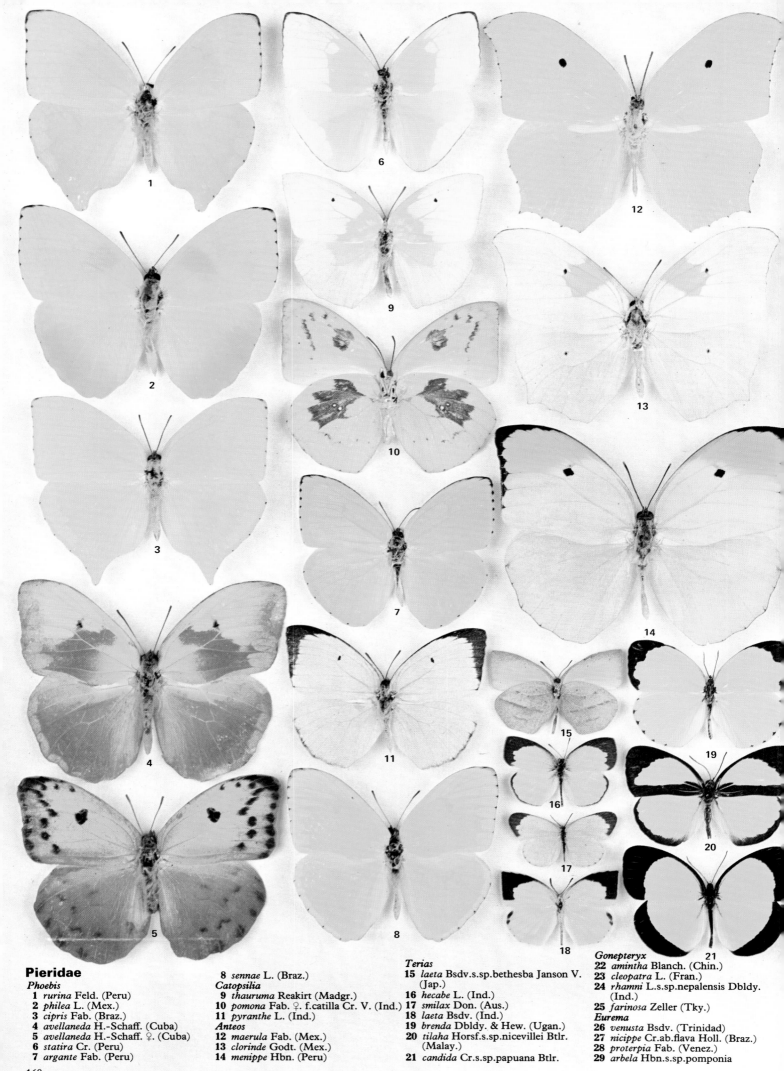

Pieridae

Phoebis
1 *rurina* Feld. (Peru)
2 *philea* L. (Mex.)
3 *cipris* Fab. (Braz.)
4 *avellaneda* H.-Schaff. (Cuba)
5 *avellaneda* H.-Schaff. ♀. (Cuba)
6 *statira* Cr. (Peru)
7 *argante* Fab. (Peru)

8 *sennae* L. (Braz.)
Catopsilia
9 *thauruma* Reakirt (Madgr.)
10 *pomona* Fab. ♀. f.catilla Cr. V. (Ind.)
11 *pyranthe* L. (Ind.)
Anteos
12 *maerula* Fab. (Mex.)
13 *clorinde* Godt. (Mex.)
14 *menippe* Hbn. (Peru)

Terias
15 *laeta* Bsdv.s.sp.bethesba Janson V. (Jap.)
16 *hecabe* L. (Ind.)
17 *smilax* Don. (Aus.)
18 *laeta* Bsdv. (Ind.)
19 *brenda* Dbldy. & Hew. (Ugan.)
20 *tilaha* Horsf.s.sp.nicevillei Btlr. (Malay.)
21 *candida* Cr.s.sp.papuana Btlr.

Gonepteryx
22 *amintha* Blanch. (Chin.)
23 *cleopatra* L. (Fran.)
24 *rhamni* L.s.sp.nepalensis Dbldy. (Ind.)
25 *farinosa* Zeller (Tky.)
Eurema
26 *venusta* Bsdv. (Trinidad)
27 *nicippe* Cr.ab.flava Holl. (Braz.)
28 *proterpia* Fab. (Venez.)
29 *arbela* Hbn.s.sp.pomponia

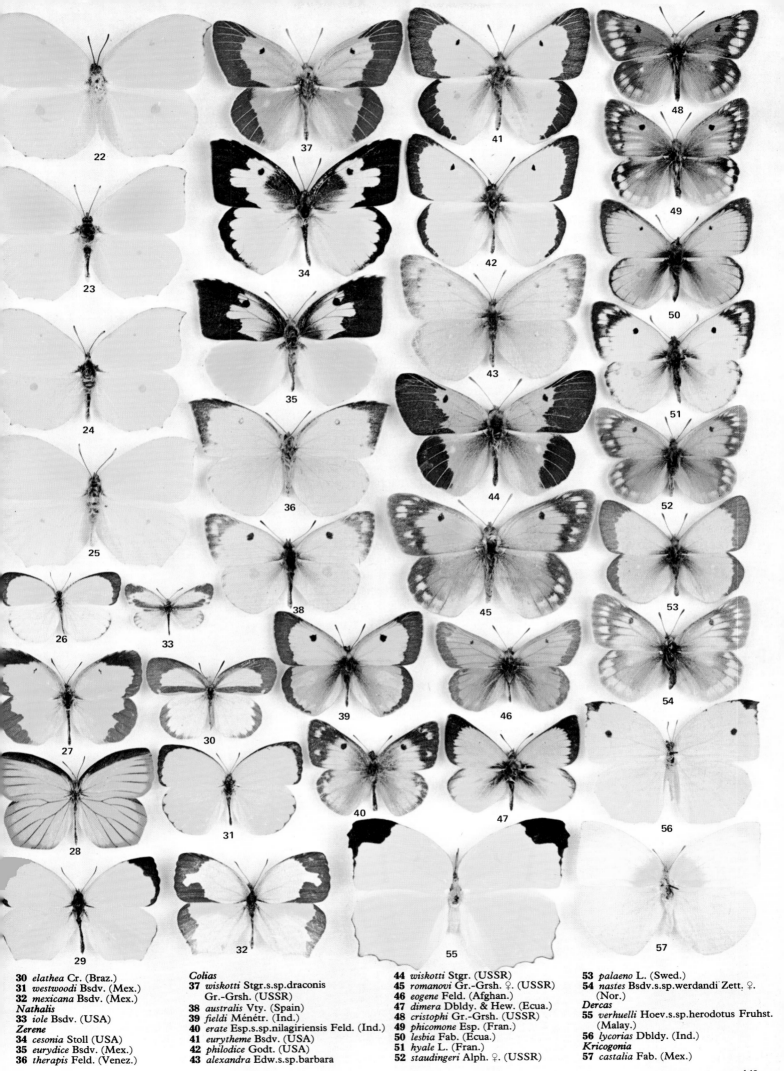

30 *elathea* Cr. (Braz.)
31 *westwoodi* Bsdv. (Mex.)
32 *mexicana* Bsdv. (Mex.)
Nathalis
33 *iole* Bsdv. (USA)
Zerene
34 *cesonia* Stoll (USA)
35 *eurydice* Bsdv. (Mex.)
36 *therapis* Feld. (Venez.)

Colias
37 *wiskotti* Stgr.s.sp.draconis
 Gr.-Grsh. (USSR)
38 *australis* Vty. (Spain)
39 *fieldi* Ménétr. (Ind.)
40 *erate* Esp.s.sp.nilagiriensis Feld. (Ind.)
41 *eurytheme* Bsdv. (USA)
42 *philodice* Godt. (USA)
43 *alexandra* Edw.s.sp.barbara

44 *wiskotti* Stgr. (USSR)
45 *romanovi* Gr.-Grsh. ♀. (USSR)
46 *eogene* Feld. (Afghan.)
47 *dimera* Dbldy. & Hew. (Ecua.)
48 *cristophi* Gr.-Grsh. (USSR)
49 *phicomone* Esp. (Fran.)
50 *lesbia* Fab. (Ecua.)
51 *hyale* L. (Fran.)
52 *staudingeri* Alph. ♀. (USSR)

53 *palaeno* L. (Swed.)
54 *nastes* Bsdv.s.sp.werdandi Zett. ♀.
 (Nor.)
Dercas
55 *verhuelli* Hoev.s.sp.herodotus Fruhst.
 (Malay.)
56 *lycorias* Dbldy. (Ind.)
Kricogonia
57 *castalia* Fab. (Mex.)

169

Lycaenidae –

hairstreaks, blues, coppers etc

This family Lycaenidae is well represented in all world regions and comprises several thousand small to medium-sized species. The very smallest have a wing-span of little more than 15mm and even the exceptional 'giants' span less than 80mm. Most species have metallic upper side colouring, usually shades of blue but sometimes coppery orange-red. In contrast the females of some species, particularly *Polyommatinae* or 'blues', may be dark brown and inconspicuous. The undersides are typically spotted or streaked in intricate patterns and hind wing tails are often present.

The hairstreaks *(Theclinae)* are so called from the characteristic delicate lines on the under side of the wings. Although represented in all regions this subfamily reaches a peak of development in tropical America where members of the genera *Evenus*, *Arcas*, etc, must rank among the most exquisite of all butterflies.

'Blues' *(Polyommatinae)* are also found in all regions, but in contrast to the last are poorly represented in the Neotropical region. The pattern of the under side spotting is very characteristic but subject to enormous variation. They are particularly associated with grasslands and in European alpine meadows, for example, their seasonal abundance is a fascinating sight.

The third broad division 'coppers' *(Lycaeninae)* is smaller in numbers and rather more northerly in distribution than the previous two groups – all but a few species being Holarctic. In addition to the brilliant copper-gold many exhibit a violet flush, and confusingly a few species are blue. The under side patterns of this attractive group are very similar to those of the *Polyommatinae*.

Several of the other subfamilies include species which are most unlike Lycaenidae in appearance – in particular the African *Lipteninae*, which may resemble Acraeidae or Pieridae. Another most curious subfamily is the *Liphyrinae*, in which the adults are very moth-like and in the early stages live together with ants; a

Right: Representing the Lycaeninae is the small copper *Lycaena phlaeas* L., which has an extraordinarily wide distribution ranging from North America through Europe and North Africa to the Far East. Unlike most coppers, in this species the male and female are very similar in appearance (X 8).

Below: A characteristic example from the sub-family Polyommatinae is the North American blue *Everes comyntas* Godt. Note particularly the delicately ringed antennae, a feature of this family (X 5).

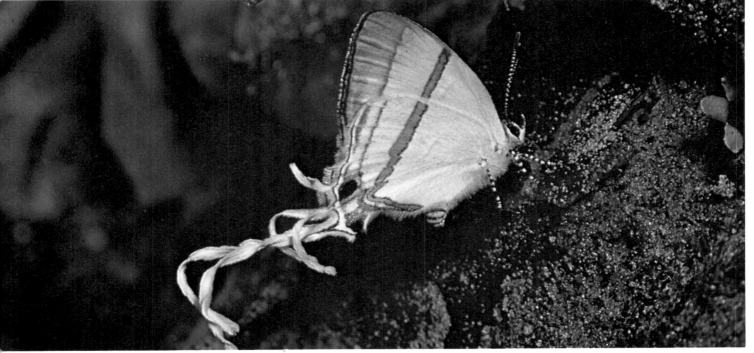

habit which is more or less developed in many other subfamilies.

The eggs are of a flattened disc shape or domed and delicately ribbed or pitted. The larvae are somewhat like woodlice in appearance, rather flattened and tapering at each end; predominantly green or brown in colouring. As might be expected in such a large family the range of food plants is enormous but, generally speaking, hairstreaks are associated with trees and shrubs, 'blues' with Leguminosae, and 'coppers' with docks (*Rumex* species). The pupae are short and stout and usually attached by a silk girdle to the leaves of the food plant. Some curiously resemble bird droppings and those of *Feniseca* and some other genera present the appearance of a tiny monkey's head. This feature has led to a great deal of amusing speculation on the supposed 'mimicry' exhibited.

Above: This amazingly long-tailed member of the Theclinae is *Hypolycaena liara* Druce from the Congo. The hindwing eye-spots in combination with the tails give the appearance of a false head, which may encourage predators to attack this point, so enabling the butterfly to escape without serious injury (X 8).

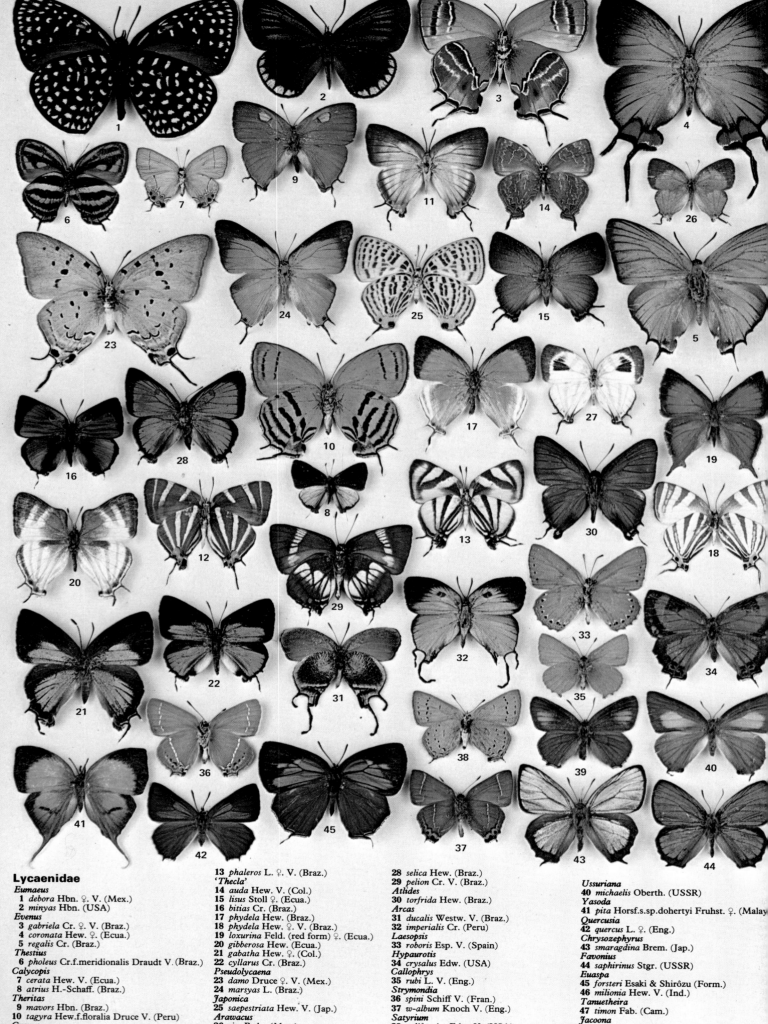

Lycaenidae

Eumaeus
1 *debora* Hbn. ♀. V. (Mex.)
2 *minyas* Hbn. (USA)
Evenus
3 *gabriela* Cr. ♀. V. (Braz.)
4 *coronata* Hew. ♀. (Ecua.)
5 *regalis* Cr. (Braz.)
Thestius
6 *pholeus* Cr.f.meridionalis Draudt V. (Braz.)
Calycopis
7 *cerata* Hew. V. (Ecua.)
8 *atrius* H.-Schaff. (Braz.)
Theritas
9 *mavors* Hbn. (Braz.)
10 *tagyra* Hew.f.floralia Druce V. (Peru)
Cycnus
11 *battus* Cr. ♀. (Ecua.)
12 *battus* Cr. V. (Mex.)

13 *phaleros* L. ♀. V. (Braz.)
'Thecla'
14 *auda* Hew. V. (Col.)
15 *lisus* Stoll ♀. (Ecua.)
16 *bitias* Cr. (Braz.)
17 *phydela* Hew. (Braz.)
18 *phydela* Hew. ♀. V. (Braz.)
19 *loxurina* Feld. (red form) ♀. (Ecua.)
20 *gibberosa* Hew. (Ecua.)
21 *gabatha* Hew. ♀. (Col.)
22 *cyllarus* Cr. (Braz.)
Pseudolycaena
23 *damo* Druce ♀. V. (Mex.)
24 *marsyas* L. (Braz.)
Japonica
25 *saepestriata* Hew. V. (Jap.)
Arawacus
26 *sito* Bsdv. (Mex.)
27 *togarna* Hew. (Ecua.)
Panthiades

28 *selica* Hew. (Braz.)
29 *pelion* Cr. V. (Braz.)
Atlides
30 *torfrida* Hew. (Braz.)
Arcas
31 *ducalis* Westw. V. (Braz.)
32 *imperialis* Cr. (Peru)
Laesopsis
33 *roboris* Esp. V. (Spain)
Hypaurotis
34 *crysalus* Edw. (USA)
Callophrys
35 *rubi* L. V. (Eng.)
Strymondia
36 *spini* Schiff V. (Fran.)
37 *w-album* Knoch V. (Eng.)
Satyrium
38 *californica* Edw. V. (USA)
Nordmannia
39 *ilicis* Esp. ♀. (Fran.)

Ussuriana
40 *michaelis* Oberth. (USSR)
Yasoda
41 *pita* Horsf.s.sp.dohertyi Fruhst. ♀. (Malay)
Quercusia
42 *quercus* L. ♀. (Eng.)
Chrysozephyrus
43 *smaragdina* Brem. (Jap.)
Favonius
44 *saphirinus* Stgr. (USSR)
Euaspa
45 *forsteri* Esaki & Shirôzu (Form.)
46 *milionia* Hew. V. (Ind.)
Tanuetheira
47 *timon* Fab. (Cam.)
Jacoona
48 *anasuga* Feld. ♀. (Malay.)
49 *anasuga* Feld. (Malay.)
Sinthusa

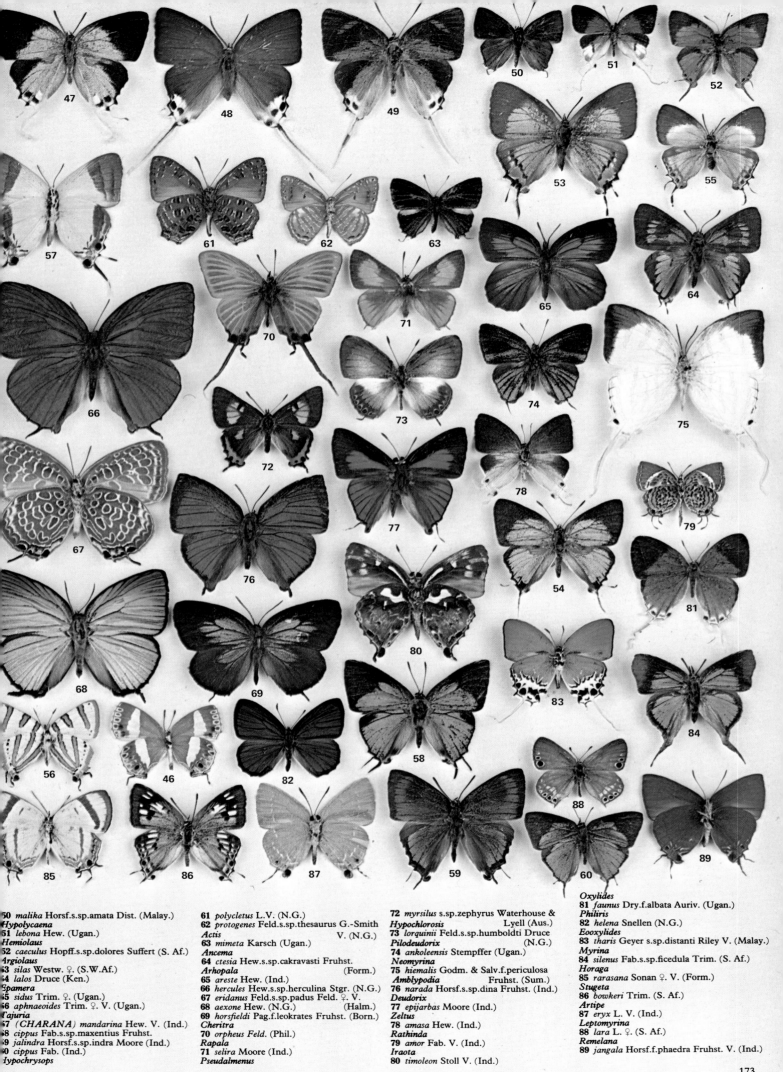

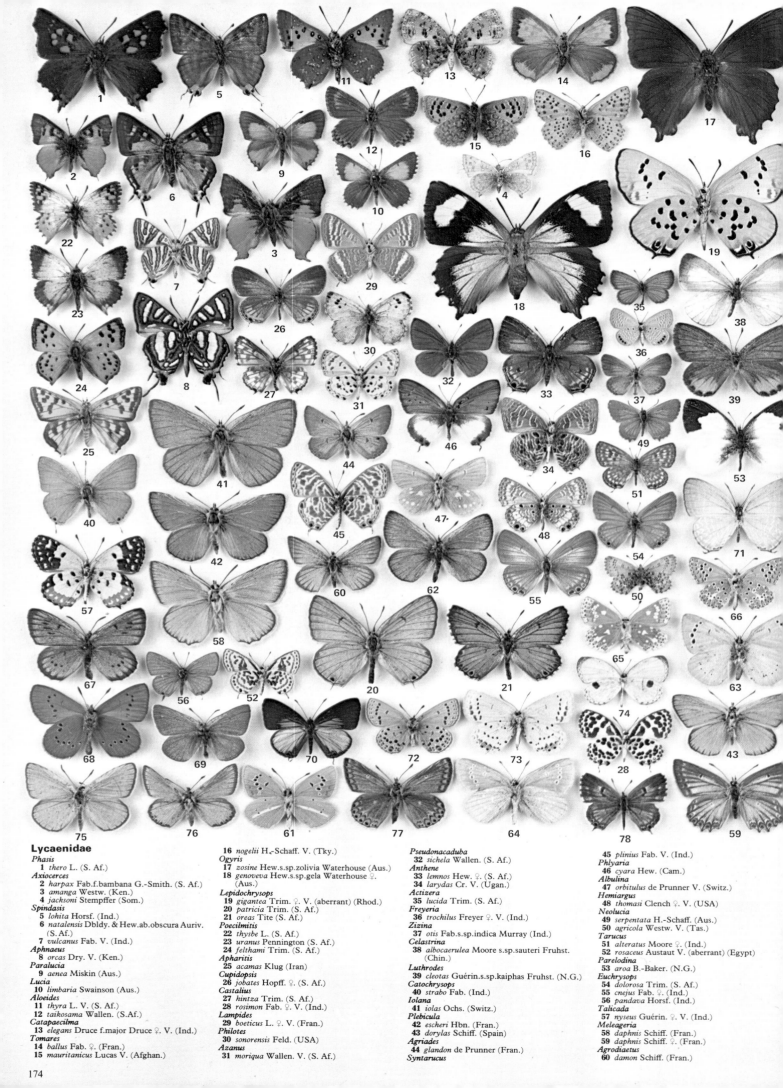

Lycaenidae

Phasis
 1 *thero* L. (S. Af.)
Axiocerces
 2 *harpax* Fab.f.bambana G.-Smith. (S. Af.)
 3 *amanga* Westw. (Ken.)
 4 *jacksoni* Stempffer (Som.)
Spindasis
 5 *lohita* Horsf. (Ind.)
 6 *natalensis* Dbldy. & Hew.ab.obscura Auriv. (S. Af.)
 7 *vulcanus* Fab. V. (Ind.)
Aphnaeus
 8 *orcas* Dry. V. (Ken.)
Paralucia
 9 *aenea* Miskin (Aus.)
Lucia
 10 *limbaria* Swainson (Aus.)
Aloeides
 11 *thyra* L. V. (S. Af.)
 12 *taikosama* Wallen. (S.Af.)
Catapaecilma
 13 *elegans* Druce f.major Druce ♀. V. (Ind.)
Tomares
 14 *ballus* Fab. ♀. (Fran.)
 15 *mauritanicus* Lucas V. (Afghan.)

 16 *nogelii* H.-Schaff. V. (Tky.)
Ogyris
 17 *zosine* Hew.s.sp.zolivia Waterhouse (Aus.)
 18 *genoveva* Hew.s.sp.gela Waterhouse ♀. (Aus.)
Lepidochrysops
 19 *gigantea* Trim. ♀. V. (aberrant) (Rhod.)
 20 *patricia* Trim. (S. Af.)
 21 *oreas* Tite (S. Af.)
Poecilmitis
 22 *thysbe* L. (S. Af.)
 23 *uranus* Pennington (S. Af.)
 24 *felthami* Trim. (S. Af.)
Apharitis
 25 *acamas* Klug (Iran)
Cupidopsis
 26 *jobates* Hopff. ♀. (S. Af.)
Castalius
 27 *hintza* Trim. (S. Af.)
 28 *rosimon* Fab. ♀. V. (Ind.)
Lampides
 29 *boeticus* L. ♀. V. (Fran.)
Philotes
 30 *sonorensis* Feld. (USA)
Azanus
 31 *moriqua* Wallen. V. (S. Af.)

Pseudonacaduba
 32 *sichela* Wallen. (S. Af.)
Anthene
 33 *lemnos* Hew. ♀. (S. Af.)
 34 *larydas* Cr. V. (Ugan.)
Actizera
 35 *lucida* Trim. (S. Af.)
Freyeria
 36 *trochilus* Freyer ♀. V. (Ind.)
Zizina
 37 *otis* Fab.s.sp.indica Murray (Ind.)
Celastrina
 38 *albocaerulea* Moore s.sp.sauteri Fruhst. (Chin.)
Luthrodes
 39 *cleotas* Guérin.s.sp.kaiphas Fruhst. (N.G.)
Catochrysops
 40 *strabo* Fab. (Ind.)
Iolana
 41 *iolas* Ochs. (Switz.)
Plebicula
 42 *escheri* Hbn. (Fran.)
 43 *dorylas* Schiff. (Spain)
Agriades
 44 *glandon* de Prunner (Fran.)
Syntarucus

 45 *plinius* Fab. V. (Ind.)
Phlyaria
 46 *cyara* Hew. (Cam.)
Albulina
 47 *orbitulus* de Prunner V. (Switz.)
Hemiargus
 48 *thomasi* Clench ♀. V. (USA)
Neolucia
 49 *serpentata* H.-Schaff. (Aus.)
 50 *agricola* Westw. V. (Tas.)
Tarucus
 51 *alteratus* Moore ♀. (Ind.)
 52 *rosaceus* Austaut V. (aberrant) (Egypt)
Parelodina
 53 *aroa* B.-Baker. (N.G.)
Euchrysops
 54 *dolorosa* Trim. (S. Af.)
 55 *cnejus* Fab. ♀. (Ind.)
 56 *pandava* Horsf. (Ind.)
Talicada
 57 *nyseus* Guérin. ♀. V. (Ind.)
Meleageria
 58 *daphnis* Schiff. (Fran.)
 59 *daphnis* Schiff. ♀. (Fran.)
Agrodiaetus
 60 *damon* Schiff. (Fran.)

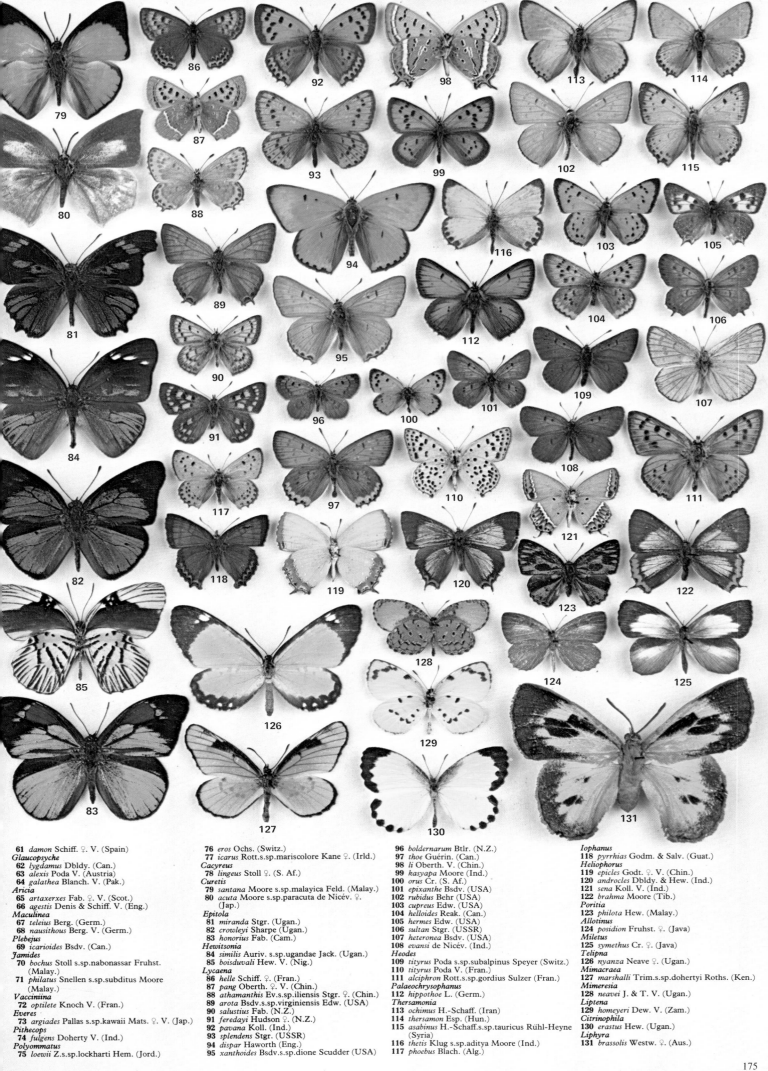

175

Chapter 18

Libytheidae – snouts and
Nemeobiidae – judies, metalmarks etc

The two families covered in this section will frequently be found united in earlier works. Although they are here regarded as separate the very small size of the former (with only about a dozen species) does not justify a complete section.

Libytheidae

Several species are migratory and although very small the family Libytheidae is represented in all world regions. They are readily distinguished from almost all other butterflies by the enormously developed labial palps – which give a curious and rather comical appearance to the head. In size and angular wing shape they are fairly uniform with a wing-span of about 40mm to 65mm. Most species are dark brown with lighter markings although one *(L. geoffroyi)* from New Guinea is remarkable for a beautiful mauve suffusion.

The eggs are oval with delicate ribbing. The larvae are green, clothed with tiny hairs and reminiscent of Pieridae. Most species feed on *Celtis*. The pupae are smooth, conspicuously hump-backed with prominent wing cases. They are suspended by the tail from the leaves of the food plant.

Nemeobiidae

In contrast to the last family the Nemeobiidae is one of the largest butterfly families, with nearly two thousand species. The vast majority of these are confined to the Neotropical region, and elsewhere the family is very scantily represented – Europe, for example,

The Nemeobiidae, formerly known as Riodinidae or Erycinidae, are particularly characteristic butterflies of the South American rain forest. Although they are generally small, their glittering colours rival even those of humming birds. The examples shown here were both photographed near the Rio Huallaga in Peru—one of the finest areas in the world for butterflies. On the right is *Mesosemia croesus* Fab. (X 10), one of many species with curious dotted eye-spots. Below is the elegant *Lasaia moeros* Stgr. (X 5).

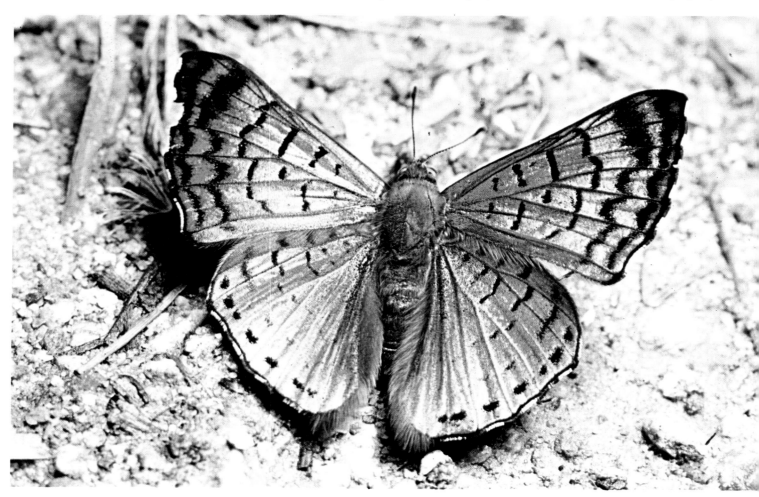

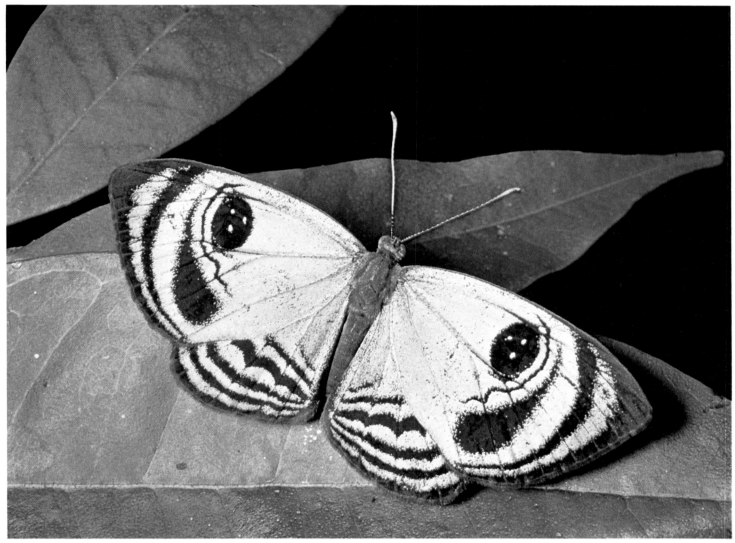

boasting only one species *(Hamearis lucina)*.

Although so numerous many species are not often seen because of their secretive behaviour, resting under leaves in moth-fashion. Other species may visit flowers or congregate in damp places.

Most species are small, ranging in wing-span from 20mm to about 65mm. However, in wing shape, pattern and colouring they show the most startling variation to be found in any butterfly family. Many exhibit vivid colour combinations or brilliant metallic and iridescent shades. Examples of the latter are members of the Neotropical *Ancyluris* species, which are often referred to as 'living jewels'. The wings may be rounded or angular and in some cases extravagantly tailed (for example *Helicopis* species). With such wide variation it is hardly surprising that many closely resemble members of other butterfly families, and also moths – a factor which causes much confusion to beginners.

The eggs are generally hemispherical with regular depressions. The larvae are shaped rather like woodlice, usually green or whitish in colour and covered with fine hairs. Some have brilliantly coloured protuberances. They feed on a very wide variety of plants. The pupae exhibit great variety of form. Some are suspended freely by the tail while others are girdled with silk to the surface of leaves, rather like Lycaenidae.

Below: The tiny Duke of Burgundy *Hamearis lucina* L. is the only European representative of the Nemeobiidae.. In colour and pattern it bears a superficial resemblance to the fritillaries (Nymphalidae) (X 10).

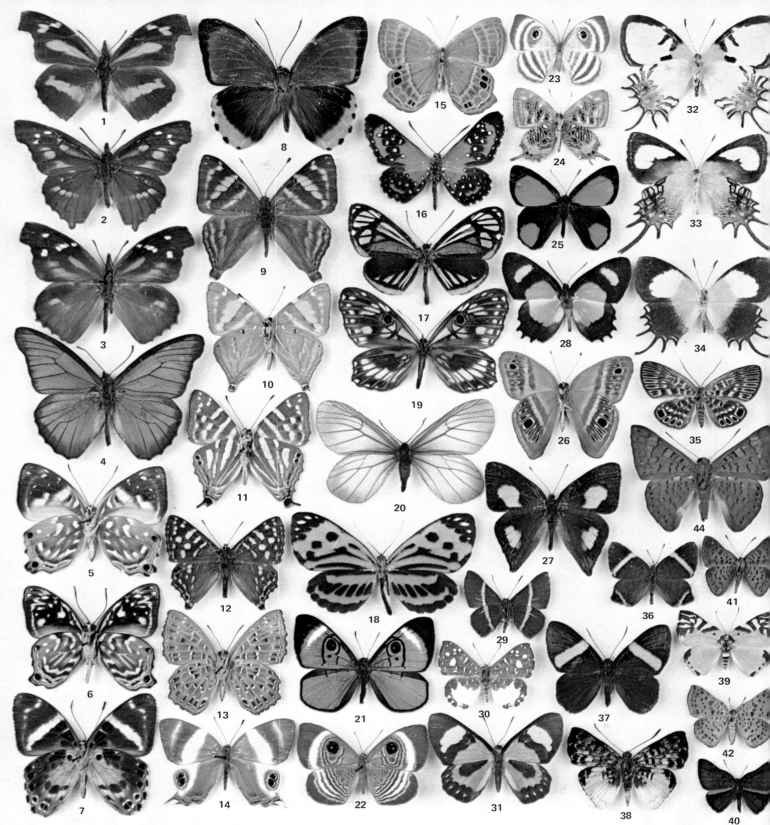

Libytheidae

Libythea
1 *myrrha* Godt. (Ind.)
2 *labdaca* Westw. (Nig.)
3 *carinenta* Cr. (USA)
4 *geoffroyi* Godt.s.sp.maenia Fruhst. (N.G.)

Nemeobiidae

Dicallaneura
5 *decorata* Hew.s.sp.conos Fruhst. ♀. V. (N.G.)
6 *ribbei* Rober.s.sp.arfakensis Fruhst. V. (N.G.)

Praetaxila
7 *segecia* Hew.s.sp.yaniya Fruhst. V. (N.G.)
8 *satraps* G.-Smith & Kirby (N.G.)

Dodona
9 *ouida* Moore (Ind.)

10 *ouida* Moore (spring fm.) V. (Ind.)
11 *eugenes* Bates s.sp.venox Fruhst. V. (Ind.)
12 *durga* Koll. (Ind.)

Zemeros
13 *flegyas* Cr. V. (Ind.)

Abisara
14 *rogersi* Druce ♀. (Cong.)
15 *kausambi* Feld. V. (Malay.)

Stalachtis
16 *phlegia* Cr.f.phlegetonia Perty. (Braz.)
17 *zephyritis* Dalm.s.sp.evelina Btlr. (Braz.)
18 *calliope* L. (Braz.)

Teratophthalma
19 *marsena* Hew.f.semivitrea Seitz V. (Peru)

Styx
20 *infernalis* Stgr. (Peru)

Mesosemia
21 *loruhama* Hew. (Ecua.)

Semomesia
22 *croesus* Fab. ♀. f.trilineata Btlr. (Braz.)

Diophtalma
23 *matisca* Hew. ♀. (Peru)

Sarota
24 *chrysus* Stoll f.dematria Westw.V. (Ecua.)

Euselasia
25 *erythraea* Hew. (Ecua.)
26 *orfita* Cr.f.euodias Hew. V. (Braz.)
27 *thucydides* Fab. (Braz.)

Methone
28 *cecilia* Cr.f.magnarea Seitz. (Braz.)

Parcella
29 *amarynthina* Feld. V. (Argent.)

Napaea
30 *nepos* Fab. (Peru)

Themone
31 *pais* Hbn. (Braz.)

Helicopis

32 *endymion* Cr. V. (Guy.)
33 *cupido* L.f.erotica Seitz V. (Braz.)
34 *acis* Fab. ♀. (Braz.)

Alesa
35 *amesis* Cr. ♀. (Peru)

Riodina
36 *lysippoides* Berg. (Argent.)

Panara
37 *phereclus* L. (Peru)

Menander
38 *hebrus* Cr. (Braz.)

Symmachia
39 *rubina* Bates ♀. (Col.)
40 *championi* Godm. & Salv. (Mex.)

Caria
41 *domitianus* Fab.f.ino Godm. & Salv. (Mex.)
42 *rhacotis* Godm. & Salv. ♀. V. (Mex.)
43 *mantinea* Feld.f.amazonica Bates (Braz.)

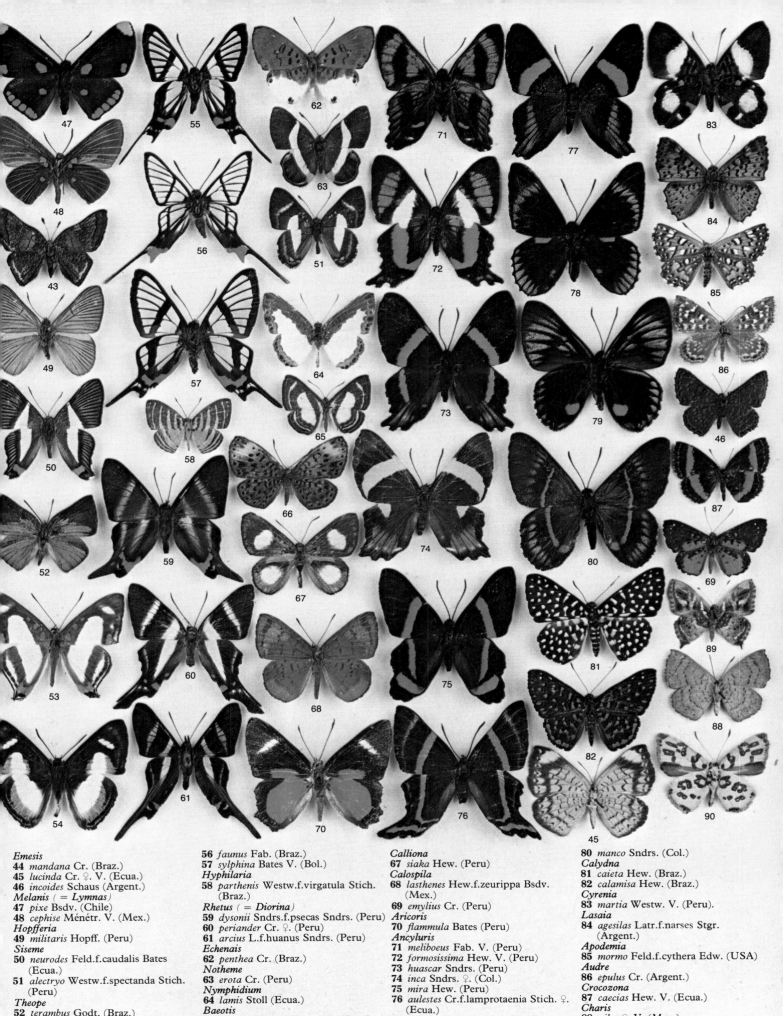

Emesis
44 mandana Cr. (Braz.)
45 lucinda Cr. ♀. V. (Ecua.)
46 incoides Schaus (Argent.)
Melanis (= Lymnas)
47 pixe Bsdv. (Chile)
48 cephise Ménétr. V. (Mex.)
Hopfferia
49 militaris Hopff. (Peru)
Siseme
50 neurodes Feld.f.caudalis Bates
(Ecua.)
51 alectryo Westw.f.spectanda Stich.
(Peru)
Theope
52 terambus Godt. (Braz.)
Thisbe
53 lycorias Hew. (Hond.)
54 irenea Stoll (Ecua.)
Chorinea (= Zeonia)
55 batesii Sndrs. (Peru)

56 faunus Fab. (Braz.)
57 sylphina Bates V. (Bol.)
Hyphilaria
58 parthenis Westw.f.virgatula Stich.
(Braz.)
Rhetus (= Diorina)
59 dysonii Sndrs.f.psecas Sndrs. (Peru)
60 periander Cr. ♀. (Peru)
61 arcius L.f.huanus Sndrs. (Peru)
Echenais
62 penthea Cr. (Braz.)
Notheme
63 erota Cr. (Peru)
Nymphidium
64 lamis Stoll (Ecua.)
Baeotis
65 bacaenis Hew.f.elegantula Hopff.
(Peru)
Metacharis
66 regalis Btlr.f.indissimilis Weeks
(Ecua.)

Calliona
67 siaka Hew. (Peru)
Calospila
68 lasthenes Hew.f.zeurippa Bsdv.
(Mex.)
69 emylius Cr. (Peru)
Aricoris
70 flammula Bates (Peru)
Ancyluris
71 meliboeus Fab. V. (Peru)
72 formosissima Hew. V. (Peru)
73 huascar Sndrs. (Peru)
74 inca Sndrs. ♀. (Col.)
75 mira Hew. (Peru)
76 aulestes Cr.f.lamprotaenia Stich. ♀.
(Ecua.)
77 pulchra Hew.s.sp.formosa Hew.
(Ecua.)
Necyria
78 vetulonia Hew. (Ecua.)
79 duellona Westw. V. (Peru)

80 manco Sndrs. (Col.)
Calydna
81 caieta Hew. (Braz.)
82 calamisa Hew. (Braz.)
Cyrenia
83 martia Westw. V. (Peru).
Lasaia
84 agesilas Latr.f.narses Stgr.
(Argent.)
Apodemia
85 mormo Feld.f.cythera Edw. (USA)
Audre
86 epulus Cr. (Argent.)
Crocozona
87 caecias Hew. V. (Ecua.)
Charis
88 nilus ♀. V. (Mex.)
Anteros
89 carausius Westw.f.principalis
Hopff. V. (Ecua.)
90 bracteata Hew. V. (Ecua.)

Chapter 19

Heliconiidae –

helicons

The family Heliconiidae comprises just under 70 Neotropical species, four of which are also found in the southern states of the USA. They are characterized by a narrow wing shape, usually long antennae, and a thin elongated abdomen. In size they are remarkably uniform, ranging from about 60mm to 100mm.

The species are 'protected' by nauseous body-fluids which render them unpalatable to predators. This property is 'advertized' by brilliant colours and distinctive patterns, combining black with red, orange, yellow and blue in a variety of ways. The enormous range of variation which may exist within a single species makes this one of the most confusing groups for the beginner, and some forms may prove very difficult to identify. Further complications arise from the considerable mimicry between species of the same or different genera and the similarity of many species to butterflies in other families, especially Ithomiidae. These features form perhaps the most outstanding evidence for the Mullerian theory of mimicry (Chapter 9).

The adults are usually slow and lazy fliers, as if 'aware' of their protected nature. They often congregate together in large numbers in open clearings and at night form 'sleeping assemblies'; hanging in clusters from low shrubs. Very often they will return to the same place night after night.

The eggs are of a peculiar spindle shape or bottle shape and are laid singly. The spinous larvae feed almost exclusively on Passi-flora species. The pupae are hump-backed and armed with spines. These are suspended, head down, from the stems of the larval food plant.

Because of the ease with which they can be reared in captivity, their longevity and variation, members of this family are among the butterflies most frequently used for experimental work.

Right: The tiger-striped *Heliconius charithonia* L. is not only the type-species of *Heliconius* but one of only two species in this genus which penetrate the USA. Heliconiidae are very long-lived butterflies and the naturalist William Beebe kept a 'pet' *charithonia* (called Higgins!) for several months. This example was photographed feeding in the Florida Everglades (X 8).

Right: The strikingly handsome *Heliconius burneyi* Hbn. sunning itself on a leaf in Amazonia, Brazil (X 3). The great length of the antennae is clearly shown. This race is *catharinae* Stgr. Another form of the species is shown on page 183.

Left: The blue-black, yellow-banded *Heliconius sara* Fab. is one of the more variable *Heliconius* species. The race shown here is *apseudes* Hbn. from Brazil (X 3). Other forms of this species are shown on page 182.

180

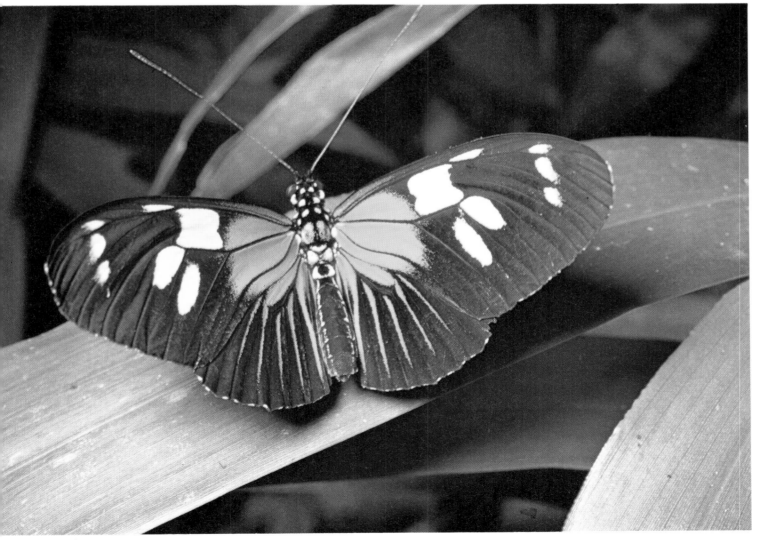

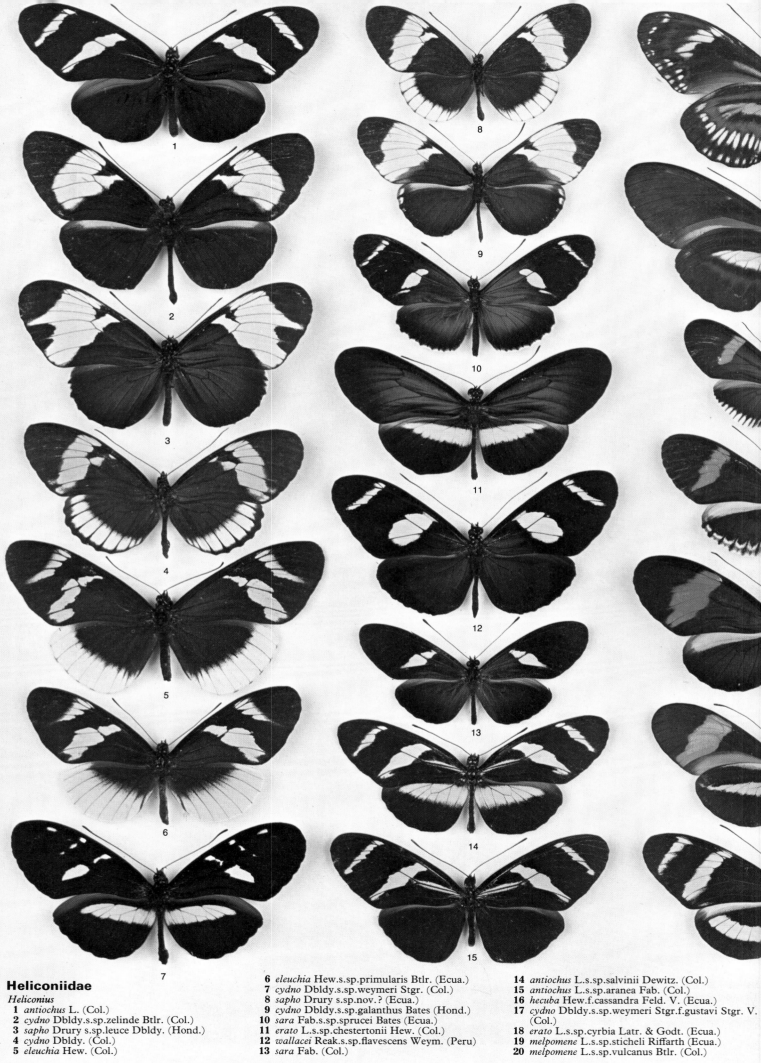

Heliconiidae

Heliconius
1 *antiochus* L. (Col.)
2 *cydno* Dbldy.s.sp.zelinde Btlr. (Col.)
3 *sapho* Drury s.sp.leuce Dbldy. (Hond.)
4 *cydno* Dbldy. (Col.)
5 *eleuchia* Hew. (Col.)

6 *eleuchia* Hew.s.sp.primularis Btlr. (Ecua.)
7 *cydno* Dbldy.s.sp.weymeri Stgr. (Col.)
8 *sapho* Drury s.sp.nov.? (Ecua.)
9 *cydno* Dbldy.s.sp.galanthus Bates (Hond.)
10 *sara* Fab.s.sp.sprucei Bates (Ecua.)
11 *erato* L.s.sp.chestertonii Hew. (Col.)
12 *wallacei* Reak.s.sp.flavescens Weym. (Peru)
13 *sara* Fab. (Col.)

14 *antiochus* L.s.sp.salvinii Dewitz. (Col.)
15 *antiochus* L.s.sp.aranea Fab. (Col.)
16 *hecuba* Hew.f.cassandra Feld. V. (Ecua.)
17 *cydno* Dbldy.s.sp.weymeri Stgr.f.gustavi Stgr. V. (Col.)
18 *erato* L.s.sp.cyrbia Latr. & Godt. (Ecua.)
19 *melpomene* L.s.sp.sticheli Riffarth (Ecua.)
20 *melpomene* L.s.sp.vulcanus Btlr. (Col.)

182

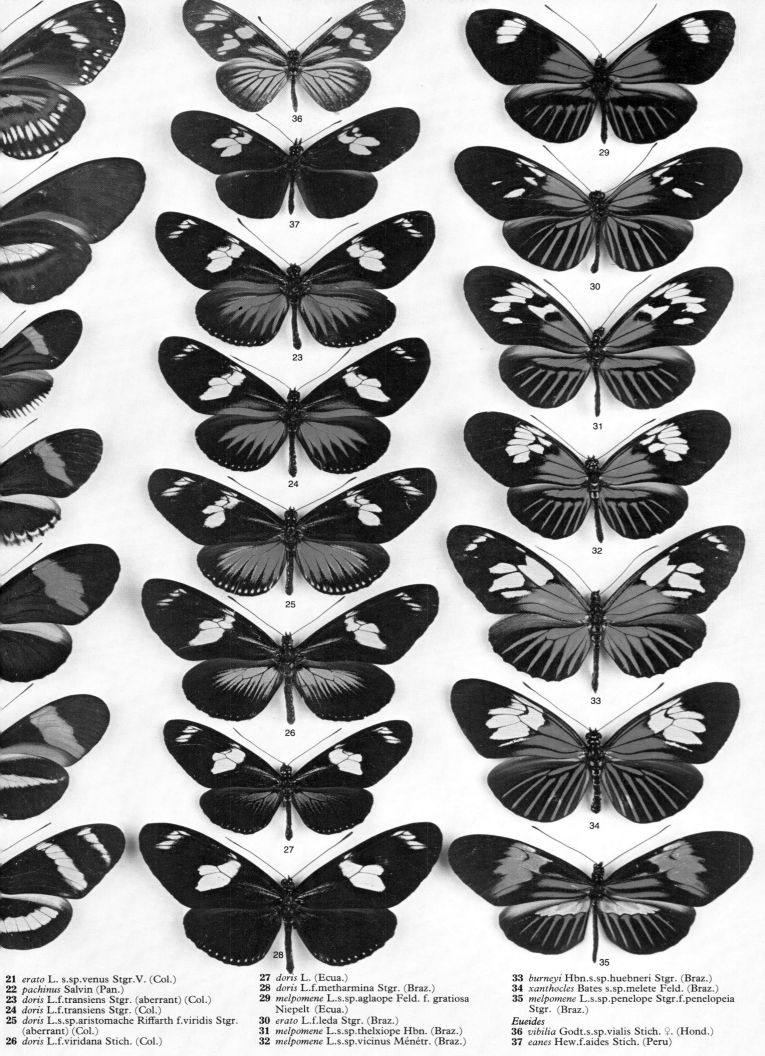

21 *erato* L. s.sp.venus Stgr.V. (Col.)
22 *pachinus* Salvin (Pan.)
23 *doris* L.f.transiens Stgr. (aberrant) (Col.)
24 *doris* L.f.transiens Stgr. (Col.)
25 *doris* L.s.sp.aristomache Riffarth f.viridis Stgr. (aberrant) (Col.)
26 *doris* L.f.viridana Stich. (Col.)

27 *doris* L. (Ecua.)
28 *doris* L.f.metharmina Stgr. (Braz.)
29 *melpomene* L.s.sp.aglaope Feld. f. gratiosa Niepelt (Ecua.)
30 *erato* L.f.leda Stgr. (Braz.)
31 *melpomene* L.s.sp.thelxiope Hbn. (Braz.)
32 *melpomene* L.s.sp.vicinus Ménétr. (Braz.)

33 *burneyi* Hbn.s.sp.huebneri Stgr. (Braz.)
34 *xanthocles* Bates s.sp.melete Feld. (Braz.)
35 *melpomene* L.s.sp.penelope Stgr.f.penelopeia Stgr. (Braz.)
Eueides
36 *vibilia* Godt.s.sp.vialis Stich. ♀. (Hond.)
37 *eanes* Hew.f.aides Stich. (Peru)

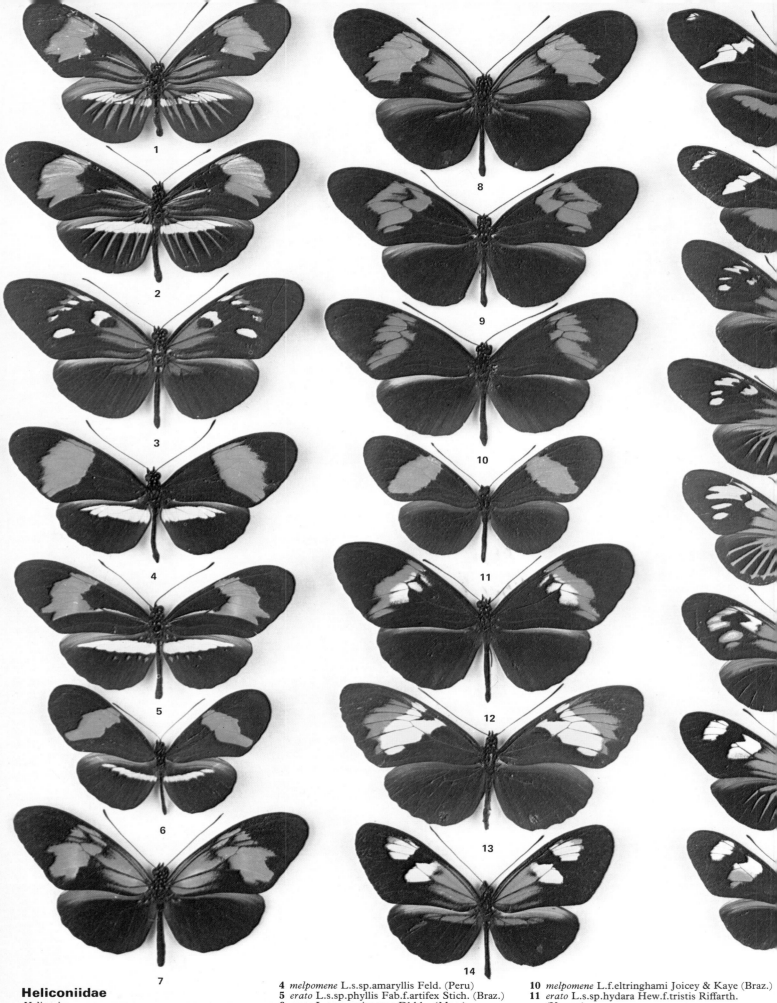

Heliconiidae

Heliconius

1 *erato* L.s.sp.phyllis Fab.f.anacreon G.-Smith & Kirby (Bol.)

2 *erato* L.s.sp.phyllis Fab.f.anacreon G.-Smith & Kirby (aberrant) (Bol.)

3 *melpomene* L.f.funebris Möschler (Guy.)

4 *melpomene* L.s.sp.amaryllis Feld. (Peru)

5 *erato* L.s.sp.phyllis Fab.f.artifex Stich. (Braz.)

6 *erato* L.s.sp.petiverana Dbldy. (Mex.)

7 *erato* L.s.sp.amalfreda Riffarth.f.dryope Riffarth. (Braz.)

8 *erato* L.s.sp.amalfreda Riffarth.f.dryope Riffarth (aberrant) (Braz.)

9 *melpomene* L.f.atrosecta Riffarth. (Guy.)

10 *melpomene* L.f.eltringhami Joicey & Kaye (Braz.)

11 *erato* L.s.sp.hydara Hew.f.tristis Riffarth. (Venez.)

12 *melpomene* L.f.lucinda Riffarth. (Guy.)

13 *heurippa* Hew. ♀. (Col.)

14 *melpomene* L.s.sp.aglaope Feld.f.isolda Niepelt (Ecua.)

15 *clysonimus* Latr.s.sp.hygiana Hew. (Ecua.)

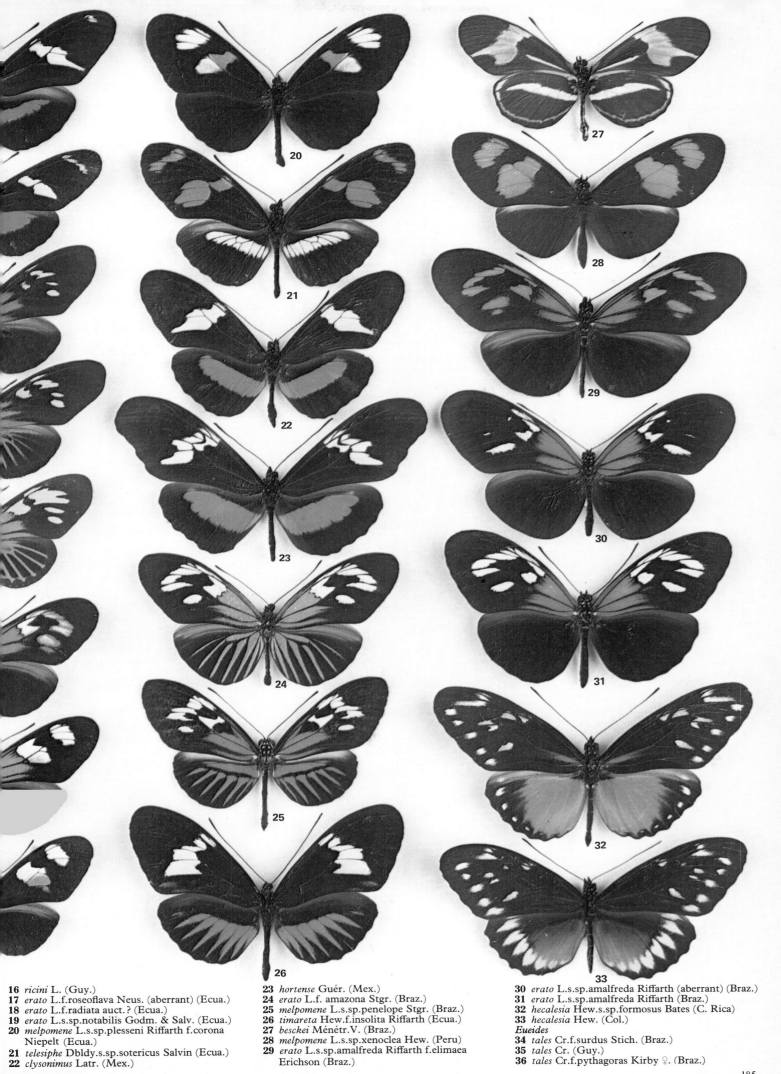

16 *ricini* L. (Guy.)
17 *erato* L.f.roseoflava Neus. (aberrant) (Ecua.)
18 *erato* L.f.radiata auct.? (Ecua.)
19 *erato* L.s.sp.notabilis Godm. & Salv. (Ecua.)
20 *melpomene* L.s.sp.plesseni Riffarth f.corona
 Niepelt (Ecua.)
21 *telesiphe* Dbldy.s.sp.sotericus Salvin (Ecua.)
22 *clysonimus* Latr. (Mex.)

23 *hortense* Guér. (Mex.)
24 *erato* L.f. amazona Stgr. (Braz.)
25 *melpomene* L.s.sp.penelope Stgr. (Braz.)
26 *timareta* Hew.f.insolita Riffarth (Ecua.)
27 *besckei* Ménétr.V. (Braz.)
28 *melpomene* L.s.sp.xenoclea Hew. (Peru)
29 *erato* L.s.sp.amalfreda Riffarth f.elimaea
 Erichson (Braz.)

30 *erato* L.s.sp.amalfreda Riffarth (aberrant) (Braz.)
31 *erato* L.s.sp.amalfreda Riffarth (Braz.)
32 *hecalesia* Hew.s.sp.formosus Bates (C. Rica)
33 *hecalesia* Hew. (Col.)
Eueides
34 *tales* Cr.f.surdus Stich. (Braz.)
35 *tales* Cr. (Guy.)
36 *tales* Cr.f.pythagoras Kirby ♀. (Braz.)

185

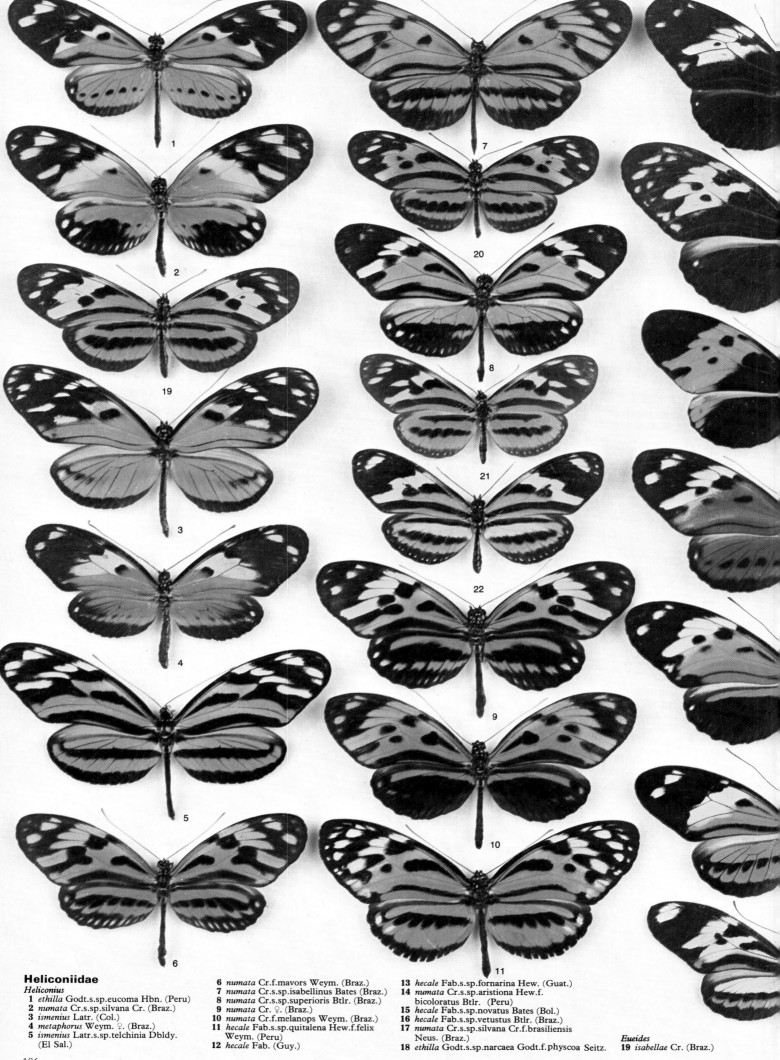

Heliconiidae

Heliconius

1 *ethilla* Godt.s.sp.eucoma Hbn. (Peru)
2 *numata* Cr.s.sp.silvana Cr. (Braz.)
3 *ismenius* Latr. (Col.)
4 *metaphorus* Weym. ♀. (Braz.)
5 *ismenius* Latr.s.sp.telchinia Dbldy. (El Sal.)

6 *numata* Cr.f.mavors Weym. (Braz.)
7 *numata* Cr.s.sp.isabellinus Bates (Braz.)
8 *numata* Cr.s.sp.superioris Btlr. (Braz.)
9 *numata* Cr. ♀. (Braz.)
10 *numata* Cr.f.melanops Weym. (Braz.)
11 *hecale* Fab.s.sp.quitalena Hew.f.felix Weym. (Peru)
12 *hecale* Fab. (Guy.)

13 *hecale* Fab.s.sp.fornarina Hew. (Guat.)
14 *numata* Cr.s.sp.aristiona Hew.f. bicoloratus Btlr. (Peru)
15 *hecale* Fab.s.sp.novatus Bates (Bol.)
16 *hecale* Fab.s.sp.vetustus Btlr. (Braz.)
17 *numata* Cr.s.sp.silvana Cr.f.brasiliensis Neus. (Braz.)
18 *ethilla* Godt.s.sp.narcaea Godt.f.physcoa Seitz.

Eueides

19 *isabellae* Cr. (Braz.)

186

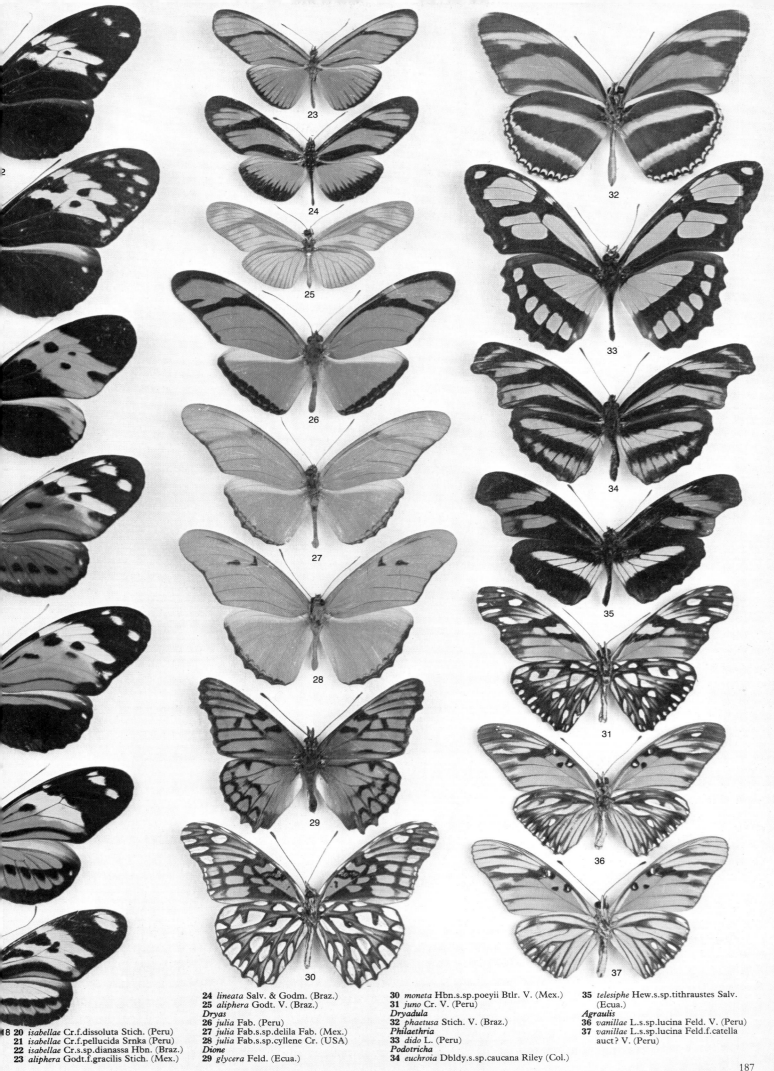

24 *lineata* Salv. & Godm. (Braz.)
25 *aliphera* Godt. V. (Braz.)
Dryas
26 *julia* Fab. (Peru)
27 *julia* Fab.s.sp.delila Fab. (Mex.)
28 *julia* Fab.s.sp.cyllene Cr. (USA)
Dione
29 *glycera* Feld. (Ecua.)

30 *moneta* Hbn.s.sp.poeyii Btlr. V. (Mex.)
31 *juno* Cr. V. (Peru)
Dryadula
32 *phaetusa* Stich. V. (Braz.)
Philaethria
33 *dido* L. (Peru)
Podotricha
34 *euchroia* Dbldy.s.sp.caucana Riley (Col.)

35 *telesiphe* Hew.s.sp.tithraustes Salv.
(Ecua.)
Agraulis
36 *vanillae* L.s.sp.lucina Feld. V. (Peru)
37 *vanillae* L.s.sp.lucina Feld.f.catella
auct? V. (Peru)

18 **20** *isabellae* Cr.f.dissoluta Stich. (Peru)
21 *isabellae* Cr.f.pellucida Srnka (Peru)
22 *isabellae* Cr.s.sp.dianassa Hbn. (Braz.)
23 *aliphera* Godt.f.gracilis Stich. (Mex.)

Chapter 20

Acraeidae –

acraeas

The family Acraeidae consists of small to medium-sized butter-flies, generally with narrow wings and long slender abdomens. Although a few species are found in the Indo-Australian region (*Pareba*, *Miyana* species, etc) and an extensive genus (*Actinote*) lives in South America, their true home is Africa. This country and Madagascar accounts for almost 200 of the known species.

In wing-span they range from a little more than 25mm (the smallest *Acraea* species) to about 90mm (*Bematistes*). They are predominantly shades of reddish brown or sandy colour, blending with the African landscape. A few species have transparent wing areas and may superficially resemble insects other than butterflies. They are slow-flying and often gregarious, sometimes assembling in such large numbers that low bushes are almost covered by them.

Most species can eject an unpleasant yellow fluid from the thorax, which affords them considerable protection from predators.

Below: The spotted bodies and wing patterns of Acraeidae are believed to 'advertise' their poisonous nature to would-be predators. The attractively marked *Acraea anacreon* Trim. is one of the most familiar species in southern Africa and may sometimes be found feeding in large groups. The example shown is deeply probing a daisy flower in search of nectar (X 10). The upper side is shown on page 190.

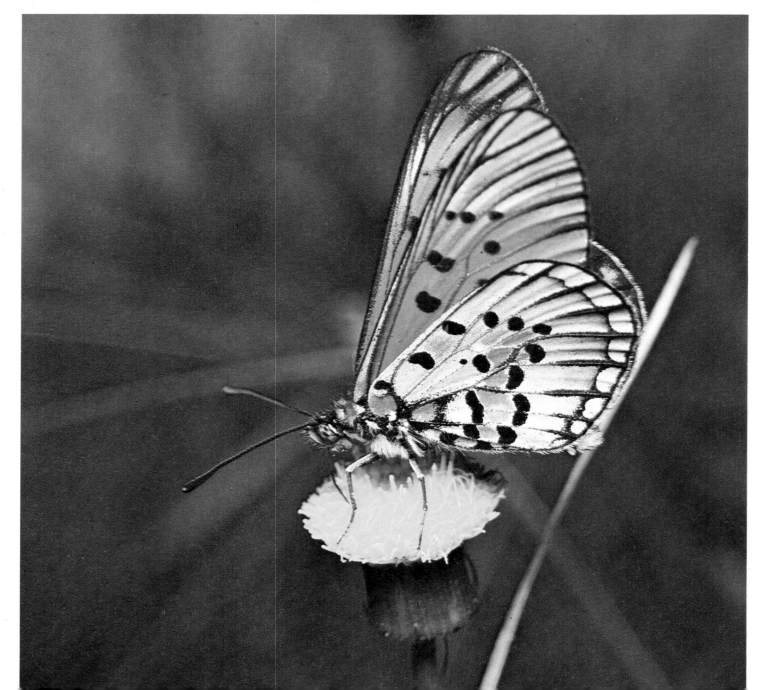

Above: In the Neotropical region this family is represented by the curious genus *Actinote*. All species are rather weak-looking with conspicuous spiny hairs on the undersides of the wings. This strikingly banded example is *Actinote momina* Jord. from the Rio Huallaga in Peru (X 8).

Left: Many lepidopterists consider the Acraeidae to be somewhat dull in appearance, but the delicate beauty of this South African *Acraea zetes* L. marks it out as an exception. This is of the race *acara* Hew. (X 8). A female example of the type-form is shown on page 190.

Because of this phenomenon a considerable number of them are mimicked by other butterflies. Members of widely differing families (eg Papilionidae and Lycaenidae) may exhibit *Acraea*-like colour and pattern and even behave in a similar way. In many respects the family parallels the Neotropical Heliconiidae.

The Neotropical representatives *(Actinote)* dwell largely in forest clearings and in addition to the normal red-brown colouration they may also show a metallic blue. The wings are more hairy than those of their African counterparts.

The larvae are spiny and those of most African species feed on Passifloraceae. The Neotropical *Actinote*, by contrast, feed on a wide variety of plants.

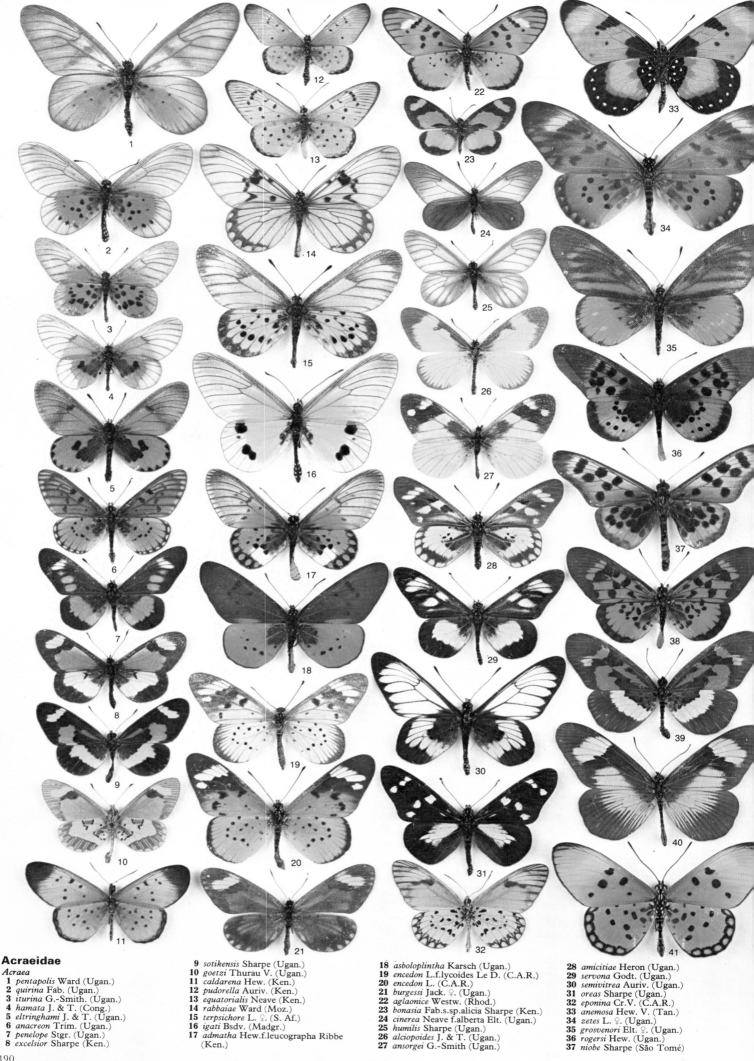

Acraeidae

Acraea

1 *pentapolis* Ward (Ugan.)
2 *quirina* Fab. (Ugan.)
3 *iturina* G.-Smith. (Ugan.)
4 *hamata* J. & T. (Cong.)
5 *eltringhami* J. & T. (Ugan.)
6 *anacreon* Trim. (Ugan.)
7 *penelope* Stgr. (Ugan.)
8 *excelsior* Sharpe (Ken.)

9 *sotikensis* Sharpe (Ugan.)
10 *goetzi* Thurau V. (Ugan.)
11 *caldarena* Hew. (Ken.)
12 *pudorella* Auriv. (Ken.)
13 *equatorialis* Neave (Ken.)
14 *rabbaiae* Ward (Moz.)
15 *terpsichore* L. ♀. (S. Af.)
16 *igati* Bsdv. (Madgr.)
17 *admatha* Hew.f.leucographa Ribbe
 (Ken.)

18 *asboloplintha* Karsch (Ugan.)
19 *encedon* L.f.lycoides Le D. (C.A.R.)
20 *encedon* L. (C.A.R.)
21 *burgessi* Jack. ♀. (Ugan.)
22 *aglaonice* Westw. (Rhod.)
23 *bonasia* Fab.s.sp.alicia Sharpe (Ken.)
24 *cinerea* Neave f.alberta Elt. (Ugan.)
25 *humilis* Sharpe (Ugan.)
26 *alciopoides* J. & T. (Ugan.)
27 *ansorgei* G.-Smith (Ugan.)

28 *amicitiae* Heron (Ugan.)
29 *servona* Godt. (Ugan.)
30 *semivitrea* Auriv. (Ugan.)
31 *oreas* Sharpe (Ugan.)
32 *eponina* Cr.V. (C.A.R.)
33 *anemosa* Hew. V. (Tan.)
34 *zetes* L. ♀. (Ugan.)
35 *grosvenori* Elt. ♀. (Ugan.)
36 *rogersi* Hew. (Ugan.)
37 *niobe* Sharpe (São Tomé)

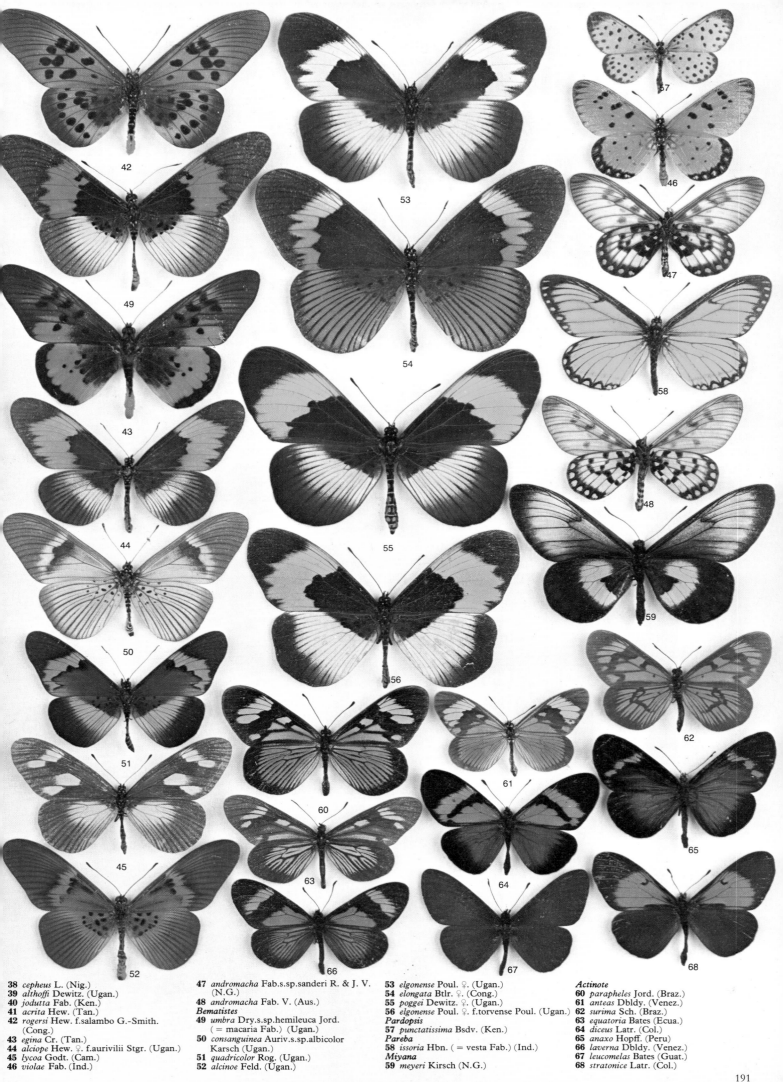

38 *cepheus* L. (Nig.)
39 *althoffi* Dewitz. (Ugan.)
40 *jodutta* Fab. (Ken.)
41 *acrita* Hew. (Tan.)
42 *rogersi* Hew. f.salambo G.-Smith. (Cong.)
43 *egina* Cr. (Tan.)
44 *alciope* Hew. ♀. f.aurivilii Stgr. (Ugan.)
45 *lycoa* Godt. (Cam.)
46 *violae* Fab. (Ind.)

47 *andromacha* Fab.s.sp.sanderi R. & J. V. (N.G.)
48 *andromacha* Fab. V. (Aus.)
Bematistes
49 *umbra* Dry.s.sp.hemileuca Jord. (= macaria Fab.) (Ugan.)
50 *consanguinea* Auriv.s.sp.albicolor Karsch (Ugan.)
51 *quadricolor* Rog. (Ugan.)
52 *alcinoe* Feld. (Ugan.)

53 *elgonense* Poul. ♀. (Ugan.)
54 *elongata* Btlr. ♀. (Cong.)
55 *poggei* Dewitz. ♀. (Ugan.)
56 *elgonense* Poul. ♀. f.torvense Poul. (Ugan.)
Pardopsis
57 *punctatissima* Bsdv. (Ken.)
Pareba
58 *issoria* Hbn. (= vesta Fab.) (Ind.)
Miyana
59 *meyeri* Kirsch (N.G.)

Actinote
60 *parapheles* Jord. (Braz.)
61 *anteas* Dbldy. (Venez.)
62 *surima* Sch. (Braz.)
63 *equatoria* Bates (Ecua.)
64 *diceus* Latr. (Col.)
65 *anaxo* Hopff. (Peru)
66 *laverna* Dbldy. (Venez.)
67 *leucomelas* Bates (Guat.)
68 *stratonice* Latr. (Col.)

191

Chapter 21
Nymphalidae –

The family Nymphalidae is one of the largest. It is represented in all world regions and contains several thousand species. The smallest are only 25mm in wingspan *(Dynamine)* and the largest less than 130mm (females of *Sasakia, Charaxes,* and *Prepona).* Some of the most brilliantly coloured butterflies belong to this family and the range of pattern and wingshape is extensive.

Many of the larger groups have received popular names. The fritillaries *(Argynnini)* are orange or tawny with darker markings and frequently silver-spotted under sides. They are found principally in the northern hemisphere. Vanessas *(Vanessidi)* are widely distributed and include that most cosmopolitan of butterflies, the painted lady *Vanessa cardui.*

The jungles of South America are rich in Nymphalidae and some of the genera occurring only there *(Callicore, Perisama, Callithea,* etc) have few rivals among butterflies for their combination of dazzling colours and arresting patterns. Larger and equally splendid are the magnificent *Agrias* and *Prepona* species. These two genera are closely allied to the splendid rajahs *(Charaxes)* which are among the most powerfully flying butterflies. These are found in all Old World regions but the great majority are confined to Africa.

Admirals *(Limenitini)* take their name from the banded appearance of their wings, recalling stripes on a naval uniform. These and their numerous allies are represented in all regions and include many confusingly similar species.

The Old World map butterflies *(Cyrestis)* have strange map-like wing markings and an unusual wing shape. Even more curious are their New World relatives *(Marpesia)* which have long hind wing tails, giving them a superficial resemblance to swallowtail butterflies (Papilionidae).

Another subfamily with Old and New World representatives is the *Apaturinae* or emperors. The males of many species exhibit the most beautiful structural coloration which is best seen when the insects are viewed at an angle.

The eggs are of many shapes but generally the horizontal axis exceeds the vertical. The surface is frequently ribbed and these ribs are sometimes extended into points. The larvae of most groups within the family have more-or-less developed spines, although those of *Charaxinae* and *Apaturinae* are smooth-skinned with head and/or tail processes only. A similar situation exists in pupal form, the most characteristic being angular with a spiked appearance but relatively smooth in *Charaxinae.* The golden appearance of the pupae in some species (for example members of the tribe *Vanessidi)* led early entomologists to refer to these as aurelia and themselves as aurelians.

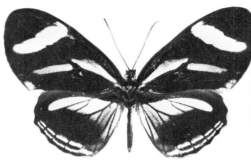

1. *Vila azeca* Dbldy. & Hew. (Peru)

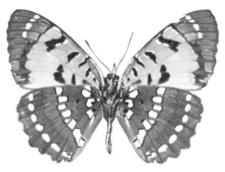

2. *Byblia acheloia* Wallen.V. (Ugan.)

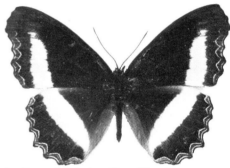

3. *Eurytela hiarbas* Dry. (Ken.)

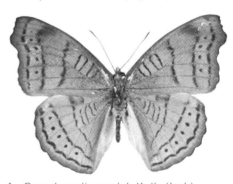

4. *Pseudergolis wedah* Koll. (Ind.)

Above: Ergolids (Eurytelinae) and a pseudo-Ergolid. Members of this curious sub-family suggest the appearance of quite unrelated species. No. 4 is a reversal of this situation: it is not a true Ergolid but is allied to *Marpesia* (page 210) (all X 1.5).

Far right (top): The exquisite *Anartia amathea* L. from Colombia (X 4).

Far right (bottom): A group of *Cyrestis elegans* Bsdv. in Madagascar (X 1.5).

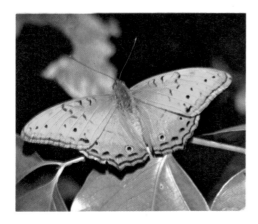

Left: *Vindula arsinoe* Cr. is a particularly powerful flier. This is s.sp. *ada* Btlr., from Australia (X. 0.25).

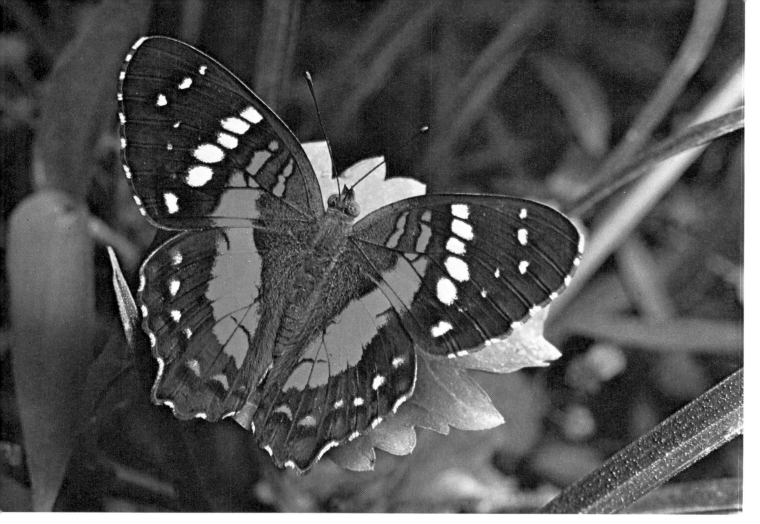

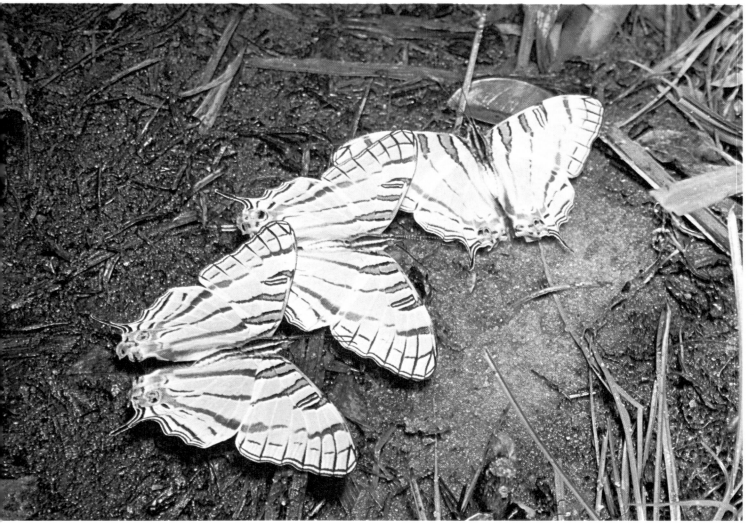

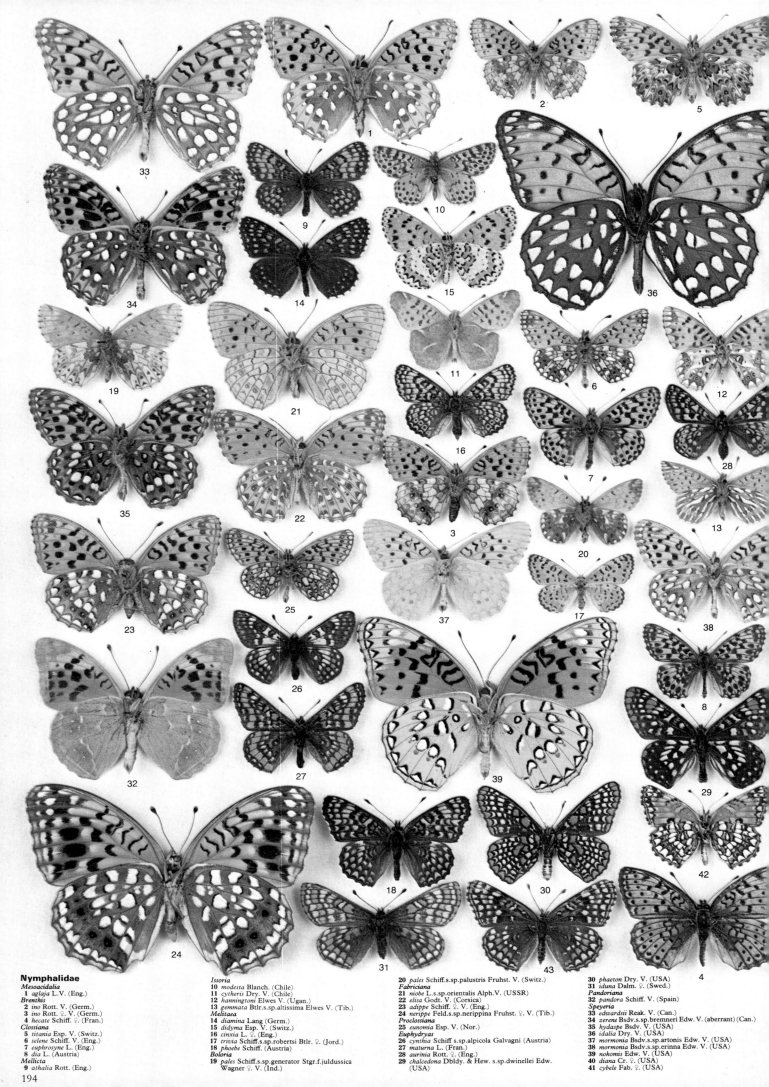

194

Nymphalidae

Mesoacidalia
1 *aglaja* L.V. (Eng.)

Brenthis
2 *ino* Rott. V. (Germ.)
3 *ino* Rott. ♀. V. (Germ.)
4 *hecate* Schiff. ♀. (Fran.)

Clossiana
5 *titania* Esp. V. (Switz.)
6 *selene* Schiff. V. (Eng.)
7 *euphrosyne* L. (Eng.)
8 *dia* L. (Austria)

Mellicta
9 *athalia* Rott. (Eng.)

Issoria
10 *modesta* Blanch. (Chile)
11 *cytheris* Dry. V. (Chile)
12 *hanningtoni* Elwes V. (Ugan.)
13 *gemmata* Btlr.s.sp.altissima Elwes V. (Tib.)

Melitaea
14 *diamina* Lang (Germ.)
15 *didyma* Esp. V. (Switz.)
16 *cinxia* L. ♀. (Eng.)
17 *trivia* Schiff.s.sp.robertsi Btlr. ♀. (Jord.)
18 *phoebe* Schiff. (Austria)

Boloria
19 *pales* Schiff.s.sp.generator Stgr.f.juldussica Wagner ♀. V. (Ind.)

20 *pales* Schiff.s.sp.palustris Fruhst. V. (Switz.)

Fabriciana
21 *niobe* L.s.sp.orientalis Alph.V. (USSR)
22 *elisa* Godt. V. (Corsica)
23 *adippe* Schiff. ♀. V. (Eng.)
24 *nerippe* Feld.s.sp.nerippina Fruhst. ♀. V. (Tib.)

Proclossiana
25 *eunomia* Esp. V. (Nor.)

Euphydryas
26 *cynthia* Schiff.s.sp.alpicola Galvagni (Austria)
27 *maturna* L. (Fran.)
28 *aurinia* Rott. (Eng.)
29 *chalcedona* Dbldy. & Hew. s.sp.dwinellei Edw. (USA)

30 *phaeton* Dry. V. (USA)
31 *iduna* Dalm. ♀. (Swed.)

Pandoriana
32 *pandora* Schiff. V. (Spain)

Speyeria
33 *edwardsii* Reak. V. (Can.)
34 *zerene* Bsdv.s.sp.bremneri Edw. V. (aberrant) (Can.)
35 *hydaspe* Bsdv. V. (USA)
36 *idalia* Dry. V. (USA)
37 *mormonia* Bsdv.s.sp.artonis Edw. V. (USA)
38 *mormonia* Bsdv.s.sp.erinna Edw. V. (USA)
39 *nokomis* Edw. V. (USA)
40 *diana* Cr. ♀. (USA)
41 *cybele* Fab. ♀. (USA)

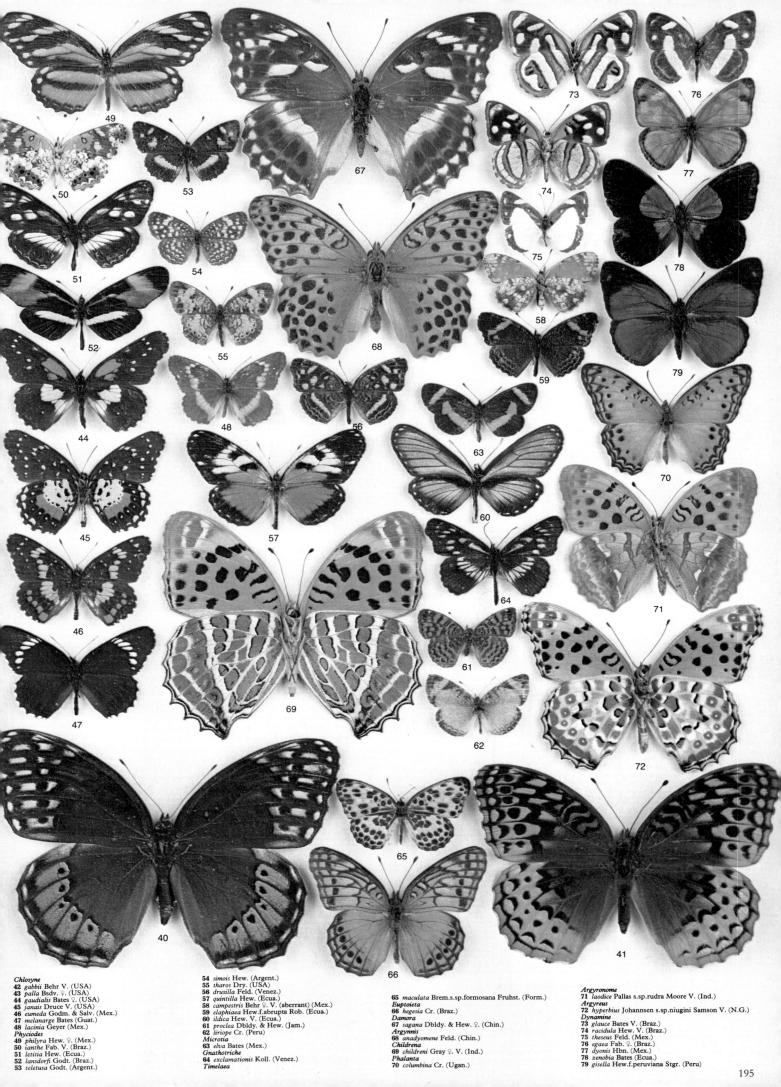

195

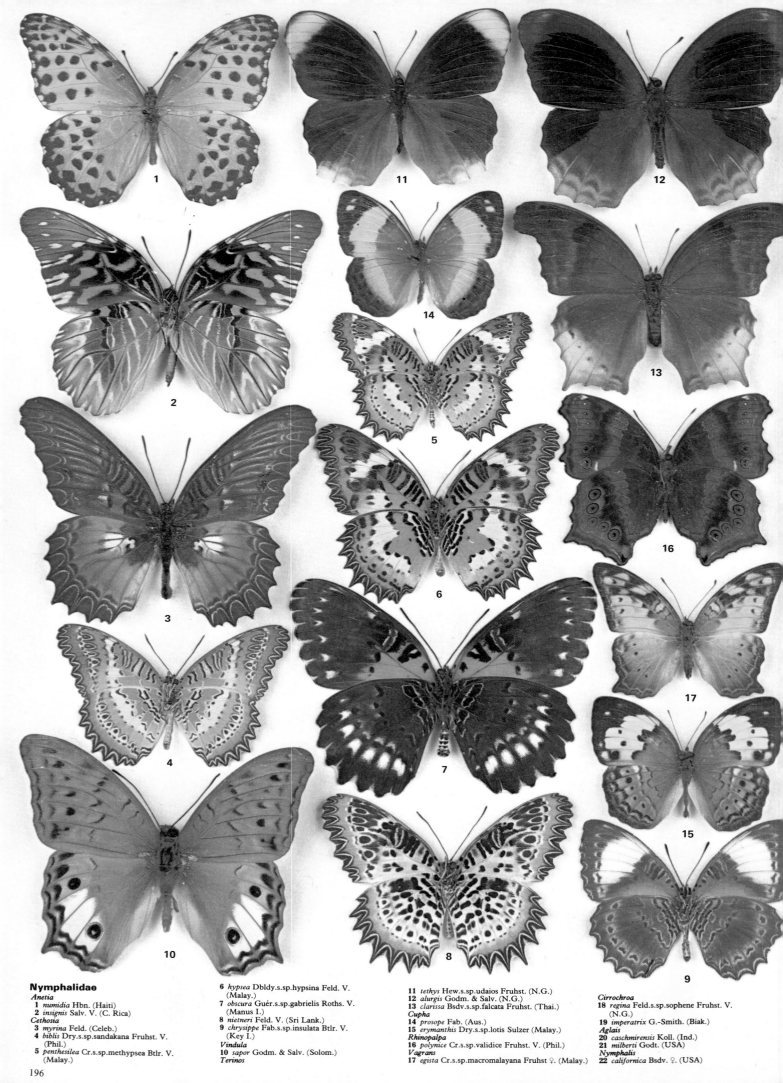

Nymphalidae

Anetia
1 *numidia* Hbn. (Haiti)
2 *insignis* Salv. V. (C. Rica)
Cethosia
3 *myrina* Feld. (Celeb.)
4 *biblis* Dry.s.sp.sandakana Fruhst. V. (Phil.)
5 *penthesilea* Cr.s.sp.methypsea Btlr. V. (Malay.)

6 *hypsea* Dbldy.s.sp.hypsina Feld. V. (Malay.)
7 *obscura* Guér.s.sp.gabrielis Roths. V. (Manus I.)
8 *nietneri* Feld. V. (Sri Lank.)
9 *chrysippe* Fab.s.sp.insulata Btlr. V. (Key I.)
Vindula
10 *sapor* Godm. & Salv. (Solom.)
Terinos

11 *tethys* Hew.s.sp.udaios Fruhst. (N.G.)
12 *alurgis* Godm. & Salv. (N.G.)
13 *clarissa* Bsdv.s.sp.falcata Fruhst. (Thai.)
Cupha
14 *prosope* Fab. (Aus.)
15 *erymanthis* Dry.s.sp.lotis Sulzer (Malay.)
Rhinopalpa
16 *polynice* Cr.s.sp.validice Fruhst. V. (Phil.)
Vagrans
17 *egista* Cr.s.sp.macromalayana Fruhst. ♀. (Malay.)

Cirrochroa
18 *regina* Feld.s.sp.sophene Fruhst. V. (N.G.)
19 *imperatrix* G.-Smith. (Biak.)
Aglais
20 *caschmirensis* Koll. (Ind.)
21 *milberti* Godt. (USA)
Nymphalis
22 *californica* Bsdv. ♀. (USA)

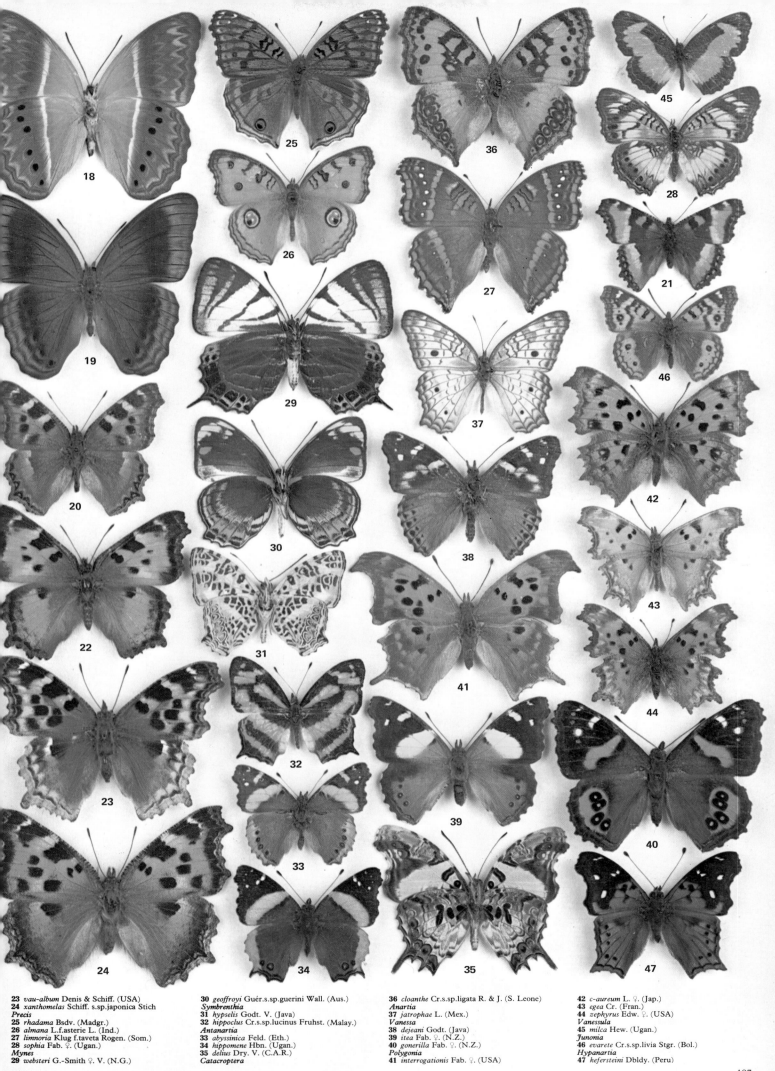

23 *vau-album* Denis & Schiff. (USA)
24 *xanthomelas* Schiff. s.sp.japonica Stich
Precis
25 *rhadama* Bsdv. (Madgr.)
26 *almana* L.f.asterie L. (Ind.)
27 *limnoria* Klug f.taveta Rogen. (Som.)
28 *sophia* Fab. ♀. (Ugan.)
Mynes
29 *websteri* G.-Smith ♀. V. (N.G.)

30 *geoffroyi* Guér.s.sp.guerini Wall. (Aus.)
Symbrenthia
31 *hypselis* Godt. V. (Java)
32 *hippoclus* Cr.s.sp.lucinus Fruhst. (Malay.)
Antanartia
33 *abyssinica* Feld. (Eth.)
34 *hippomene* Hbn. (Ugan.)
35 *delius* Dry. V. (C.A.R.)
Catacroptera

36 *cloanthe* Cr.s.sp.ligata R. & J. (S. Leone)
Anartia
37 *jatrophae* L. (Mex.)
Vanessa
38 *dejeani* Godt. (Java)
39 *itea* Fab. ♀. (N.Z.)
40 *gonerilla* Fab. ♀. (N.Z.)
Polygonia
41 *interrogationis* Fab. ♀. (USA)

42 *c-aureum* L. ♀. (Jap.)
43 *egea* Cr. (Fran.)
44 *zephyrus* Edw. ♀. (USA)
Vanessula
45 *milca* Hew. (Ugan.)
Junonia
46 *evarete* Cr.s.sp.livia Stgr. (Bol.)
Hypanartia
47 *kefersteini* Dbldy. (Peru)

197

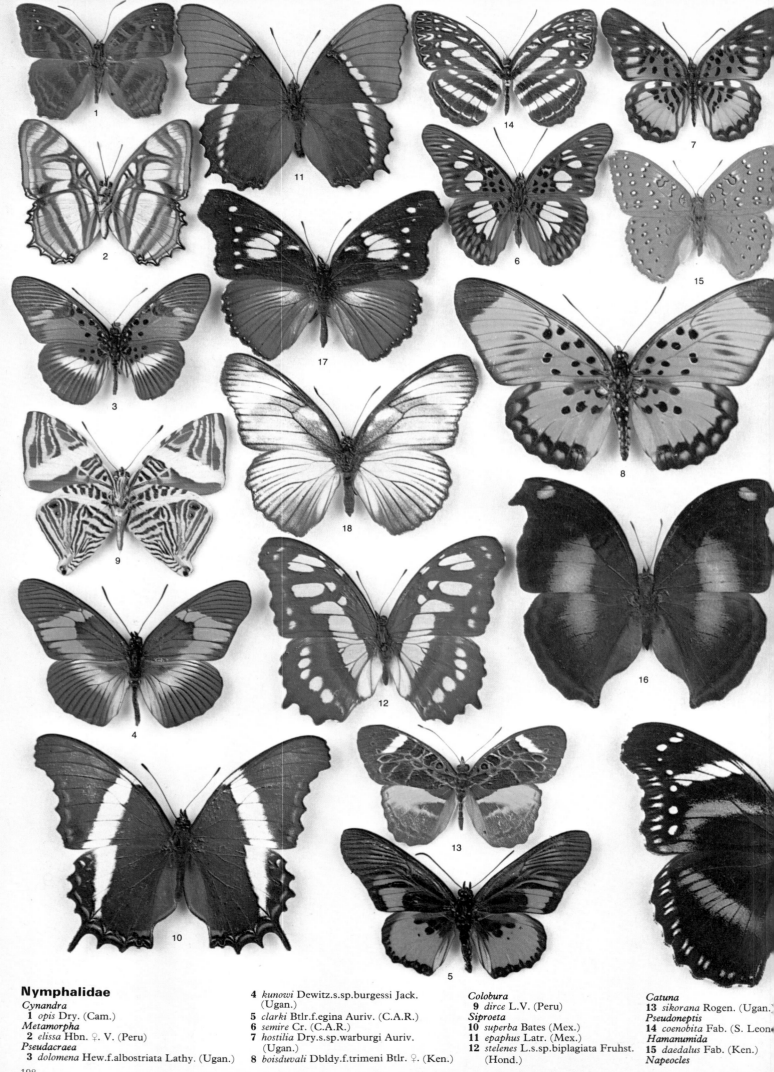

Nymphalidae

Cynandra
1 *opis* Dry. (Cam.)
Metamorpha
2 *elissa* Hbn. ♀. V. (Peru)
Pseudacraea
3 *dolomena* Hew.f.albostriata Lathy. (Ugan.)

4 *kunowi* Dewitz.s.sp.burgessi Jack. (Ugan.)
5 *clarki* Btlr.f.egina Auriv. (C.A.R.)
6 *semire* Cr. (C.A.R.)
7 *hostilia* Dry.s.sp.warburgi Auriv. (Ugan.)
8 *boisduvali* Dbldy.f.trimeni Btlr. ♀. (Ken.)

Colobura
9 *dirce* L.V. (Peru)
Siproeta
10 *superba* Bates (Mex.)
11 *epaphus* Latr. (Mex.)
12 *stelenes* L.s.sp.biplagiata Fruhst. (Hond.)

Catuna
13 *sikorana* Rogen. (Ugan.)
Pseudoneptis
14 *coenobita* Fab. (S. Leon.)
Hamanumida
15 *daedalus* Fab. (Ken.)
Napeocles

198

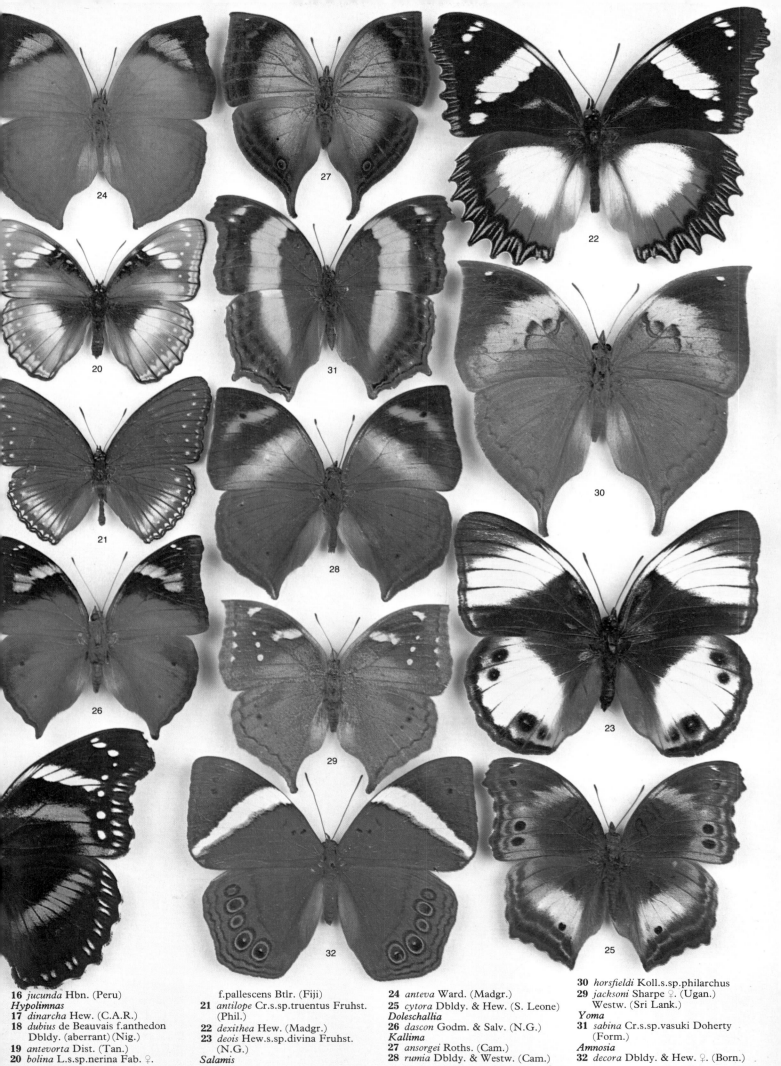

16 *jucunda* Hbn. (Peru)
Hypolimnas
17 *dinarcha* Hew. (C.A.R.)
18 *dubius* de Beauvais f.anthedon
 Dbldy. (aberrant) (Nig.)
19 *antevorta* Dist. (Tan.)
20 *bolina* L.s.sp.nerina Fab. ♀.

f.pallescens Btlr. (Fiji)
21 *antilope* Cr.s.sp.truentus Fruhst.
 (Phil.)
22 *dexithea* Hew. (Madgr.)
23 *deois* Hew.s.sp.divina Fruhst.
 (N.G.)
Salamis

24 *anteva* Ward. (Madgr.)
25 *cytora* Dbldy. & Hew. (S. Leone)
Doleschallia
26 *dascon* Godm. & Salv. (N.G.)
Kallima
27 *ansorgei* Roths. (Cam.)
28 *rumia* Dbldy. & Westw. (Cam.)

30 *horsfieldi* Koll.s.sp.philarchus
29 *jacksoni* Sharpe ♀. (Ugan.)
 Westw. (Sri Lank.)
Yoma
31 *sabina* Cr.s.sp.vasuki Doherty
 (Form.)
Amnosia
32 *decora* Dbldy. & Hew. ♀. (Born.)

199

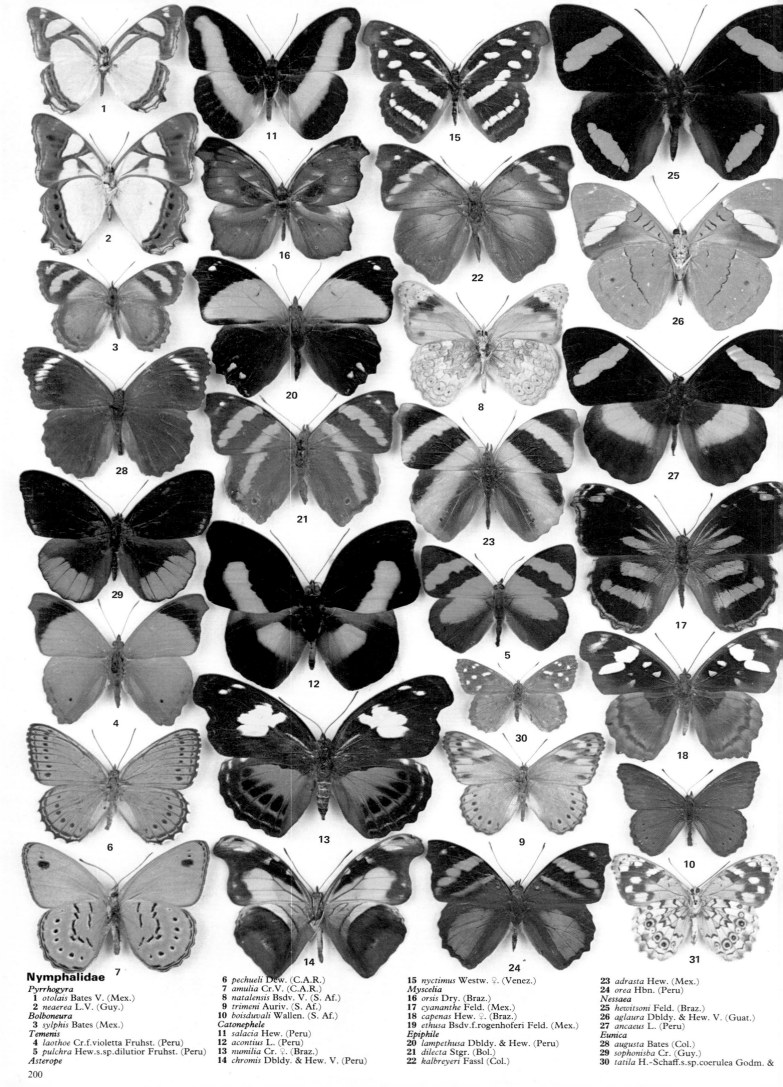

Nymphalidae

Pyrrhogyra
 1 *otolais* Bates V. (Mex.)
 2 *neaerea* L.V. (Guy.)
Bolboneura
 3 *sylphis* Bates (Mex.)
Temenis
 4 *laothoe* Cr.f.violetta Fruhst. (Peru)
 5 *pulchra* Hew.s.sp.dilutior Fruhst. (Peru)
Asterope

6 *pechueli* Dew. (C.A.R.)
7 *amulia* Cr.V. (C.A.R.)
8 *natalensis* Bsdv. V. (S. Af.)
9 *trimeni* Auriv. (S. Af.)
10 *boisduvali* Wallen. (S. Af.)
Catonephele
11 *salacia* Hew. (Peru)
12 *acontius* L. (Peru)
13 *numilia* Cr. ♀. (Braz.)
14 *chromis* Dbldy. & Hew. V. (Peru)

15 *nyctimus* Westw. ♀. (Venez.)
Myscelia
16 *orsis* Dry. (Braz.)
17 *cyananthe* Feld. (Mex.)
18 *capenas* Hew. ♀. (Braz.)
19 *ethusa* Bsdv.f.rogenhoferi Feld. (Mex.)
Epiphile
20 *lampethusa* Dbldy. & Hew. (Peru)
21 *dilecta* Stgr. (Bol.)
22 *kalbreyeri* Fassl (Col.)

23 *adrasta* Hew. (Mex.)
24 *orea* Hbn. (Peru)
Nessaea
25 *hewitsoni* Feld. (Braz.)
26 *aglaura* Dbldy. & Hew. V. (Guat.)
27 *ancaeus* L. (Peru)
Eunica
28 *augusta* Bates (Col.)
29 *sophonisba* Cr. (Guy.)
30 *tatila* H.-Schaff.s.sp.coerulea Godm. &

200

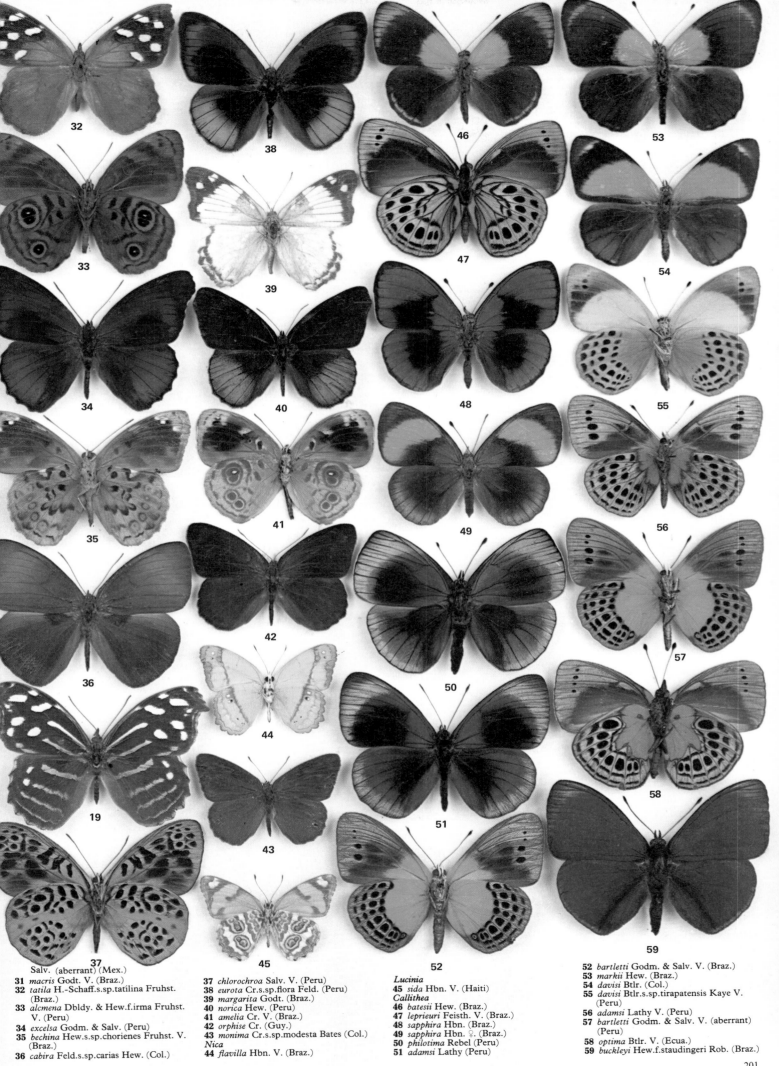

32

38

33

39

46

53

34

40

47

54

35

41

48

55

36

42

49

56

19

44

50

57

37

43

51

58

45

52

59

Salv. (aberrant) (Mex.)

31 *macris* Godt. V. (Braz.)
32 *tatila* H.-Schaff.s.sp.tatilina Fruhst. (Braz.)
33 *alcmena* Dbldy. & Hew.f.irma Fruhst. V. (Peru)
34 *excelsa* Godm. & Salv. (Peru)
35 *bechina* Hew.s.sp.chorienes Fruhst. V. (Braz.)
36 *cabira* Feld.s.sp.carias Hew. (Col.)

37 *chlorochroa* Salv. V. (Peru)
38 *eurota* Cr.s.sp.flora Feld. (Peru)
39 *margarita* Godt. (Braz.)
40 *norica* Hew. (Peru)
41 *amelia* Cr. V. (Braz.)
42 *orphise* Cr. (Guy.)
43 *monima* Cr.s.sp.modesta Bates (Col.)
Nica
44 *flavilla* Hbn. V. (Braz.)

Lucinia
45 *sida* Hbn. V. (Haiti)
Callithea
46 *batesii* Hew. (Braz.)
47 *leprieuri* Feisth. V. (Braz.)
48 *sapphira* Hbn. (Braz.)
49 *sapphira* Hbn. ♀. (Braz.)
50 *philotima* Rebel (Peru)
51 *adamsi* Lathy (Peru)

52 *bartletti* Godm. & Salv. V. (Braz.)
53 *markii* Hew. (Braz.)
54 *davisi* Btlr. (Col.)
55 *davisi* Btlr.s.sp.tirapatensis Kaye V. (Peru)
56 *adamsi* Lathy V. (Peru)
57 *bartletti* Godm. & Salv. V. (aberrant) (Peru)
58 *optima* Btlr. V. (Ecua.)
59 *buckleyi* Hew.f.staudingeri Rob. (Braz.)

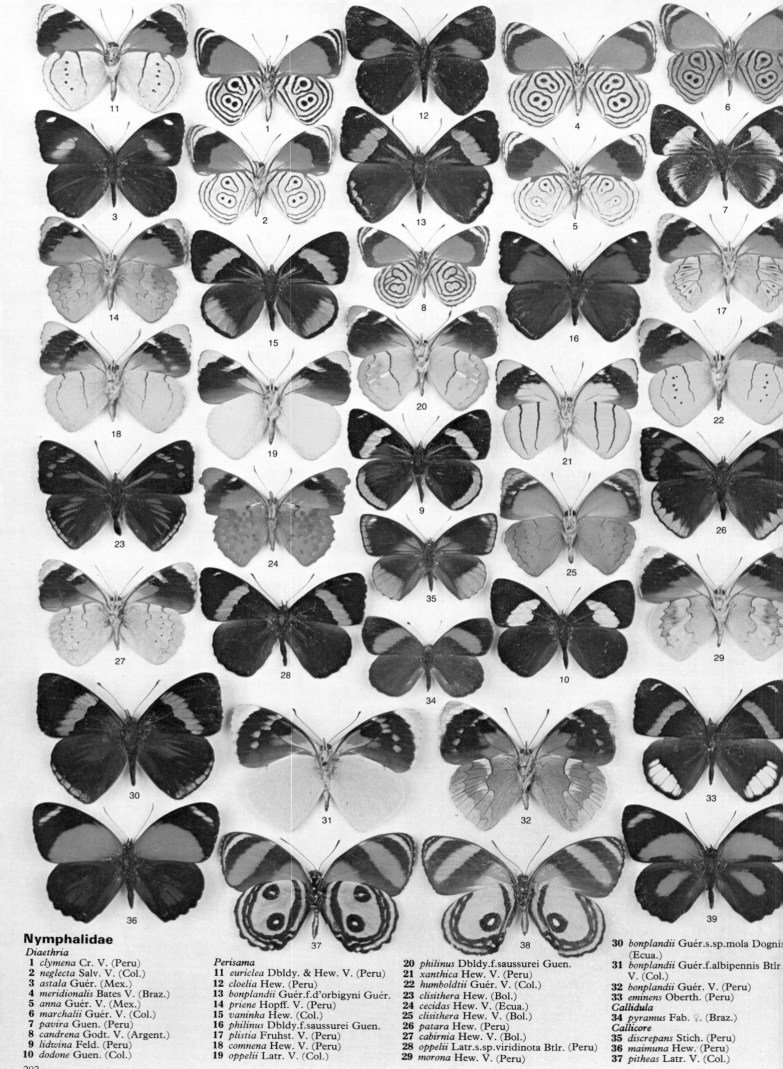

Nymphalidae

Diaethria
1 *clymena* Cr. V. (Peru)
2 *neglecta* Salv. V. (Col.)
3 *astala* Guér. (Mex.)
4 *meridionalis* Bates V. (Braz.)
5 *anna* Guér. V. (Mex.)
6 *marchalii* Guér. V. (Col.)
7 *pavira* Guen. (Peru)
8 *candrena* Godt. V. (Argent.)
9 *lidwina* Feld. (Peru)
10 *dodone* Guen. (Col.)

Perisama
11 *euriclea* Dbldy. & Hew. V. (Peru)
12 *cloelia* Hew. (Peru)
13 *bonplandii* Guér.f.d'orbigyni Guér.
14 *priene* Hopff. V. (Peru)
15 *vaninka* Hew. (Col.)
16 *philinus* Dbldy.f.saussurei Guen.
17 *plistia* Fruhst. V. (Peru)
18 *comnena* Hew. V. (Peru)
19 *oppelii* Latr. V. (Col.)

20 *philinus* Dbldy.f.saussurei Guen.
21 *xanthica* Hew. V. (Peru)
22 *humboldtii* Guér. V. (Col.)
23 *clisithera* Hew. (Bol.)
24 *cecidas* Hew. V. (Ecua.)
25 *clisithera* Hew. V. (Bol.)
26 *patara* Hew. (Peru)
27 *cabirnia* Hew. V. (Bol.)
28 *oppelii* Latr.s.sp.viridinota Btlr. (Peru)
29 *morona* Hew. V. (Peru)

30 *bonplandii* Guér.s.sp.mola Dogni
(Ecua.)
31 *bonplandii* Guér.f.albipennis Btlr
V. (Col.)
32 *bonplandii* Guér. V. (Peru)
33 *eminens* Oberth. (Peru)

Callidula
34 *pyramus* Fab. ♀. (Braz.)

Callicore
35 *discrepans* Stich. (Peru)
36 *maimuna* Hew. (Peru)
37 *pitheas* Latr. V. (Col.)

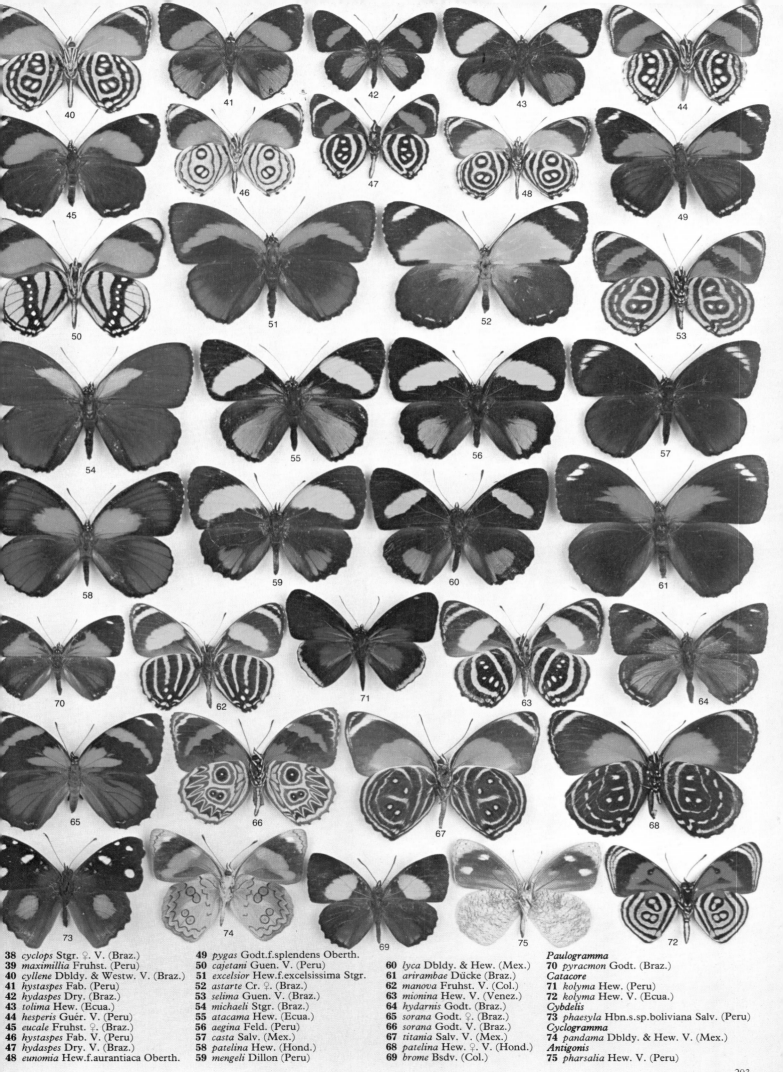

38 *cyclops* Stgr. ♀. V. (Braz.)
39 *maximillia* Fruhst. (Peru)
40 *cyllene* Dbldy. & Westw. V. (Braz.)
41 *hystaspes* Fab. (Peru)
42 *hydaspes* Dry. (Braz.)
43 *tolima* Hew. (Ecua.)
44 *hesperis* Guér. V. (Peru)
45 *eucale* Fruhst. ♀. (Braz.)
46 *hystaspes* Fab. V. (Peru)
47 *hydaspes* Dry. V. (Braz.)
48 *eunomia* Hew.f.aurantiaca Oberth.

49 *pygas* Godt.f.splendens Oberth.
50 *cajetani* Guen. V. (Peru)
51 *excelsior* Hew.f.excelsissima Stgr.
52 *astarte* Cr. ♀. (Braz.)
53 *selima* Guen. V. (Braz.)
54 *michaeli* Stgr. (Braz.)
55 *atacama* Hew. (Ecua.)
56 *aegina* Feld. (Peru)
57 *casta* Salv. (Mex.)
58 *patelina* Hew. (Hond.)
59 *mengeli* Dillon (Peru)

60 *lyca* Dbldy. & Hew. (Mex.)
61 *arirambae* Dücke (Braz.)
62 *manova* Fruhst. V. (Col.)
63 *mionina* Hew. V. (Venez.)
64 *hydarnis* Godt. (Braz.)
65 *sorana* Godt. ♀. (Braz.)
66 *sorana* Godt. V. (Braz.)
67 *titania* Salv. V. (Mex.)
68 *patelina* Hew. ♀. V. (Hond.)
69 *brome* Bsdv. (Col.)

Paulogramma
70 *pyracmon* Godt. (Braz.)
Catacore
71 *kolyma* Hew. (Peru)
72 *kolyma* Hew. V. (Ecua.)
Cybdelis
73 *phaesyla* Hbn.s.sp.boliviana Salv. (Peru)
Cyclogramma
74 *pandama* Dbldy. & Hew. V. (Mex.)
Antigonis
75 *pharsalia* Hew. V. (Peru)

203

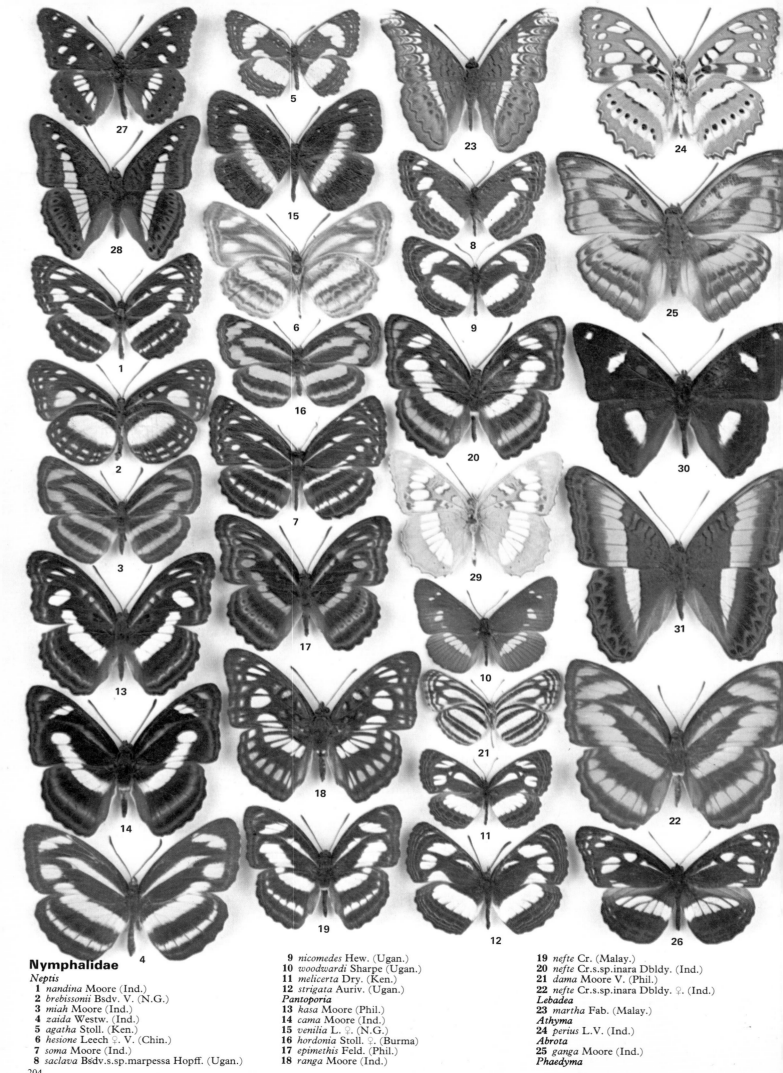

Nymphalidae

Neptis
1 *nandina* Moore (Ind.)
2 *brebissonii* Bsdv. V. (N.G.)
3 *miah* Moore (Ind.)
4 *zaida* Westw. (Ind.)
5 *agatha* Stoll. (Ken.)
6 *hesione* Leech ♀. V. (Chin.)
7 *soma* Moore (Ind.)
8 *saclava* Bsdv.s.sp.marpessa Hopff. (Ugan.)

9 *nicomedes* Hew. (Ugan.)
10 *woodwardi* Sharpe (Ugan.)
11 *melicerta* Dry. (Ken.)
12 *strigata* Auriv. (Ugan.)

Pantoporia
13 *kasa* Moore (Phil.)
14 *cama* Moore (Ind.)
15 *venilia* L. ♀. (N.G.)
16 *hordonia* Stoll. ♀. (Burma)
17 *epimethis* Feld. (Phil.)
18 *ranga* Moore (Ind.)

19 *nefte* Cr. (Malay.)
20 *nefte* Cr.s.sp.inara Dbldy. (Ind.)
21 *dama* Moore V. (Phil.)
22 *nefte* Cr.s.sp.inara Dbldy. ♀. (Ind.)

Lebadea
23 *martha* Fab. (Malay.)

Athyma
24 *perius* L.V. (Ind.)

Abrota
25 *ganga* Moore (Ind.)

Phaedyma

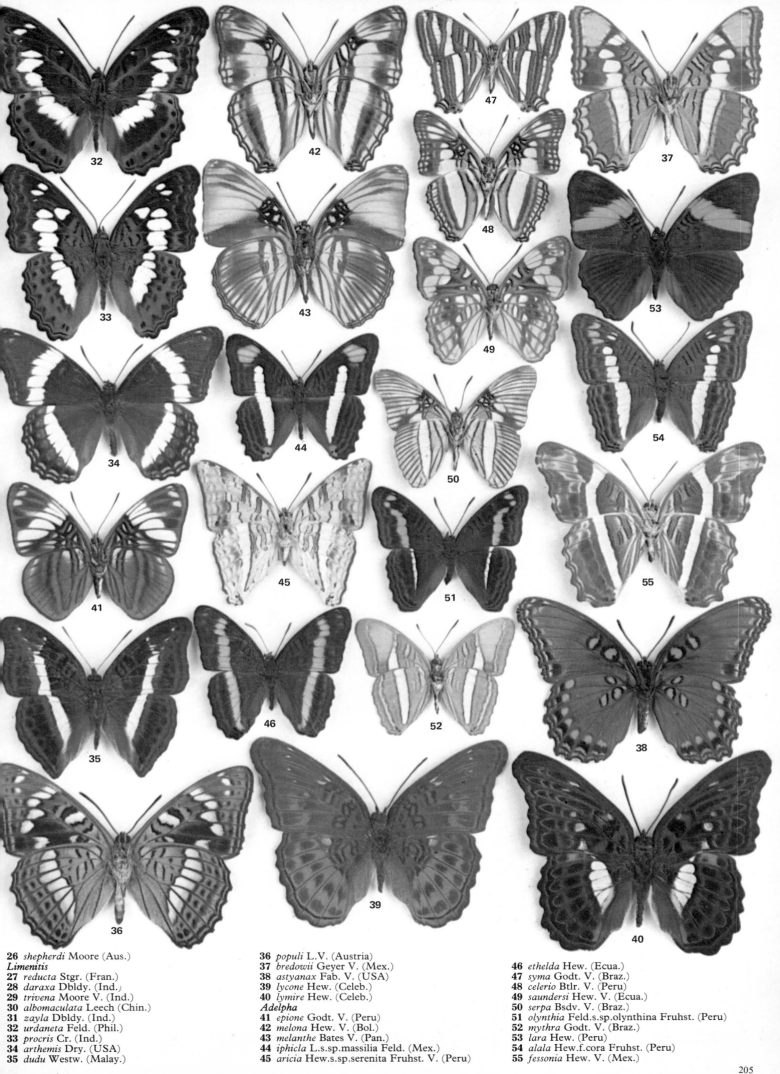

26 *shepherdi* Moore (Aus.)
Limenitis
27 *reducta* Stgr. (Fran.)
28 *daraxa* Dbldy. (Ind.)
29 *trivena* Moore V. (Ind.)
30 *albomaculata* Leech (Chin.)
31 *zayla* Dbldy. (Ind.)
32 *urdaneta* Feld. (Phil.)
33 *procris* Cr. (Ind.)
34 *arthemis* Dry. (USA)
35 *dudu* Westw. (Malay.)

36 *populi* L.V. (Austria)
37 *bredowii* Geyer V. (Mex.)
38 *astyanax* Fab. V. (USA)
39 *lycone* Hew. (Celeb.)
40 *lymire* Hew. (Celeb.)
Adelpha
41 *epione* Godt. V. (Peru)
42 *melona* Hew. V. (Bol.)
43 *melanthe* Bates V. (Pan.)
44 *iphicla* L.s.sp.massilia Feld. (Mex.)
45 *aricia* Hew.s.sp.serenita Fruhst. V. (Peru)

46 *ethelda* Hew. (Ecua.)
47 *syma* Godt. V. (Braz.)
48 *celerio* Btlr. V. (Peru)
49 *saundersi* Hew. V. (Ecua.)
50 *serpa* Bsdv. V. (Braz.)
51 *olynthia* Feld.s.sp.olynthina Fruhst. (Peru)
52 *mythra* Godt. V. (Braz.)
53 *lara* Hew. (Peru)
54 *alala* Hew.f.cora Fruhst. (Peru)
55 *fessonia* Hew. V. (Mex.)

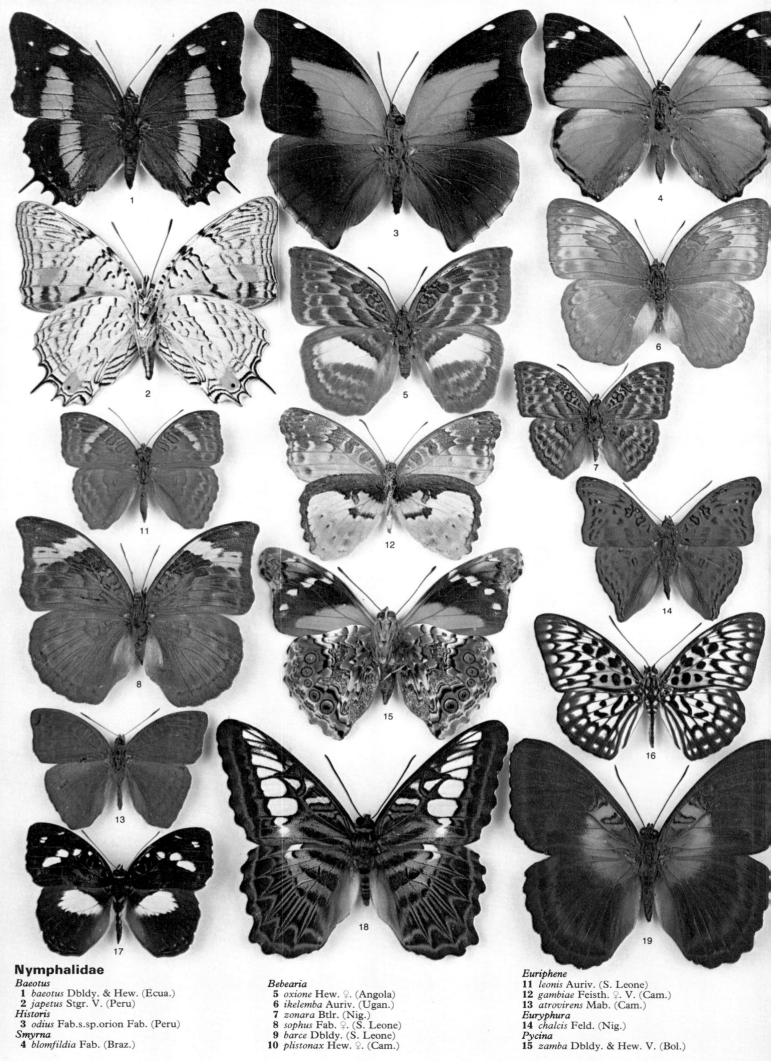

Nymphalidae

Baeotus
1 *baeotus* Dbldy. & Hew. (Ecua.)
2 *japetus* Stgr. V. (Peru)

Historis
3 *odius* Fab.s.sp.orion Fab. (Peru)

Smyrna
4 *blomfildia* Fab. (Braz.)

Bebearia
5 *oxione* Hew. ♀. (Angola)
6 *ikelemba* Auriv. (Ugan.)
7 *zonara* Btlr. (Nig.)
8 *sophus* Fab. ♀. (S. Leone)
9 *barce* Dbldy. (S. Leone)
10 *plistonax* Hew. ♀. (Cam.)

Euriphene
11 *leonis* Auriv. (S. Leone)
12 *gambiae* Feisth. ♀. V. (Cam.)
13 *atrovirens* Mab. (Cam.)

Euryphura
14 *chalcis* Feld. (Nig.)

Pycina
15 *zamba* Dbldy. & Hew. V. (Bol.)

206

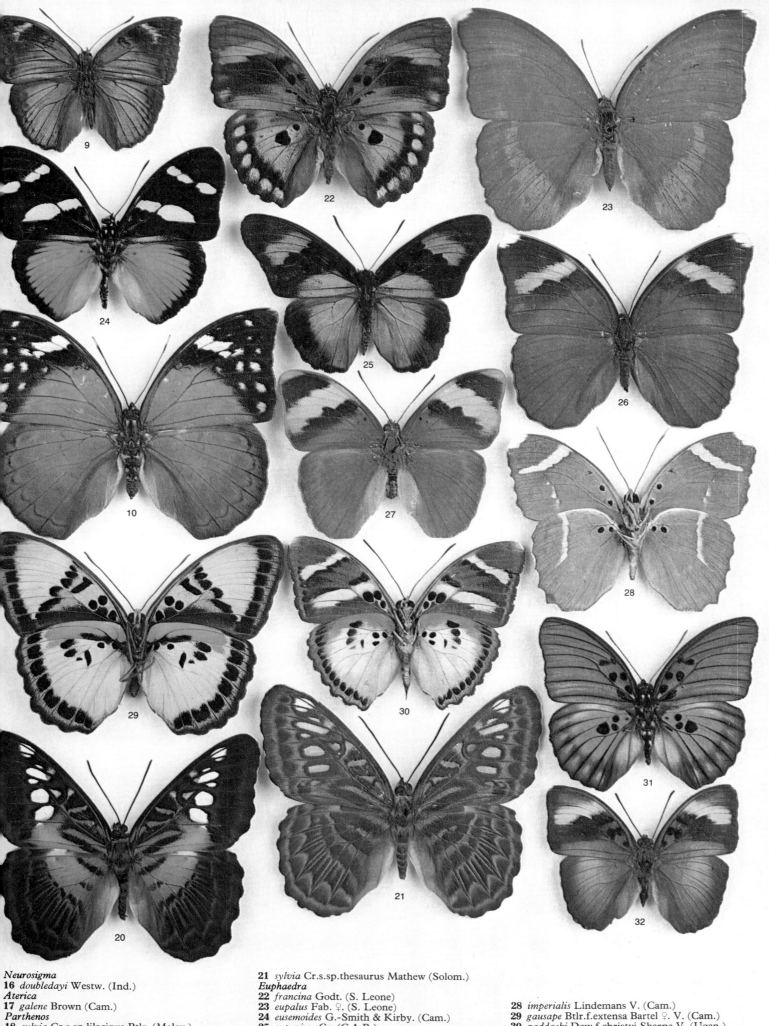

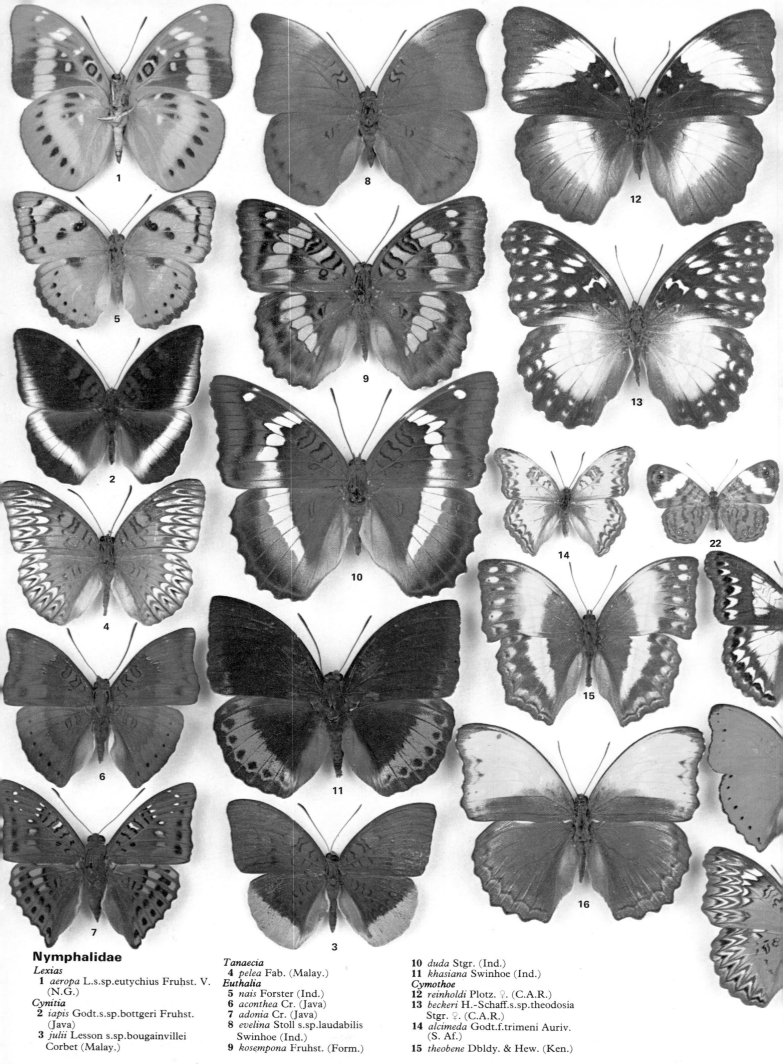

Nymphalidae

Lexias
1 *aeropa* L.s.sp.eutychius Fruhst. V. (N.G.)

Cynitia
2 *iapis* Godt.s.sp.bottgeri Fruhst. (Java)
3 *julii* Lesson s.sp.bougainvillei Corbet (Malay.)

Tanaecia
4 *pelea* Fab. (Malay.)

Euthalia
5 *nais* Forster (Ind.)
6 *aconthea* Cr. (Java)
7 *adonia* Cr. (Java)
8 *evelina* Stoll s.sp.laudabilis Swinhoe (Ind.)
9 *kosempona* Fruhst. (Form.)

10 *duda* Stgr. (Ind.)
11 *khasiana* Swinhoe (Ind.)

Cymothoe
12 *reinholdi* Plotz. ♀. (C.A.R.)
13 *beckeri* H.-Schaff.s.sp.theodosia Stgr. ♀. (C.A.R.)
14 *alcimeda* Godt.f.trimeni Auriv. (S. Af.)
15 *theobene* Dbldy. & Hew. (Ken.)

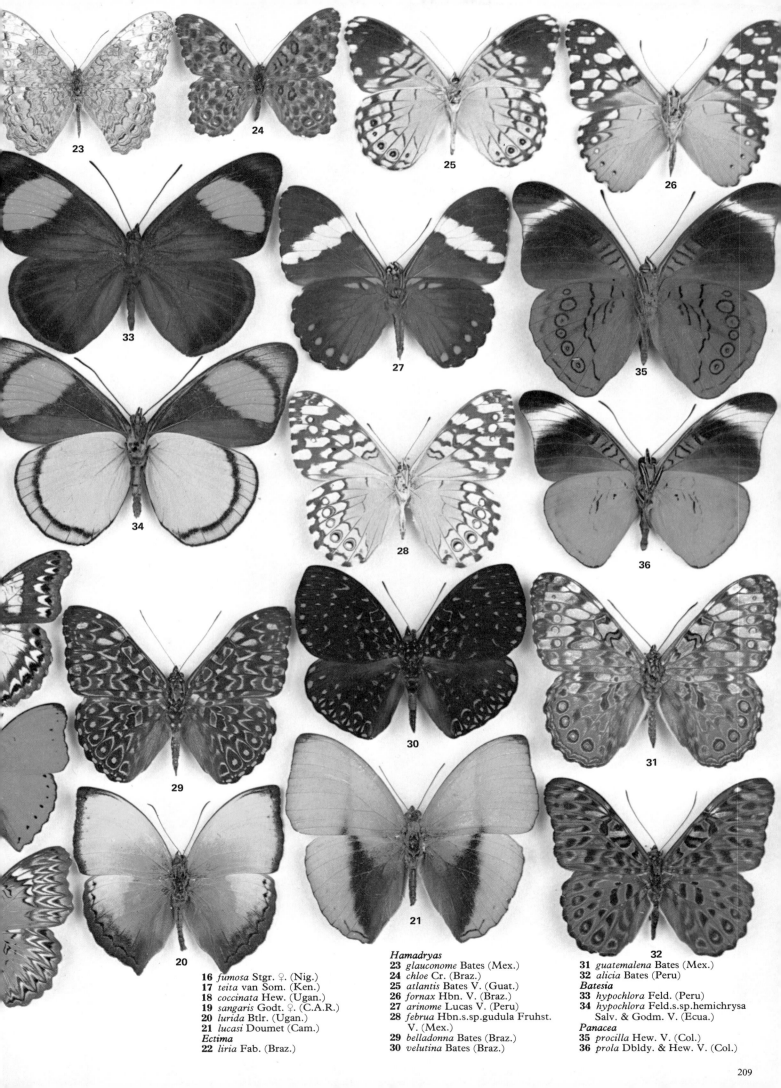

16 *fumosa* Stgr. ♀. (Nig.)
17 *teita* van Som. (Ken.)
18 *coccinata* Hew. (Ugan.)
19 *sangaris* Godt. ♀. (C.A.R.)
20 *lurida* Btlr. (Ugan.)
21 *lucasi* Doumet (Cam.)
Ectima
22 *liria* Fab. (Braz.)

Hamadryas
23 *glauconome* Bates (Mex.)
24 *chloe* Cr. (Braz.)
25 *atlantis* Bates V. (Guat.)
26 *fornax* Hbn. V. (Braz.)
27 *arinome* Lucas V. (Peru)
28 *februa* Hbn.s.sp.gudula Fruhst.
V. (Mex.)
29 *belladonna* Bates (Braz.)
30 *velutina* Bates (Braz.)

31 *guatemalena* Bates (Mex.)
32 *alicia* Bates (Peru)
Batesia
33 *hypochlora* Feld. (Peru)
34 *hypochlora* Feld.s.sp.hemichrysa
Salv. & Godm. V. (Ecua.)
Panacea
35 *procilla* Hew. V. (Col.)
36 *prola* Dbldy. & Hew. V. (Col.)

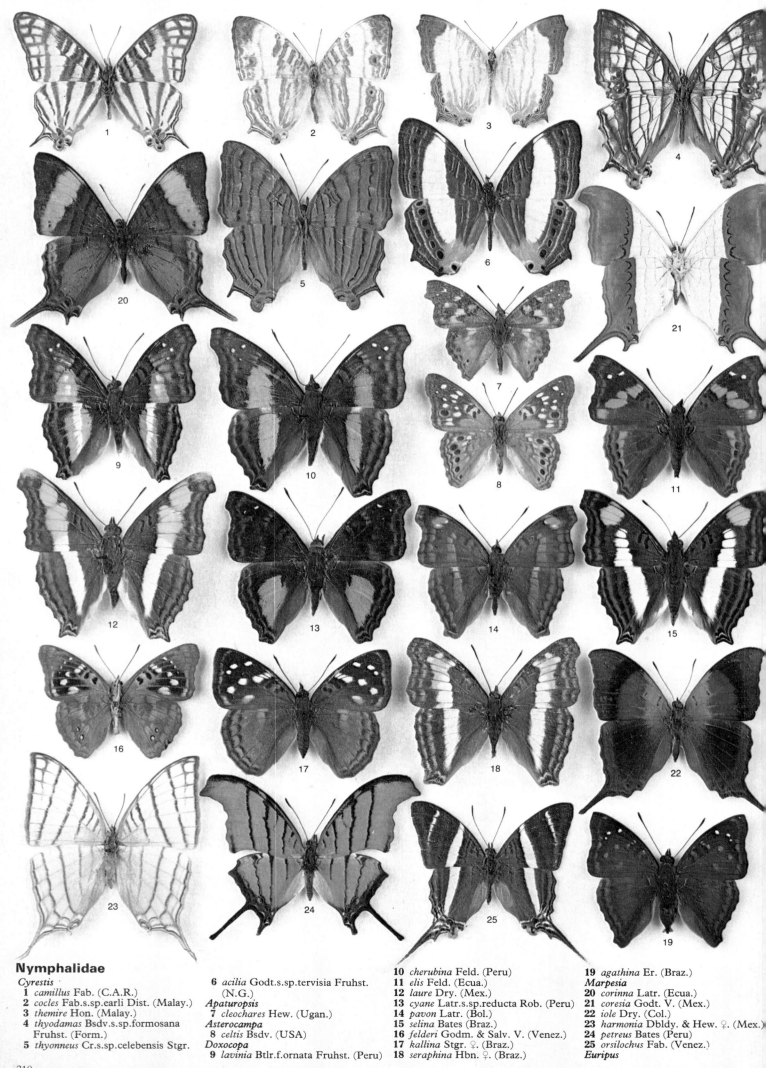

Nymphalidae

Cyrestis
1 *camillus* Fab. (C.A.R.)
2 *cocles* Fab.s.sp.earli Dist. (Malay.)
3 *themire* Hon. (Malay.)
4 *thyodamas* Bsdv.s.sp.formosana
 Fruhst. (Form.)
5 *thyonneus* Cr.s.sp.celebensis Stgr.

6 *acilia* Godt.s.sp.tervisia Fruhst.
 (N.G.)
Apaturopsis
7 *cleochares* Hew. (Ugan.)
Asterocampa
8 *celtis* Bsdv. (USA)
Doxocopa
9 *lavinia* Btlr.f.ornata Fruhst. (Peru)

10 *cherubina* Feld. (Peru)
11 *elis* Feld. (Ecua.)
12 *laure* Dry. (Mex.)
13 *cyane* Latr.s.sp.reducta Rob. (Peru)
14 *pavon* Latr. (Bol.)
15 *selina* Bates (Braz.)
16 *felderi* Godm. & Salv. V. (Venez.)
17 *kallina* Stgr. ♀. (Braz.)
18 *seraphina* Hbn. ♀. (Braz.)

19 *agathina* Er. (Braz.)
Marpesia
20 *corinna* Latr. (Ecua.)
21 *coresia* Godt. V. (Mex.)
22 *iole* Dry. (Col.)
23 *harmonia* Dbldy. & Hew. ♀. (Mex.)
24 *petreus* Bates (Peru)
25 *orsilochus* Fab. (Venez.)
Euripus

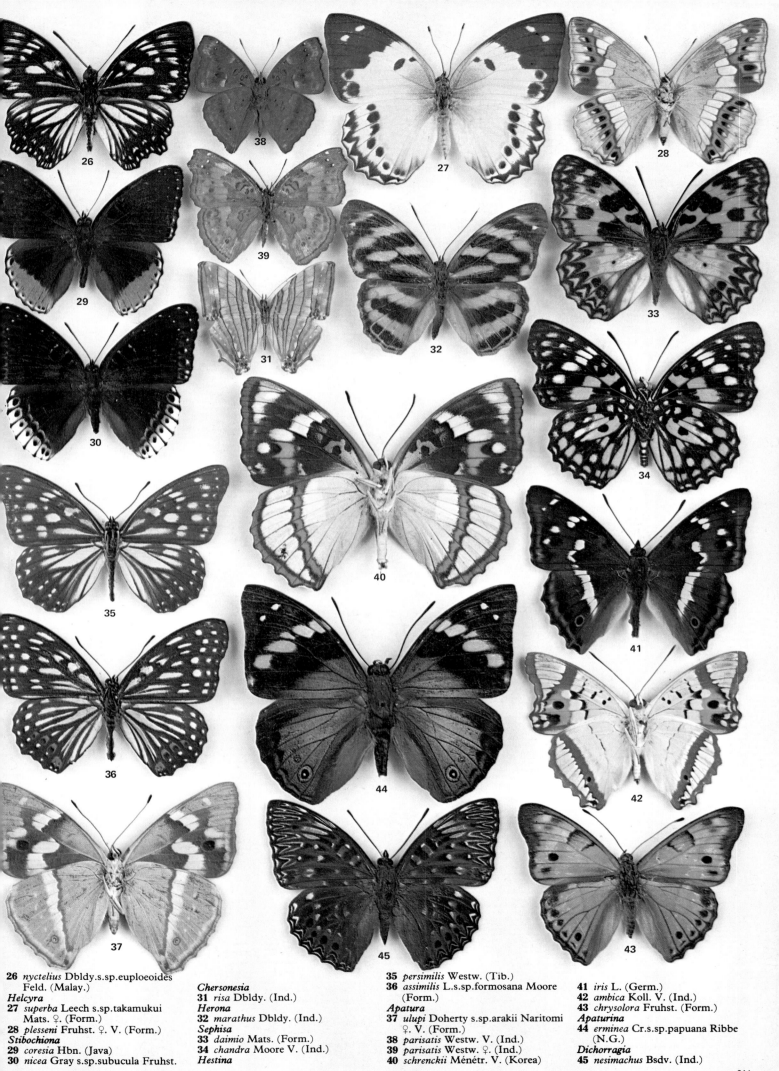

26 *nyctelius* Dbldy.s.sp.euploeoides
 Feld. (Malay.)
Helcyra
27 *superba* Leech s.sp.takamukui
 Mats. ♀. (Form.)
28 *plesseni* Fruhst. ♀. V. (Form.)
Stibochiona
29 *coresia* Hbn. (Java)
30 *nicea* Gray s.sp.subucula Fruhst.

Chersonesia
31 *risa* Dbldy. (Ind.)
Herona
32 *marathus* Dbldy. (Ind.)
Sephisa
33 *daimio* Mats. (Form.)
34 *chandra* Moore V. (Ind.)
Hestina

35 *persimilis* Westw. (Tib.)
36 *assimilis* L.s.sp.formosana Moore
 (Form.)
Apatura
37 *ulupi* Doherty s.sp.arakii Naritomi
 ♀. V. (Form.)
38 *parisatis* Westw. V. (Ind.)
39 *parisatis* Westw. ♀. (Ind.)
40 *schrenckii* Ménétr. V. (Korea)

41 *iris* L. (Germ.)
42 *ambica* Koll. V. (Ind.)
43 *chrysolora* Fruhst. (Form.)
Apaturina
44 *erminea* Cr.s.sp.papuana Ribbe
 (N.G.)
Dichorragia
45 *nesimachus* Bsdv. (Ind.)

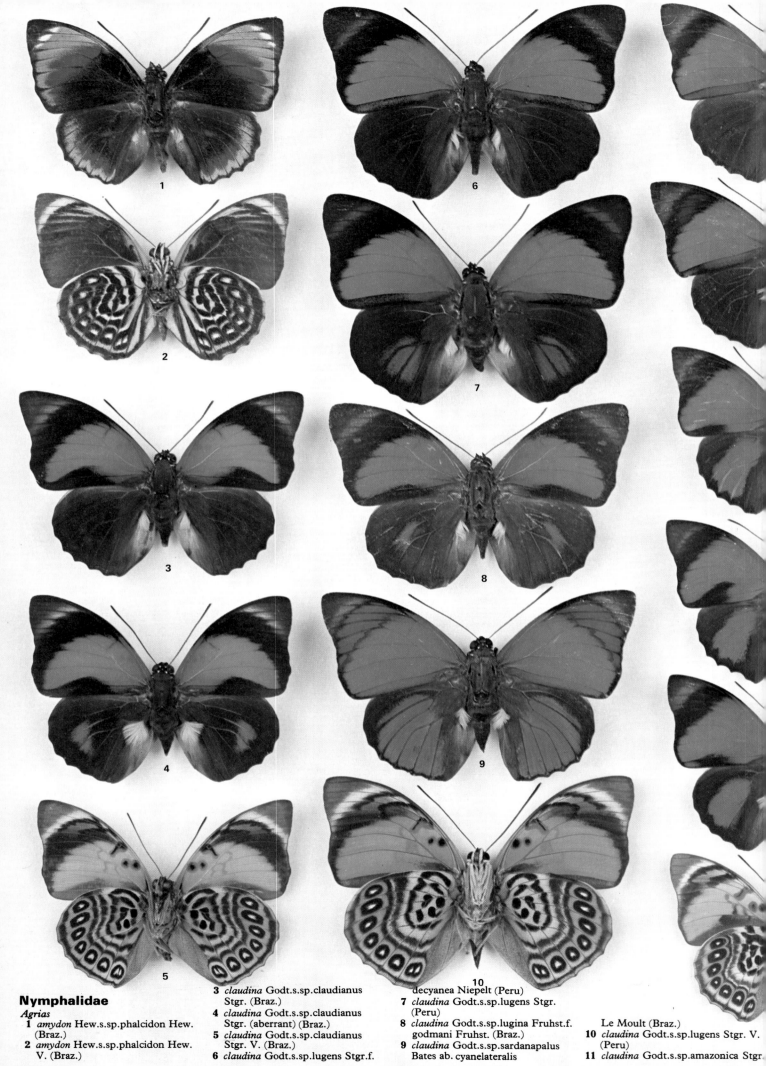

Nymphalidae

Agrias

1 *amydon* Hew.s.sp.phalcidon Hew. (Braz.)

2 *amydon* Hew.s.sp.phalcidon Hew. V. (Braz.)

3 *claudina* Godt.s.sp.claudianus Stgr. (Braz.)

4 *claudina* Godt.s.sp.claudianus Stgr. (aberrant) (Braz.)

5 *claudina* Godt.s.sp.claudianus Stgr. V. (Braz.)

6 *claudina* Godt.s.sp.lugens Stgr.f.
decyanea Niepelt (Peru)

7 *claudina* Godt.s.sp.lugens Stgr. (Peru)

8 *claudina* Godt.s.sp.lugina Fruhst.f. godmani Fruhst. (Braz.)

9 *claudina* Godt.s.sp.sardanapalus Bates ab. cyanelateralis

10 *claudina* Godt.s.sp.lugens Stgr. V. (Peru)

Le Moult (Braz.)

11 *claudina* Godt.s.sp.amazonica Stgr

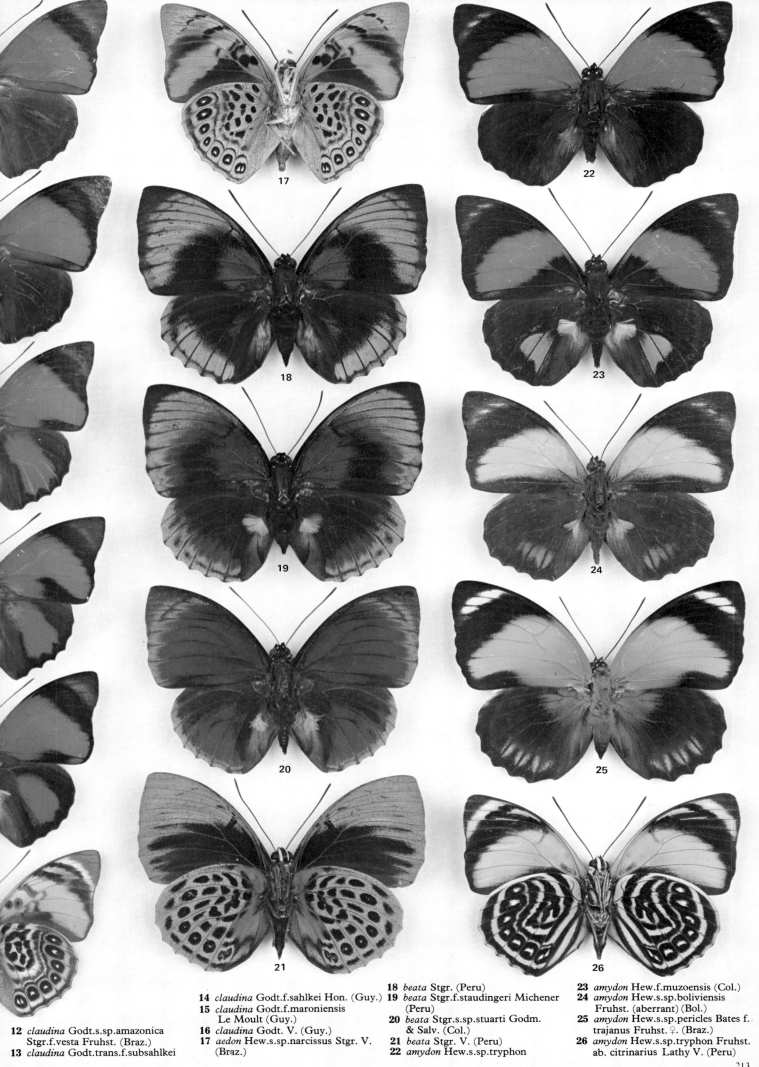

14 *claudina* Godt.f.sahlkei Hon. (Guy.)
15 *claudina* Godt.f.maroniensis
 Le Moult (Guy.)
16 *claudina* Godt. V. (Guy.)
17 *aedon* Hew.s.sp.narcissus Stgr. V.
 (Braz.)

12 *claudina* Godt.s.sp.amazonica
 Stgr.f.vesta Fruhst. (Braz.)
13 *claudina* Godt.trans.f.subsahlkei

18 *beata* Stgr. (Peru)
19 *beata* Stgr.f.staudingeri Michener
 (Peru)
20 *beata* Stgr.s.sp.stuarti Godm.
 & Salv. (Col.)
21 *beata* Stgr. V. (Peru)
22 *amydon* Hew.s.sp.tryphon

23 *amydon* Hew.f.muzoensis (Col.)
24 *amydon* Hew.s.sp.boliviensis
 Fruhst. (aberrant) (Bol.)
25 *amydon* Hew.s.sp.pericles Bates f.
 trajanus Fruhst. ♀. (Braz.)
26 *amydon* Hew.s.sp.tryphon Fruhst.
 ab. citrinarius Lathy V. (Peru)

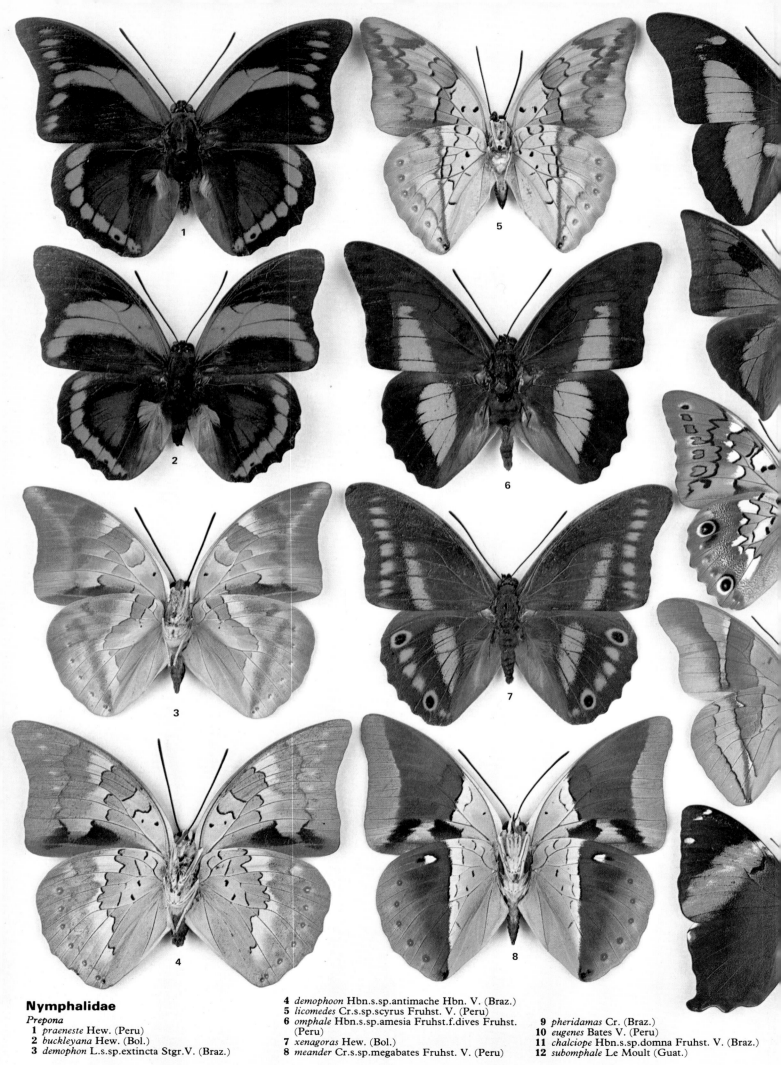

Nymphalidae

Prepona
1 *praeneste* Hew. (Peru)
2 *buckleyana* Hew. (Bol.)
3 *demophon* L.s.sp.extincta Stgr.V. (Braz.)

4 *demophoon* Hbn.s.sp.antimache Hbn. V. (Braz.)
5 *licomedes* Cr.s.sp.scyrus Fruhst. V. (Peru)
6 *omphale* Hbn.s.sp.amesia Fruhst.f.dives Fruhst. (Peru)
7 *xenagoras* Hew. (Bol.)
8 *meander* Cr.s.sp.megabates Fruhst. V. (Peru)

9 *pheridamas* Cr. (Braz.)
10 *eugenes* Bates V. (Peru)
11 *chalciope* Hbn.s.sp.domna Fruhst. V. (Braz.)
12 *subomphale* Le Moult (Guat.)

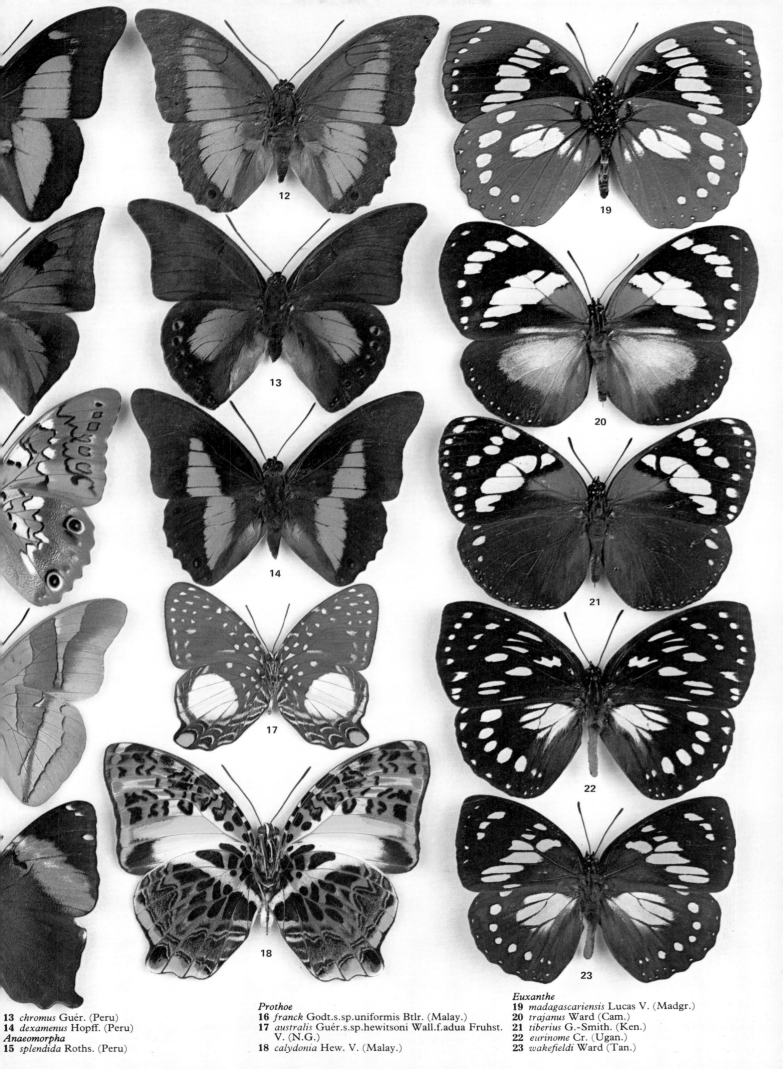

13 *chromus* Guér. (Peru)
14 *dexamenus* Hopff. (Peru)
Anaeomorpha
15 *splendida* Roths. (Peru)

Prothoe
16 *franck* Godt.s.sp.uniformis Btlr. (Malay.)
17 *australis* Guér.s.sp.hewitsoni Wall.f.adua Fruhst.
V. (N.G.)
18 *calydonia* Hew. V. (Malay.)

Euxanthe
19 *madagascariensis* Lucas V. (Madgr.)
20 *trajanus* Ward (Cam.)
21 *tiberius* G.-Smith. (Ken.)
22 *eurinome* Cr. (Ugan.)
23 *wakefieldi* Ward (Tan.)

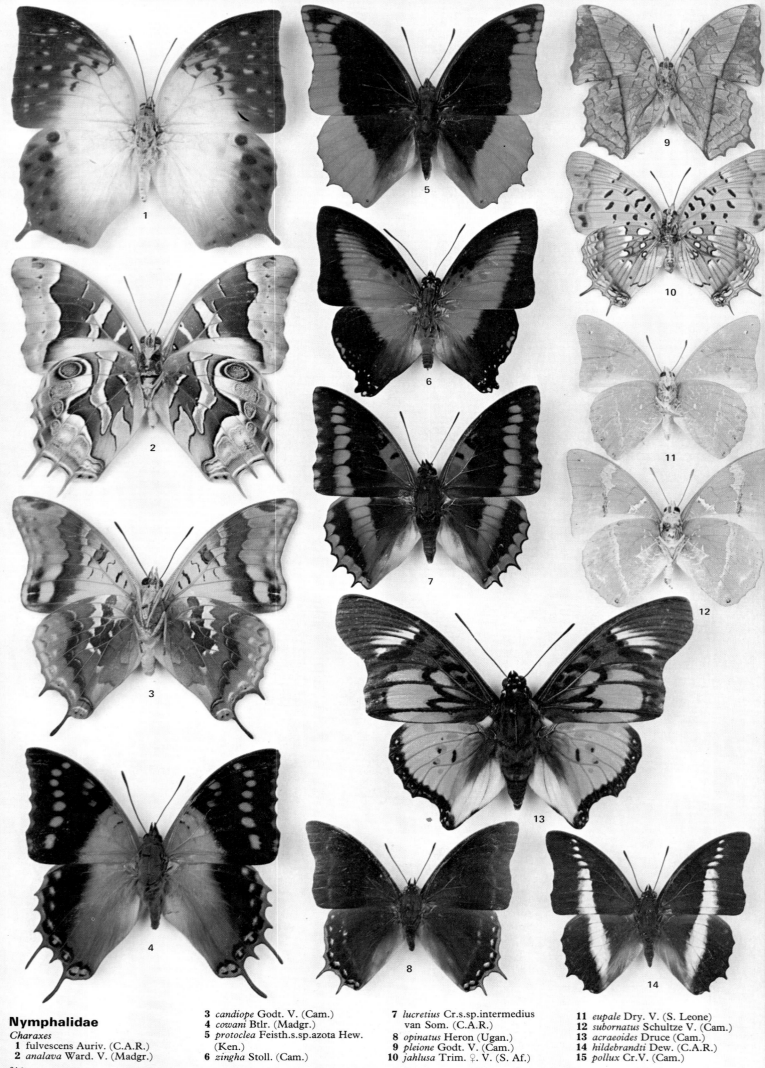

Nymphalidae

Charaxes
1 fulvescens Auriv. (C.A.R.)
2 analava Ward. V. (Madgr.)

3 candiope Godt. V. (Cam.)
4 cowani Btlr. (Madgr.)
5 protoclea Feisth.s.sp.azota Hew. (Ken.)
6 zingha Stoll. (Cam.)

7 lucretius Cr.s.sp.intermedius van Som. (C.A.R.)
8 opinatus Heron (Ugan.)
9 pleione Godt. V. (Cam.)
10 jahlusa Trim. ♀. V. (S. Af.)

11 eupale Dry. V. (S. Leone)
12 subornatus Schultze V. (Cam.)
13 acraeoides Druce (Cam.)
14 hildebrandti Dew. (C.A.R.)
15 pollux Cr.V. (Cam.)

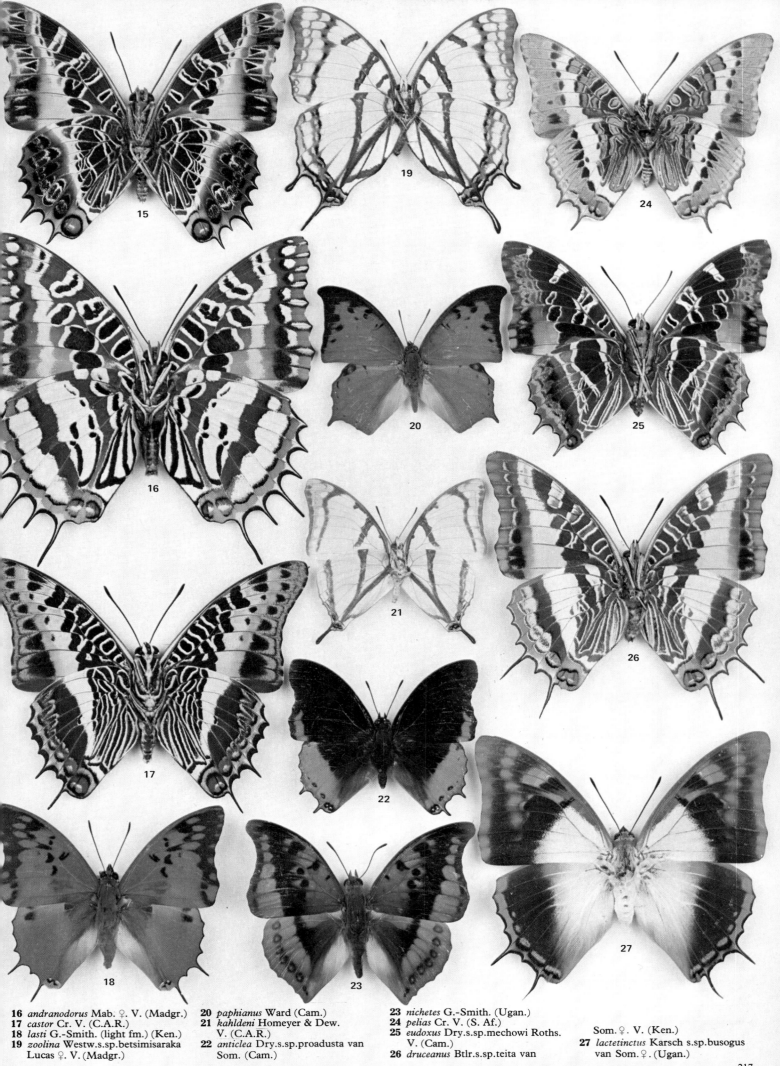

16 *andranodorus* Mab. ♀. V. (Madgr.)
17 *castor* Cr. V. (C.A.R.)
18 *lasti* G.-Smith. (light fm.) (Ken.)
19 *zoolina* Westw.s.sp.betsimisaraka
 Lucas ♀. V. (Madgr.)

20 *paphianus* Ward (Cam.)
21 *kahldeni* Homeyer & Dew.
 V. (C.A.R.)
22 *anticlea* Dry.s.sp.proadusta van
 Som. (Cam.)

23 *nichetes* G.-Smith. (Ugan.)
24 *pelias* Cr. V. (S. Af.)
25 *eudoxus* Dry.s.sp.mechowi Roths.
 V. (Cam.)
26 *druceanus* Btlr.s.sp.teita van

Som. ♀. V. (Ken.)
27 *lactetinctus* Karsch s.sp.busogus
 van Som. ♀. (Ugan.)

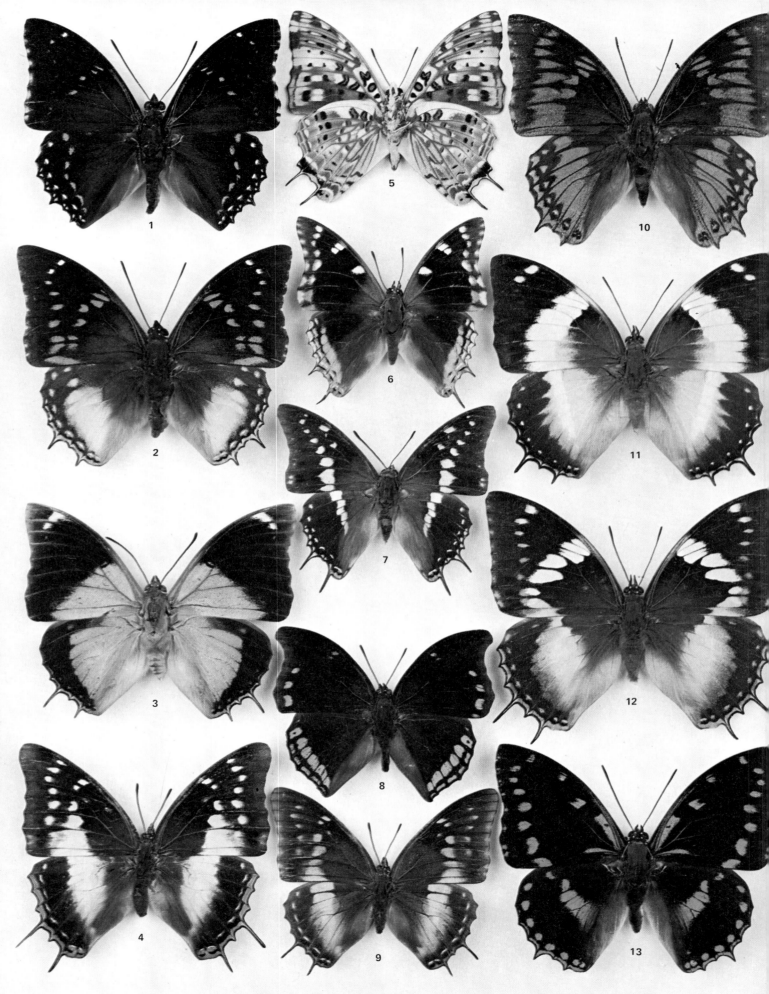

Nymphalidae

Charaxes
1 *numenes* Hew. (Cam.)
2 *cithaeron* Feld.s.sp.nairobicus van Som. (Ken.)

3 *bohemani* Feld. (Tan.)
4 *aubyni* van Som. & Jack.♀. (Ken.)
5 *etesipe* Godt. V. (Cam.)
6 *guderiana* Dew. (Tan.)
7 *fabius* Fab.s.sp.cerynthus Fruhst. (Sri Lank.)

8 *laodice* Dry. (Cong.)
9 *etheocles* Cr.s.sp.ochracea Roths. ♀. (Gabon)
10 *montieri* Stgr. & Schatz (São Tomé)
11 *violetta* G.-Smith. ♀. (Tan.)
12 *xiphares* Cr.s.sp.maudei J. & T. ♀. (Tan.)

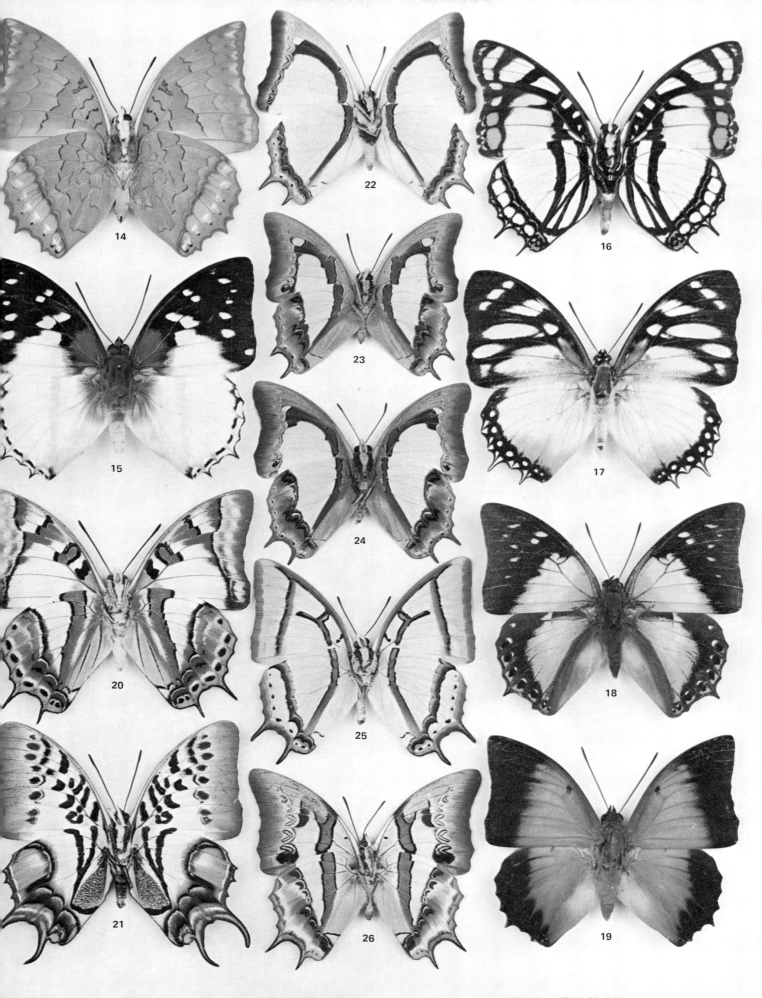

13 *ameliae* Doumet (C.A.R.)
14 *distanti* Hon. V. (Malay.)
15 *hadrianus* Ward (Cam.)
16 *nobilis* Druce V. (C.A.R.)
17 *lydiae* Holl. (Cam.)

18 *nitebis* Hew. (Celeb.)
19 *latona* Btlr.s.sp.papuensis Btlr. (N.G.)
Polyura
20 *pyrrhus* L.s.sp.sempronius Fab. V. (Aus.)
21 *dehaani* Dbldy. V. (Java)

22 *jalysus* Feld. V. (Malay.)
23 *athamas* Dry.s.sp.samatha Moore V. (Malay.)
24 *moori* Dist. V. (Malay.)
25 *narcaea* Hew.s.sp.meghaduta Fruhst. V. (Form.)
26 *schreiberi* Godt.s.sp.tisamenus Fruhst. V. (Malay.)

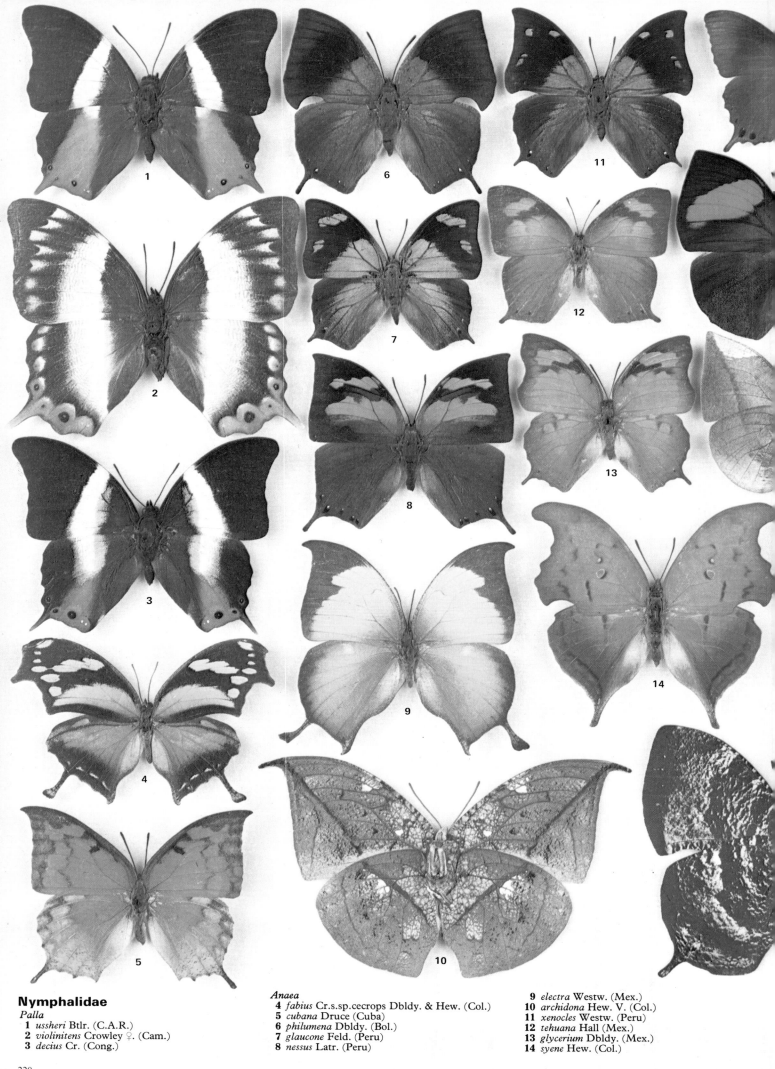

Nymphalidae

Palla
1 *ussheri* Btlr. (C.A.R.)
2 *violinitens* Crowley ♀. (Cam.)
3 *decius* Cr. (Cong.)

Anaea
4 *fabius* Cr.s.sp.cecrops Dbldy. & Hew. (Col.)
5 *cubana* Druce (Cuba)
6 *philumena* Dbldy. (Bol.)
7 *glaucone* Feld. (Peru)
8 *nessus* Latr. (Peru)

9 *electra* Westw. (Mex.)
10 *archidona* Hew. V. (Col.)
11 *xenocles* Westw. (Peru)
12 *tehuana* Hall (Mex.)
13 *glycerium* Dbldy. (Mex.)
14 *syene* Hew. (Col.)

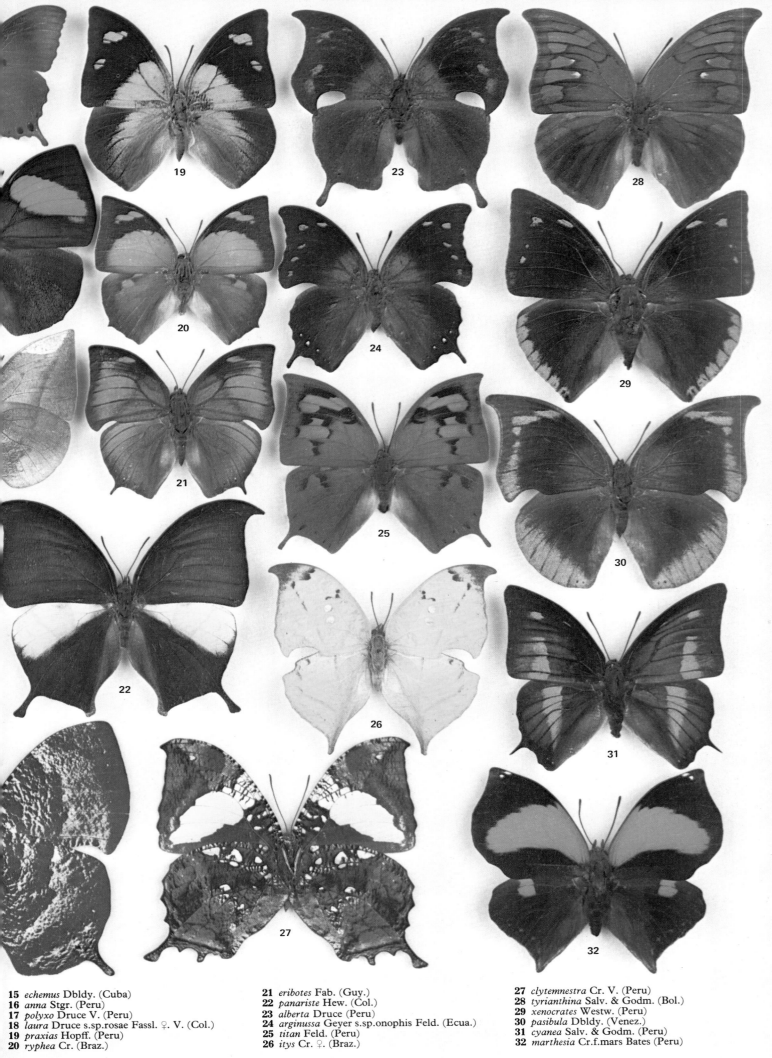

15 *echemus* Dbldy. (Cuba)
16 *anna* Stgr. (Peru)
17 *polyxo* Druce V. (Peru)
18 *laura* Druce s.sp.rosae Fassl. ♀. V. (Col.)
19 *praxias* Hopff. (Peru)
20 *ryphea* Cr. (Braz.)

21 *eribotes* Fab. (Guy.)
22 *panariste* Hew. (Col.)
23 *alberta* Druce (Peru)
24 *arginussa* Geyer s.sp.onophis Feld. (Ecua.)
25 *titan* Feld. (Peru)
26 *itys* Cr. ♀. (Braz.)

27 *clytemnestra* Cr. V. (Peru)
28 *tyrianthina* Salv. & Godm. (Bol.)
29 *xenocrates* Westw. (Peru)
30 *pasibula* Dbldy. (Venez.)
31 *cyanea* Salv. & Godm. (Peru)
32 *marthesia* Cr.f.mars Bates (Peru)

Amathusiidae –

fauns, saturns, palm-kings, duffers, jungle-glories, jungle-queens etc

The family Amathusiidae includes less than 100 species which are virtually confined to the Indo-Australian region, although one or two may penetrate the eastern Palaearctic zone. The smallest (*Faunis* species) have a wing-span of about 65mm and at the other end of the scale the female of *Zeuxidia aurelius* can span 150mm. They stand in close relationship to the Morphidae of South America and a few possess a beautiful blue coloration reminiscent of species in that family. More characteristic is the presence of eye-spots (ocelli) on the lower surface of the wings.

Many species have a large wing area relative to body size and are thus not particularly powerful fliers, preferring to fly short distances and keep among bamboo and dense thickets. Some genera are almost entirely crepuscular, flying only in the evening or early morning half-light. They are not found at high altitudes or in exposed places but may be attracted into clearings by over-ripe fruit.

The Malaysian saturns *(Zeuxidia)* are notable for their unusual pointed wing shape and delicate mauve coloration. A similar shape is shared by the much duller palm-kings *(Amathusia)*. However, the latter have most strikingly banded under sides.

Two genera with more rounded wings are *Thaumantis* (jungle-glories), which includes the most brilliant blue species, and *Taenaris*, comprising a large number of species in which the eye-spots of the underside reach a peak of size development.

Fauns *(Faunis)* and duffers *(Discophora)* include most of the smaller species and few are brightly coloured. In contrast to these the jungle queens *(Stichophthalma)* are very large with long chains of spots on the under side. These are among the most *Morpho*-like species.

The eggs are spherical or flattened and the larvae are usually gregarious. These have hair tufts and forked head and tail projections, recalling both Morphidae and Satyridae. Some of the species which feed on palms may occur in such numbers as to strip the trees of their leaves. The pupae are suspended and rather elongated with prominent paired head projections enclosing the unusually long palpi.

Below, left: A group of *Faunis eumeus* Dry. feeding on over-ripe fruit in Hongkong; this type of food is favoured by many other species in this family.

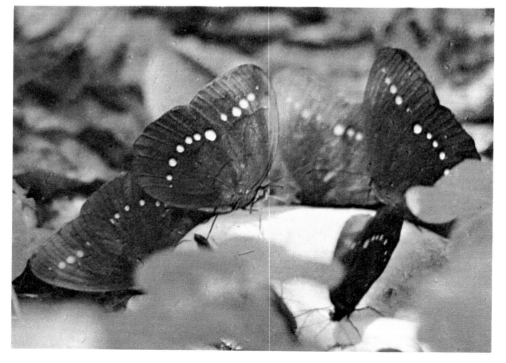

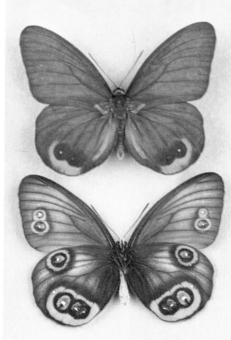

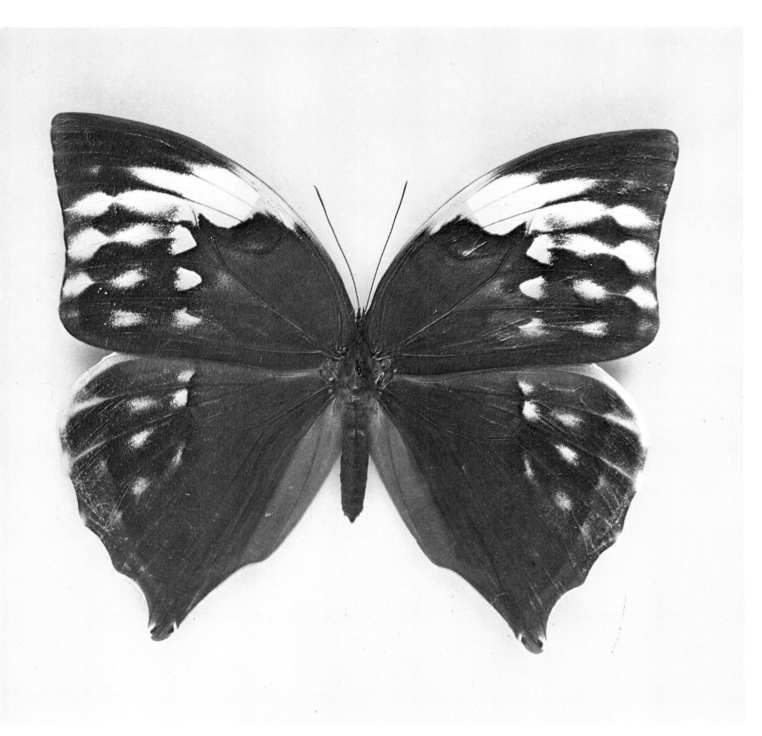

Left: Butterflies of the genus *Taenaris* are particularly noteworthy for the enormously developed eye-spots on both surfaces of the wings. This, together with the variability of most species, makes them particularly popular with collectors. One of the rarest and most interesting species is *T.butleri* Oberth., found locally in Papua, of which both surfaces are shown (slightly reduced in size). Other examples of this fascinating genus are shown on pages 226/227.

Above: One of the most magnificent of the Amathusiidae is the Malaysian *Zeuxidia aurelius* Cr. The female (X 1.5) is one of the largest butterflies in the region. (The male is shown in the centre of pages 224/225.) Both sexes fly at dusk; the more secretive female is seldom seen, but it can be lured with rotting fruit. Perfect specimens are rare in the wild and even rarer in collections because the huge wings are vulnerable to rubbing and tearing.

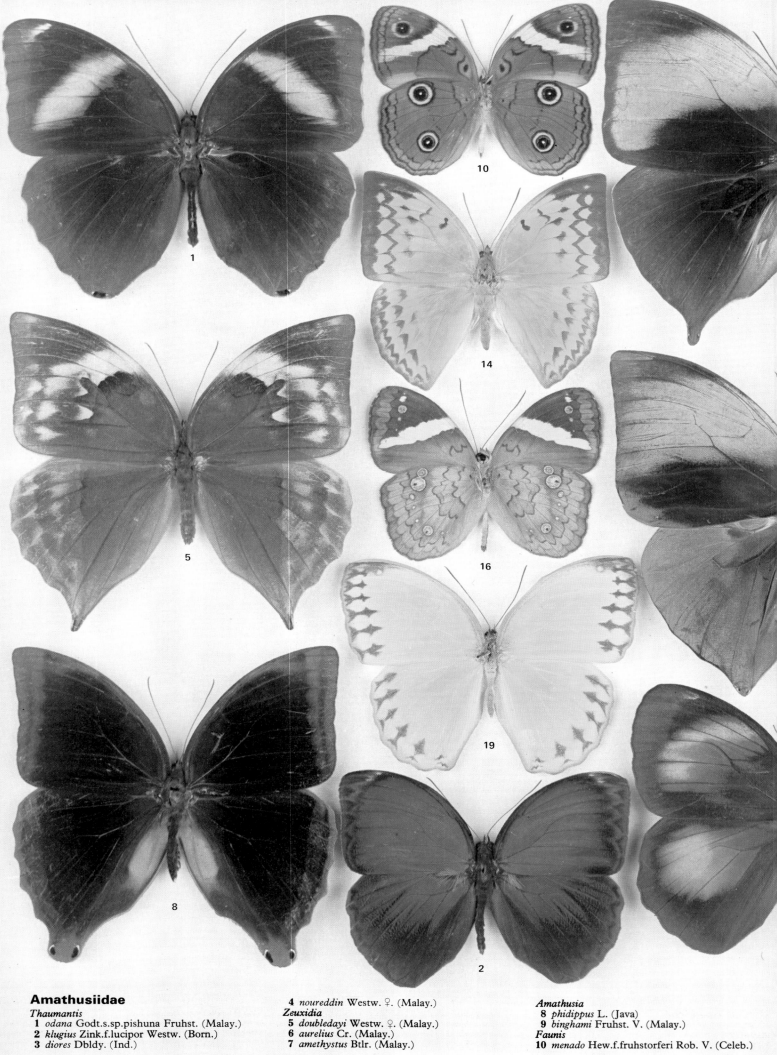

Amathusiidae

Thaumantis
1 *odana* Godt.s.sp.pishuna Fruhst. (Malay.)
2 *klugius* Zink.f.lucipor Westw. (Born.)
3 *diores* Dbldy. (Ind.)

4 *noureddin* Westw. ♀. (Malay.)
Zeuxidia
5 *doubledayi* Westw. ♀. (Malay.)
6 *aurelius* Cr. (Malay.)
7 *amethystus* Btlr. (Malay.)

Amathusia
8 *phidippus* L. (Java)
9 *binghami* Fruhst. V. (Malay.)
Faunis
10 *menado* Hew.f.fruhstorferi Rob. V. (Celeb.)

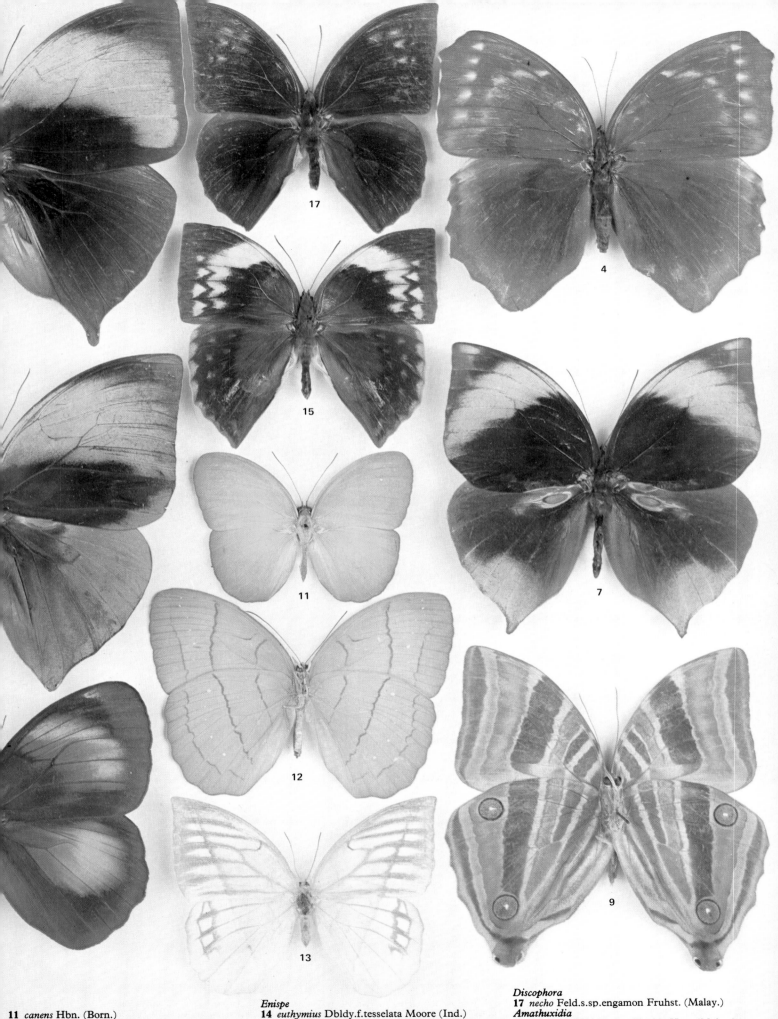

11 *canens* Hbn. (Born.)
12 *aerope* Leech ♀. V. (Chin.)
Aemona
13 *lena* Atk. (Chin.)

Enispe
14 *euthymius* Dbldy.f.tesselata Moore (Ind.)
15 *cycnus* Westw.s.sp.verbanus Fruhst. (Ind.)
Xanthotaenia
16 *busiris* Westw. V. (Malay.)

Discophora
17 *necho* Feld.s.sp.engamon Fruhst. (Malay.)
Amathuxidia
18 *amythaon* Dbldy.s.sp.dilucida Hon. (Malay.)
Stichophthalma
19 *neumogeni* Leech (Chin.)

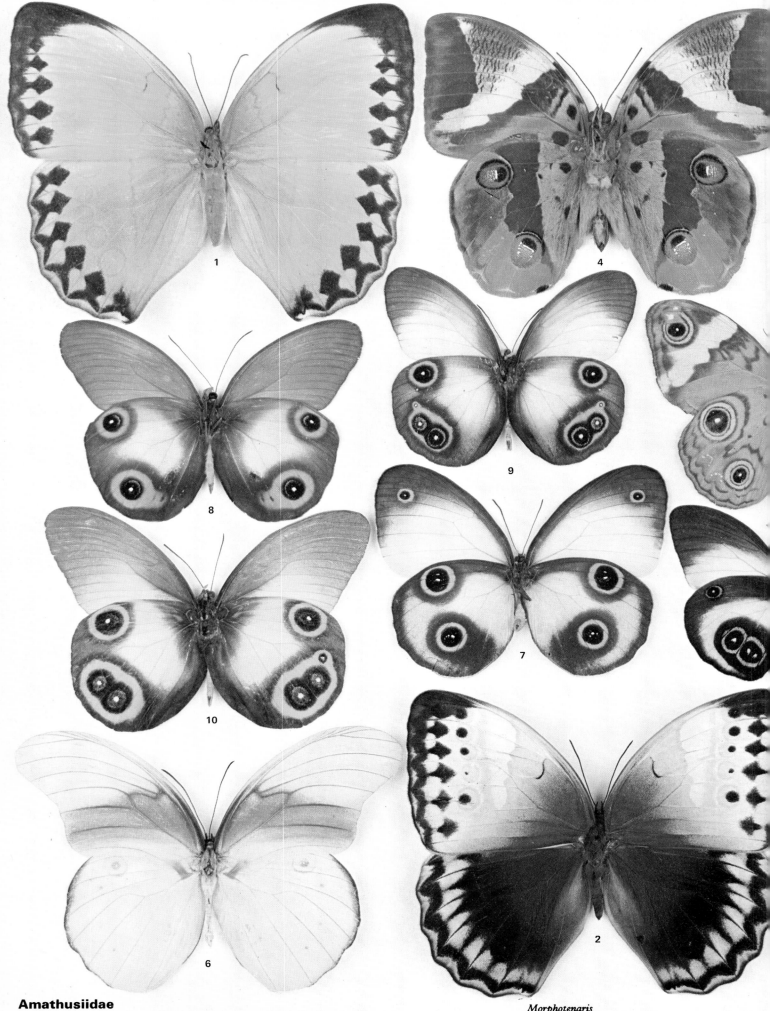

Amathusiidae

Stichophthalma
1 *howqua* Westw.s.sp.formosana Fruhst. ♀. (Form.)
2 *camadeva* Westw.s.sp.camadevoides de Nicév.
(Ind.)

3 *fruhstorferi* Rob. ♀. (Chin.)
Thauria
4 *aliris* Westw. V. (Born.)
5 *aliris* Westw.s.sp.pseudaliris Btlr. (Malay.)

Morphotenaris
6 *schoenbergi* Fruhst.s.sp.littoralis Roths. & Durra
(N.G.)
Hyantis
7 *hodeva* Hew.f.infumata Stgr. ♀. V. (N.G.)

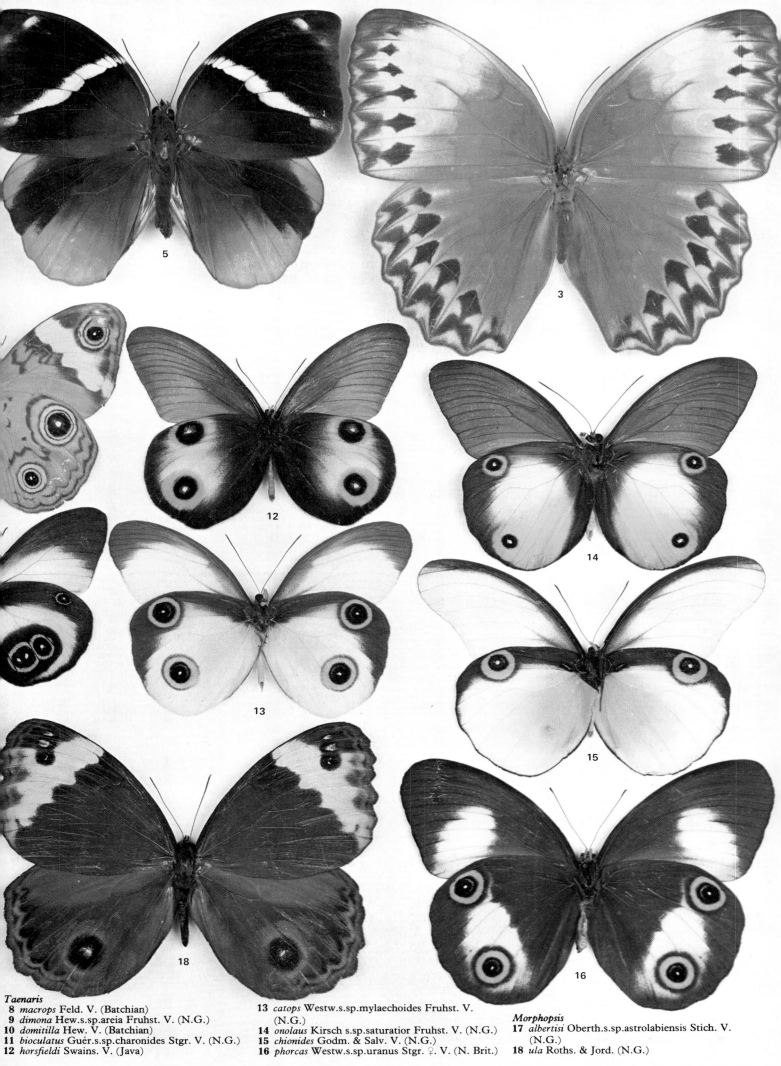

Taenaris
8 *macrops* Feld. V. (Batchian)
9 *dimona* Hew.s.sp.areia Fruhst. V. (N.G.)
10 *domitilla* Hew. V. (Batchian)
11 *bioculatus* Guér.s.sp.charonides Stgr. V. (N.G.)
12 *horsfieldi* Swains. V. (Java)

13 *catops* Westw.s.sp.mylaechoides Fruhst. V. (N.G.)
14 *onolaus* Kirsch s.sp.saturatior Fruhst. V. (N.G.)
15 *chionides* Godm. & Salv. V. (N.G.)
16 *phorcas* Westw.s.sp.uranus Stgr. ♀. V. (N. Brit.)

Morphopsis
17 *albertisi* Oberth.s.sp.astrolabiensis Stich. V. (N.G.)
18 *ula* Roths. & Jord. (N.G.)

227

Chapter 23

Morphidae –

morphos

Morpho means beautiful or shapely and is certainly appropriate for the members of the small family Morphidae. In any museum or display of butterflies it is the dazzling blue coloration of most Morpho species which first attracts the attention of the public. There are about 80 species, all of which are confined to the Neotropical region. There they are among the most conspicuous and famous denizens of the tropical forest. The smallest species *(M. rhodopteron)* is a little more than 75mm in wing-span and the largest *(M. hecuba)* is more than 200, making them giants among the South American butterflies. Their large wing area relative to body size gives them an effortless soaring flight.

Not all species have metallic blue shades and in several species it is virtually confined to the males. The peculiarly intense reflective quality of these colours (which being structural do not fade) has led to their wings being widely used for jewellery and butterfly-wing 'pictures' – a practice that is happily no longer so popular.

All species whether blue, delicate greenish-white (eg *catenaria* group) or shades of brown (*hercules* group and others) have in common more-or-less developed chains of eye-spots or ocelli on the underside of the wings.

The eggs are hemispherical and the larvae have conspicuous brightly-coloured 'hair tufts' and often a tail fork, recalling that of the Satyridae. They are generally gregarious, feeding on a variety of climbing plants, particularly Leguminosae. The pupae have distinctly projecting wing cases and small head processes. They are normally suspended.

Right: A rare sight from the jungles of Peru is this mating pair of the huge *Morpho neoptolemus* Wood (X 2). The paler female is the top specimen. The upper surfaces in both sexes are dark with broad blue bands, very similar to *M.deidamia* (page 236).

Below: One of the very largest all-blue species is the Peruvian *Morpho didius* Hopff., shown here probing wet sand in a jungle clearing (X 1.25). The under-side colouring and development of the ocelli show great variation in this species. The upper side is similar to that of *M.amathonte* (pages 234/235, which also show the female of *didius*).

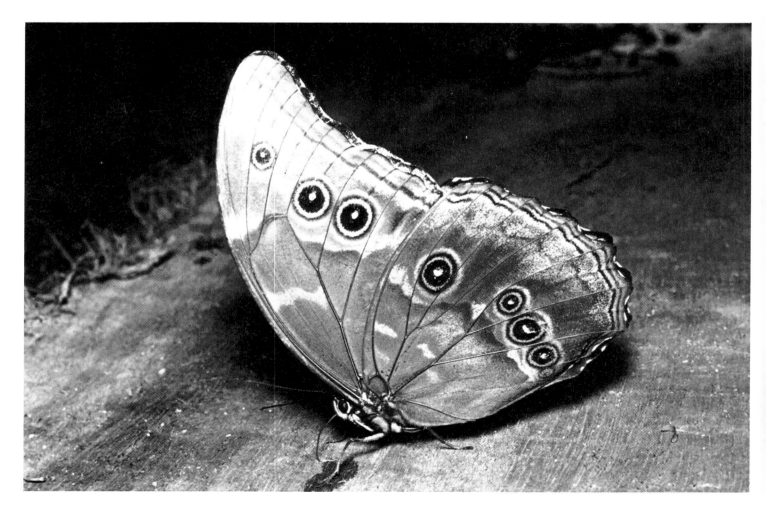

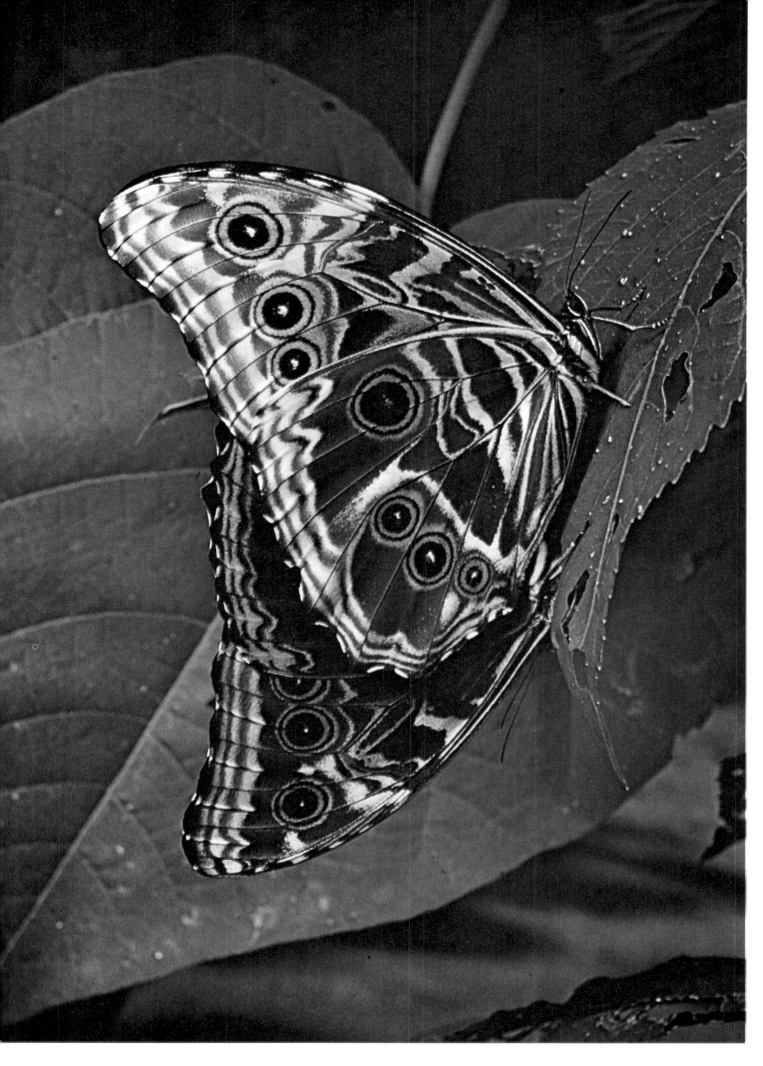

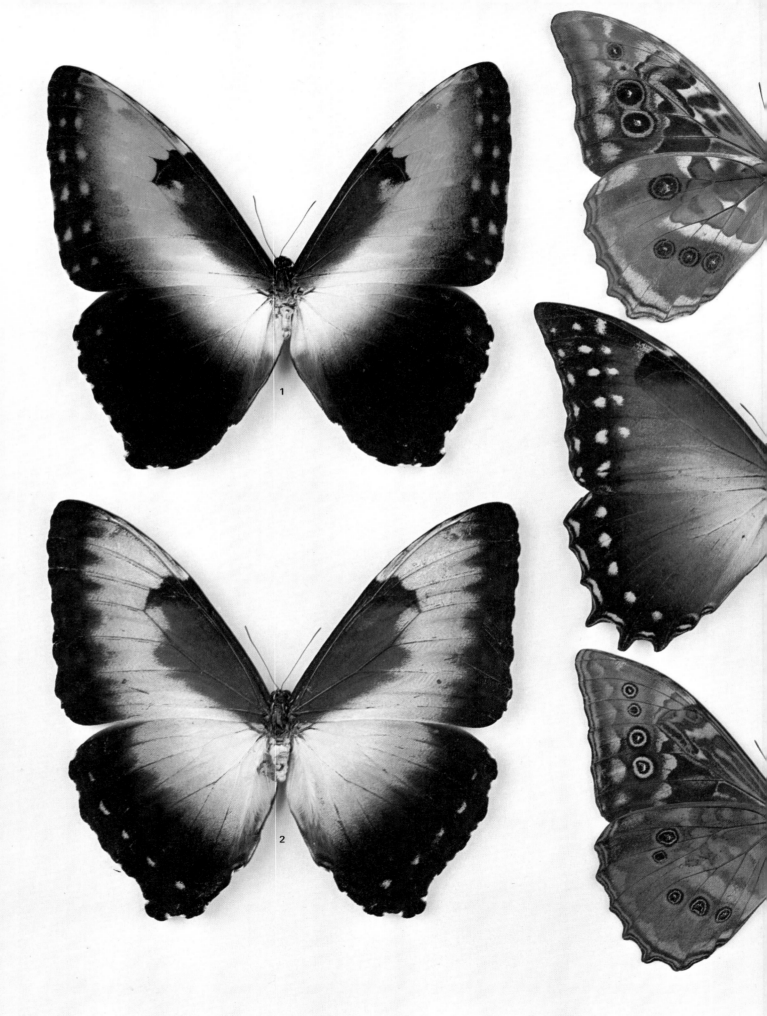

Morphidae

Morpho
1 *hecuba* L.s.sp.obidona Fruhst. (Braz.)
2 *cisseis* Feld. (Braz.)

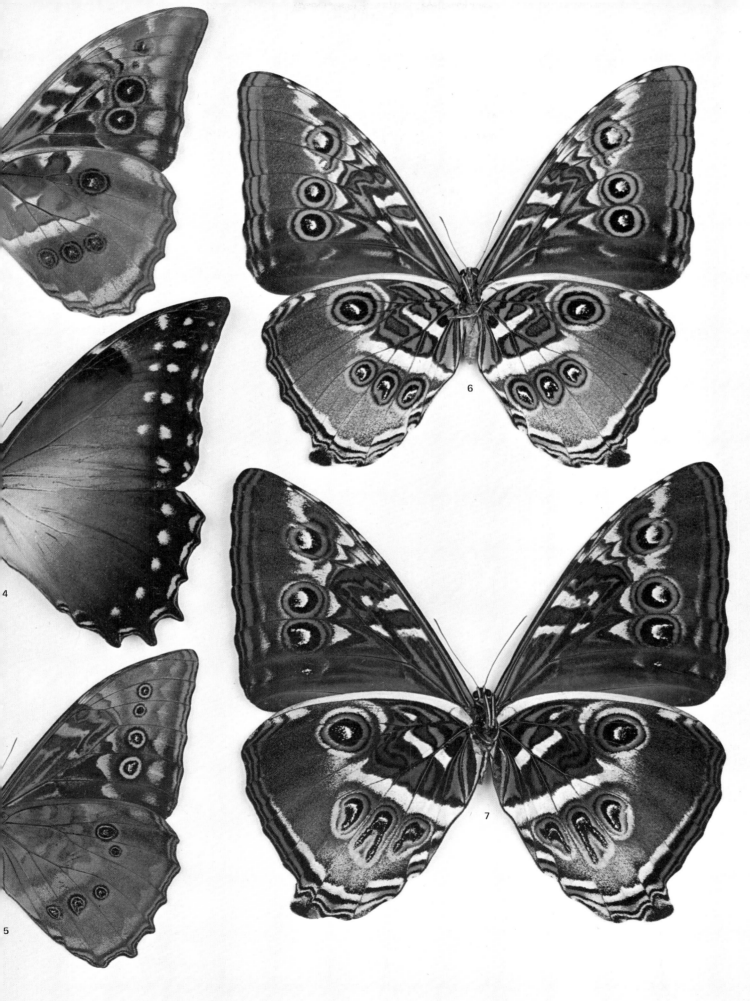

3 *hercules* Dalman. V. (Braz.)
4 *amphitrion* Stgr. (Peru)
5 *telemachus* L.f.metellus Cr. V. (Braz.)
6 *hecuba* L.s.sp.obidona Fruhst. V. (Braz.)
7 *phanodemus* Hew. V. (Peru)

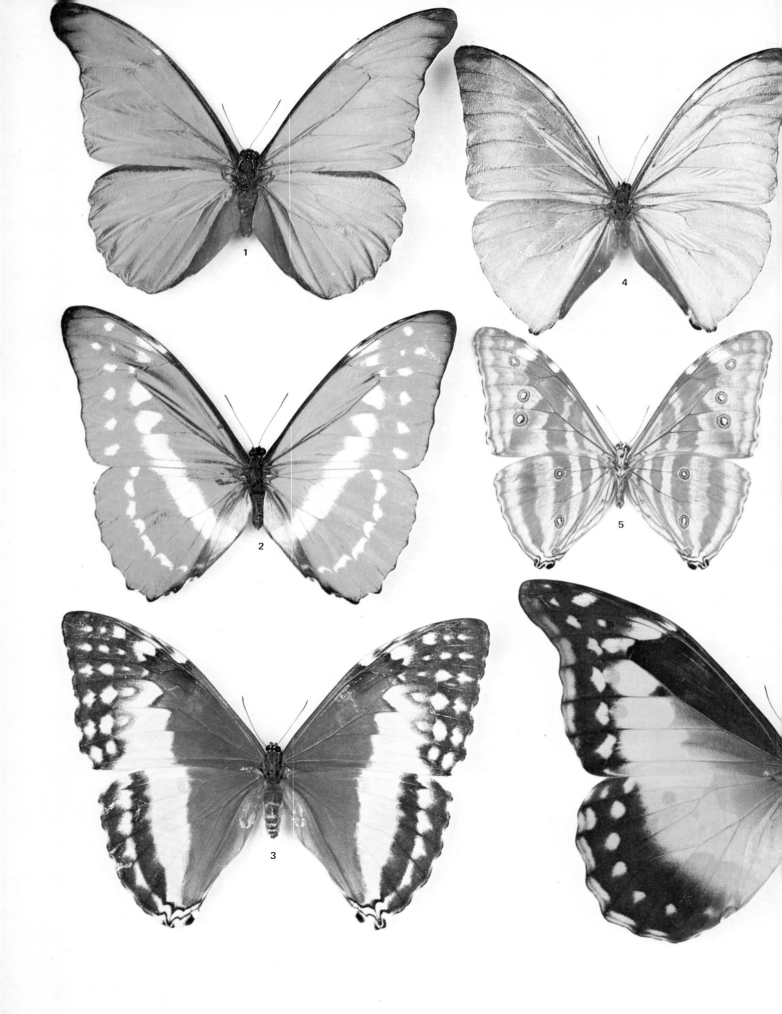

Morphidae
Morpho
 1 *rhetenor* Cr. (Guy.)

2 *cypris* Westw. (Col.)
3 *adonis* Cr.s.sp.huallaga Michael ♀. (Peru)
4 *adonis* Cr. (Guy.)
5 *adonis* Cr.s.sp.huallaga Michael (? = marcus

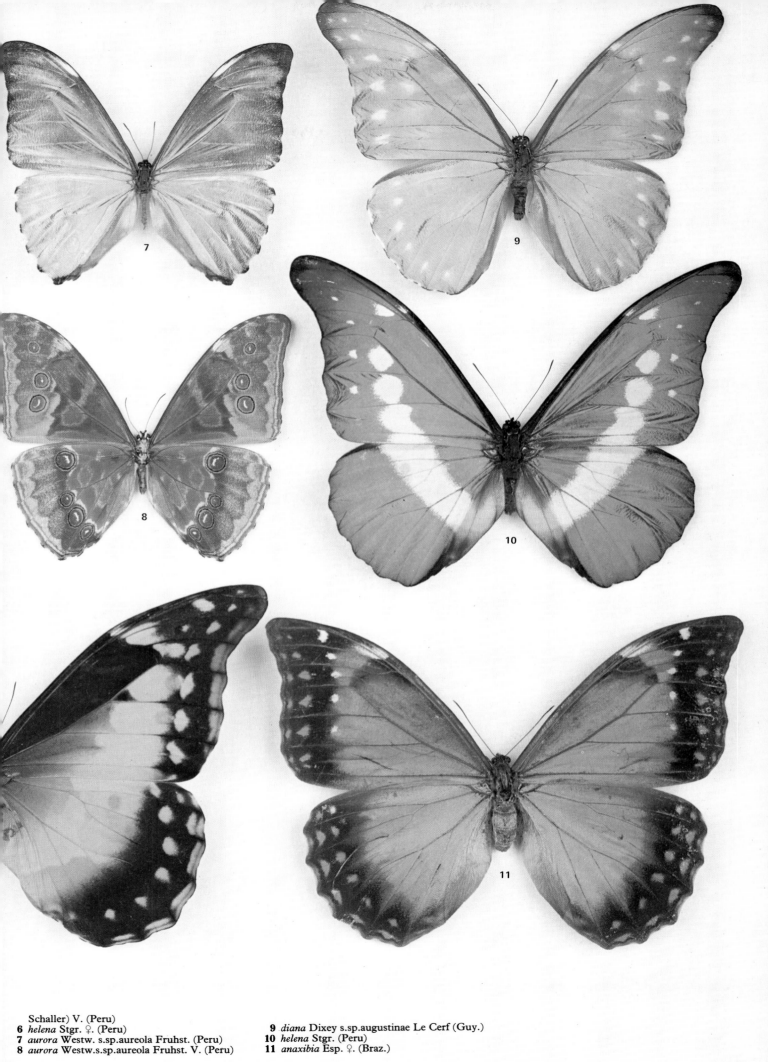

Schaller) V. (Peru)
6 *helena* Stgr. ♀. (Peru)
7 *aurora* Westw. s.sp.aureola Fruhst. (Peru)
8 *aurora* Westw.s.sp.aureola Fruhst. V. (Peru)
9 *diana* Dixey s.sp.augustinae Le Cerf (Guy.)
10 *helena* Stgr. (Peru)
11 *anaxibia* Esp. ♀. (Braz.)

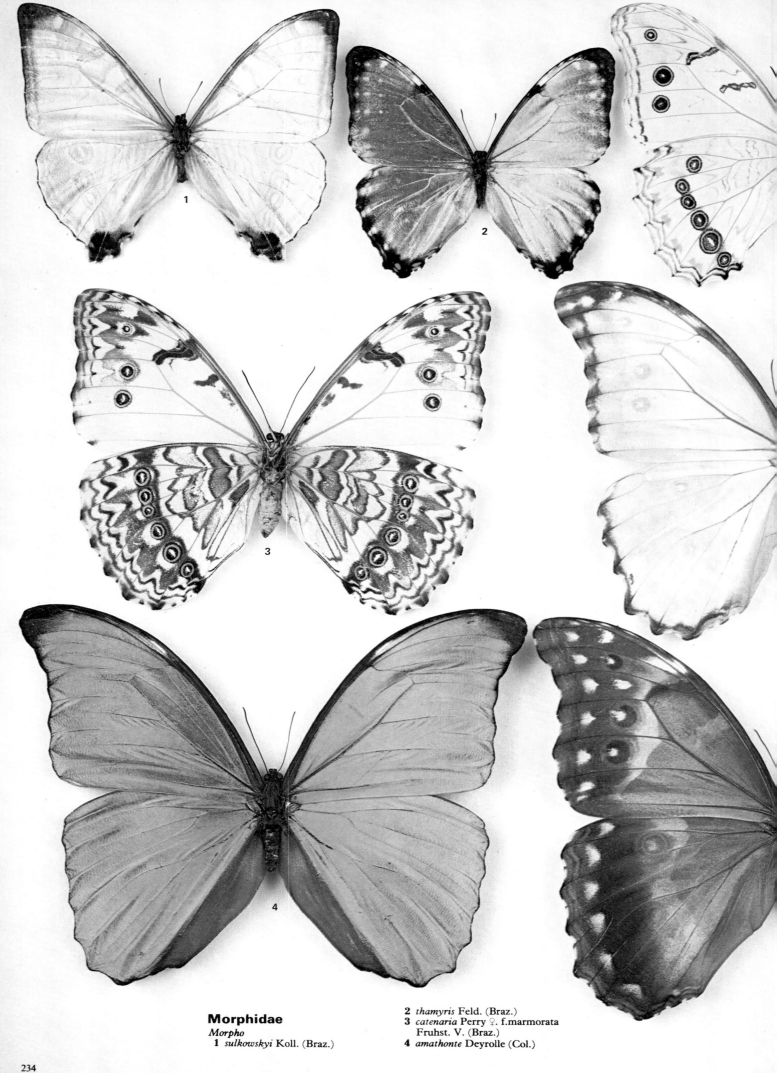

Morphidae
Morpho
 1 *sulkowskyi* Koll. (Braz.)

2 *thamyris* Feld. (Braz.)
3 *catenaria* Perry ♀. f.marmorata
 Fruhst. V. (Braz.)
4 *amathonte* Deyrolle (Col.)

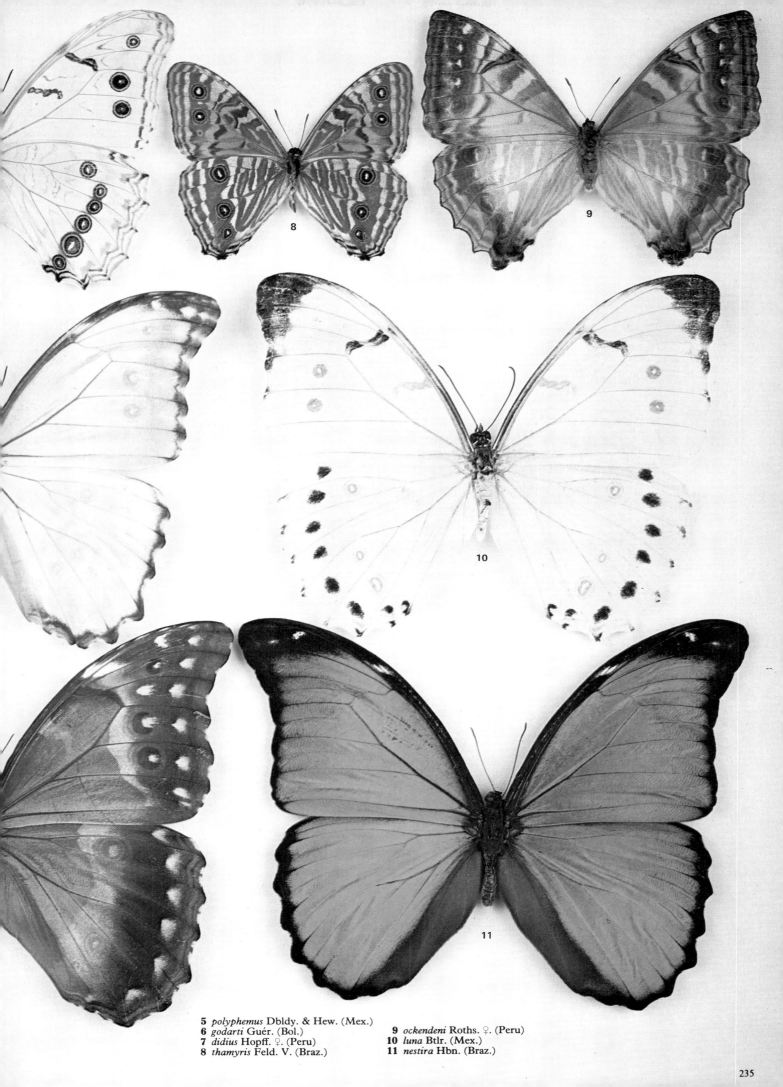

5 *polyphemus* Dbldy. & Hew. (Mex.)
6 *godarti* Guér. (Bol.)
7 *didius* Hopff. ♀. (Peru)
8 *thamyris* Feld. V. (Braz.)

9 *ockendeni* Roths. ♀. (Peru)
10 *luna* Btlr. (Mex.)
11 *nestira* Hbn. (Braz.)

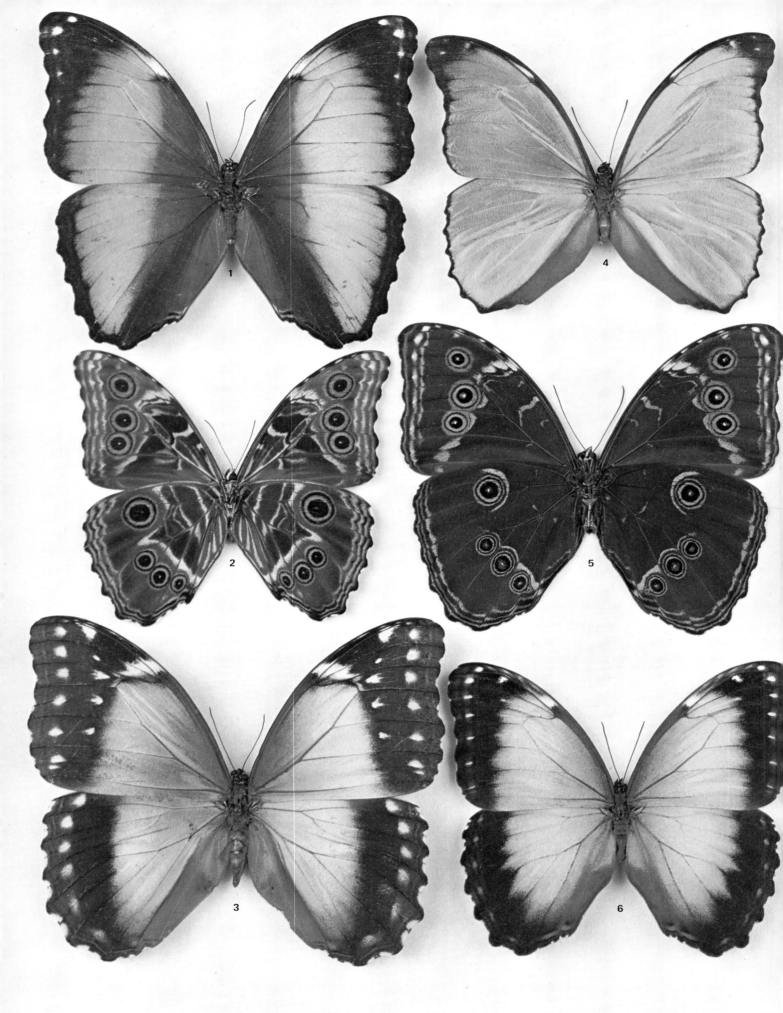

Morphidae

Morpho
1 *deidamia* Hbn. (Guy.)

2 *deidamia* Hbn. V. (Guy.)
3 *menelaus* L.s.sp.terrestris Btlr. ♀. (Braz.)
4 *menelaus* L.s.sp.guyanensis Le Moult (Guy.)
5 *patroclus* Feld.s.sp.orestes Weber V. (Peru)

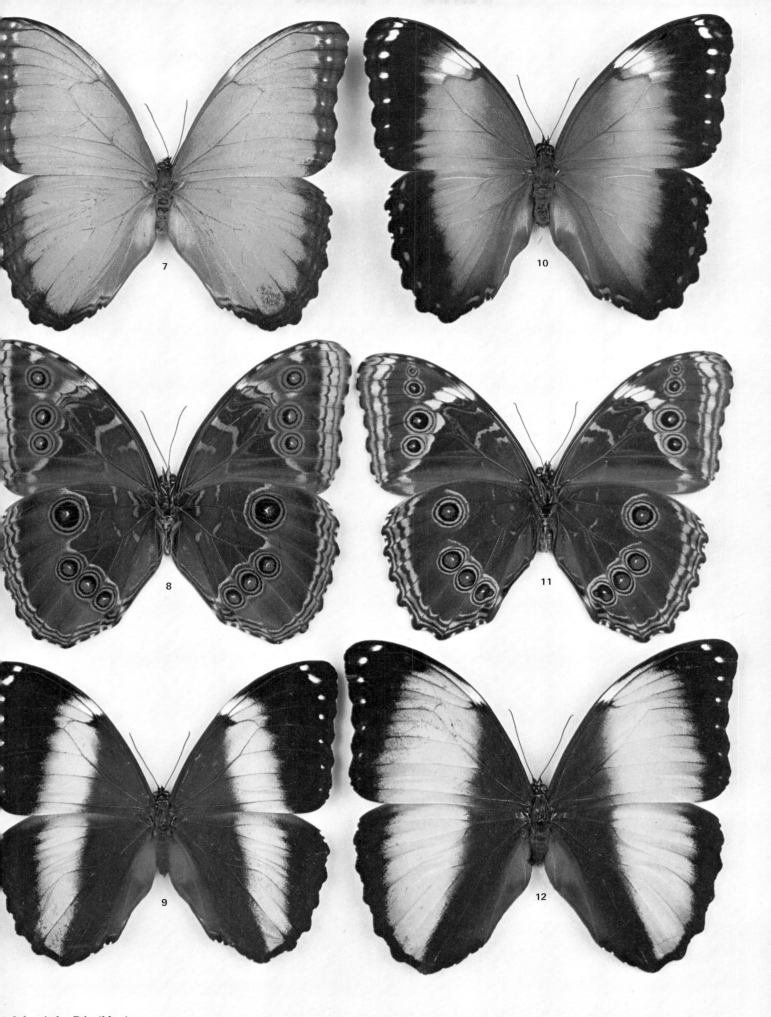

Brassolidae –

owls

Just under 80 Neotropical species are included in the family Brassolidae. The majority are quite large, some of the *Caligo* species reaching 200mm in wing-span. By contrast the small, rather dull *Narope* species have a wing-span of less than 60mm. On the upper side a dull brown appearance more-or-less banded with lighter shades, is most usual. However a few have deep blue or purple-flushed wings, duller than those of the Morphidae but nevertheless very beautiful. The females are generally larger, otherwise the sexes are very similar in appearance. Scent patches and hair pencils are present in the males of most species.

The vast majority are forest dwellers and crepuscular ie flying only at dusk or, in a few cases, in the early morning. Some of the giant owl butterflies *(Caligo)* are banana pests in Central America and may be observed flying in great numbers around the plantations at twilight. These imposing creatures are among the largest South American butterflies and familiar to every naturalist from the supposed protection afforded by the staring 'eyes' of the underside. Predatory birds are perhaps equally likely to be disturbed by the 'clatter' produced by the flapping of the great wings.

Other members of the family may show similar under side patterns but the eye-spots are seldom so prominent. Among the most curious are the huge moth-like *Dynastor* species considered to be among the most primitive members of the family.

The eggs are spherical, occasionally somewhat flattened, and prominently ribbed. The larvae are usually gregarious, feeding on palm, banana and other monocotyledons. They are longitudinally striped and sometimes have short spines; the head is densely haired. The stout pupae are attached head-down to the food plant. In one genus *(Brassolis)* they remain in the larval 'nests'.

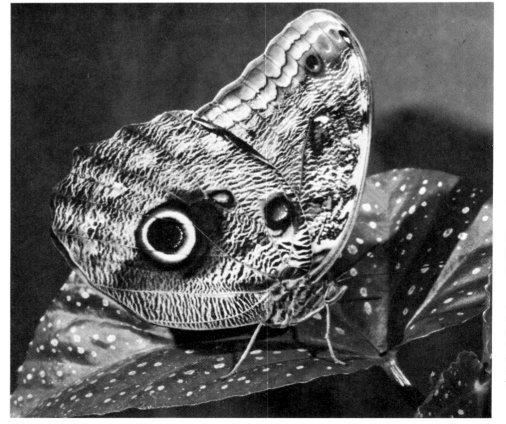

Left: The genus *Caligo* or 'owl butterflies' are so called from the appearance of the under sides, suggesting feathers surrounding huge eyes. *Caligo eurilochus* Cr. is the best known species – the example shown here being s.sp. *brasiliensis* Feld. (X 0.75). Another form of this species is shown on pages 242/243.

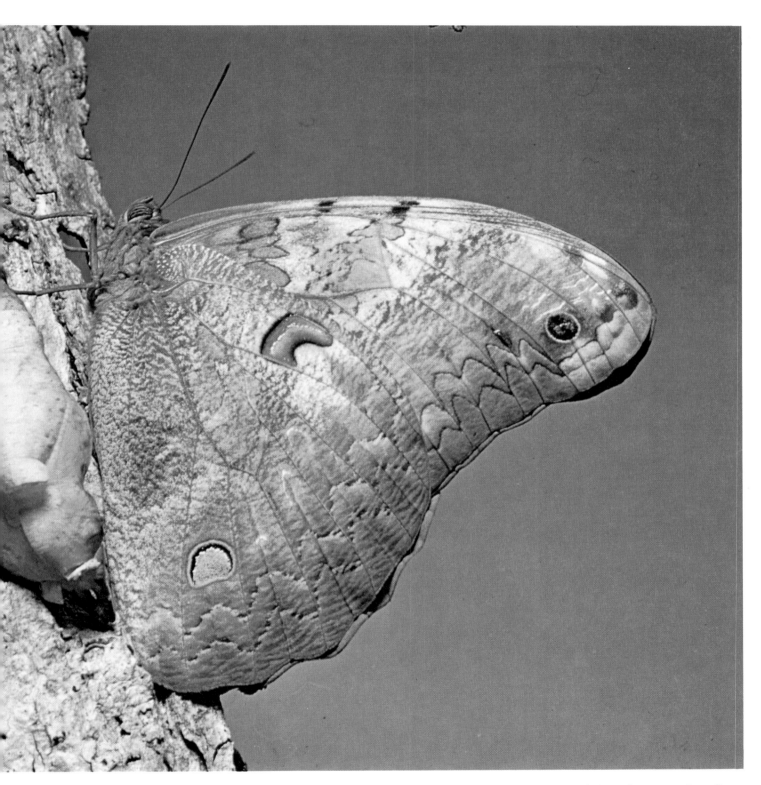

Left: The curiously shaped *Penetes pamphanis* Westw. is unique among Brassolidae in both wing shape and venation, and it is the only species in this genus. *Pamphanis* is found solely in Brazil, and although it occurs in several different localities here it must be considered something of a rarity (X 0.25).

Above: This *Selenophanes cassiope* Cr. has recently emerged from the pupa case to its left. Native to Peru, this example is designated sub-species *cassiopeia* Stgr. Note how effectively the cryptic coloration of the underside blends with the tree bark, a feature found in many other members of this family (X 4).

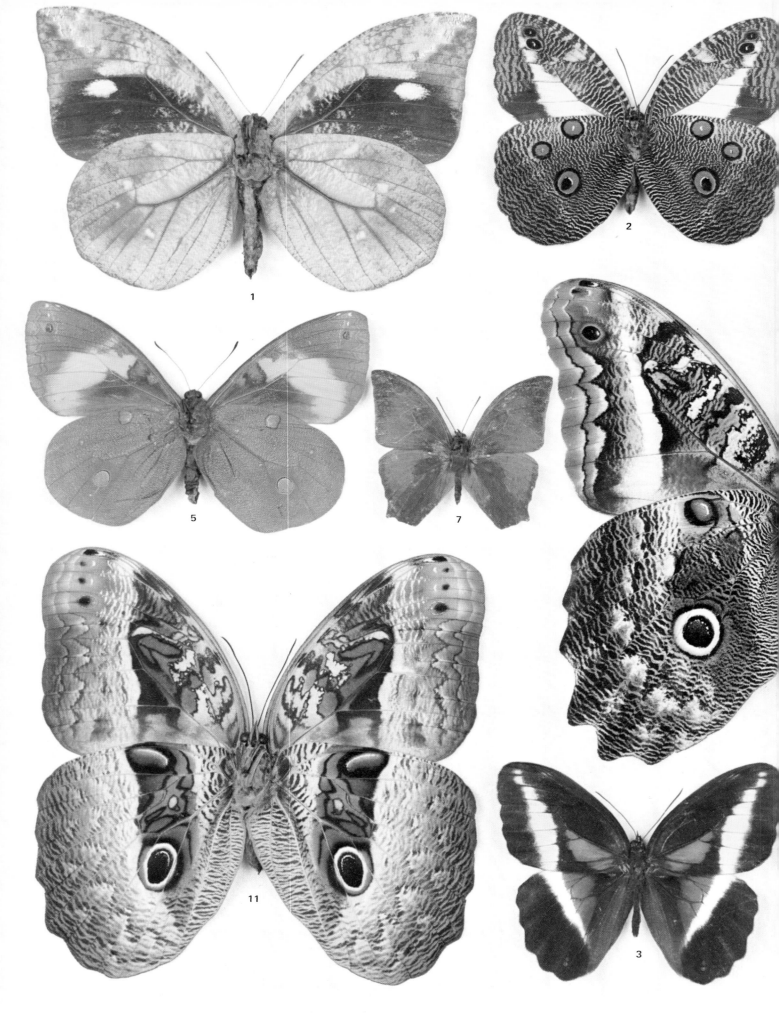

Brassolidae

Dynastor
1 *napoleon* Westw. V. (Braz.)

Dasyophthalma
2 *creusa* Hbn. V. (Braz.)
3 *rusina* Godt. (Braz.)
4 *rusina* Godt.f.geraensis auct? (Braz.)

Brassolis
5 *sophorae* L. ♀. V. (Guy.)
6 *astyra* Godt. (Braz.)

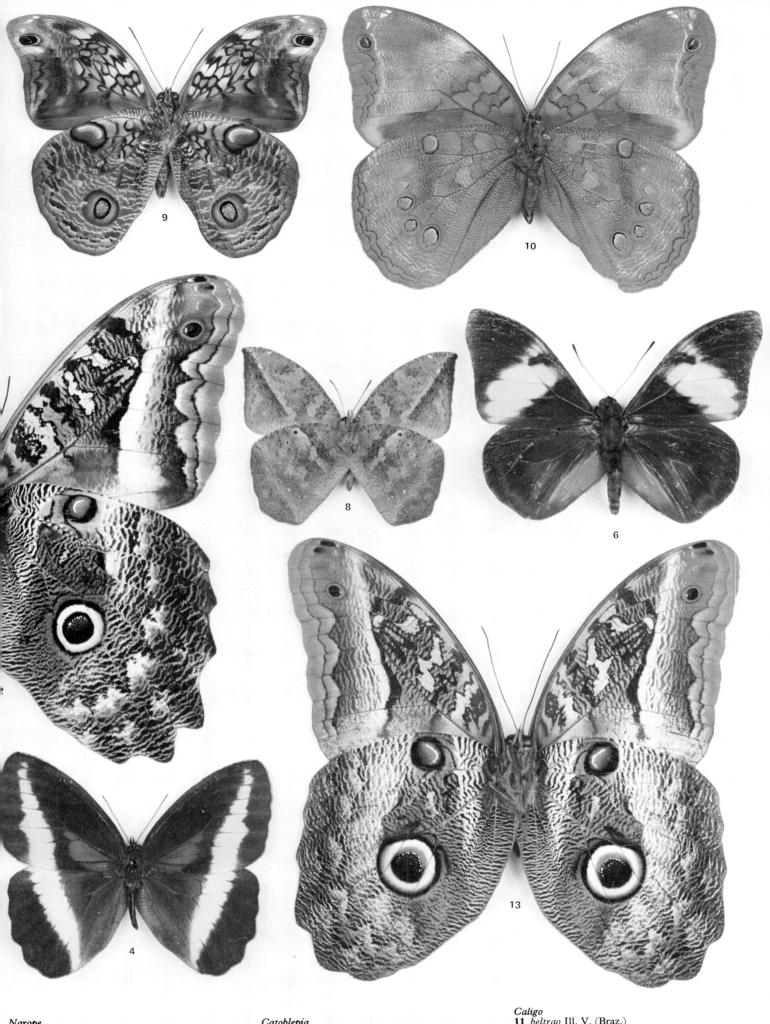

Narope
7 *cyllastros* Westw. (Braz.)
8 *sarastro* Stgr. V. (Col.)

Catoblepia
9 *amphirhoe* Hbn.s.sp.placita Stich. V. (Braz.)
10 *berecynthia* Cr.s.sp.midas Stich. ♀. V. (Peru)

Caligo
11 *beltrao* Ill. V. (Braz.)
12 *idomeneus* L.s.sp.agamemnon Weym. ♀. V. (Ecua.)
13 *idomeneus* L.s.sp.idomenides Fruhst. V. (Peru)

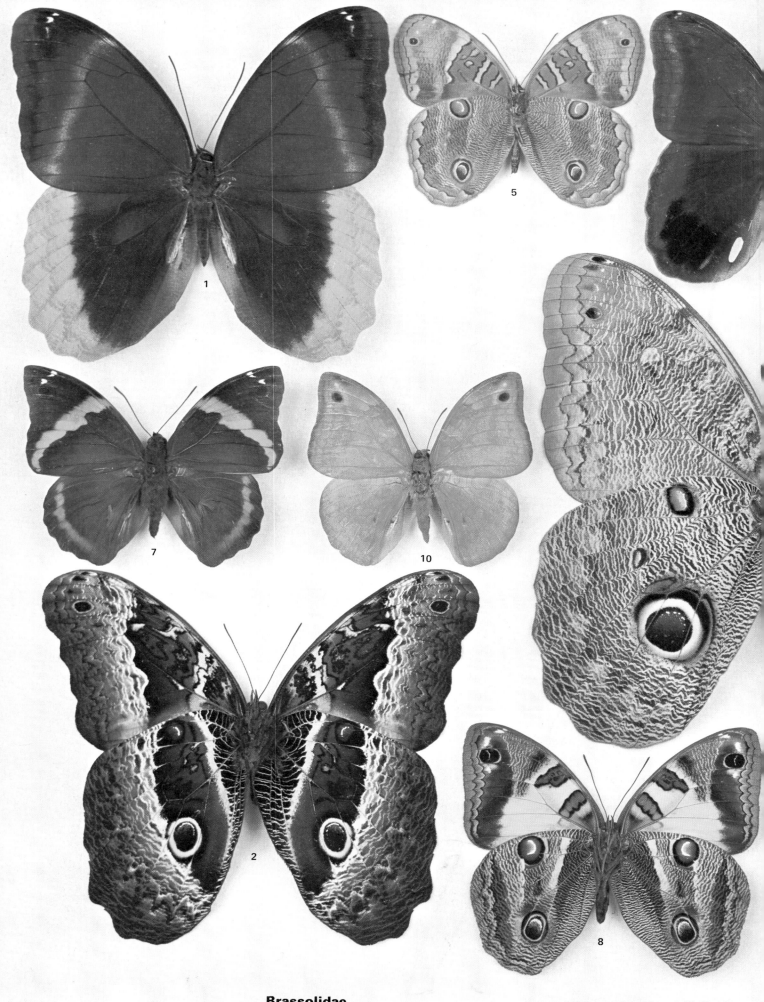

Brassolidae

Caligo
 1 *uranus* H.-Schaff. (Mex.)
 2 *oberthurii* Deyrolle.s.sp.phokilides
 Fruhst. V. (Peru)

 3 *eurilochus* Cr.s.sp.livius Stgr. ♀. V. (Peru)
 4 *placidianus* Stgr. V. (Peru)
Opoptera
 5 *sulcius* Stgr. V. (Braz.)
 6 *aorsa* Godt.s.sp.hilara Stich. (Peru)

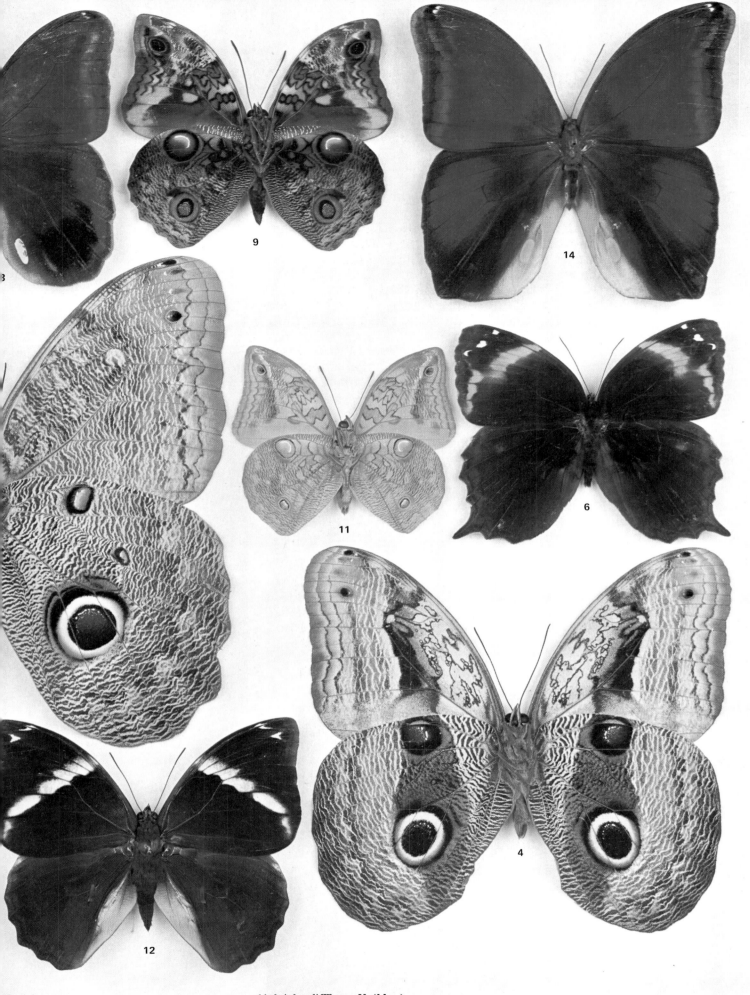

Opsiphanes
7 *invirae* Hbn.s.sp.agasthenes Fruhst. (Peru)
8 *batea* Hbn. V. (Braz.)
9 *quiteria* Cr.s.sp.farraga Stich. V. (Bol.)
10 *boisduvali* Westw. (Mex.)

11 *boisduvali* Westw. V. (Mex.)
12 *tamarindi* Feld.s.sp.bogotanus Dist. (Col.)
Eryphanis
13 *aesacus* H.-Schaff. (Mex.)
14 *polyxena* Meerb.s.sp.amphimedon Feld. (Braz.)

Chapter 25

Satyridae–

browns and satyrs

The newcomer to the study of Lepidoptera might well be forgiven for regarding this family as rather dull. Certainly the majority of the 2,500 to 3,000 species included are predominantly shades of brown. However, as might be expected with such a large number, spread throughout all world regions, the range of wing shape and pattern is very extensive. Indeed, a large number of species are far removed from the foregoing notion of 'typical' Satyrid appearance and many resemble butterflies of other families.

In wingspan they range from about 25mm *(Coenonympha)* to 130mm *(Neorina)*. Eye-spots (ocelli) are one of the most characteristic features of the family. Sometimes these are extensively developed, forming series or chains; only a few genera are without some vestige of these.

One of the most unusual groups is the Neotropical *Haeterinae*, many members of which have transparent wings and brilliant patches of colour. South America is rich in Satyridae and many groups found there are not represented in other regions.

Many tropical Satyridae prefer to fly at dusk or keep to to the shade. In general, species of northern regions do not share this behaviour. The latter are to be found in almost all suitable terrain. Some are particularly characteristic of sub-arctic *(Oeneis)* or montane regions *(Erebia)*.

Species of the genus *Elymnias* are among the most interesting Indo-Australian Satyrids. Almost all species closely resemble butterflies of other families, especially Danaidae. In several cases males and females of the same species may 'copy' quite different models, rendering them very different in appearance.

The eggs are generally spherical and delicately ribbed. The larvae are generally smooth and frequently shades of green, sometimes with longitudinal striping. A forked posterior 'tail' is always more or less developed. The great majority feed on grasses or allied plants. The pupae are usually rather squat without noticeable projections. They may be suspended by the tail or lie at the grass roots or under stones.

Top: The dainty *Pierella dracontis* Hbn. from Brazil (X 2.5).

Above: This typical specimen of the European *Aphantopus hyperantus* L. should be compared with the aberrant example on pages 54/55 (X 8).

Left: The European *Melanargia galathea* L. superficially resembles a member of the 'whites' (Pieridae). The normal form is black and white like a chess-board. Very rare aberrations may be almost totally black or white (X 5).

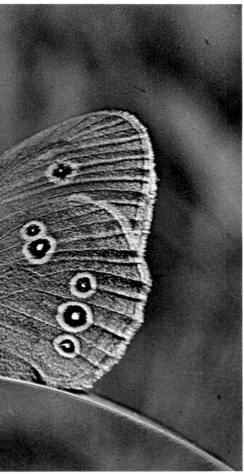

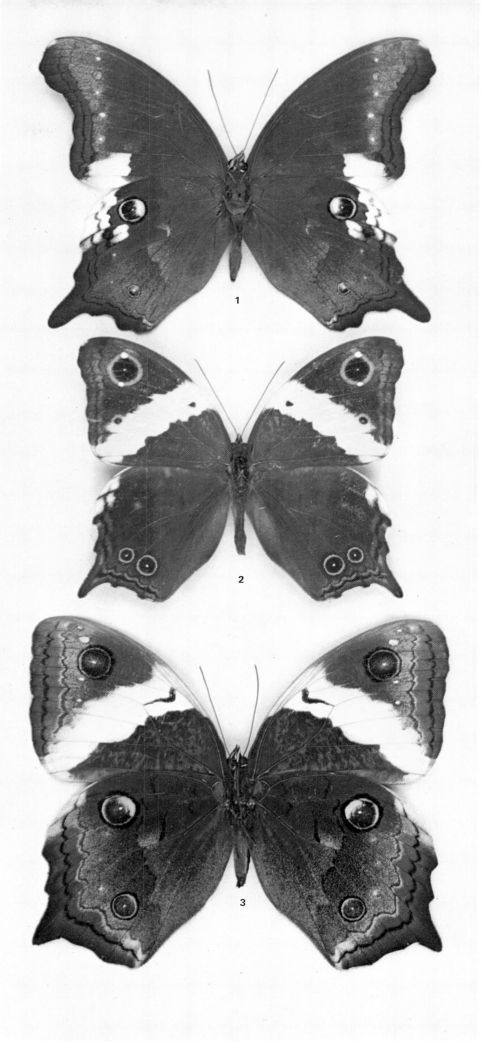

Right: The genus *Neorina* includes some of the largest of the Satyridae. Shown life size here are: 1. *N.lowii* Dbldy. s.sp. *neophyta* Fruhst. V (Malay). 2. *N.krishna* Westw. s.sp. *archaica* Fruhst. (Ind.). 3. *N. patria* Leech s.sp *westwoodi* Moore ♀ V (Ind.).

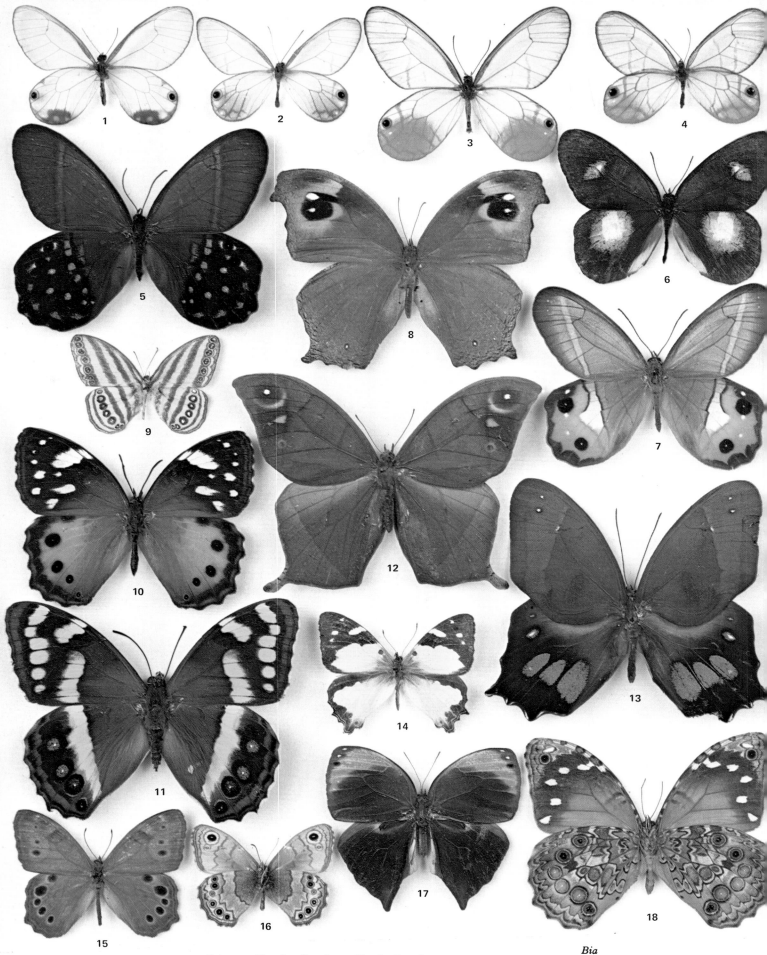

Satyridae

Cithaerias
1 *esmeralda* Dbldy. (Braz.)
2 *philis* Cr. (Guy.)
3 *aurorina* Weym. (Peru)
4 *pireta* Cr.s.sp.menander Dry. ♀.
 (Ecua.)

Pierella
5 *lena* L.s.sp.glaucolena Stgr. (Peru)

6 *hortona* Hew.f.ocellata f.nov. (Peru)
7 *nereis* Dry. (Braz.)

Melanitis
8 *leda* L. (Ken.)

Ragadia
9 *crisia* Gey. V. (Java)

Paralethe
10 *dendrophilus* Trim. (S. Af.)

Aeropetes
11 *tulbaghia* L. (S. Af.)

Caerois
12 *gerdrudtus* Fab. (Ecua.)

Antirrhea
13 *philoctetes* L. (Braz.)

Aphysoneura
14 *pigmentaria* Karsch (Ken.)

Enodia
15 *andromacha* Hbn. (USA)

Paramecera
16 *xicaque* Reak. V. (Mex.)

Bia
17 *actorion* L. (Peru)

Mantaria
18 *maculata* Hopff. V. (C. Rica)

Patala
19 *yama* Moore V. (Ind.)

Neope
20 *pulaha* Moore s.sp.didia Fruhst.
 (Form.)

Ethope
21 *himachala* Moore (Ind.)

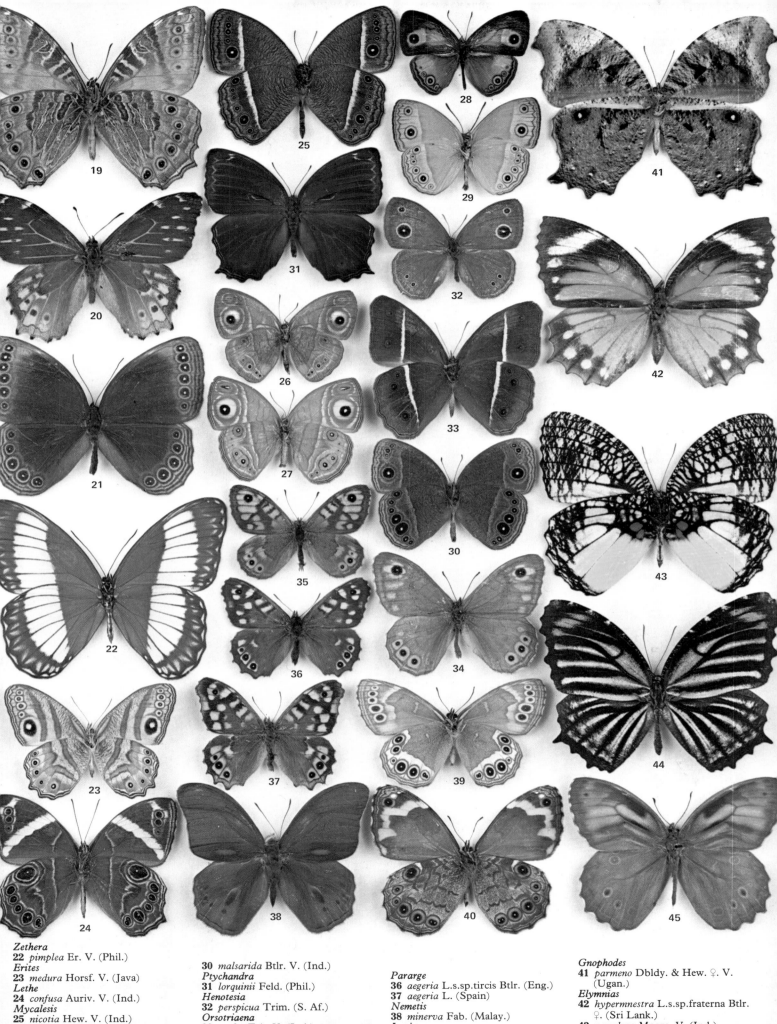

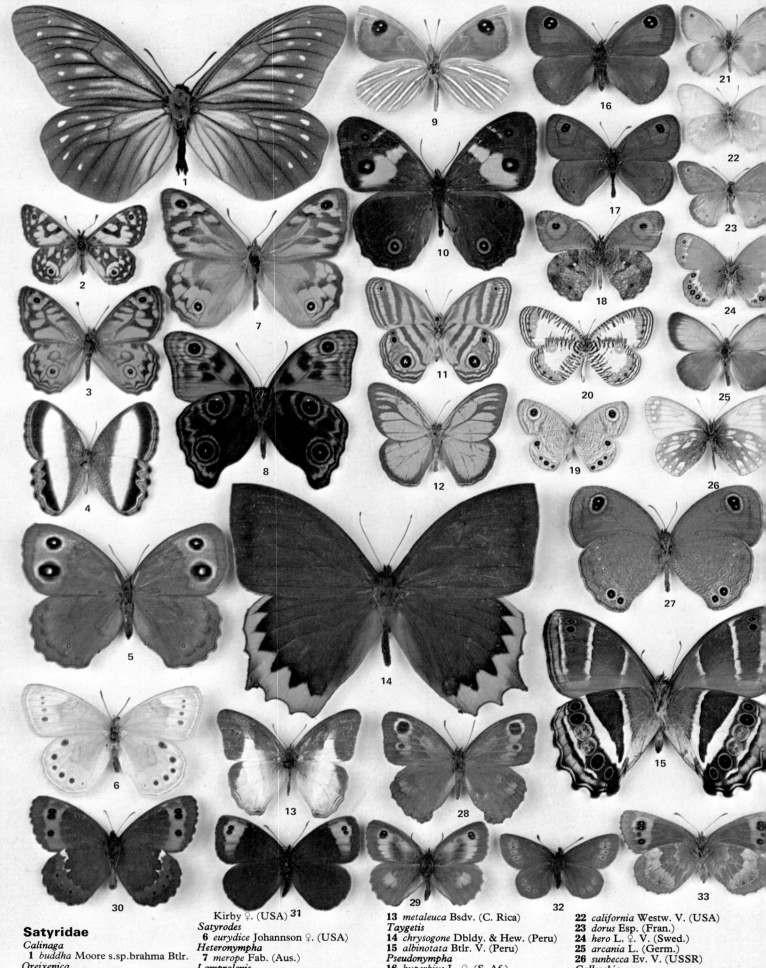

Satyridae

Calinaga
 1 *buddha* Moore s.sp.brahma Btlr.
Oreixenica
 2 *lathionella* Westw.s.sp.herceus
 Waterhouse & Lyell (Aus.)
Geitoneura
 3 *acantha* Don. (Aus.)
Oressinoma
 4 *typhla* Dbldy. & Hew. V. (Ecua.)
Cercyonis
 5 *pegala* Fab.f.nephele

Kirby ♀. (USA) **31**
Satyrodes
 6 *eurydice* Johannson ♀. (USA)
Heteronympha
 7 *merope* Fab. (Aus.)
Lamprolenis
 8 *nitida* Godm. & Salv. (N.G.)
Argyrophenga
 9 *antipodum* Dbldy. V. (N.Z.)
Tisiphone
 10 *abeona* Don. (Aus.)
Euptychia
 11 *chloris* Cr. V. (Braz.)
 12 *cephus* Fab. (Braz.)

 13 *metaleuca* Bsdv. (C. Rica)
Taygetis
 14 *chrysogone* Dbldy. & Hew. (Peru)
 15 *albinotata* Btlr. V. (Peru)
Pseudonympha
 16 *hyperbius* L. ♀. (S. Af.)
 17 *trimeni* Btlr. (S. Af.)
Ypthima
 18 *tamatevae* Bsdv. V. (Madgr.)
 19 *huebneri* Kirby. V. (Ind.)
Physcaeneura
 20 *pione* Godm. V. (Ken.)
Coenonympha
 21 *pamphilus* L. (Eng.)

 22 *california* Westw. V. (USA)
 23 *dorus* Esp. (Fran.)
 24 *hero* L. ♀. V. (Swed.)
 25 *arcania* L. (Germ.)
 26 *sunbecca* Ev. V. (USSR)
Callerebia
 27 *scanda* Moore V. (Ind.)
Pampasatyrus
 28 *limonias* Phil. (Argent.)
Pyronia
 29 *tithonus* L. (Eng.)
Erebia
 30 *ligea* L. V. (Swed.)
 31 *zapateri* Oberth. (Spain)

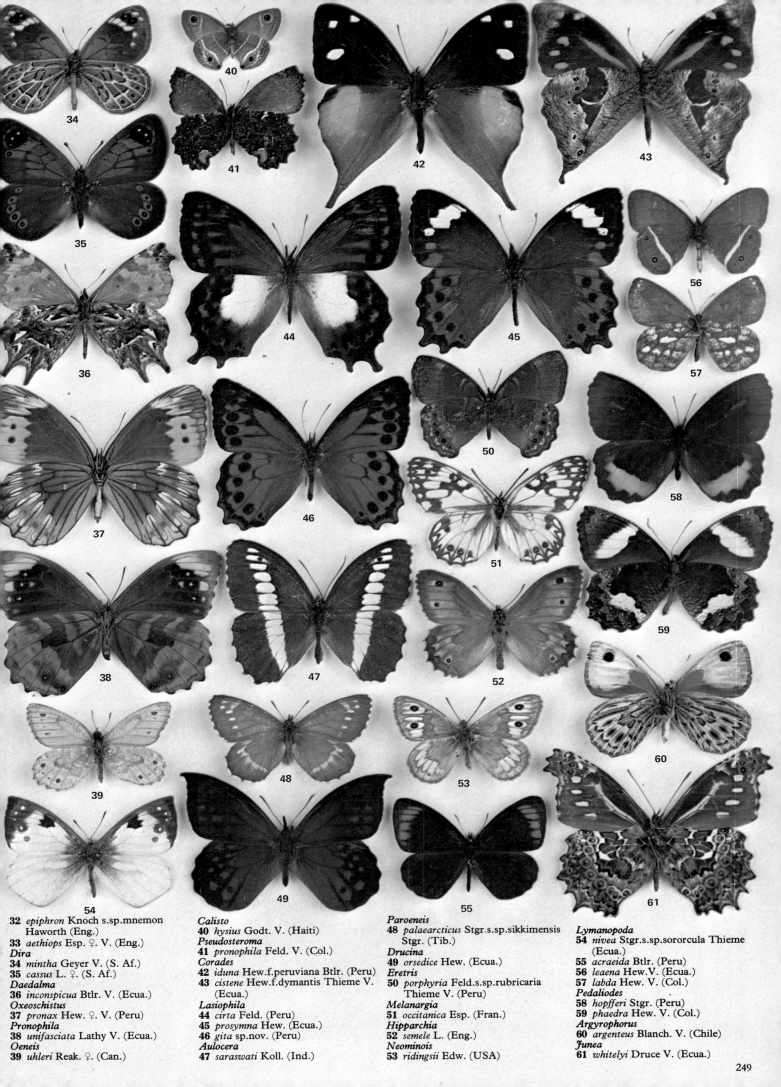

32 *epiphron* Knoch s.sp.mnemon
Haworth (Eng.)
33 *aethiops* Esp. ♀. V. (Eng.)
Dira
34 *mintha* Geyer V. (S. Af.)
35 *cassus* L. ♀. (S. Af.)
Daedalma
36 *inconspicua* Btlr. V. (Ecua.)
Oxeoschistus
37 *pronax* Hew. ♀. V. (Peru)
Pronophila
38 *unifasciata* Lathy V. (Ecua.)
Oeneis
39 *uhleri* Reak. ♀. (Can.)

Calisto
40 *hysius* Godt. V. (Haiti)
Pseudosteroma
41 *pronophila* Feld. V. (Col.)
Corades
42 *iduna* Hew.f.peruviana Btlr. (Peru)
43 *cistene* Hew.f.dymantis Thieme V.
(Ecua.)
Lasiophila
44 *cirta* Feld. (Peru)
45 *prosymna* Hew. (Ecua.)
46 *gita* sp.nov. (Peru)
Aulocera
47 *saraswati* Koll. (Ind.)

Paroeneis
48 *palaearcticus* Stgr.s.sp.sikkimensis
Stgr. (Tib.)
Drucina
49 *orsedice* Hew. (Ecua.)
Eretris
50 *porphyria* Feld.s.sp.rubricaria
Thieme V. (Peru)
Melanargia
51 *occitanica* Esp. (Fran.)
Hipparchia
52 *semele* L. (Eng.)
Neominois
53 *ridingsii* Edw. (USA)

Lymanopoda
54 *nivea* Stgr.s.sp.sororcula Thieme
(Ecua.)
55 *acraeida* Btlr. (Peru)
56 *leaena* Hew.V. (Ecua.)
57 *labda* Hew. V. (Col.)
Pedaliodes
58 *hopfferi* Stgr. (Peru)
59 *phaedra* Hew. (Col.)
Argyrophorus
60 *argenteus* Blanch. V. (Chile)
Junea
61 *whitelyi* Druce V. (Ecua.)

Chapter 26

Ithomiidae –

ithomiids

The interesting family Ithomiidae consists of several hundred small to medium-sized butterflies with narrow wing shape and attenuated abdomens. In wing-span they range from a little over 25mm *(Scada)* to about 115mm *(Thyridia)*.

Many species have almost wholly transparent wings, while others are brightly coloured in shades of orange-brown, with arresting striped and spotted patterns in black and white. Some of the latter so closely resemble members of the Heliconiidae that they appear virtually identical. However, an examination of the wing venation and other structural features (such as the presence of long hair tufts on the hind wings of males in *Ithomiinae*) will serve to separate them.

With a single exception all the species belong to the subfamily *Ithomiinae* and are confined to the Neotropical region. The exception is *Tellervo zoilus* from Australia and New Guinea, popularly known as the hamadryad.

Like the Heliconiidae all species are 'protected' by nauseous body fluids and many are subject to mimicry by unprotected species of other families. The adults are slow flying and largely confined to forest areas, although numbers of some transparent species may congregate in open clearings.

The larvae are smooth or sparsely haired and the majority feed on Solonaceae. The pupae are stout and strongly bowed with prominent wing cases. They are suspended head-down from a silken pad.

Right: The Australian *Tellervo zoilus* Fab. is something of an evolutionary puzzle. The only member of this family to occur outside the American region, it is geographically so widely separated from its allies that its origin remains a mystery. So far as is known it is the only example of its sub-family, and it differs from the other Ithomiidae by the absence of scent hairs in the male. Some of the numerous forms of *zoilus* found in the Australian region have in the past been treated as separate species.

Right: Like many other Ithomiidae *Mechanitis polymnia* L. is confusingly similar to species in the family Heliconiidae. Since both families are distasteful to certain predators it is probable that such resemblances are mutually beneficial (see Chapter 9). This is a Trinidad specimen of s.sp.*solaria* Forbes (X 8).

Left: With its delicate transparent wings and long antennae *Ithomia ellara* Hew. is one of the most characteristic members of this family. The example shown here was photographed in Peru and is s.sp. *eleonora* Haensch (X 8).

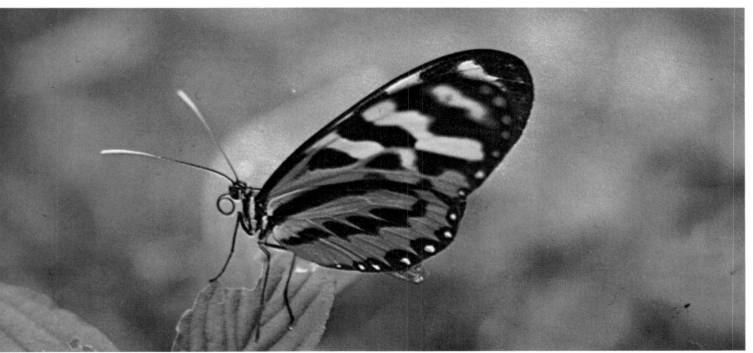

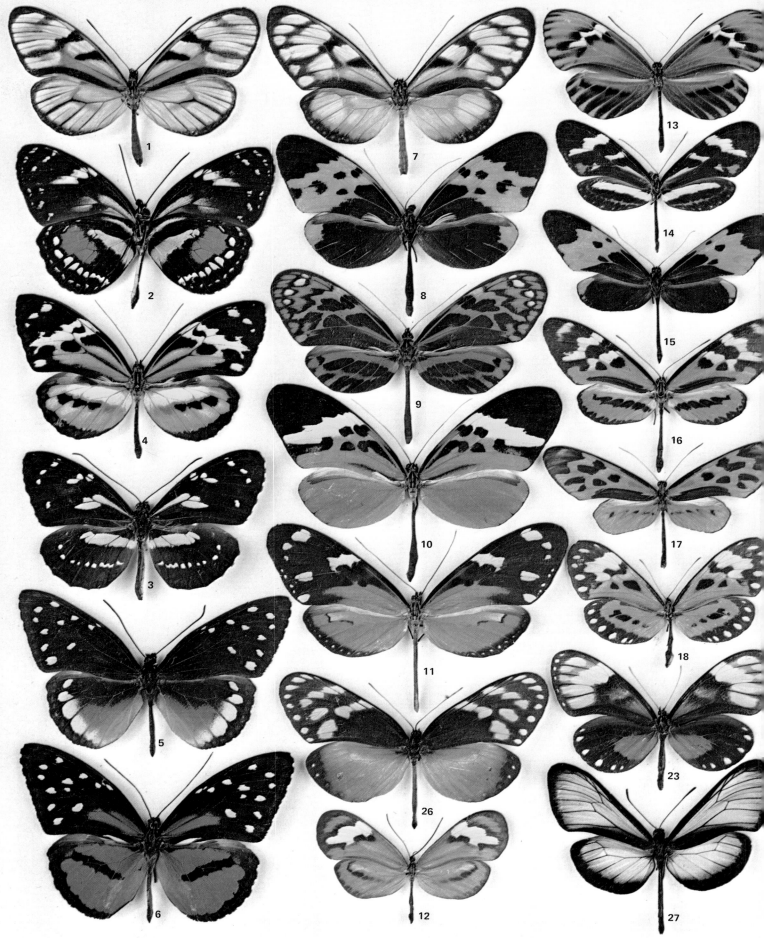

Ithomiidae

Athesis
1 *clearista* Dbldy. & Hew. ♀. (Venez.)
Elzunia
2 *cassandrina* Srnka V. (Col.)
3 *pavonii* Btlr. (Ecua.)
Tithorea
4 *harmonia* Cr.s.sp.pseudethra Btlr. (Braz.)
5 *tarricina* Hew. (Col.)
6 *tarricina* Hew.s.sp.duenna Bates (Mex.)
Eutresis
7 *hypereia* Dbldy. & Hew. (Venez.)

Melinaea
8 *comma* Forbes s.sp.simulator Fox (Ecua.)
9 *maelus* Hew.s.sp.cydon Godm. & Salv. (Peru)
10 *mneophilus* Hew.s.sp.zaneka Btlr. (Ecua.)
11 *mnemopsis* Berg (Bol.)
Sais
12 *rosalia* Cr.s.sp.mosella Hew. ♀. (Venez.)
13 *zitella* Hew. (Peru)
Mechanitis
14 *mantineus* Hew. ♀. (Ecua.)

15 *messenoides* Feld.s.sp.deceptus Btlr. (Peru)
16 *lycidice* Bates (Venez.)
17 *truncata* Btlr.s.sp.huallaga Stgr. (Peru)
Hypothyris
18 *antonia* Hew. ♀. (Ecua.)
19 *lycaste* Fab.s.sp.dionaea Hew. ♀. (Mex.)
20 *euclea* Latr. ♀. (Ecua.)
21 *pyrippe* Hopff. (Ecua.)
22 *daeta* Bsdv. (Braz.)
Godyris

23 *zygia* Godm. & Salv.s.sp.sosunga Reak. ♀. (Hond.)
24 *zavaleta* Hew. (Col.)
25 *duillia* Hew. (Peru)
Hyalyris
26 *excelsa* Feld.s.sp.decumana Godm. & Salv. ♀. (C. Rica)
27 *avinoffi* Fox (Venez.)
28 *oulita* Hew.♀. (Peru)
29 *coeno* Dbldy. & Hew. ♀. (Venez.)

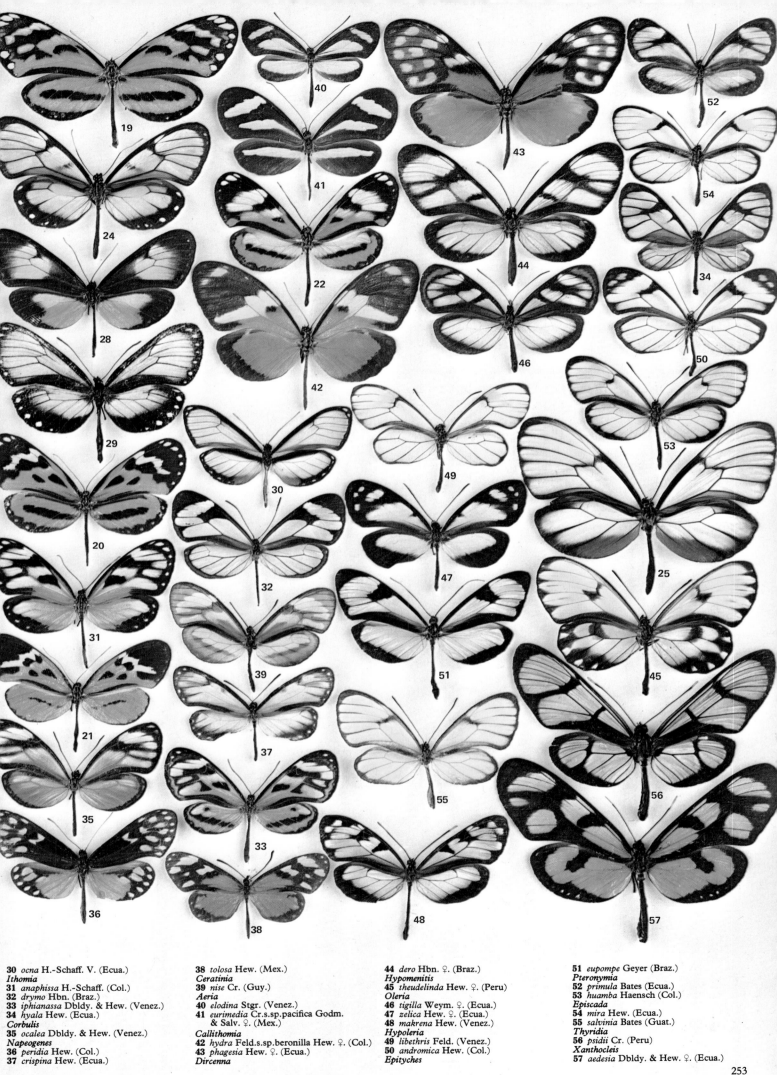

Danaidae –

tigers, crows etc

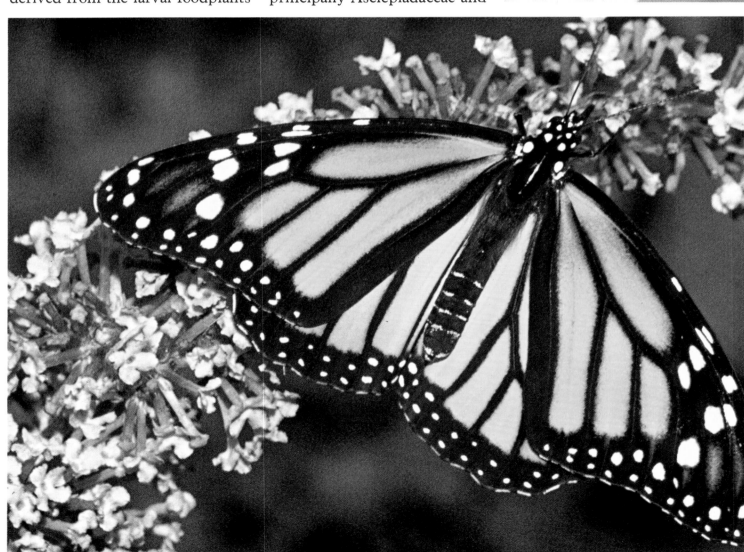

The family Danaidae is of predominantly tropical and sub-tropical distribution and contains some 300 species. A remarkable degree of uniformity exists in wing shape and pattern. They range in wing-span from about 50mm *(Danaus pumila)* to 180mm *(Idea)*. Members of the various genera are often very widely distributed some being notable migrants and extending their range into temperate regions. However they seem unable to establish themselves in the latter and similarly are not found at high altitudes. In warm low-lying areas they are often among the most abundant and conspicuous butterflies. Most species are slow flying, and have striking wing patterns and white-spotted body segments.

The tigers or milkweed butterflies *(Danaus)* have orange or whitish wings, conspicuously dark veined and spotted. They include one of the most famous butterfly migrants *Danaus plexippus* whose distribution almost encircles the globe. Particularly outstanding are the giant Oriental *Idea* species which have a lazy sailing flight and a strangely 'tissue-paper' appearance.

Lycorea and *Ituna* species are almost exclusively Neotropical. The unusual features of this small subfamily suggest a kinship with members of the family Ithomiidae.

The crows *(Euploea* species) are, as their name implies, almost black but many species are enlivened by brilliant purple reflections. This Indo-Australian genus is the largest within the family.

All species contain unpleasant or toxic body fluids which are derived from the larval foodplants – principally Asclepiadaceae and

Apocynaceae. The 'protection' thus afforded them renders them relatively free from attacks by predators and it is significant that many species are mimicked by a variety of non-poisonous butterfly groups.

The eggs have a flattened dome shape and prominent ribbing. The larvae are smooth, generally with brilliant body striping and have two to four pairs of filamentous tubercles, giving them a very 'aggressive' appearance. The pupae are suspended head downwards from a thin silk pad and have a squat rounded shape without extensive projections. In addition to a peculiarly waxy texture and coloration they are usually decorated with brilliant gold or silver spots, those of some species being almost entirely metallic or nacreous in appearance.

Above: The delicate lace-like appearance of the Indian *Danaus limiace* Cr. conceals the fact that it is a very distasteful species and is consequently shunned by predators. It is one of a group of very similar species which are found in all tropical zones of the Old World (X 3.5).

Right: Butterflies of the Old World genus *Idea* include the largest of the Danaidae. These examples are all shown at slightly less than half their natural size.
1. *I.d'urvillei* Bsdv. (N.G.) 2. *I.blanchardi* March. (Celeb.) 3. *I.lynceus* Dry. s.sp. *reinwardti* Moore (Malay.).

Left: The cosmopolitan scope of the famous migrant *Danaus plexippus* L. is indicated by the number of common names given to it in various countries. These include monarch, milkweed, wanderer and black-veined brown. The species has almost encircled the globe, and for sustained flight over long periods it probably has no rival among butterflies (see Chapter 5) (X 4).

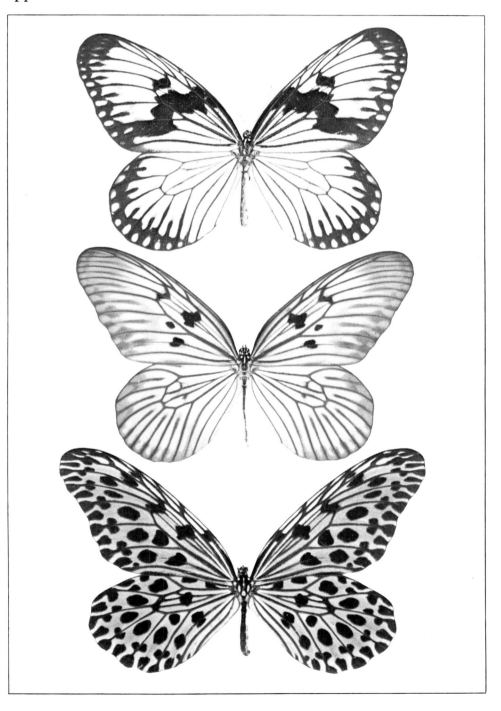

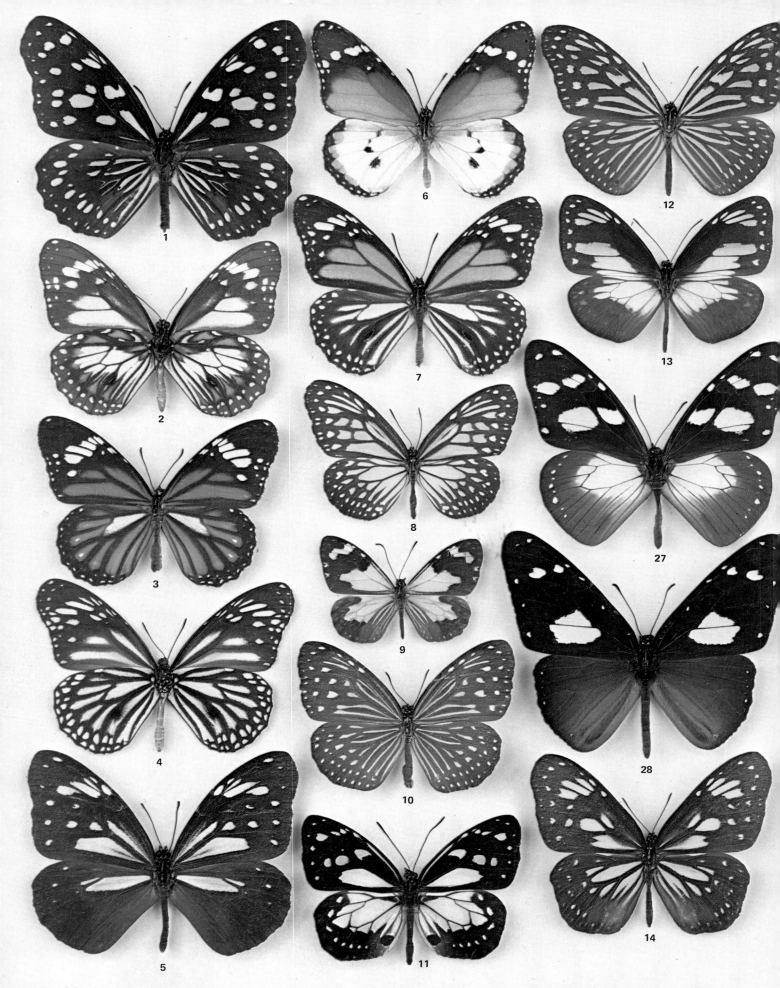

Danaidae

Danaus
1 *limniace* Cr.s.sp.petiverana Dbldy. & Hew. (Cam.)
2 *affinis* Fab. V. (Aus.)
3 *genutia* Cr.s.sp.conspicua Btlr. ♀. (Celeb.)

4 *melanippus* Cr.s.sp.lotis Cr. V. (Born.)
5 *fumata* Btlr. (Sri Lank.)
6 *chrysippus* L.f.alcippus Cr. (S. Af.)
7 *melanippus* Cr.s.sp.hegesippus Cr. (Malay.)
8 *aspasia* Fab. ♀. (Malay.)
9 *pumila* Bsdv. (Loyalty Isles)

10 *eryx* Fab. ♀. (Burma)
11 *weiskei* Roths. (N.G.)
12 *vulgaris* Btlr.s.sp.macrina Fruhst. (Malay.)
13 *melusine* G.-Smith s.sp.cythion Fruhst. (N.G.)
14 *cleona* Cr.s.sp.luciplena Fruhst. (Celeb.)
15 *choaspes* Btlr. (Celeb.)

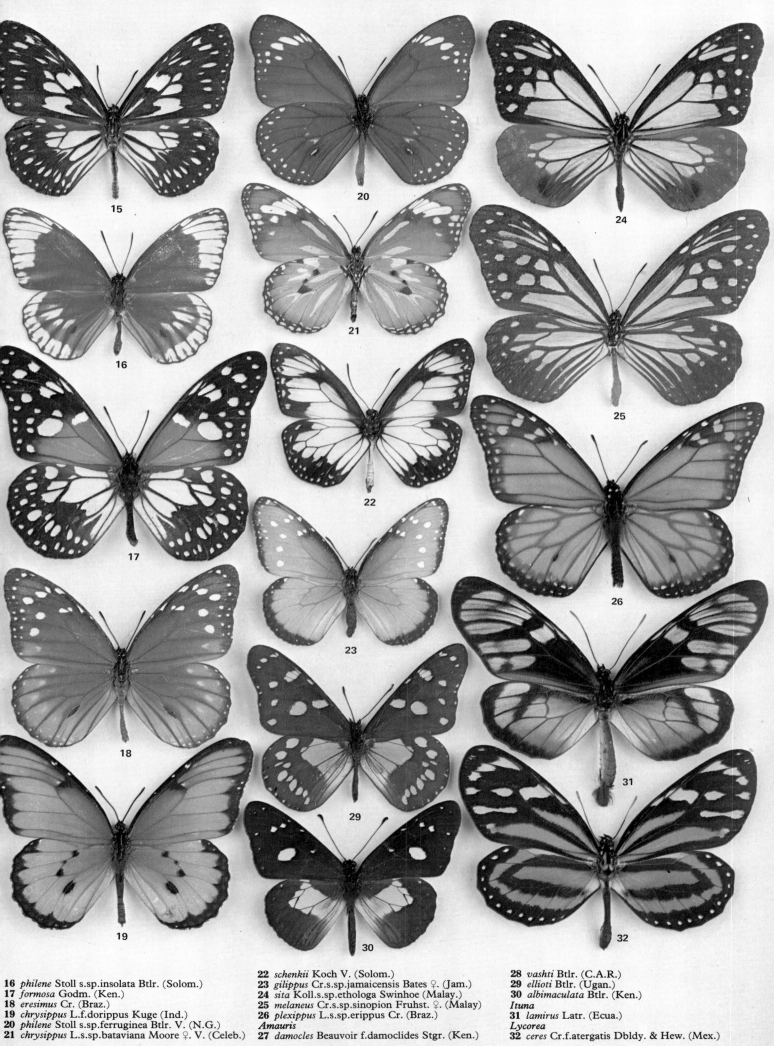

16 *philene* Stoll s.sp.insolata Btlr. (Solom.)
17 *formosa* Godm. (Ken.)
18 *eresimus* Cr. (Braz.)
19 *chrysippus* L.f.dorippus Kuge (Ind.)
20 *philene* Stoll s.sp.ferruginea Btlr. V. (N.G.)
21 *chrysippus* L.s.sp.bataviana Moore ♀. V. (Celeb.)

22 *schenkii* Koch V. (Solom.)
23 *gilippus* Cr.s.sp.jamaicensis Bates ♀. (Jam.)
24 *sita* Koll.s.sp.ethologa Swinhoe (Malay.)
25 *melaneus* Cr.s.sp.sinopion Fruhst. ♀. (Malay)
26 *plexippus* L.s.sp.erippus Cr. (Braz.)
Amauris
27 *damocles* Beauvoir f.damoclides Stgr. (Ken.)

28 *vashti* Btlr. (C.A.R.)
29 *ellioti* Btlr. (Ugan.)
30 *albimaculata* Btlr. (Ken.)
Ituna
31 *lamirus* Latr. (Ecua.)
Lycorea
32 *ceres* Cr.f.atergatis Dbldy. & Hew. (Mex.)

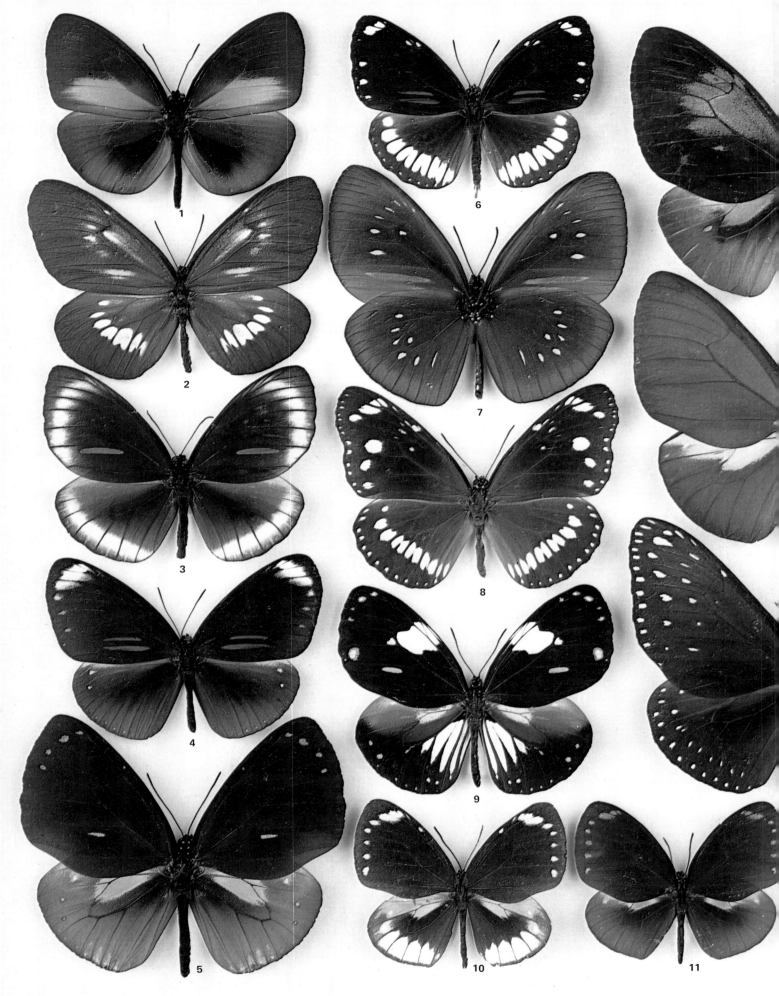

Danaidae
Euploea
1 *wallacei* Feld.s.sp.melia Fruhst. (N.G.)
2 *treitschkei* Bsdv. ♀. (N.G.)
3 *eurianassa* Hew. (N.G.)

4 *dufresne* Godt. (Phil)
5 *leucostictos* Gmelin (Born.)
6 *sylvester* Fab. (Aus.)
7 *batesi* Feld.s.sp.honesta Btlr. V. (Solom.)
8 *core* Cr.s.sp.corinna Macleay ♀. (Aus.)

9 *radamanthus* Fab. (Ind.)
10 *tulliolus* Fab.s.sp.niveata Btlr. (Aus.)
11 *tulliolus* Fab.s.sp.saundersi Btlr. (Aru.)
12 *callithoe* Bsdv.f.hansemanni Hon. (N.G.)
13 *phaenareta* Schaller s.sp.unibrunnea Godm. &

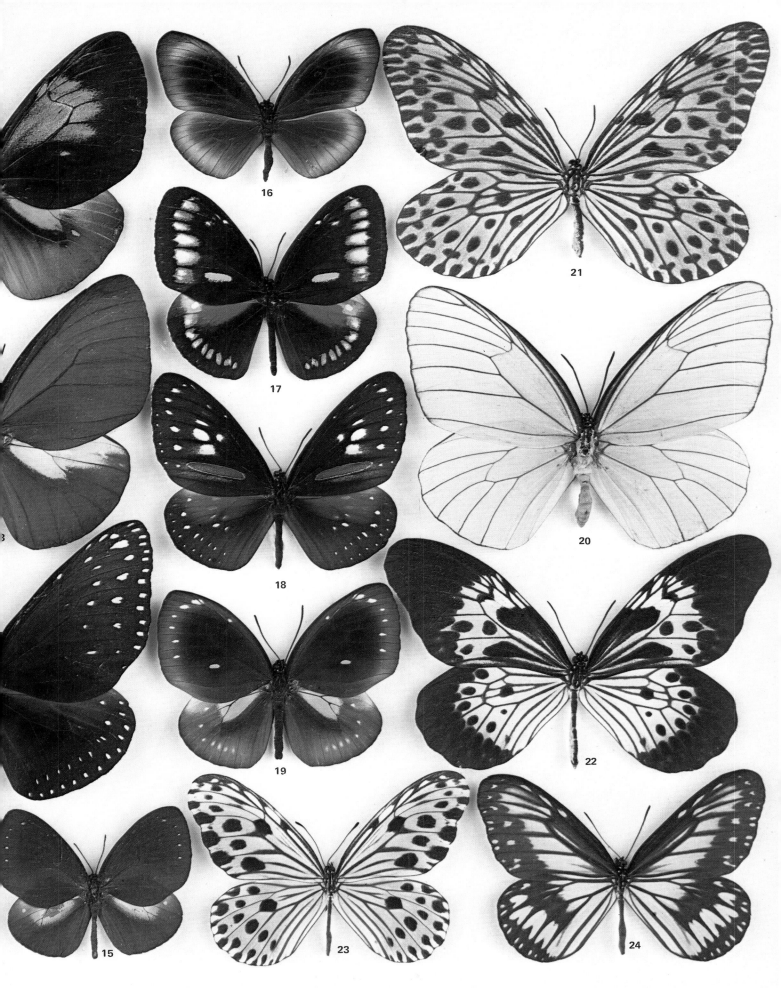

Salv. (N. Brit.)
14 *redtenbacheri* Feld.s.sp.malayica Btlr. (Malay.)
15 *stephensii* Feld.s.sp.pumila Btlr. (N.G.)
16 *boisduvali* Lucas s.sp.bakeri Poulton (N. Heb.)
17 *mniszechi* Feld. (Celeb.)

18 *algea* Godt.f.fruhstorferi Rob. (Celeb.)
19 *nemertes* Hbn.s.sp.novarum-ebudum Carpenter
(N. Heb.)
20 *phaenareta* Schaller s.sp.unibrunnea Godm. &
Salv. f. browni Godt. ♀. (N. Brit.)

Idea
21 *jasonia* Westw. ♀. (Ind.)
22 *hadeni* Wood-Mason (Burma)
Ideopsis
23 *gaura* Horsf.s.sp.perakana Fruhst. (Malay.)
24 *vitrea* Blanch. ♀. (Celeb.)

The World's Butterflies – a systematic list

As set out below, this list includes all known species from eight butterfly families, all genera from three and all tribes from the remaining four. We were obliged to make this selection because of limitations of space.

All known species included. Papilionidae, Libytheidae, Heliconiidae, Acraeidae, Amathusiidae, Morphidae, Brassolidae, and Danaidae.

All genera covered. (In very many cases all known species within each genus are included.) Pieridae, Nymphalidae, and Ithomiidae.

All tribes covered. (Where these are small all genera are included – and in several cases all known species.) Hesperiidae, Lycaenidae, Nemeobiidae, and Satyridae.

Abbreviations employed:
(in addition to those for descriptors and countries on pages 108–109)

*	illustrated	h/w	hind-wing(s)
♂	male	Lfp	larval food plant(s)
♀	female	Pal.	Palearctic
@	about	poss.	possibly
ab.	aberration	R	recto or upperside
Af.	African	sg.	subgenus
Aust.	Australasian	s.sp.	subspecies
comp.	compare	TS	type-species
f.	form	v.	very
f/w	fore-wing(s)	V	verso or underside
Gc	ground colour	w-	wing
Grp.	group	?	status doubtful

It should be pointed out that it has long been a convention to place the author of a specific name in brackets where the generic name employed is not that under which the species was originally included. Since this now applies to the vast majority of species and has additionally been greatly misused, this convention is not observed in the present work.

For each butterfly the information given is as follows:
a) Always included: name of descriptor, indication of type-species, distribution.

b) Included wherever particularly important or possible: larval foodplants, earlier latin names of families, genera and species, descriptive points (for species not illustrated), special features – such as mimicry, doubtful status, etc.

Pages 110-113
FAMILY HESPERIIDAE Stout, broad-headed butterflies. Antennae wide apart basally. All six legs fully developed.

Subfamily Coeliadinae 7 Old World genera allied to Pyrrhopyginae. Larvae often colourful. Lfp dicotyledons.

Genus Coeliades 20 African species. Lfp Combretum
forestan Stoll TS
*chalybe Westw.
*hanno Plotz

Genus Pyrrhochalcia Monotypic.
*iphis Dry. TS

Genus Hasora @ 30 Indo-Aust species. Lfp Mucuna, Pangamius.
badra Moore TS
*discolor Feld.
*borneensis Elwes & Edw.

Genus Choaspes @ 6 Indo-Aust species.
*benjaminii Guér.

Genus Allora 2 Indo-Aust species.
doleschalii Feld. TS
major Roths.

Genus Badamia 2 Indo-Aust species.
exclamationis Fab. TS
atrox Btlr.

Subfamily Pyrrhopyginae 20 Neotropical genera.

Genus Pyrrhopyge @ 60 species. Lfp Psidium, etc.
phidias L. TS
araxes Hew. Also found in S. USA.
*maculosa Hew.
*telassa Hew.
*aziza Hew.
*cometes Cr. (subgenus Yanguna)

Genus Mysoria Under 6 species.
*barcastus Sepp TS

Genus Amenis 2 species.
*pionia Hew. TS

baroni G. & S.

Genus Jemadia Over 6 species.
*hospita Btlr. TS

Genus Myscelus @ 10 species.
nobilis Cr. TS Similar to next.
*phoronis Hew.

Genus Oxynetra 4 species.
*semihyalina Feld. TS

Genus Mimoniades @ 10 species.
ocyalus Hbn. TS Similar to next.
*versicolor Latr.
*nurscia Swains. (subgenus Mahotis)

Subfamily Pyrginae All world regions. @ 150 genera & hundreds of species.

Genus Phareas Neotropical Monotypic.
*coeleste Westw. TS Recto dark blue.

Genus Phocides @ 20 Neotropical species. Pyrrhopyge-like.
polybius Fab. TS
*pigmalion Cr. Also found in S. USA.

Genus Astraptes (Telegonus) Almost 3 dozen species.
narcosius Stoll (aulestes Cr.) TS
*anaphus Cr.

Genus Pythonides (Ate) 15 Neotropical species.
jovianus Stoll TS Similar to next.
*herennius Geyer
*lancea Hew.

Genus Autochton (Cecropterus) 12+ Neotropical species. 2 reach S. USA.
*itylus Hbn. TS

Genus Mylon @ 12 Neotropical species.
lassia Hew. TS
*cajus Plotz (subgenus Eudamidas)

Genus Heliopetes 12 Nearctic & Neotropical species.
arsalte L. TS Similar to next.
*laviana Hew.

Genus Noctuana @ 6 Neotropical species.
*noctua L. TS

Genus Antigonus (Chaetoneura) 6+ Neotropical species.
*erosus Hbn. TS

Genus Systasea 3 Central American species.

*pulverulenta Feld. TS Also S. USA.

Genus Aguna 12+ Neotropical species. (formerly in Epargyreus). Lfp Leguminosae.
camagura Williams TS
asander Hew. v large, dark brown.
claxon Evans Recently also in USA.

Genus Urbanus (Eudamus) 24+ Nearctic & Neotropical species. Lfp Leguminosae.
proteus L. TS Similar to next.
*simplicius Stoll

Genus Achlyodes (Sebaldia) Under 6 Neotropical species.
*busiris Cr. TS Moth-like Lfp Citrus.

Genus Pyrgus (Syrichtus) @ 24+ Holarctic species. Lfp Potentilla, Malva, etc.
*malvae L. TS
*cacaliae Rambur
oileus L. (syrichthus Fab.)

Genus Erynnis @ 15 species Holarctic. Lfp Lotus, Eryngium, etc.
*tages L.
*icelus Scudder & Burgess

Genus Spialia @ 30 Old World species.
*galba Fab. TS

Genus Gomalia African. Monotypic.
*elma Trim. TS

Genus Eretis Under 12 African species. (formerly with Sarangesa).
melania Mab. TS Similar to next.
*djaelaelae Wallen.

Genus Sarangesa 20+ African & Oriental species. Lfp Asystasia.
dasahara Moore TS
*bouvieri Mab.
*maculata Mab.

Genus Eagris 6+ African species.
sabadius Gray TS
*lucetia Hew.

Genus Netrobalane African. Monotypic.
*canopus Trim. TS (formerly in Eagris)

Genus Caprona (Abaratha) Under 6 Oriental & African species.
pillaana Wallen. TS
*agama Moore (syrichthus Feld.)

Genus Celaenorrhinus 60+ Old World species. Not Aust. Lfp Strobilanthes
eligius Stoll. TS
*ratna Fruhst.
*illustris Mab.
*proxima Mab.

Genus Coladenia @ 12 Oriental species.
indrani Moore TS
*dan Fab.

Genus Abantis 12+ African species.
tettensis Hopff.
*paradisea Btlr.

Genus Tagiades @ 15 Oriental & African species. Lfp Discorea.
*japetus Stoll TS
*flesus Fab.
*litigiosa Mosch.

Genus Odontoptilium 3 Oriental species Lfp Allophyllus.
*angulata Feld. TS

Genus Euschemon Aust Monotypic Lfp Wilkiea & Tristania.
*rafflesia Macleay TS ♂ Moth-like.

Subfamily Trapezitinae 16 genera & @ 60 Australasian species.
Genus Dispar Monotypic. Lfp Poa etc.
*compacta Btlr. TS

Subfamily Hesperiinae 250+ genera & 2000+ species in all world regions.
Genus Hesperia 16+ Nearctic species. Lfp Festuca etc.
*comma L. TS Also Palearctic.

Genus Poanes 12+ Nearctic & Central American species.
massasoit Scudder TS
*hobomok Harris

Genus Hylephila (Euthymus) under 12 Neotropical species.
*phylaeus Dry. TS Also USA & Canada.

Genus Ochlodes @ 16 Holarctic species. Lfp Holcus etc.
agricola Bsdv. (nemorum Bsdv.) TS
*venata Brem. & Grey
*sylvanoides Bsdv.

Genus Telicota 20+ Indo-Aust species. Lfp Imperata.
*augias L. (colon Fab.) TS

Genus Thymelicus @ 8 Palearctic species. Lfp Holcus etc.
*acteon Rott. TS
*sylvestris Poda
*lineola Ochs. Also Nearctic.

Genus Carterocephalus 12+ species most Palearctic. Lfp Bromus
palaemon Pallas TS Also Nearctic.

Genus Lepella African. Monotypic.
*lepeletieri Latr.

Genus Metisella @ 20 African species.
metis L. TS Similar to next
*orientalis Auriv.
*willemi Wallen.

Genus Gegenes 4 Old World species.
*pumilio Hoffmansegg TS Europe.

Genus Pelopidas 20+ Oriental & Ethiopian species.
midea Walker (thrax Hbn.) TS
*mathias Fab. last is similar.

Genus Sabera Under 12 Aust species.
caesina Hew. TS
*fuliginosa Miskin

Genus Sancus Oriental. Monotypic.
*fuligo Mab. TS Lfp Phrynium.

Genus Taractrocera 12+ Indo-Aust species. Lfp Imperata.
*maevius Fab. TS

Genus Ampittia 8 Indo-Chin & African species.
*dioscorides Fab. (maro Fab.) TS

Genus Iambrix 5 Oriental species.
*salsala Moore TS

Genus Notocrypta Under 12 Indo-Aust species. Lfp Alpinia.

curvifascia Feld. TS
*waigensis Plotz

Genus Erionota 6+ Oriental species. Lfp Rhaphis etc.
*thrax L. TS

Genus Plastingia 24 Oriental species.
flavescens Feld. TS
*liburnia Hew.

Genus Leona @ 9 African species.
leonora Plotz TS
*lissa Evans

Genus Pardaleodes 6 African species.
edipus Stoll TS
*sator Westw.

Genus Xanthodisca 3 Ethiopian species.
*vibius Hew. TS

Genus Osmodes Under 12 African species.
laronia Hew. TS
*thora Plotz

Genus Ceratrichia 12 African species.
nothus Fab. TS
*flava Hew.
*brunnea B.-Baker.

Genus Acleros 8 Ethiopian species.
leucopyga Mab. TS
*mackenii Trim.

Genus Artitropa 6+ Ethiopian species.
erinnys Trim. TS

Genus Alera 4 Neotropical species.
furcata Mab. TS
*vulpina Feld.

Genus Perichares 8 Neotropical species.
*phileteus Gmelin TS Also recently USA.

Genus Vettius 20+ Neotropical species.
phyllus Cr. TS
*diversa H.–Schaff.
*coryna Hew.

Genus Parphorus 12+ Neotropical species.
storax Mab. TS
*decora H.-Schaff.

Subfamily Megathyminae Small number of very large American species. 2 genera.
Genus Aegiale Mexican. Monotypic.
hesperiaris Walker TS

Genus Megathymus @ 12 Nearctic & Central American species. Lfp Yucca.
yuccae Bsdv. & Leconte TS
*streckeri Skinner

Pages 114-159
FAMILY PAPILIONIDAE Often very large butterflies. Hind-wings may be tailed. Tarsal claws simple. All six legs fully developed.

Subfamily Baroniinae
Genus Baronia Mexican. Monotypic.
*brevicornis Salv. TS Primitive.

Subfamily Parnassiinae Palearctic & Nearctic, montane. Female has horny abdominal pouch (sphragis) after copulation. Larvae have secondary spines. Lfp Sedum, Saxifraga etc. Pupa in web.

Tribe Parnassini
Genus Archon Near East. Monotypic.
*apollinus Hbst. TS Lfp Aristolochia.
Genus Hypermnestra Persia Monotypic.
*helios Nick. TS Desert species.
Genus Parnassius
*apollo L. TS Many races & forms.
*apollonius Evers.
*honrathi Stgr.
bremeri Bremer Prominent black veins.
*phoebus Fab. (delius Esp.) Holarctic.
actius Evers. Turkestan. Pointed f/w.
*jaquemontii Bsdv. Very variable.
*epaphus Oberth.
*tianschanicus Oberth. (discobolus Alph.)
*nomion Hbn.
?nomius Gr.-Grsh. (poss nomion-form)
?beresowskyi Stgr. (poss epaphus-form)
(Subgenus Doritis) Genitalia differ?
Grp. I (mnemosyne-group)
*mnemosyne L.
*glacialis Btlr.
stubbendorfii Ménétr. Like last.
*eversmanni Ménétr. Holarctic.
nordmanni Nordmann Hyaline f/w apex.
ariadne Lederer (clarius Evers.)
*clodius Ménétr.
orleans Oberth. China. Blue h/w spots.
Grp. II (hardwickii-group)
*hardwickii Gray
Grp. III (szechenyii-group)
*szechenyii Friv.
cephalus Gr.-Grsh. Blue h/w spots.
pythia Roths.
Grp. IV (acco-group) Largely Tibetan.
*acco Gray (subgenus Tadumia).
przewalskii Alph.
maharaja Avin.
rothschildianus Bryk
?hunningtoni Avin. (poss small acco-form)
Grp. V (delphius-group) Kashmir – USSR.
*delphius Evers. Very variable.
acdestis Gr.-Grsh.
patricius Niepelt
stenosemus Hon.
?stoliczkanus R.-Feld. (poss delphius-form)
Grp. VI (charltonius-group)
*charltonius Gray (subgenus Kailasius).
autocrator Avin. Pamir rarity.
inopinatus Kotzsch
loxias Pungeler Turkestan.
Grp. VII (tenedius-group)
*tenedius Evers.
Grp. VIII (simo-group)
*simo Gray
Grp. IX (imperator-group)
*imperator Oberth.

Tribe Zerynthini
Genus Allancastria Europe-Asia Minor.
*cerisy Godt. TS. Lfp Aristolochia.
deyrollei Oberth. Syria. Lfp as last.
Genus Sericinus China. Monotypic.
*montela Gray (telamon Don.) TS ♂ pale.
Genus Parnalius (Zerynthia & Thais).
polyxena Denis & Schiff. TS
*rumina L. Lfp Aristolochia. Both.

Genus Luehdorfia Lfp Aristolochia.
*puziloi Ersch. TS
*japonica Leech
?bosniackii Rebel Fossil form.
Genus Bhutanitis (Armandia).
*lidderdalii Atk. TS
*thaidina Blanch.
ludlowi Gabriel
?mansfieldi Riley (poss Luehdorfia).

Subfamily Papilioninae Comprises all species popularly called 'Swallowtails'.

Tribe Leptocircini Species have scaled tibiae & tarsi.
Genus Lamproptera (Leptocircus).
*curius Fab. TS Lfp Combretaceae.
*meges Zink. Green bands.
Genus Teinopalpus Lfp Daphne.
*imperialis Hope TS
?aureus Mell China. (poss s.sp. of last).
Genus Eurytides (iphitas Hbn. TS) Mostly Neotropical, few Nearctic. Lfp Anonaceae.
Grp. I (marcellus-group)
*marcellus Cr. (ajax L.) Very variable.
celadon Lucas Cuba Gc pale green.
arcesilaus Lucas Venezuela.
zonaria Btlr. Haiti.
*philolaus Bsdv.
oberthuri R. & J. Honduras.
xanticles Bates Panama. Gc yellow.
*epidaus Dbldy.
*bellerophon Dalm.
Grp. II (lysithous-group) Species mimic Parides. Red basal spots verso.
*lysithous Hbn. Very variable.
*phaon Bsdv.
*harmodius Dbldy.
ariarathes Esp.
ilus Fab. Venez & Colombia. As next.
belesis Bates Similar to ariarathes.
branchus Dbldy. Honduras. As last.
*xynias Hew. Spiky tails.
*trapeza R. & J.
*thymbraeus Bsdv.
*asius Fab.
*euryleon Hew.
microdamas Burmeister Battus-mimic.
*pausanias Hew. Helicon-mimic.
*protodamas Godt.
chibeha Fassl
kumbachi Vogeler
?hipparchus Stgr. poss aberration.
Grp. III (protesilaus-group)
*protesilaus L.
*telesilaus Feld.
*glaucolaus Bates
*molops R. & J.
*stenodesmus R. & J.
*agesilaus Guér.
*orthosilaus Weym. Rare.
helios R. & J. Brazil. Gc yellowish.
earis R. & J. Ecua. Gc pinkish.
embrikstrandi d'Almeida
travassosi d'Almeida
Grp. IV (thyastes-group)
*thyastes Dry.
*marchandi Godt.
*leucaspis Godt.
*lacandones Bates
calliste Bates Guat. Gc yellowish.
dioxippus Hew. Colombia. Very dark.
Grp. V (dolicaon-group)
*dolicaon Cr.
iphitas Hbn. TS Brazil. Gc buffish.
orabilis Btlr. Panama & C. Rica.
*columbus Koll.
serville Godt. Peru. Similar to last.
callias R. & J. Narrow dark markings.
*salvini Bates Like protesilaus-group.
Genus Protographium Monotypic.
*leosthenes Dbldy. TS Lfp Melodorum.
Genus Iphiclides Palearctic.
*podalirius L. Lfp Prunus.
?feisthamelii Duponchel poss s.sp.
?podalirinus Oberth. Tibet poss s.sp.
Genus Graphium (sarpedon L. TS) Old World. Many sub-species. Lfp Anonaceae.
Grp. I (codrus-group) Indo-Aust.
*codrus Cr. (subgenus Idaides).
*macleayanus Leach
weiskei Ribbe Similar to next.
*stressemanni Roths.
*cloanthus Westw.
*sarpedon L. TS (see APPENDIX 1)
protensor Gistel Similar to last.
*milon Feld.
*gelon Bsdv.
*empedocles Fab. (empedovana Corbet).
*mendana Godm. & Salv. Very rare.
?clymenus Leech poss cloanthus-form.
Grp. II (eurypylus-group) Indo Aust.
*eurypylus L.
*evemon Bsdv.
doson Feld. Similar to last.
*arycles Bsdv.
*bathycles Zink.
leechi Roths. China. Similar to last.
*agamemnon L.
meeki Roths. Close to last. Rare.
*macfarlanei Btlr.
*meyeri Hopff.
?procles G.-Smith. (poss doson-form).
Grp. III (wallacei-group)
*wallacei Hew.
hicateon Mathew Similar to last.
*browni Godm. & Salv.
(Subgenus Arisbe) (Zelima) Ethiopian.
Grp. I (antheus-group)
antheus Cr. Similar to next.
*evombar Bsdv.
*mercutius G.-Smith & Kirby. antheus f.?
Grp. II (porthaon-group)
*porthaon Hew.
Grp. III (colonna-group)
colonna Ward Darker than next.
Grp. IV (policenes-group)
*policenes Cr.
nigrescens Eimer Cameroun. Rare.

junodi Trim. Mozambique.
polistratus G.-Smith.
?*boolae* Strand
Grp. V (*illyris*-group)
illyris Hew.
gudenusi Rebel
kirbyi Hew.
Grp. VI (*philonoe*-group)
philonoe Ward
Grp. VII (*leonidas*-group)
leonidas Fab. Danaid-mimic.
cyrnus Bsdv.
levassori Oberth. Gc overall cream.
Grp. VIII (*ucalegon*-group)
ucalegon Hew.
hachei Dew.
ucalegonides Stgr.
almansor Hon.
adamastor Bsdv.
agamedes Westw.
odin Strand
martensi Dufresne
auriger Btlr.
weberi Holl.
olbrechtsi Berger
?*simoni* Auriv. (poss ucalegon-form).
?*fulleri* G.-Smith. ucalegonides f.?
?*aurivilliusi* Seeldrayers agamedes f.?
Grp. IX (*tyndareaus*-group)
tyndereaus Fab.
latreilliianus Godt.
Grp. X (*pylades*-group)
pylades Fab. (agamalus Goeze).
morania Angas S. Af. Similar to last.
endochus Bsdv.
taboranus Oberth.
ridleyanus White Acraea-mimic.
(Subgenus Pathysa)
Grp. I (*antiphates*-group) Indo-Aust.
antiphates Cr.
nomius Esp.
aristeus Cr.
euphrates Feld.
epaminondas Oberth.
androcles Bsdv.
rhesus Bsdv.
dorcus de Haan Celeb. Similar to last.
agetes Westw. (subgenus Deoris).
stratiotes G.-Smith Born. red h/w spot.
Grp. II (*macareus*-group) Danaid-mimics.
macareus! Godt. (subgenus Paranticopsis).
xenocles Dbldy.
ramaceus Westw. (leucothoe Westw.)
delesserti Guér. Malay. Black & white.
megarus Westw.
deucalion Bsdv.
thule Wall.
enceladus Bsdv.
phidias Oberth. Annam. Tailed.
megaera Stgr. Palawan. Like megarus.
stratocles Feld. Phil. Like macareus.
idaeoides Hew. Phil. Huge Idea-mimic.
Grp. III (*eurous*-group) Palearctic.
eurous Leech
mandarinus Oberth.
alebion Gray
tamerlanus Oberth.
glycerion Gray (subgenus Pazala).
caschmirensis Roths. poss eurous-f.?
Genus Dabasa (Meandrusa)
hercules Blanch.
gyas Westw.
payeni Bsdv.

Tribe Papilionini 'True Swallowtails'.
Species have unscaled tibiae & tarsi.
Lfp principally Lauraceae & Rutaceae.
Genus Papilio (machaon L. TS).
Division I Indo-Aust Mostly Danaid-
mimics. Lfp Lauraceae
Grp. I (*agestor*-group) Also Palearctic.
agestor Gray (subgenus Cadugoides).
epicydes Hew.
slateri Gray
Grp. II (*clytia*-group)
clytia L. Also Palearctic Variable.
paradoxa Zink. (telearchus Hew.).
Grp. III (*veiovis*-group)
veiovis Hew.
Grp. IV (*laglaizei*-group)
laglaizei Depuiset Mimics Alcidis moth
toboroi Ribbe
moerneri Auriv. Similar to last.
Division II Principally Old World. Lfp
Rutaceae, Umbelliferae etc.
Grp. I (*anactus*-group) Position doubtful
anactus Macleay (poss machaon-group?)
Grp. II (*aegeus*-group) Australasian.
aegeus Don. ♂ Gc black & cream ♀ varies
tydeus Feld. Moluccas. Similar to last.
bridgei Math.
weymeri Niepelt (cartereti Oberth.)
gambrisius Cr.
inopinatus Btlr.
oberon G.-Smith. poss aegeus-form.?
woodfordi Godm. & Salv.
ptolychus Godm. & Salv.
?*heringi* Niepelt
?*erskinei* Math.
Grp. III (*godeffroyi*-group)
godeffroyi Semp. Samoa. Like next.
ilioneus Don. (amynthor Bsdv.)
schmeltzi H.-Schaff. Fiji. Very dark.
Grp. IV (*polytes*-group) (subgenus
Menelaides) Oriental.
polytes L. Also Palearctic. ♀ mimetic.
ambrax Bsdv.
phestus Guér.
Grp. V (*castor*-group) Oriental.
castor Westw. (subgenus Tamera).
dravidarum W.-Mas.
?*mahadeva* Moore castor-form?
Grp. VI (*fuscus*-group) Indo-Aust.
fuscus Goeze. Very variable.
canopus Westw.
albinus Wall.
hipponous Feld.
diophantus G.-Smith. Sumatra.
antonio Hew. Phil. cream f/w patch.
nobilei de Nicév. Burma. As last.
?*walkeri* Jans. India.

?*sakontala* Hew. India.
?*jordani* Fruhst. Celeb.
Grp. VII (*helenus*-group) Oriental.
helenus L. Also Palearctic.
sataspes Feld.
iswaroides Fruhst.
iswara White
chaon Westw. Also Palearctic.
nephelus Bsdv. poss form of last.
nubilus Stgr. Borneo. As last.
Grp. VIII (*memnon*-group) Indo-Aust.
memnon L. Variable. ♀ polymorphic.
ascalaphus Bsdv.
polymnestor Cr.
mayo Atk.
lowi Druce
rumanzovia Esch.
deiphobus L. Halm. Similar to last.
oenomaus Godt. Timor. ♀ mimetic.
forbesi G.-Smith. Sum. Like next.
lampsacus Bsdv.
acheron G.-Smith. Borneo. Darker.
Grp. IX (*protenor*-group) Indo-Chin.
protenor Cr. (subgenus Sainia).
alcmenor Feld. (rhetenor Westw.)
demetrius Cr. poss protenor-form?
macilentus Jans.
thaiwanus Roths.
Grp. X (*bootes*-group) Indo-Chin.
bootes Westw. Mimetic species.
janaka Moore (maraho Shiraki & Sonan).
elwesi Leech (maraho Shiraki & Sonan).
Grp. XI (*demolion*-group) Old World.
demolion Cr. (subgenus Araminta).
liomedon Moore India. Similar to last.
gigon Feld.
euchenor Guér.
menestheus Dry. Next is similar.
lormieri Dist. f/w band straight.
ophidicephalus Oberth.
demodocus Esp.
erithonioides G.-Smith.
morondavana G.-Smith.
grosesmithi Roths.
Grp. XIII (*xuthus*-group). Oriental.
xuthus L. Also Palearctic.
?*benguetana* J. & T. s.sp. of last?
Grp. XIV (*machaon*-group) Holarctic.
machaon L. TS Lfp Umbelliferae.
hippocrates Feld. s.sp. of last?
alexanor Esp.
hospiton Guen.
zelicaon Lucas Nearctic (& next 10).
indra Reak. Many races.
brevicauda Saunders. Orange bands.
bairdi Edw. Similar to machaon.
oregonia Edw. poss form of last.
polyxenes Fab. Very variable.
?*joanae* Heitzman poss form of last.
?*gothica* Remington zelicaon-form?
?*nitra* Edw. probably zelicaon-form.
?*rudkini* Comstock
?*kahli* Chermock
Grp. XIV (*paris*-group) Indo-Palearctic.
This and the next 3 groups are
known as 'Gloss-Papilios'.
Lfp principally Rutaceae.
paris L. (subgenus Achillides) Variable
karna Feld. Java. Similar to last.
bianor Cr.
maackii Ménétr. Japan. Similar to last.
dialis Leech
hoppo Mats.
krishna Moore
arcturus Westw.
polyctor Bsdv. (subgenus Sarbaria).
elphenor Dbldy. India. Tail-less.
Grp. XV (*palinurus*-group) Oriental.
palinurus Fab. Several races.
crino Fab. (subgenus Harimala).
buddha Westw.
blumei Bsdv.
Grp. XVI (*peranthus*-group) Indo-Aust.
peranthus Fab. Many subspecies.
pericles Wall.
lorquinianus Feld. Halmaheira.
neumoegeni Hon. Sumba. ♀ like palinurus
Grp. XVII (*ulysses*-group) Australasian.
ulysses L. Many races. Close to next.
montrouzieri Bsdv.
Division III Ethiopian.
Grp. I (*rex*-group) Danaid-mimics.
rex Oberth. (subgenus Melindopsis).
Grp. II (*phorcas*-group)
phorcas Cr. ♀ sometimes yellow.
constantinus Ward
nobilis Rogen. (see APPENDIX 1).
euphranor Trim.
hesperus Westw. Next is similar.
pelodurus Btlr. more h/w spots.
dardanus Brown. Mimetic ♀ forms.
?*nandina* Roths. phorcas aberration?
Grp. III (*cynorta*-group) No tails.
cynorta Fab. ♂ similar to next.
plagiatus Auriv.
echerioides Trim.
zoroastres Druce
jacksoni Sharpe
fulleborni Karsch
sjoestedti Auriv.
Grp. IV (*gallienus*-group)
gallienus Auriv. Similar to next.
mechowi Dew.
zenobius Godt. (cypraeofila Btlr.)
zenobia Fab.
mechowianus Dew. Next is similar.
andronicus Ward f/w bands curve out.
Grp. V (*nireus*-group) (subgenus Eques).
nireus L. Next is similar.
sosia Roths. Straight-edged even band.
mackinnoni Sharpe.
charopus Westw.
hornimani Dist.
aethiops R. & J.
oribazus Bsdv.
bromius Dbldy. Next is similar.
brontes Godm. (magdae Gifford).
thuraui Karsch

manlius Fab.
epiphorbas Bsdv.
phorbanta L.
?*teita* van Som. Like nireus.
?*interjecta* van Som. As last.
Grp. VI (*delalandii*-group)
delalandii Godt.
mangoura Hew.♀ blue-banded.
Grp. VII (*leucotaenia*-group)
leucotaenia Roths.
Division IV Nearctic. Lfp Lauraceae etc
Grp. I (*troilus*-group) (subgenus Pterourus)
troilus L. Battus-mimic.
palamedes Dry.
Grp. II (*glaucus*-group) subgenus
Jasoniades)
glaucus L. (turnus L.) ♂ like next.
rutulus Lucas Next is similar.
eurymedon Lucas Gc White.
pilumnus Bsdv. Next is similar.
multicaudata Kirby (daunus Bsdv.)
?*alexiares* Hopff. Mexico.
Division V Neotropical.
Grp. I (*thoas*-group) (subgenus Heraclides).
Lfp Rutaceae.
thoas L. Similar to next.
cresphontes Cr.
paeon Bsdv. recto similar to last.
homothoas R. & J. Close to cresphontes
andraemon Hbn.
machaonides Esp.
ornythion Bsdv.
lycophron Hbn. (astyalus Godt.)
thersites Fab.
androgeos Cr. (subgenus Calaides).
aristodemus Esp.
caiguanabus Poey Next is similar.
aristor Godt. Haiti. Broken bands.
Grp. II (*anchisiades*-group). Some species
resemble Parides. Lfp Citrus
anchisiades Esp.
chiansiades Westw. Similar to last.
isidorus Dbldy. Next is similar.
rhodostictus Btlr. & Druce C. Rica.
maroni Moreau Guy. Like isidorus.
erostratinus Vazquez As last.
erostratus Westw. Next is similar.
oxynius Hbn. Cuba. Spotted margins.
epenetus Westw. Ecua. No tail.
pelaus Fab. Jam. & Cuba. pale f/w band.
hyppason Cr.
pharnaces Dbldy.
rogeri Bsdv.
Grp. III (*torquatus*-group) Lfp Citrus.
torquatus Cr. ♀ black & red.
hectorides Esp. As last.
tasso Stgr. Brazil. As next.
himeros Hopff. Similar to torquatus.
garleppi Stgr. Bolivia.
lamarchei Stgr. Bolivia.
peleides Stgr.
?*neyi* Niepelt. Ecua. (poss zagreus-form)
Grp. IV (*zagreus*-group) Mimic species.
zagreus Dbldy.
ascolius Feld.
bachus Feld.
hellanichus Hew.
xanthopleura Godm. & Salv.
birchalli Hew. Col. No tails.
Grp. VI (*homerus*-group) Lfp Lauraceae.
homerus Fab. Largest Swallowtail.
garamas Hbn.♂ similar to last.
euterpinus Godm. & Salv.
warscewiczi Hopff.
cacicus Lucas
victorinus Dbldy. Next is similar.
diazi Racheli & Sbordoni 2 tails.
cleotas Gray
aristeus Cr.
?*cephalus* Godm. & Salv. (poss cleotas f.)
?*judicael* Oberth. (poss aristeus-form).

Tribe Druryeini African. (see
APPENDIX 2).
Genus Druryeia
antimachus Dry. TS
Genus Iterus
zalmoxis Hew. TS
Tribe Troidini Old & New Worlds. Lfp
usually Aristolochia. Tibiae & tarsi
unscaled.♂ usually has conspicuous
anal scent fold.
Genus Euryades Neotropical temperate
zone.
corethrus Bsdv. TS
duponchelii Lucas
Genus Cressida (Eurycus) Australia.
This genus and the last have
Parnassius-like features.
cressida Fab. (heliconides Swains.)
Genus Parides (echemon Hbn. TS)
Neotropical. Shade-dwellers.
Grp. I (*ascanius*-group) Tailed species.
ascanius Cr.
gundalachianus Feld. (columbus H.-Sch)
agavus Dry. Next is similar.
proneus Hbn. Brazil. Straight f/w band.
phalaecus Hew. Ecua. As last.
chamissonia Esch.
perrhebus Godm. & Salv.
alopius Godm. & Salv.
montezuma Westw.
photinus Dbldy.
?*dares* Hew. Nicar. (poss form of last).
Grp. II (*aeneas*-group) White w-margins.
Not usually tailed.
aeneas L.
schuppi Rob. Stugr. N. Arfak Mts.
coelus Bsdv.
klagesi Ehrmann Venez. Close to last.
steinbachi Roths. Bol. As coelus. Large.
triopas Godt. (subgenus Ascanides).
hahneli Stgr. Peru. As last but 3 f/w spots.
quadratus Stgr. Peru. Very long wings.
chabrias Hew. Peru. Tiny. Few h/w spots.
pizarro Stgr. Peru. Small but no spots.
tros Fab. (dardanus Fab.) Tailed.
orellana Hew. Peru. Extensive h/w red.
sesostris Cr. (subgenus Endopogon).

childrenae Gray
erlaces Gray
drucei Btlr.
vertumnus Cr.
erithalion Bsdv.♂ like last.
anchises L. Similar to next.
iphidamas Fab.
lycimenes Bsdv. Central American.
polyzelus Feld. As last. No f/w spot.
phosphorus Bates Guy. Like drucei.
cutorina Stgr. Ecua. and Peru. As last.
nephalion Godt. Brazil.
eversmanni Ehrmann
burchellanus Westw. Braz. Dark f/w.
?*hedae* Foetterle (poss anchises-form)
Grp. III (*lysander*-group) Red w-margins.
lysander Cr.♂ similar to neophilus.
timias Gray As last.
zacynthus Fab.
aglaope Gray Bol. Similar to last.
neophilus Hbn.
echemon Hbn. (echelus Hbn.) TS
arcas Cr.
panthonus Cr.
Genus Atrophaneura (semperi Feld. TS).
Large some times tailed species
principally Indo-Aust.
Grp. I (*antenor*-group) Madagascar.
antenor Dry. Lfp Combretaceae.
Grp. II (*latreillei*-group) Narrow wings.
latreillei Don.
polyeuctes Dbldy. (philoxenus Gray).
dasarada Moore (subgenus Panosmia).
nevilli W.-Mas. Chin. No tail spot.
adamsoni G.-Smith. Tenasserim.
alcinous Klug
crassipes Oberth. Burma. Like last.
daemonius Alph. Chin. Like alcinous.
hedistus Jord. Yunnan. Narrow tail.
plutonius Oberth. W. Chin. Very dark.
mencius Feld. As last.
impediens Roths. As last.
laos Riley & Godfrey Like alcinous.
febanus Fruhst. Form. Extended red.
?*lama* Oberth. (polyeuctes-form?).
?*polla* de Nicév. (latreillei-form?)
Grp. III (*nox*-group) Hair like extensions
on h/w scent folds in the first four
species.
nox Swains. (subgenus Karanga).
varuna White Next is similar.
zaleucus Hew. Burma. White h/w spots.
luchti Roepke
sycorax G.-Smith. Sumatra. Like next.
priapus Bsdv.
hageni Rogen. Similar to last.
aidoneus Dbldy. Ind. Dark. Like varuna.
horishanus Mats. (sauteri Heyne).
semperi Feld. (erythrosoma Reak.) TS.
kuehni Hon. Celeb. h/w verso has red.
dixoni G.-Smith. Celeb. As last.
Grp. IV (*coon*-group) Spatulate tails.
coon Fab. Some races have red h/w spot
rhodifer Btlr. Andamans. Like last.
neptunus Guér. (subgenus Balignina).
Genus Pachliopta Indo-Aust.
aristolochiae Fab. TS
atropos Stgr. Palawan. Very dark.
maniae Semp. Phil. Similar to next.
annae Feld. Phil. Next is similar.
pheginus Hopff. Phil. Like annae.
schadenbergi Semp. Phil. As last.
strandi Bryk Phil. Close to last.
liris Godt. Tenimber. Striated f/w.
oreon Doherty Sumba. As last.
polydorus L. Many races. Not tailed.
pandiyana Moore Ind. Close to last.
jophon Gray Next is similar.
polyphontes Bsdv. Celeb. & Moluccas.
hector L. (subgenus Tros).
Genus Troides (helena L. TS) Principally
Indo-Aust. This and the next 2
genera are known as 'birdwings'.
Grp. I (*hypolitus*-group)
hypolitus Cr. Largest in genus.
Grp. II (*amphrysus*-group)
amphrysus Cr. Malay. Similar to next.
cuneifer Oberth.
mirandus Btlr. Blue-flushed f/w (♂)
andromache Stgr. Borneo. Small and dark.
Grp. III (*haliphron*-group)
haliphron Stgr. widespread and variable
darsius Gray Sri Lank.
vandepolli Snell.
criton Feld.
riedeli Kirsch Tenimber.
?*plato* Wall. Timor. (poss haliphron-f.?)
Grp. IV (*helena*-group)
helena L. TS Similar to last.
oblongomaculatus Goeze
Grp. V (*aeacus*-group)
aeacus Feld. Next is similar.
minos Cr. India.
rhadamantus Lucas Phil. Very dark.
magellanus Feld. h/w reflective.
prattorum J. & T. Buru. As last.
Genus Trogonoptera Long f/w.
brookianus Wall. TS. Borneo.
s.sp.albescens Roths. Malay.
s.sp.trogon Voll. Sumatra.
s.sp.natunensis Roths. Natuna Isles.
trojana Stgr. Palawan.
Genus Ornithoptera (priamus L. TS).
Australasian. Largest and finest of
all butterflies.
(Subgenus Schoenbergia) No sex brand
on ♂ f/w.
paradisea Stgr. N.G. Tailed species.
s.sp.arfakensis J. & T. Arfak Mts.
s.sp.tarunggarensis J. & T. Wanggar.
tithonus de Haan N.G. Like chimaera.
s.sp.waigeuensis Roths. Waigeu.
chimaera Roths. N.G. Greener than next
s.sp.flavidior Roths. (poss only form)
?s.sp.charybdis van Eecke (form?)
rothschildi Kenrick N.G.
tros Fab. (dardanus Fab.) Tailed.
goliath Oberth. Waigeu (same as next?)
s.sp.supremus Rob. N.G.
s.sp.titan G.-Smith. N.G.

s.sp.atlas Roths. Kapaur.
s.sp.samson Niepelt Arfak Mts.
s.sp.procus Roths. Ceram. (APPENDIX 3)
(Subgenus Ornithoptera) Sex brand on ♂ f/w
priamus L. TS Amboina. Very large.
s.sp.poseidon Dbldy. N.G.
s.sp.teucrus J. & T. Biak. Like last.
s.sp.demophanes Fruhst. Trobriands.
s.sp.admiralitatis Roths. Admiralties.
s.sp.arruana Feld. (hecuba Rob.) Aru.
s.sp.boisduvali Mont. Woodlark Is.
s.sp.bornemanni Pag. N. Brit. Very dark.
s.sp.pronomus Gray Cape York.
s.sp.euphorion Gray N. Queensland.
s.sp.richmondia Gray S. Q'land. Tiny.
s.sp.urvilleanus Guér. Solom. Blue race.
s.sp.caelestis Roths. Louisiade. Blue.
s.sp.miokensis Ribbe Mioko. Blue-green.
aesacus Ney Obi. Similar to priamus.
croesus Wall. Batchian. Golden-orange.
s.sp.lydius Feld. Halm. Very similar.
(Subgenus Aetheoptera) Long narrow f/w.
victoriae Gray Guad. ♀ very large.
s.sp.regis Roths. Bougain. ♀ dark.
s.sp.reginae Salv. Malaita.
s.sp.rubianus Roths. Rubiana. Darker.
s.sp.isabellae Roths. Ysabel Is.
s.sp.epiphanes Schmid San Cristoval.
s.sp.resplendens Ehrmann Choiseul.
(poss large regis-f.?)
alexandrae Roths. N.G. Largest species.
?*allotei* Roths. Bougain. (poss hybrid see
APPENDIX 4).
Genus Battus (polydamas L. TS) American.
Grp. I (*philenor*-group)
philenor L. (subgenus Laertias).
devilliers Godt. N. American.
zetides Munroe (zetes Westw.). Haiti.
streckerianus Hon. Peru. Yellow spots.
polystictus Btlr. Braz. Weak spotting.
archidamas Bsdv. recto like next.
polydamas L. TS (subgenus Ithobalus).
philetas Hew.
madyes Dbldy. Variable.
Grp. II (*belus*-group)
belus Cr. Very variable.
laodamas Feld.
lycidas Cr.
crassus Cr.
eracon Godm. & Salv. Mex. Band of spots.

Pages 160-169
FAMILY PIERIDAE Ground colour usually
white or yellow. Tarsal claws bifid.
All six legs fully developed.
Subfamily Pseudopontiinae African.
Genus Pseudopontia
paradoxa Plotz A curious primitive.
?*cepheus* Ehrmann (poss form of last).
Subfamily Dismorphiinae Delicate,
long-winged. All but a few Neotropical
Genus Leptidea Palearctic. Lfp
Leguminosae.
sinapis L. TS White, dark f/w tips.
duponchelei Stgr.
morsei Fenton
amurensis Ménétr.
gigantea Leech Chin. Largest species.
Genus Pseudopieris Neotropical
(like Pieris).
nehemia Bsdv. TS
?*penia* Hopff. probably only form.
Genus Dismorphia 100+ Neotropical
species, some mimetic.
laia Cr. TS Close to next.
amphione Cr. Mechanitis-mimic.
orise Bsdv. Thyridia-mimic.
nemesis Latr.
teresa Hew.
medora Dbldy.
lysis Hew.
lygdamis Hew.
theugenis Dbldy.
(Subgenus Enantia)
melite L. Also found in S. USA.
Subfamily Pierinae 'Whites'. 1000+
species. All world regions.
Tribe Pierini
Genus Aporia 12+ Palearctic species.
Lfp Rosaceae.
crataegi L. TS Next is similar.
largeteaui Oberth. faint f/w bands.
lotis Leech Chin. Dark margins.
nabellica Bsdv. Chin. w-bases dark.
larraldei Oberth. Also Oriental.
potanini Alph. As last.
hippia Brem.
Genus Metaporia 6+ Indo-Chin. species.
agathon Gray TS
soracta Moore
procris Leech
leucodice Evers.
Genus Mesapia Tibetan. Monotypic.
peloria Hew. TS Like small A. hippia.
Genus Baltia @ 5 high-altitude Tibetan
species. Rounded wings
shawii Bates TS
butleri Moore
sikkima Fruhst.
Genus Neophasia Nearctic.
menapia Feld. Next is similar.
terlootii Behr Gc of ♀ orange.
Genus Eucheira Neotropical. Monotypic
socialis Westw. Affinities with last.
Genus Phulia @ 6 Neotropical temperate
zone montane species.
nymphula Blanch. TS. Bol. Euchloe-like.
Genus Piercolias 3 species.
huanaco Stgr. TS. Bol. Like tiny Colias.
Genus Pieris @ 30 largely Palearctic
species, several migratory. ♀♀ darker.
Lfp Cruciferae.
brassicae L. TS
rapae L. Also Nearctic.
napi L. As last. Very variable.
cruciferarum Bsdv. Nearctic. napi-f.?
virginiensis Edw. Nearctic.
bryoniae Ochs. Variable.
melete Ménétr.
euridice Leech

261

ergane Hbn.
manni Mayer
krueperi Stgr.
naganum Moore
brassicoides Guér. Ethiopian. dark veins.
(Subgenus Pontieuchloia) Nearctic.
*protodice L.
beckerii Edw. Similar to last.
sisymbrii Bsdv. As last.
(Subgenus Theochila) Neotropical.
meneacte Bsdv. A few allied species.
Genus Ascia 6+ American species.
*monuste L. TS. Migrant. Next is similar.
josephina Godt. (subgenus Ganyra).
buniae Hbn. Braz. Largest species.
?paramaryllis Coms. Jam. josephina-f.?
Genus Pontia Mostly Palearctic.
*daplidice L. TS.
chloridice Hbn. Similar to last.
*glauconome Klug.
helice L. Ethiopian.
Genus Synchloe Palearctic. Monotypic.
*callidice Hbn. TS. poss Pontia-species
Genus Tatochila @ 12 Neotropical species.
autodice Hbn. TS. Argent.
*xanthodice Lucas. Close to last.
*microdice Blanch. Next is similar.
theodice Bsdv. Chile & Peru.
orthodice Weym. Bol. Close to last.
Genus Leptophobia 6+ Neotropical species.
eleone Dbldy. TS. Col. & Venez.
*caesia Lucas
*penthica Koll.
Genus Itaballia 6+ Neotropical species.
Verso striped.
pandosia Hew. TS. Similar to next.
*pisonis Hew.
mandela Feld. Widespread. ♀ forms.
Genus Perrhybris 6+ Neotropical species.
♀♀ may resemble Heliconius-species.
*pamela Cr. (pyrrha Cr.) TS.
lorena Hew. Peru. Similar to last.
*lypera Koll.
Genus Anapheis Indo-Aust. Monotypic.
java Sparrman TS. (see APPENDIX 5).
Genus Belenois 20+ African species.
*calypso Dry. TS. Lfp Capparis.
*aurota Fab.
gidica Godt. Close to last.
*rubrosignata Weym. Next is similar.
theora Dbldy. Very variable.
thysa Hopff. As last.
*antsianaka Ward
*solilucis Btlr.
*raffrayi Oberth.
creona Cr.
*severina Cr. poss creona-form?
Genus Dixeia Ethiopian ♀♀ darker.
doxo Godt. TS. Lfp Capparis.
*pigea Bsdv.
cebron Ward Resembles B. solilucis.
dixeyi Neave
orbona Geyer
spilleri Spiller All-yellow.
capricornis Ward
astarte Btlr.
Genus Pinacopteryx African. Monotypic.
*eriphia Godt. TS. Compare Melanargia (Sat.)
Genus Mylothris @ 24 Ethiopian species
Grp. I (chloris-group) 16 species.
chloris Fab. TS. White. Dotted margins.
poppea Cr. Orange-flushed f/w bases.
rhodope Fab. f/w orange.
agathina Cr. ♀ resembles crocea.
Grp. II (trimenia-group)
trimenia Btlr. Yellow h/w.
*smithi Mab. Largest species.
splendens Le Cerf
*crocea Btlr.
Grp. III (sagala-group)
sagala G.-Smith ♂ has dark f/w.
ruandana Strand
Grp. IV (bernice-group)
bernice Hew. May have red costal mark.
carcassoni van Son
Genus Pseudomylothris Af. Monotypic.
leonora Kruger TS. Resembles Mylothris
Genus Cepora (Huphina) 30+ Indo-Aust
species. Lfp Capparidaceae.
'Parallel' forms in Delias.
nerissa Fab. TS. Like next, no orange.
*lea Dbldy. (judith Fab.) See next.
judith Fab. Java. poss same species.
*aspasia Stoll
*abnormis Wall. typical form dark.
*eperia Bsdv.
*perimale Don. Very dark form shown.
quadricolor Godm. & Salv. N. Brit.
laeta Hew. Timor. Like Delias splendida
affinis Voll. (subgenus Aoa). Dark bands
Genus Phrissura Phil. Monotypic.
aegis Feld. TS. Malay. Dark margins.
Genus Ixias @ 12 Indo-Aust species. Lfp
Capparis. (see APPENDIX 6).
*pyrene L. TS variable. Also Palearctic.
*marianne Cr.
vollenhovi Wall. Timor. Like venilia.
*venilia Godt.
reinwardti Voll. Timor. Like venilia.
Genus Hesperocharis (Cathaemia) @ 15
Neotropical species.
*erota Lucas TS.
anguitia Godt. Brazil. Close to last.
nereina Hopff. Bol. & Peru. As last.
hirlandia Stoll. Yellow and orange verso
Genus Leodonta Neotropical.
*dysoni Dbldy. TS.
tellane Hew. Col. Col yellow.
Genus Catasticta 50+ Neotropical
species (some doubtful).
nimbice Bsdv. TS. Similar to next.
*manco Dbldy.
actinotis Btlr. ♀ mimetic.
*sisamnus Fab.
*pieris Hopff.
*straminea Btlr.
*corcyra Feld.
*teutila Dbldy.
Genus Archonias Less than 6 Neotropical
mimetic species.

*tereas Godt. TS. Mimics Parides (Pap.)
*bellona Cr. Helicon-mimic.
Genus Charonias Neotropical.
*eurytele Hew. TS.
theano Bsdv. Brazil. Darker.
Genus Pereute @ 10 Neotropical species.
callinice Feld. TS. Close to next.
*callinira Stgr.
leucodrosine Koll. Larger.
swainsoni Gray Yellow spot h/w verso.
*telthusa Hew.
Genus Delias (aglaia L. TS) 150+ largely
Indo-Aust species. Variable
Lfp Loranthus.
Grp. I (singhapura-group)
singhapura Wall. Borneo.
Grp. II (nysa-group)
*themis Hew. Last is similar.
agoranis G.-Smith. Burma.
kuehni Hon. Celebes.
Grp. II (nysa-group)
nysa Fab. Aust. Small.
*dice Voll. Next is similar.
maudei J. & Noakes Biak.
enniana Oberth. W. Irian. Close to dice.
lemoulti T. Timor. Only one known.
georgina Feld. Borneo.
blanca Feld. Borneo.
schuppi T. Serang.
dumasi Roths. Buru.
mansuelensis T. Ceram.
waterstradti Roths. Halm.
hempeli Dannatt Halm.
momea Bsdv. Sumatra.
fruhstorferi Hon. Java.
ribbei Rob. Aru.
?pulla T.
Grp III (chrysomelaena-group)
*chrysomelaena Voll.
ladas G.-Smith. N.G.
totila Heller N. Brit. Recto colourful.
talboti J. & Noakes Biak.
caliban G.-Smith Goodenough Isle.
*viridomara Fruhst. N.G.
Grp. IV (stresemanni-group)
stresemanni Roths. Ceram.
*schmassmanni J. & T.
lecerfi J. & T. W. Irian.
Grp. V (geraldina-group) N.G.
geraldina G.-Smith. Close to next.
*aroa Ribbe (?poss. pheres-form).
pheres Jord.
sagessa Fruhst.
*microsticha Roths. Next is similar.
sphenodiscus Roepke
*heroni Kenrick
eudiabolus Roths.
imitator Kenrick
hypomelas R. & J.
argentata Roepke
itamputi Ribbe
nigropunctata J. & Noakes
thompsoni J. & T.
cuningunti Ribbe
?abrophora Roepke (poss. sagessa-f.)
?rileyi J. & T.
?citrona J. & T.
Grp. VI (eichhorni-group) N.G.
eichhorni Roths. Close to next.
*hallstromi Sanf. & Bnt.
carstenziana Roths. Intricate next.
gilliardi Sanf. & Bnt. As last.
leucobalia Jord. Gc whitish.
toxopei Roepke
catisa Jord.
Grp. VII (bornemanni-group) N.G.
*bornemanni Ribbe
nais Jord. Darker.
caroli Kenrick
castaneus Kenrick
*pratti Kenrick
zebra Roepke
Grp. VIII (iltis-group) N.G.
iltis Ribbe Close to next.
*mesoblema Jord.
callista Jord.♀ like weiskei. . .
bakeri Kenrick
?luctuosa Jord. (poss. iltis-form).
Grp. IX (weiskei-group)
*weiskei Ribbe
callima J. & T. Very dark.
campbelli J. & T.
phippsi J. & T.
hapalina Jord.♀ like weiskei.
marguerita J. & T.
?leucias Jord (poss. weiskei-form).
Grp. X (kummeri-group)
kummeri Ribbe h/w red band broken.
*ligata Roths. Last is similar.
isocharis Roths.
alepa Jord.
dixeyi Kenrick
bothwelli Kenrick
Grp. XI (nigrina-group)
nigrina Fab. Smaller than next.
*joiceyi T.
*ornytion Godm. & Salv.
dohertyi Oberth. Biak. Close to last.
funerea Roths. Halm. As last.
*duris Hew.
eximia Roths. N. Ireland.
wollastoni Roths. W. Irian.
prouti J. & T. Buru.
Grp. XII (belladonna-group) Largely
Palearctic.
belladonna Fab. Close to next.
*wilemani Jord. Next is similar.
lativitta Leech Chin.
berinda Moore Indo-Chin.
sanaca Moore Ind.
patrua Leech Chin.
subnubila Leech Chin.
benasu Mart. Celebes.
Grp. XIII (aglaia-group) v. variable.
aglaia L. TS Indo-Chin.
henningia Esch. Close to last.
*thysbe Cr.
crithoe Bsdv.
ninus Wall. Malaysia.
woodi T. Mindanao.
?acalis Godt.

Grp. XIV (albertisi-group) N.G.
*albertisi Oberth. Next is similar.
discus Hon. White f/w bands.
Grp. XV (clathrata-group) N.G.
*clathrata R. & J.
*mariae J. & T.
*mira Roths.
elongatus Kenrick
catocausta Jord.
klossi Roths.
?inexpectata (poss. mira-form).
Grp. XVI (niepelti-group) N.G.
*niepelti Ribbe Next is similar.
meeki R. & J. White h/w patch.
anamea Bennett (?niepelti-form).
Grp. XVII (belisama-group)
*belisama Cr.
aurantiaca Doherty (?form of last).
*descombesi Bsdv.
*diaphana Semp.
*splendida Roths.
*madetes Godm. & Salv.
*eumolpe G.-Smith.
*aruna Bsdv. Recto yellow.
zebuda Hew. Celebes.
levicki Roths. Mindanao.
ellipsis de Joannis N. Caled. Rare.
aganippe Don. Aust. Red-spotted.
harpalyce Don. As last.
?sthenoboea Bsdv. Moluccas.
Grp. XVIII (dorimene-group)
dorimene Cr. Ambon. Darker than next.
*agostina Hew. Next is similar.
baracasa Semp. Malay.
biaka J. & Noakes Biak. Dark.
gabia Bsdv. N.G. As dice No costal black.
subviridis J. & T. Serang.
melusina Stgr. Celebes.
dorylaea Feld. Java.
apatala J. & T. Buru.
eileenae J. & T. Timor.
echidna Hew. Ambon.
rothschildi Holl. Buru.
hippodamia Wall. Aru.
narses Heller N. Brit.
mavroneria Fruhst. N.G. Small.
alberti Roths. Choiseul.
?omissa Roths. N.G.
Grp. XIX (isse-group)
isse Cr. Ambon, etc. Dark margins.
*ennia Wall.
candida Voll. Batchian. Large.
sacha G.-Smith. Obi.
bosnikiana J. & Noakes Biak.
parennia Roepke N.G.
lytaea Godm. & Salv. N. Brit.
?multicolor J. & Noakes (ennia-form).
Grp. XX (hyparete-group) v. variable.
(Subgenus Piccarda) ? not valid.
*hyparete L.
*rosenbergi Voll.
*eucharis Dry.
*salvini Btlr. Next is similar.
bagoe Bsdv. N. Ireland. Yellow f/w bands.
argenthona Fab. Aust. Close to next.
*schoenbergi Roths.
*timorensis Bsdv.
*periboea Godt.
*mysis Fab. Next is similar.
euphemia G.-Smith. Biak. Larger.
*doylei Sanf. & Bnt.
nitisi Stgr. Sula Isles.
fasciata Roths. Sumba.
sambawana Roths. Sambawa.
poecilea Voll. Batchian & Halm.
caeneus L. Ambon. Like duris.
Genus Prioneris. Largely Indo-Malay.
May resemble Delias but ♂ has
serrate f/w costa.
*thestylis Dbldy. TS varies seasonally.
cornelia Voll. Borneo. Close to last.
sita Feld. Ind. Like D. eucharis.
autothisbe Hbn. Next is similar.
hypsipyle Weym. Sum. h/w cell not red.
clemanthe Dbldy. Ind. Close to next.
*philonome Bsdv. Next is similar.
vollenhovi Wall. Borneo.
Genus Appias 40+ species largely Indo-
Aust. Some African species
resemble Mylothris but♂♂ have
anal hair-tufts. Lfp Capparis.
libythea Fab. TS paler than next.
*lyncida Cr.
*nero Fab. variable.
*celestina Bsdv.
indra Moore Ind. Variable.
*pandione Geyer Last is similar.
melania Fab. Next may be form.
paulina Cr. Also Palearctic.
sylvia Fab. African. Like Mylothris.
drusilla Cr. Only American species.
Genus Saletara Indo-Aust.
panda Bsdv. TS Indonesia Gc yellow.
*cycinna Hew. Recto like A. celestina.
liberia Cr. Moluccas. Close to last.
?giscon G.-Smith. Solom. Like panda.
Genus Melete (Daptonoura) Less than
12 Neotropical species. Variable.
*lycimnia Cr. TS Next is similar.
florinda Btlr. Venez.
salacia Godt. Mex. Central band verso.
Genus Mathania @ 6 Neotropical
montane species.
esther Godt. TS Bol. Gc yellow.
*agasicles Hew. Paler than last.
aureomaculata Dognin Ecua.
Genus Udaiana Malay. Monotypic.
cynis Hew. TS Gc white, black tips.
Genus Elodina (therasia Feld. TS)
Genus Elodinesthes (anticyra Fruhst. TS).
Genus Leuciacria (Monotypic acuta
R.♂ & J. TS).
3 genera with 20+ Australasian species.
Gc white/pale yellow, black tips. Lfp
Capparis. Poss. allied to Neotropical
Leptophobia.
Genus Leptosia. Old World Gc white
dark f/w spot. Lfp Capparis.
*nina Fab. (xiphia Fab.) TS Widespread.
medusa Cr. Ethiopian

alcesta Stoll As last.
uganda Neus. As last.
Genus Leucidia 4 Neotropical species.
Gc white. Very small.
elvina Bsdv. TS.
Genus Anthocharis Holarctic. Lfp
Cruciferae. (see APPENDIX 7).
*cardamines L. TS
*cethura Feld.
*pima Edw. (?poss. form of last).
*sara Bsdv.
damone Bsdv. Palearctic.
*belia L. Last is similar.
gruneri H.-Schaff. Pal. Gc yellow.
eupheno L. Pal. (?poss. belia-form).
bambusarum Oberth. Chin. f/w all red.
?dammersi Coms. Nearctic.
Genus Falcapica Holarctic Lfp Cruciferae
(often united with last).
genutia Fab. (midea Hbn.) TS Nearctic.
*scolymus Btlr. Last is similar.
lanceolata Bsdv. Nearctic.
bieti Oberth. Chin.
Genus Zegris Palearctic. Small orange tips.
Larva hairy. Pupa in cocoon.
eupheme Esp. TS
fausti Christ.
Genus Microzegris Asian. Monotypic.
pyrothoe Evers. TS Close to last.
Genus Elphinstonia 4 Palearctic species
Close to next genus.
charlonia Donzel TS
Genus Euchloe Less than 10 species.
Most Palearctic. Lfp Cruciferae.
*ausonia Hbn. TS
*belemia Esp.
fallowi Allard Also Ethiopian.
ausonides Bsdv. Nearctic.
creusa Dbldy. & Hew. As last.
olympia Edw. As last.
Tribe Colotini (Teracolini) Separated from
Pierini by venation. Largely Old World.
Genus Eroessa Neotropical. Monotypic.
chilensis Guér. TS Chile. Montane.
Genus Hebomoia Indo-Aust. Largest of
the Pieridae.
*glaucippe L. TS Also Pal. Variable.
*leucippe Cr.
Genus Colotis (Teracolus) @ 50 species
Ethiopian and Oriental. Marked
seasonal variation.♀♀ may be
dimorphic. Lfp Capparis.
Grp. I (amata-group) @ 12 species.
*amata Fab. TS Africa to India.
*aurigineus Btlr.
vesta Reiche Similar to last.
*protomedia Klug
Grp. II (celimene-group)
celimene Lucas Africa. Purple f/w tips.
Grp. III (halimede-group)
*halimede Klug
*zoe Grand.
venosus Stgr.
pleione Klug
Grp. IV (ione-group) 6 species.
ione Godt. Close to next.
regina Trim.
Grp. V (danae-group) 3 species.
*danae Fab. Africa and Ind.
Grp. VI (eucharis-group)
*eucharis Fab. Africa & Ind.
Grp. VII (antevippe-group)
antevippe Bsdv. No dark f/w band.
evenina Wallen. Both African.
Grp. VIII (evippe-group) 6 species.
*evippe L. Variable.
*daira Klug♀ dimorphic.
*etrida Bsdv.
Grp. IX (agoye-group)
agoye Wallen. Africa. Dark veins.
Grp. X (liagore-group)
liagore Klug Africa. Pale orange tips.
Grp XI (evanthides-group)
evanthides Holl. Africa. Tiny.
Grp. XII (evagore-group)
*evagore Klug very variable.
niveus Btlr. Socotra Isle.
Grp. XIII (mananhari-group)
mananhari Ward Africa. Gc yellow.
Grp. XIV (eris-group)
*eris Klug
Grp. XV (subfasciatus-group)
subfasciatus Swains. Gc yellow.
ducissa Dognin (? form of last).
Grp. XVI (fausta-group)
*fausta Olivier Africa to India.
Grp. XVII (eulimene-group)
eulimene Klug Afr. (subgenus Calopieris)
Genus Gideona Madagascar. Monotypic
(often united with last)
*lucasi Grand.
Genus Eronia African.
*cleodora Hbn. TS
*leda Bsdv.
Genus Nepheronia African. Variable.
*argia Fab. TS
*thalassina Bsdv.
pharis Bsdv.
usambara Auriv.
buqueti Bsdv.
Genus Valeria (Pareronia) @ 10 Indo-Aust.
species.♀♀ mimic Danaids. Lfp
Capparis etc.
*valeria Cr. TS
*boebera Esch. (? poss. form of last).
tritaea Feld. Celeb. Large. Dark margins.
Subfamily Coliadinae 'Yellows' @ 200
species. Examples in all world
regions.
Genus Catopsilia (Callidryas) Largely
Indo-Aust. Often migratory. Lfp
Cassia etc.
crocale Cr. TS gc yellow.
*pomona Fab. very variable.
*pyranthe L.
scylla L. Malay. yellow h/w.
florella Fab. Ethiopian.
*thauruma Reak.
?grandidieri Mab. Madgr.
?mabilli Neus. As last.

Genus Phoebis (formerly united with
last) New World.
*argante Fab. TS verso band broken.
*agarithe Bsdv. Recto close to last.
*cipris Fab.
*rurina Feld.
*philea L.
*sennae L. (eubule L.)
*avellaneda H.-Schaff. (see APPENDIX 9)
*statira Cr. (subgenus Aphrissa).
trite L. Neotropical Gc yellow.
editha Btlr. Haiti.
godartiana Swains. As last.
orbis Poey Cuba.
boisduvalii Feld. Colombia.
jada Btlr. Guatemala.
Genus Anteos Neotropical Lfp Cassia.
*maerula Fab. TS vagrant in USA.
*clorinde Godt. As last.
*menippe Hbn. (subgenus Klotsius).
Genus Gonepteryx Palearctic Lfp
Rhamnus.
*rhamni L. TS Next is similar.
mahaguru Gistel (zaneka Moore) Oriental
*farinosa Zeller
*amintha Blanch.
alvinda Blanch. Tibet.
*cleopatra L.
?cleobule Hbn. Canaries (form of last).
?aspasia Ménétr. Chin. (?mahaguru-f.).
Genus Kricogonia Neotropical.
*castalia Fab. TS Next is poss. form.
?lyside Godt. Also in USA.
?cabrerazi Ramsden Cuba.
Genus Dercas Indo-Malay & Chin.
verhuelli Hoev. TS Several races.
*lycorias Dbldy.
enara Swinhoe Chin. (?verhuelli-f.).
Genus Eurema @ 40 American species
(see APPENDIX 10).
daira Godt. TS Close to next.
*elathea Cr.
arbela Hbn.
*mexicana Bsdv. Variable.
nicippe Cr.
venusta Bsdv.
*proterpia Fab. (subgenus Pyrisitia).
*westwoodi Bsdv.
atinas Hew. (subgenus Terioolias) Bol.
Genus Terias @ 30 Old World species.
Lfp Cassia etc.
*hecabe L. TS
*laeta Bsdv.
*brenda Dbldy. & Hew.
*tilaha Horsf.
*candida Cr.
*smilax Don.
harina Horsf. (subgenus Gandaca).
Genus Nathalis Tiny American species.
Pupa has no cephalic projection.
*iole Bsdv. TS
plauta Dbldy. & Hew. Venez. Like Colias.
Genus Colias @ 70 largely Holarctic
species. Status of many doubtful.
♀♀ frequently dimorphic. Lfp
Leguminosae.
*hyale L. TS
*erate Esp.
*australis Vty. (calida Vty.).
*crocea Geoffroy (edusa Fab.)
*fieldi Ménétr.
*eogene Feld.
*romanovi Gr.-Grsh.
*staudingeri Alph.
*wiskotti Stgr.
*phicomone Stgr.
*cristophi Gr.-Grsh.
*palaeno L. Also Nearctic.
*nastes Bsdv. As last.
*lesbia Fab.
*dimera Dbldy. & Hew.
*electo L. Ethiopian.
*eurytheme Bsdv.
*philodice Godt.
*alexandra Edw.
harfordii Edw. Close to last.
occidentalis Scudder Nearctic.
pelidne Bsdv. & Leconte As last.
gigantea Strecker Like eurytheme.
interior Scudder Like alexandra.
behrii Edw. Nearctic Gc dark green.
meadii Edw. Nearctic.
hecla Lefebre As last.
boothii Curtis Arctic.
Genus Zerene (Megonostoma). Often
included with last. Several other
species named – probably only
sub-forms.
*cesonia Stoll TS USA.
*eurydice Bsdv.
*therapis Feld. (? poss. cesonia-form).
Pages 170-175
FAMILY LYCAENIDAE Antennae usually
ringed with black and white. All
six legs developed but anterior
pair in♂♂ may be shorter.
Hundreds of genera and several
thousand species.
Subfamily Lipteninae Almost 50 African
genera with many species
resembling butterflies of other
families. Larvae have hair-tufts.
Lfp Lichens.
Tribe Pentilini
Genus Telipna 25+ species.
acraea Westw. TS
*nyanza Neave
Tribe Liptenini
Genus Mimacraea 20+ species.
darwinia Btlr. TS
*marshalli Trim.
Genus Mimeresia 12 species.
libentina Hew. TS
*neavei J. & T.
Genus Citrinophila @ 10 species.
marginalis Kirby TS
*erastus Hew.
Genus Liptena 70+ species.
undularis Hew. TS
*homereyi Dew.

Genus *Epitola* 80+ species.
posthumus Fab. TS Close to next.
crowleyi Sharpe
honorius Fab.
miranda Stgr.
Genus *Hewitsonia* 8 species.
boisduvali Hew. TS
similis Auriv. (see APPENDIX 11).
Subfamily Poritiinae 6 Oriental genera allied to last. Early stages similar.
Genus *Poritia* @ 6 species.
hewitsoni Moore TS
philota Hew. Last is similar.
Subfamily Liphyrinae @ 6 species mostly African. Larvae ant-dependent.
Genus *Liphyra*
brassolis Westw. TS Aust.
castnia Strand N.G.
Subfamily Miletinae 4 tribes of principally African & Oriental genera. Larvae feed on aphids.
Genus *Miletus* (Gerydus) @ 6 species.
symethus Cr. TS
Genus *Allotinus* @ 6 species.
fallax Felder
posidion Fruhst.
Other tribes in this subfamily are Tarakini, Lachnocnemini and Spalgini. To the last belongs the well-known American 'harvester' *Feniseca tarquinius* Fab.
Subfamily Ogyrinae (has been treated as a tribe of Theclinae).
Genus *Ogyris* @ 16 Aust. species. Lfp Loranthus. Larvae ant-associated.
abrota Westw. TS Smaller than next.
zosine Hew.
genoveva Hew. ♂ all blue.
Subfamily Theclinae 'hairstreaks'. A vast number of species, often tailed.
Tribe Theclini @ 30 genera mainly Holarctic & Oriental. h/w never with more than 1 tail.
Genus *Laeosopis* Palearctic. Monotypic.
roboris Esp. TS Lfp Fraxinus.
Genus *Thecla* (Zephyrus) Palearctic. Monotypic (see APPENDIX 12).
betulae L. TS Lfp Prunus.
Genus *Ussuriana* @ 4 Palearctic species.
michaelis Oberth. TS
Genus *Japonica* @ 5 Palearctic species.
saepestriata Hew. TS recto orange.
Genus *Hypaurotis*. Nearctic. Monotypic.
crysalus Edw. TS Lfp Quercus.
Genus *Euaspa* @ 4 Indo-Palearctic species.
milionia Hew. TS
forsteri Esaki & Shirôzu
Genus *Chrysozephyrus* 6+ Palearctic species. Lfp Quercus.
smaragdina Brem. TS
Genus *Favonius* @ 6 Palearctic species. Lfp Quercus.
orientalis Murray TS
saphirinus Stgr.
Genus *Quercusia* @ 5 Palearctic species. (formerly included with Thecla (Zephyrus)).
quercus L. TS Lfp Quercus.
Tribe Arhopalini 'oak blues' 17 genera of large Indo-Aust. species. May have up to 3 h/w tails.
Genus *Arhopala* (Narathura with *hypomuta* Hew. is often employed for this genus) @ 200 species divided between several subgenera. Lfp Hopea etc. Larvae ant-associated.
phryxus Bsdv. TS
hercules Hew. Largest species.
aexone Hew.
horsfieldi Pag.
areste Hew.
eridanus Feld.
Tribe Zesiini 4 small Indo-Aust. genera. Species usually tailed. Lfp Acacia. Larvae ant-associated.
Genus *Pseudalmenus* Aust. Monotypic.
myrsilus Westw. TS
Other genera in this tribe are Zesius, Jalmenus & Protialmenus.
Tribe Amblypodiini 2 Indo-Aust. genera and 1 African. Species stoutly built.
Genus *Amblypodia* (Horsfieldia)
narada Horsf. TS
anetta Stgr. Moluccas.
Genus *Iraota* 5 species.
maecenas Fab. TS (? form of next).
timoleon Stoll recto blue.
Genus *Myrina* 3 African species.
silenus Fab. TS Lfp Ficus.
Tribe Oxylidini A single African genus. Species have 3 h/w tails.
Genus *Oxylides* @ 12 species.
faunus Dry. TS
melanomitra Karsch (subgen. Syrmoptera).
Tribe Hypothecini Indo-Aust. 1 h/w tail.
Genus *Hypochlorosis* @ 6 species.
antipha Hew. TS
lorquinii Feld.
Genus *Hypothecla*.
astyla Hew. TS
Tribe Loxurini 6 Oriental genera. Species have at least 1 long h/w tail.
Genus *Yasoda* Monotypic.
pita Horsf. (*tripuncta* Hew.) TS
Genus *Loxura* A few species similar to last.
atymnus Stoll TS Lfp Dioscorea.
Genus *Neomyrina* Monotypic.
hiemalis Godm. & Salv. (*nivea* G. & S.) TS
Genus *Eooxylides* @ 5 species.
tharis Geyer TS
Remaining genera in this tribe are Thamala & Drina.
Tribe Horagini Oriental. Species have 3 h/w tails.
Genus *Horaga* @ 8 species.
onyx Moore TS Lfp Coraria.
rarasana Sonán
Genus *Rathinda* poss. Monotypic. (other species doubtful).
amor Fab. TS Lfp Eugenia etc.
Tribe Cheritrini 6 Oriental & 1 African genus. Species have 2 h/w tails
Genus *Cheritra* Lfp Xylia.
freja Fab. TS dark brown, long tails.
aurea Druce (subgenus Ritra)
orpheus Feld. As last.
Tribe Iolaini 30+ Oriental & African genera. Species have 2 or 3 h/w tails.
Genus *Tajuria* @ 30 Oriental species. Lfp Loranthus.
cippus Fab. TS Variable.
jalindra Horsf.
mandarina Hew. (subgenus Charana).
Genus *Jacoona* 6+ Oriental species. (sometimes included with Neocheritra TS *amrita* Feld.)
anasuga Feld. TS
(The following 5 genera are Ethiopian. All formerly included in *Iolaus* TS.)
eurisus Cr.) Lfp Loranthus.
Genus *Epamera* 40+ species.
sidus Trim. TS
aphnaeoides Trim. Resembles Aphnaeus.
Genus *Argiolaus*
silas Westw. TS
lalos Druce
crawshayi Btlr.
Genus *Tanuetheira* Monotypic.
timon Fab. TS
Genus *Stugeta* @ 6 species.
bowkeri Trim. TS
Genus *Hemiolaus* @ 6 species principally Madgr.
caeculus Hopff. TS
Tribe Remelanini Oriental.
Genus *Remelana* Monotypic.
jangala Horsf. TS recto with blue.
Genus *Ancema* (Camena)
ctesia Hew. TS (see APPENDIX 13).
Genus *Pseudotajuria*
donatana de Nicév. TS
Tribe Hypolycaenini African & Oriental species. Usually with 2 or 3 h/w tails – 1 often very long.
Genus *Hypolycaena* 30+ species. Majority African. Lfp Vangoeria etc.
sipylus Feld. TS Moluccas.
lebona Hew.
liara Druce
Genus *Zeltus* Oriental. Monotypic.
amasa Hew. (*etolus* Fab.) TS
Genus *Leptomyrina* 7 African species. Lfp Cotyledon etc.
phidias Fab. TS Similar to next.
lara L. (subgenus Gonatomyrina).
(The remaining genera in this tribe are Chiliaria & poss. Tatura.)
Tribe Deudorigini @ 20 genera largely African & Oriental. Most species tailed.
Genus *Deudorix* @ 5 Oriental species. Larvae feed on fruits of Punica, Psidium etc.
epijarbas Moore TS
(The next 3 genera are often included with the last)
Genus *Artipe* @ 4 Oriental species.
eryx L. TS
Genus *Actis* 3 African species.
mimeta Karsch (*perigrapha* Karsch) TS
Genus *Pilodeudorix* 12 African species
camerona Plotz TS Similar to next.
ankoleensis Stempffer
Genus *Sinthusa* @ 8 Oriental species.
nasaka Horsf. TS Close to next.
malika Horsf.
Genus *Rapala* 30+ Indo-Aust. & Palearctic species divided into several subgenera. Lfp Nephalium etc.
varuna Horsf. TS blue-black.
selira Moore (subgenus Hysudra).
Tribe Eumaeini More than 60 genera, mostly Neotropical, some Holarctic. Hundreds of species divided with 1 or 2 h/w tails (see APPENDIX 14).
Genus *Callophrys* @ 30 Holarctic species divided into several subgenera. Lfp varied Genista, Pinus Vaccinium etc.
rubi L. TS
niphon Hbn. (subgenus Incisalia) USA.
Genus *Normannia* @ 5 Palearctic species. Lfp Prunus, Quercus.
myrtale Klug TS Lebanon. Close to next.
ilicis Esp.
Genus *Strymonidia* 16+ Palearctic species. Lfp Prunus, Ulmus.
thalia Leech TS Chin.
spini Schiff.
w-album Knoch
pruni L. Close to last.
Genus *Strymon* 30+ species largely Neotropical. Lfp Trema, Malva etc. (see APPENDIX 15).
melinus Hbn. TS. Also found in USA.
Genus *Satyrium* @ 5 species largely Holarctic. Lfp Quercus, Salix etc. No tails.
fulginosa Edw. TS No tails.
californica Edw. (*acadica* Edw.)
Genus *Calycopis* 25+ Neotropical species.
cecrops Fab. TS Also found in USA.
cerata Hew.
atrius H.-Schaff.
Genus *Panthiades* 25+ Neotropical species. Lfp Quercus.
pelion Cr. TS Recto bright blue.
selica Hew.
m-album Bsdv. & Leconte Also USA.
Genus *Arawacus* 20+ Neotropical species.
linus Fab. TS Close to next.
togarna Hew.
sito Bsdv.
Genus *Cycnus* @ 10 Neotropical species.
phaleros L. TS
battus Cr.
(The following allied '*Thecla*' species are of uncertain generic position)
gibberosa Hew. Strange f/w shape.
phydela Hew.
Genus *Pseudolycaena* Neotropical.
marsyas L. TS
damo Druce Recto like last.
Genus *Atlides* @ 20 Neotropical species Lfp Phorodendron etc.
halesus Cr. TS Recto like next. Also USA.
torfrida Hew.
Genus *Thestius* 5+ Neotropical species.
pholeus Cr. TS
(The following allied '*Thecla*' species are of uncertain generic position)
cyllarus Cr.
bitias Cr. (*syncellus* Cr.).
gabatha Hew.
lisus Stoll
auda Hew.
loxurina Feld. normal form purplish.
Genus *Theritas* Exact limit of this Neotropical genus uncertain (name often misused)
mavors Hbn. TS
tagyra Hew. (provisional placing)
Genus *Evenus* @ 10 Neotropical species.
regalis Cr. TS
gabriela Cr. (provisional placing)
coronata Hew. (as last) ♂ all blue.
Genus *Arcas* 7 Neotropical species.
imperialis Cr. TS
ducalis Westw. Recto like next.
tuneta Hew. Larger. Verso green, banded.
Genus *Eumaeus* American species resembling Nemeobiidae.
minyas Hbn. TS
atala Poey USA Close to last.
debora Hbn. Central America only.
Tribe Lucinii 8 genera mostly Australasian. No h/w tails. Larvae of many ant-associated.
Genus *Lucia* Monotypic.
limbaria Swains. TS
Genus *Paralucia* Lfp Bursaria.
aenea Miskin TS
aurifer Blanch. Close to last.
Genus *Hypochrysops* 60+ species.
polycletus L. TS
apelles Fab. Close to last.
protogenes Feld.
Genus *Philiris* 50+ species.
ilias Feld. TS Ambon etc. See next.
helena Snell. Larger & darker.
(Remaining genera in this tribe are Pseudodipsas, Waigeum, Parachrysops & Titea).
Tribe Catapaecilmatini
Genus *Catapaecilma* @ 4 Oriental species.
elegans Druce TS
delicatum de Nicév. (subgen. Acupicta)
Tribe Aphnaeini 15 African & Oriental genera. Most species tailed. May resemble 'coppers' (Lycaeninae).
Genus *Aphnaeus* 12+ African species.
orcas Dry. TS
hutchinsoni Trim. Silver-spotted verso.
Genus *Apharitis* @ 6 African & Paleo-Oriental species. Lfp Cassia.
epargyros Evers. TS Close to next.
acamas Klug
Genus *Cigaritis* 2 or 3 Palearctic species.
zohra Donzel TS
Genus *Spindasis* 40+ African & Oriental (formerly Aphnaeus) species. Lfp Convolvulaceae etc.
natalensis Dbldy. & Hew. TS
lohita Horsf.
vulcanus Fab.
aderna Plotz (subgenus Lipaphnaeus)
ella Hew. S. Africa (as last).
Genus *Axiocerces* 6 African species. Lfp Ximenia.
harpax Fab. (perion Cr.) TS
amanga Westw.
jacksoni Stempffer
Genus *Phasis* @ 4 African species. Lfp Melianthus, Rhus, etc. Larvae ant-associated.
thero L. TS
Genus *Aloeides* @ 24 African species. Some doubtful. Lfp Aspalathus.
pierus Cr. TS More orange than next.
taikosama Wallen.
thyra L.
Genus *Poecilmitis* @ 30 African species. Lfp Zygophyllum.
lycegenes Trim. TS Similar to next.
felthami Trim.
thysbe L.
uranus Pennington
Tribe Tomarini @ 6 Palearctic species. No tails. Resemble 'coppers' (Lycaeninae) but closer to last. Lfp Leguminosae
Genus *Tomares* (Thestor)
ballus Fab. TS ♂ brown. ♂♀ verso green.
mauritanicus Lucas
nogelii H.-Schaff.
Subfamily Curetinae @ 10 principally Indo-Malay species. No tails. Marked sexual dimorphism. Lfp Pongamia.
Genus *Curetis* Variable.
thetis Dry. TS Similar to next.
santana Moore
acuta Moore ♂ orange.
Subfamily Polyommatinae 'blues'. Vast number of genera & species. All world regions; majority Holarctic & Oriental. May have small h/w tails.
Tribe Lycaenesthini 5 African & Oriental genera. Tiny false 'tails'.
Genus *Anthene* 120+ species, mostly African. Lfp Cassia, Nephelium etc. (Formerly included in *Lycaenesthes* TS *bengalensis* Moore).
larydas Cr. TS
lemnos Hew.
amarah Guér.
sylvanus Dry.
robusta Auriv. (subgenus Cupidesthes). (Remaining genera in this tribe are Neurypexina, Neurellipes, Monile & Triclema).
Tribe Candalidini 8 Australasian genera. Species unusually coloured. No tails. (often included in 1 genus Candalides).
Genus *Candalides*
xanthospilos Hbn. TS Yellow f/w spots.
Tribe Niphandini Oriental. No tails.
Genus *Niphanda* poss. Monotypic (other species doubtful).
tessellata Moore TS Anthene-like.
Tribe Polyommatini 140+ genera & hundreds of species. All world regions (greatly in need of revision).
Genus *Cupidopsis* 3 African species. Lfp Leguminosae.
jobates Hopff. TS
Genus *Pseudonacaduba* (Petrelaea). @ 6 African & Oriental species.
aethiops Mab. Similar to next.
sichela Wallen.
dana de Nicév. (TS of Petrelaea)
Genus *Nacaduba* @ 10 Oriental species. Similar to last.
kurava Moore TS
Genus *Neolucia* 5 Aust. species. Lfp Rhagodia & Atriplex.
agricola Westw. TS
serpentata H.-Schaff.
Genus *Danis* (Thysonotis) @ 20 Aust. species. Lfp Alphitonia.
danis Cr. TS
cyanea Cr. Similar; smaller.
Genus *Lampides* (Cosmolyce) Monotypic. Lfp Leguminosae.
boeticus L. TS Migrant. All Old World.
Genus *Jamides* @ 30 Indo-Aust. tailed species. Lfp Leguminosae. (formerly included with last).
bochus Stoll TS
philatus Snell.
celeno Cr. Close to last.
Genus *Catochrysops* @ 6 Indo-Aust. tailed species. Lfp Leguminosae.
strabo Fab. TS
Genus *Phlyaria* African.
cyara Hew. TS
heritsia Hew.
Genus *Cacyreus* @ 8 African tailed species. Lfp Labiatae etc.
lingeus Stoll TS
Genus *Syntarucus* 15+ species; mostly African. Lfp Plumbago.
pirithous L. (*telivanus* Lang) TS. Widespread
plinius Fab. Indo-Aust. Last is similar
Genus *Castalius* @ 15 species, mostly African. Lfp Zizyphus.
rosimon Fab. TS
hintza Trim. (subgenus Zintha).
Genus *Tarucus* @ 15 species, largely African & Oriental. Lfp Zizyphus.
theophrastus Fab. TS
alteratus Moore (? form of last).
rosaceus Aus. (*mediterraneae* B.-Baker.)
Genus *Zizina* @ 6 Old World species. Lfp Leguminosae.
otis Fab. TS Widespread.
Genus *Actizera* African; tiny. Lfp Oxalis.
atrigemmata Btlr. TS Close to next.
lucida Trim.
stellata Trim.
Genus *Everes* @ 6 Holarctic & Indo-Aust. species. Tiny h/w tails. Lfp Medicago etc.
argiades Pallas TS (see APPENDIX 16).
comyntas Godt.
lacturnus Godt.
Genus *Cupido* 3 or 4 tiny Palearctic species. Lfp Leguminosae.
minimus Fuessly TS
Genus *Talicada* Oriental. Monotypic.
nyseus Guér. TS
Genus *Pithecops* @ 5 Oriental species. No tails. Lfp Leguminosae.
corax Fruhst. TS Verso close to next.
fulgens Doherty
Genus *Azanus* @ 12 Ethiopian & Oriental species. No tails. Lfp Acacia
ubaldus Stoll TS Darker than next.
moriqua Wallen.
isis Dry.
Genus *Celastrina* 12+ Holarctic & Indo-Aust. species (may be included in *Lycaenopsis* TS *haraldus* Feld.) No tails. Lfp Ilex etc.
argiolus L. TS
albocaerulea Moore
Genus *Parelodina* N.G. Monotypic.
aroa B.-Baker TS Resembles Pierid.
Genus *Glaucopsyche* @ 6 Holarctic species. Lfp Lathyrus Astragalus etc.
lygdamus Dbldy. TS
alexis Poda (*cyllarus* Rott.)
galathea Blanch.
Genus *Philotes* @ 12 Holarctic species mostly American. Lfp Sedum, etc.
sonorensis Feld. TS
Genus *Iolana* Palearctic. Monotypic.
iolas Ochs. TS Lfp Colutea.
Genus *Maculinea* @ 6 Palearctic species. Larvae ant-dependent.
alcon Schiff. TS Less spots than next.
teleius Berg.
arion L. Brighter than last.
nausithous Berg.
Genus *Euchrysops* 30+ species most African some Indo-Aust. (formerly included with *Catochrysops*). Some tailed. Lfp Leguminosae.
cnejus Fab. TS
dolorosa Trim.
pandava Horsf.
Genus *Lepidochrysops* @ 70 African species. Lfp Selago etc. Larvae ant-associated.
parsimon Fab. TS
oreas Tite
patricia Trim.
gigantea Trim.
Genus *Polyommatus* @ 6 Palearctic species. Lfp Leguminosae (see APPENDIX 17).
icarus Rott. TS typical ♀ duller.
loewii Z.
eros Ochs.
Genus *Plebejus* 12+ Holarctic species, most American. Lfp Leguminosae.
argus L. TS
icarioides Bsdv. (subgenus Icaricia).
Genus *Cyaniris* 3 or 4 Palearctic species. Lfp Leguminosae.
semiargus Rott. (*acis* Schiff.) TS
Genus *Aricia* @ 6 Palearctic species. Most without blue. Lfp Geraniaceae etc.
agestis Denis & Schiff. TS
artaxerxes Fab.
allous Geyer (form of last).
Genus *Agriades* @ 4 Palearctic species. Lfp Primulaceae.
glandon de Prunner TS Also USA.
Genus *Vacciniina* Holarctic. poss. Monotypic. Lfp Vaccinium.
optilete Knoch TS
Genus *Albulina* Palearctic. poss. Monotypic. Lfp Astragalus.
orbitulus de Prunner (*pheretes* Hbn.) TS
Genus *Meleageria* Palearctic poss. Lfp Thymus etc.
daphnis Schiff. (*meleager* Esp.) TS.
Genus *Agrodiaetus* @ 6 Palearctic species. Lfp Onbrychis.
damon Schiff. TS
Genus *Lysandra* @ 6 Palearctic species. Lfp Hippocrepis etc.
coridon Poda TS Variable (see p. 73).
bellargus Rott.
Genus *Plebicula* @ 7 Palearctic species Lfp Astragalus.
dorylas Schiff. TS
escheri Hbn.
Genus *Luthrodes* Aust. (formerly included with *Chilades* TS *laius* Stoll).
cleotas Guér. TS
buruana Holl. Obi. No h/w orange.
Genus *Freyeria* Old World. poss. Monotypic Lfp Indigofera etc.
trochylus Freyer TS Widespread.
Genus *Hemiargus* @ 5 American species. Lfp Prosopis, Abrus, etc.
antibubastus Hbn. TS (? form of next).
ceraunus Fab. Similar to next.
thomasi Clench
Subfamily Lycaeninae 'coppers'. Largely Holarctic. Most males red-gold. Some tailed.
Genus *Lycaena* (Chrysophanus) Lfp Rumex, Polygonum etc (see APPENDIX 17).
phlaeas L. TS Holarctic.
dispar Haworth Type-form extinct.
splendens Stgr.
pavana Koll.
kasyapa Moore
li Oberth.
pang Oberth.
helle Schiff (*amphidamas* Esp.)
athamanthis Ev.
evansi de Nicév.
sultan Stgr.
irmae Bailey Palearctic.
standfussi Gr.-Grsh. Palearctic.
tseng Oberth. Palearctic.
ouang Oberth. Palearctic.
caspius Lederer Pal. (sg. Hyrcanana)
sarthus Stgr. Pal. (sg. Sarthusia)
phoenicurus Led. Pal. (sg. Phoenicurusia)
hermes Edw.
rubidus Behr (subgenus Chalceria).
cupreus Edw.
thoe Guér.
xanthoides Bsdv. (subgenus Gaeides).
helloides Reak.
arota Bsdv. (subgenus Tharsalea).
heteronea Bsdv. ♂ bright blue.
epixanthe Bsdv. (subgenus Epidemia).
editha Mead Nearctic.
gorgon Bsdv. Nearctic.
mariposa Reak. Nearctic.
nivalis Bsdv. Nearctic.
dorcas Kirby Nearctic.
snowi Edw. (?form of *cupreus*).
orus Cr. Ethiopian. Lfp Polygonum.
clarki Dickson As last.
abotti Holl (poss. *phlaeas*-form).
(Subgenus Antipodolycaena) (see APPENDIX 18).
boldenarum Btlr. Lfp Muhlenbeckia.
salustius Fab. As last.
feredayi Hudson As last.
Genus *Heodes* Palearctic. Lfp Rumex.
virgaureae L. TS recto like *T. ochimus*.
alciphron Rott.
tityrus Poda (*dorilis* Hufnagel).
ottomanus Lefebre
Genus *Palaeochrysophanus*. Palearctic. Lfp Rumex.
hippothoe L. (*chryseis* Den. & Shf.) TS
Genus *Thersamonia*. Palearctic. Lfp Rumex, Sarothamnus.
thersamon Esp. TS
phoebus Blach.
ochimus H.-Schaff.
asabinus H.-Schaff.
thetis Klug s.s.p. shown poss. of next.
solskyi Ersch. Close to last.
lampon Lederer
Genus *Heliophorus* (Ilerda) @ 10 Palearctic & Oriental species. Resemble Theclinae. Lfp Rumex, etc.
epicles Godt. TS
androcles Dbldy. & Hew.
brahma Moore
loewii Z.
Genus *Iophanus* Neotropical. Monotypic.
pyrrhias Godm. & Salv. (see APPENDIX 19)

FAMILY LIBYTHEIDAE The elongate palpi serve to distinguish species in this family from all but a few other butterflies.♂♂ have forelegs atrophied & brush-like (as Nymphalidae). ♀♀ have all six legs fully developed.

Genus Libythea All world regions. Some migratory. Lfp Celtis etc.
*celtis L. TS Lfp Celtis etc.
lepita Moore poss. form of last.
narina Godt. Oriental.
*myrrha Godt. As last.
*labdaca Trim. African.
laius Trim. poss. form of last.
cinyras Trim. As last.
*geoffroyi Godt. Indonesia & Aust. (Subgenus Libytheana TS bachmanii).
bachmanii Kirtland American.
carinenta Cr. As last.

FAMILY NEMEOBIIDAE (Erycinidae or Riodinidae) All world regions but the vast majority Neotropical. Antennal clubs frequently pointed. ♂♂ have forelegs atrophied. ♀♀ have all six legs fully developed.

Section I Old World genera.
Genus Hamearis Palearctic. Monotypic.
*lucina L. TS Lfp Primula.
Genus Dodona 15+ Oriental species. Lfp Moesa etc.
*durga Koll. TS
*eugenes Bates
*ouida Moore Variable.
Genus Hyporion (princeps Oberth. TS)
Genus Polycaena (tamerlana Stgr. TS) Two genera with @ 6 small east Palearctic species close to Hamearis.
Genus Abisara @ 20 Oriental & African species. Lfp Myrsineae.
*kausambi Feld. TS
*rogersi Druce
Genus Saribia 3 Ethiopian species. Close to last but 2 h/w tails.
tepahi Bsdv. TS Madgr.
Genus Zemeros Indo-Palearctic. Lfp Moesa.
*flegyas Cr. TS
emesoides Feld.
Genus Laxita (teneta Hew. TS)
Genus Taxila (haquinus Fab. TS). Two genera with @ 12 Indo-Malay species. Verso blue-spotted. Close to next.
Genus Dicallaneura @ 12 Australasian species.
pulchra Guér. TS Similar to next.
*ribbei Rob.
*decorata Hew.
Genus Praetaxila (Sospita) 12 Australasian species.
segecia Hew. TS
*satraps G.-Smith.
Genus Stiboges Indo-Chin. Monotypic. Resembles Neotropical **Nymphidium**.
nymphidia Btlr. TS
Section II New World genera. Only a few examples from the approx. 150 genera included (see APPENDIX 20). Neotropical unless otherwise stated.
Genus Euselasia @ 100 species.
gelon Stoll TS
*erythraea Hew.
*thucydides Hew.
*orfita Cr. Resembles Euptychia (Sat.).
abreas Edw. Vagrant in USA.
Genus Methone (Methonella). Monotypic.
*cecilia Cr. TS
Genus Helicopis Multi-tailed species.
*cupido L. TS
*endymion Cr.
*acis Fab.
Genus Eurybia 12+ species. Prominent f/w 'eye-spots'.
halimede Hbn. TS
Genus Mesosemia @ 70 species. The next 2 genera formerly included here.
philocles L. TS
*loruhama Hew.
Genus Semomesia 3 species.
*croesus Fab. TS
Genus Teratophthalma @ 5 species.
phelina Feld. TS Similar to next.
*marsena Hew.
Genus Diophthalma @ 5 species.
telegone Bsdv. TS
*matisca Hew.
Genus Hyphilaria @ 4 species.
nicia Hbn. TS
*parthenis Westw.
Genus Napaea @ 8 species.
eucharila Bates TS
*nepos Fab.
Genus Alesa @ 5 species.♂♂ usually almost black.
prema Godt. TS
*amesis Cr.
Genus Themone
*pais Hbn. TS
poecila Bates
Genus Panara
thisbe Fab. TS Similar to next.
*phereclus L.
Genus Riodina (Erycina) @ 5 species.
lysippus L. TS Larger than next.
*lysippoides Berg. Last is similar.
Genus Melanis (Lymnas) @ 30 species.
melander Stoll (electron Fab.). TS
*pixe Bsdv.
*cephise Ménétr.
Genus Chorinea (Zeonia)
licursis Fab. TS
*batesii Sndrs.
*faunus Fab.
*sylphina Bates
timandra Sndrs.

amazon Sndrs.
*heliconides Swains. (TS of Zeonia).
Genus Rhetus (Diorina).
*arcius L. TS
*dysonii Sndrs.
*periander Cr.♂ shining blue.
arthurianus E.-Sh.
Genus Ancyluris Some of the most beautiful species.
*meliboeus Fab. TS Recto red banded.
*aulestes Cr.♂ similar to last. Varies.
*mira Hew.
colubra Sndrs. Narrower bands than last
*pulchra Hew.
*huascar Sndrs.
*inca Sndrs.
jurgenseni Sndrs. Close to next.
*formosissima Hew. Recto white bands.
aristodorus Mor. Close to last.
Genus Cyrenia Monotypic.
*martia Westw. TS
Genus Necyria
bellona Westw. TS Similar to next.
*duellona Westw.
*vetulonia Hew.
*manco Sndrs.
ingaretha Hew.
saundersi Hew.
zaneta Hew.
Genus Lyropteryx
*apollonia Westw. TS
lyra Sndrs. Red bands (? form of last).
terpsichore Westw.
diadocis Stich.
Genus Notheme Monotypic
*erota Cr. (ouranus Stoll) TS.
Genus Hopfferia Monotypic.
*militaris Hopff. (luculenta Ersch.) TS
Genus Symmachia 30+ species.
probeter Godt. TS Similar to next.
*championi Godm. & Salv.
*rubina Bates Resembles Lithosiid moth.
Genus Caria @ 16 species.
plutargus Fab. TS Close to next.
*mantinea Feld.
*rhacotis Godm. & Salv.
*domitiana Fab. Also found in USA.
Genus Baeotis @ 12 species.
hisbon Cr. TS
*bacaenis Hew.
Genus Anteros 8 species.
formosus Cr. TS Similar to next.
*bracteata Hew.
*carausius Westw.
Genus Sarota @ 7 species.
*chrysus Stoll TS
Genus Charis 'metalmarks'. 30+ species with iridescent lines.
ania Hbn. (auius Cr.) TS. (Subgenus Calephelis (Lephelisca)).
*nilus Feld. USA (with @ 5 others).
virginiensis Guér. (TS of Calephelis).
Genus Crocozona
pheretima Feld. TS No h/w red band.
*caecias Hew. Last is similar.
fasciata Hopff.
Genus Parcella (Amblygonia) Monotypic.
*amarynthina Feld. TS
Genus Amarynthis Monotypic. Like last but red bands & larger.
meneria Cr. TS Very variable.
Genus Lasaia @ 6 species.
meris Hbn. TS h/w costal white spot.
*agesilas Latr. Also USA. Last is close.
*moeros Stgr.
Genus Calydna
thersander Stoll TS
*calamisa Hew.
*caieta Hew.
Genus Emesis 25+ species.
cereus L. TS
*mandana Cr.
zela Btlr. Also found in USA.
emesia Hew. As last.
*lucinda Cr.
fatima Cr. (subgenus Nelone)
*incoides Schaus (as last).
Genus Siseme @ 8 species.
*alectryo Westw. TS
*neurodes Feld.
Genus Apodemia @ 12 species, half of which are Nearctic.
*mormo Feld. TS USA.
Genus Audre (Hamearis) @ 16 species.
*epulus Cr. TS
Genus Metacharis @ 10 species.
ptolomaeus Fab. TS
*regalis Btlr.
Genus Calospila (Polystichtis or Lemonias) @ 30 species.
zeanger Stoll TS
*lasthenes Hew.
*emylius Cr.
Genus Echenais 30+ species.
thelepus Cr. TS
*penthea Cr.
Genus Calliona
irene Westw. TS Smaller than next
*siaka Hew.
latona Hew.
Genus Nymphidium @ 50 species.
caricae L. TS orange h/w bands.
*lamis Stoll (subgenus Juditha).
Genus Thisbe Females resemble Dynamine (Nymphalidae).
*irenea Stoll TS
*lycorias Hew.
molela Hew.
Genus Menander (Tharops) @ 10 species.
menander Stoll TS
*hebrus Cr.
Genus Stalachtis @ 10 species which resemble Ithomiidae.
phaedusa Hbn. TS
*phlegia Cr.
*zephyritis Dalm.
calliope L.
Genus Aricoris 25+ species.
tisiphone Westw. TS
*flammula Bates

Genus Theope 40+ species.
*terambus Godt. TS
Genus Styx. Monotypic.
*infernalis Stgr. TS (see APPENDIX 21).

FAMILY HELICONIIDAE Almost entirely Neotropical. Forewings long & narrow. Antennae usually long. Cell of hindwing closed. First pair of legs abbreviated. Variation & intra − specific mimicry extensive − all subspecies included. Lfp Passiflora etc.

Genus Heliconius (charithonia L. TS) Almost 50 species.
*numata Cr.
*s.sp.silvana Cr.
*s.sp.superioris Btlr.
*s.sp.isabellinus Bates
*s.sp.aristona Hew (see APPENDIX 22).
s.sp.peeblesi J.
s.sp.talboti J. & Kaye
s.sp.leopardus Weym.
s.sp.messene Feld.
s.sp.euphone Feld.
s.sp.zobrysi Fruhst.
*ismenius Latr. (fritschei Mosch).
*s.sp.telchinia Dbldy.
s.sp.clarescens Btlr.
s.sp.occidentalis Neus.
s.sp.immoderata Stich.
s.sp. fasciatus Godm. & Salv.
*metaphorus Weym. Comp. C. hydra (Ith.).
pardalinus Bates. Amazon. Close to next.
*hecale Fab. (urania Muller).
*s.sp.quitalena Hew.
*s.sp.fornarina Hew.
s.sp.novatus Bates
*s.sp.vetustus Blh.
s.sp.barcanti Brown & Yeper
s.sp.clearei Hall
s.sp.radiosus Btlr.
s.sp.latus Riffarth
s.sp.ennuis Weym.
s.sp.nigrofasciatus Weym.
s.sp.styx Niepelt
s.sp.zuleika Hew.
s.sp.melicerta Bates
s.sp.semiphorus Stgr.
s.sp.jucundus Bates
s.sp.xanthicles Bates
s.sp.anderida Hew.
s.sp.ithaca Feld.
s.sp.vittatus Btlr.
s.sp.sisyphus Salv.
ethilla Godt. (flavidus Weym.)
*s.sp.narcaea Godt.
s.sp.eucoma Hbn.
s.sp.claudia Godm. & Salv.
s.sp.semiflavidus Weym.
s.sp.metalilus Btlr.
s.sp.thielei Riffarth
s.sp.flavomaculatus Weym. Like narcaea.
s.sp.adela Neus.
s.sp.tyndarus Weym.
s.sp.nebulosa Kaye
s.sp.aerotome Feld.
godmani Stgr. Col. Like hecalesia
aoede Hbn. Ecua. Resembles erato.
s.sp.astydamia Erichson
s.sp.bartletti Druce
s.sp.faleria Fruhst.
metharme Erichson Widespread. Like doris
s.sp.thetis Bsdv.
hierax Hew. Ecua. As timareta. h/w red.
*hecuba Hew. Comp. E. cassandra (Ith.).
crispinus Kruger Col. Similar to atthis.
choarina Hew. Ecua. More spots. More spots.
xanthocles Bates (vala Stgr.)
*s.sp.melete Feld.
*s.sp.mellitus Stgr.
*s.sp.caternaulti Oberth.
s.sp.melior Stgr.
wallacei Reak.
*s.sp.flavescens Weym.
*s.sp.clytia Cr.
s.sp.kayi Neus.
s.sp.elsa Riffarth
burneyi Hbn.
*s.sp.catharinae Stgr.
*s.sp.nuebneri Stgr.
s.sp.lindigii Feld.
*s.sp.serpensis Kaye
egeria Cr. Guy. Similar to burneyi.
*s.sp.egerides Feld.
s.sp.hylas Weym.
s.sp.homogena Bryk
astraea Stgr. Also like burneyi.
*doris L. Wide colour variation.
*s.sp.aristomache Riffarth
nattereri Feld. Braz. Rare. Yellow-banded
?fruhstorferi Riffarth (?dark f. of last).
*atthis Dbldy. (see p. 81).
elevatus Noldner Amazon. Like xanthocles.
s.sp.bari Oberth.
s.sp.schmassmanni J. & T.
s.sp.perchlora J. & T.
s.sp.roraima Turner
s.sp.luciana Lichy
s.sp.tumaturnari Kaye
s.sp.pseudocupidineus Neus.
?s.sp.taracuanus Bryk
*heurippa Hew.
*besckei Ménétr.
melpomene L. Very variable.
*s.sp.aglaope Feld.
*s.sp.plesseni Riffarth
*s.sp.penelope Stgr.
*s.sp.xenoclea Hew.
*s.sp.theixiope Hbn.
*s.sp.vulcanus Btlr.
*s.sp.sticheli Riffarth
s.sp.meriana Turner
s.sp.rosina Bsdv.
s.sp.modesta Riffarth
s.sp.cythera Hew.

s.sp.euryades Riffarth
s.sp.amandus G.-Smith. & Kirby
s.sp.nanna Stich.
*cydno Dbldy.
*s.sp.zelinde Btlr.
*s.sp.weymeri Stgr.
*s.sp.galanthus Bates
s.sp.alithea Hew.
s.sp.wernickei Weym.
*timareta Hew.
*pachinus Salv.
hermathena Hew. Amazon. Rare. As besckei.
s.sp.vereatta Stich. (?poss. distinct).
himera Hew. Ecua. Rare. Like clysonimus.
*erato L. Very variable.
*s.sp.cyrbia Latr. & Godt.
*s.sp.phyllis Fab.
*s.sp.petiverana Dbldy. Also USA.
*s.sp.amalfreda Riffarth
*s.sp.hydara Hew.
s.sp.notabilis Godm. & Salv.
s.sp.chestertonii Hew.
*s.sp.venus Stgr.
*s.sp.amphitrite Riffarth
*s.sp.venustus Salv.
*s.sp.demophon Ménétr.
*s.sp.microlea Kaye
s.sp.favorinus Hopff.
s.sp.lativitta Bates
s.sp.dignus Stich.
s.sp.meliorina Neus.
s.sp.reductimacula Bryk
s.sp.estrella Bryk
*hecalesia Hew. Comp. T. tarricina (Ith.).
*s.sp.formosus Bates
s.sp.eximus Stich.
*telesiphe Dbldy. (see p. 78).
*s.sp.soterius Salv. (as last).
?s.sp.nivea Kaye (?f.cretaceus Neus.).
*clysonimus Latr.
*s.sp.hygiana Hew.
*s.sp.montanus Salv.
*s.sp.fischeri Fassl
s.sp.semirubra J. & Kaye
*hortense Guér.
*charithonia L. TS Also USA.
s.sp.simulator Rob.
s.sp.punctata Hall
?s.sp.peruviana Feld. (see APPENDIX 23).
*ricini L. (insularis Stich.)
demeter Stgr. Peru. Yellow f/w patch.
s.sp.turneri Brown & Benson
s.sp.eratosignis J. & T.
*s.sp.beebei Turner
s.sp.bouqueti Nöldner
*sara Fab. (magdalena Bates).
*s.sp.apseudes Hbn.
s.sp.eucoma Hbn.
*s.sp.sprucei Bates
s.sp.veraepacis Stich.
*s.sp.fulgidus Hew.
*s.sp.theudda Hew.
s.sp.brevimaculata Stgr.
s.sp.thamar Hbn. (rhea Cr.)
leucadia Bates Ecua. Like sara sprucei.
*antiochus L.
*s.sp.salvinii Dew.
*s.sp.aranea Fab.
*s.sp.alba Riffarth
*sapho Dry. (see APPENDIX 24).
*s.sp.leuce Dbldy.
congenor Weym. Ecua. Like wallacei.
*eleuchia Hew.
*s.sp.primularis Btlr.
*s.sp.eleusinus Stgr.
hewitsoni Stgr. C. Rica. Like pachinus.
Genus Eueides (dianassa Hbn. TS) Often treated as a subgenus of the last. Easily separated by their generally smaller size & shorter antennae.
procula Dbldy. Venz. Like H. clysonimus.
s.sp.edias Hew.
s.sp.eurysaces Hew.
lampeto Bates Ecua. Like H. numata.
s.sp.acacates Hew.
vibilia Godt. Braz.
*s.sp.vialis Stich. (vicinalis Stich.).
s.sp.unifasciatus Btlr.
*isabellae Cr.
*s.sp.dianassa Hbn. TS (see APPENDIX 25).
pavana Ménétr. Braz. Like vibilia, paler.
*lineata Salv. & Godm.
*eanes Hew.
*tales Cr.
s.sp.xenophanes Feld.
s.sp.cognata Weym.
lybia Fab. Widespread. Like lineata.
s.sp.olympia Fab.
*aliphera Godt. Comp. D. julia. (next).
?cleobaea Geyer (isabellae-f.) + USA.
Genus Dryas (Colaenis) Monotypic.
*julia Fab. (iulia Fab.) TS Also USA.
*s.sp.delila Fab.
*s.sp.cyllene Cr.
*s.sp.hispaniola Hall
?s.sp.moderata Stich. (poss. delila-f.).
?s.sp.carteri Riley (poss. cyllene-f.).
?s.sp.nudeola Stich. (as last).
?s.sp.warneri Hall (as last).
?s.sp.juncta Coms.
?s.sp.dominicana Hall
?s.sp.lucia Riley (poss. moderata-f.).
?s.sp.framptoni Riley (as last).
Genus Dryadula Monotypic.
*phaetusa Stich. TS Vagrant in USA.
Genus Philaethria (This was formerly incorrectly known as Metamorpha − a Nymphalid genus).
*dido L. TS Comp. S. stelenes (Nymph.).
?wernickei Rob. (poss. s.sp. of last).
Genus Dione (species in this & the next genus superficially resemble Argynninae (Nymphalidae).
*juno Cr. TS
?s.sp.huascana Reak. poss. only form.
?s.sp.andicola Bates As last.
*glycera Feld. (gnophota Stich.).
moneta Hbn.

Genus Agraulis Monotypic (often combined
Genus Agraulis Monotypic (often combined with last).
vanillae L. TS Also USA.
*s.sp.lucina Feld.
s.sp.nigrior Michener
s.sp.insularis Maynard
s.sp.galapagensis Holl.
s.sp.maculosa Stich.
?s.sp.forbesi Michener (?f. of last).
Genus Podotricha
euchroia Dbldy. TS
*s.sp.caucana Riley
s.sp.mellosa Stich.
?s.sp.straminea (?form of last).
*telesiphe Hew. (see p. 78)
*s.sp.tithraustes Salv. (as last).

FAMILY ACRAEIDAE. Largely Ethiopian A few Indo-Aust. & 1 genus entirely Neotropical. First pair of legs greatly reduced. Anal region of hindwing without fold for abdomen.

Genus Acraea (horta L. TS)
Lfp. Passiflora etc.
Grp. I (satis-group).
satis Ward
zonata Hew.
*rabbaiae Ward
Grp. II (pentapolis-group).
*pentapolis Ward Typical f. less h/w red
vesperalis G.-Smith.
Grp. III (terpsichore-group).
*terpsichore L. (neobule Dbldy.) Also Ind
obeira Hew. Madgr. Close to last.
lia Mab. Madgr. As last.
hova Bsdv. Madgr.
ranavalona Bsdv. Madgr.
*iturina G.-Smith.
kalinzu Carpenter Close to last.
*humilis Sharpe
*quirina Fab.
*rogersi Hew. Variable.
*admatha Hew. Typical f. no h/w white.
punctimarginea Pinhey
*eltringhami J. & T. Next is similar.
insignis Dist. h/w marginal band entire.
*igati Bsdv. Next is very similar.
damii Voll. Dark spot on h/w costa.
*hamata J. & T. Rare.
eugenia Karsch
bourgeoni Schouteden
rileyi Le D.
acutipennis Schouteden
machequena G.-Smith.
zambesina Auriv.
horta L. TS
camaena Dry.
cerasa Hew.
?kraka Auriv. (?form of last)
?unimaculata G.-Smith. (?cerasa-f.)
?cerita Sharpe (as last)
?matuapa G.-Smith. (?terpsichore-f.).
?iturinoides Stoneham
Grp. IV (zetes-group) Larger species.
*zetes L. Variable.
chilo Godm.
?hypoleuca Trim.
Grp. V (anemosa-group)
*-nemosa Hew.
pseudolycia Btlr.
turna Mab. Madgr.
?welwitschii Rogen.
Grp. VI (egina-group)
*egina Cr.
Grp. VII (cepheus-group)
*cepheus L.
petraea Bsdv. Close to last.
guillemei Oberth.
diogenes Suffert
buttneri Rogen.
violarum Bsdv.
asema Hew.
omrora Trim.
lofua Elt.
bailunduensis Wichgraf
nohara Bsdv.
chambezi Neave
mansya Elt.
onerata Trim.
atolmis Westw.
periphanes Oberth.
?rohlfsi Suffert (petraea-form).
Grp. VIII (aureola-group)
aureola Elt. Angola. orange-yellow.
Grp. IX (acrita-group)
*acrita Hew. Variable.
chaeribula Oberth.
lualabae Neave
?manca Thurau poss. acrita-form.
Grp. X (caecilia-group)
caecilia Fab.
*caldarena Hew.
*pudorella Auriv.
*equatoralis Neave
*aglaonice Westw.
*asboloplintha Karsch
leucopyga Auriv.
intermedia Wichgraf
rhodesiana Wichgraf
mima Neave
braesia Godm.
sykesi Sharpe
doubledayi Guér. & Lefebre
oncaea Hopff.
ela Elt.
axina Westw.
mamois Rogen.
atergatis Westw.
stenobea Wallen.
lygus Druce
natalica Bsdv.
Grp. XI (rahira-group)
rahira Bsdv.
*anacreon Trim.
guichardi Gabriel
zitja Bsdv.

mirifica Lathy
?wigginsi Neave (?anacreon-form).
Grp. XII (encedon-group)
*encedon L. Very variable.
lycia Fab. Like pale form of last.
?fumosa Auriv.
Grp. XIII (bonasia-group) Small species.
*bonasia Fab. Variable.
*goetzi Thurau
*excelsior Sharpe
*sotikensis Sharpe Variable.
*eponina Cr. As last.
*burgessi Jack.
mirabilis Btlr.
miranda Riley
uvui B.-Baker. Like excelsior.
lumiri B.-Baker.
cabira Hopff.
rupicola Sch.
viviana Stgr.
acerata Hew.
pullula Grünberg
bettiana T.
bettiana T.
jordani Le D.
maji Carpenter
?rangatana Elt. (poss. eponina-f.)
?ventura Hew. As last.
?karschi Auriv. (poss. sotikensis-f.)
Grp. XIV (oberthuri-group)
oberthuri Btlr.
*althoffi Dew.
bergeri Gaede
Grp. XV (pharsalus-group)
pharsalus Ward As cepheus. Pale f/w bar
?vuilloti Mab. (?form of last.)
Grp. XVI (circeis-group)
circeis Dry.
*grosvenori Elt.
*penelope Stgr.
*servona Godt.
*oreas Sharpe
*semivitrea Auriv.
perenna Dbldy.
orina Hew.
peneleos Ward
pelopeia Stgr.
parrhasia Fab.
ungemachi Le Cerf
kukenthali Le D.
newtoni Sharpe
ntebiae Sharpe (mairessei Auriv.)
melanoxantha Sharpe
conradti Oberth.
buschbecki Dew.
Grp. XVII (masamba-group)
masamba Ward
*cinerea Neave
igola Trim.
aubyni Le D.
simulata Le D.
orestia Hew.
quirinalis G.-Smith.
fornax Btlr.
strattipocles Oberth.
sambavae Ward.
siliana Oberth.
?sambar Stoneham (?orestia-f.)
Grp. XVIII (jodutta-group)
*jodutta Fab.
*lycoa Godt.
*niobe Sharpe
*amicitiae Heron
*ansorgei G.-Smith. ♀ polymorphic.
*alciope Hew. As last.
*alciopoides J. & T.
safie Feld.
baxteri Neave
disjuncta G.-Smith.
actinotina Neave
esebria Hew.
johnstoni Godm. Variable.
insularis Sharpe
Grp. XIX (violae-group) Indo-Aust.
*violae Fab. (subgenus Telchinia).
Grp. XX (andromacha-group) Aust.
*andromacha Fab. Variable
Genus Pareba Oriental & E. Palearctic. Monotypic. (Often united with last genus).
*issoria Hbn. (vesta Fab.) TS. Widespread.
Genus Pardopsis African. Monotypic.
*punctatissima Bsdv. TS Also Madgr.
Genus Miyana Australasian.
moluccana Feld. Like A. semivitrea.
*meyeri Kirsch
Genus Bematistes (Planema) African. Larger than other Acraeidae. Species mimicked by butterflies in several families.
Grp. I (umbra-group)
*umbra Dry. (macaria Fab.) TS Next close.
macarista Sharpe Nocostal f/w spot.
*alcinoe Feld.
*quadricolor Rogen.
*consanguinea Auriv. Pale form shown.
*elgonense Poul. Variable.
*poggei Dew.
*elongata Btlr.
vestalis Feld.
aganice Hew.
scalivittata Btlr.
adrasta Weym.
formosa Btlr.
pseudeuryta Godm. & Salv.
excisa Btlr.
persanguinea Rebel
consanguinoides Le D.
epiprotea Btlr.
simulata Le D.
Grp. II (epaea-group)
epaea Cr. ♀ variable (see p. 76).
tellus Ward
epitellus Stgr.
Genus Actinote (thalia L. TS) Neotropical. Lower surface of f/w (in some cases h/w) with bristles. Lfp Compositae etc.
Grp. I (abana-group)
abana Hew.

erinome Feld.
radiata Hew. (subgenus Altinote).
Grp. II (hylonome-group)
hylonome Dbldy.
euryleuca Jord.
Grp. III (neleus-group)
neleus Latr.
alcione Hew. Similar to next.
*stratonice Latr.
Grp. IV (ozomene-group)
ozomene Godt. Close to next.
*leucomelas Bates
*diceus Latr. Variable.
*anaxo Hopff.
*laverna Dbldy.
*momina Jord.
demonica Hopff. Close to last.
adoxa Jord.
callianthe Feld.
naura Druce
trinacria Feld.
tenebrosa Hew.
segesta Weym.
flavibasis Jord.
jucunda Jord.
griseata Btlr.
hilaris Jord.
amphilecta Jord.
eresia Feld.
desmiala Jord.
leontine Weym.
negra Feld.
Grp. V (thalia-group)
*thalia L. TS Close to next.
*anteas Dbldy.
*parapheles Jord.
*equatoria Bates Variable.
*surima Schaus
cedestes Jord.
terpsinoe Feld.
guatemalena Bates Like equatoria.
melampeplos Godm. & Salv.
lapitha Stgr. Semi-transparent.
pellenea Hbn. Like parapheles. Variable.
pyrrha Fab.
carycina Jord.
quadra Schaus
perisa Jord.
alalia Feld.
Grp. VI (mamita-group)
mamita Burmeister Semi-transparent.
canutia Hopff.

Pages 192-221
FAMILY NYMPHALIDAE 'brush-footed' butterflies. All world regions. Antennae usually strongly clubbed. The first pair of legs atrophied & brush-like. Many species robustly built. Great variety of wingshape (see APPENDIX 26)
Subfamily Argynninae 'fritillaries'. All world regions but majority Holarctic. Ground colour tawny or fulvous – dark spotted.
Section I (Tribe Argynnini) Largely temperate zones but extend from subarctic to tropical. Often silvery verso markings.
Genus Speyeria Nearctic. Large species. Very variable. Some authorities regard many forms as distinct, recognising more than 30 species. Lfp Viola.
*idalia Dry. TS
*cybele Fab. (subgenus Neoacidalia).
*nokomis Edw.
*mormonia Bsdv. Very variable.
*edwardsii Reak.
*zerene Bsdv.
*hydaspe Bsdv.
*diana Cr. Gc. of ♂ tawny.
aphrodite Fab. Can. & East USA.
atlantis Edw. As last.
calippe Bsdv. West USA.
coronis Behr As last.
egleis Behr As last.
Genus Fabriciana Largely Palearctic. Lfp Viola.
*niobe L. TS
*adippe Schiff. (cydippe L.)
*elisa Godt.
*nerippe Feld.
kamala Moore Ind.
?jainadeva Moore
?taigetana Reuss
?auresiana Fruhst.
Genus Mesoacidalia Largely Palearctic. Lfp Viola.
*aglaia L. (charlotta Haworth) TS.
clara Blanch.
vitatha Moore.
claudia Fawcett
alexandra Ménétr. As next.
?liauteyi Oberth. (poss. aglaia-form).
Genus Argynnis Palearctic & Oriental. Lfp Viola. (Earlier authors employed this name for all fritillaries).
*paphia L. TS ♂ dimorphic.
*anadyomene Feld.
Genus Pandoriana Palearctic. Monotypic. Lfp Viola.
*pandora Schiff. (maja Cr.) TS
Genus Childrena Oriental.
*childreni Gray TS. Next is close.
zenobia Leech Chin. Smaller.
Genus Damora Palearctic. Monotypic.
*sagana Dbldy. & Hew. Stgr ♂ like paphia'
Genus Argyreus Palearctic & Indo-Aust. Monotypic. Lfp Viola.
*hyperbius Johannsen TS Widespread.
Genus Argyronome Indo-Palearctic.
*laodice Pallas TS Next is similar.
ruslana Motsch Chin. & Japan.
Genus Issoria Several regions. Lfp Viola etc.
*lathonia TS Palearctic. Migrant.
*hanningtoni Elwes
excelsior Btlr. Ethiopian.

smaragdifera Btlr. As last.
uganda Rob. As last.
*gemmata Btlr.
eugenia Ev. Chin. Close to last.
(Subgenus Yramea) Temperate N/tropical.
*cytheris Dry. TS High altitudes.
*modesta Blanch. As last.
darwini Stgr. As last.
inca Stgr. Bol. High altitudes.
cora Lucas Peru. As last.
Genus Brenthis Palearctic. Lfp Viola etc.
*hecate Schiff. TS.
*ino Rott. Variable.
daphne Schiff.
Genus Clossiana Palearctic & Nearctic. Some authors may regard forms of Nearctic species as distinct. Lfp Viola.
*selene Schiff. TS Also USA.
*euphrosyne L.
*dia L.
*titania Esp. Also USA.
frigga Thunberg Holarctic.
freija Thunberg Holarctic.
improba Btlr. Holarctic.
polaris Bsdv. Holarctic.
chariclea Schmeider As last.
thore Hbn. Palearctic.
selenis Ev. Pal.
hegemone Stgr. Pal.
oscarus Ev. Pal.
gong Oberth. Extensive silver spots.
iphigenia Graes. Pal.
angarensis Ersch. Pal.
jerdoni Lang Pal.
hakutosana Mats. As last.
?perryi Btlr.
?erubescens Stgr.
?amphilochus Ménétr.
astarte Dbldy. Nearctic.
kriemhild Strecker Nearctic.
toddi Holl. (bellona Fab.) Nearctic.
alberta Edw. Nearctic.
distincta Gibson Nearctic.
epithore Edw. As last.
Genus Proclossiana Holarctic. Monotypic
*eunomia Esp. (aphirape Hbn.) TS.
Genus Boloria Palearctic Lfp Vaccinium etc.
*pales Schiff. TS. Variable.
graeca Stgr. Balkans. Close to last.
napaea Hoffmanseg Also Nearctic.
?sifanica Gr.-Grsh.
?aquilonaris Stich. (poss. pales-form).
Genus Phalanta (Atella) 3 or 4 Ethiopian & Oriental species Lfp Alsodeia & Salix. (see APPENDIX 27).
phalantha Dry. TS Widespread.
*columbina Cr.
Genus Smerina Monotypic.
manoro Ward TS Madgr. Falcate f/w.
Genus Lachnoptera Ethiopian. ♂♂ have h/w scent patch. ♀♀ whitish-banded. Lfp Rawsonia.
anticlia Hbn. (iole Fab.) TS
ayresii Trim.
Section II (Tribe Melitaeini) 'checkerspots'. Largely Holarctic.
Genus Euphydryas 13 species, some Nearctic only. Lfp Plantago, Scabiosa etc.
*phaeton Dry. TS
*chalcedona Dbldy. & Hew.
*aurinia Rott.
*cynthia Schiff.
*maturna L.
*iduna Dalm.
Genus Mellicta 13 Palearctic species. Lfp Linaria, Veronica etc. (Earlier authors included this genus with the next).
*athalia Rott. TS Doubtfully in USA.
Genus Melitaea @ 40 largely Palearctic species. Lfp Plantago, Centaurea etc.
*cinxia L. TS
*diamina Lang
*phoebe Schiff.
*didyma Esp.
*trivia Schiff.
Genus Microtia Central American. Tiny.
*elva Bates TS Also S. USA.
dymas Edw. As last.
draudti Rob.
Genus Chlosyne 'patch' butterflies. @ 25 American species. Very variable. Lfp Aster etc.
*janais Druce TS
*eumeda Godm. & Salv.
*gaudialis Bates
*gabbii Behr
*palla Bsdv.
*lacina Geyer
*melanarge Bates
ehrenbergii Hbn. (subgenus Anameca).
leanira Feld. (subgenus Thessalia).
perezi H.-Schaff. (subgenus Atlantea).
elada Hew. (subgenus Texola).
(Subgenus Poladryas ?invalid).
minuta Edw. TS Nearctic. Lfp Pentstemon
pola Bsdv.
Genus Phyciodes American. Very variable Lfp Compositae etc.
Grp I (subgenus Phyciodes) poss. 100+ species.
*tharos Dry. TS
*liriope Cr.
*simois Hew.
*teletusa Godt.
*drusilla Feld.
*campestris Behr
*elaphiaea Hew.
*ianthe Fab.
Grp. II (subgenus Antillea) W. Indies.
pelops Dry. TS No white apical spot.
*proclea Dbldy. & Hew.
Grp. III (subgenus Eresia) @ 50 species. Resemble Ithomiidae.
eunice Hbn. TS Like next.
*philyra Hew.

*letitia Hew.
*ildica Hew.
*landsorfi Godt.
*quintilla Hew.
Genus Gnathotriche Neotropical.
*exclamationis Koll. TS
sodalis Stgr. Col. Similar.
Genus Timelaea Palearctic.
*maculata Brem. TS Small example shown.
albescens Oberth.
nana Leech
Section III (Tribe Dynamini) provisional. (see APPENDIX 28).
Genus Dynamine @ 50 Neotropical species. Marked sexual dimorphism. Lfp Tragia, Dalechampia etc.
mylitta Cr. TS Close to next.
*dyonis Hbn. Also S. USA.
*glauce Bates
*racidula Hew.
*egaea Fab.
*zenobia Bates
*gisella Hew.
*theseus Feld.
Subfamily Anetinae provisional (see APPENDIX 29).
Genus Anetia (Clothilda) Cent. America & Antilles.
*numidia Hbn. TS
*insignis Salv. Next is similar.
cubana Salv. Haiti & Cuba.
Subfamily Nymphalinae All world regions Species show great diversity of form.
Section I (genus Cethosia & allies). Indo-Aust. Often marked sexual dimorphism.
Genus Cethosia 'lacewings'. ♀♀ mostly duller, sometimes dimorphic. Lfp Passiflora. Some features suggest kinship with Heliconiidae.
cydippe L. TS (? form of next).
*chrysippe Fab. Unusual form shown.
*biblis Dry. Very variable.
*hypsea Dbldy.
*penthesilea Cr.
*obscura Guér.
nietneri Feld.
myrina Feld. Has attractive scent.
cyane Dry. Ind.
moesta Feld.
lamarcki Godt. Timor. Gc Deep blue.
lechenaulti Godt. Resembles N. antiopa.
?gabinia Weym.
?luzonica Feld.
?mindanensis Feld.
Genus Terinos @ 8 species. Lfp Antidesma & Rinorea.
*clarissa Bsdv. TS Next is similar.
terpander Hew. Malay. Smaller.
*alurgis Godm. & Salv.
*tethys Hew.
Genus Rhinopalpa Monotypic. (Earlier authors treated some forms as distinct).
*polynice Cr. TS Variable.
Genus Vindula (Cynthia) 'cruisers' ♀♀ larger, usually white-banded. Lfp Adenia etc.
*arsinoe Cr. TS Next is similar.
erota Fab. Indo-Malay.
sapor Godm. & Salv.
obiensis Roths. Obi.
Genus Cupha 12+ species. Rounded f/w Lfp Flacourtia.
*erymanthis Dry. TS
*prosope Fab.
Genus Cirrochroa @ 20 species, only a few brightly coloured. Lfp Hydnocarpus. Lfp
aoris Dbldy. TS Ind. Like small Vindula.
*imperatrix G.-Smith.
*regina Feld.
satyrina Feld. (subgenus Algia).
fasciata Feld. (subgenus Raduca-invalid)
Section II (Tribe Vanessidi) All world regions. Little sexual dimorphism. Some show marked seasonal variation.
Genus Vanessa (Pyrameis) Lfp Urtica, Carduus, various Compositae etc.
atalanta L. TS Holarctic. Red bands.
indica Hbst. Oriental.
*itea Fab. (subgenus Bassaris).
*gonerilla Fab.
*dejeani Godt. Next is similar.
samani Hagen Sumatra.
tameamea Esch. Hawaii. Large.
limenitoides Oberth. (subgenus Lelex).
?vulcania Godt. (form of indica).
(Subgenus Cynthia)
*cardui L. TS
anabella Feld Nearctic.
virginiensis Dry. (huntera Fab.) USA.
terpsichore Phil. Neotropical.
myrinna Bsdv. As last.
?kershawi Mcoy Aust. (?cardui-form).
?carye Hbn. (?synonym of anabella).
Genus Vanessula African. Monotypic.
*milca Hew. TS
Genus Antanartia African. Lfp Urtica, Musanga etc.
*delius Dry. TS
*hippomene Hbn.
*abyssinica Feld.
schaenia Trim.
borbonica Oberth.
Genus Hypanartia 9 Neotropical species sometimes included in the last genus.
*lethe Fab. TS
*kefersteini Dbldy.
Genus Symbrenthia @ 6 principally Indo-Malay species. Lfp Urtica.
*hippoclus Cr. TS
*hypselis Godt.
Genus Aglais Widespread. Lfp Urtica. (Formerly included in Vanessa or

Nymphalis).
*urticae L. TS
*milberti Godt.
*caschmirensis Koll.
Genus Inachis Palearctic. Monotypic. Lfp Urtica. (Formerly with Vanessa or Nymphalis).
*io L. TS
Genus Nymphalis (Vanessa). Largely Holarctic. Lfp Ulmus, Salix etc.
*polychloros L. TS
*xanthomelas Schiff.
*californica Bsdv.
*vau-album Denis & Schiff. (see APPENDIX 30).
*antiopa L.
canace L. (subgenus Kaniska) blue bands.
cyanomelas Dbldy. & Hew. Mex. Like last.
Genus Polygonia 'anglewings' or 'commas' @ 15 largely Holarctic species. Lfp Urtica, Humulus etc.
*c-aureum L. TS
*c-album L.
*egea Cr.
*zephyrus Edw.
*interrogationis Fab.
progne Cr. (subgenus Grapta).
Genus Araschnia @ 6 Palearctic species, somewhat similar to Chlosyne. Lfp Urtica.
*levana L. TS Varies seasonally.
Genus Precis (Junonia) 'pansies' 40+ Old World species, most Ethiopian. Lfp Labiatae, Acanthaceae.
*octavia Cr. TS Varies seasonally.
*tugela Trim.
*sophia Fab.
*limnoria Klug
*rhadama Bsdv.
*almana L. Varies seasonally.
*hierta Fab. Next is similar.
westermanni Westw. orange not yellow.
atlites L. Oriental. Grey with ocelli.
orithya L. Ethiopian & Oriental. Gc blue
iphita Cr. Oriental. Very dark.
Genus Catacroptera African. Monotypic.
*cloanthe Cr. TS
Genus Junonia (Precis) American. Lfp Plantago etc.
evarete Cr. (lavinia Cr.) TS
*livia Stgr. (?probably evarete-form).
?genoveva Cr. (as last).
Genus Mynes @ 6 Australasian species. Lfp Laportea.
*geoffroyi Guer. TS Next is similar.
doubledayi Wall. Serang. Larger.
*websteri G.-Smith. Rare.
Genus Anartia Neotropical. Lfp Jatropha, Lippia etc.
*jatrophae L. TS Also S. USA.
*amathea L.
fatima Fab. Also S. USA.
lytrea Godt. Cuba.
Genus Metamorpha Neotropical.
*elissa Hbn. TS
Genus Siproeta (Victorina) Neotropical. Lfp Blechum.
trayja Hbn. TS (? form of next).
*epaphus Latr.
*superba Bates
*stelenes L. Also S. USA. Variable.
Section III (genus Pseudacraea & allies) Ethiopian. Most species resemble members of other sections or families.
Genus Pseudacraea (eurytus L. TS) Most mimic distasteful species especially Acraeidae. Lfp Chrysophyllum etc.
Grp. I (semire-group)
*semire Cr.
Grp. II (hostilia-group)
*hostilia Dry.
*boisduvali Dbldy. Comp. Acraea egina.
Grp. III (eurytus-group)
*eurytus L. TS Very variable.
*dolomena Hew.
dolichiste Hall
Grp. IV (lucretia-group)
lucretia Cr. White bands. Variable.
*kunowi Dew.
*clarki Btlr.
kumothales Overlaet
acholica Riley
poggei Dew. Like D. chrysippus (Dan.).
deludens Neave Like A. echeria (Dan.).
Grp. V (glaucina-group)
glaucina Guen. As semire. h/w dark.
amaurina Neus.
Genus Hamanumida Monotypic. Early stages suggest link with Euphaedra. Lfp Combretum.
*daedalus Fab. TS
Genus Aterica Species resemble Euriphene. Lfp Quisqualis.
rabena Bsdv. TS Madgr. h/w orange.
*galene Brown ♀ has orange h/w.
Genus Crenidomimas Monotypic.
concordia Hopff. Resembles A. pechueli.
Genus Cynandra Monotypic.
*opis Dry. TS Euriphene-like.
Genus Pseudargynnis Monotypic.
hegemone Godt. TS Gc orange.
Genus Catuna Like Euriphene.
crithea Dry. TS h/w patch white.
*sikorana Rogen. Last lacks f/w band.
angustata Feld.
oberthueri Karsch
Genus Pseudoneptis Monotypic.
*coenobita Fab. TS Resembles Neptis.
Section IV (Tribe Hypolimnidi) Largely Old World, sometimes polymorphic.
Genus Hypolimnas (pandarus L. TS) Old World tropics. Lfp Portulaca, Pseuderanthemum, Fleurya etc.
Grp. I (misippus-group) Indo-Aust. (For mimicry in misippus see p. 78).
*misippus L. Also USA, Africa & Palearctic.
*bolina L. Also Africa. ♀ polymorphic.

*pandarus L. TS Next is similar.
saundersii Hew. Timor.
octocula Btlr. N. Heb. Close to last.
*deois Hew.
*antilope Cr.
pithoeka Kirsch Similar to last.
alimena L. Aust. Blue-banded.
diomea Hew. Celebes. Violet-banded.
?dimona Fruhst. (poss. form of last.)
Grp. II (salmacis-group) Ethiopian.
salmacis Dry. Grey-blue; darker veins.
monteironis Druce Similar to last.
chapmani Hew. Duller.
*antevorta Dist.
*dexithea Hew.
Grp. III (dinarcha-group) Ethiopian.
*dinarcha Hew.
mechowi Dew. Close to last.
Grp. IV (dubius-group) Ethiopian.
*dubius de Beauvais Unusual form shown.
deceptor Trim.
usambara Ward Red anal h/w spot.

Genus Amnosia Oriental. Monotypic.
*decora Dbldy. & Hew. TS

Genus Kallima (paralekta Horsf. TS).
'leaf-butterflies' (see p. 61). Lfp Acanthaceae.
Grp. I (inachus-group) Oriental.
inachus Bsdv. Gc blue, orange f/w bands.
*paralekta Horsf. TS Recto as last.
*horsfieldi Koll.
spiridiva G.-Smith. Sumatra.
?alompra Moore (poss. form of last).
*albofasciata Moore (horsfieldi-form).
Grp. II (rumia-group) African.
*rumia Dbldy. & Westw. ♀ white-banded.
*jacksoni Sharpe ♂ brighter blue.
Grp. III (cymodoce-group)
cymodoce Cr. Darker than next.
*ansorgei Roths.

Genus Salamis Ethiopian. Angular wing-shape. Lfp Asystasia, Isoglossa etc.
Grp. I (augustina-group)
augustina Bsdv. TS Madgr.
*anteva Ward Last is similar.
cacta Fab. Lacks light f/w band.
Grp. II (parhassus-group) Gc pearly.
parhassus Dry. ♂ has pinkish reflection.
anacardii L. More dark markings.
duprei Vinson Madgr. Strongly angled.
?strandi Rob.
Grp. III (cytora-group)
*cytora Dbldy.
temora Feld. Gc deep blue.

Genus Yoma Indo-Aust.
*sabina Cr. TS Widespread.
algina Bsdv. N.G. Less angular.

Genus Napeocles Neotropical. Monotypic. (provisional placing).
*jucunda Hbn. TS

Genus Doleschallia 10 Indo-Aust. species. Lfp Pseuderanthemum.
bisaltide Cr. TS Widespread. Gc tawny.
*dascon Godm. & Salv.

Section V (Tribe Coloburini) Neotropical. Lfp Urticaceae.

Genus Historis Vagrants in USA.
*odius Fab. TS Small example shown.
acheronta Fab. (subgenus Coea). Tails.

Genus Smyrna
*blomfildia Fab. TS Next is similar.
karwinskii Hbn. Central America & Mex.

Genus Pycina
*zamba Dbldy. & Hew. TS
zelys Stfr. & Druce Panama & C. Rica.

Genus Baeotus (Megistanis)
*baeotus Dbldy. & Hew. TS
*japetus Stgr. Verso paler.
deucalion Feld. Yellow median bands.

Genus Colobura (Gynaecia) Monotypic.
*dirce L. TS Recto brown, cream f/w bar.

Genus Tigridia (Callizona) Monotypic. Lfp Theobroma (shows some affinity with Biblini).
acesta L. TS Small; striped verso.

Subfamily Eurytelinae All tropical zones but most Neotropical.

Tribe Biblini 'Ergolids' Widespread. Costal veins basally swollen (see APPENDIX 31). May resemble species in other families.

Genus Ariadne (Ergolis) @ 16 species, most Indo-Aust. Lfp Ricinus & Tragia.
ariadne L. TS Resembles P. wedah.
enotrea Cr. Ethiopian.
pagenstecheri Suffert As last.

Genus Laringa Malay.
horsfieldi Bsdv. TS Grey-blue bands.
castelnaui Feld. ♂ deep blue.

Genus Eurytela African. Lfp Ricinus & Tragia.
dryope Cr. TS Yellow bands.
*hiarbas Dry. Last is similar.
alinda Mab.
narinda Ward

Genus Neptidopsis Ethiopian. Resemble Neptis.
ophione Cr. TS
fulgurata Bsdv.

Genus Mesoxantha African.
ethosea Dry. TS Yellow, dark margins.
katera Stoneham

Genus Byblia African. Lfp Tragia.
ilithyia Dry. TS Also Ind.
acheloia Wallen.
anvatara Bsdv.

Genus Biblis (Didonis) Neotropical, also S. USA. Monotypic. Lfp Tragia
hyperia Cr. (biblis Fab.) Red h/w band.

Genus Libythina Neotropical. Monotypic. Long palpi.
cuvieri Godt. TS Purple. Like Eunica.

Genus Mestra (Cystineura) @ 7 Neotropical species. Lfp Tragia
hypermnestra Hbn. TS Delicate, whitish.
amymone Ménêtr. Also S. USA.
teleboas Ménêtr. (subgenus Archimestra)

Genus Vila (Olina) @ 6 Neotropical species resembling Ithomiidae.

*azeca Dbldy. & Hew. TS

Tribe Eunicini Largely Neotropical (one genus Ethiopian). Small, often brightly coloured.

Genus Pyrrhogyra @ 8 Neotropical species. Lfp ? Paullinia.
*neaerea L. TS Recto bands white.
edocla Dbldy. & Hew. Bands pale green.
otolais Bates.

Genus Temenis
*laothoe Cr. TS Very variable.
(Subgenus Callicorina – see APPENDIX 32)
*pulchra Hew. Comp. C. cynosura.

Genus Lucinia Antilles. Monotypic. Swollen median f/w vein.
*sida Hbn. TS

Genus Bolboneura Neotropical. Monotypic. Swollen median f/w vein. (Formerly included in Temenis.)
*sylphis Bates TS

Genus Nica Neotropical. Monotypic.
*flavilla Hbn. TS Very variable.

Genus Peria Northern Neotropical. Monotypic.
lamis Cr. TS Gc brown. Verso like last.

Genus Asterope (Crenis) Ethiopian @ 16 species. Lfp Excoecaria.
rosa Hew. TS Close to next.
pechueli Dew.
natalensis Bsdv.
boisduvali Wallen.
trimeni Auriv.
amulia Cr.
madagascariensis Bsdv. (subgenus Sallya)

Genus Epiphile @ 20 Neotropical species. Lfp Paullinia etc.
*orea Hbn. TS Very variable.
*adrasta Hew.
*lampethusa Dbldy. & Hew.
*dilecta Hew.
*kalbreyeri Fassl

Genus Catonephele @ 12 Neotropical species. Marked sexual dimorphism. Lfp Alchornia.
*acontius L. TS ♂ f/w verso scent-comb.
orites Stich. Similar to last.
*chromis Dbldy. & Hew.
*salacia Hew.
*nyctimus Westw. Typical ♀ pattern.
*numilia Cr. ♂ oval orange spots.

Genus Nessaea Neotropical. Marked sexual dimorphism.
*ancaeus L. (obrinus L.) TS Next close.
batesii Feld. Guy. Reduced h/w band.
*aglaura Dbldy. & Hew. Orange h/w spot.
*hewitsoni Feld. Next is similar.
regina Salv. Venez. No blue on h/w.
lesondieri Le Moult Brazil.
thalia Bargmann Colombia.

Genus Myscelia @ 12 Neotropical species. Lfp Dalechampia.
*orsis Dry. TS
*ethusa Bsdv. Vagrant in USA.
*cyananthe Feld. As last.
*capenas Hew.

Genus Eunica @ 40 Neotropical species, several with median f/w veins swollen. Lfp Zanthoxylum, Sebastiana etc.
*monima Cr. TS Migrant. Also S. USA
*tatila H.-Schaff. Variable. Also S. USA.
*orphise Cr.
*amelia Cr.
*norica Hew.
*margarita Godt.
*eurota Cr.
*alcmena Dbldy. & Hew.
*excelsa Godm. & Salv.
*bechina Hew.
*cabira Feld.
*augusta Bates
*macris Godt.
*chlorochroa Salv. Verso Callithea-like.
*sophonisba Cr. As last.

Tribe Catagrammidi Neotropical. Usually small. Verso often as brilliantly coloured as recto.

Genus Callithea (leprieuri Feisth. TS) Antennae strongly clubbed. Colour patterns parallel those of Agrias.
Grp. I (sapphira-group) ♂ h/w disc smooth.
*sapphira Hbn.
*markii Hew.
*batesii Hew.
*bartletti Godm. & Salv. Variable.
*adamsi Lathy
*buckleyi Hew. Comp. Agrias beata.
*davisi Btlr. (hewitsoni Stgr.) Variable.
degandii Hew. Similar to bartletti.
srnkai Hon. Less verso spots than last.
whitelyi Salv.
salvini Stgr.
lugens Druce.
Grp. II (leprieuri-group) ♂ h/w disc hairy.
*leprieuri Feisth. TS Recto blue-green.
*philotima Rebel Comp. Agrias beata.
*optima Btlr. Recto like last.
depuiseti Feld. Similar to leprieuri.
freyja Rob. Close to philotima.
fassli Rob. As last.

Genus Diaethria (Callicore) @ 40 species, most with marked 88 or 89 verso pattern. ? Trema. (see APPENDIX 34).
*clymena Cr. TS Vagrant in USA.
*lidwina Feld. Verso like last.
*astala Guér.
*anna Guér.
*marchalii Guér.
*candrena Godt.
*meridionalis Bates
*neglecta Salv.
*pavira Guen.
*dodone Guen. Perisama-like.
asteria Godm. & Salv. Vagrant in USA.

Genus Perisama 50+ species with a wide range of metallic colouring.
*bonplandii Guér. TS Very variable.
*cabirnia Hew.

*euriclea Dbldy. & Hew.
*priene Hopff.
*morona Hew.
*philinus Dbldy. (? chaseba Hew.)
*oppelii Latr. Variable.
*cloelia Hew.
*comnena Hew.
*eminens Oberth.
*humboldtii Guér.
*xanthica Hew.
*vaninka Hew.
*patara Hew.
*clisithera Hew.
*plistia Fruhst.
campaspe Hew. (subgenus Orophila).
*cecidas Hew. (as last).

Genus Cybdelis Monotypic.
*phaesyla Hbn. (mnasilus Dbldy. & Hew).

Genus Antigonis Monotypic (Formerly with last).
*pharsalia Hew. TS Recto purple.

Genus Cyclogramma
*pandama Dbldy. & Hew. TS Next is close.
bachis Dbldy. No orange f/w band recto.
tertia Strecker C. Rica.

Genus Callidula (Haematera) Monotypic. (Some species treated as distinct by other authors). Lfp Sapindaceae.
*pyramus Fab. TS ♂ red on all wings.

Genus Paulogramma (Formerly united with the next genus).
*pyracmon Godt. TS Next is similar.
peristera Hew. Red h/w patch.

Genus Callicore (Catagramma) (astarte Cr. TS). Lfp Allophylus.
Grp. I (hydaspes-group)
*hydaspes Dry.
*aegina Feld.
*mengeli Dillon
*lyca Dbldy. & Hew.
*mionina Hew.
*brome Bsdv.
transversa Rob. Bolivia.
maronensis Oberth. Guy. & Venez.
Grp. II (atacama-group)
*atacama Hew. Verso like next.
*manova Fruhst.
*hesperis Guér.
*cajetani Guen. Next is very similar.
felderi Hew. Ecua. & Peru.
faustina Bates Panama. Like atacama.
Grp. III (cyllene-group)
*cyllene Dbldy. & Westw. f/w red or yellow
*pygas Godt.
*eucale Fruhst.
aphidna Hew. Venez. Like pygas.
Grp. IV (hydarnis-group)
*hydarnis Godt. Verso Diaethria-like.
Grp. V (tolima-group)
*tolima Hew.
*eunomia Hew. f/w red or yellow.
*hystaspes Fab.
*discrepans Stich.
denina Hew. Col. & Peru.
chimana Oberth. Ecua.
platytaenia Rob. Col.
guatemalena Bates Mex. to Nicar.
pacifica Bates As last.
peralta Dillon C. Rica.
levi Dillon Peru.
bugaba Stgr. Mex. to Panama.
Grp. VI (texa-group)
texa Hew. Close to next.
*maximilla Fruhst.
*titania Salv.
maimuna Hew. f/w red or yellow.
Grp. VII (cynosura-group) Larger species
*cynosura Dbldy. & Westw.
*astarte Cr. TS ♂ like next.
*selima Guen.
*excelsior Hew. Variable.
*michaeli Stgr.
coruscans Rob. Close to last.
*pastazza Stgr.
*patelina Hew.
*casta Salv.
*arirambae Dücke
*sorana Godt. Next is similar.
oculata Guen. Bol. No red f/w band.
ines Hopp Col. Like large discrepans.
Grp. VIII (pitheas-group)
*pitheas Latr. Recto like cynosura.
*cyclops Stgr. Rare.

Genus Catacore Monotypic. Very variable.
*kolyma Hew. May have red f/w band.

Subfamily Limenitidinae All world regions.

Section I (Tribe Limenitini) Both Old and New World genera. Most species have light bands on darker ground. Little sexual dimorphism.

Genus Limenitis 'admirals' @ 50 Holarctic & Oriental species. Lfp (Old World) Lonicera, Mussaenda & Nauclea. (New World) Salix etc.
*populi L. TS
*reducta Stgr.
*trivena Moore Next is similar.
camilla L. (subgenus Ladoga). Darker.
*daraxa Dbldy. (subgenus Sumalia).
*urdaneta Feld.
*procris Cr. (subgenus Moduza).
*zayla Dbldy. (subgenus Parasarpa).
*lycone Hew.
*lymire Hew.
*dudu Westw.
*albomaculata Leech Comp. H. misippus.
*danava Moore (subgenus Auzakia).
*archippus Cr. Mimics D. plexippus. (Dan.)
*arthemis Dry. (poss. next is conspecific)
*astyanax Feld. Mimics B. philenor. (pap.)
weidemeyeri Edw. Nearctic.
lorquini Bsdv: As last.
bredowii Geyer Transitional to Adelpha.

Genus Adelpha Poss. 100 Neotropical species, very close to last. Lfp? Gonzalea.
mesentina Cr. TS Smaller than next.
*melanthe Bates. Last is similar.

*fessonia Hew. Also USA. (as Limenitis).
*epione Godt.
*melona Hew.
*iphicla L.
*aricia Hew.
*ethelda Hew. Next is similar.
leuceria Druce Mex. Broader bands.
*syma Godt.
*celerio Btlr.
*saundersi Hew.
*serpa Bsdv.
*olynthia Feld.
*mythra Godt.
*alala Hew.
*lara Hew.
isis Dry. Braz. Similar to last.
zina Hew. Col. Round white h/w spot.
demialba Btlr. C. America. Spotted apices.

Genus Lebadea Oriental.
*martha Fab. TS
alankara Horsf. Java & Sumatra.

Genus Pandita Oriental. ? Monotypic.
sinope Moore TS Malay. orange/black.
?imitans Btlr. Nias. (poss. sinope-f.)

Genus Parthenos 'clippers' Indo-Aust. Lfp Adenia & Tinospora.
*sylvia Cr. TS Many races.
*tigrina Fruhst.
*aspila Hon.

Genus Neurosigma Monotypic.
*doubledayi Westw. TS Himalayan.

Genus Abrota Indo-Palearctic.
*ganga Moore TS
pratti Leech India.

Genus Athyma @ 12 Oriental species. Lfp Phyllanthus.
*perius L. TS Widespread.
eulimene Godt. Australasian.

Section II (Tribe Neptini) 'sailers' & 'sergeants'. Old World. Gc black & white or black & brown.

Genus Pantoporia 12+ Indo-Aust. species. Marked sexual dimorphism. ♀♀ often polymorphic. Lfp Olea & Lonicera.
*hordonia Stoll TS
*kasa Moore
*dama Moore
*cama Moore
venilia L.
*epimethis Feld.
*ranga Moore.
*nefte Cr. Very variable.

Genus Lasippa @ 12 Indo-Aust. species.
heliodore Fab. TS Burma. Like N. miah.

Genus Neptis 100+ species. Largely Old World tropics. Lfp varied Leguminosae, Malvaceae, Tiliaceae etc.
hylas L. TS Close to next.
*nandina Moore
*brebissonii Bsdv.
*miah Moore
*zaida Moore
*hesione Leech
*soma Moore
*agatha Stoll
saclava Bsdv.
*nicomedes Hew.
*woodwardi Sharpe
*melicerta Dry.
*strigata Auriv.
rivularis Scop. European.
sappho Pallas As last.

Genus Phaedyma @ 7 Indo-Aust. species Lfp Brachychiton, Celtis.
amphion L. (heliodora Cr.) TS Moluccas.
*shepherdi Moore Last is similar.

Genus Aldania Palearctic. Danaid-mimics.
raddei Brem. TS Siberia.
imitans Oberth. Chin. Like D. sita.
(genus Cymothoe & allies).
Ethiopian. Lfp Rinorea &
Dorvyalis.

Genus Cymothoe (caenis Dry. TS). 80+ species. Marked sexual dimorphism.
Grp. I (theobene-group)
*theobene Dbldy. & Hew.
Grp. II (oemilius-group)
oemilius Doumet White median bands.
fernandina Hall
Grp. III (hyarbita-group) ♂♂ yellow.
hyarbita Hew. Close to next.
*reinholdi Plotz Dark line on verso h/w
hyarbitina Auriv.
beckeri H.-Schaff. ♀ black & white.
*theodosia Stgr. (?form of last).
Grp. IV (lucasi-group) ♂♂ orange.
*lucasi Doumet
cloetensi Seeldrayers
owassae Hall
egesta Cr.
Grp. V (lurida-group) 11 species.
*lurida Btlr.
hypatha Hew. Dark median band.
Grp. VI (fumana-group) ♂♂ yellow.
fumana Westw. Darker than next.
fumosa Stgr.
vosiana Overlaet
diphyia Karsch
haynae Dew.
superba Auriv.
Grp. VII (caenis-group) 40+ species.
caenis Dry. TS Gc cream; dark margins.
*alcimeda Godt.
*teita von Som.
herminia G.-Smith.
jodutta Westw.
Grp. VIII (sangaris-group) @ 18 species.
*sangaris Godt. ♂ close to next.
*coccinata Hew. Next is similar.
aramis Hew. More orange-red.
anitorgis Hew. Close to sangaris.

Genus Kumothales Monotypic. (see APPENDIX 36).
inexpectata Overlaet TS

Genus Euptera @ 8 small species, often included in Cymothoe.
sirene Stgr. TS Brown; yellow bands.
elabontas Hew. Delicate lacy markings.

Genus Pseudathyma 4 species which resemble Neptis.
sibyllina Stgr. TS Like N. agatha.

Section IV (Tribe Euthalini) Most Indo-Aust. Some Ethiopian & Palearctic. species stoutly-built. Larvae have feathery lateral spines.

Genus Euryphura African. Angular wing-shape. Some affinity with Cymothoe.
Grp. I (porphyrion-group)
porphyrion Ward TS Like P. clarki.
nobilis Stgr.
Grp. II (achlys-group)
achlys Hopff.
*chalcis Feld.
plautilla Hew.

Genus Euryphaedra African. Monotypic.
thauma Stgr. TS Green. Acraea-like.

Genus Harmilla African. Blue-green. Euphaedra-like.
elegans Auriv. TS Yellow f/w bands.
hawkeri J. & T. Rare.

Genus Euriphene (Diestogyna) @ 60 African species. Many variable. ♀♀ usually have pale f/w band.
caerulea Bsdv. (felicia Btlr.) TS.
*atrovirens Mab.
*gambiae Feisth.
*leonis Auriv.

Genus Bebearia @ 60 African species. Many resemble Euriphene. (see APPENDIX 35).
iturina Karsch TS Close to next.
*zonara Btlr.
absolon Fab. Similar to last.
*sophus Fab.
*barce Dbldy.
*plistonax Hew.
*oxione Hew.
*ikelemba Auriv.
octogramma G.-Smith & Kirby. Like E. francina.

Genus Euphaedra (cyparissa Cr. TS) @ 50 African species. Lfp Deinbollia, Phialodiscus etc.
Grp. I (neophron-group)
*neophron Hopff.
Grp. II (medon-group) @ 12 species.
*medon L. Variable.
*eupalus Fab.
*losinga Hew. Next is similar.
spatiosa Mab. Reduced f/w bands.
*imperialis Lindemans
Grp. III (xypete-group)
*xypete Hew. Magenta h/w verso.
*gausape Btlr.
*herberti Sharpe
adolfi-friderici Sch.
crockeri Btlr.
Grp. IV (themis-group)
themis Hbn. Very variable.
*cyparissa Cr. TS
janetta Btlr.
eberti Auriv.
Grp. V (ceres-group) @ 13 species.
ceres Fab. Like next. No h/w spots.
*francina Godt.
preussi Stgr. Very variable.
Grp. VI (eleus-group) 7 species.
eleus Dry. (sg. Romaleosoma) Gc orange
*edwardsi Hoev.
Grp. VII (perseis-group)
perseis Dry. Close to next.
*eusemoides G.-Smith. & Kirby.
*zaddachi Dry.
pseudeleus Hall

Genus Tanaecia @ 17 Oriental species. Some have blue h/w margins suggesting the next genus.
*pelea Cr.
aruna Feld. Similar to last.

Genus Cynitia (Felderia) @ 15 Oriental species sometimes united with the next genus.
phlegethon Semp. TS.
*julii Lesson Last is similar.
*iapis Godt. Variable.

Genus Euthalia (Adolias) (lubentina Cr. TS). 'barons' & 'counts'. Oriental, some east Palearctic. Robust species. Marked sexual dimorphism & local variation. Lfp Diospyros, Loranthus, Mangifera, Melastoma etc.
Grp. I (aconthea-group) 30+ species.
*aconthea Cr.
*adonia Cr. Next is similar.
lubentina Cr. TS
franciae Gray Ind. Verso pink-banded.
Grp. II (evelina-group) 40+ species.
*evelina Stoll
*kosempona Fruhst.
*duda Stoll
thibetana Pouj. Also Palearctic.
kardama Moore As last.
Grp. III (nais-group)
*nais Forster
Grp. IV (dirtea-group) @ 10 species.
dirtea Fab. Similar to next.
*khasiana Swinhoe ♀ brown, yellow spots
canescens Btlr. Borneo. Close to last.
cyanipardus Btlr. Assam. Very large.

Genus Euthaliopsis Australasian. Monotypic.
aetion Hew. TS Gc brown, cream markings

Genus Lexias Indo-Aust.
*aeropa L. TS
panopus Feld. Phil.

Section V (Tribe Ageroniini) Neotropical. Lfp Dalechampia (see APPENDIX 36).

Genus Hamadryas (Ageronia) 'calicoes' or 'clicks'. Species have a structure at the base of the f/w which produces a sharp sound.
*amphinome L. TS.
*februa Hbn.
*guatemalena Bates
*glauconome Bates Next is similar.
amphichloe Bsdv. (ferox Stgr.)

*atlantis Bates
*chloe Cr. (TS of Ageronia).
 albicornis Stgr. Amazon. Close to last.
*fornax Hbn. Vagrant in USA.
*arinome Lucas
*alicia Bates
*velutina Bates Next is similar.
 arethusa Cr. (subgenus Peridromia)
 arete Dbldy. Verso not reflective.
*belladonna Bates
 feronia L. Like guatemalena. Also USA.
 ipthime Bates Widespread. As last.
 epinome Feld. Close to feronia.
?lelaps Godm. & Salv. (atlantis-form)
?rosandra Fruhst. (?belladonna-form).
Genus Ectima
 iona Dbldy. & Hew. TS Peru.
*liria Fab.
 rectifascia Btlr. & Druce. C. America.
Genus Panacea (Pandora)
*prola Dbldy. & Hew. TS Next is larger.
 regina Bates Verso h/w ocelli.
*procilla Hew. Next is similar.
 chalcothea Hew. Col. h/w light red.
Genus Batesia Monotypic. Formerly
 included with last.
*hypochlora Feld. TS Type verso green.
Subfamily Cyrestiinae (Marpesiinae).
 Both Old & New World genera.
 Structure & early stages suggest
 link with Apaturinae. Lfp Ficus
 or allies.
Genus Cyrestis @ 20 species largely
 Indo-Aust.
*thyonneus Cr. TS
*thyodamas Bsdv. Also east Palearctic.
 nivea Zink. Widespread. Like last.
 maenalis Erichson Close to thyodamas.
 achates Btlr. N. G. As last.
 lutea Zink. Java. Gc yellow.
 themire Hon. (periander Fab.)
*cocles Fab.
*acilia Godt.
*camillus Fab. Ethiopian.
*elegans Bsdv. As last.
Genus Chersonesia @ 8 species, mostly
 Indo-Malay. Gc yellow or orange.
 rahria Moore TS Close to next.
*risa Dbldy.
Genus Pseudergolis (Provisional placing)
 Oriental. Lfp Urticaceae. (see
 APPENDIX 37).
 avesta Feld. TS Celebes.
*wedah Koll. Last is similar.
Genus Marpesia (Megalura) @ 24
 Neotropical species with long
 h/w tails.
 eleuchea Hbn. TS Antilles. Like next.
*petreus Bates (peleus Sulzer). + USA.
*coresia Godt. Also USA.
 chiron Fab. As last.
*orsilochus Fab.
*iole Dry. Next is similar.
 hermione Feld. Lacks purple flush.
*harmonia Dbldy. & Hew. ♂ orange.
 berania Hew. Like ♂ of last.
 corita Westw. Black point in f/w band.
*corinna Latr. Last & next close.
 marcella Feld. orange band unmarked.
Subfamily Apaturinae All world regions
 ♂♂ often have brilliant blue or
 purple reflection. Larvae smooth
 with cephalic 'horns' and a
 Satyrid-like appearance.
Genus Apatura 20+ Palearctic & Indo-
 Malay species. Lfp Salix, Ulmus,
 Ostrya etc.
*iris L. TS
 ilia Schiff. Smaller. f/w ocellus.
*ambica Koll.
*schrenckii Ménétr.
*chrysolora Fruhst. ♂ of next similar.
*ulupi Doherty ♂ has dark f/w band.
 leechi (chevana) Moore Neptis-like.
 sordida Moore (subgenus Chitoria)
*parisatis Westw. (subgenus Rohana).
Genus Dilipa Oriental. Often united with
 last.
 morgiana Westw. TS Ind. As last.
 fenestra Leech. Chin. Orange/black.
Genus Apaturina N.G. ? Monotypic.
 (Variation may embrace another
 species).
*erminea Cr. TS
Genus Eulaceura Malay. Monotypic.
 Lfp Gironniera.
 osteria Westw. TS Similar to L. dudu
Genus Helcyra Indo-Aust. & Palearctic.
 chionippe Feld. TS N.G. Next larger.
*superba Leech
*plesseni Fruhst.
?hemina Hew. Ind. (poss. superba-form).
Genus Hestina @ 10 Palearctic &
 Oriental species. Danaid mimics.
*assimilis L. TS
*persimilis Westw.
 japonica Feld. (subgenus Diagora).
Genus Euripus (Idrusia) Palearctic &
 Oriental. ♀♀ polymorphic & mimic
 Euploea-species. Lfp Urticaceae.
 halitherses Dbldy. TS Like next.
*nyctelius Dbldy.
 consimilis Westw.
 robustus Wall.
Genus Herona Oriental.
*marathus Dbldy. TS
 sumatrana Moore
 djarang Fruhst. Nias. Rare.
Genus Thaleropis Asiatic. Monotypic.
 ionia Fischer & Evers. TS Like P. egea.
Genus Sephisa Indo-Chin.
 dichroa Koll. TS Close to next.
*daimio Mats.
*chandra Moore
Genus Sasakia China & Japan.
*charonda Hew TS ♀ no purple, larger.
 funebris Leech Chin. Dark-veined.
Genus Dichorragia Indo-Aust.
*nesimachus Bsdv. TS
 ninus Feld. N.G.

Genus Stibochiona Oriental (see
 APPENDIX 38).
*coresia Hbn. TS
*nicea Gray
 schoenbergi Hon. Borneo.
Genus Asterocampa Principally Nearctic.
 Lfp Celtis.
*celtis Bsdv. TS Next two similar.
 clyton Bsdv. & Leconte
 leila Edw.
 argus Bates Guat. & Honduras.
Genus Doxocopa (Chlorippe) 30+
 Neotropical species. ♂♂ usually have
 brilliant structural colour. (see
 APPENDIX 39). ♀♀ may resemble
 Adelpha. Lfp Celtis.
*agathina Cr. TS
*felderi Godm. & Salv. Recto like last.
*elis Feld.
*pavon Latr. Also S. USA.
*kallina Stgr. ♂ like agathina.
*selina Bates
*laure Dry.
*cyane Latr.
*lavinia Btlr.
*cherubina Feld.
*seraphina Hbn. ♂ like last.
Genus Apaturopsis Ethiopian. provisional
 placing. (see APPENDIX 40).
*cleochares Hew. TS
 kilusa G.-Smith. Close to last.
Subfamily Charaxinae All world regions
 but largely tropical. A very
 distinct subfamily. Species
 stoutly built, often brightly
 coloured. Eggs globular or
 flattened. Larvae smooth with
 cephalic 'horns'. Pupae squat,
 similar to those of Danaidae or
 Apaturinae.
Tribe Preponini Neotropical.♂♂ have
 prominent scent tufts at the base of
 the hind-wings.
Genus Agrias (claudina Godt. (claudia
 Schulze) TS) 4–9 species (see
 APPENDIX 41).
Grp. I (amydon-group)
*amydon Hew.
*phalcidon Hew. (? amydon s.s.p.).
*pericles Bates (?amydon s.s.p.).
*beata Stgr. Next has yellow f/w base.
 hewitsonius Bates (?beata s.s.p.).
Grp. II (claudina-group)
*claudina Godt. (claudia Schulze) TS.
*sardanapalus Bates (? claudina s.s.p.).
 aedon Hew. Recto like A.c. lugens.
*narcissus Stgr. (?aedon s.s.p.).
Genus Prepona Very closely allied to last.
 All but a few species have blue-
 green median bands.
 (Subgenus Prepona – h/w tufts yellow)
 demodice Godt. TS (?form of next).
 laertes Hbn. Close to next.
*eugenes Bates
*omphale Hbn.
 pseudomphale Le Moult
*subomphale Le Moult (? form of last).
*pheridamas Cr.
*dexamenus Hopff. Verso like meander.
*xenagoras Hew. Next is similar.
 garleppiana Stgr. Bol. & Peru.
 deiphile Godt. Braz. Like xenagoras.
 brooksiana Godt. Mex. As last.
 pylene Hew.
 gnorima Bates
 neoterpe Hon.
 lygia Fruhst.
 joiceyi Le Moult
 lilianae Le Moult
 philipponi Le Moult
 pseudojoiceyi Le Moult
 rothschildi Le Moult
 werneri Hering & Hopp.
*praeneste Hew.
*buckleyana Hew.
?sarumani sp.nov. (see APPENDIX 42).
 (Subgenus Archaeoprepona – h/w tufts black)
*demophon L. TS Recto as next.
*demophoon Hbn. Recto blue-banded.
*meander Cr. As last.
*chalciope Hbn. As last.
*licomedes Cr. As last.
 camilla Godt. & Salv.
 phaedra Godt. & Salv.
?luctuosus Walch.
 (Subgenus Noreppa – h/w tufts black)
*chromus Guér. TS
?priene Hew. (poss. s.s.p. of last).
Genus Anaeomorpha Monotypic.
*splendida Roths. TS.
Tribe Prothoini Indo-Aust.
Genus Prothoe Lfp Oxymitra etc.
*franck Godt. TS
*australis Guér.
 regalis Btlr. Assam.
 ribbei Roths. Solom.
*calydonia Hew. (subgenus Agatasa).
 chrysodonia Stgr. Mindanao.
Tribe Charaxini Old World, largely
 Ethiopian. May be marked sexual
 dimorphism.
Genus Euxanthe Ethiopian. Rounded wings
 Lfp Deinbollia etc.
*eurinome Cr. TS Next is similar.
 crossleyi Ward. Extended h/w patch.
*wakefieldi Ward
*madagascariensis Lucas (sg. Godartia).
*trajanus Ward (subgenus Hypomelaena)
*tiberius G.-Smith.
Genus Charaxes (jasius L. TS). Mostly
 Ethiopian, some Indo-Aust. &
 Palearctic. Lfp very varied
 Allophyllus, Syzygium, Scutia,
 Acacia, Deinbollia etc.
Grp. I (varanes-group)
 (Subgenus Stonehamia (Hadrodontes).
 varanes Cr. (TS of Stonehamia)
*fulvescens Auriv. Last is similar.
 acuminatus Thurau. Very pointed f/w.
 balfouri Btlr.

*analava Ward
Grp. II (candiope-group)
*candiope Godt.
 antamboulou Lucas Madgr. Like next.
*cowani Btlr.
Grp. III (cynthia-group)
 cynthia Btlr. Similar to lucretius.
*protoclea Feisth.
 boueti Feisth. Close to next.
*lasti G.-Smith.
Grp. IV (lucretius-group)
*lucretius Btlr.
 octavus Minig
 odysseus Stgr.
 lactetinctus Karsch
Grp. V (jasius-group)
 jasius L. TS Variable. Also Palearctic.
*pelias Cr. Smaller than last.
 hansali Feld.
*castor Cr.
 brutus Cr. Dark, white bands.
 andara Ward Madgr.
 ansorgei Roths.
 phoebus Btlr.
*pollux Cr.
 druceanus Btlr.
 phraortes Dbldy. Madgr. Close to next.
*andranodorus Mab.
*eudoxus Dry.
 richelmanni Rob.
Grp. VI (tiridates-group)
 tiridates Cr. Close to next.
*numenes Hew.
 bipunctatus Roths. Similar to last.
*violetta G.-Smith.
 fuscus Plantrou
 mixtus Roths.
 bubastis Sch.
 albimaculatus van Som.
 barnsi J. & T.
*bohemani Feld.
 schoutedeni Ghesquière
*montieri Stgr. & Schatz
 smaragdalis Btlr.
*xiphares Cr.
*cithaeron Feld.
 nandina Roths. & Jord.
 imperialis Btlr.
*ameliae Doumet
 pythodoris Hew.
?overlaeti Schouteden
Grp. VII (hadrianus-group)
*hadrianus Ward
Grp. VIII (nobilis-group)
*nobilis Druce
 superbus Schultze Very like next.
*acraeoides Druce
*fournierae Le Cerf Rare.
*lydiae Holl. Polyura-like.
Grp. IX (zoolina-group)
*zoolina Westw. Varies seasonally.
*kahldeni Homeyer & Dew. As last.
Grp. X (eupale-group)
*eupale Dry.
 dilutus Roths. Close to last.
*subornatus Schultze
 montis Jack.
Grp. XI (jahlusa-group)
*jahlusa Trim.
Grp. XII (pleione-group)
*pleione Godt. (lichas Dbldy.)
*paphianus Ward
Grp. XIII (zingha-group)
*zingha Stoll (subgenus Zingha).
Grp. XIV (etesipe-group)
*etesipe Godt.
 penricei Roths.
 cacuthis Hew.
 paradoxa Lathy
 achaemenes Feld.
Grp. XV (etheocles-group)
*etheocles Cr. Very variable.
*anticlea Dry.
 baumanni Rogen.
*opinatus Heron.
 thysi Capronnier
*hildebrandti Dew.
 blanda Roths.
 kheili Stgr.
 northcotti Roths.
*guderiana Dew.
 pembanus Jord.
 usambarae van Som. & Jack.
 contrarius Weym.
 petersi van Som.
 marieps van Som. & Jack.
 karkloof van Som.
 martini van Som.
 gallagheri van Son
 alpinus van Som. & Jack.
 nyikensis van Som.
 maccleeryi van Som.
 grahamei van Som.
*aubyni van Som. & Jack.
 chepalungu van Som.
 virilis Roths.
 fulgurata Auriv.
 berkeleyi van Som. & Jack.
 baileyi van Som.
 manica Trim.
 pseudophaeus van Som.
 chintechi van Som.
 protomanica van Som.
 ethalion Bsdv. Very variable.
 pondoensis van Som.
 viola Btlr. Very variable.
 phaeus Hew.
 vansoni van Som.
 variata van Son
 loandae van Som.
 brainei van Son
 cedreatis Hew.
 mafuga van Som.
Grp. XVI (nichetes-group)
*nichetes G.-Smith.
Grp. XVII (laodice-group)
*laodice Dry.
 zelica Dru.
 porthos G.-Smith.
 dunkeli Rob.

 doubledayi Auriv.
 mycerina Godt.
Grp. XVIII (fabius-group) Indo-Aust. (see
 APPENDIX 43).
*fabius Fab.
 solon Fab. (? form of last).
 orilus Btlr. Timor. Rare.
Grp. XIX (polyxena-group) Indo-Aust.
 polyxena Cr. Widespread. Also Pal.
 amycus Feld. Phil.
 affinis Btlr. Celebes.
*latona Btlr.
 marmax Westw. Ind.
 aristogiton Feld.
 kahruba Moore Ind.
*distanti Hon.
 harmodius Feld. Java & Sumatra.
 antonius Semp. Mindanao.
 plateni Stgr. Palawan.
 bupalus Stgr. Palawan.
 borneensis Btlr. Malay.
?ocellatus Fruhst. Sumbawa.
?psaphon Westw. Sri Lank. (polyxena-f.).
?fervens Btlr. Nias. (As last).
Grp. XX (eurialus-group) Malay-Aust.
 eurialus Cr. Ambon & Ceram. Large.
 durnfordi Dist. Malay.
*nitebis Hew.
 mars Stgr. Celebes.
Genus Polyura (Eriboea) (pyrrhus L. TS)
 Indo-Aust., a few east Palearctic.
 Sexual dimorphism usually less
 marked than in Charaxes. Lfp very
 varied Acacia, Albizzia, Grewia etc.
*athamas Dry. Variable.
 arja Feld. Ind. Paler.
*moori Dist.
 hebe Btlr. Close to last.
*jalysus Feld.
*narcaea Hew. Next is similar.
 eudamippus Dbldy. Indo-Chin. Large.
 rothschildi Leech Chin. (?form of last).
 posidonius Leech Chin.
 nepenthes G.-Smith. Thai.
 dolon Westw. Ind.
 delphis Dbldy. Indo-Malay.
*schreiberi Godt. Variable.
 cognatus Voll. Celebes (?f. of last).
*dehaani Dbldy. (kadeni Feld.).
 gamma Lathy N. Caled. Small.
 aristophanes Fruhst. Solom. (?f. of last)
 caphontis Hew. Fiji.
 epigenes Godm. & Salv. Sol.♂♂ dimorphic
*pyrrhus L. TS
 clitarchus Hew. N. Caled.
?jupiter Btlr. N.G. (poss. pyrrhus form)
Genus Palla Ethiopian. Marked sexual
 dimorphism. Lfp Porana,
 Toddalia etc.
*decius Cr. TS
*violinitens Crowley♂ close to last.
*ussheri Btlr.
 publius Stgr. Similar to ussheri.
Tribe Anaeini Almost entirely Neotropical.
 Lfp varied inc. Piper, Croton,
 Camphoromoea, Goeppertia.
Genus Anaea (troglodyta Fab. TS).
 (Subgenus Coenophlebia)
*archidona Hew. TS
 (Subgenus Siderone)
*marthesia Cr. TS (see APPENDIX 44).
 (Subgenus Zaretis)
*itys Cr. TS (isidora Cr.) ♂ brown.
 syene Hew.
 callidryas Feld.
 (Subgenus Hypna)
*clytemnestra Cr. TS Variable.
 (Subgenus Anaea)
 troglodyta Fab. TS Similar to next.
*cubana Druce
 portia Fab.
 borinquenalis Johnson & Coms.
 astina Fab.
 minor Hall
 aidea Guér. Also USA.
 floridalis Johnson & Coms.
 andria Scudder Also USA.
 (Subgenus Polygrapha)
*cyanea Salv. & Godm. TS
 tyrianthina Salv. & Godm.
*xenocrates Westw.
 suprema Schaus
 (Subgenus Consul (Protogonius))
*fabius Cr. (hippona Fab.) TS Variable
*electra Westw.
*panariste Hew.
 pandrosa Niepelt
 jansoni Salv.
 excellens Bates
 (Subgenus Fountainea)
*ryphea Cr. TS
 eurypyle Feld.
 ecuadoralis Johnson & Coms.
 sosippus Hopff.
*glycerium Dbldy. Also USA.
 johnsoni Avin. & Shoumatoff
 venezuelana Johnson & Coms.
 cratias Hew.
 (Subgenus Memphis (polycarmes Fab. TS))
Grp. I (nessus-group)
*nessus Latr.
*titan Feld.
 nesea Godt.
 nobilis Bates
Grp. II (pasibula-group)
*pasibula Dbldy.
 falcata Hopff.
Grp. III (aureola-group)
 aureola Bates Marked like pasibula.
*anna Stgr.
*polyxo Druce.
 dia Godm. & Salv.
 elina Stgr. As anna. f/w bar orange.
Grp. IV (halice-group)
 halice Godt. Similar to next.
*tehuana Hall
 chrysophana Bates
 fumata Hall
 moretta Druce
 evelina Coms.

Grp. V (verticordia-group)
 verticordia Hbn. f/w spots.
*echemus Dbldy. Last is similar.
 pleione Godt.
 morena Hall
 lankesteri Hall
 artacaena Hew.
 perenna Godm. & Salv.
Grp. VI (arginussa-group)
*arginussa Geyer
 austrina Coms.
 herbacea Btlr. & Druce
 pithyusa Feld. Also USA.
 lemnos Druce
Grp. VII (hedemanni-group)
 hedemanni Feld. More angular than next
*praxias Hopff.
*acaudata Rob.
Grp. VIII (glauce-group)
*glauce Feld. Very like next.
*glaucone Bates
 centralis Rob.
 cicla Mosch.
 felderi Rob.
Grp. IX (appias-group)
*appias Hbn. Similar to next.
*xenocles Westw.
 xenippa Hall
Grp. X (polycarmes-group)
*polycarmes Fab. TS Dark blue ♂ no tail
*laura Druce Very large.
 grandis Druce
 nenia Druce
 vasilia Cr.
 bella Coms.
 vicinia Stgr.
 phantes Hopff.
 offa Druce
 gudrun Niepelt
 lynceus Rob.
 lyceus Druce
 proserpina Salv.
 schausiana Godm. & Salv.
 elara Godm. & Salv.
 phoebe Druce
 ambrosia Druce
 forreri Godm. & Salv.
 lineata Salv.
 florita Druce
 orthesia Godm. & Salv.
 annetta Coms.
 memphis Feld.
 aulica Rob.
 cleomestra Hew.
 anassa Feld.
 octavius Fab.
Grp. XI (morvus-group)
 morvus Fab. Some forms like next.
*philumena Dbldy.
 oenomais Bsdv.
 chaeronea Feld.
 xenica Bates
Grp. XII (eribotes-group)
*eribotes Fab.
 leonida Cr.
 hirta Weym.
 otrere Hbn.
 arachne Cr. Very variable.
 eleanora Coms.
 catinka Druce
 pseudiphis Stgr.
 beatrix Druce
Grp. XIII (iphis-group)
*iphis Latr. Close to next.
*alberta Druce
 cerealia Druce
 moeris Feld.
 lorna Druce
 boliviana Druce
 cluvia Hopff.

Pages 222-227
FAMILY AMATHUSIIDAE Largely Indo-
 Aust. Ocelli on verso of both pairs
 of wings. Antennae usually
 gradually tapered. Palpi long. In
 some genera ♂♂ have elaborate
 hair-pencils & scent-diffusing
 apparatus.
Genus Aemona
 amathusia Hew. TS Indo-Chin.
*lena Atk. Usually paler than last.
?peali W.-Mas. Assam. poss. lena-form.
Genus Faunis (Clerome)
*eumeus Dry. TS
*aerope Leech
*canens Hbn. (arcesilaus Fab.)
*menado Hew.
 assama Westw. Assam.
 gracilis Btlr. Malay.
 stomphax Westw. Borneo & Sumatra.
 kirata de Nicév. As last.
 leucis Feld. Phil.
 phaon Erichson As last.
?taraki Pendlebury Malay (poss. canens-f.)
?rufus Brooks
Genus Melanocyma (Often included with
 last). Poss. Monotypic.
 faunula Westw. TS
?faunuloides de Nicév. Burma. Large fm.
Genus Xanthotaenia Monotypic.
*busiris Westw.
Genus Enispe
 euthymius Dbldy. TS
 lunatus Leech Chin. Close to last.
*cycnus Westw.
Genus Discophora 'duffers' ♂♂ have
 circular f/w scent patch.
 celinde Stoll TS Java Yellow f/w spots.
*necho Feld. Last is close.
 amathystina Stich. Borneo.
 bambusae Feld. Celebes.
 continentalis Stgr. Ind.
 lepida Moore As last.
 deo de Nicév. Burma.
 sondaica Bsdv. (tullia Cr.) Widespread
 philippina Moore Phil.
 simplex Stgr. As last.
 ogina Latr. & Godt. As last.
 timora Westw. Malay.

Genus Amathusia 'palm-kings'. Angular wings & banded verso. ♂♂ have scent-combs on abdominal sides. Lfp Palm.
*phidippus L. TS Widespread.
*binghami Fruhst.
andamensis Fruhst. Andamans.
duponti Toxopeus Java.
lieftincki Toxopeus As last.
ochrotaenia Toxopeus Sumatra.
masina Fruhst. Borneo.
perakana Hon. Malay.
gunneryi Corbet & Pendlebury As last.
schonbergi Hon. Sumatra.
virgata Btlr. Celeb. (sg. Pseudamathusia)
?patalena Westw. (poss. phidippus-form)
?holmanhunti Corbet & Pendlebury (do.).
?friderici ?auct.
?utana Corbet & Pendlebury.
?ochraceofusca Hon.

Genus Zeuxidia 'saturns' Very angular.
luxeri Hbn. TS Java.
*aurelius Cr. ♀ very large.
*amethystus Btlr. Reduced h/w mauve.
*doubledayi Westw.♂ close to last.
dohrni Fruhst. Java.
semperi Feld. Phil. Like aurelius.
sibulana Hon. Phil. As last.
?nicevillei Fruhst. Sum. ?doubledayi-f.
?mindanaica Stgr.

Genus Amathuxidia
*amythaon Dbldy. TS♀ f/w band yellow.
plateni Stgr. Celeb. Close to last.

Genus Thaumantis 'jungle glories'.
*odana Godt. TS
*noureddin Godt.♂ less purple.
*klugius Zink.
*diores Dbldy.

Genus Thauria Monotypic.
*aliris Westw. TS

Genus Stichophthalma 'jungle queens'.
Verso chains of ocelli.
*howqua Westw. TS
*neumogeni Leech
*camadeva Westw.
*fruhstorferi Rob. Next is similar.
louisa W.-Mas. Chin.
nourmahal Westw. Sikkim.
editha Riley & Godfrey Thai.
godfreyi Roths. As last.
*sparta de Nicév. Assam.
?tytleri Roths. As last.

Genus Taenaris Largely Aust. Very large ocelli. In ♂♂ inner f/w margin bowed. Verso spaces very variable.
nysa Hbn. TS (?form of next).
urania L. Ambon etc. Close to last.
*macrops Feld. Next is similar.
diana Btlr. Batchian & Halm.
selene Westw. Buru. Like macrops.
*domitilla Hew.
*dimona Hew. Next is similar.
gorgo Kirsch N.G.
*horsfieldi Swains.
*catops Westw. Next is similar.
artemis Voll. Dark f/w bases.
myops Feld. As last.
*chionides Godm. & Salv.
alocus Brooks N.G. Usually 1 h/w ocellus
cyclops Stgr. N.G. As last.
*phorcas Westw.
*bioculatus Guér.
dina Stgr. N.G. Large blue ocelli.
*butleri Oberth.
scylla Stgr. (dohertyi G.-Smith.) Biak.
*onolaus Kirsch Last & next similar.
hyperbolus Kirsch N.G. Larger ocelli.
dioptrica Voll. N.G. As last.
honrathi Stgr. N.G. As last.
montana Stich. N.G. (?small f. of last)
mailua G.-Smith. N.G. Very dark.

Genus Hyantis Monotypic Wing shape differs from Taenaris & f/w ocellus always present.
*hodeva Hew. TS

Genus Morphotenaris Sometimes included with last.
*schoenbergi Fruhst. TS
nivescens Roths. N.G. Huge, all-white.

Genus Morphopsis New Guinea. All species rather pure.
*albertisi Oberth. TS Paler than next.
phippsi J. & T. Narrower f/w bands.
*ula Roths. Next is close.
meeki J. & Jord. Bluish f/w bands.

Pages 228-237
FAMILY MORPHIDAE Neotropical. The first pair of legs reduced & brush-like. Antennae slender & only slightly thickened at the extremities. Considerable seasonal & geographical variation. Lfp Leguminosae etc.

Genus Morpho (achilles L. TS) (see APPENDIX 45).
(Subgenus Iphimedeia)
Grp. I (hercules-group)
*hercules Dalm. TS Recto close to next.
*amphitrion Stgr.
?richardus Fruhst. Brazil.
Grp. II (hecuba-group)
*hecuba G. Type-form larger.
*phanodemus Hew. Recto mid last & next.
*cisseis Feld.
?werneri Hopff. Colombia. Smaller.
Grp. III (telemachus-group) Gc variable.
*telemachus L. (perseus Cr.) Variable.
theseus Deyrolle Toothed h/w.
justitiae Godm. Central America.
(Subgenus Iphixibia)
*anaxibia Esp. ♂ velvety blue.
(Subgenus Cytheritis)
Grp. I (sulkowskyi-group)
*sulkowskyi Koll. Next is similar.
Grp. II (lympharis-group)
lympharis Btlr. Verso spots unbroken.
*ockendeni Roths. ♂ like sulkowskyi.
?stoffeli Le Moult & Real
*eros Stgr.

?nymphalis Le Moult & Real
Grp. III (rhodopteron-group) Smaller.
rhodopteron Godm. & Salv. Colombia.
?schultzei Le Moult & Real As last.
Grp. IV (portis-group)
portis Hbn. Reduced verso ocelli.
*thamyris Feld. Last is very similar.
Grp. V (zephyritis-group) Close to next.
zephyritis Btlr. Bol. & Peru.
Grp. VI (aega-group)
*aega Hbn. ♂ shining blue.
Grp. VII (adonis-group) ♂♂ silvery blue
*adonis Cr.
eugenia Deyrolle Guyana. Larger.
uraneis Bates Brazil. As last.
?marcus Schaller (poss. adonis-form).
(Subgenus Balachowskyna)
*aurora Westw. Type-form paler.
(Subgenus Cypritis)
Grp. I (cypris-group)
*cypris Westw. ♀ usually brown & cream.
aphrodite Le Moult & Real Nicaragua.
Grp. II (rhetenor-group)
*rhetenor Cr. f/w may have white spots.
cacica Stgr. Ecua. White-spotted f/w.
*diana Dixey
*helena Stgr.
(Subgenus Pessonia) Gc greenish-white.
Grp. I (polyphemus-group)
*polyphemus Dbldy. & Hew.
*luna Btlr.
Grp. II (catenaria-group)
*catenaria Perry Variable especially ♀
*laertes Dry. (epistrophis Hbn.)
titei Le Moult & Real Paraguay.
(Subgenus Grasseia)
Grp. I (amathonte-group)
*amathonte Deyrolle Verso ocelli yellow
?centralis Stgr. (poss. form of last).
Grp. II (menelaus-group)
*menelaus L. Widespread. Very variable.
occidentalis Feld. Brazil. Larger.
mattogrossensis T. As last.
*nestira Hbn. Next is similar.
melacheilus Stgr. Braz. dark f/w apex.
*didius Hopff. Very variable.
*godarti Guér. (poss. form of last).
(Subgenus Morpho) Dark, blue-banded.
Grp. I (deidamia-group)
*deidamia Hbn.
*neoptolemus Wood Larger.
electra Rob. Like deidamia.
*hermione Rob.
?briseis Feld.
Grp. II (granadensis-group) Close to last.
granadensis Feld. Nicaragua to Ecuador
lycanor Fruhst. Colombia.
Grp. III (rugitaeniata-group) achilles-like.
rugitaeniata Fruhst. Col. & Ecua.
micropthalmus Fruhst. Colombia.
?taboga Le Moult & Real Coiba I. (Pan.)
Grp. IV (peleides-group)
*peleides Koll. Widespread. Variable.
*montezuma Guen. Recto like next.
*hyacinthus Btlr. Next is close.
octavia Bates Central America.
marinita Btlr. As last.
corydon Guen. Venezuela.
?confusa Le Moult & Real Colombia.
Grp. V (peleus-group) Close to last.
peleus Rob. Colombia & Venezuela.
?tobagoensis Sheldon Tobago. f. of last.
?parallela Le Moult Venez. (As last)
Grp. VI (helenor-group)
helenor Cr. Widespread. Like achilles.
papirius Hopff. Broader bands.
*achilleana Hbn. Very variable.
coelestis Btlr. Bolivia.
?trojana Rob.
?leontius Feld.
Grp. VII (achilles-group)
*achilles L. TS Many races.
*patroclus Feld. Next is similar.
pseudagamedes Weber
guaraunos Le Moult Col, Venez. & Bol.
?telamon Rob. (poss. form of last).
Grp. VIII (vitrea-group)
vitrea Btlr. Col, Venez. & Bol.

Pages 238-243
FAMILY BRASSOLIDAE Neotropical. Cell of hindwing closed by prominent discocellular vein. First pair of legs reduced;♂♂ have hair-pencils. (see APPENDIX 46).

Genus Brassolis Primitive. Larvae gregarious in bag-like nests on Palm.
*sophorae L. TS
*astyra Godt.
haenschi Stich. Ecuador.
isthmia Bates C. America & Colombia.
granadensis Stich. Col. & Ecuador.

Genus Dynastor Lfp Banana.
*napoleon Westw. TS Recto brown & orange.
macrosiris Westw. Large. Violet-tinged.
darius Fab. Smaller. White banded.

Genus Dasyophthalma Lfp Bamboo.
*rusina Godt. TS Variable.
*creusa Hbn. Next is similar.
vertebralis Btlr. Brazil.

Genus Penetes Monotypic.
*pamphamis Dbldy. TS Unusual wingshape

Genus Narope Small species which superficially resemble Anaea (Nymphalidae). Lfp Bamboo.
Grp. I (cyllastros-group) Angular h/w.
*cyllastros Westw. TS
*sarastro Stgr.
anartes Hew. Peru & Bol. Like last.
Grp. II (Nesope-group) Rounded h/w.
nesope Hew. Ecuador.
Grp. III (albopunctum-group)
albopunctum Stich. ♂ no f/w scent spot

Genus Catoblepia Lfp Banana.
Grp. I (xanthus-group) 2 h/w verso ocelli
xanthus Feld. TS Close to last.
*amphiroe Hbn. Ochre f/w bands.
xanthicles Godm: Pan.; Col.; & Bolivia.
singularis Weym. Guatemala.

versitincta Stich. Guyana.
oretorix Hew. Cent. America & Ecuador.
?rivalis Niepelt (poss. xanthus-form).
Grp. II (generosa-group) 5–6 verso ocelli
generosa Stich. Ecuador & Peru.
*berecynthia Cr. Last is similar.

Genus Selenophanes
Grp. I (cassiope-group) Reniform ocellus
*cassiope Cr. TS Orange f/w bands.
supremus Stich. Ecua. & Peru. Like last.
?andromeda Stich. Bol. (?cassiope-form)
Grp. II (josephus-group) Rounded ocellus
josephus Godm. & Salv. Guat. & Colombia.

Genus Opsiphanes (sallei Westw. TS)
Lfp Palm & Banana.
Grp. I (batea-group)
*batea Hbn. TS (subgenus Blepolensis).
didymaon Feld. Brazil. Like last.
catharinae Stich. Brazil.
bassus Feld. Brazil.
ornamentalis Stich. As last.
Grp. II (cassiae-group)
cassiae L. Ochre f/w band.
*invirae Hbn. Next is similar.
cassina Feld. Orange f/w spot.
*quiteria Cr.
*boisduvali Westw.
sallei Westw. TS Ochre f/w band.
*tamarindi Feld. Last & next close.
camena Stgr. Col. Ochre f/w band.
zelotes Hew. Col. & Pan. As last.
?lutescentefasciatus Kirby

Genus Opoptera (syme Hbn. TS).
Grp. I (aorsa-group)
*aorsa Godt. Next is similar.
arsippe Hopff. Peru & Bolivia.
Grp. II (syme-group)
syme Hbn. TS f/w bands narrow.
*sulcius Stgr. Last is similar.
fruhstorferi Rob. Braz. White f/w bands
Grp. III (staudingeri-group) pointed f/w.
staudingeri Godm. & Salv. C. America.

Genus Eryphanis
Grp. I (polyxena-group)
*polyxena Meerb. TS
Grp. II (aesacus-group)
*aesacus H.-Schaff.
gerhardi Weeks Bol. & Ecuador.
reevesi Westw. Braz. Like polyxena.
zolvizora Hew. Col. to Bolivia.

Genus Caligopsis Verso like Eryphanis but wingshape & structure like Caligo.
seleucida Hew. TS Bolivia.
dondoni Fassl Brazil.

Genus Caligo 'owls' Lfp Banana etc.
Grp. I (eurilochus-group)
*eurilochus Cr. TS Very variable.
*idomeneus L. Narrower wings.
*illioneus Cr. Widespread.
memnon Feld. Central America.
bellerophon Stich. Ecuador.
prometheus Koll. Col. & Ecuador.
teucer L. Widespread.
Grp. II (arisbe-group)
arisbe Hbn. Brazil.
*oberthurii Deyrolle
martia Godt. Brazil. White f/w bands.
Grp. III (atreus-group)
atreus Koll. Dark margin to h/w yellow.
*uranus H.-Schaff. (often treated as s.sp.)
Grp. IV (oileus-group)
oileus Feld. Central band not dark.
*placidianus Stgr. Last is similar.
oedipus Stich. Honduras.
zeuxippus Druce Ecuador.
Grp. V (beltrao-group)
*beltrao Ill. Recto blue; yellow apices.

Pages 244-249
FAMILY SATYRIDAE All world regions. Palpi usually hairy. Most species have f/w veins basally swollen. First pair of legs reduced. Antennae delicate, tapering. Almost 400 genera are recognised.
Subfamily Calinaginae Indo-Palearctic. Formerly these butterflies were considered allied to the Apaturinae (Nymphalidae) & in some respects they fall between the two families.

Genus Calinaga.
*buddha Moore TS Oriental, Widespread.
lhatso Moore Tibet.
cercyon de Nicév. Chin.

Subfamily Haeterinae Neotropical. Shade-dwellers.

Genus Cithaerias (Callitaera) (see APPENDIX 47).
*pireta Cr. TS
*aurorina Weym.
*esmeralda Dbldy.
*philis Cr.
*pyropina Godm. & Salv.
pellucida Btlr. Bol. & Peru. h/w clear.

Genus Dulcedo Monotypic.
polita Hew. TS C. America. Transparent.

Genus Haetera (Oreas)
*piera L. TS
*macleannania Rob. Pan. & C. Rica.

Genus Pierella @ 12 species.
*nereis Dry. TS
*dracontis Hbn.
*lena L.
*hortona Hew. (see APPENDIX 47).
*hyceta Hew. (see p. 58)

Genus Pseudohaetera Monotypic.
hypaesia Hew. TS Col. to Bol. Dark h/w.

Subfamily Biinae All world regions. Many species large with angular wingshape.
Tribe Antirrhini Neotropical.

Genus Antirrhea @ 12 species. Lfp? Palm.
archaea Hbn. TS Braz. Large ocelli.
*philoctetes L.
tomasia Btlr. (subgenus Triteleuta).

Genus Caerois
chorinaeus Fab. TS Brown. Ochre f/w band
*gerdrutus Fab.

Genus Sinarista Monotypic.
adoptiva Westw. TS Col. Like Antirrhea.
Tribe Biini Neotropical.

Genus Bia Monotypic. A striking resemblance to Old World Amathusiidae.
*actorion L. (actoriaena Hbn.) TS
Tribe Melanitini Largely Old World.

Genus Cyllogenes Oriental.
suradeva Moore TS broadly like M. leda
janetae de Nicév.

Genus Gnophodes 4 African species.
*parmeno Dbldy. & Hew. TS

Genus Hipio @ 6 Indo-Aust. species.
constantia Cr. TS

Genus Melanitis @ 12 species from all Old World regions. Crepuscular. Lfp Setaria, Cynodon etc.
*leda L. TS Widespread. Very variable.

Genus Parantirrhoea Monotypic. Antirrhea-like.
marshalli W.-Mas. TS S. India. Rare.

Genus Mantaria (Tisiphone). Provisional placing. Neotropical.
hercyna Hbn. TS Braz. Close to next.
*maculata Hopff.

Subfamily Elymniinae Principally Old World tropics but a few Holarctic species.

Tribe Lethini
Genus Aeropetes (Meneris). S. African. Monotypic.
*tulbaghia L. TS

Genus Paralethe S. African. Often united with last. Lfp Hebenstreitia, Stenotaphrum etc.
*dendrophilus Trim. TS
indosa Trim. (poss. form of last).

Genus Aphysoneura African. Monotypic.
*pigmentaria Karsch TS

Genus Enodia Nearctic. Often included in Lethe.
*andromacha Hbn. (portlandia Fab.) TS
creola Skinner Similar to last.

Genus Lethe 50+ Oriental species for which many subgeneric names are employed. Species usually crepuscular. Lfp Bamboo etc.
europa Fab. TS Also Palearctic.
*confusa Auriv. Last is similar.

Genus Nemetis @ 6 Oriental species, often united with Lethe.
*minerva Fab. TS Prominent scent patches.

Genus Neope 10+ Indo-Palearctic species.
bhadra Moore TS Ind. Larger than next.
*pulaha Moore Shorter 'tails'.

Genus Patala Oriental. Monotypic. Formerly included with last.
*yama Moore TS

Genus Ptychandra 3 Oriental species.
*lorquinii Feld. TS ♀ whitish.

Genus Satyrodes Nearctic. Monotypic. (Often as Lethe).
*eurydice Johannson TS Pale form shown.

Genus Kirinia @ 4 Palearctic species.
epimenides Ménétr. TS Darker than next
*roxelana Cr.

Genus Lasiommata 6+ Palearctic species often united with Pararge. Lfp Poa, Festuca etc.
*megera L. TS
*maera L. (f. shown poss. distinct).

Genus Lopinga @ 5 Palearctic species. Lfp Lolium, Triticum etc.
*achine Scop. Verso of last similar.

Genus Pararge @ 5 Palearctic species. Lfp Triticum etc.
*aegeria L. TS Variable.

Genus Tatinga @ 5 Palearctic species often included with last.
thibetanus Oberth. TS Chin.
*praeusta Leech Less markings than last.

Genus Ethope (Anadebis or Theope) Oriental.
*himachala Moore TS
diademoides Moore Resembles Euploea.

Genus Neorina Large Oriental species.
hilda Westw. TS Himalayas. Less 'tails'.
*krishna Westw. Last is similar.
*lowii Dbldy. (subgenus Hermianax).
patna Leech

Tribe Zetherini Oriental. Unusual wing-patterns.
*pimplea Er. TS
incerta Hew. (subgenus Amechania).

Genus Callarge Monotypic.
sagitta Leech TS Whitish, dark veins.

Genus Penthema Oriental. Provisional placing. These large dark-veined species were formerly treated as Nymphalidae. Very variable. Resemble Danaus & Euploea (Danaidae).
lisarda Dbldy. TS
darlisa Moore Gc bluish.
formosana Roths. Smaller.
adelma Feld. (subgenus Isodema).

Tribe Elymniini Largely Indo-Aust., & east Pal. (1 species African). Patterns often suggest other families especially Danaidae. Lfp Palm etc.

Genus Elymnias @ 35 species.
*hypermnestra L. TS Comp. D. chrysippus.
*nesaea L. (subgenus Melynias).
*vasudeva Moore (subgenus Mimadelias).
patna Westw. Resembles Euploea (Dan.)
kuenstleri Hon. ♂ As last. ♀ Like Bia.
esaca Westw. (subgenus Agrusia).
penanga Westw. (subgenus Bruasa).
agondas Cr. (sg. Dyctis) Like Taenaris.

Genus Elymniopsis African. Variable.
phegea Feld. Orange bands.
*bammakoo Westw. Last is similar.
rattrayi Sharpe f/w orange. h/w white.

Tribe Mycalesini 'bush browns'. Indo-Aust. & Ethiopian @ 40 genera (including subgenera of Mycalesis) with several hundred species. Ocelli usually conspicuous.

Genus Mycalesis Indo-Aust. & Ethiopian. 150+ species.
*francisca Cr. TS Very variable.
*nicotia Hew.
*phidon Hew.
*ita Feld.
terminus Fab. Aust. Gc orange.
*patnia Moore (subgenus Nissanga).
*malsarida Btlr. (subgenus Kabanda).

Genus Henotesia 50+ Ethiopian species.
wardii Btlr. TS
*perspicua Trim.

Genus Orsotriaena Oriental.
*medus TS Very variable.
jopas Hew. Celebes.

Subfamily Eritinae Oriental.
Genus Coelites 3 species.
nothis Westw. & Hew. TS

Genus Erites @ 4 species.
*medura Horsf. Variable.

Subfamily Ragadiinae Oriental.
Genus Acrophtalmia Monotypic.
artemis Feld. TS

Genus Acropolis (Pharia) Monotypic.
thalia Leech TS

Genus Ragadia @ 5 species.
*crisia Geyer TS

Subfamily Satyrinae All world regions. The greater part of the Satyridae belongs here. Lfp almost exclusively grasses.

Tribe Hypocystini Principally Aust. @ 20 genera.
Genus Lamprolenis N.G. Monotypic.
*nitida Feld. & Salv. TS Recto reflective.

Genus Argyrophenga N.Z. Monotypic.
*antipodum Dbldy. TS

Genus Geitoneura Aust. Resemble Pararge
klugii Guér. TS Like next.
*acantha Don.
minyas Waterhouse & Lyell.

Genus Heteronympha @ 7 Aust. species.
*merope Btlr. TS

Genus Oreixenica 6 Aust. species.
*lathoniella Westw. TS

Genus Tisiphone Aust.
*abeona Don. TS
helena Olliff Paler f/w bands.

Genus Erycinidia (gracilis R. & J. TS).

Genus Dodonidia (helmsii Btlr. TS).
Species in these genera resemble Nemeobiidae.

Tribe Ypthimini 20+ Old World genera largely tropical. Ocelli conspicuous.

Genus Ypthima 50+ Oriental & Ethiopian species, placed in several subgenera.
*huebneri Kirby TS
*tamatevae Bsdv.

Genus Pseudonympha @ 20 African species.
hippia Cr. TS Similar to next.
*hyperbius L.
*trimeni Btlr.

Genus Physcaeneura African. Unusual verso patterns.
panda Bsdv. TS Darker than next.
*pione Godm.
leda Gerstaecker Similar to last.

Genus Callerebia @ 4 Himalayan species (often placed in Erebia).
*scanda Moore TS

Tribe Euptychiini American. 40+ genera (including subgenera of Euptychia) & several hundred species.

Genus Euptychia 200+ Neotropical species in many subgenera. (Some also Nearctic).
mollina Hbn. TS Grey-white, banded.
hesione Sulzer (TS of Pareuptychia).
*metaleuca Bsdv.
*chloris Cr. (TS of Chloreuptychia).
*cephus Fab. (TS of Cepheuptychia).

Genus Oressinoma Neotropical. Monotypic.
*typhla Dbldy. & Hew. TS

Genus Paramecera Mex. Monotypic.
*xicaque Reak. TS

Genus Taygetis 20+ Neotropical species.
memeria Cr. TS No h/w orange band.
*chrysogone Dbldy. & Hew. Last is close.
*albinotata Btlr. (subgen. Paratygetis).

Tribe Coenonymphini Holarctic.
Genus Aphantopus 'ringlets'.
*hyperantus L. TS
maculosa Leech Chin. Like last.
arvensis Oberth. As last.

Genus Coenonympha @ 20 species.
oedippus Fab. TS Like A. hyperantus.
haydenii Edw. Nearctic. As last.
*pamphilus L. (subgenus Chortobius).
*dorus Esp. (subgenus Sicca).
arcania L.
*hero L.
sunbecca Ev.
*tullia Müller
*california Westw. (?form of last).
macmahoni Swinhoe (subgenus Lyela).
myops Stgr. (subgenus Dubierebia).

Tribe Maniolini Holarctic.
Genus Cercyonis 12+ Nearctic species. most of doubtful status.
*pegala Fab. TS
meadii Edw.
stenele Behr

Genus Hyponephele Palearctic.
lycaon Rott. TS Like small M. jurtina.
iupina Costa
maroccana Blachier

Genus Maniola (Epinephele) 12+ Palearctic species.
*jurtina L. TS
nurag Ghiliani Sardinia.

Genus Pyronia @ 6 Palearctic species. Formerly united with Epinephele.
*tithonus L. TS
cecilia Vallantin (subgenus Idata).
bathseba Fab. (subgenus Pasiphana).

Tribe Erebiini Holarctic. Most alpine

or sub-alpine.
Genus Erebia 70+ very variable species. The many subgenera are of little value.
*ligea L. TS
*aethiops Esp. (sg. Truncaefalcia).
*epiphron Knoch
*zapateri Oberth.
pronoe Esp. (subgenus Syngea).
Tribe Dirini S. African.
Genus Dira (Leptoneura) @ 12 species which resemble Erebia.
clytus L. TS Close to next.
*mintha Geyer (subgenus Torynesis).
*cassus L. (subgenus Cassus).
dingana Trim. (subgenus Dingana).
cassina Btlr. (subgenus Tarsocera).
Tribe Pronophilini 60+ Neotropical genera (1 Nearctic) with several hundred species.
Genus Gyrocheilus Nearctic. Monotypic.
patrobas Hew. TS Large f/w ocelli.
Genus Calisto @ 6 Antillean species.
zangis Hbn. TS
*hysius Godt. Smaller than last.
Genus Corades 12+ Neotropical species. Unusual wingshape.
enyo Hew. TS Gc brown, ochre f/w spots.
*iduna Hew.
*cistene Hew.
Genus Drucina @ 5 Neotropical species.
leonata Bates TS C. Rica. Cream f/w spots.
*orsedice Hew. Smaller than last. (Formerly Proboscis (propylea Hew. TS))
Genus Daedalma @ 5 Neotropical species.
dinias Hew. TS Orange f/w patch.
*inconspicua Btlr.
Genus Eretris @ 12 small Neotropical species.
decorata Feld. TS Close to next.
*porphyria Feld.
Genus Lasiophila 12+ Neotropical species. Excavate h/w costa (only Daedalma shares this feature).
*cirta Feld. TS
*prosymna Hew.
*gita sp. nov. (see APPENDIX 48).
orbifera Btlr. Close to last.
Genus Oxeoschistus @ 8 Neotropical species.
puerta Hew. TS h/w ocelli.
*pronax Hew. Last is similar.
Genus Pedaliodes 100+ Neotropical species divided between several subgenera as Altopedaliodes, Parapedaliodes, etc.
philonis Hew. TS No orange h/w band.
*hopfferi Stgr. Last is similar.
*phaedra Hew.
Genus Junea (Polymastus) @ 6 Neotropical species. Unusual verso pattern.
doraete Hew. TS
*whitelyi Druce Last is similar.
Genus Pronophila @ 12 high-altitude Neotropical species.
thelebe Dbldy. TS Close to next.
*unifasciata Lathy
Genus Steroma @ 3 Neotropical species.
bega Westw. TS Like next.
Genus Pseudosteroma @ 4 Neotropical species.
*pronophila Feld. TS
Genus Argyrophorus High-altitude Neotropical. Monotypic.
*argenteus Blanch. TS Recto all silver.
Genus Punargenteus As last genus.
lamna Thieme TS Bol. Only f/w silver.
Genus Pampasatyrus @ 12 Neotropical montane species, resembling Maniola or Pyronia.
gyrtone Berg. TS
*limonias Phil. Last is similar.
Genus Lymanopoda @ 30 Neotropical species in several subgenera.
samius Westw. TS Col. Gc pale blue.
*nivea Stgr.
*labda Hew.
*leaena Hew. (subgenus Penrosada).
*acraeida Btlr. (subgenus Zabirnia).
Tribe Satyrini 'satyrs' or 'graylings' 20 Holarctic genera, most formerly united as **Satyrus** (actaea L. TS).
Genus Aulocera @ 5 Himalayan species.
brahminus Blanch. TS Narrower bands.
*saraswati Koll. Last is similar.
Genus Brintesia Palearctic. Monotypic.
circe Fab. TS Like last but larger.
Genus Chazara Palearctic.
briseis L. TS Similar to H. semele.
prieuri Pierret
Genus Hipparchia @ 12 Palearctic species.
fagi Scop. TS Larger than next.
fagi Scop. TS Larger than next.
*semele L. (formerly in Eumenis).
Genus Paroenis Palearctic.
pumilus Feld. TS Close to next.
*palaearcticus Stgr.
Genus Neominois Nearctic. Monotypic.
*ridingsii Edw. TS
Genus Oeneis @ 20 Holarctic species, arctic & sub-artic.
norna Thunberg TS Palearctic. Darker.
*uhleri Reak. Nearctic. Smaller than last.
aello Hbn. (subgenus Chionobas).
Genus Davidina Palearctic. Monotypic. (Provisional placing).
armandi Oberth. TS Like Aporia (Pier.)
Tribe Melanargini The single Palearctic genus has been divided into several subgenera.
Genus Melanargia (Arge or Agapetes) 12+ black & white species.
*galathea L. TS
*occitanica Esp.

Pages 250-253
FAMILY ITHOMIIDAE Almost entirely Neotropical. First pair of legs reduced. Antennae usually long,

only slightly thickened at the tips. (see APPENDIX 49).
Subfamily Tellervinae Aust.
Genus Tellervo Monotypic. The forms shown as doubtful are almost certainly only sub-species. Lfp Parsonia
*zoilus Fab. TS
*assarica Stoll
?fallax Stgr.
?nedusia Geyer
?parvipuncta J. & T.
?juriaansei J. & T.
?aequicinctus Godm. & Salv.
Subfamily Ithomiinae Neotropical. ♂♂ have long hairs on costal h/w margin. Lfp principally Solonaceae.
Tribe Tithoreini
Genus Roswellia Monotypic.
acrisione Hew. TS Ecua. Like next.
Genus Athesis Monotypic.
*clearista Dbldy. & Hew. TS
Genus Eutresis
*hypereia Dbldy. & Hew. TS
dilucida Stgr. Central America.
Genus Patricia Formerly included in Athesis. Species resemble small P. dido (Heliconiidae).
dercyllidas Hew. TS Colombia & Ecuador
oligyrtis Hew. Bolivia & Ecuador.
Genus Olyras Like Hyaliris but larger
crathis Dbldy. TS Venezuela & Ecuador.
theon Bates Mexico & Guatemala.
insignis Salv. Central America.
Genus Athyrtis Monotypic. Like large Mechanitis.
mechanitis Feld. TS Colombia – Bolivia.
Genus Tithorea (Hirsutis)
harmonia Cr. TS Very variable.
*tarricina Hew. As last.
Genus Elzunia (Tithorea)
bonplandii Guér. TS Close to next.
*cassandrina Srnka
*regalis Stoll.
*pavonii Btlr. Comp. Heliconius atthis.
humboldtii Latr. Colombia & Ecuador.
tamasea Hew. Colombia.
atahualpa Fox Peru.
Tribe Melinaeini
Genus Melinaea @ 18 species; some closely resemble Heliconiidae.
egina Cr. (ludovica Cr.) TS Widespread.
*comma Forbes Comp. H. numata aristiona.
mothone Hew. Very close to last.
*mnemopsis Berg.
*mneophilus Hew.
*maelus Hew.
Tribe Mechanitini
Genus Mechanitis @ 17 species.
*polymnia L. TS
*mantineus Hew.
*messenoides Feld. Comp. Melinaea comma.
*lycidice Bates
*truncata Btlr. (subgenus Forbestra).
Genus Sais
*rosalia Cr. TS
*zitella Hew.
Genus Scada @ 6 very small species. Like Aeria but antennae shorter.
karschina Hbst. TS
Genus Xanthocleis (Aprotopus) @ 5 species.
*aedesia Dbldy. & Hew. TS
Tribe Napeogenini
Genus Aremfoxia Monotypic. (Formerly included in Leucothyris (Oleria)).
ferra Haensch TS Bol. Thyridia-like.
Genus Napeogenes (part as Ceratinia) 40+ species.
cyrianassa Dbldy. & Hew. TS Widespread.
*crispina Hew.
*tolosa Hew.
*peridia Hew.
Genus Placidula Brazil etc. Monotypic. Formerly in Ceratinia.
euryanassa Feld. TS Like H. daeta.
Genus Rhodussa Brazil etc. ?Monotypic. (Formerly in Ceratinia).
pamina Haensch TS (?form of next).
cantobrica Hew. Like N. euclea.
Genus Garsauritis Brazil. Monotypic.
xanthostola Bates TS Braz. Like N. tolosa.
Genus Hypothyris (Ceratinia) 30+ species.
ninonia Hbn. TS Close to next.
*euclea Latr.
*antonia Hew.
*daeta Bsdv.
*lycaste Fab.
*pyrippe Hopff.
Genus Hyaliris 20+ species.
*coeno Dbldy. & Hew. TS
*excelsa Feld.
*avinoffi Fox
*oulita Hew.
*ocna H.-Schaff.
Tribe Ithomiini
Genus Ithomia 25+ species.
*drymo Hbn. TS
*hyala Hew.
*ellara Hew.
*iphianassa Dbldy. & Hew.
*anaphissa H.-Schaff.
Genus Pagyris @ 3 species formerly with last genus.
ulla Hew. TS Col. Brownish, transparent.
Genus Miraleria Formerly with Ithomia.
cymothoe Hew. TS Venezuela & Colombia.
sylvella Hew. Like E. salvinia.
Tribe Oleriini
Genus Oleria (part as Leucothyris) @ 24 species.
astrea Cr. TS Guy. No red apex.
*tigilla Weym. Last is similar.
*makrena Hew.
*zelica Hew.
Genus Aeria @ 6 species.
*eurimedia Cr. (aegle Fab.) TS
*elodina Stgr.
Genus Hyposcada @ 9 species, resembling

small Napeogenes or Mechanitis.
adelphina Bates TS Like N. tolosa.
fallax Stgr. Like M. messenoides.
Tribe Dircennini
Genus Callithomia @ 15 species, some referred to subgenus Leithomia.
alexirrhoe Bates TS Braz. Dark h/w.
*phagesia Hew. Last is similar.
*hydra Feld.
Genus Dircenna 15+ species.
jemima Geyer (iambe Dbldy.) TS Col.
*dero Hbn.
marica Feld. Close to last.
Genus Velamysta @ 6 transparent species.
cruxifera Hew. TS. Like H. theudelinda.
Genus Ceratinia (Calloleria) @ 12 Mechanitis-like species.
neso Hbn. TS Close to last.
*nise Cr.
Genus Episcada @ 13 species.
*salvinia Bates TS
*mira Hew.
Genus Hyalenna @ 4 transparent species, formerly included in last genus.
parasippe Hew. TS
Genus Pteronymia 50+ species.
aletta Hew. TS Colombia & Venezuela.
*huamba Haensch Last is similar.
*primula Bates
Tribe Godyridini (Thyridini)
Genus Thyridia @ 4 species.
*psidii Cr. TS
Genus Epityches @ 6 species.
*eupompe Geyer TS (Formerly in Ceratinia).
Genus Godyris (Dismenitis) @ 12 species.
*duillia Hew. TS
*zygia Godm. & Salv.
*zavaleta Hew. (TS of sg. Dismenitis).
Genus Dygoris @ 4 species.
dircenna Feld. TS Col. Similar to last.
Genus Pseudoscada 10+ tiny transparent species.
utilla Hew. (pusio Godm. & Salv.) TS Col.
Genus Hypoleria @ 17 species.
libera Godm. & Salv. TS (?form of next).
vanilia H.-Schaff. Col. Rust h/w.
*morgane Hbn. Last is similar.
*andromica Hew.
*libethris Hew.
diaphanus Dry. (subgenus Greta).
Genus Mcclungia 3 or 4 small transparent species.
salonina Hew. TS Bolivia.
Genus Hypomentis @ 4 species.
*theudelinda Hew. TS
Genus Veladyris @ 5 species.
pardalis Salv. TS Ecua. Close to last.
Genus Heterosais 3 or 4 transparent species.
nephele Bates (edessa Hew.) TS Amazon.
Genus Corbulis (Epithomia) @ 6 transparent species.
agrippina Hew. (callipero Bates) TS
*ocalea Dbldy. & Hew. Last is similar.

Pages 254-259
FAMILY DANAIDAE All world regions but principally tropical. The first pair of legs atrophied and, in males, brush-like. Antennae gradually thickened towards the tips. Sex brands & elaborate scent-diffusing structures are present in males of many species. Lfp principally Asclepiadaceae & Apocynaceae.

Subfamily Lycoreinae Almost exclusively Neotropical. Species have some features in common with Ithomiidae. Lfp ?Ficus.
Genus Lycorea (Lycorella)
atergatis Dbldy. & Hew. TS (?f. of next)
*ceres Cr. Also S. USA.
pasinuntia Stoll Guyana.
?cleobaea Godt. (ceres-form)
?halia Hbn. Braz. (as last).
?eva Fab. Guyana. (as last).
Genus Ituna
phenarete Dbldy. TS More transparent.
*lamirus Latr. Last is similar.
ilione Cr. S. Brazil. (poss. phenarete-f.)
Subfamily Danainae All world regions.
Genus Danaus 'milkweeds' or 'tigers'.
Grp. I (plexippus-group) American.
*plexippus L. (archippus Fab.) TS
*gilippus Cr. (subgenus Anosia).
*eresimus Cr.
cleophile Godt. Antilles. Smaller.
?plexaure Godt. Braz. (poss. plexippus-f.).
?cleothera Godt. (poss. eresimus-form).
Grp. II (formosa-group) African.
*formosa Godm. (subgenus Melinda).
Grp. III (chrysippus-group) Indo-Aust.
*chrysippus L. Also Af. (sg. Panlymnas).
*genutia Cr. (plexippus L.) (sg. Salatura)
*philene Stoll
*affinis Fab.
*melanippus Cr.
Grp. IV (ismare-group) Celeb. & Moluccas.
ismare Cr. Black & White. formosa-shape.
Grp. V (limniace-group) Indo-Aust.
*limniace Cr. Also Af. (sg. Tirumala).
melissa Stoll Ind. Close to last.
hamata MacLeay (poss. form of last).
gautama Moore Burma.
*choaspes Btlr.
?ishmoides Moore (poss. melissa-form).
Grp. VI (aspasia-group)
*aspasia Fab.
*cleona Cr.
*pumila Bsdv.
*schenkii Koch
*melusinae G.-Smith.
*weiskei Roths.
*eryx Fab. (agleoides Feld.)
philo G.-Smith.
vitrina Feld.
clinias G.-Smith.
garamantis Godm. & Salv.
apatela J. & T.
?kirbyi G.-Smith.

Grp. VII (aglea-group)
aglea Cr. Smaller than next (s.g. Parantica).
*melaneus Cr.
*fumata Btlr.
*sita Koll. (tytia Gray) comp. P. agestor (Pap.)
melanoleuca Moore
phyle Feld.
albata Zink.
nilgiriensis Moore
luzonensis Feld.
banksi Moore
crowleyi Jenner-Weir
menadensis Moore
dannatti T.
?taprobana Feld.
Grp. VIII (similis-group)
similis L. Close to next.
*vulgaris Btlr. Next is similar.
juventa Cr. Indo-Aust. Widespread.
oberthueri Doherty
Genus Ideopsis. Appears 'transitional' between Danaus and Idea but is more closely allied to the former.
*gaura Horsf. TS
*vitrea Blanch
daos Bsdv.
anapis Feld.
ribbei Rob.
klassika Mart.
inuncta Btlr.
hewitsoni Kirsch
Genus Idea 'paper-butterflies'. Large Oriental species with a lazy flight.
idea L. TS Moluccas paler than next.
*blanchardi March
d'urvillei Bsdv.
*hadeni W.-Mas. (agamarschana Feld.)
*lynceus Dry.
*leuconoe Er.
*jasonia Westw. Next is similar.
hypermnestra Westw. Larger, rounded wings.
logani Moore
electra Semp.
?malbarica Moore
?stolli Moore
Genus Amauris (niavius L. TS) Ethiopian. Lfp Tylophona & Cyanchum.
Grp. I (vashti-group) . .
*vashti Btlr. (subgenus Cadytis).
Grp. II (ansorgei-group)
ansorgei Sharpe (subgenus Panamauris).
*ellioti Btlr. Markings more yellow.
Grp. III (niavius-group)
*niavius L. TS
tartarea Mab.
*damocles Beauvoir (?form of last).
Grp. IV (egialea-group)
egialea Cr. As damocles. f/w bands whole
fenestrata Auriv.
nossima Ward
ochlea Bsdv.
hecate Btlr.
dira Neave
inferna Btlr.
dannfelti Auriv.
hyalites Btlr.
Grp. V (echeria-group)
*echeria Stoll Very variable.
*albimaculata Btlr.
lobulenga Sharpe Close to last.
comorana Oberth.
reducta Auriv.
intermedius Hulstaert
phaedon Fab.
Subfamily Euploeinae Almost entirely Indo-Aust. A small number found in the Ethiopian & Palearctic regions. Basically dark brown with white markings — many flushed with purple-blue. Sexual dimorphism is more marked than in other Danaid subfamilies.

Genus Euploea. Lfp Ficus, Nerium, etc.
Grp. I (corus-group)
corus Fab. TS Close to next.
*phaenareta Schaller Variable.
*callithoe Bsdv.
althaea Semp.
eucala Stgr.
Grp. II (leucostictos-group)
*leucostictos Gmelin Widespread.
*mniszechii Feld.
*nemertes Hbn. Variable.
*treitschkei Bsdv. Variable.
*radamanthus Fab. (diocletianus Fab.)
eustachius Kirby
midamus L. Also Palearctic.
eleusina Cr.
vollenhovii Feld. Like mniszechii.
dehaanii Lucas
meyeri Hopff.
labreyi Moore
asyllus Godm. & Salv.
usipetes Hew. Like nemertes.
gamelia Hbn. (blossomae Schaus)
martinii de Nicév.
roepstorffi Moore
atossa Pag.
simillima Moore
fabricii Moore
dameli Moore
klugii Moore
eupator Hew.
?depuiseti Oberth.
Grp. III (stephensii-group)
*stephensii Feld. (pumila Btlr.)
*tulliolus Fab. Very variable.
arisbe Feld.
mazares Moore
visenda Btlr.
menamoides Fruhst.
hopfferi Feld.
pyres Godm. & Salv.
trimenii Feld.
hewitsonii Feld.
Grp. IV (mulciber-group) Indo-Malay.
*mulciber Cr.
gelderi Snell.
euctemon Hew.

?semperi Feld. poss. mulciber-f.
Grp. V (sylvester-group) Most Aust.
*sylvester Fab.
*dufresne Godt. Variable.
coreta Godt. Ind.
melina Godt.
peloroides J. & T.
albicosta J. & Noakes
?gloriosa Btlr.
?picina Btlr.
Grp. VI (wallacei-group)
*wallacei Feld.
*redtenbacheri Feld.
*batesii Feld.
*algea Godt.
*boisduvalii Lucas
climena Cr.
eyndhovii Feld.
palmedo Doherty
compta Rob.
eboraci G.-Smith.
lewinii Feld.
radica Fruhst.
albomaculata van Eecke
jennesis Carpenter
insulicola Strand
latefasciata Weym.
crameri Lucas
nobilis Strand
cratis Btlr.
modesta Btlr.
cameralzeman Btlr.
deheerii Doherty
funerea Godt.
alecto Btlr.
obscura Pag.
eichhorni Stgr.
ebenina Btlr.
resarta Btlr.
*eleutho Godt.
Grp. VII (eurianassa-group)
*eurianassa Hew.
*core Cr. Widespread.
distantii Moore
orontobates Fruhst.
scherzeri Feld. (camorta Moore).
lacon G.-Smith.
andamanensis Atk.
amymone Godt.
bauermanni Rob.
alcathoe Godt.
snelleni Moore
tobleri Semp.
deione Westw.
swainson Godt.
abjecta Btlr.
horsfieldii Feld.
maura Feld.
schmeltzi H.-Schaff.
subnobilis Strand
helcita Bsdv.
guerini Feld.
illudens Btlr.
hemera Fruhst.
dalmanii Feld.
charox Kirsch
lapeyrousei Bsdv.
netscheri Snell.
dentiplaga Roths.
baudiniana Godt.
irene Fruhst.
transfixa Mont.
Grp. VIII (euphon-group) Seychelles etc.
euphon Fab.
desjardinsii Guér.
goudotii Bsdv.
mitra Moore
rogeri Geyer

APPENDIX see page 274

All species illustrated or mentioned in the general text are included here. Many more will be found classified in the appropriate sections of the systematic list. Note: Bold figures indicate where butterflies are illustrated elsewhere than on the large double-spreads.

273

Appendix

1 Two aberrations figured have been named as follows:
Graphium sarpedon ab.*antenigra* ab.nov. – for specimens with all black f/w. *Papilio nobilis* ab.*josetta* ab.nov. – for ♀♀ with greatly extended spotting.
2 Tribe Druryeini tribus nov. Large, stoutly-bodied species, basically red-brown & black, wing pattern primitive, shape as in the *cynorta*-group of Papilionini. Head & thorax black, white spotted, abdomen yellow, striped or spotted. Antennae short, black, unscaled. – Two genera – Druryeia – Drury.ia – Abdomen reaches anal angle, hindwing anal area simple.
Type-species *antimachus* Drury.
Iterus – Abdomen does not reach anal angle, hindwing anal area shows modification and rudimentary extra vein.
Type-species *zalmoxis* Hewitson.
(The females of both species are tree-top dwellers in primeval forest and in consequence very seldom seen.)
The placing of the African species *antimachus* and *zalmoxis* within the Papilionini obscures their unique character. Early authors linked them with Troidini which is even less justified. However the presence of body-poisons in *antimachus* is well known and detailed study of the life-history of this species may yet prove i) that the larva feeds on members of the Aristolochiaceae and ii) that the early stages show features not present in Papilionini. The oft-repeated suggestion that *antimachus* is a mimic of some lost *Acraea*, is an example of one-way thinking. The red-black pattern, common to many aposematic species, may be much more primitive than is generally believed, indeed ancestral *antimachus*-forms, which may have been smaller, possibly provided a pattern for other species.
zalmoxis, to a lesser extent also exhibits a wing-pattern found in other protected species. The strange blue colouration is likely to be a secondary acquisition as is the extension of the fore-wing apex in male *antimachus*. It should be pointed out that if the wing-pattern, body-colour etc. of *antimachus/zalmoxis* were presumed to be primitive then some re-interpretation of mimetic theory would be necessary. Looking elsewhere, for example the Neotropical *zagreus*-group might well present the survival of a more primitive type, albeit with secondary 'Mullerian' changes rather than a subsequent modification.
3 Over-enthusiasm for subspecies designation has led to the creation of many other 'forms' of *Ornithoptera* particularly *paradisea* and *goliath* – most of these are best disregarded.
4 The famous *allotei* is extremely rare but whether it is a true species or a hybrid *O.p.urvilleanus X O.v.regis* is still in doubt, although larvae produced from such a mating have been reared with partial success.
5 Scudder (1875) selected the African *creona* Cr. as the type of the genus *Anaphaeis* but this is congeneric with *calypso* Dry. – type-species of *Belenois*.
6 Superficial resemblance between this genus and *Hebomoia* obscures its true nature. In structure and life-history it is close to *Cepora*.
7 Members of this and the following genera within the Pierini have been grouped by some authors as a subfamily Euchloeinae. However such a broad division obscures the close relationships within the Pierinae and cannot justifiably be maintained.
8 *crocale* Cr. is now known to be a recurrent form of *pomona* Fab. *pomona*-forms have red antennae; males above are similar to *Phoebis statira*. *crocale*-forms have black or only slightly reddened antennae; males are generally more yellow than *pomona*-forms.
9 The old specimens of *avellaneda* shown cannot do justice to this most splendid of the Pieridae, which takes its name from Getrudis Gomez de Avellaneda (1814–1873) Cuba's national poetess.
10 The generic names *Eurema* and *Terias* have been much misused. They are here treated, according to their type-species, as divided into New World (*Eurema*) and Old World (*Terias*) forms. In other works they will frequently be found united under *Eurema*.
11 The subspecies of *similis* figured is associated with *kirbyi* Dew. by some authors.
12 It should be noted that '*Thecla*' is still used indiscriminately for species in a vast number of other genera, particularly Neotropical.
13 *ctesia* is included by some authors in the genus *Pratapa* (Deudorigini) of which the type-species is *deva* Moore.
14 For many Neotropical species the generic designation '*Thecla*' will be found even in current works and museum collections. It is used here for only a few species of uncertain position. Such usage is a matter of convenience and should not be confused with the true genus *Thecla* (type-species *betulae* L.). A thorough revision of this tribe is long overdue.
15 A number of new genera have been based on this name such as *Euristrymon*, *Chlorostrymon* etc.
16 The exact species limits within this genus are uncertain £ the form of *argiades* figured is sometimes regarded as a *lacturnus*-form. Further some authorities regard *argiades* and *comyntas* as conspecific.
17 The name *Polyommatus* was originally used much more widely to embrace a large section of the 'blues'. At other times it was employed for the 'coppers' (Lycaeninae) and *Lycaena* applied to the present subfamily.
18 The complete isolation of these three species and certain small but significant differences in pattern element, particularly on the undersides suggest that they are entitled to subgeneric rank. Accordingly the name *Antipodolycaena* gen.nov. (type-species *boldenarum* Btlr.) is here proposed as a subgenus of *Lycaena*.
19 Two species which seem closely allied to this genus have recently been reported from New Guinea.
20 The only extensive monograph on this enormous section (Seitz. Macrolepidoptera vol. V 1924) is now regrettably out of date. A revision of the family is long overdue and no attempt has been made here to indicate tribal or other divisions.
21 This curiosity has a chequered taxonomic history. In the past it has been associated with Pieridae, Ithomiidae or even given a family of its own – Stygidae. Current entomological opinion suggests that it is correctly placed here but its affinities are still not clear.
22 This form is a member of a Neotropical 'mimicry ring' which includes *Papilio bachus* (Papilionidae) *Melinaea mothone*, *M. comma*, *Mechanitis messenoides* & *Hyposcada fallax* (Ithomiidae) and several other butterflies, and at least two moths *Castnia strandi* (Castniidae) and *Pericopis hydra* (Arctiidae).
23 This may well prove to be a distinct species. It is somewhat similar in appearance to *Elzunia pavonii* (Ithomiidae).
24 The specimen figured is possibly a new subspecies. It differs from *s sapho* in the broader h/w margins.
25 The unfortunate situation that the type-species of *Eueides* is now regarded as an *isabellae*-form will need to be rectified.
26 The two preceding families and all of those which follow are frequently united – either as one family Nymphalidae – or given super-family status as Nymphaloidea. The first of these systems would treat the butterflies covered in this section as a subfamily Nymphalinae, and the second as a number of smaller families such as Charaxidae, Limenitidae etc. Both these systems have their merits but involve complications that would be unacceptable in an introductory work. Therefore the 'traditional' view of Nymphalidae is retained here. Much work remains to be done on the systematics of this family; however the broad divisions which are indicated here, despite imperfections, should be helpful to the beginner. 'Sections' and tribes must be regarded as somewhat arbitrary, and the divisions employed should not necessarily be regarded as of equal status.
27 This genus and the two which follow are 'false fritillaries' and only provisionally placed here; they have several features in common with *Cupha*, *Vagrans* and *Vindula* (Nymphalinae).
28 The genus *Dynamine* has suffered much at the hands of taxonomists and has previously been placed in Limentinae or Eurytelinae. Neither position is wholly satisfactory. Their placement here is only tentative – there is some evidence of affinity with Melitaeini.
29 Many authorities believe that the genus *Anetia* properly belongs to the Danaidae.
30 This Holarctic species also known as *l-album* Esp. or *j-album* Bsdv. & Leconte has frequently been incorrectly placed in the genus *Polygonia*.
31 It should be pointed out that swollen sub-costal veins are found in other genera for example *Eunica*, *Bolboneura* and *Lucinia* so this feature alone cannot be regarded as diagnostic.
32 As a subgenus of *Temenis* the name *Callicorina* gen.nov. (type-species *pulchra* Hewitson) is proposed as a replacement for the invalid name *Paromia* Hewitson. This new name refers to the recto surface recalling a small *Callicore*-species.
33 Dillon (1948) suggested that this genus should be placed in a tribe of its own.
34 The earlier name *Callicore* is now applied to another genus which may give rise to some confusion. The present genus *Callicore* (type-species *astarte* Cr.) was formerly known as *Catagramma*. The use of the latter name is regrettably now invalid for two reasons:
(i) *Catagramma* was based on a mis-identified type-species *hydaspes* Bsdv. (= *pygas* Godt.).
(ii) There is no justification for a generic separation of the nominal species *pygas* from *astarte*.
35 The relationships of the single species *inexpectata* are uncertain – very little is known of this rarity. Although there is some resemblance to females of the *caenis*-group of *Cymothoe*, the wingshape, olive ground colour and red cell spots suggest *Euthalia*. Structurally there are similarities to *Pseudacraea*.
36 The Neotropical genera which constitute this section are placed by some authors with Eurytelinae, on the basis of the swollen forewing veins, characteristic of many genera in that subfamily. Both the early stages and the adult structure exhibit specialised features and there

is some justification for treating them as a subfamily.

37 Earlier authors placed this species in Eurytelinae but Shirôzu (1955) suggested that it properly belongs here.

38 Fruhstorfer, in Seitz Macrolepidoptera (1927), placed this genus in Nymphalinae but it would seem to be closely allied to *Dichorragia*.

39 The specimens figured of *laure, cyane, cherubina* and *lavinia* have a somewhat distorted appearance since they have been tilted to display their reflective quality.

40 The Apaturinae are quite possibly not represented in the Ethiopian region and the inclusion of *Apaturopsis* in this subfamily is tentative only. Most authorities refer them to Nymphalinae but study of the early stages may confirm their placement here.

41 Although this Neotropical genus probably comprises less than half a dozen species, the enormous range of local variation, together with extensive polymorphism and parallelism (resembling other *Agrias*-species or other Nymphalid genera) give rise to hundreds of forms. In consequence determination of specimens may well be difficult. The majority of forms are of great beauty and rarity and are in consequence highly prized by collectors. Because of this any study of the genus is likely to be hampered by two factors. Firstly the difficulty and expense of obtaining wide-ranging material, and secondly the reluctance of field collectors to disclose exact localities, rendering gaps inevitable in any distribution survey.

42 *Prepona sarumani* sp.nov.
♂ recto. f/w red with pronounced magenta flush – towards the outer margin orange-red. Apical third, outer and hind-margins black. Purple-blue suffusion on hind-margin and a broad streak of the same colour running from the costa between the red area and the apex. Outer margin strongly excavate.
h/w black with extensive purple-blue central patch surrounding the cell and only slightly invading it. A broken band of very faint red submarginal scaling. Hair tufts yellow. Outer margin strongly dentate; pronounced lobe at anal angle.
♂ verso. f/w pinkish-red. Two orange-margined black spots in cell. Apical third dark grey-brown, crossed by two sinuate black lines.
h/w dark grey-brown. Black spotting in and around cell of *Agrias*-pattern but much reduced; basally reddish. Two squarish cream submedian spots as in *buckleyana*. Median band broad, consisting of fine silvery-white dots on a darker ground. Complete chain of submarginal blue, white-centered, ocelli as in *A.c. lugens* but much smaller and surrounding area darker.
This remarkable insect in appearance lies midway between *P. buckleyana* and *A.c. lugens* but the wingshape and overall facies, particularly on the lower surface, are much closer to the former. While it may possibly yet prove to be an *Agrias*-form it affords the most striking evidence of the close relation between these two genera.
Holotype♂ in the Saruman Museum. Type locality Rio Huallaga, Peru.
♀ not known.

43 This arrangement of the Indo-Australian *Charaxes* into three groups is tentative only and will certainly need revision.

44 Rydon (1971) regards the forms of this species as distinct but this is based on rather questionable evidence of the larval stages and remains non-proven (see page 65).

45 Considerable variation is found in some *Morpho*-species, for example *M. telemachus* which may be basally blue or ochre-yellow and the many species of the *achilles*-complex. It is therefore quite probable that the number of recognised species may well be drastically revised. The arrangement here is adapted from that of Le Moult & Real (1962-3). It should be pointed out that the subgeneric names employed (with the exception of *Iphimedeia*) have yet to be accepted, but few would find fault with the species-groups.

46 This family has affinities with Satyridae and Miller (1968) includes the Brassolids under that heading. However such a broad arrangement would necessarily also embrace the allied Morphidae and Amathusiidae and cannot be employed here.

47 The name *Callitaera*, previously employed for the genus *Cithaerias*, would seem to be based on a misidentified type-species *aurora* Felder.
The form figured of *Pierella hortona* is unusual and seems to be confined to a small area of Peru. *orellata* f.nov. is proposed for this form in which the normally all-blue patches are white-centred.

48 *Lasiophila gita* sp.nov.
♂ recto. f/w bright chestnut brown with narrow dark brown margins. Submarginal row of four dark brown spots. Costa darkened from the mid-point of the cell, this darkening extending over the cell-apex and the median and first cubital veins.
h/w similarly coloured. Six to seven dark brown submarginal spots in a curving row. Outer margin dentate especially at Cu¹ but not 'tailed'.
♂ verso. f/w similar to, but paler than, recto with silver-grey patch at the costal apex.
h/w marbled with silver-grey and crossed by a broad, angled dark-brown median band. An extensive patch of the latter colour towards the outer margin encloses two yellow lunulate spots which are continuous with a fine dentate submarginal band.
This species was previously considered to be a form of *orbifera* Btlr.
Holotype♂ in the Saruman Museum. Type locality Rio Huallaga, Peru.
♀ not known.

49 The arrangement of tribes and genera in this family has been subject to more than the usual amount of nomenclatural mishap, especially in vol. V of Seitz Macrolepidoptera.

References

Ackery, P. R. (1975) A guide to the genera and species of Parnassiinae. Bull. Brit. Mus. nat. Hist. (Ent.) 31:4 74–105.
Bateson, W. (1909) Mendel's principles of heredity. London.
Beebe, W. (1950) High jungle.
Beirne, B. P. (1947) The origin and history of the British Macro-Lepidoptera. Trans. R. ent. Soc. Lond. 98:7.
Bowdler-Sharpe, E. (1914) A monograph of the genus *Teracolus*. London.
Bright, P. M. & Leeds, H. A. (1938) A monograph of the British aberrations of the chalk-hill blue butterfly. Bournemouth.
Brooks, C. J. (1950) A revision of the genus *Taenaris*. Trans. R. ent. Soc. Lond. 101:179–238.
Brower, J. VZ. (1958) Experimental studies of mimicry in some North American butterflies. Evolution. 12:3.
Bryk, F. (1935) Lepidoptera Parnassiidae II. 65:790pp.
Carcasson, R. H. (1961) The *Acraea* butterflies of East Africa. Journal of the East African Nat. Hist. Soc. Suppl. 8 48pp.
Carpenter, F. M. (1930) A review of our present knowledge of the geological history of insects. Psyche 37:15–34.
Carpenter, G. D. H. (1941) The relative frequency of beak-marks on butterflies of different edibility to birds. Proc. zool. Soc. Lond. 111:223–231.
Carpenter, G. D. H. (1953) The genus *Euploea* in Micronesia, Melanesia, Polynesia & Australia. Trans. zool. Soc. Lond. 28:1–165.
Clarke, C. A. and Sheppard, P. M. (1959–1962) The genetics of *Papilio dardanus*. Genetics. 44, 45 and 47.
Clarke, C. A. & F. M. M. & Sheppard, P. M. (1968) Mimicry and *Papilio memnon*. Malay nat. J. 21:4.
Clarke, C. A. and Sheppard, P. M. (1972) The genetics of *Papilio polytes*. Phil. Trans. Roy. Soc. Lond. Biol. Sc. 263:855.
Committee for protection of British Lepidoptera. (1929) Report on the establishment of the large copper in the British Islands. Proc. ent. Soc. Lond. 4: 53–68.
Comstock, W. P. (1961) Butterflies of the American tropics: the genus *Anaea*. Amer. Mus. of Nat. Hist.
Corbet, A. S. (1943) A key for the separation of the Indo-Australian and African species of the genus *Euploea*. Proc. R. ent. Soc. Lond. (B) 12:17–22.
Cowan, C. F. (1968 & 1970) Annotationes rhopalocerologicae.
Dethier, V. G. (1937) Gustation and olfaction in Lepidopterous larvae. Biol. Bull., 72:7–23.
Dillon, L. S. (1948) The tribe Catagrammini. Part I. The genus *Catagramma* and allies. Reading Museum Scientific publication. 8.
Dowdeswell, W. H., Fisher, R. A. & Ford, E. B. (1940) The quantitative study of populations in the Lepidoptera. Annuls of Eugenics. 10:123–36.
Ehrlich, P. R. (1958) The comparitive morphology, phylogeny and higher classification of the butterflies. Univ. of Kansas Sc. Bull. 39:305–370.
Eliot, J. N. (1963) A key to the Malayan species of *Arhopala*. Journal of the Malay nat. Soc. 17:4. 188–217.
Eliot, J. N. (1969) An analysis of the Eurasian and Australian Neptini. Bull. Brit. Mus. nat. Hist. (Ent.), Suppl. 15:1–155.
Eliot, J. N. (1973) The higher classification of the Lycaenidae: a tentative arrangement. Bull. Brit. Mus. nat. Hist. (Ent.) 28:6. 373–505.
Eltringham, H. D. (1910) African mimetic butterflies. Oxford.
Eltringham, H. D. (1912) Monograph of the African species of the genus *Acraea*. Trans. ent. Soc. Lond. 1:374.
Eltringham, H. D. (1916) On specific and mimetic relationships in the genus *Heliconius*. Trans. ent. Soc. Lond. 101–148.
Eltringham, H. D. (1930) Histological and illustrative methods for entomologists, Oxford.
Eltringham, H. D. (1933) The senses of insects. Methuen.
Emsley, M. G. (1963) A morphological study of imagine Heliconiinae. Zoologica, 48:85–130.

Emsley, M. G. (1964) The geographical distribution of the color-pattern components of *Heliconius erato* and *Heliconius melpomene*. Zoologica 49:245–289.
Emsley, M. G. (1965) Speciation in *Heliconius*. Zoologica 50:191–254.
Euw, J. V. et al. (1967) Cardenolides. Nature. 214:5083.
Evans, W. H. (1939–1955) A catalogue of the Hesperiidae. Brit. Mus. nat. Hist.
Evans, W. H. (1957) A revision of the *Arhopala* group of Oriental Lycaenidae. Bull. Brit. Mus. nat. Hist. (Ent.) (5) 3:85–141.
Ferris, C. D. (1973) A revision of the *Colias alexandra* complex aided by ultraviolet reflectance photography. J. Lep. Soc. 27:1.57–73.
Forbes, W. T. M. (1932) How old are the Lepidoptera? Amer. Nat. 66:452–460.
Forster, W. (1964) Beitrage zur kenntnis der Insecktenfauna Boliviens XIX Lepidopetra III Satyridae. Veroff. Zool. Staatssammal. Munchen 8:5–188.
Fox, R. M. (1956) A monograph of the Ithomiidae part I. Bull. Amer. Mus. Nat. Hist. III:1. 1–76.
— (1960) Part II. Trans. Amer. Ent. Soc. LXXXVI: 109–171.
— (1967) Part III. Trans. Amer. Ent. Soc. XCIII: 190pp.
— (1971) Part IV. (completed by H. G. Real). Mem. Amer. Ent. Inst. 15.
Goldschmidt, R. (1938) Intersexuality and development. Amer. Nat. 72:228–242.
Hemming, F. (1967) The generic names of the butterflies and their type-species. Bull. Br. Mus. nat. Hist., Suppl. 9.
Higgins, L. G. (1941) An illustrated catalogue of the Palearctic *Melitaea*. Trans. R. ent. Soc. Lond. 91:7. 175–365.
Higgins, L. G. (1950) A descriptive catalogue of the Palaearctic *Euphydryas*. Trans. R. ent. Soc. Lond. 101:12.435–496.
Higgins, L. G. (1955) A descriptive catalogue of the genus *Mellicta*. Trans. R. ent. Soc. Lond. 106:1. 131pp.
Howarth, T. G. (1959) A description of a new race of *Acraea cerasa* with some notes on related species. Entomologist 92.1154.133–136.
Howarth, T. G. (1960) Further notes on *Acraea cerasa*. Entomologist 93.1168. 184–185.
Howarth, T. G. (1962) The Rhopalocera of the Rennell and Bellona Islands in The natural history of the Rennell and Bellona Is. Copenhagen (4:63–83).
Imms, A. D. (1957) A general textbook of entomology. Revised edition. Methuen.
Klots, A. B. (1933) A generic revision of the Pieridae. Ent. Amer. n.s., 9:99–171.
Klots, A. B. (1958) The world of butterflies and moths. Harrap.
Le Moult, E. & Real, P. (1962–63) Les *Morpho* d'Amerique du Sud et Centrale. Paris.
Mani, M. S. (1962) Introduction to high altitude entomology. Methuen.
McAlpine, D. (1970) A note on the status of *Ornithoptera allotei*. J. Aust. ent. Soc. 9.
Meek, A. S. (1913) A naturalist in cannibal land. London.
Miller, L. D. (1968) The higher classification, phylogeny and zoogeography of the Satyridae. Mem. Amer. Ent. Soc. 24.
Minnich, D. E. (1936) The responses of caterpillars to sounds. J. exp. zool., 72:439–453.
Munroe, E. (1961) The classification of the Papilionidae. Canad. Ent. Suppl. 17.1–51.
Nicolay, S. S. (1971) A review of the genus *Arcas* with descriptions of new species. J. Lep. Soc. 25:2. 87–108.
Norris, W. (1955) Dawn adventure. Chambers Journal.
Punnett, R. C. (1915) Mimicry in butterflies. Cambridge.
Rebillard, P. (1961) Revision systematique des lepidopteres Nymphalidaes du genre *Agrias* Mem. Mus. Nat. Hist. Paris. zool. XXII. 2.
Rothschild, W. & Jordan, K. (1906) A revision of the American Papilios. Novit. Zool. 13:412–752.
Rydon, A. H. B. (1971) The systematics of the Charaxidae. Ent. Rec. J. Var. 83: 219–233, 283–287, 310–316, 336–341, 384–388.
Schmid, F. (1970) Considérations sur le male d'*Ornithoptera allotei*. J. Lep. Soc. 24.2.
Schmid, F. (1973) Hybridisme chez les Ornithoptères. Nederland Ent. Veren. 116.9.
Scudder, S. H. (1875) Historical sketch of the generic names proposed for butterflies. Proc. Amer. Acad. Art. & Sc. 10:91–203.
Shirôzu, T. (1955) Butterflies in Fauna and flora of Nepal Himalaya. Kyoto University.
Stempffer, H. (1967) The genera of the African Lycaenidae. Bull. Brit. Mus. nat. Hist. Suppl. 10: 300pp.
Talbot, G. (1928–1937) A monograph of the Pierine genus *Delias*. London.
Teale, E. W. (1947) Near horizons. New York.
Tite, G. E. & Dickson, C. G. C. (1973) The genus *Aloeides* and allied genera. Bull. Brit. Mus. nat. Hist. (Ent.) 21 (7) 367–388.
van Someren, V. G. L. (1963–1975) Bull. Brit. Mus. nat. Hist. (Ent.) 13, 15, 18, 23, 25–27, 29 & 32.
Vane-Wright, R. I. & Smiles, R. L. (1975) The species of the genus *Zethera*. J. of Entomology. R. ent. Soc. Lond. (B) 44(1) 81–100.
Vane-Wright, R. I., Ackery, P. R. & Smiles, R. L. (1975) The distribution, polymorphism and mimicry of *Heliconius telesiphe* and the species of *Podotricha*. Trans. R. ent. Soc. Lond. 126:611–36.
Verity, R. (1940) Revision of the *athalia* group of the genus *Melitaea*. Trans. R. ent. Soc. Lond. 89:14.591–706.
Warren, B. C. S. (1926) Monograph of the tribe Hesperiidi. Trans. ent. Soc. Lond. 74:170pp.
Warren, B. C. S. (1936) Monograph of the genus *Erebia*. Brit. Mus. nat. Hist.
Warren, B. C. S. (1944) Review of the classification of the Argynnidi; with a systematic revision of the genus *Boloria*. Trans. R. ent. Soc. 94:(11) 101pp.
Williams, C. B. (1930) The migration of butterflies. Oliver & Boyd.
Williams, C. B. (1958) Insect Migration. Collins.
Young, A. M. (1974) The rearing of the Neotropical butterfly *Morpho peleides*. J. Lep. Soc. 28:2.
Zeuner, F. E. (1943) Studies in the systematics of *Troides*. Trans. zool. Soc. Lond. 25:107–184.

Picture Credits

The publishers wish to thank the following photographers and organisations who have supplied photographs for this book.
Photographs have been credited by page number. Where more than one photograph appears on the page, references are made in the order of the columns across the page and then from top to bottom.
Some references have, for reasons of space, been abbreviated as follows:
SPA: Saruman Photographic Agency
NHPA: Natural History Photographic Agency
NSP: Natural Science Photos

Cover: SPA. Endpapers: T. Scott, SPA. Title page: A. Bannister, NHPA. Contents page: R. Revels, SPA. Author's photo: SPA. Introduction : A. Bannister, NHPA.

14–15: F. Baillie, NHPA. **17:** SPA. **19:** H. Angel. **20:** J. C. S. Marsh, SPA. **21:** E. Ross, NSP. **22:** H. Angel. **22–23:** H. Angel. **25:** H. Angel. **26–27:** E. Ross, NSP. **29:** A. Bannister, NHPA. **30:** R. Revels, SPA/J. C. S. Marsh, SPA/R. Revels, SPA. **31:** A. Bannister, NHPA/R. Revels, SPA/A. Bannister, NHPA. **32:** E. Ross, NSP/E. Ross, NSP/R. Revels, SPA/E. Ross, NSP/J. C. S. Marsh, SPA/J. C. S. Marsh, SPA/R. Revels, SPA/R. Revels, SPA/R. Revels, SPA. **33:** A. Bannister, NHPA/A. Bannister, NHPA/A. Bannister, NHPA. **34:** S. Dalton, NHPA/R. Revels, SPA/S. Dalton, NHPA/J. C. S. Marsh, SPA/R. Revels, SPA/M. Rees, SPA. M. Rees, SPA. **35:** E. Ross, NSP. **36–37:** H. Angel. **38–39:** H. Angel. **40–41:** R. Goodden. **42–43:** T. Scott, SPA. **44–45:** H. W. O'Donnell, NHPA. **46–47:** E. Ross, NSP. **48–49:** A. Bannister, NHPA. **50–51:** E. Elms, NHPA. **51:** E. Elms, NHPA. **53:** SPA. **54–55:** SPA/R. Revels, SPA. **56:** SPA. **56–57:** R. Revels, SPA. **58–59:** SPA/SPA. **60:** R. Revels, SPA/R. Revels, SPA. **61:** SPA/R. Revels, SPA. **62:** A. Bannister, NHPA. **63:** SPA. **64–65:** SPA. **66:** SPA. **67:** SPA. **68:** SPA/SPA/J. C. S. Marsh, SPA. **69:** SPA. **70:** R. Revels, SPA. **72:** R. Revels, SPA/R. Revels, SPA. **73:** R. Revels, SPA/R. Revels, SPA/R. Revels, SPA/R. Revels, SPA. **74–75:** SPA. **76:** SPA. **77:** SPA. **78–79:** SPA. **80–81:** SPA. **82:** SPA/SPA. **83:** SPA. **84:** SPA. **85:** SPA. **86–87:** SPA. **87:** SPA. **88–89:** Illustrated London News/SPA. **90–91:** Illustrated London News/SPA. **93:** SPA. **94:** SPA. **95:** SPA. **96:** SPA. **97:** D. Lacombe, NSP/SPA. **98:** SPA/SPA. **100:** J. C. S. Marsh, SPA. **101:** SPA. **102–103:** P. E. Smart, SPA. **104:** R. Revels, SPA. **105:** R. Revels, SPA. **106:** SPA/SPA. **107:** SPA. **110:** R. Revels, SPA/E. Elms, NHPA. **111:** E. Ross, NSP. **112–113:** SPA. **114:** F. Baillie, NHPA/S. Dalton, NHPA. **115:** F. Baillie, NHPA. **116–159:** SPA. **160:** P. E. Smart, SPA/S. Dalton, NHPA/E. Elms, NHPA. **161:** S. Dalton, NHPA. **162–169:** SPA. **170:** E. Ross, NSP. **171:** R. Revels, SPA/E. Ross, NSP. **172–175:** SPA. **176:** R. Revels, SPA/E. Ross, NSP. **177:** E. Ross, NSP/R. Revels, SPA. **178–179:** SPA. **181:** S. Dalton, NHPA/E. Ross, NSP. **182–187:** SPA. **188:** A. Bannister, NHPA. **189:** E. Ross, NSP. **189:** A. Bannister, NHPA. **190–191:** SPA. **192:** E. Elms, NHPA. **193:** E. Ross, NSP/E. Ross, NSP. **194–221:** SPA. **223:** SPA/SPA/J. C. S. Marsh, SPA. **224—227:** SPA. **228:** E. Ross, NSP. **229:** E. Ross, NSP. **230–237:** SPA. **238–239:** E. Clifton, SPA/SPA. **240–243:** SPA. **244:** R. Revels, SPA. **244–245:** E. Ross, NSP/R. Revels, SPA. **245:** SPA. **246–249:** SPA. **250:** E. Ross, NSP. **251:** E. Elms, NHPA/F. Baillie, NHPA. **252–253:** SPA. **254:** R. Revels, SPA. **254–255:** P. E. Smart, SPA. **255:** SPA. **256–259:** SPA.

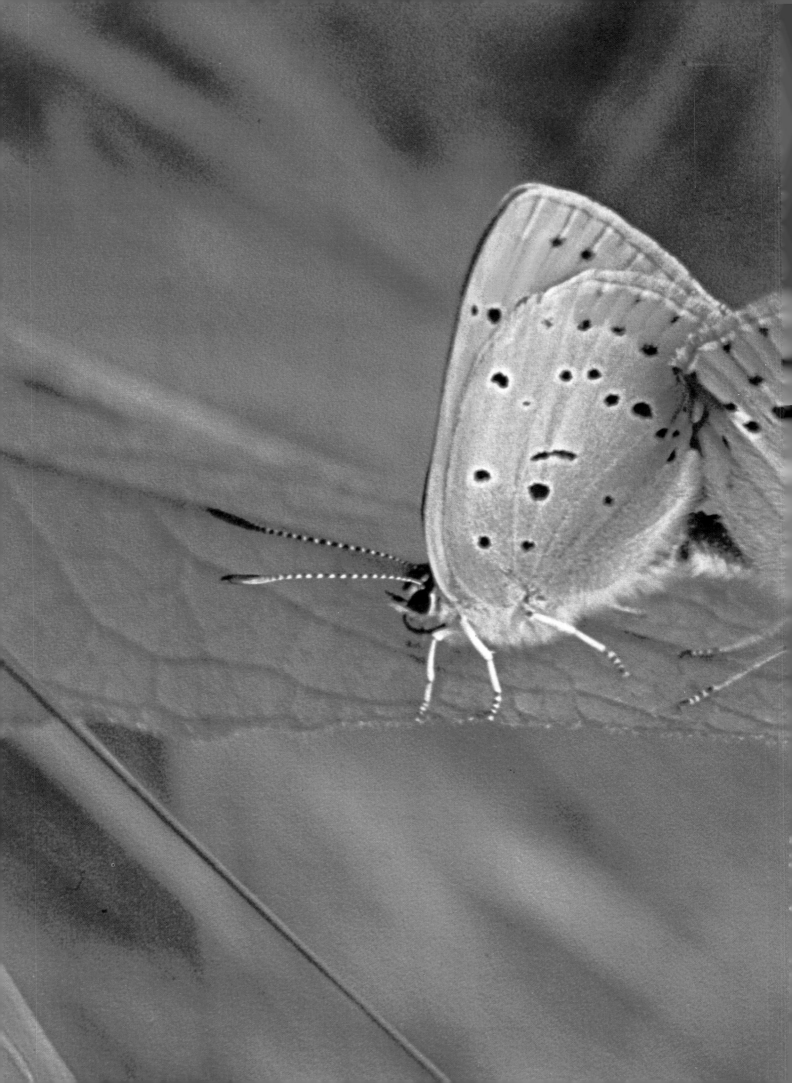